abbreviations, acronyms, and trademarks. 332 pages. H.M. Paper-
bound Pub. at $11.95 **$8.36**

**605247 VATICAN TREASURES: 2000 Years of Art and Culture in the
Vatican and Italy.** Ed. by Giovanni Morello. A dazzling selection of
200 works progressing from Byzantine icons by anonymous crafts-
men to works by Michelangelo, Raphael, Durer, and Rubens, with
text discussing the influence of Christian faith on art and chronicl-
ing the construction of Saint Peter's. 200 color illus. 303 pages. Elec-
ta/Abbeville. 9¾x11. Pub. at $55.00 **$32.95**

614718 ENCYCLOPEDIA OF TEXTILES. By Judith Jerde. Covers all
aspects of design, manufacture, dyes, printing techniques, weav-

Vatican Treasures
2000 Years of Art and Culture
in the Vatican and Italy

Vatican Treasures
2000 Years of Art and Culture in the Vatican and Italy

edited by
Giovanni Morello

Electa / Abbeville
Milan New York

Front cover
Gian Lorenzo Bernini, *Project for Saint Peter's bell towers*, 1645. Vatican City, Biblioteca Apostolica Vaticana.

Back cover
Head of the apostle Peter, 12th century. Ravenna, Museo Arcivescovile.

Phototypesetting
and reproductions by
Bassoli Olivieri Prestampa, Milan
ISBN 1-55859-298-9

First U.S. edition

Catalogue editor-in-chief
Giovanni Morello

Authors of the catalogue entries
Agata Altavilla (A.A.)
Giancarlo Alteri (G.A.)
Sandra Barberi (S.B.)
Giovanna Bernard (G.B.)
Ernesto Brivio (E.B.)
Alberto Carlo Carpiceci (A.C.C.)
Cristina Casali (C.C.)
Roberto Conti (R.C.)
Rosa Morello Dattola (R.M.D.)
Maria Concetta Di Natale (M.C.D.N.)
Giovanni Giordano (G.G.)
Giovanni Morello (G.M.)
Maria Teresa Paliani (M.T.P.)
Paolo Peri (P.P.)
Leone Porru (L.P.)
Clementina Rinaldi (C.R.)
Angelandreina Rorro (A.R.)
Pino Rubini (P.R.)
Antonio Savioli (A.S.)
Gianmaria Silvan (G.M.S.)
Pierluigi Silvan (P.L.S.)
Carlenrica Spantigati (C.S.)
Calcedonio Tropea (C.T.)
Fabio Venturoli (F.V.)
Roberta Vicchi (R.V.)
Roberto Zagnoli (R.Z.)
Lucia Zannini (L.Z.)

The unsigned catalogue entries were drawn up by the editorial staff

Translations from the Italian
Shanti Evans
Kevin William Halliwell
Jeff Jennings
Carol Lee Rathman
Kiaran O'Malley
Dominic Ronayne
David Stanton

Press Office
Electa, Milan

Vatican Treasures
2000 Years of Art and Culture in the Vatican and Italy

Denver
The Colorado History Museum
July 3rd - August 31st 1993

Ente Nazionale Italiano
per il Turismo
Italian State Tourist Board

Organized by
Fondazione Gioventù Chiesa e Speranza, Rome
Colorado Historical Society, Denver

in collaboration with
the Pontifical Council for the Laity
Italian Bishops Congress

and with the participation of the
Biblioteca Apostolica Vaticana
Musei Vaticani
Reverenda Fabbrica di San Pietro
Tesoro della Sacrestia Pontificia
Italian dioceses

The exhibition would not have been possible without the contribution of

S.E.R. Card. Angelo Sodano
Secretary of State, Vatican City

S.E.R. Card. Eduardo Francisco Pironio
Chairman of the Pontifical Council for the Laity

S.E.R. Card. Camillo Ruini
Cardinal Vicar General to His Holiness in Rome Chairman of the CEI

S.E.R. Card. Virgilio Noè
Dean of the Patriarchal Vatican Basilica Cardinal Vicar General to His Holiness in Vatican City President of the Reverenda Fabbrica di San Pietro

S.E.R. Card. Rosalio José Castillo Lara
Chairman of the Papal Commission for the Vatican City

S.E.R. Card. Paul Poupard
Chairman of the Pontifical Cultural Council

S.E.R. Mons. Luigi Poggi
Pro-Librarian and Pro-Archivist of SRC

S.E.R. Card. Giacomo Biffi
Archbishop of Bologna

S.E.R. Card. Giovanni Canestri
Archbishop of Genoa

S.E.R. Card. Marco Cè
Patriarch of Venice

S.E.R. Card. Michele Giordano
Archbishop of Naples

S.E.R. Card. Carlo Maria Martini
Archbishop of Milan

S.E.R. Card. Silvio Oddi
Papal Delegate for the Patriarchal Basilica of San Francesco in Assisi

S.E.R. Card. Salvatore Pappalardo
Archbishop of Palermo

S.E.R. Card. Silvano Piovanelli
Archbishop of Florence

S.E.R. Card. Giovanni Saldarini
Archbishop of Turin

S.E.R. Card. Jodeph Louis Bernardin
Archbishop of Chicago

S.E.R. Card. Anthony Joseph Bevilacqua
Archbishop of Philadelphia

S.E.R. Card. James Aloysious Hickey
Archbishop of Washington

S.E.R. Card. Bernard Francis Law
Archbishop of Boston

S.E.R. Card. Roger Michael Mahony
Archbishop of Los Angeles

S.E.R. Card. John Joseph O'Connor
Archbishop of New York

S.E.R. Mons. William Henry Keeler
Archbishop of Baltimore Chairman of the National Conference of Catholic Bishops

S.E.R. Mons. Giovanni Battista Re
Deputy Secretary of State, Vatican City

S.E.R. Mons. Dionigi Tettamanzi
Secretary General of the CEI

S.E.R. Mons. Agostino Cacciavillan
Papal Nuncio in Washington

S.E.R. Mons. Renato Raffaele Martino
Papal Nuncio Permanent Observer at the United Nations

Carlo Pietrangeli
General Director of Papal Monuments, Museums and Galleries

S.E.R. Mons. J. Francis Stafford
Archbishop of Denver

S.E.R. Mons. Ottorino Pietro Alberti
Archbishop of Cagliari

S.E.R. Mons. Luigi Amaducci
Archbishop of Ravenna-Cervia

S.E.R. Mons. Ennio Appignanesi
Archbishop of Matera-Irsina

S.E.R. Mons. Alfredo Battisti
Archbishop of Udine

S.E.R. Mons. Tarcisio Bertone
Archbishop of Vercelli

S.E.R. Mons. Antonio Cantisani
Archbishop of Catanzaro-Squillace

S.E.R. Mons. Beniamino De Palma
Archbishop of Amalfi - Cava dei Tirreni

S.E.R. Mons. Franco Festorazzi
Archbishop of Ancona-Osimo

S.E.R. Mons. Pietro Garlato
Chairman of the National Council for Eccelsiastic Cultural Assets

S.E.R. Vittorio Luigi Mondello
Archbishop of Reggio Calabria - Bova

S.E.R. Mons. Mario Peressin
Archbishop of L'Aquila

S.E.R. Mons. Giovanni Maria Sartori
Archbishop of Trent

S.E.R. Mons. Serafino Sprovieri
Archbishop of Benevento

S.E.R. Mons. Francesco Tarcisio Bertozzi
Bishop of Faenza

S.E.R. Mons. Egidio Caporello
Bishop of Mantua

S.E.R. Mons. Vincenzo Cirrincione
Bishop of Piazza Armerina

S.E.R. Mons. Renato Corti
Bishop of Novara

S.E.R. Mons. Domenico Crusco
Bishop of Oppido Mamertina - Palmi

S.E.R. Mons. Ovidio Lari
Bishop of Aosta

S.E.R. Mons. Vincenzo Manzolla
Bishop of Caltagirone

S.E.R. Mons. Antonio Mazza
Bishop of Piacenza-Bobbio

S.E.R. Mons. Carlo Poggi
Bishop of Fidenza

S.E.R. Mons. Antonio Riboldi
Bishop of Acerra

S.E.R. Simone Scatizzi
Bishop of Pistoia

S.E.R. Francesco Zerrillo
Bishop of Tricarico

S.E.R. Mons. Marcello Costalunga
Papal Delegate for the Basilica of Sant'Antonio in Padua

Rev. Padre Leonard E. Boyle O.P.
Prefect of the Biblioteca Apostolica Vaticana

Rev. Mons. Piero Marini
Master of Ceremonies

Rev. Dennis M. Schnurr
Assistant Secretary NCCB Coordinator WYD 93

Rev. Edward Buelt
Executive Director of the Diocese of Dever for WYD 93

Prof. Carlo Azeglio Ciampi
Prime Minister

Prof. Beniamino Andreatta
Minister of Foreign Affairs

Dott. Alberto Ronchey
Minister of Environmental and Cultural Assets

Sen. Antonio Maccanico
Ministry of Environmental and Cultural Assets

Dott. Francesco Sisinni
General Director Ministry of Foreign Affairs

Dott. Francesco Corrias
General Director, Emigration Ministry of Foreign Affairs

Dott. Alessandro Vattani
General Director Cultural Relations Ministry of Foreign Affairs

Dott. Riccardo Sessa
Assistant to the General Director, Emigration Ministry of Foreign Affairs

Dott. Boris Biancheri
Italian Ambassador to the United States, Washington D.C.

Dott. Silvio Fagiolo
Minister Plenipotentiary at the Italian Embassy, Washington D.C.

Dott. Stefano Cacciaguerra
Consul General , Chicago

Dott. Alberto Boniver
Consul General, New York

Dott. Gabriella Meneghello
Consul General, Los Angeles

Dott. Marcello Griccioli
Consul General, San Francisco

Dott. Pietro Sebastiani
Assistant Consul, New York

Prof. Furio Colombo
Istituto Italiano di Cultura, New York

Sig.ra Caterina Noya Scordo
Vice Consul, Denver

Dott. Marino Corona
President ENIT

Dott. Mario Falcone
General Director ENIT

Dott. Agostino Petti
Representative ENIT, Los Angeles

Organizing Committee

Guzman Carriquiry
Assistant Secretary of the Pontifical Council for the Laity

Marcello Bedeschi
Chairman of the Fondazione Gioventù Chiesa Speranza

Giovanni Morello
Curator of the Musei Vaticani and Biblioteca Apostolica Vaticana

Carlo Mazza
Representative CEI

Pierluigi Silvan
Executive member of the Technical Division of the Reverenda Fabbrica di San Pietro

Cesare Mari
Installation Design

Roberto Zagnoli
Acting Secretary

Gabriele Turella
Administrator

Organization of the Exhibition

Fondazione Gioventù Chiesa Speranza, Rome

General Coordination
Guzman Carriquiry
Marcello Bedeschi

Acting Secretary
Roberto Zagnoli
Roberta Vicchi

Installation Design
Arch. Cesare Mari, Panstudio Architetti Associati, Bologna
in collaboration with
Kevin Scott, Denver

Installation
Luigi Botta Arredamenti, Bologna

Restoration
Piero Tiburzi

Clima Box
Nicolangelo Scianna, Forlì

Graphic Design
Colorado Historical Society, Denver

Exhibition Guide
Roberto Zagnoli, Roberta Vicchi

Audio Tour
Antenna Audio Tour, Sausalito, San Francisco

Publicity
Stefania Scorpio, Prime Time Promotions srl, Rome

Official Carrier
Tavoni Trasporti Arte, Bologna

Packing
Montenovi, Rome

Insurance
Paros International Insurance Brokers, Rome

Lending Institutes

Vatican City, Biblioteca Apostolica Vaticana
Vatican City, Musei Vaticani
Vatican City, Reverenda Fabbrica di San Pietro
Vatican City, Tesoro della Sacrestia Pontificia

Amalfi, Cathedral
Amalfi - Cava dei Tirreni, Parish of San Pietro a Cava
Ancona, Museo Diocesano
Aosta, Museo della Cattedrale
Arona, Collegiate Church of the Santi Martiri
Assisi, Museo della Basilica di San Francesco
Bedonia, Diocesan Seminary
Benevento, Metropolitan Church
Bova, Church of Pietrapennata
Busseto, Collegiate Church of San Bartolomeo
Cagliari, Basilica of Nostra Signora di Bonaria
Cagliari, Parish of Sant'Anna
Cagliari, Parish of Sant'Eulalia
Cagliari, Tesoro del Duomo
Caltagirone, Tesoro della Cattedrale
Catanzaro-Squillace, Church of Santa Barbara in Taverna
Cava dei Tirreni, Basilica of Santa Maria dell'Olmo
Cava dei Tirreni, Cathedral

Certaldo, Church of San Lazzaro a Lucardo
Chieri, Church of San Giorgio
Cividale, Museo Cristiano
Faenza, Parish of the Santissimo Cuore di Gesù in Zattaglia
Florence, Archbishopric
Gemona, Tesoro del Duomo
Gignod, Museum of the Parish Church of Sant'Ilario
L'Aquila, Museo Nazionale d'Abruzzo
Lucca, Diocese
Mantua, Museo del Duomo
Matera, Museo Nazionale
Melfi, Bishop's Palace
Miglionico, Church of Santa Maria Maggiore
Milan, Veneranda Fabbrica del Duomo
Monza, Museo del Duomo
Naples, Archbishopric
Padua, Tesoro della Basilica di Sant'Antonio
Palermo, Church of Gesù
Palermo, Church of Sant'Orsola
Palermo, Museo Diocesano
Piazza Armerina, Tesoro del Duomo
Piacenza, Sacrestia Capitolare
Pistoia, Museo della Cattedrale
Ravenna, Museo Arcivescovile
Sinopoli, Parish of Maria Santissima delle Grazie
Turin, Biblioteca Reale

Particular thanks go to

Salvatore Abita, Superintendent
of Artistic and Historical Assets
of the Basilicata region; Father
Olindo Baldassa, of the Basilica
of Sant'Antonio in Padua; Gabriella
Belli, Director of the Museo di Arte
Moderna e Contemporanea in Trent;
Father Nicola Giandomenico, of the
Basilica of San Francesco in Assisi;
Maria Grazia Benini, Ministry of
Cultural and Environmental Assets
Attaché; Laura d'Agostino and
Antonella Renzi, of the same
Ministry; Feliciano Benvenuti and
Mons. Antonio Meneguolo, of the
Procuratia of the Basilica of San
Marco in Venice; Giancarlo Boiano,
Director of the Museo Internazionale
delle Ceramiche in Faenza; Mons.
Michael Bransfield, Rector of the
National Sanctuary of the
Immaculate Conception in
Washington; Roberto Conti,
Director of the Museo del Duomo
in Monza; Canon Luigi Guarino,
Mons. Gastone Lastrucci, Don
Michele Leone, Don Aldo Marengo,
Maria Mariotti, Mons. Gian Carlo
Menis, Don Leone Porru, Mons.
Cesare Recanatini, Mons. Franco
Strazzullo, members of the CEI
National Advisory Council for
Ecclesiastic Cultural Assets; Renzo
Mancini, Superintendent for
Historical, Artistic, Architectural and
Environmental Assets of L'Aquila;
Franco Ambrosio, Maurizio
Armaroli, Doriana Comerlati,
Giorgia Dalla Pietà, Stefania
Di Gioia and Marcello Francone
of Electa publishers, Milan

If the past is to be recalled and discovered as true and plausible, it needs the support of something tangible: human hands must touch, human ears must hear, human eyes must see.

The monuments of art, whether great buildings or small objects, whether of illustrious parentage or the work of unknown artisans, become the "living stones" that activate memory. Scholars discover and evaluate them; communities guard them jealously and are proud to take from them the sense of their own roots; millions of people visit them and perhaps, without realizing it, gain the insight that history is part of a project, and that the basic elements of its ideal continuity can only be bound together by linking past, present and future.

This is precisely the meaning and significance of the exhibition presented in this catalogue.

The story that art objects are telling, the Church believes, is important: it is a story of continuity and the story of a project; the story of a man, Jesus Christ, believed by many Christians to be the incarnate Word of God, who deeply changed human thought and behavior. This man won the enthusiastic fidelity of the many who, believing in him, proclaimed his Name to the ends of the earth. Many Christian artists have been fascinated and deeply moved by him and have communicated his message in their works. This exhibition, Vatican Treasures: 2000 Years of Art and Culture in the Vatican and Italy, *will show through works of art – some of them by well-known artists – the impact Christ has had on human art and culture. Some people may be interested in the aesthetic qualities of the works exhibited. This approach is legitimate, but the Church believes that it presents the risk of overlooking the historical context in which they were made. The visitor is invited to look beyond the aesthetic aspects to the inspiration behind the creation of the works.*

I hope that many young people, coming to Denver to celebrate their World Day with the Pope, will visit the exhibition. It has been conceived especially with this event in mind. Young people today, responding to the accelerated rhythm of social interaction, are in danger of being unable to interpret what the Church sees as the continuity and the meaning of history in God's design.

This exhibition may provide an explanatory note to that sense of history and continuity. The past is made of many events in succession, of many insights linked one to the other. The idea of history is well expressed by the image of the relay race. One after the other the athletes run their part of the race, passing the baton to the next, who sets off at top speed for a goal further on. So it is from one generation to the next. Young people are the athletes who, after grasping the baton, have to keep the race going. The progress of history depends on each one, with his or her commitment and gifts. Works of art also become in this way signs of the same necessity. Every work, however beautiful, always looks forward to a new insight that will express beauty still more completely. The work of religious art is like a period in history and a small and partial manifestation of the Christian's belief in the great beauty of God.

Cardinal Eduardo F. Pironio
President of the Pontifical Council for the Laity

Museums help to build community. Today, as the concept of "world community" assumes special significance, museums play an important role in building understanding and appreciation for the variegated tapestry of humanity's cultural heritage. For its part, the Colorado Historical Society has long fulfilled its educational mission by presenting to the public the history of diverse cultures that comprise the heritage of Colorado and the American West. For five hundred years, this region has had strong ties to the cultures of Europe, and so it is with special pride that we present to the people of the Rocky Mountains, and indeed, all North America, this exhibition from which part of our heritage springs. Vatican Treasures: 2000 Years of Art and Culture in the Vatican and Italy was planned at the request of Pope John Paul II for an exhibition to coincide with World Youth Day, when Catholic youth from seventy countries would gather in Denver, Colorado, during August 1993 in conjunction with a visit by the Pope. On July 31, 1992, while making preparations for World Youth Day, Dr. Marcello Bedeschi and representatives of the Fondazione Gioventù Chiesa Speranza (Foundation of Youth, Church, and Hope) and the Vatican visited the Colorado History Museum. They explained to senior staff that the proposed exhibition would trace 2000 years of Christianity through the person of Saint Peter, his tomb, the basilica of Saint Peter, the colonnades of Saint Peter's piazza, the pilgrimages and celebrations of the Church, and the artistic manifestations of the Church throughout the regions of Italy.

Although Colorado Historical Society staff felt that it would be difficult to assemble artifacts from all of the regions of Italy, to design and install the exhibit, and to produce related educational materials in less than a year, we believed that such an exhibition would be a wonderful way to place World Youth Day and the papal visit into historical perspective.

At times the issues raised in the negotiation of the contract – insurance, shipping, security, conservation, design, marketing, and public relations – seemed daunting. However, throughout negotiations a genuine friendship arose between the parties that led to a partnership rooted in mutual respect and trust. A visit to Rome in January 1993, which included a preview of treasures in the Vatican library and the tomb of Saint Peter, confirmed our enthusiasm for the project. In February 1993 the Colorado Historical Society's board of directors voted to proceed with the exhibition.

For Colorado History Museum visitors, Vatican Treasures represents a once-in-a-lifetime opportunity to experience the art and history of a culture which helped to shape western civilization on both sides of the Atlantic ocean. The Colorado Historical Society is honoured to be selected as the premier and only North American venue for this important exhibition – and to play a part in the historic events surrounding World Youth Day 1993.

The Vatican-Italian-American partnership that was created during the preparation of the exhibition has resulted in cross-cultural friendships and professional growth for the Society's staff. On their behalf, we wish to thank all of the representatives of the Fondazione, the Vatican, World Youth Day, and Italian regions that made possible this unique international cultural exchange.

Andrew E. Masich
Project Director

Georgianna Contiguglia
Curator

Colorado Historical Society
Colorado History Museum

Contents

Art. The Way of Faith
Paul Poupard

Beauty is "beyond"

Talking to Pope Paul VI, the philosopher Jean Guitton defined beauty in this way: "I would say that beauty is an irradiation, a phosphorescence more than a light. Or rather, as a figure from ancient times put it, a splendour. Almost like a vapour, a halo, an aura, it is the projection towards the outside, although not at a great distance, of the innermost region of things. It is for this reason that beauty is more interior than the interior and is beyond any form, any sign. Beyond even the work which commemorates it. Even in the beautiful things of the world, beauty is 'beyond'".[1]

Art, goodness, truth and beauty

Beauty, this silent irradiation, this mysterious ancient light, certainly has a relationship with the intimate side of man, with that "interior" of man where truth resides. And the work of art is the vehicle and the means of mediation par excellence, the deposit and the custodian of beauty, and therefore in a certain sense also the custodian of God. The Church views the physical material, through the transfigurative power of art, as the word of God, catechism of its faith, image of the transcendent, a portion of that "beauty" which is an irradiation of the One and Only Truth-Goodness-Beauty.

In keeping with that tradition Guitton reminds the reader that: "Art initiates man in beauty through harmony which is the image of grace and at times a preparation for it and a reminder of it".[2] Over the various centuries and in all its multiplicity of forms, art has therefore been, and still is, an educator in the forms of beauty, the knowledge of goodness, the search for truth. Historically, the Church has held that art educates people in the knowledge of God. The believer cannot keep at a distance from beauty, just as he cannot decline to be a witness to goodness and truth, on which it is nourished. The artist thus becomes a mediator between God and man. "I have always sought the company of artists," Paul VI confided to Guitton. "I have always secretly loved them and whenever I can, in spite of their fierce reserve, I try to talk to them. There is an affinity between priest and artist; even more, a wonderful opportunity for understanding."[3] With these words Paul VI raised the idea of art for the Church to the level of, and understood as being, a genuine priesthood offering itself as the sign and seal of cooperation between the good, the true and the beautiful, between the artist and the common man.

In the contemporary world, faced with the devastating pollution of ideas and culture, the cunning perversion of the concept of beauty and goodness, the loss of the sense of truth, and faced with the continual threats to which man, as a store of values, is subjected – man in his dignity as the image of God, the image of beauty – these words ring out as the sincere, profound, spontaneous and yet considered viaticum and teaching which Paul VI proposes to us, and to which he exhorts the whole of humanity.

Art reveals man to himself

Now, as never before, the democratization of society has had the positive effect of enabling a more active and direct contact between the world of art and artists and the world of those who appreciate and benefit from their past and present creations, through an ever-growing number of events and the ease with which they can be organized. At the same time a double responsibility has developed, one which is too often forgotten, or even denied, and of which visitors are reminded on a trip to an exhibition or an art gallery. On the one hand the artist becomes a highly sensitive educator, also in the faith, by means of his work which operates through images and feelings, memories and impressions, truth, hopes and pain. He feels more than others the weight of suffering and expectation of the world and of humanity, transfiguring his faith and communicating it at the same time as he sublimates it. Those, on the other hand, who walk through the exhibition rooms and corridors take in this message, internalize it and experience it: what emerges is the responsibility of recognizing what is genuine, the responsibility of not falling short by slipping into dehumanized, pointless superficiality and banality. Because in seeing, in grasping the spirit of the work of art, in that satisfaction of one's own senses, in that experience of new feelings and sensations in the heart and in the mind, man discovers himself, a part of his mystery, and thus discovers also part of the mystery of God. Art makes people responsible for the beauty of God, educators and students of this beauty alike. Truth lives in art.

Thus, for the Church, art reveals man to himself, helps him to understand himself and many of the secrets of God. For this reason there does not exist a people on the face of the earth who do not produce art. Artistic creation is a universal and inescapable peculiarity of man. It is an internal need which allows the artist to give vent to a charge of energy which he is unable to suppress or eliminate because it is part of his nature.

Art is an expression of the intelligence and at times acute sensitivity of man, an emanation of his inner life, a fruit of his conscience, which is of a spiritual nature. Therefore, the Church holds that the artist cannot but be a spiritualist and those who appreciate his work

cannot but appreciate this spirit and, through it, allow themselves to be led into the presence of Truth, the knowledge of Good, the contemplation of Beauty.

Art is a universal language

Art is a universal language, whether it is a matter of imposing a constructive will onto space, as in architecture; of modelling a plastic mass, as in sculpture; of forming allusive shapes through colour, as in painting; of organizing sounds in sequence, as in music; or different shapes, as in the decorative arts. Through a process of elaboration, usually painstaking and at times arduous, art always achieves its *raison d'être*, which is to express the soul of the artist, together with a portion of beauty and truth. "The work of art is a document, not only of the technical ability of the artist but, even more, of his deepest thoughts and his most human and most intense feelings",[4] including, the Church holds, his religious feelings. In this sense the work of art is a response not only to a need for beauty and to aesthetic criteria but to an urgent need on the part of the artist for a dialogue with the world around him. The aesthetic theory of Benedetto Croce, of art for art's sake, does not seem to have any real consistency.

As Benvenuto Matteucci explains, "If we mean to say that art can stand alone, that it is not an instrument or means of expression of man as man, that it has no relation with life, as it reveals itself in history with its good and its evil, then it is not rationally sustainable".[5] In other words, art belongs to the life of man and is the expression of his convictions, feelings, responsibilities in front of his own conscience, his own time and God.

Art belongs to the spirit of man.

Art belongs to the culture of man

Art is at the heart of the culture of man, and at the same time it generates a new culture. There is, for example, a classical culture from which the artist draws his sense of measurement, of proportion, of balance. There is a romantic culture from which the artist draws impulsive forms of vitality and asymmetry. There is a scientific culture from which the artist draws geometrical forms and rhythms. But there is also a culture of faith, from which art draws inspiration and to which it leads.

This was already recognized by Saint Augustine: every truth, he says, comes from God, even artistic truth. It was in art that the saint from Hippo discovered that surprising beauty as ancient as it is new.

Art, culture, society: opening up to God

A problem which has been quite widely debated in modern cultural circles results from this.[6]

In a hegemonic culture which has lost the substance of Christian humanism, this axiom may be misinterpreted and become a pretext for accusing religion of cultural hegemony and for breaking the essential and indissoluble bond between art and the transcendent, between art and God, so long held by the Church. Therefore, it sees the atmosphere of immanentism as emptying art of its transcendent content. Art has undergone a process of secularization, with a consequent break between culture and religion that can be observed in present society.

Art, culture and society

The English historian Christopher Dawson maintains, on the other hand, that the intimate structure of a society cannot be understood without understanding its religion, which is the key to its history, the custodian of its tradition and its morality, its teacher of knowledge. And it is the ultimate inspiration of its art. To Dawson the separation, which is not a distinction, between religion and culture has been the greatest error of western thought in the modern and contemporary age. In Christianity, by contrast, adds Dawson, the liturgy was the centre of a rich tradition of poetry, music and artistic and religious symbolism. In fact, the art of Christianity, in its Byzantine as well as in its medieval phase, was essentially a liturgical art. And the same is true, to a large extent, for popular culture.[7]

Art and liturgy

Art, in the liturgy of the Church, creates the relationship between God and man in its optimum form, revealing the mystery of Christ and the genuine nature of the Church. This artistic production tends to deepen this fundamental relationship. "The infinite divine beauty must somehow be expressed in the works of man. The arts are all the more inclined towards God and towards the magnification of his praises and his glory because, in so far as the Church is concerned, no other goal has been assigned to them than that of helping as efficiently as possible to fully direct minds and men to God."[8] Religious art, sacred art, thus occupies pride of place among the most noble activities of the human creative imagination. And it is for this reason that the Church, with its content of faith, has been a very particular and attentive custodian of art throughout the course of its two thousand year history, in the pursuit of that noble service which, in the sacred rite, has always provided protection

and teaching, "in the clear and joyful affirmation of the life of faith and the sacraments of faith; by discovering with a sense of wonder these treasures of art and faith of the first Christian generations, convictions of the faithful are reinforced by contact with their serene faith in the resurrection of the dead".[9]

The message of the II Vatican Council

Thus the Church says to artists: "If you are friends of art in this sense, you are our friends". And the II Vatican Council, after honouring the work of artists, among the most fertile of alliances, confirms the great mission with which they have been charged: "Remember that you are the custodians of the beauty of the world". And, therefore, also custodians of God, who has created, inspires and incarnates this beauty. The message continues, "This world in which we live needs beauty in order not to succumb to desperation. Beauty, like truth, is what places joy in the hearts of men, it is the precious fruit which resists the erosion of time, which unites the generations enabling them to communicate with one another through admiration".[10]

Art enables us to share in the beauty of God

At this point, the philosophy of Saint Thomas opens up a new theologically and ontologically daring metaphor which is particularly striking for the Church: "The beauty of God is the *raison d'être* of all that exists".[11] It follows that the Word of God, incarnate and revealed as "Way, Truth and Life"[12] of man and "light of the world",[13] makes the artist its chosen instrument since, by giving physical form to his intuitions in images, shapes and sounds, he becomes the way to goodness, truth of conscience and the life of the soul for men who are thirsting for the absolute. Sharing in the light, which in the Church is Christ, he illuminates those who live in the darkness of error and evil. He lights up the life of man, giving meaning to this life and enabling it to share in the beauty of God.

By pointing to Christ as the light of the world and the model of all perfection, the Church believes that Christianity, on the one hand, does not limit the freedom of artists but integrates it with truth, since according to what Christ says in the Gospel, "The truth shall make you free".[14] On the other hand, the idea draws the observer to a free and highly personal dialogue with this view of the truth, rediscovering it through beauty in all its various forms and enabling him to savour the mysterious bond between God and man, between Christ as image of the Father and man redeemed by Christ.

A fragment of Paradise now on this earth
Art, testimony of faith

From this point of view, art becomes the testimony of faith, the deposit of Christian Revelation, which adapts itself, as no other form, to the times and sensitivities of the different historical eras, thanks to the richness and beauty which it always contains. Distancing itself from ideologies based on different premises, it is nourished (or at least it should be) by the intimate dialogue between the artist and himself, between the artist and nature, society and the history of man, that history which is also the history of God and which leads towards a great hope. It is the hope, both human and spiritual at the same time, for a "new culture", based on the incomparable dignity of the human person as the image of God and on the consequent "development of the whole man and of all men".[15]

The responsibilty of the artist

John Paul II feels this responsibility acutely because, in his view, thanks to culture, and artistic culture in particular, an enduring communion of spirits is made possible. This reveals a profound effective affinity between people who, thanks to the universality of art and rising above their divisions, together seek the truth, seek God. He summons artists and those who appreciate art to take on a new ethical and religious responsibility in the face of history and the future of humanity: "It is a vital field in which what is at stake at this close of the 20th century is the destiny of the world".[16]

Fra Angelico, patron saint of artists

For this reason the Pope calls upon artists and art lovers to make their activity a vehicle for reaching out, following the example of Fra Angelico, the Church's patron saint of artists, acknowledged as a model figure by artists. Through his work the artist becomes responsible for beauty, and responsible for God. John Paul II reminds us that Fra Angelico, by consecrating himself to God, succeeded in being even more a man, not only with others but for others. He believes that an artist consecrates himself to God, or at least should do so. And thus his works become "a perennial message of living Christianity and at the same time a supremely human message, based on the transhuman power of religion, in virtue of which every man who comes into contact with God and his mysteries becomes once again similar to Him in holiness, in beauty, in blessedness: a man, in other words, according to the original plans of his Creator".[17]

God and man enter into dialogue and close relations thanks to art

and the beauty which it expresses. For this reason art is the inviolable patrimony of humanity. Don Angelico Surchamp, the founder of the French "Zodiaque" collection, underlines this point: "The patrimony of humanity would be considerably diminished if everything that is concerned, whether closely or remotely, with the sphere of the divine, the sphere of the sacred, were to be removed".

*The exhibition of sacred works of art,
mysterious epiphany of God*

Thus, in the view of the Church, an exhibition of sacred works of art is also a reminder of this ethical duty of conservation as well as an invitation to appreciate the works. Just as the artist should become aware of the grace which is granted to him at the moment in which he himself becomes a creator, so the faithful should all take on responsibility for the correct utilization and the rightful conservation of those hard-won precious fruits. And just as the artist provides an enduring inscription of the epiphany of the infinite in the very transience of things and in their irremediable finitude, testifying to presence in absence, the longing for another place whose mysterious beauty made present becomes the promise of a happiness transcending desire, so they must become sensitive, not dumb, witnesses of this epiphany, attentive discoverers of this mysterious presence of God.

Thus the itinerary of art and culture assembled by the Church and covering two thousand years of Christian history, from Saint Peter's to the places of evangelization in Italy, is also an *itinerarium mentis ad Deum*, a *sequela Christi*, a door opened upon the mystery of Jesus, this man who is a brother to the faithful, this brother who is their God, inexhaustible source of beauty and of Goodness, of Truth and of Life, "light which shines in a dark place until the day breaks and the morning star rises in your hearts".[18] In this view, those who are caught up in the evocative power of the beautiful, can feel in themselves a longing for Christ, the beauty of God. Otherwise, it is argued, where does the fascination of art spring from, if not from this mysterious light of the inaccessible God who has made himself visible through the incarnation of the Word, living image of the living God?

The beauty created by the artist is the irradiation from another world which pierces through an opaque worldliness, opening it up and illuminating it at the same time. Through the centuries, innumerable Christians have been, and still are, sustained in their faith and encouraged in prayer by contemplation of beautiful works of art. Thus, in the eyes of the Church, art and faith combined in a fertile symbiosis lead man in his unceasing search for the inner life and for peace.[19] Art and faith together build the City of God among men. Far from being ephemeral entertainment, art and faith call upon man not to slide into indifference but to continually transcend himself, to look for and recognize He who is the origin and the fount of all beauty and who gives sense to the world, to man and to all things: a fragment of Paradise, now on this earth.

[1] Cf. J. Guitton, *Dialoghi con Paolo VI*, Rusconi, Milan 1986, pp. 209-211.
[2] *Ibid.*, p. 209.
[3] *Ibid.*, p. 211.
[4] Paul VI, "Angelus" of 24th May 1970, in *Insegnamenti di Paolo VI*, Libreria Editrice Vaticana, Vatican City 1967 (= *Ins.*), II, p. 539.
[5] B. Matteucci, *Cultura religiosa e laicismo*, Ed. Paoline, Alba 1960, p. 211.
[6] Cf. P. Poupard, *Costruire l'uomo del futuro*. Città Nuova Editrice, Rome 1987, pp. 117-137.
[7] Cf. C. Dawson, *Religione e cristianesimo nella storia della civiltà*, Ed. Paoline, Alba 1984, p. 243.
[8] Cf. *Sacrosantum Concilium*, no. 122.
[9] P. Poupard, *Guida a Roma*, Piemme, Casale Monferrato 1991, p. 164.
[10] Cf. Paul VI, "Aux artistes", in *Ins.* III (1965), p. 755.
[11] Thomas of Aquinas, *De divinis nominibus*, IV.
[12] John 14, 6.
[13] John 8, 12.
[14] John 8, 32.
[15] Paul VI, encyclical *Populorum Progressio*, no. 42.
[16] John Paul II, signed letter for the inauguration of the Pontificio Consiglio della Cultura, in *A.A.S.*, no. 74, 1983, pp. 683-688; cf. also P. Poupard, *Chiesa e culture. Orientamenti per una pastorale dell'intelligenza*, Vita e Pensiero, Milan 1985.
[17] John Paul II, "Omelia per il Giubileo degli Artisti", 18th February 1984, in *La Traccia*, 1984, II, pp. 163-166.
[18] II Peter 1, 19.
[19] Cf. P. Poupard, "L'Eglise, les artistes et l'art", in *Le Festival du Comminges, Cahier des Arts et de la Musique*, Mazères-sur-le-Salat, no. 12, 1990, pp. 1-3.

In the Footsteps of Saint Peter
Works from the Vatican

Art for the Liturgy
Virgilio Noè

An ever-topical subject

The role of art in the liturgy is always a topical subject for the Church. We start to discuss it when we have to do something new, whether it be building a church, making an altar or designing something to be used in the celebration of the mass. The discussion continues when we have to renew or restore something for the liturgy. We talk about liturgical art when we see an exhibition of religious art.

The important thing in these exhibitions is that, for the faithful, the most beautiful things are those which were created for the glory of God. They have opened up a path to the mystery of God for many people. Artistically speaking, they are masterpieces, but on a more practical level they help to interpret and contemplate the mystery of God. The artistic debate does not start of its own accord, but in response to the demands of the liturgy.

In planning new works or restoration projects, the Church accepts the aesthetic forms which the artist has suggested for the liturgy, since it is here that he takes his inspiration, and he uses his artistic ability to serve it. Historically, the style of every era has always been welcome in the Church, as long as it has fit in with the aim of the liturgy: to glorify God and to provide worshippers with a path towards God (the way to Beauty!) and a means of prayer.

The Church has thus created an artistic treasure over the centuries, as rich and varied as the artists who have used their talent to serve the faithful. The works of art which enhance the solemnity of certain religious feasts throughout the year are used at other times by the Church to satisfy the aesthetic needs of visitors and to convey a religious message. This, in the particular context of art, is sometimes more powerful than the word itself: it leads to reflection, it moves and changes the heart.

Three Councils speak of art

The role of art in the liturgy was discussed, at the highest level, by the second Vatican Council (1962-65). This was not the first time that the Church had spoken of art. Centuries ago, during the second Nicene Council, the Church defended the exposition and veneration of holy images against the attacks of the iconoclasts. During the Council of Trent too, art was discussed with the bishops: they were to protect art in the churches from the serious challenges posed by the Renaissance period, particularly as far as iconography was concerned. The second Vatican Council, in a short chapter of the Liturgical Constitution (chapter seven, consisting of only eight points) placed the liturgy at the centre of artistic creation in the Church, and put art in a liturgical context. If the liturgy is the life of the Church, art is the instrument which must reveal the face of the Church when it celebrates an event, in a given place and at a particular time, according to its own rite. Since active, conscious participation in the celebration is encouraged in the faithful, the Church accepts changes in liturgical elements, such as the "new" position of the altar, or the new layout for the liturgy. Amongst the most important changes is that regarding the simplification of art, so that Christians may find it easier to take part in the liturgy, and not be distracted in their understanding of the holy mysteries by complicated works of art.

Always look for beauty

When the Church talks about art for the liturgy, it does not confine the argument to art which builds and organizes places where a congregation can gather for a liturgical celebration. The argument can be extended to the various elements which are used during the mass, and to mark the timing of its celebration. This should be seen and treated as a concert, in which everyone attending has a role to play: someone presides over the liturgy, someone proclaims the Word, someone serves, or sings or plays music. The liturgy is art in every respect. For the Chruch, the ideal to pursue in every liturgy is the attainment of that perfection which puts all the participants at ease, and produces an experience of joy in the encounter with God, an experience shared with many brothers and sisters. The model provided by Sirach should be revived and copied: he praised the patriarchs and presented them as men "pulchritudinis studium habentes, pacificantes in domibus suis" (Sir 44, 6); beauty should always be sought and the harmony of the spirit preserved. Why then does the Church's liturgy love and search for beauty? The liturgy looks for beauty in all its forms, according to era, culture, time and place: beauty paves the way for truth. This ideal was sought and applied, starting with that most fundamental of arts: architecture. No matter what historical or artistic form one might choose to contemplate, whether it be an early Christian or Byzantine basilica, a Romanesque or Gothic cathedral, a Baroque church or a contemporary building for worship, the aim is always the same: to bring beauty to the place of worship. This is done by the definition of the architectural space, which varies according to the artistic era. In this space, the early Christian artist would spread the mosaic decoration along the walls of the church, along the nave, on the triumphal arch, in the presbytery and the apse, where Christ is depicted as Pantocrator, seated on the globe of the world, surround-

ed by angels, the elders and saints. The design of the cupola has been handed down from Byzantine architecture to all eras of Christian art, thus giving a concrete image of the sky arched above the earth. The Church sought new spatial forms in the Romanesque cathedral, the Gothic cathedral, the Baroque church, and in modern and contemporary churches. In order to make these places more eloquent, the early Christian, Ravenna or Norman mosaics were replaced by large stained-glass windows, but with the same aim as the decorations used by the Church earlier: to praise the glory of God, to present truth as something beautiful (the *Biblia pauperum*), and to celebrate the holiness of God in the saints.

The Church believes that beauty can be combined with anything connected with worship in some way. Every element is the believer's tribute to God. The explanation for this is to be found in the verse from the psalm: "Confessio et pulchritudo in conspectu eius", which was sung during the solemn liturgy in the basilica of San Lorenzo fuori le Mura in Rome; everything was beautiful, and psalm 95 expressed the awe of all present. But the acclamation can be reaffirmed everywhere. The Church seeks to offer the most beautiful objects to God, in the conviction that nothing is too good for Him. The liturgy uses the most precious materials: gold, silver, incense and light; the most beautiful things, the vestments with their colour-symbolism, the chalices, ciboria and monstrances, and of course song – the most fragile, penetrating element.

The Denver exhibition will show the *documenta* from different eras. They show how the Church has always striven to offer things of beauty to the Lord, who, the faithful believe, is present and active in the liturgy. The exhibition will also provide visitors with a further opportunity for personal meditation on the element of beauty which has always been part of the liturgy. This is an invitation for our generation to realize that liturgical beauty fulfils more than an aesthetic need in the view of the Church. If, as Plato teaches, "beauty is the splendour of truth", then, to the Church, it is the royal way which leads to God. The attempt to make everything used in the celebration of the liturgy ever more beautiful emphasizes this: fullness of beauty is nothing less than the manifestation of the Lord, "a beauty always ancient and always new" (Saint Augustine, *Confessions*, 1, X, ch. 27).

The Image of Peter

Giovanni Morello

The first images of Christian art appeared between the end of the 2nd and the beginning of the 3rd centuries. The oldest pictures in the catacombs are dated to about the year 200, while the first figurative sculptures on Christian sarcophagi date back to the beginning of the 3rd century.

The delay of about three centuries in the appearance of Christian art can be explained by the prohibition on the use of images by the Jewish religion, from which the early Christian communities emerged.

When they then began to open themselves to the world of the Gentiles and to free themselves of the Jewish restraints on their new beliefs, Christians belonging to the churches which were gradually appearing throughout the regions of the Roman Empire immediately had to face up to the problem of images representing the divinity. Because of a natural wish to distance themselves from idolatry, the first Christian images were exclusively symbolic.

"Our seals must bear the image of a dove, of a fish or of a ship at full sail; of a lyre, which Polycrates made use of, or an anchor which Seleucus had engraved on his ring. If a fisherman is depicted, it is to recall the apostles and the children whom they fished from the water. But take care not to have idols drawn: it is forbidden even to look at them." Thus wrote Clement of Alexandria (*Il pedagogo*, book III, chapter IX), one of the first Christian writers, who lived at the turn of the 2nd-3rd century.

Portrayals of animals which personified Christian virtues, such as doves and peacocks, or objects which represented the truths of the faith, such as bread and fish, were initially used to decorate the places where the early Christians met, to listen to the Word and celebrate the Eucharist, in commemoration of the Last Supper.

The "Domus cultae" and the underground cemeteries, the catacombs, soon became the principal places of worship, used in order to escape from the ever more violent persecution which the Roman authorities unleashed upon the new religion and its followers. These places thus began to be decorated with figures and small images. In fact the systematic destruction of the buildings of Christian worship, with all that they contained, is the principal reason for that gap of about three centuries, which resulted in the beginning of early Christian art being placed in the 3rd century. This period coincided with the more tolerant religious climate introduced by the emperors of the Severan dynasty.

Indeed the first reference to an image of Christ comes from the imperial palace of Alexander Severus (222-235), who preserved it devotedly, together with portraits of his own ancestors and other righteous men, according to the account given by his biographer Aelius Lampridus, in the *Historiae Augustae Scriptores* (chapter XXIX, 2).

This is not the only report of an icon of Jesus in late antiquity. In his *Historia ecclesiastica*, Eusebius of Caesarea (c. 265-339/340), the main historian of the early Church, speaks of a sculpture group depicting Christ healing the woman "diseased with an issue of blood" (Matthew 9, 20), preserved in the Palestinian city of Panea. This was considered to be a true portrait of Jesus Christ.

The transition from symbols to portrayals of Biblical subjects and characters or figurative scenes showing, for example, the Sacraments took place quite quickly. And it is not surprising that the first Christian iconographers borrowed subjects and stylistic methods from classical art.

However it is in the East, at the extreme edge of the Empire, that the first evidence of Christian art has been preserved. This is in the city of Dura-Europos, located on the middle reaches of the Euphrates in present-day Iraq. The building in question had a large room used as a baptistry by the local early Christian community. It was deliberately interred in an attempt to improve the defences of the city. This occurred at the time when the city was besieged and then conquered by the Parthians in 256. Thanks to this interment the picture cycle which decorated the room, and which had certainly been carried out some time before the date of the siege, has been almost entirely preserved.

The room came to light during the excavations of 1931-32. The site of the baptismal font could be seen in the centre of an apsidal niche, where there were frescoes of a scene showing the Good Shepherd in the middle of his flock. Other images along the walls depicted Biblical episodes, such as Adam and Eve and David and Goliath, and scenes drawn from the Gospels, such as the Samaritan woman at the well, the healing of the paralytic and the three Marys at the tomb. The frescoes were removed and transported to the United States, where they were recomposed in a room in the University Art Gallery at Yale which recreated their original setting.

These paintings, which date back therefore to the first half of the 3rd century, are of exceptional interest, not only because they preserve some of the oldest images of Christian art but also because it is in one of these frescoes that we can trace the first appearance in Christian iconography of the figure of Peter.

In a fragmentary scene, in which part of a sailing boat is visible, two figures walking on the water can be distinguished. One of the two, of whom only the lower half of the body remains, stretches out a

hand to grasp that of the other person who is turning towards him. This is undoubtedly a representation of a famous episode recounted in the Gospel of Saint Matthew (14, 24-31): "But the ship was now in the midst of the sea, tossed with waves: for the wind was contrary. And in the fourth watch of the night, Jesus went unto them, walking on the sea. And when the disciples saw him walking on the sea, they were troubled, saying, It is a spirit; and they cried out for fear. But straightway Jesus spake unto them, saying, Be of good cheer: it is I: be not afraid. And Peter answered him and said, Lord, if it be thou, bid me come unto thee on the water. And he said, Come. And when Peter was come down out of the ship, he walked on the water to go to Jesus. But when he saw the wind boisterous, he was afraid; and beginning to sink, he cried, saying, Lord save me. And immediately Jesus stretched forth his hand, and caught him, and said unto him, O thou of little faith, wherefore didst thou doubt?"

This scene was at first linked to baptismal iconography but later came to symbolize Christ's promise of divine assistance to his Church, represented in the person of Peter.

According to the evidence of those involved in the digging, the fresco at Duro-Europos was found in a perfect state of preservation. Whether or not it was an attempt at a portrait, the figure of Peter, despite being extremely basic and not very carefully drawn, does nevertheless display some of the characteristics which later became established features in the iconography of the Prince of the Apostles, such as the short beard framing the chin and the curly hair.

In the absence of a physical description handed down by the Scriptures of the humble fisherman from Galilee who was chosen by Jesus to be the founder of the Church, one can only wonder what image of him the early Christians had. Neither the Gospels, nor the Acts of the Apostles, nor the canonical scriptures of the first two centuries have provided us with a physical description of Simon-Peter and so we are obliged to turn to the first images that we have of him.

However, the endurance of a constant iconography relating to the figure of Peter, and similarly Paul, suggests that it derives from a prototype which must have been known to the Christian community. Although critics are in broad agreement in considering the oldest portrayals of the apostles Peter and Paul as idealized images, derived from the philosopher-thinker model of classical art, it is not fanciful to think that the early Christians may have circulated among themselves images of the two saints which they considered, rightly or wrongly, to be true portraits. This is all the more likely

since it is only for Peter and Paul that we find realistic representations, with characteristic facial details, while for the other apostles we only have idealized images.

Eusebius of Caesarea states explicitly: "the physical appearance of Peter and Paul and of Christ himself is preserved in certain pictures. It appears that, following a practice of the Gentiles, it was common to pay such an honour to those who were looked upon as liberators".

The use of portraits among the Romans was, in fact, quite a widespread practice, and this did not apply only to public portraits of emperors or important personalities, for which we have a great deal of evidence: marble busts, ivory diptychs, frescos, graffiti on gold glass and, obviously, medals and coins. Private portraits too, especially for funerary purposes to perpetuate the image of loved ones, were a feature of the classical world. Indeed the practice was very widespread, as can be seen from the numerous funerary cippi and the splendid tablets of El Fayyum.

In fact the first numerous images of Peter and Paul, who were often drawn together initially, come down to us from the world of the cemeteries, in other words the catacombs, that immense network of sepulchral galleries, whose climatic conditions have enabled the preservation of many pictures and sculptures of the early Christian centuries. We find them on both gold glass ornaments and bronze medallions (both objects which were attached to niches on graves) as well as on sarcophagi and in frescoes. Peter and Paul are usually portrayed as two rather elderly men, as they must have appeared at the time of their stay in the Eternal City, where they arrived when they were already at an advanced age. It was here that they were martyred, apparently during Nero's persecution in the year 64.

Most of the portraits depict them following an established model: Peter with a short beard and curly hair and Paul with a long pointed beard and clear signs of baldness. This leads one to believe that these iconographic representations may be based on authentic information dating back to an earlier age and which has now been lost. This is all the more likely since the one and only description of Paul's appearance that we have (preserved in an apocryphal scripture, the *Acta Pauli et Tecla*, which can be dated to between 160 and 190) agrees with the iconography which developed in Rome and then spread to the East.

When Constantine granted freedom of worship to the Christians, with the edict of Milan in 313, the iconographic model representing the two apostles had already become established in the canons and it spread rapidly over the entire Christian world, reaching down

even to us. In the basilica built on the site where the apostle was martyred and on his tomb, the emperor had the figures of Peter and Paul included beside the Saviour, in the apsidal mosaic of the new church, creating a prototype which would very soon be repeated elsewhere.

The most commonly occurring image in Christian iconography during the first five centuries, after that of Our Lord and the Virgin Mother, is undoubtedly that of the Prince of the Apostles. Thus, as in the Gospels where Peter is mentioned fully 195 times, more than all the other apostles put together, he is also the figure most often depicted in images, with scenes including him greatly outnumbering all others. The catalogue listing the appearances of Peter during the period referred to is a lengthy one, with over 530 certain images and a further 200 possible ones.

Among the most ancient images are those of the so-called Peter Trilogy, contained in a group of sarcophagi which come from a Roman workshop of the beginning of the 4th century, in other words a little before Constantine's edict. The three scenes depict Peter making water gush from a rock, like a new Moses, Peter's arrest and the episode of the cock crowing, with Peter's denial. The image of the apostle is here already canonically fixed, as can be seen in the surviving head which is kept in the museum annex of the Saint Sebastian catacombs.

A fresco in the hypogeum of the Aurelians, which came to light at the beginning of the century and can be dated to the end of the 2nd or the beginning of the 3rd century, shows the short stocky figure of an old man, with a short rounded beard and a broad forehead, over which some locks of hair have fallen. Dressed in a tunic, he holds the roll of the *Lex* in his left hand. Experts are not all in agreement but many of them see in this the image of Peter which can be placed almost at the head of the entire iconographic tradition.

The image of Peter has also been recognized in the figure of the aged teacher, a fresco in the catacombs of Saints Peter and Marcellus, which can be placed at the end of the 2nd century.

However, perhaps one of the most interesting finds in connection with the iconography of the apostles Peter and Paul is held in the Museo Sacro of the Biblioteca Apostolica Vaticana. This consists of two tablets with half-length images of Peter and Paul, dressed in pallia, painted on a gold background. The two tablets were the two sliding doors of a small box, as shown by the remains of grooves. The two images were on the inner sides; from the outside the box looks completely anonymous, without any decoration. It was probably a small reliquary shrine, designed to hold at most a thin piece of material, given the narrow space available once the two doors were overlapping. Indeed it could even be argued that it was not designed to hold anything except the two images, which would thus have the value of relics themselves.

The fact that the images were warily safeguarded, as though hidden, on the inside of the box suggests that they may date back to a period before the liberalization of Christian worship, in other words before Constantine's edict in the year 313.

The little box was jealously kept, together with the most precious reliquary shrines of the Roman church, in the so-called Treasure of the Holy of Holies at the Lateran. In the case of this exceptional find, the type of object and the pictorial technique itself go back to ancient times, perhaps even to the 3rd century, although the majority of critics suggest a later dating, in the 5th or 6th century.

An ancient legend, from before the 6th century, recounts that, when Constantine was suffering from leprosy, Pope Sylvester brought him an icon with the images of Saints Peter and Paul. On seeing this the emperor recovered. This scene, which had been preserved in a fresco in the old Vatican basilica, is evidence of the continuing tradition of icons with the images of the two apostles. Even though it cannot be accorded absolute historical verification, it is further testimony of the emergence and the diffusion from Rome of the iconographic model for Peter and Paul, the two apostles who spread the Gospel in the East and in the West and bore witness to their devotion to Christ through their martyrdom in Rome.

From the Tomb to the Dome
The Architectural Evolution of the "Memorial" to the Apostle Peter
Pierluigi Silvan

A great deal more has been learned about the history of the tomb of the apostle Peter over the last fifty years, ever since Pius XII decided to permit thorough archaeological investigation of almost all the ground beneath the Vatican crypts, as well as under the papal throne. Gradually stripped of its legendary accretions and of the not always very erudite hypotheses that have tended to distort its history, "Peter's memorial" can now be viewed, after all the excavations and studies, in a more accurate perspective, and one that has made possible a comparison with works and texts from ancient times.

This is the story that we intend to recount here, within the limits of the space available. It starts from the place of Saint Peter's burial, from its chorographic and archaeological description, and then goes on to examine the monuments that have been used to mark the tomb of Saint Peter since the middle of the 2nd century.

What makes this history so extraordinary and fantastic is the fact that all the above-mentioned monuments are still in existence, notwithstanding the many rearrangements of the site and the extensive works that have been carried out there. These include the construction of the first basilica – the one built during the papacy of Sylvester I (314-335) and under the reign of Constantine between 320 and 333 –, the successive elevations of the presbytery by Gregory the Great (590-604) and Calixtus II (1119-1124), and the erection of the existing basilica, which took place between 1506 and 1615, a period presided over by eighteen popes, from Julius II (1503-1513) to Paul V (1605-1621).

The "memorial" has never ceased to be the centre, fulcrum and sole reason for all the constructions that have been raised there over the centuries. The first architectural structure to have been built on the burial place of Saint Peter was brought to light by the archaeologists in charge of the excavations in the area known as the *confessio*, carried out between 1939 and 1945. This is located beneath the papal throne and is visible to anyone who, going down into the crypts, passes through the archaeological area of the necropolis.

Once over his initial surprise, the visitor realizes that he is walking on what was once the side of a hill, between two rows of majestic burial chambers, originally located in the open air. The majority of the chambers date from the 2nd century A.D. After a brief climb to the north, he finds himself in a narrow passage that rises slowly toward the west, in the direction of the papal throne and running parallel to the longitudinal axis of the basilica. As he advances, he will become convinced that the mausoleums have been subjected to an ever more intensive work of demolition, to the point where, at the end of the passage and right on the edges of the area underneath the papal throne, the last of these monuments has been reduced to a few remnants of a wall.

At the same time, the visitor will gain a clear idea of the problems faced by the architects who were given the task of building the first basilica. On the side of a hill, occupied by an imposing graveyard that had never fallen into disuse, they had to create an artificial platform that extended, obviously, well beyond the boundaries of the basilica to be erected. This required movements of earth on a huge scale and the building of massive structures to contain this earth. The top of this platform was carefully set at a level that left a small monument with niches above the earth, along with the low walls behind it, intact and isolated. These were at the focal point of the new construction, placing them right in the centre of the apse.

Thus it was a modest funeral chapel in a cemetery for well-to-do commoners, closed down by imperial authority, that provided the reason for the construction of a great basilica and for the transformation of an entire area that, at the time, was located in open countryside.

In the area immediately underneath the papal throne, the excavations brought to light a seven-metre-long wall, running from south to north. Built around the middle of the 2nd century, it was plastered and coloured red, and is consequently known as the "red wall". In the middle of the excavated part of the so-called red wall are two niches. Created at the time the wall was built, these form part of a small monumental complex that will be described later. In front of this small monument lay an area, about four metres long and the same in width, surrounded on three sides by walls of the "family tombs" of the Vatican necropolis. What we have just described is the appearance of the tomb of Saint Peter, as it looked from the middle of the 2nd century onwards.

That small monumental complex, of enormous significance, as we have suggested, for the construction of the two basilicas, is no less singular in the context of the necropolis in which it is set. It is not just an individual shrine built right in the middle of a group of mausoleums, but it also breaks up the alignment of these mausoleums. In fact the closest of them surround the space of which the shrine forms the centre.

In the midst of the surrounding mausoleums, the area on which the shrine stands and the shrine itself appear to be the result of a precise intention to retain an earlier tomb in the new necropolis, and at the same time to make it an integral part of this cemetery.

Much of the ground of this protected area appears to be material that has been brought in to fill the space bounded by the outer walls of the surrounding mausoleums. This has created a flat area at the same level as the small monument, built on a particularly steep slope.

The subsequent architectural elaboration of that tomb, linked with the construction of the red wall, which has created and shaped the small monument known as the "trophy of Gaius", is certainly the most important in antiquity. The monument, which, as has already been said, must have been built at the same time as the red wall, was examined to a height of 245 cm and revealed a series of niches set one on top of the other: a very rough one underground, another well-built one above it, at ground level (the niche of the Pallia), and a third one at the top, on the same axis but wider. The two upper niches are separated by a thick slab of travertine, inserted in the red wall on one side and resting on two small columns of white marble on the other. The latter rest in turn on another slab of travertine, with a moulding, that forms the threshold of an entrance.

We can assume that the upper part of the "trophy", concealed within the medieval altar above, ended in a tympanum, probably raised on supports (walls, small pillars, or something of the kind). Similar structures can be found in the cemetery area of Via Ostiense.

The asymmetrical shape of the monument must be due to the construction of the "g wall", or "graffiti wall", that is set at right angles to the red wall, on the right of the monument. It is possible that the function of the g wall was to buttress the red wall. The investigators discovered a crack at the very point where the g wall abuts onto this wall, but in our view the presumed technical motivations for its construction are not sufficient to justify the significant damage that it caused to Peter's memorial.

Note, in fact, that: a) the symmetry of the monument was sacrificed, with the right-hand column of the "trophy" shifted a considerable distance toward the middle, since the g wall occupies the original location of the column; b) on the northern side, the entrance to the tomb was actually destroyed to allow construction of the foundation of the g wall; c) the threshold with mouldings referred to above was cut, again on the northern side; d) the slab of travertine between the two niches above the ground was shortened by 23 cm on the northern side to make room for the g wall.

These are the most notable consequences of the building of the graffiti wall, as revealed by the exhaustive surveys and studies carried out by the archaeologists. Yet these do not seem to be enough

to explain the role played by the g wall later on, together with the rest of Peter's memorial. Ever since its construction, in fact, the graffiti wall has assumed an importance at least equal to that of the trophy. The care with which the latter was built and then preserved – a care that was constantly maintained over a long period of time, clearly showing that the grave had been protected and venerated from the beginning – contrasts strongly with the damage caused to the monument by the construction of the g wall. This is even more true when one considers that it was not the only, indispensable solution to the problem of shoring up the red wall where it was cracked.

The subsequent modifications and embellishments that were made up until the 4th century did not alter the substance of the complex, which continued to lack both an axis of symmetry and its original monumental character, however many precious decorations were added to it.

Even this, however, confirms the continuity and strength of the veneration reserved for this small site, which Constantine and Sylvester had no difficulty in recognizing as the tomb of the apostle Peter.

There has been a great deal of discussion over the date of construction of Constantine's basilica but, for the purposes of our study, it matters little whether it was completed by Constantine or by his sons. We would like, on the other hand, to draw attention to the guiding principle behind its design and the way in which the various stages of its construction were carried out.

Ever since 1586, when, at the behest of Sixtus V, Domenico Fontana transported the obelisk from its original location to the open space in front of what was left of the old basilica, the hypothesis had been advanced that much of Constantine's basilica had been built on top of the structures of Nero's circus, in whose precincts the obelisk once stood. This idea was taken up by Grimaldi and was put forward again not so many years ago. In particular, it was Fontana's fascinating theory – and undoubtedly to Sixtus's liking – that the foundation walls of the two southern rows of columns and of the outer wall of the basilica once formed the enclosure of the north wing of Nero's circus. However, excavations have revealed that those walls date from the period of Constantine. At the same time, they have exploded the myth that the area under the nave of the basilica was once occupied by a Roman road and a circus. Nevertheless, these could not have been very far away, as is confirmed by the *titulus* of the mausoleum of Popilius Heracla.

So it is now clear that Constantine decided to raise the temple dedi-

*Reconstruction of a portion of the area
excavated around the "red wall".
The "trophy of Gaius", the first monument
erected on the tomb of the Prince
of the Apostles, emerges from the wall.*

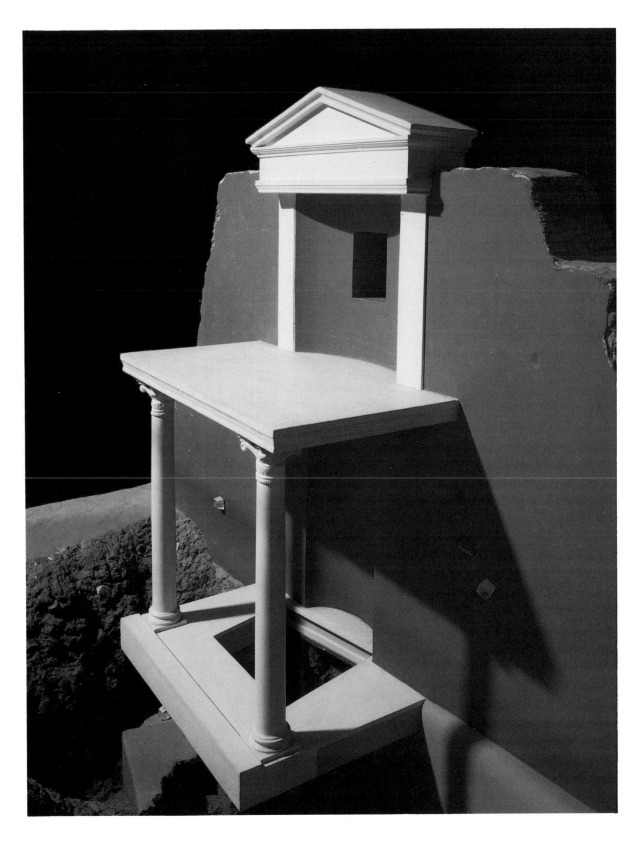

29

cated to Saint Peter, not over Via Cornelia and the circus, but on top of the great necropolis that covered the slopes of the Vatican hill. The tombs of this necropolis, judging by what the excavations have brought to light, were arranged in at least two parallel rows and were not all set on the same level. Rather, they followed the lie of the ground, which sloped fairly steeply downwards in a north-south direction and more gently from west to east.

As a consequence of the very precise decision about the level on which the basilica was to stand, Constantine's architects were obliged, in their construction of the required platform, to demolish the roofs of some of the mausoleums, which protruded above this level, and fill them with material. Both the chambers and the corridors between the mausoleums were filled with all kinds of rubble, mostly provided by demolition of those structures that protruded above the level established for the platform, and with the earth that had to be excavated from part of the Vatican hill, toward the north. Although the tombs functioned as containment boxes for the filling material, it also proved necessary to connect the structures with those of the basilica's new foundations, by a series of linking and reinforcing walls.

In addition to the formidable amount of work required for the construction of this platform, there were the considerable technical difficulties involved in the erection, over a relatively short period of time, of such a massive building on top of filling material.

Nor should it be forgotten the legal and political problems, or the difficulties of a religious and psychological nature, that the destruction of an enormous part of the Vatican necropolis may have created for the emperor himself.

These arguments seem more than sufficient to demonstrate the determination of Constantine and Sylvester I to build the basilica devoted to Saint Peter on a particular site and at a particular level. Not even the fact that, on top of the aforementioned difficulties, the site was a highly unsuitable one would make them swerve from their intention. The level was determined by the slab with mouldings that formed the threshold of the trophy of Gaius.

By the construction of a monument right in the middle of the presbytery of their basilica, the aim of the emperor and the pope was to protect, embellish and draw attention to the group of structures on the slope of the Vatican hill that they had identified as the tomb of the Prince of the Apostles. The evidence of uninterrupted veneration for those structures, for that "memorial", constituted the prime reason for the decision to construct the basilica on that site. The excavations have shown that the builders of Constantine's ba-

silica were concerned exclusively with the preservation of the above-mentioned group of structures; the whole of the rest of the necropolis, in fact, was indiscriminately covered with earth. The original "memorial" was spared and incorporated into a splendid monument built out of precious marble, along with all the structures that had been set immediately on top of it or alongside it at various times. Unquestionably, the most important of these added structures was the g wall, for the reasons already given and because from that time on it acquired an importance within the complex of the memorial to Saint Peter at least equal to that of the surviving part of the original grave and the trophy, which were preserved and continued to be venerated, rightly, as relics.

The construction of the g wall shifted the axis of the complex to the north. Constantine and Sylvester I wished to respect this axis and use it as the basis for the construction of their monument and basilica. Constantine's monument has a number of unusual features, with regard to its dimensions, its orientation and its construction, which appears to be of uncommon regularity. It encloses the whole complex of the "memorial", which is given additional protection by walls on the south and north sides. The latter, close to the graffiti wall, is considerably thicker than the one to the south. As a consequence, the niche of the Pallia, above the tomb, is displaced even further from the axis of the complex, so that it is located exactly halfway between the tomb and the graffiti wall. Even in the existing basilica, the niche of the Pallia is in a clearly asymmetrical position, which no one has ever dared to correct.

Significant evidence for the reverence that was shown for Constantine's monument comes from an examination of the major modifications that were made to the area surrounding it during the Middle Ages. At the end of the 6th century, during the papacy of Saint Gregory the Great (590-604), and at the beginning of the 12th, under Pope Calixtus II (1119-1124), the height of the presbytery was raised, the so-called semi-annular corridors were created inside the apsidal wall, and the altars and their ciboria were reconstructed. Yet all this was done with the same spirit of uncompromising respect that had motivated Constantine and Sylvester I to encapsulate the complex of Peter's memorial in order to ensure the preservation of all its essential structures.

The same spirit drove the architects of the Renaissance and of the 16th century who were entrusted with the renovation of the basilica. On April 18, 1506, at the point where the pier of the Veronica now stands, the first stone was laid of what, after a hundred years of plans, constructions, demolitions and reconstructions, is still the

largest church in Christendom. The *confessio* and the whole area of the raised presbytery, from the apse to the *pergula* of the medieval basilica, were enclosed by the walls of the so-called *tegurio* or holy house, designed by Donato Bramante, the same architect from whom Julius II (1503-1513) had commissioned the project for the new basilica.

The purpose of that building, whose base is still partially visible, was to protect the apostle's memorial from any possible damage resulting from the demolition work, the weather, or the dangers of the construction site. It did so up until the time of Clement VIII (1592-1605), that is until the lantern of the dome was completed in 1592.

As well as allowing people to go on worshipping at the tomb of Saint Peter and the sacred rites to be performed on the altar of the *confessio*, the *tegurio* served to mark the boundaries of the area that was not to be touched by the construction of the new church.

The work carried out previously by the architect Bernardo Rossellino (1409-1464), during the papacy of Nicholas V (1447-1455), for the construction of a new tribune, had not affected the area inside the apse, since this structure abutted onto the west wall of the transverse arm. Until 1514, the year of his death, Bramante was responsible for demolitions on the one hand and constructions on the other; the latter included the four great piers of the dome, the arches linking them, and part of the walling of the choir screen. In this way, he gave irreversible form to the central part of the new basilica, every element of which was intended to be centripetal to the dome. The result of this was that all the subsequent designs based on a Greek cross had to take account of these structures and their constraints.

The guiding principle of the plan for the new basilica was to have the temple serve as a gigantic ciborium for the apostle's memorial, which was supposed to stand at the focal point of the system, that is at the intersection of the longitudinal, transverse and vertical axes. As for the treatment of the *confessio*, it is reasonable to suppose that Bramante, like other architects who followed him, was referring to the hypogeum of his Tempietto of San Pietro in Montorio. Even in the plan drawn up by Du Pérac (in 1569, five years after the death of Michelangelo), we find a similar configuration.

It was not until the papacy of Clement VIII (1592-1605) that, with the creation of the sacred crypts, the central area of the basilica was given a complete and systematic organization. The decisions taken at the Council of Trent were undoubtedly responsible for the changes that were made to the original plan, variations that rightly took into consideration the not merely archaeological value of the ancient altar. In the spirit of the revival of the cult of relics, the *confessio* regained its proper significance and it was decided to completely isolate the central nucleus of the basilica, consisting of the memorial, Constantine's monument and the various altars, and to link the unroofed *confessio* to the new semi-annular corridor (*peribolos*) with ambulatories. In this way it was connected with the chapel closest to the tomb of Saint Peter, known as the Clementine chapel. This marked a return to the concept current in the 6th and 7th centuries (Gregory the Great), and similar structures were created to restore the overall functionality of the whole structure and make it more accessible to all those who wished to show their devotion to Saint Peter.

The demolition of the structure erected by Bramante to protect the remains of the ancient presbytery and, at the same time, of the apse of the original basilica that had stood for almost thirteen centuries, made it necessary to tackle the problem of building a new papal altar and giving a suitable layout to the space in front. Known as the new altar, it was consecrated in 1594. Unfortunately, this new altar is no longer in its original position, as during Bernini's redecoration of the presbytery, which followed the erection of the baldaquin, it was raised by two steps and set back. The reasons for this were almost exclusively aesthetic and functional.

Details of the story of the various phases in the construction, modification and completion of the basilica have deliberately been left out in order to underline the continuity of tradition and worship that has, quite apart from the geometric or architectural alterations described, characterized every stage in the evolution of Saint Peter's basilica. It is an evolution that has affected not only the construction, but also the decoration, especially in the area of the *confessio* and the crypts.

While the numerous artists who have bestowed the gifts of their art on the basilica have not always been the greatest of geniuses, by playing down the differences between their respective artistic backgrounds and the times in which they lived, they have strived to the maximum of their abilities to make their works an effective instrument of instruction for the Church, in the renewed spirit of the Counter-Reformation.

The majority of visitors are unaware of the artistic catechesis of Saint Peter's basilica: they see it as an immense and sumptuously decorated monument, but are oblivious of the fact that every single architectural and artistic feature of the church has grown out of deep religious feeling.

On Saint Peter's Tomb

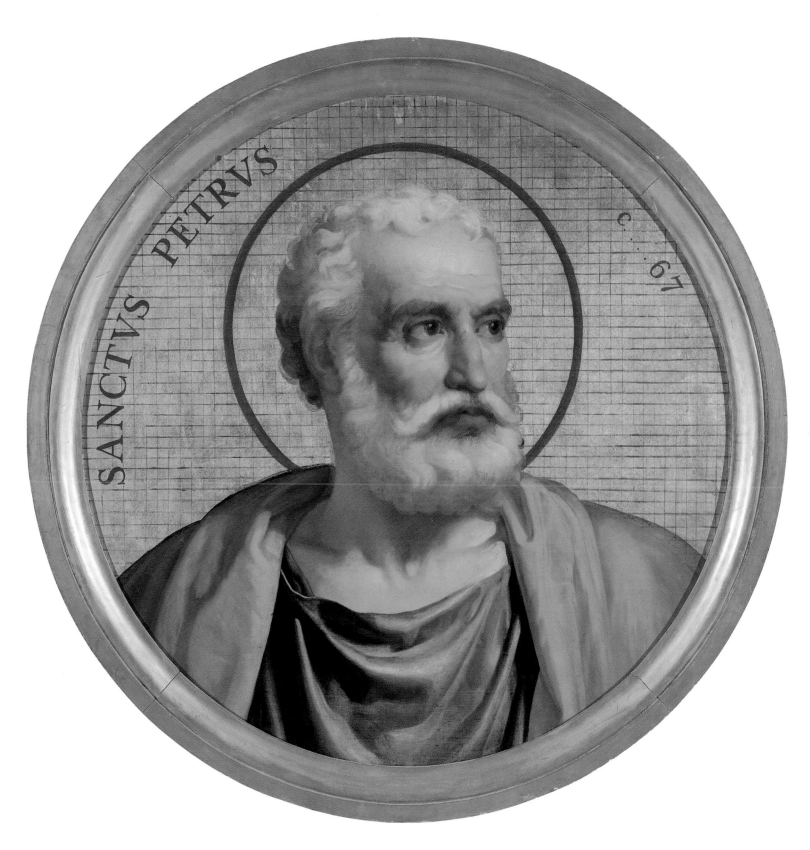

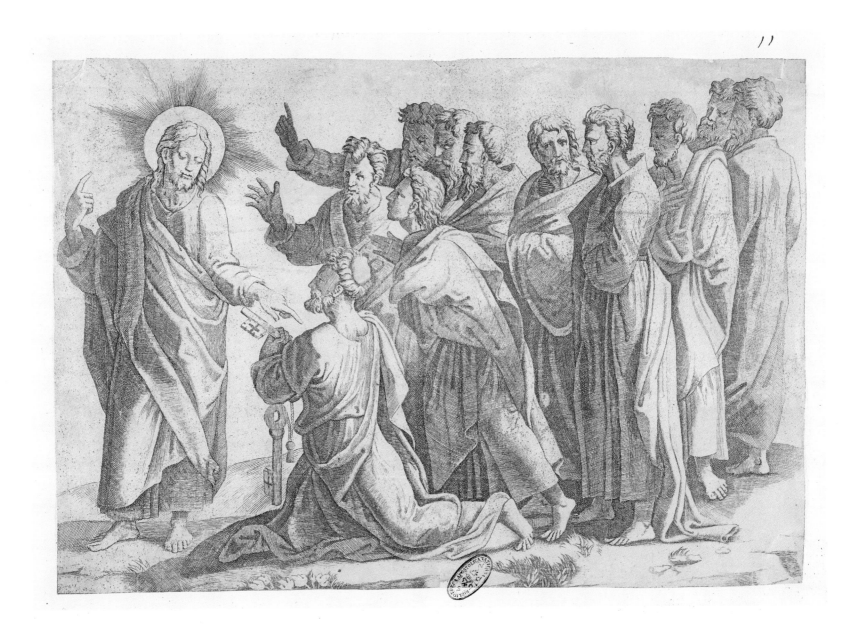

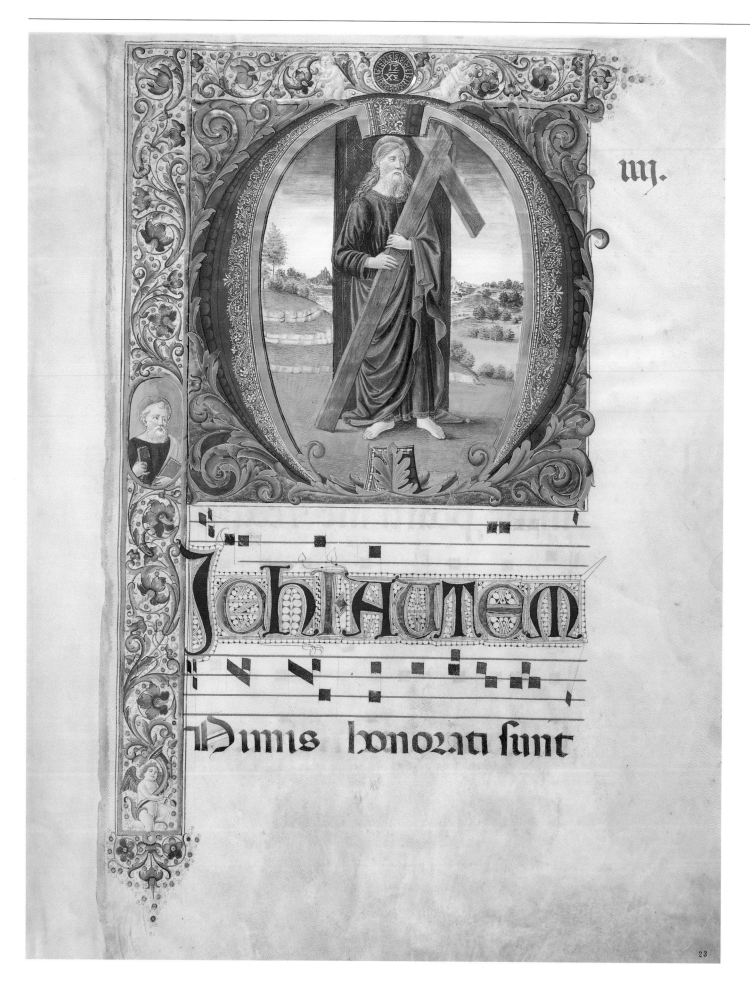

iij.

Ihī Autem

Dimis honorati sunt

23

36

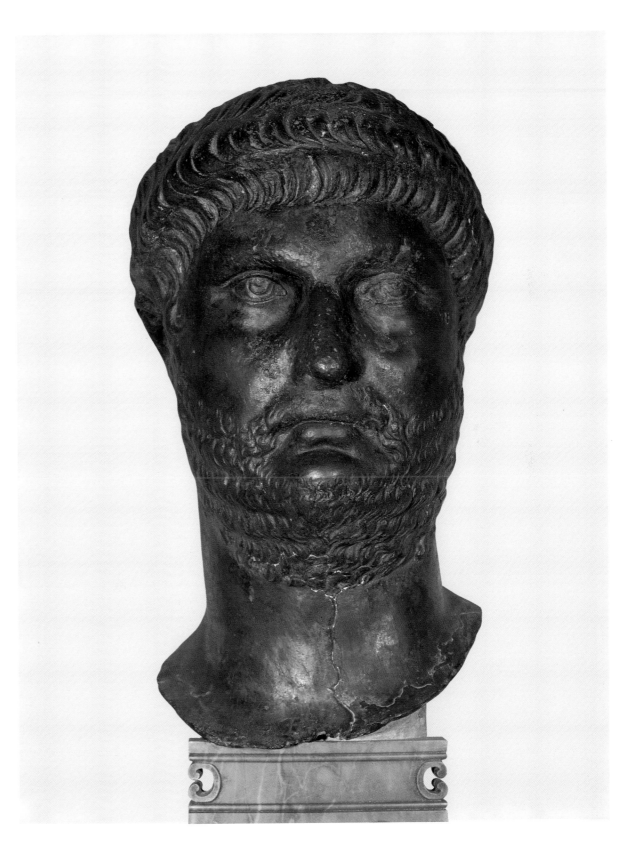

37

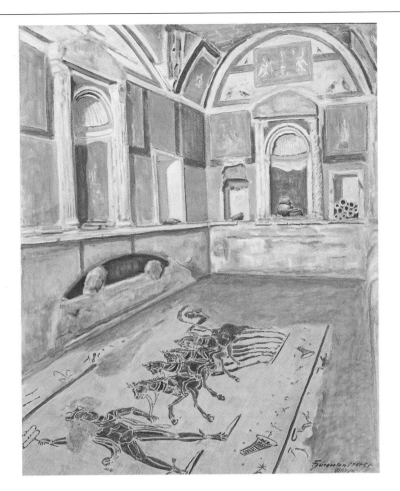

F. Jurgenson, View of the interior of mausoleum I, known as "della quadriga", 1951-53 (cat. no. 7).

F. Jurgenson, View of the interior of mausoleum F, known as "C. Caetennius Antigonus", 1957-58 (cat. no. 8).

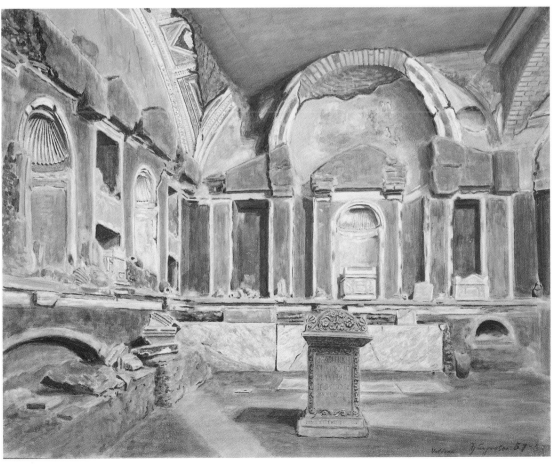

F. Jurgenson, View of the interior
of mausoleum H, known as
"Valerius Herma", 1953-55 (cat. no. 9).

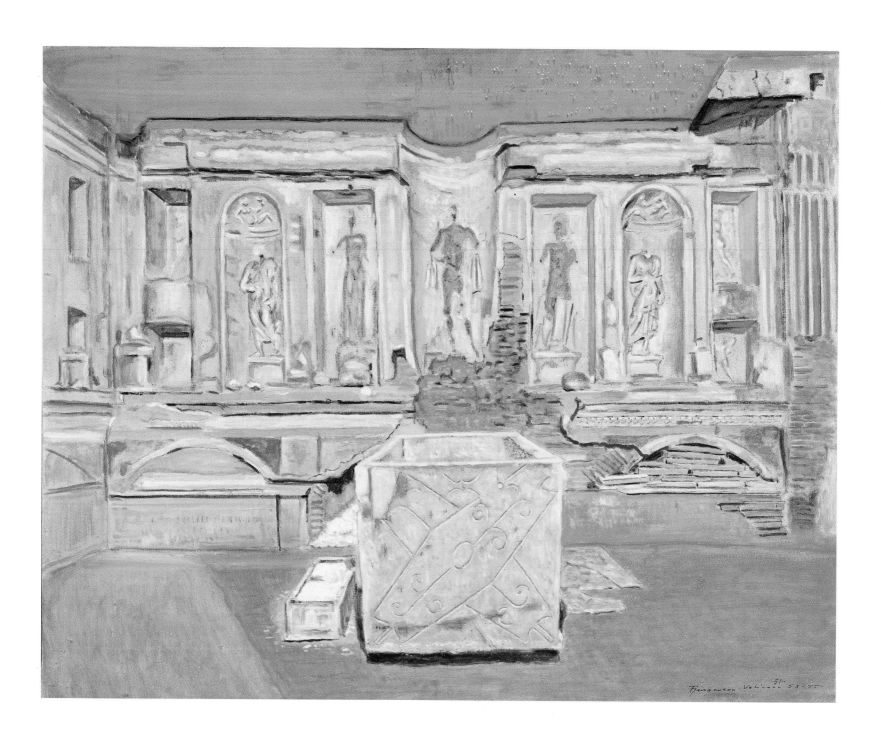

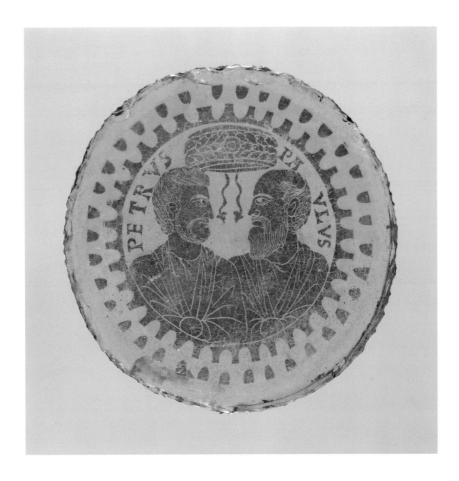

Early Christian terracotta oil lamp with the bust of a cloaked personage, probably Saint Peter, second half of 5th century A.D. (cat. no. 11).

Early Christian terracotta oil lamp with a jewelled monogrammed cross, late 5th - mid-6th century A.D. (cat. no. 12).

Early Christian terracotta lamp with christogram, late 4th - early 5th century A.D. (cat. no. 13).

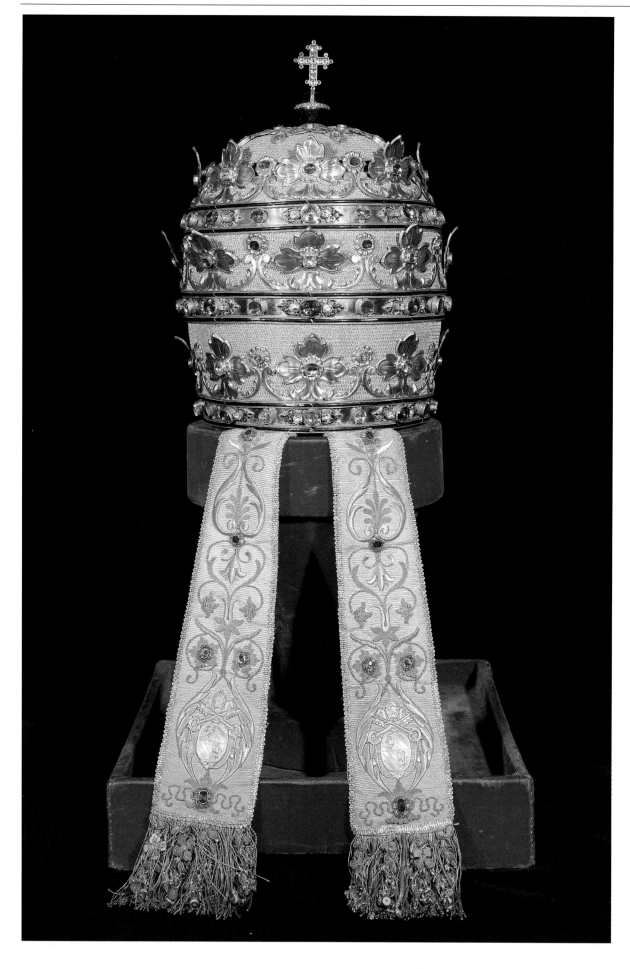

Pius IX's Tiara, mid-19th century (cat. no. 15).

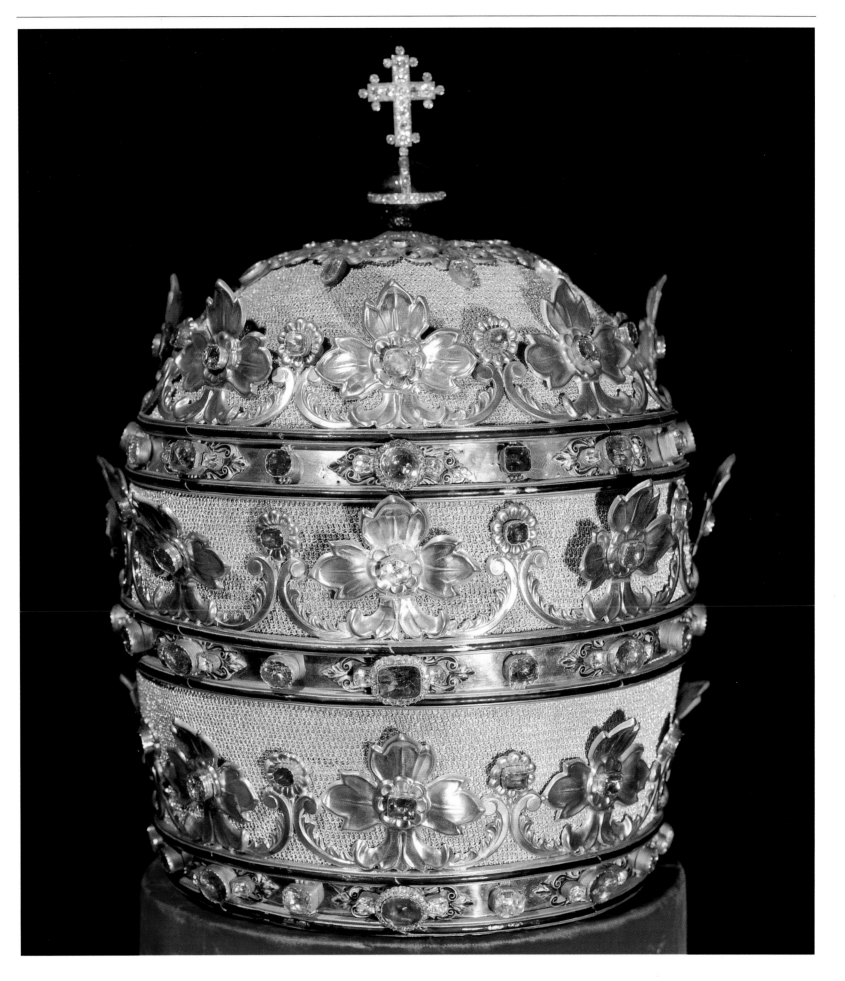

Old Saint Peter's: The Original Basilica

Pieter van Lint and Pietro de Balliu,
Constantine Inaugurates the
Construction of the Basilica and
The Pilgrims Go to Visit Saint Peter,
1637 and 1635 (cat. no. 17).

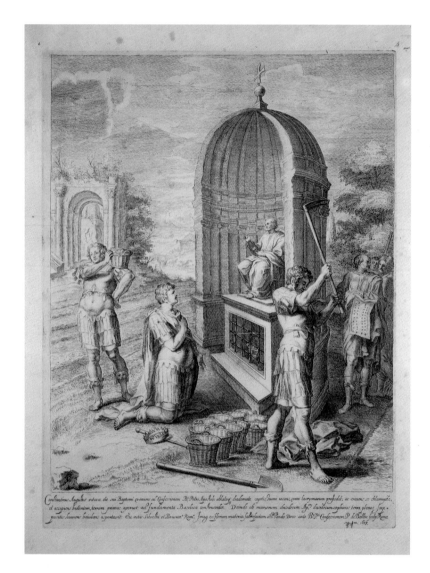

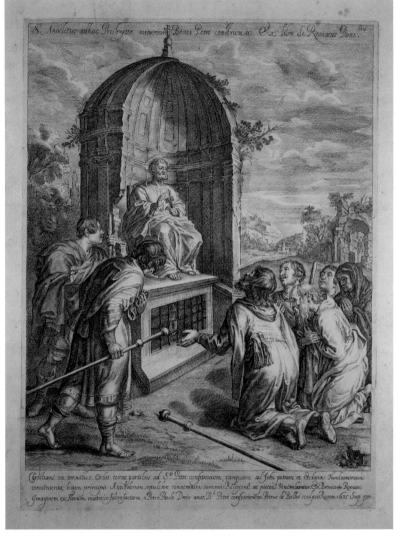

Alberto Carlo and Mauro Carpiceci,
Reconstruction of Old Saint Peter's,
1985 (cat. no. 18).

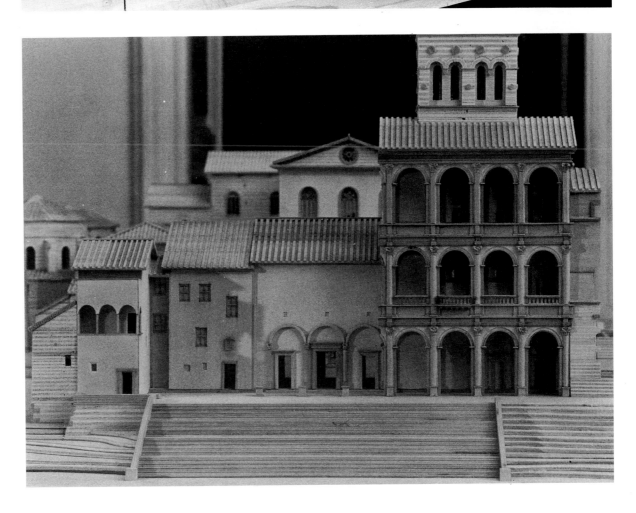

Giovan Battista Ricci da Novara,
North-south section of Old Saint
Peter's, 1616 (cat. no. 19).

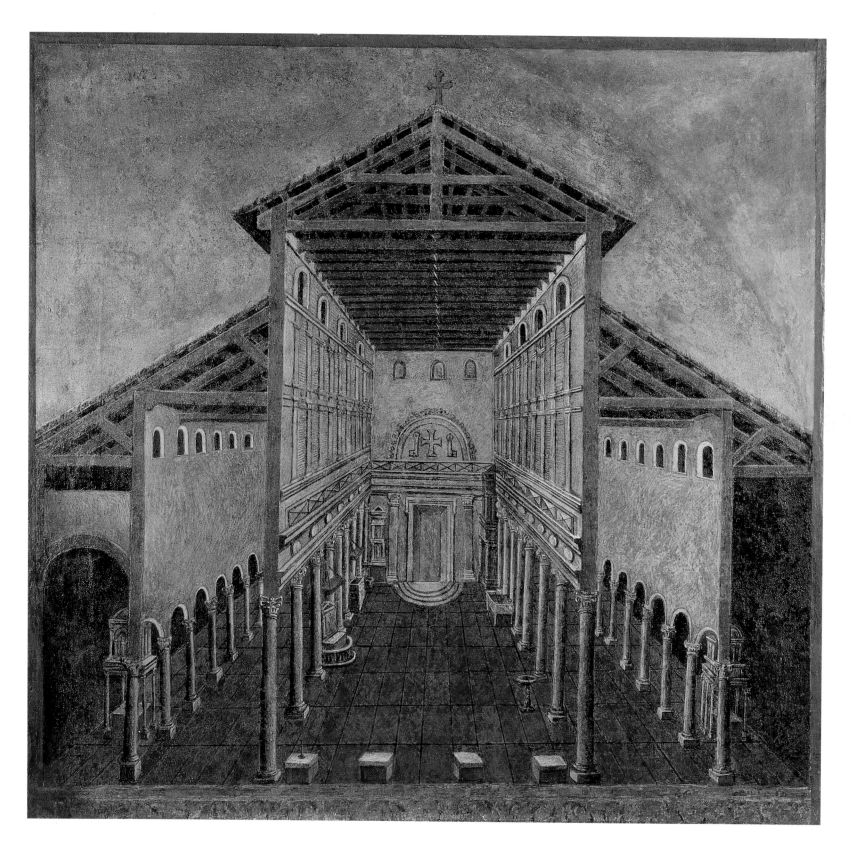

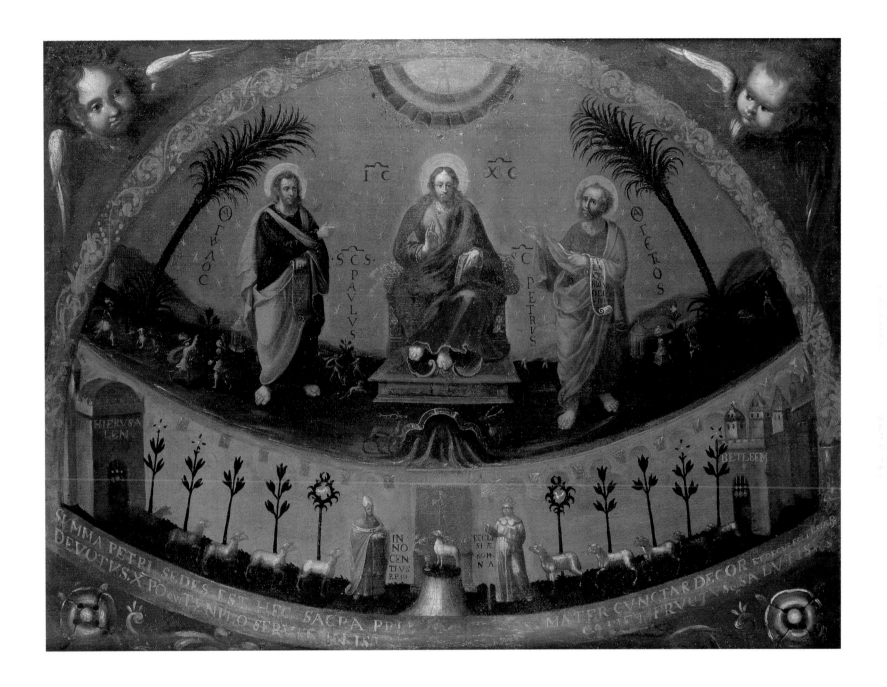

Copy of the apse mosaic in Old Saint Peter's, 17th century (cat. no. 20).

Domenico Tasselli, View of the facade and atrium of Old Saint Peter's, c. 1611 (cat. no. 21).

Tiberio Alfarano, Engraving representing a plan of Old Saint Peter's, 1589-90 (cat. no. 22).

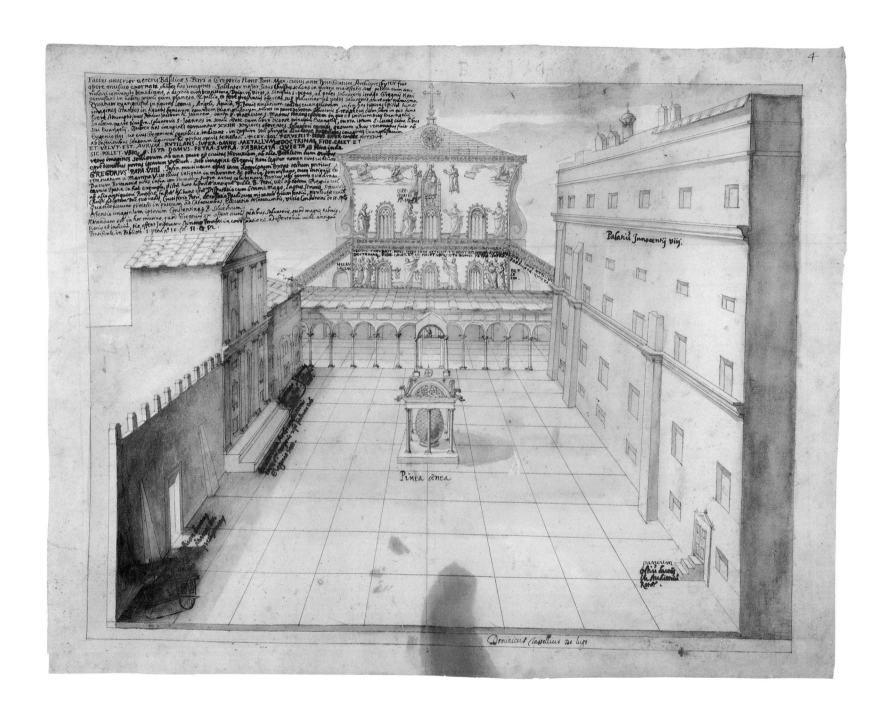

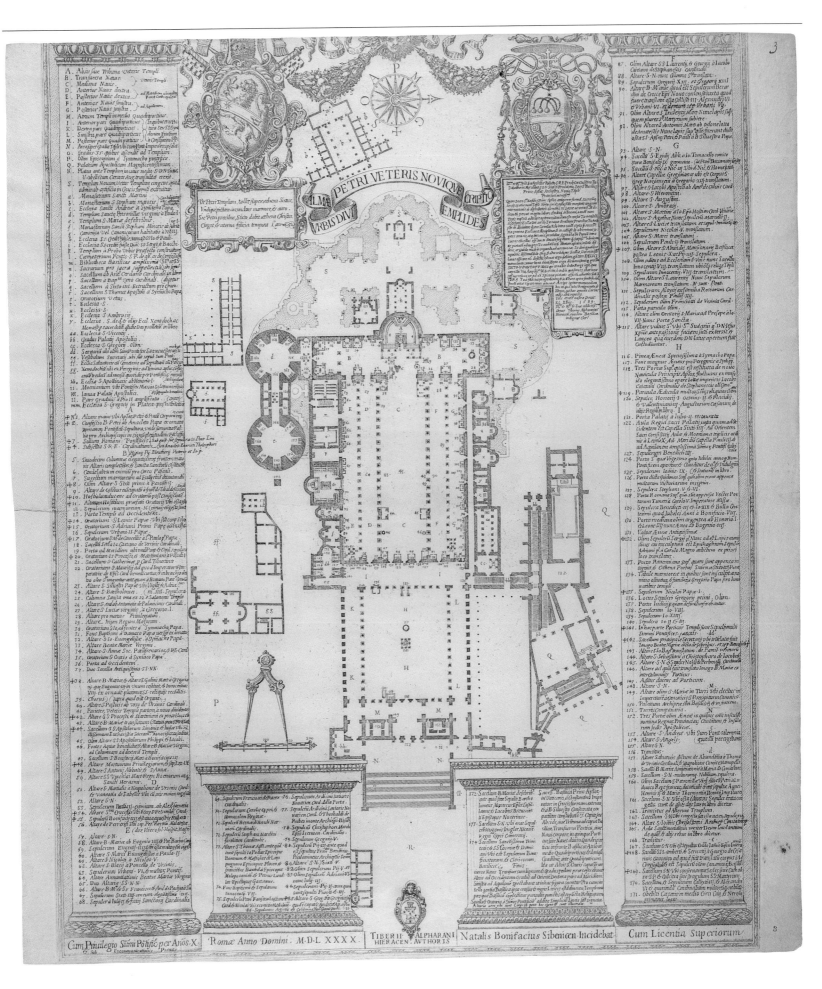

Fragment of frieze from the oratory of Pope John VII, 2nd century A.D. (cat. no. 23).

Fragments of the Bramantesque tabernacle of the Holy Lance, late 15th century (cat. no. 24).

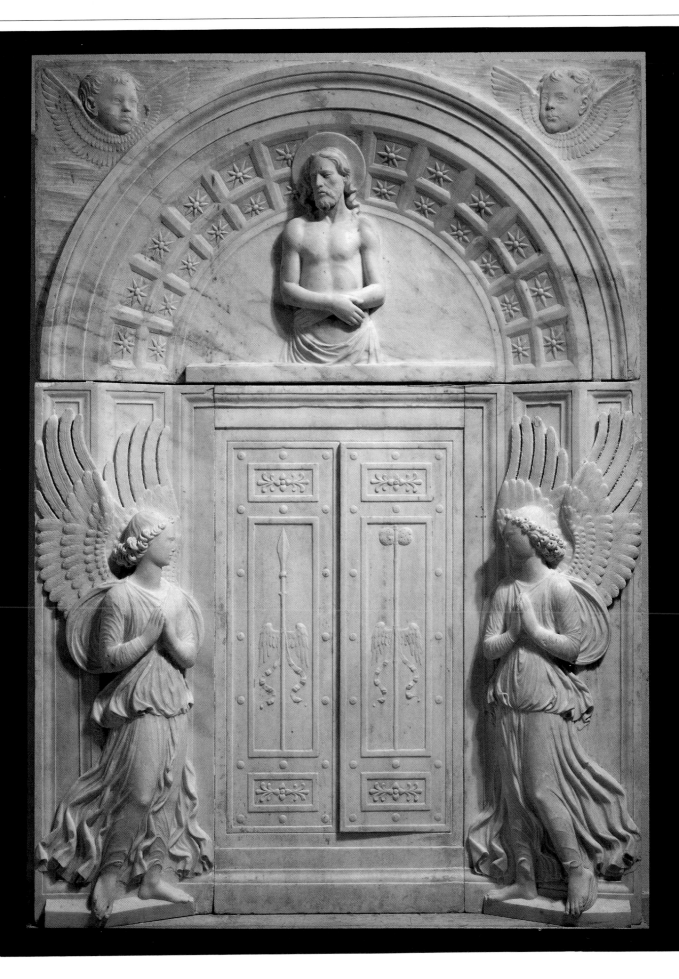

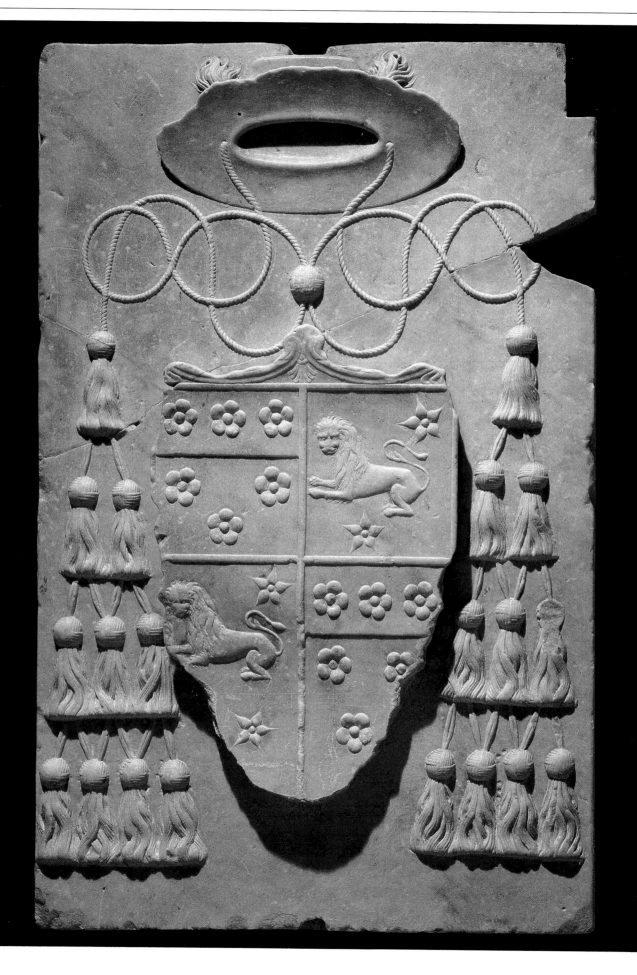

Marble coat of arms of Cardinal Richard Olivier de Longueil, 1465-70 (cat. no. 25).

Statuette representing Christ Enthroned, c. 1215 (cat. no. 26).

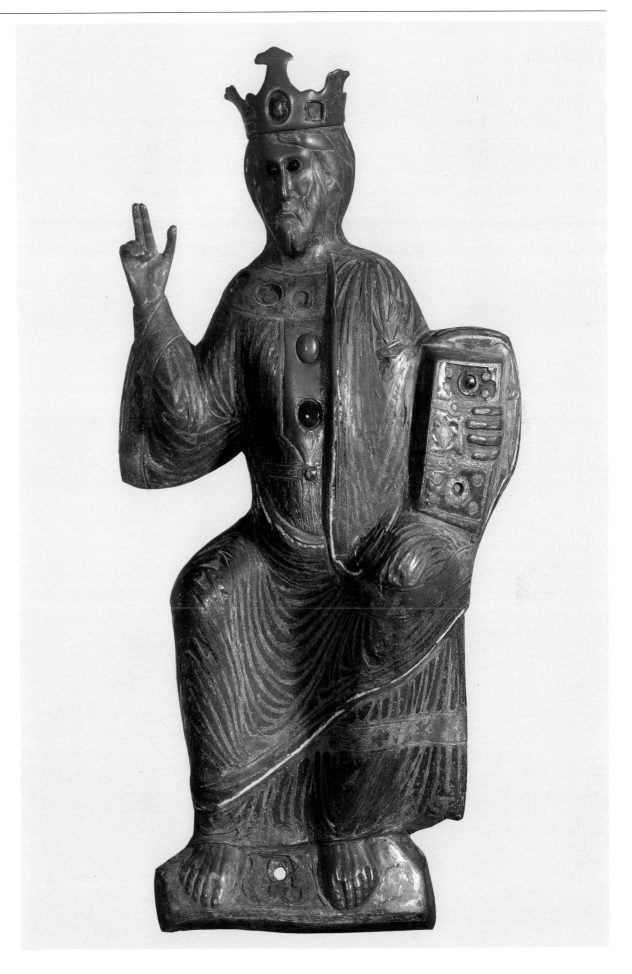

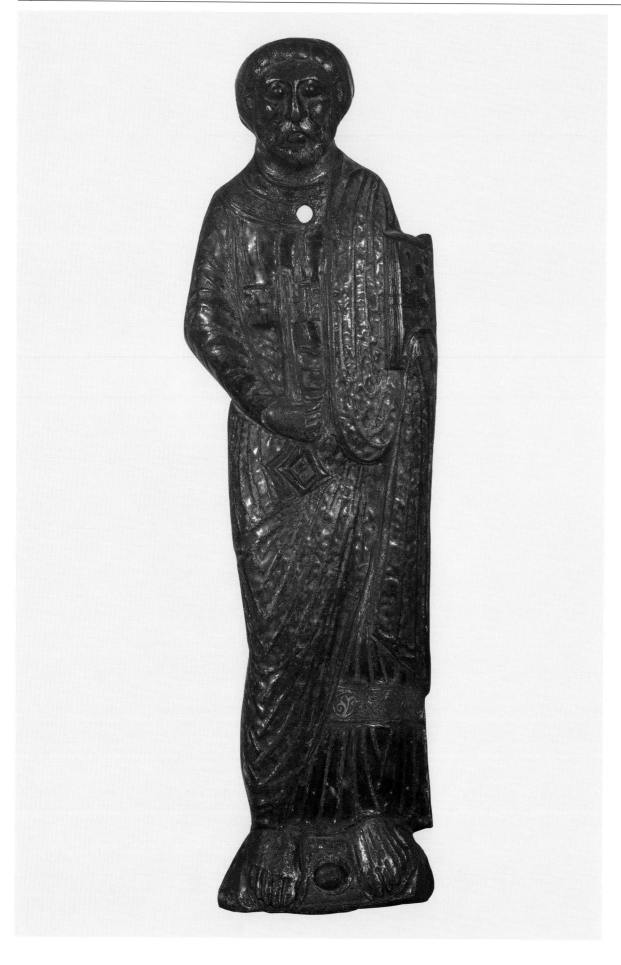

Statuette representing Paul the apostle,
c. 1215 (cat. no. 28).

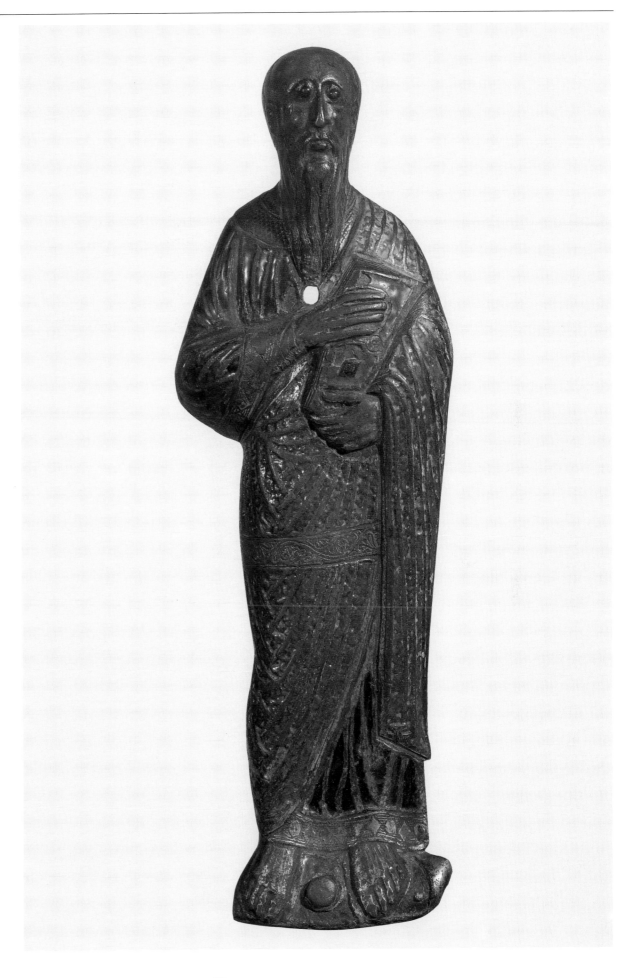

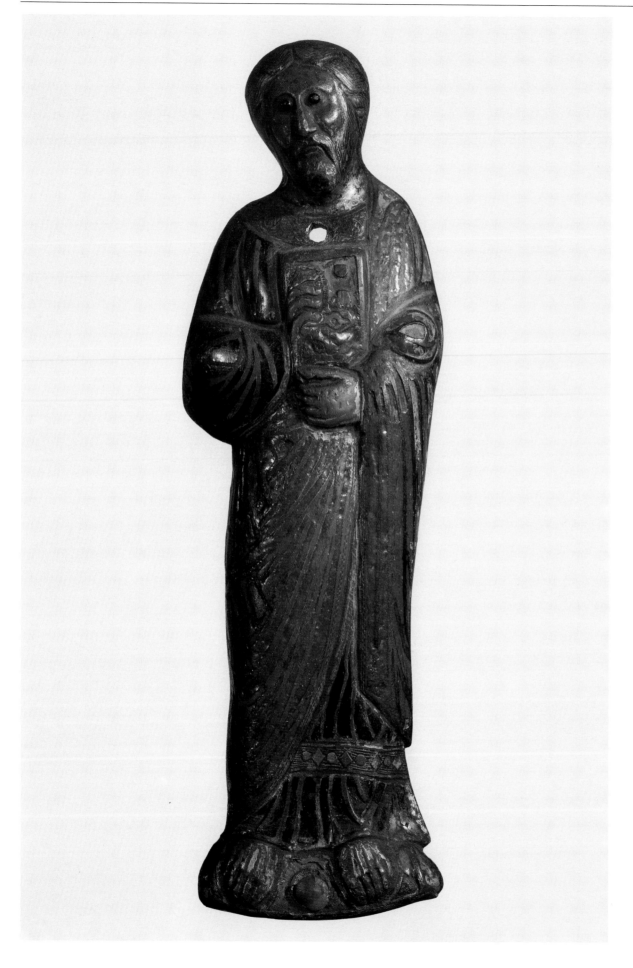

Statuette representing an apostle,
c. 1215 (cat. no. 30).

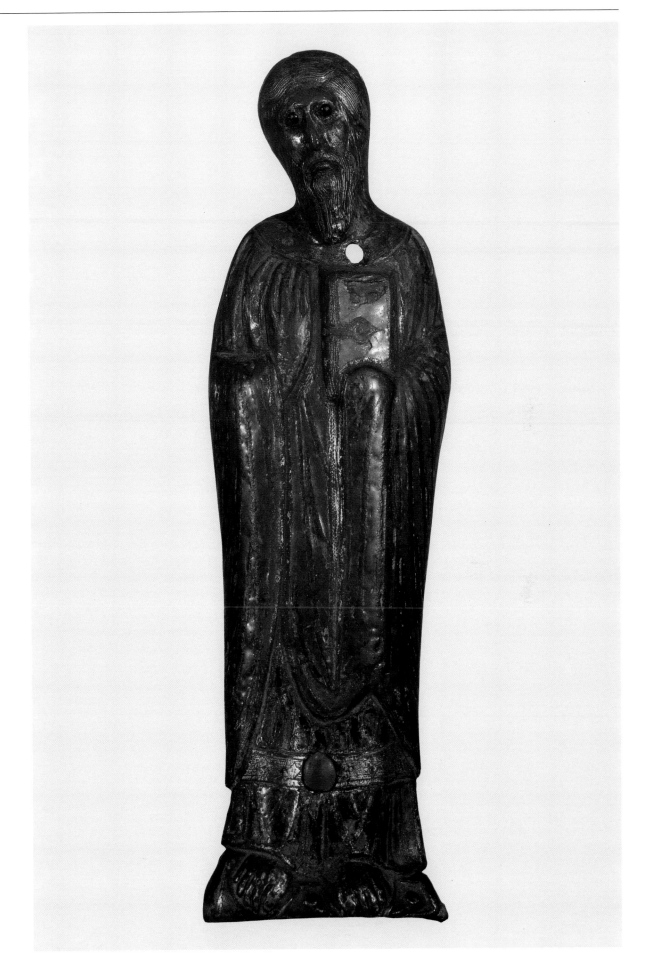

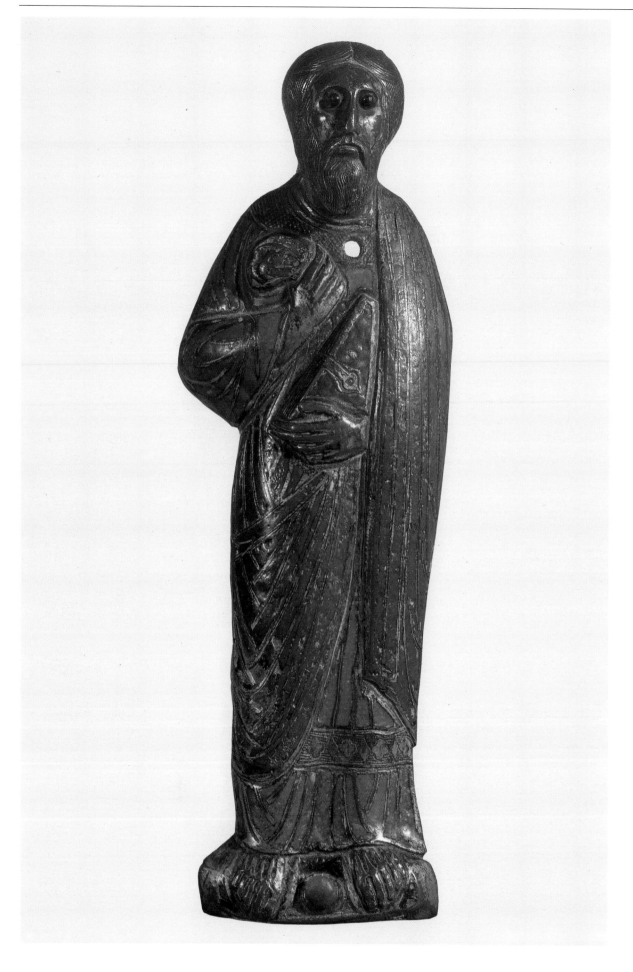

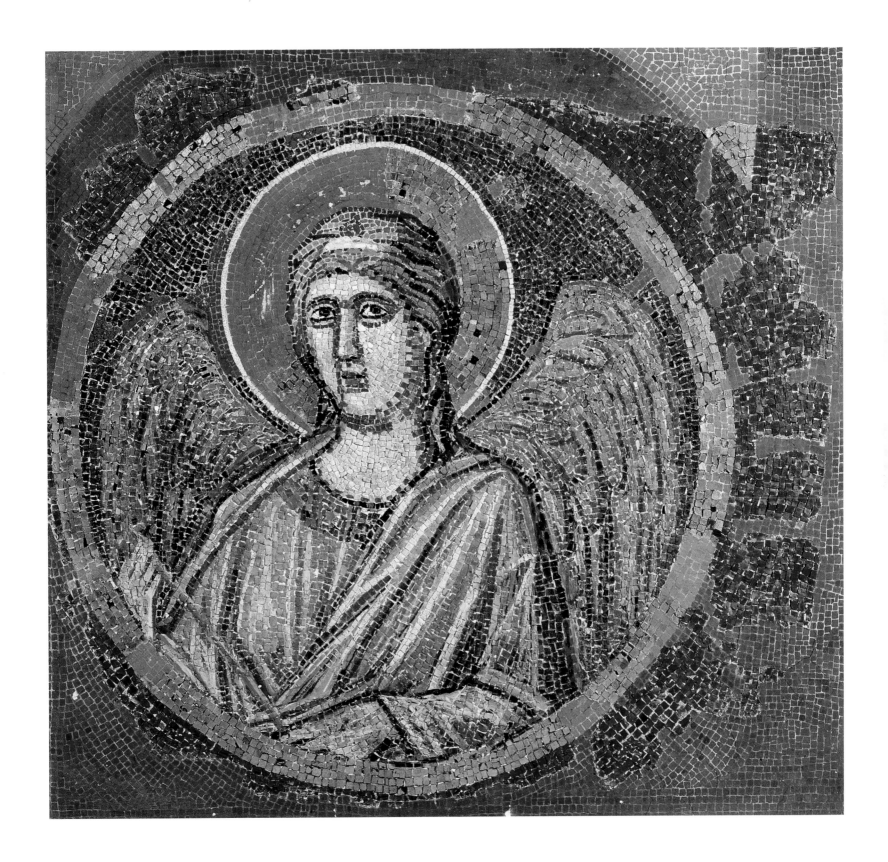

Jubilee and Pilgrimage

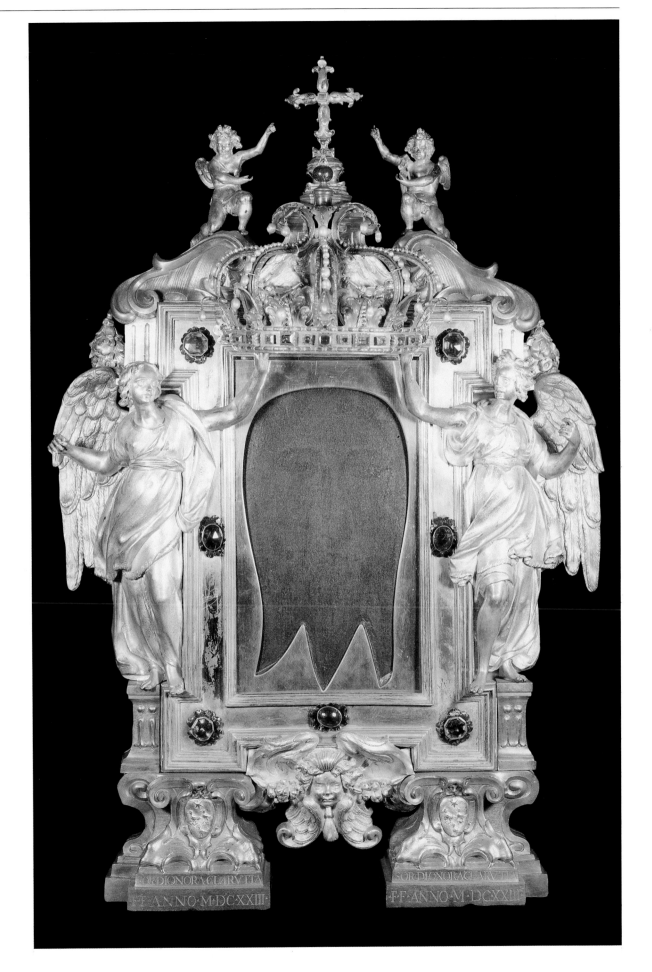

Reliquary of the Volto Santo
or Mandilion of Edessa,
3rd-5th centuries (cat. no. 33).

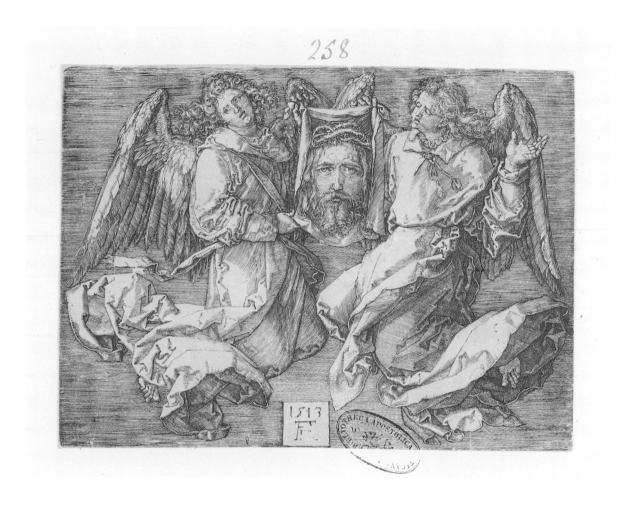

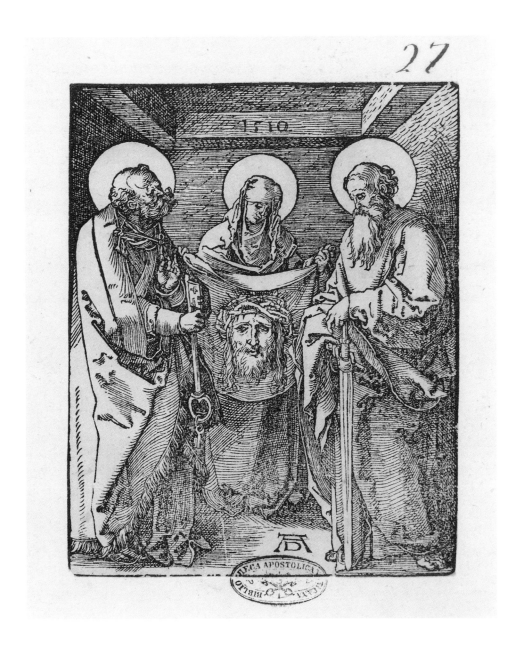

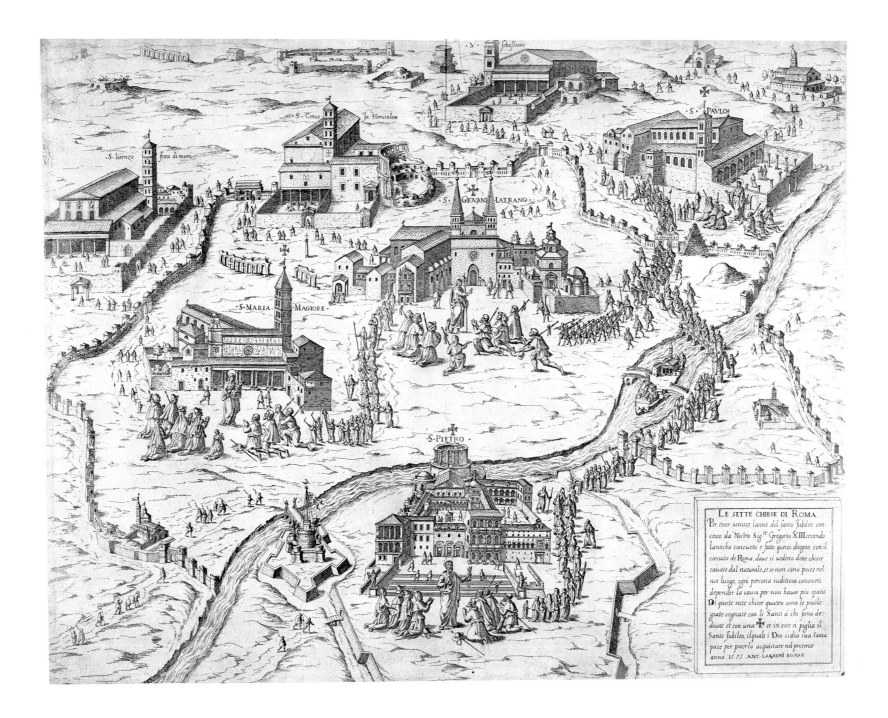

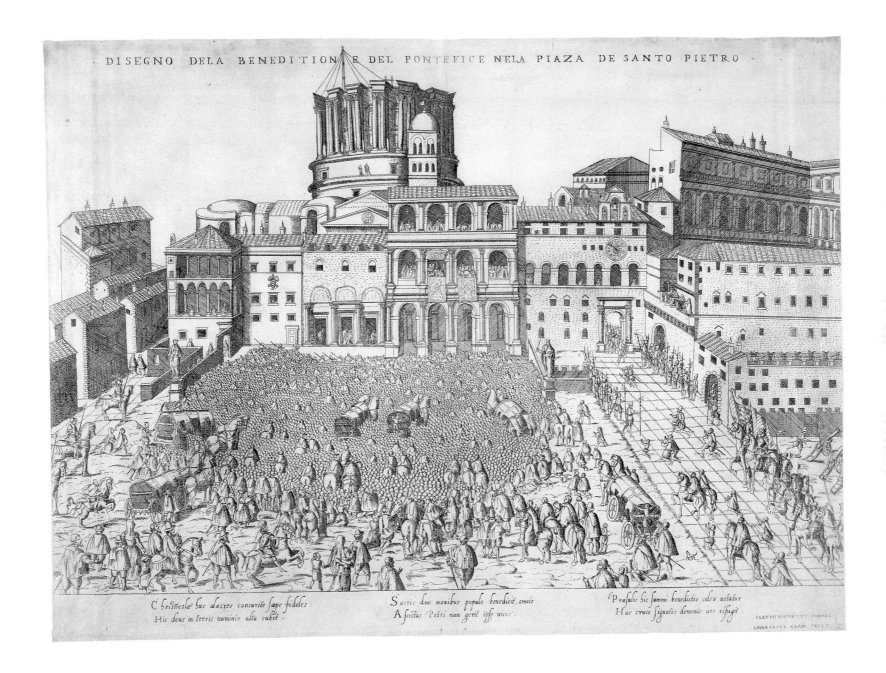

DISEGNO DELA BENEDITIONE DEL PONTEFICE NELA PIAZA DE SANTO PIETRO

Christicolæ huc alacres concurrite sæpe fideles:
Hic deus in terris numinis alta subit.

Sacris dum manibus populo benedicit, amice
Assistas Petri nam gerit ipse uices.

Præsulis hic summi benedictio celsa notatur
Hac cruce signatos demonis ars refugit.

CLAVDII DVCHETTI FORMIS

AMBROSIVS BRAM FECIT

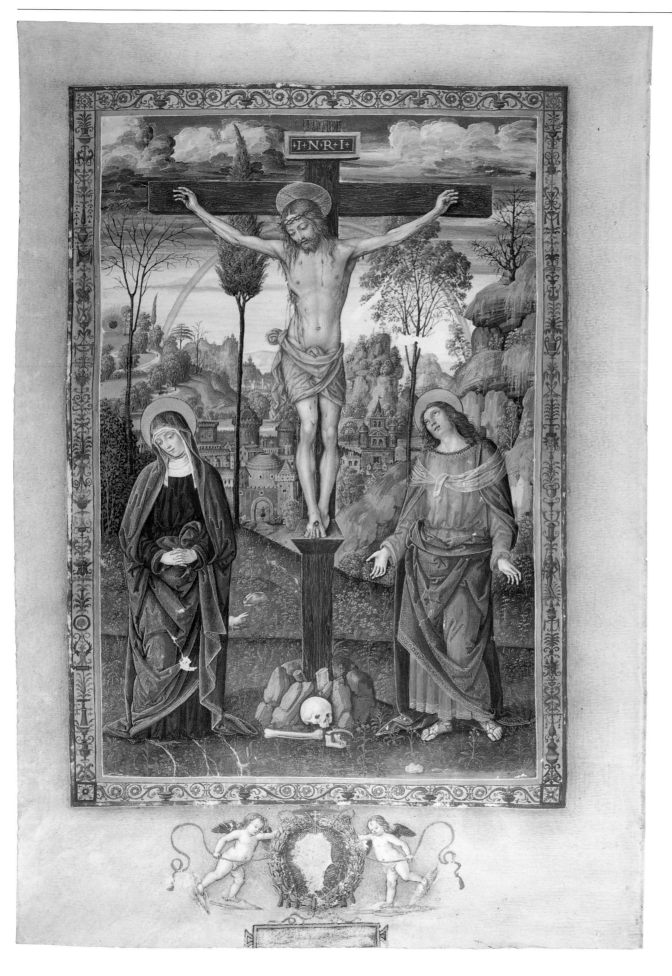

Bernardino di Betto, called
Pinturicchio, Crucifixion,
c. 1495 (cat. no. 38).

Michelangelo Buonarroti, Pietà, copy,
1975 (cat. no. 39).

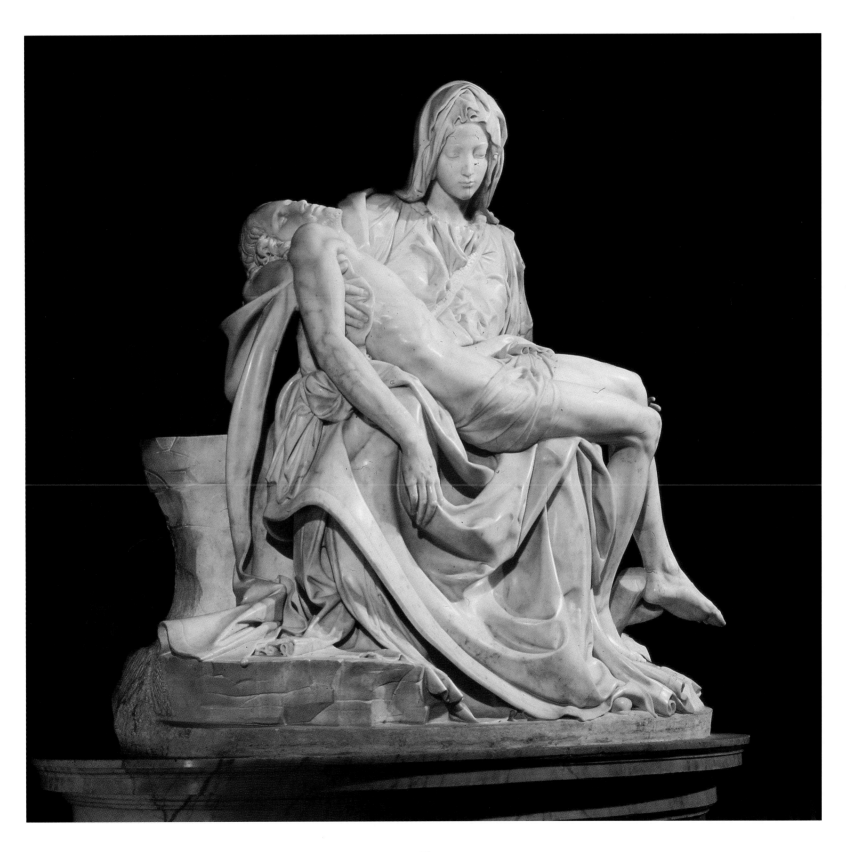

Bernardino di Betto, called
Pinturicchio, Crucifixion,
c. 1495 (cat. no. 38).

Michelangelo Buonarroti, Pietà, copy,
1975 (cat. no. 39).

71

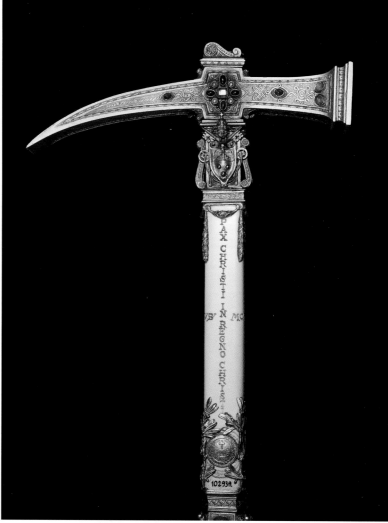

Commemorative brick for the Holy Year of 1900 (cat. no. 42).

Commemorative brick for the Holy
Year of 1825 (cat. no. 43).

Commemorative brick for the Holy
Year of 1925 (cat. no. 44).

Mould for the imprint of the bricks used to wall up the Holy Door in 1750 (cat. no. 45).

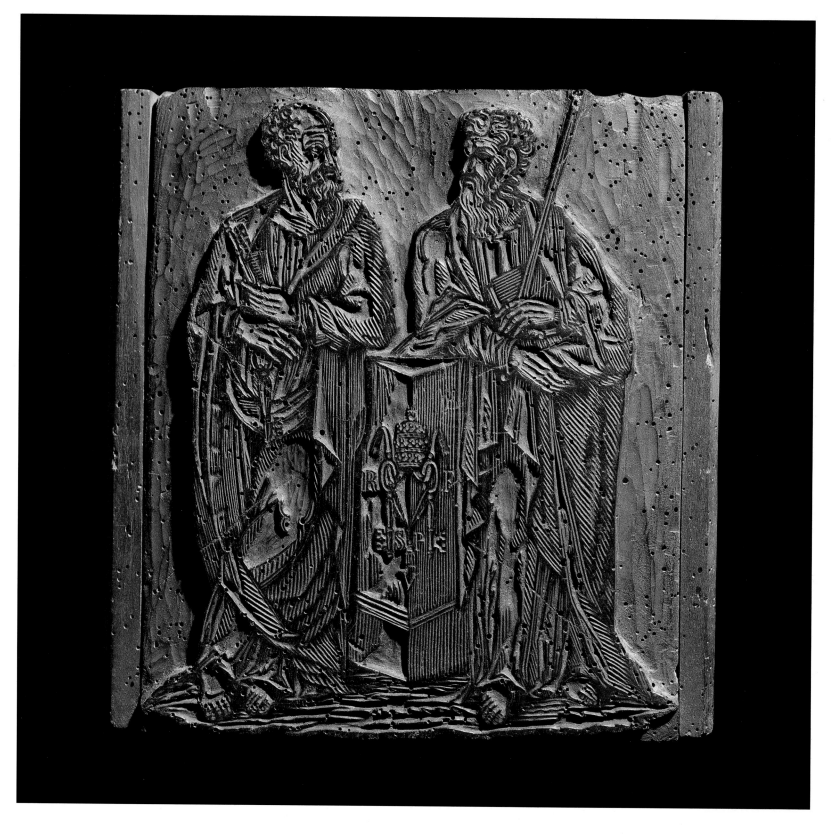

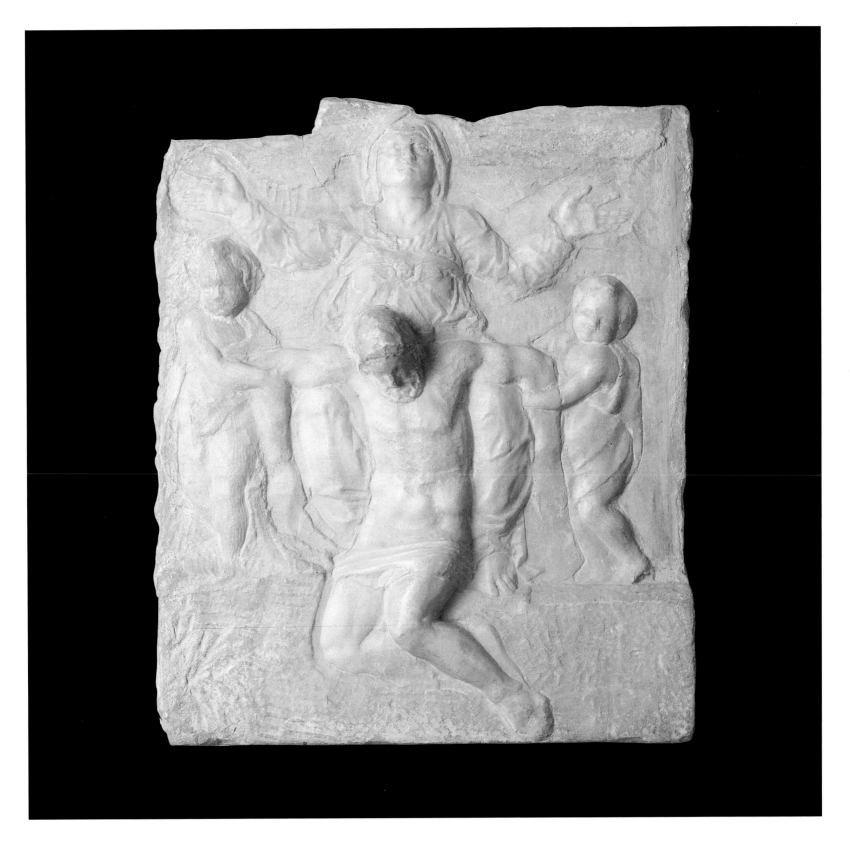

The Modern Basilica

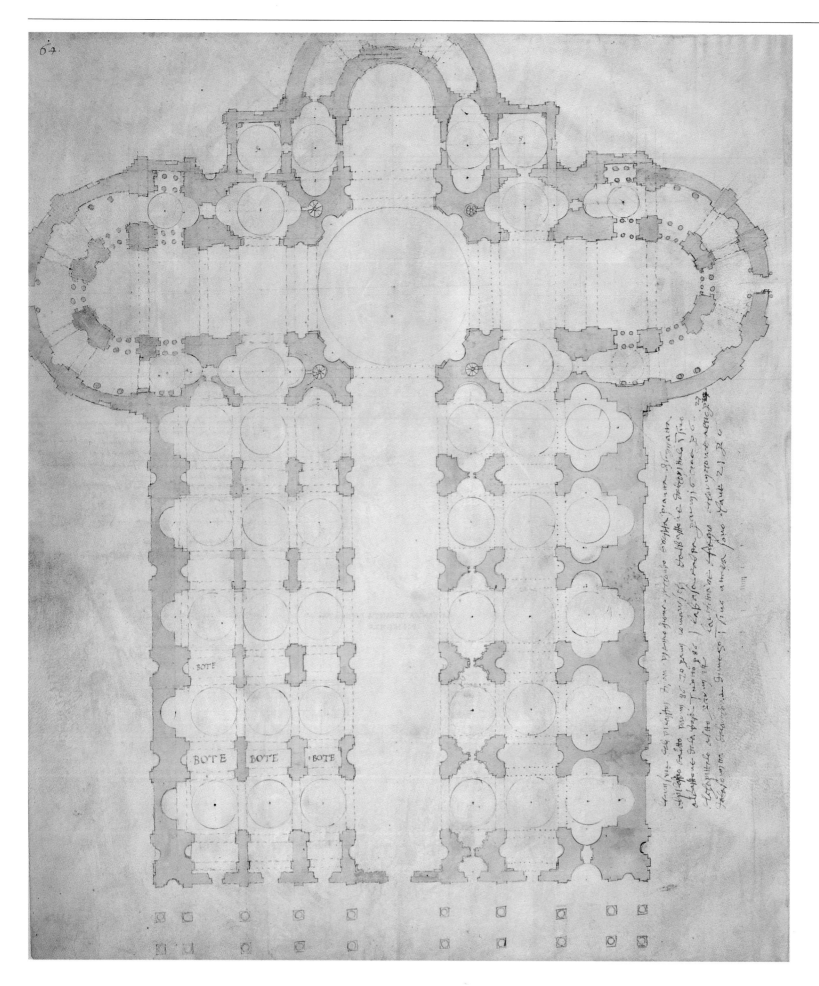

Giuliano da Sangallo, Plan of Saint Peter's, 1515-16 (cat. no. 49).

Fabrizio D'Ambrosio, Portrait of Pope Julius II, 1848 (cat. no. 50).

Roberto Bompiani, Portrait of Pope Paul V, 1849 (cat. no. 51).

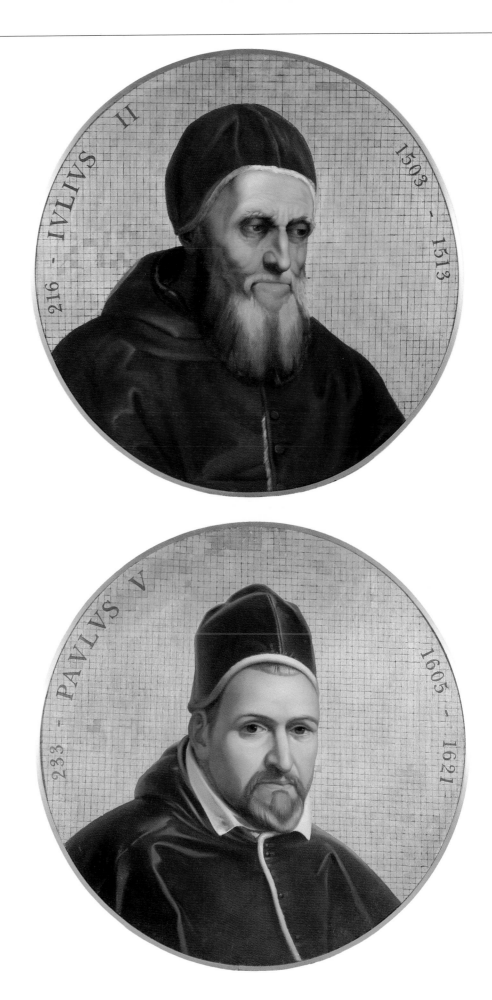

View of Saint Peter's square and the
basilica under construction, 1544-45
(cat. no. 52).

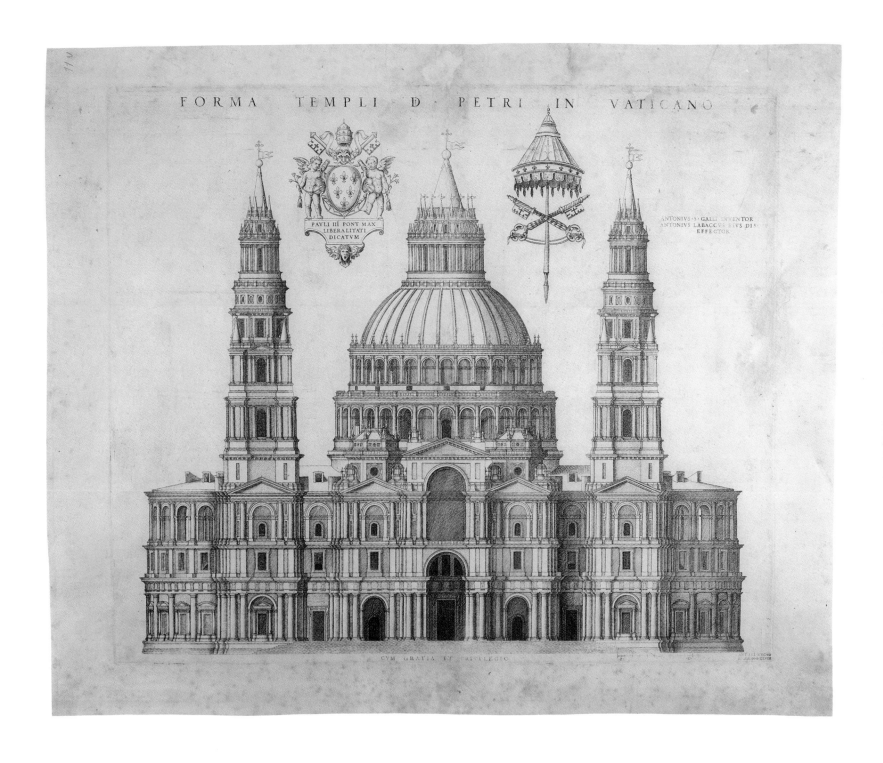

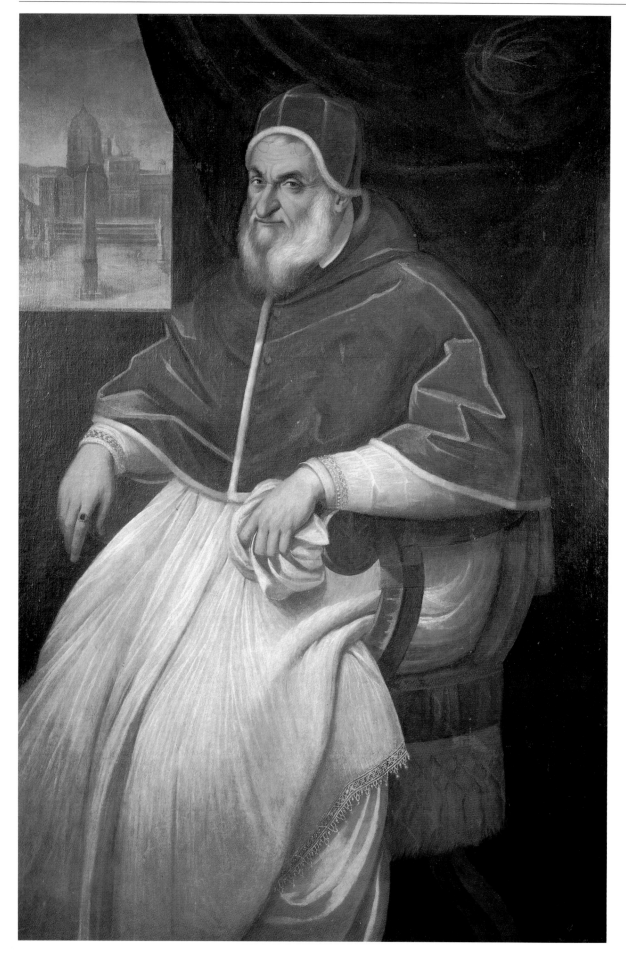

Portrait of Sixtus V, 1588-90
(cat. no. 54).

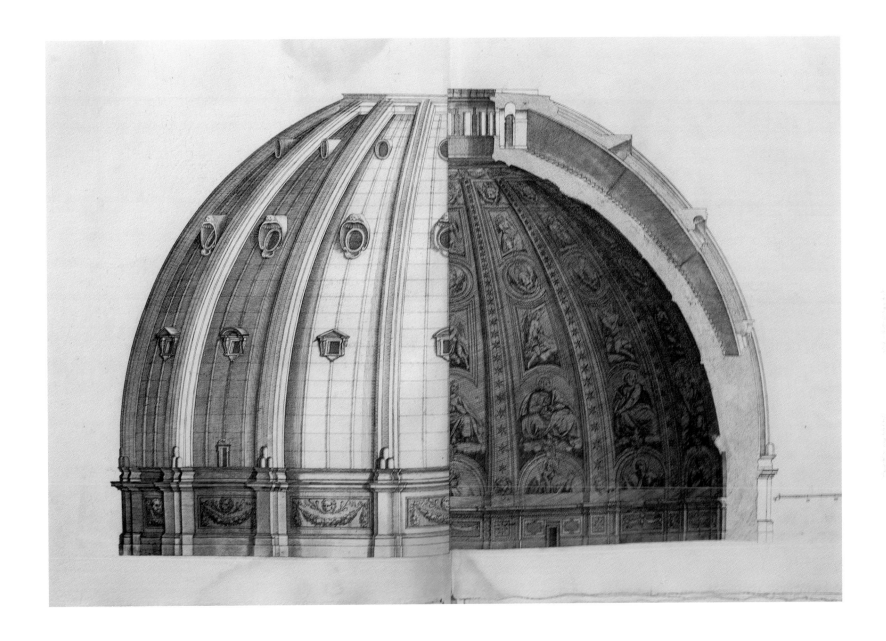

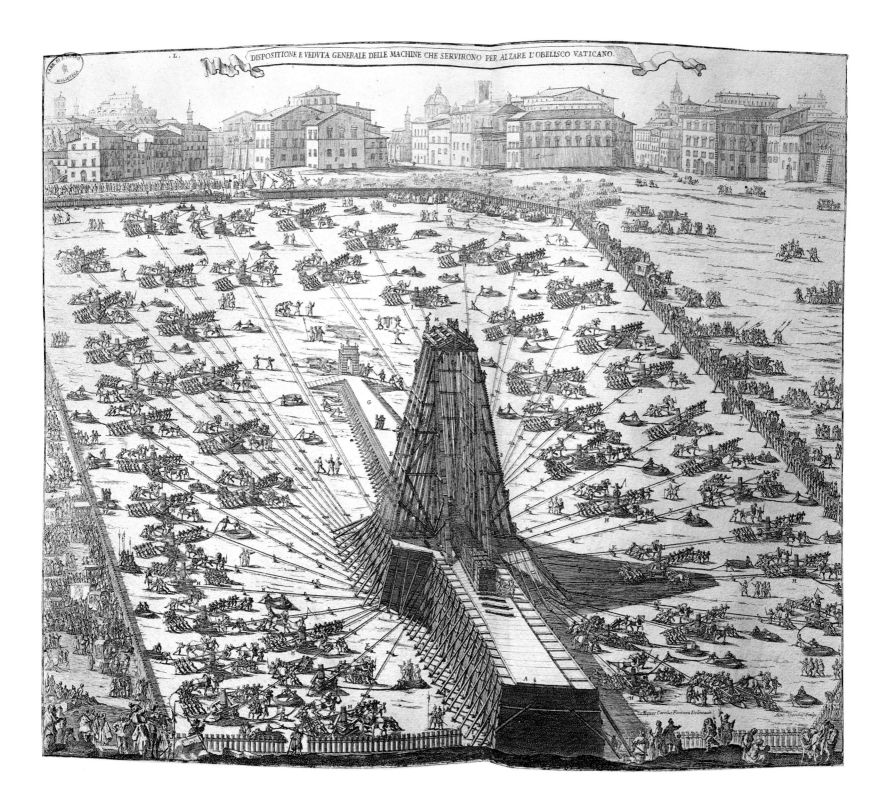

Alessandro Specchi, after Carlo Fontana, Erection of the Vatican Obelisk in front of the Basilica of Saint Peter's (cat. no. 56).

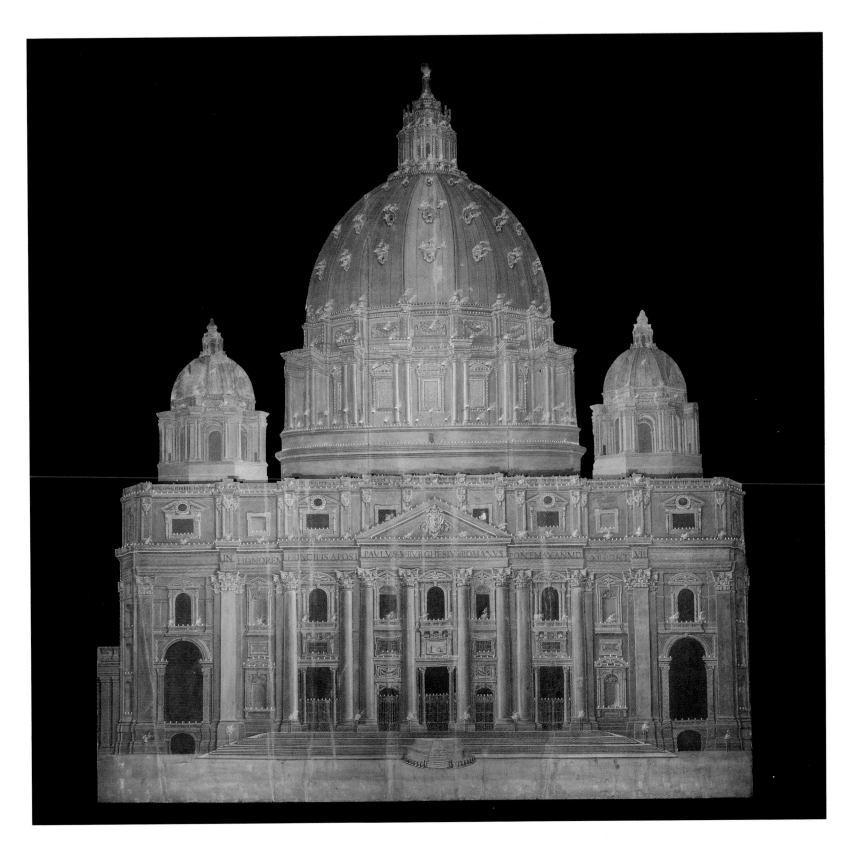

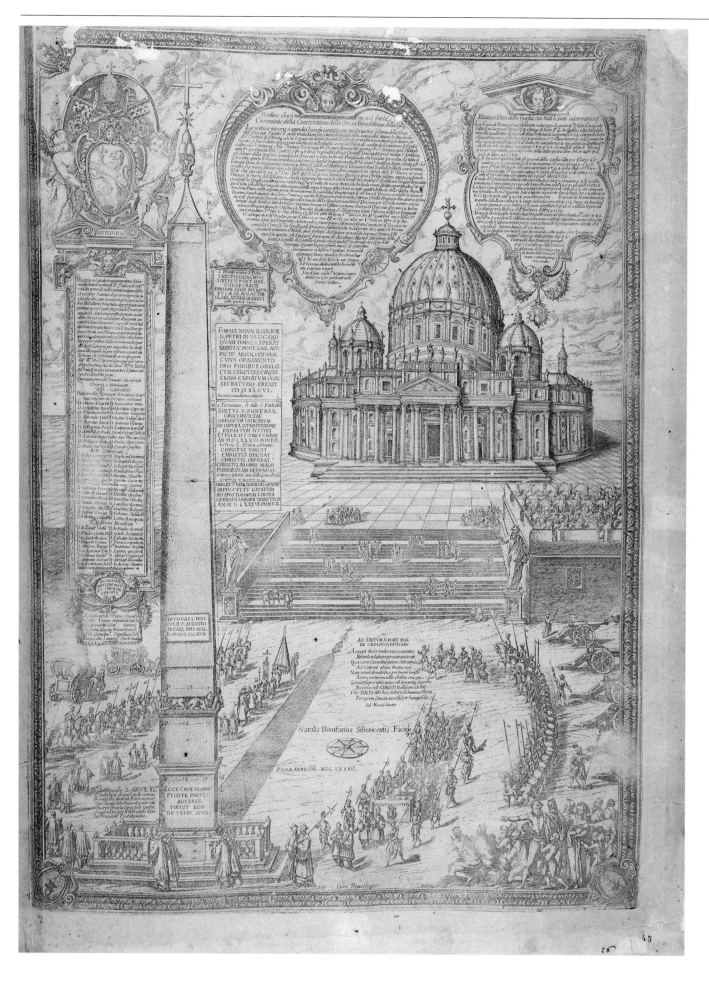

Natale Bonifacio, after Giovanni
Guerra, *Saint Peter's Square and the
Consecration of the Obelisk, 1587*
(cat. no. 58).

Gian Lorenzo Bernini, *Bust of Pope
Urban VIII, 1623-33* (cat. no. 59).

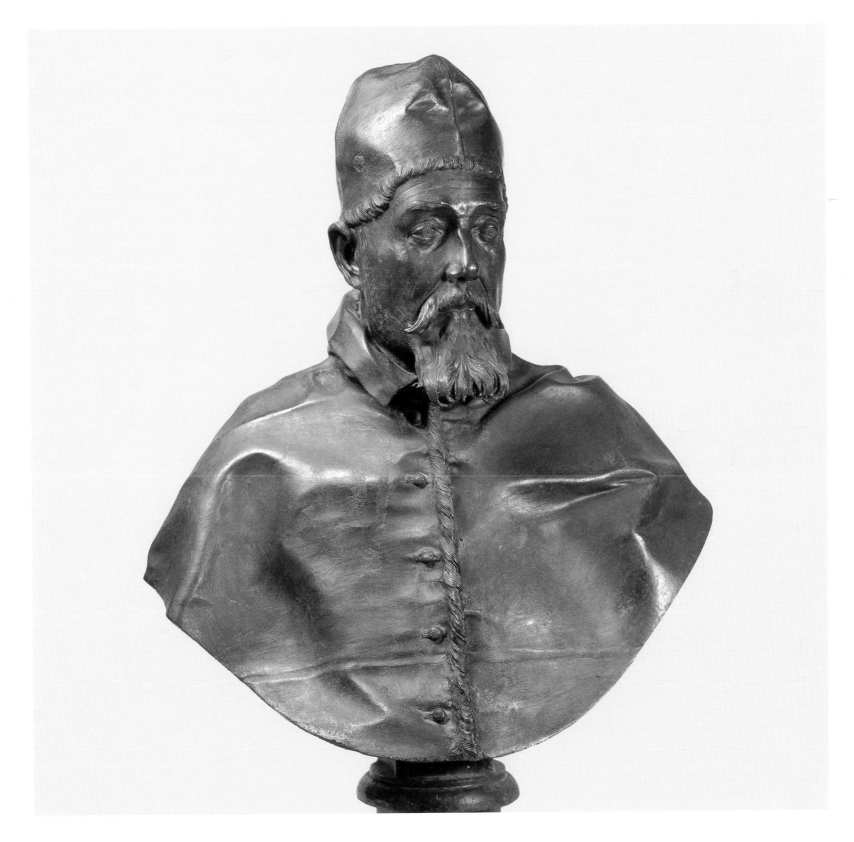

Workshop of Gian Lorenzo Bernini,
Pier of the Veronica (cat. no. 60).

Workshop of Gian Lorenzo Bernini,
Angel bearing a cartouche, 1630-35
(cat. no. 61).

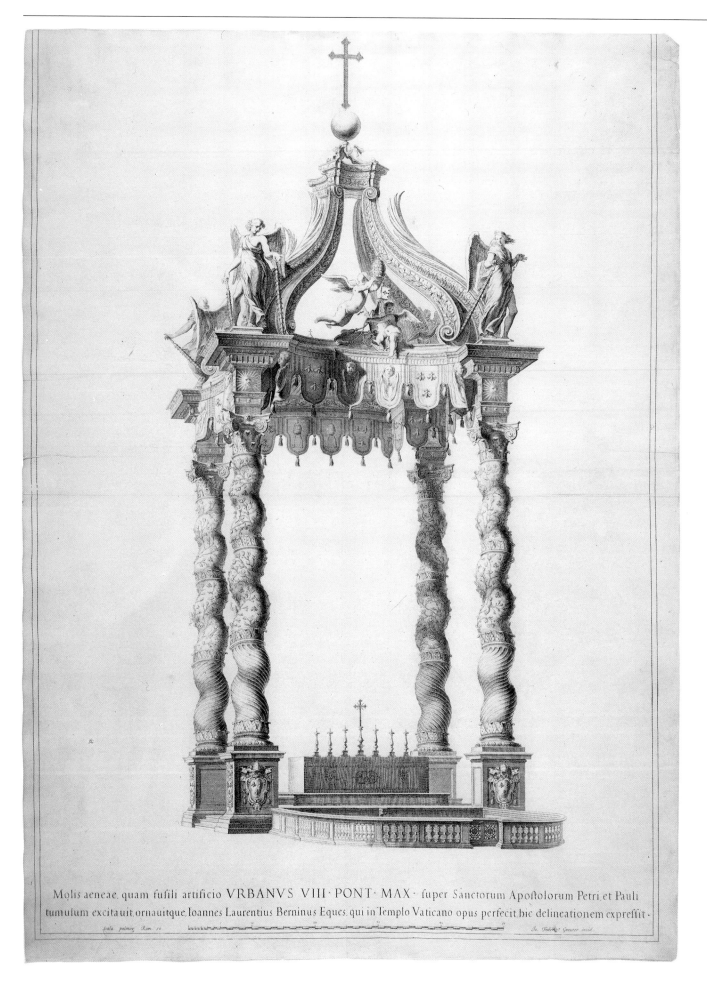

Molis aeneae, quam fusili artificio VRBANVS VIII · PONT · MAX · super Sanctorum Apostolorum Petri, et Pauli
tumulum excitauit ornauitque, Ioannes Laurentius Berninus Eques, qui in Templo Vaticano opus perfecit hic delineationem expressit ·

scala palmos Rom 10 Io. Federi.s Greuter incid.

Giovanni Federico Greuter,
The Baldacchino of Saint Peter's,
c. 1633 (cat. no. 62).

Circle of Gian Lorenzo Bernini,
Portrait of Gian Lorenzo Bernini,
c. 1640 (cat. no. 63).

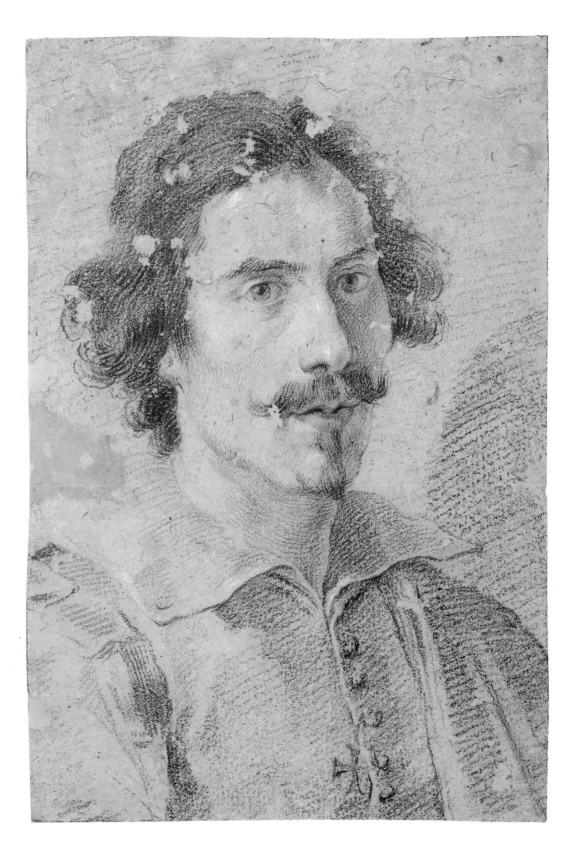

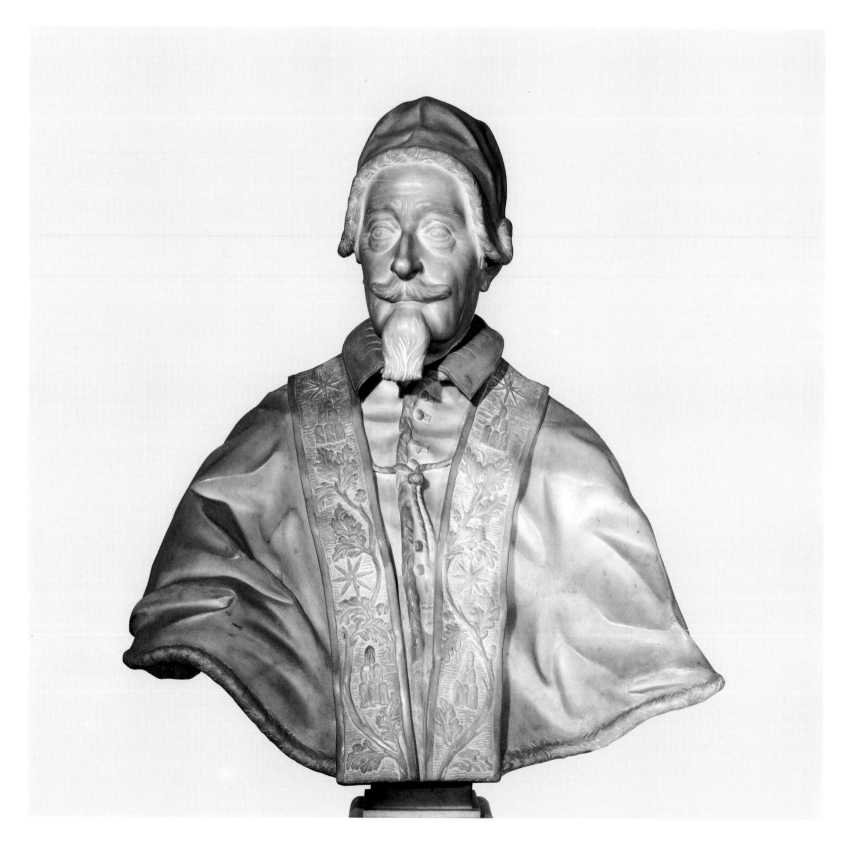

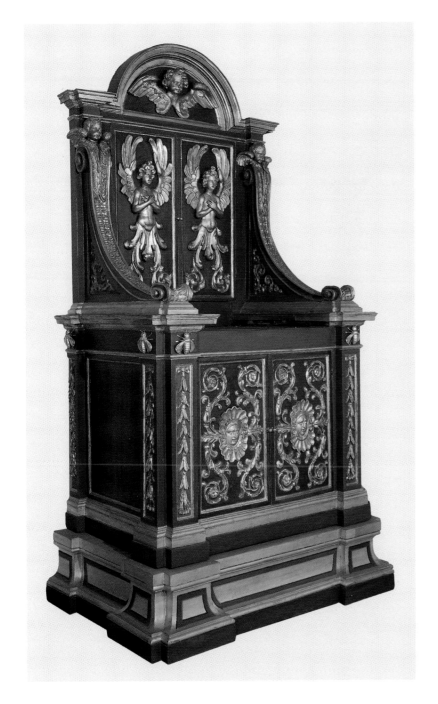

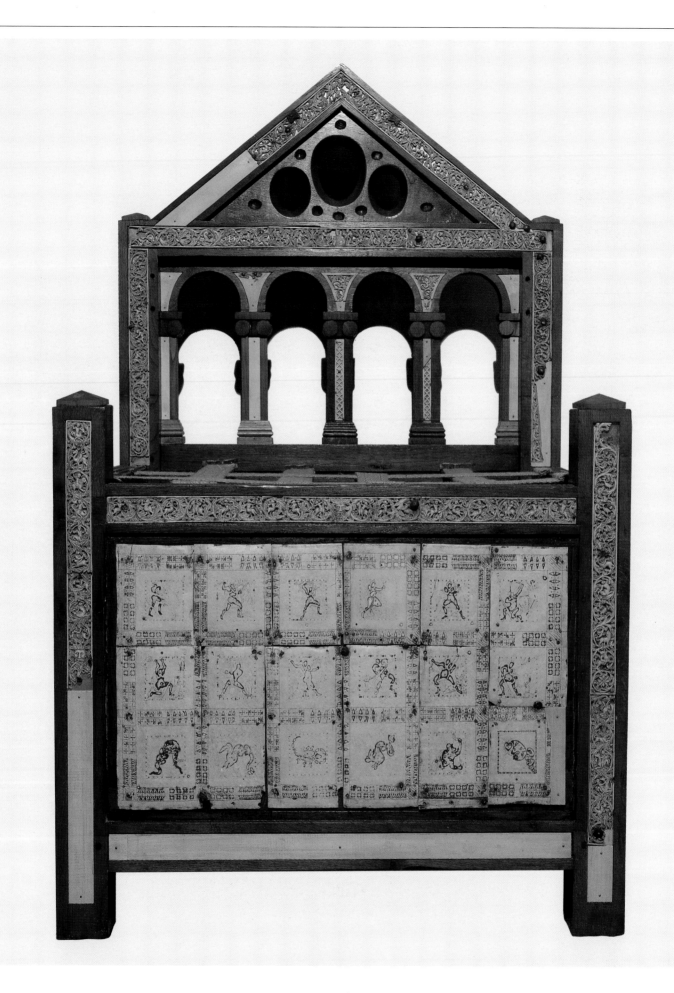

Copy of the cathedra of Saint Peter,
1705 (cat. no. 66).

Gian Lorenzo Bernini, Drawings for
the cathedra of Saint Peter, 1656-57
(cat. no. 67).

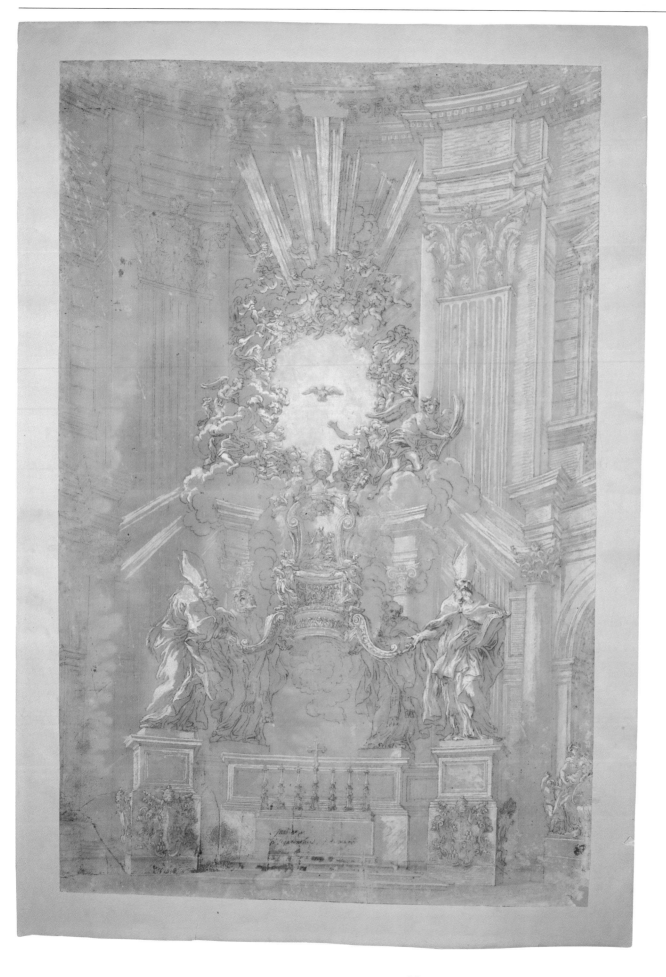

Giacinto Gimignani and Lazzaro Morelli, Cathedra of Saint Peter, 1666 (cat. no. 68).

Gian Lorenzo Bernini, Charity, with four putti, c. 1627-28 (cat. no. 69).

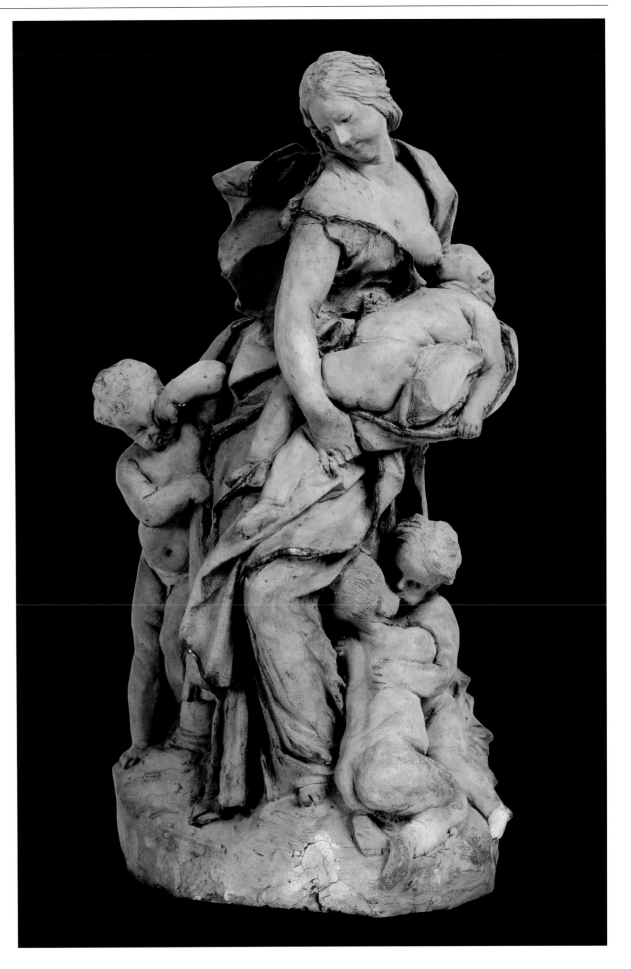

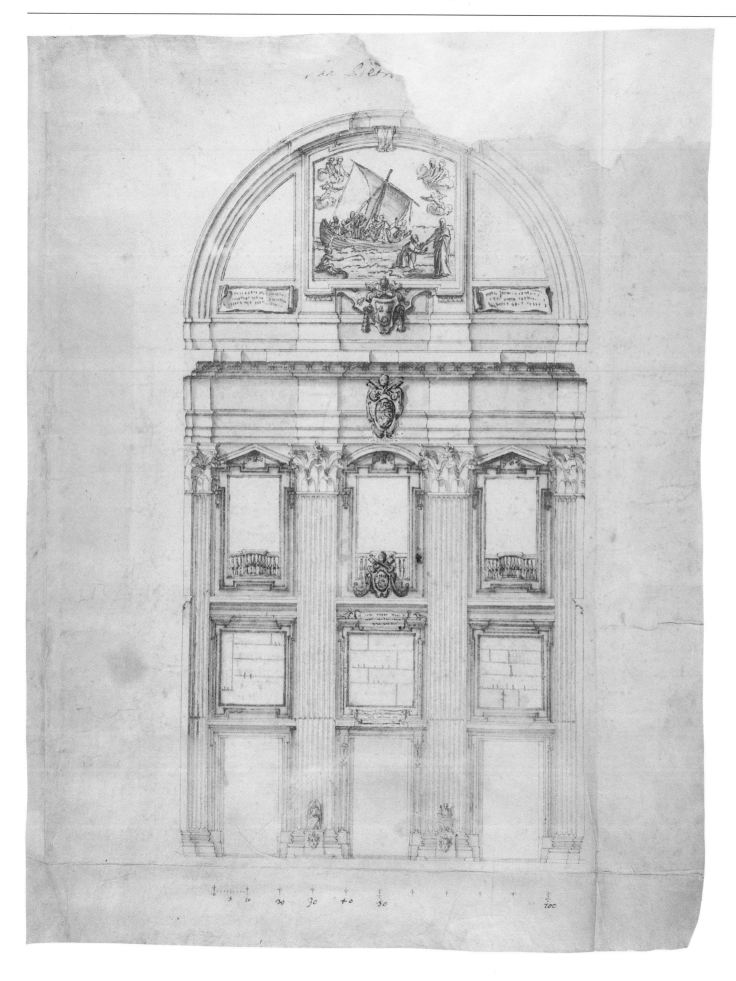

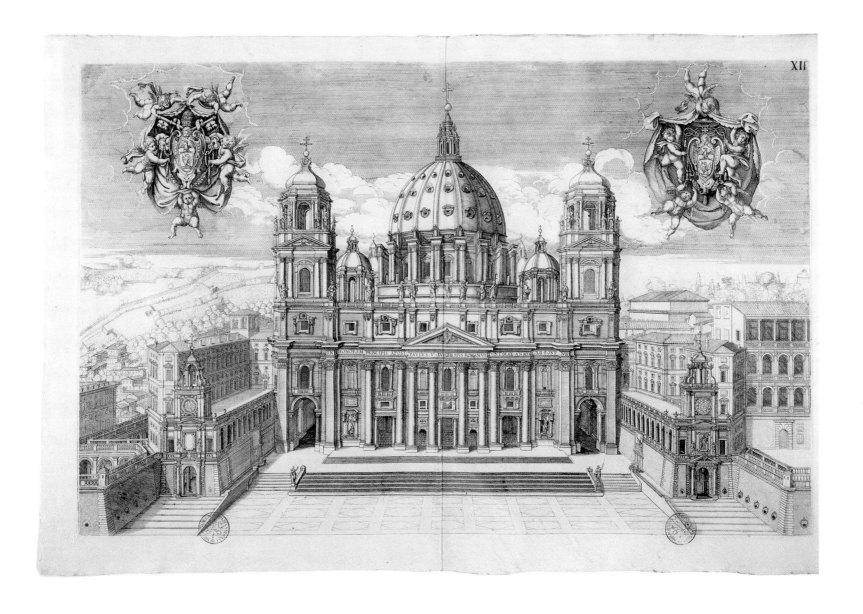

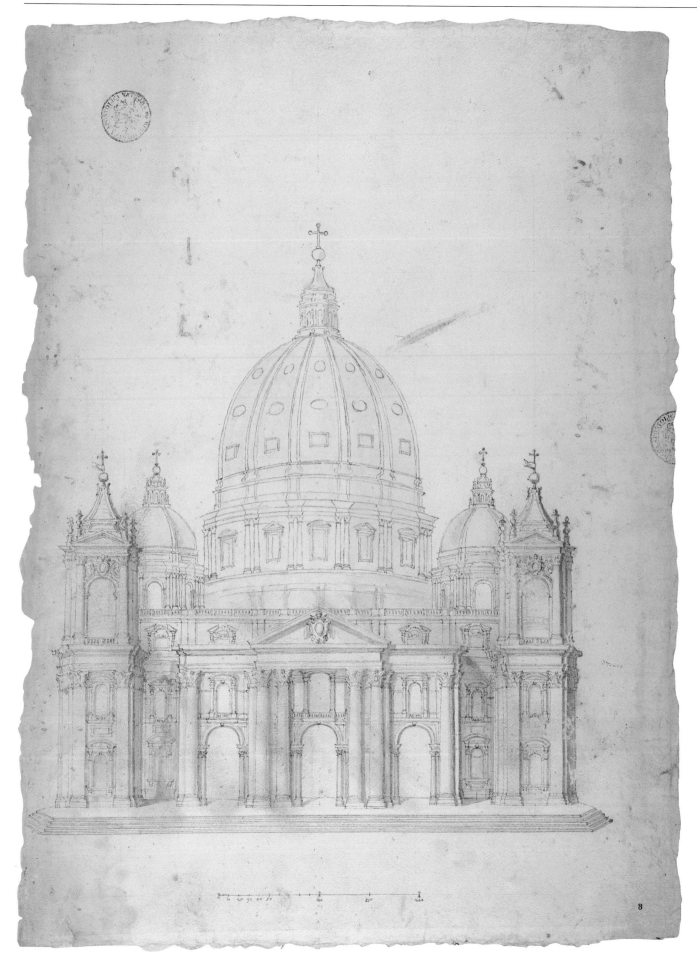

*Gian Lorenzo Bernini, Project
for Saint Peter's bell towers, 1645
(cat. no. 72).*

*Facade of Saint Peter's, c. 1645
(cat. no. 73).*

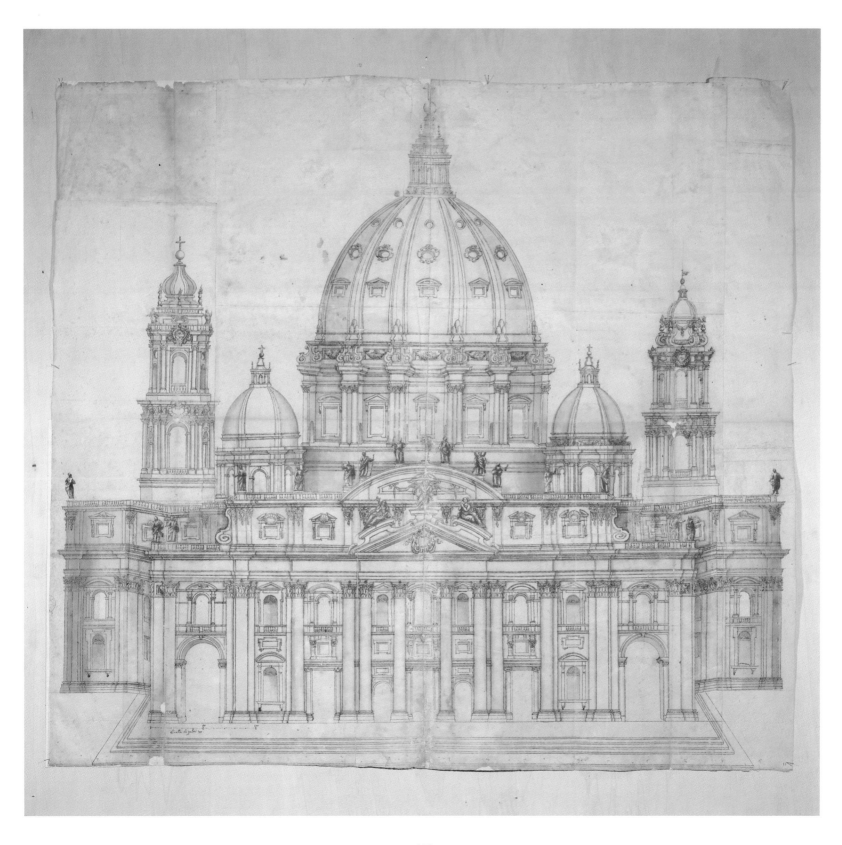

Guasparri di Bartolomeo Papini,
from a cortoon by Alessandro Allori,
Antependium of Clement VIII, 1593-97
(cat. no. 74).

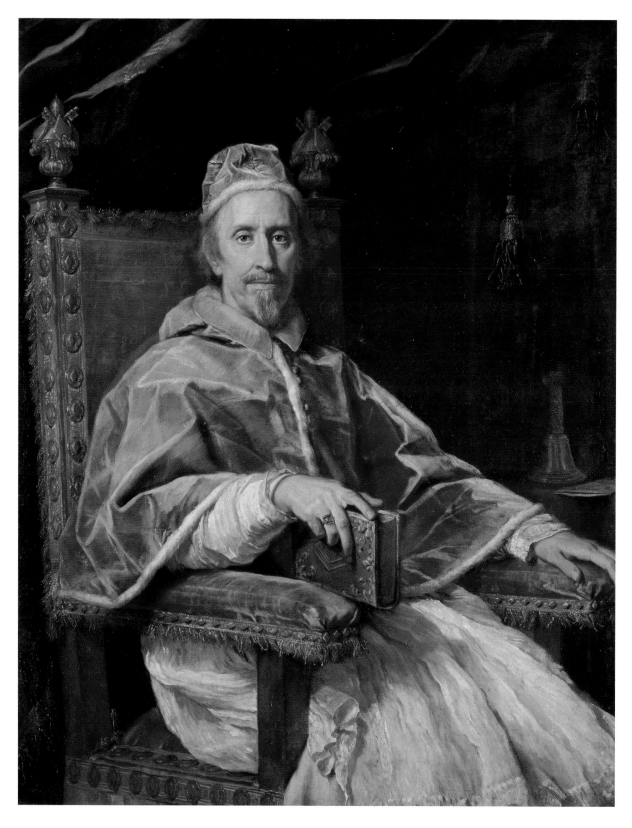

Carlo Maratta, Portrait of Clement IX,
1669 (cat. no. 75).

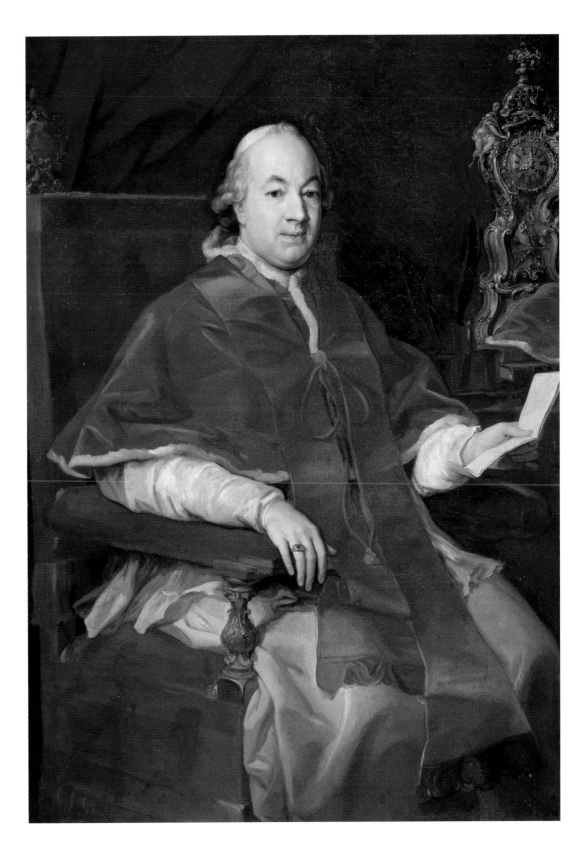

Pompeo Batoni, Portrait of Pius VI,
1775 (cat. no. 76).

Giovanni Maggi, View of Saint
Peter's, the Vatican buildings
and gardens, 1615 (cat. no. 77).

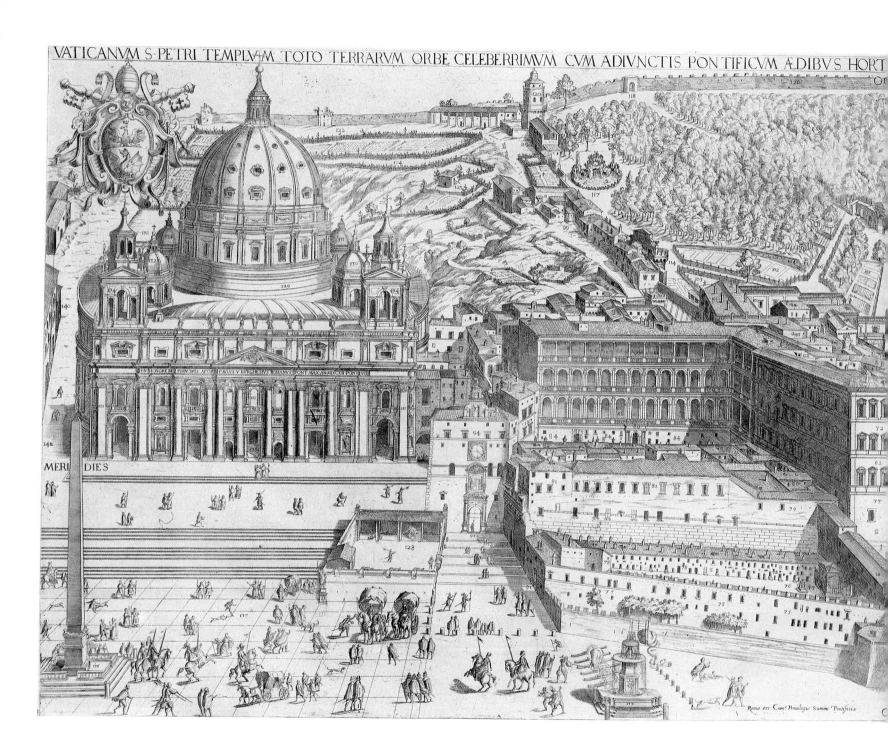

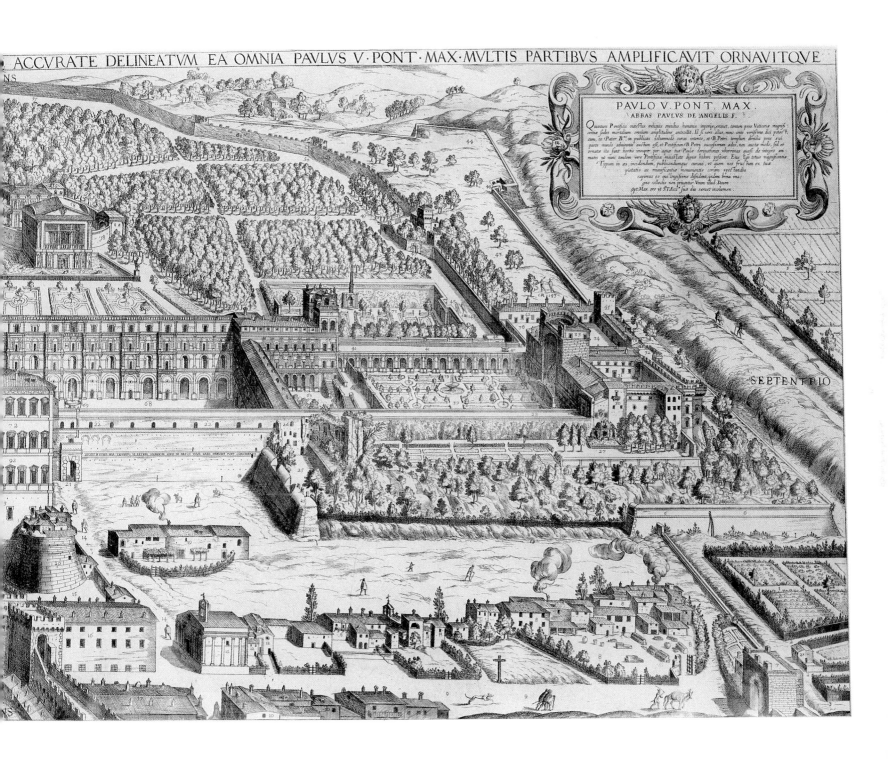

ACCVRATE DELINEATVM EA OMNIA PAVLVS V · PONT · MAX · MVLTIS PARTIBVS AMPLIFICAVIT ORNAVITQVE

PAVLO V. PONT. MAX.
ABBAS PAVLVS DE ANGELIS F.

SEPTENTRIO

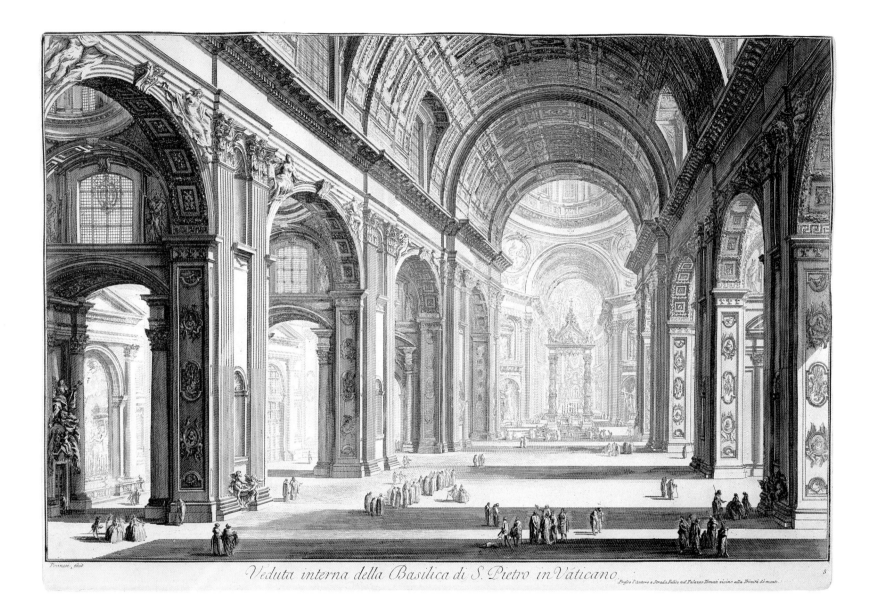

Veduta interna della Basilica di S. Pietro in Vaticano.

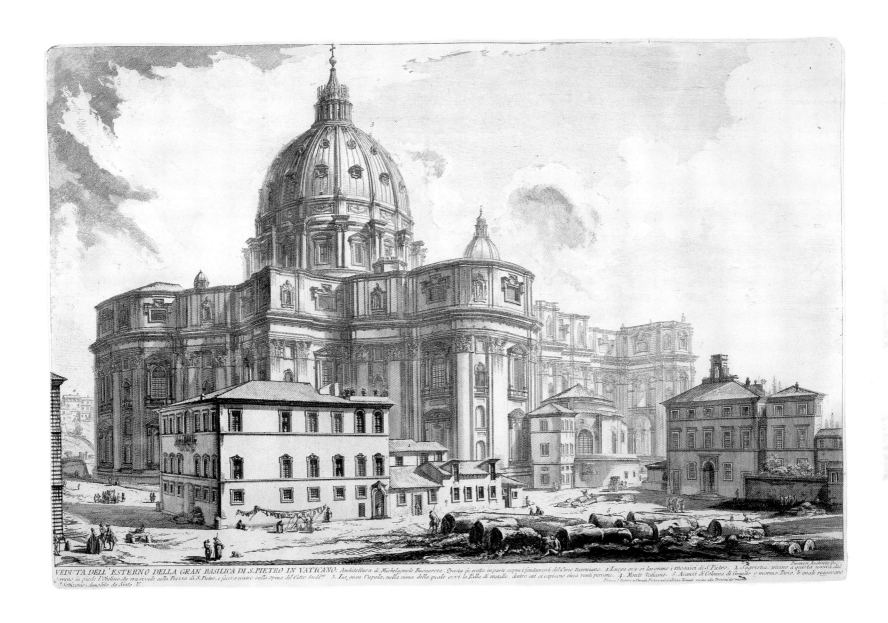

VEDUTA DELL'ESTERNO DELLA GRAN BASILICA DI S.PIETRO IN VATICANO. *Architettura di Michelangelo Buonaroti. Questa fu eretta in parte sopra i fondamenti del Circo Neroniano.* 1 Luogo ove si lavorano i mosaici di S.Pietro. 2 Sagrestia. viene a questa usciva dal ... in piedi l'Obelisco che ora si vede nella Piazza di S.Pietro, e facea centro sulla Spina del Circo Suddetto. 3 La gran Cupola, nella cima della quale evvi la Palla di metallo, dentro cui si capiscono circa venti persone. 4 Monte Vaticano. 5 Avanzi di Colonne di Granito e marmo Pario, le quali reggevano ... Settevano, demolite da Sisto V.

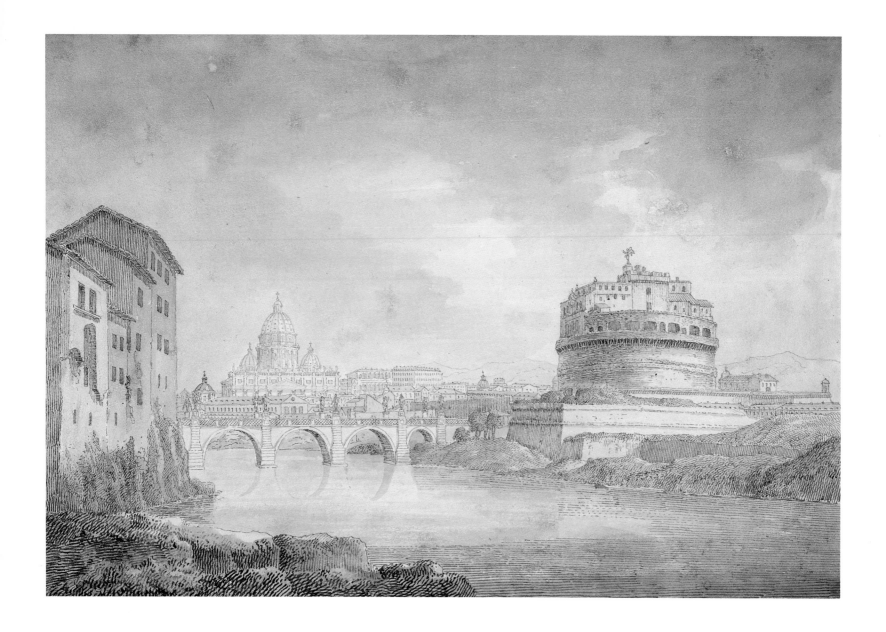

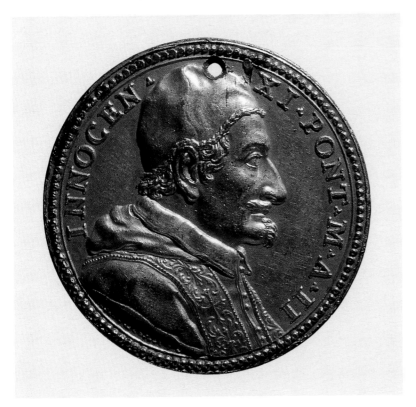

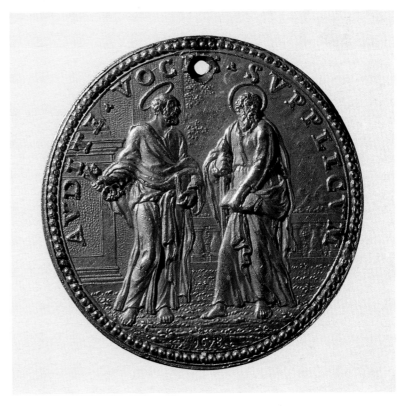

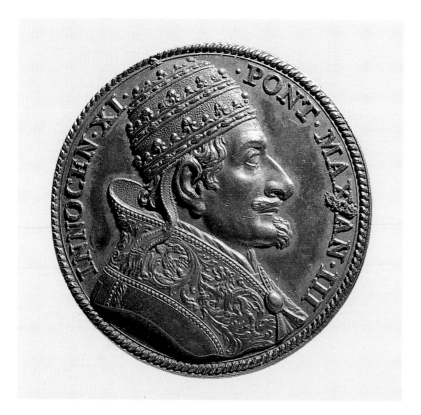

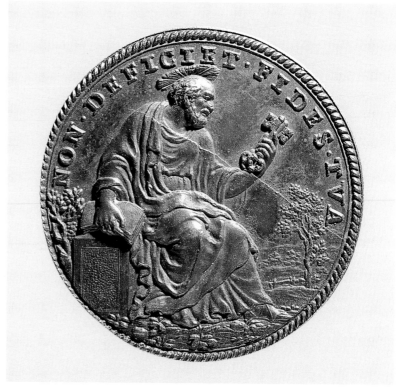

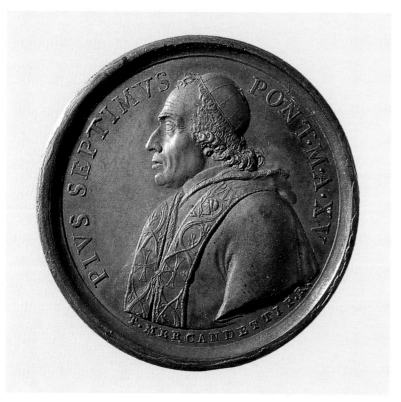

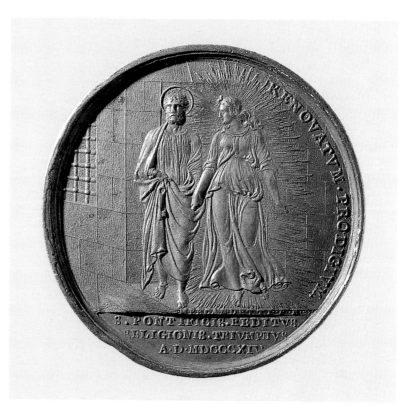

Giuseppe Cerbara, Leo XII, 1824
(cat. no. 85).

Giuseppe Girometti, Pius IX, 1847
(cat. no. 86).

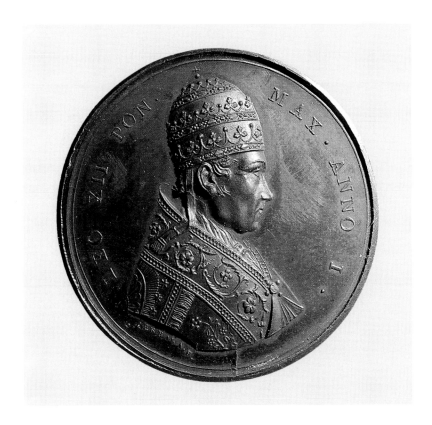

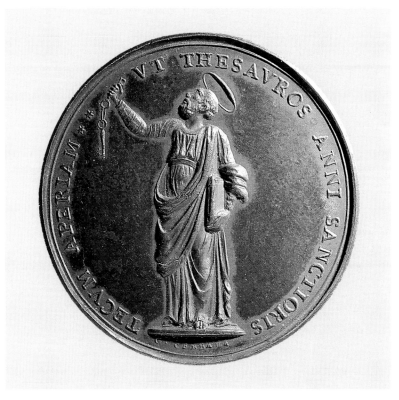

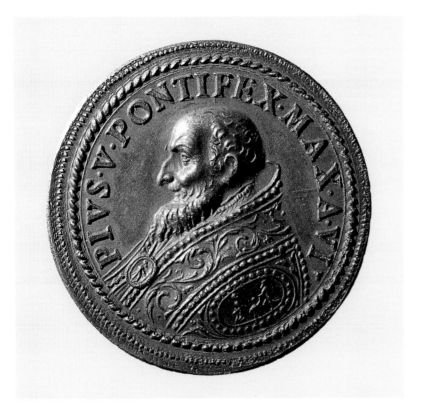

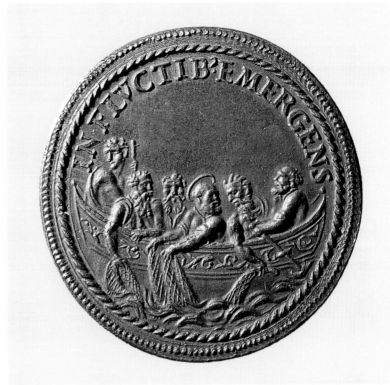

Lorenzo Fragni, Pius V, 1572 *Giorgio Rancetti, Clement VIII, 1601*
(cat. no. 88). *(cat. no. 89).*

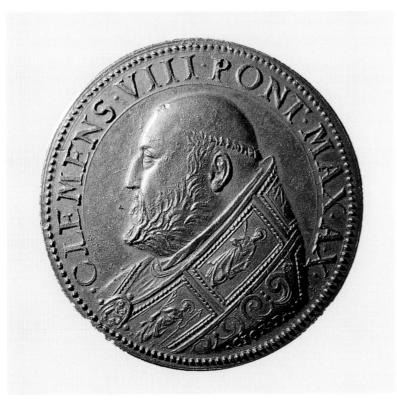

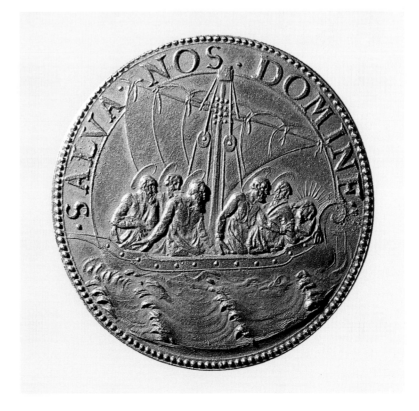

Ermenegildo Hamerani, Clement XI,
1719 (cat. no. 90).

Francesco Bianchi, Pius X, 1906
(cat. no. 91).

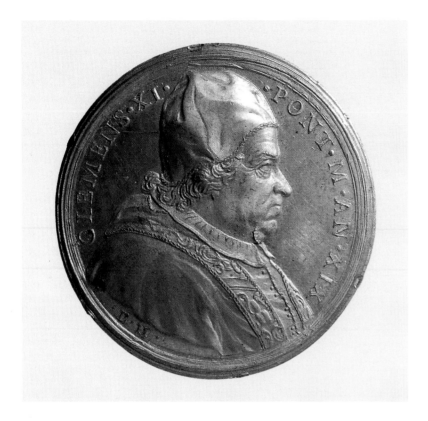

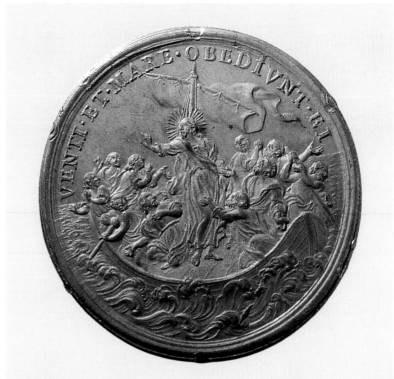

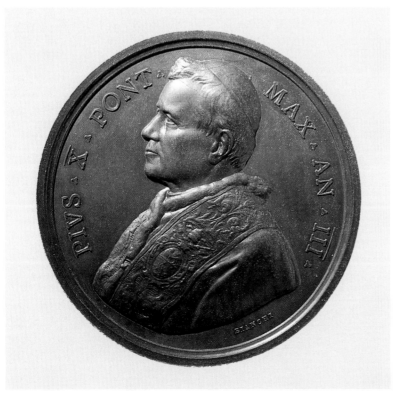

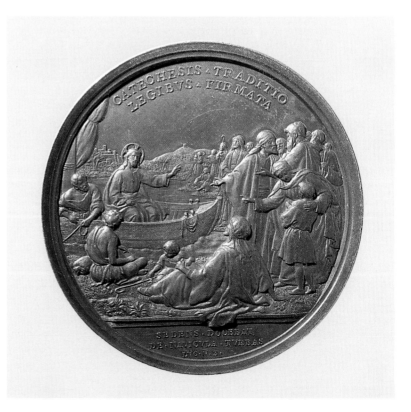

Gianfederico Bonzagni, Marcellus II, 1555 (cat. no. 92).

Alberto Hamerani, Clement X, 1670 (cat. no. 93).

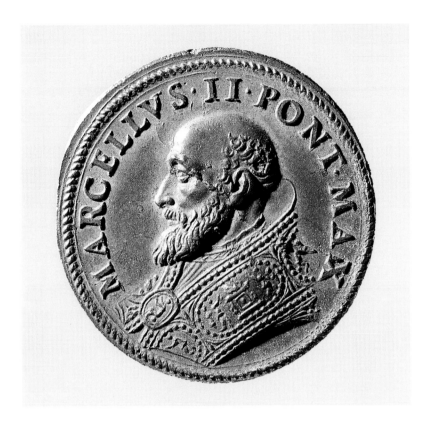

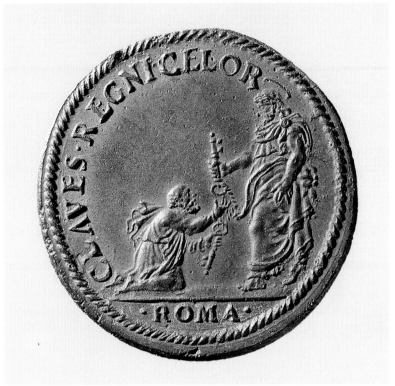

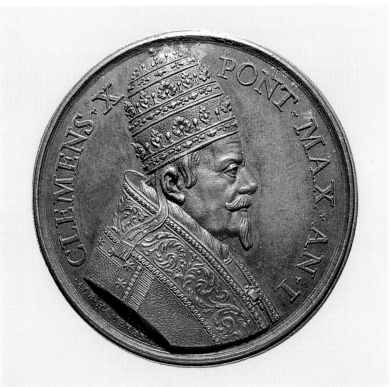

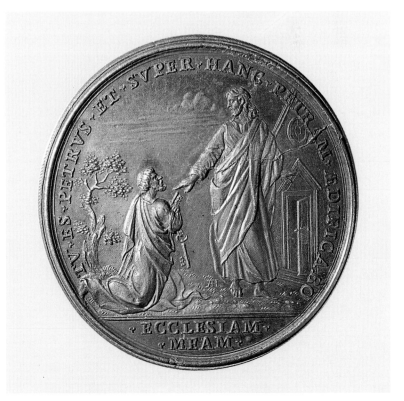

Giuseppe Bianchi, Pius IX, 1869
(cat. no. 94).

Egidio Boninsegna, Leo XIII, 1903
(cat. no. 95).

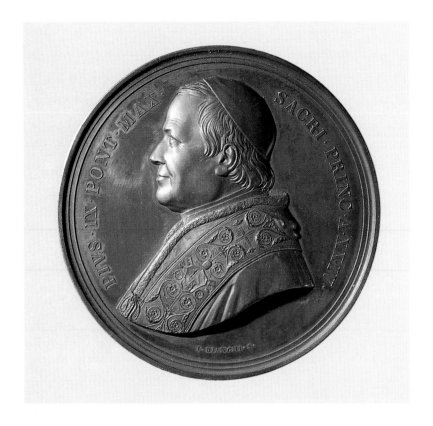

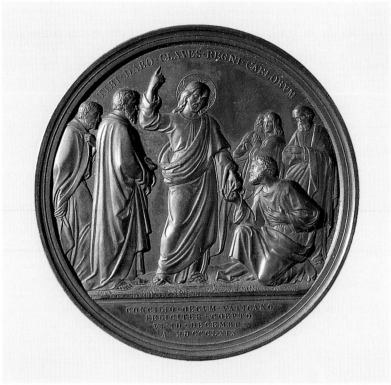

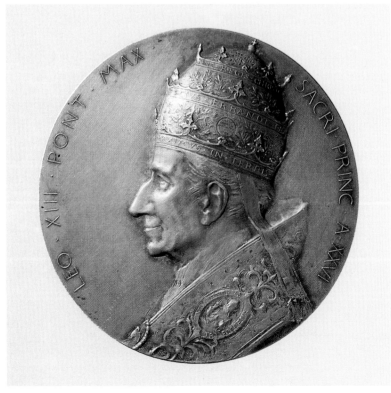

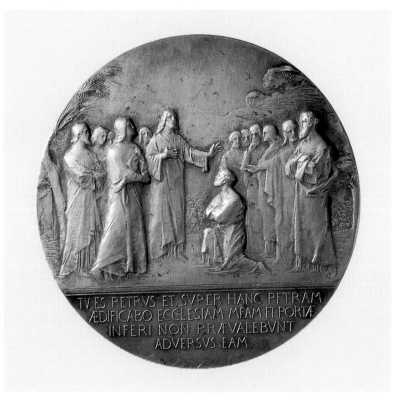

Giuseppe Bianchi, Pius IX, 1869
(cat. no. 94).

Egidio Boninsegna, Leo XIII, 1903
(cat. no. 95).

*Cristoforo Foppa known
as Il Caradosso, Julius II, 1506
(cat. no. 96).*

*Alessandro Cesati (obverse),
Giangiacomo Bonzagni (reverse),
Paul III, 1550 (cat. no. 97).*

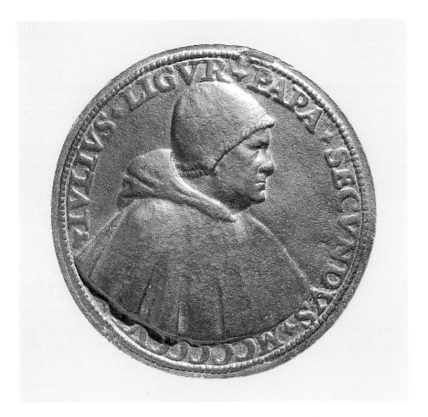

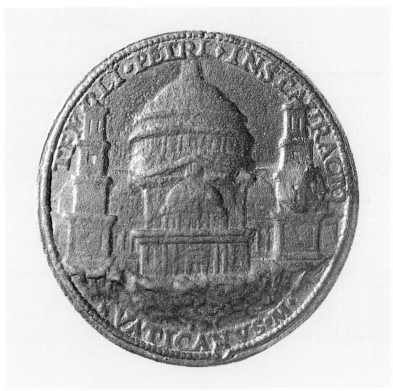

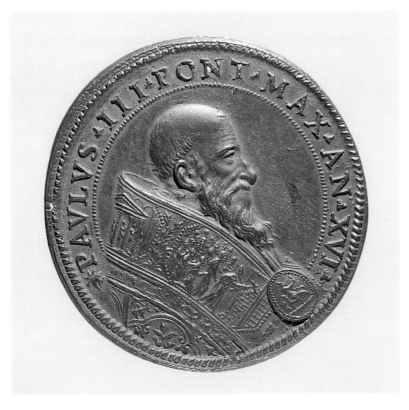

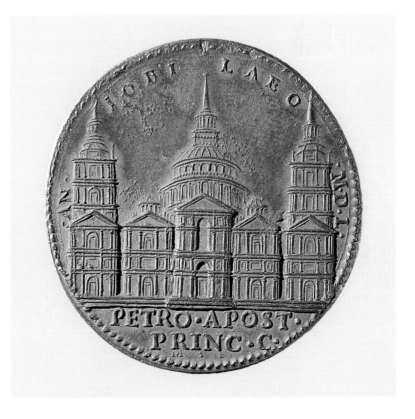

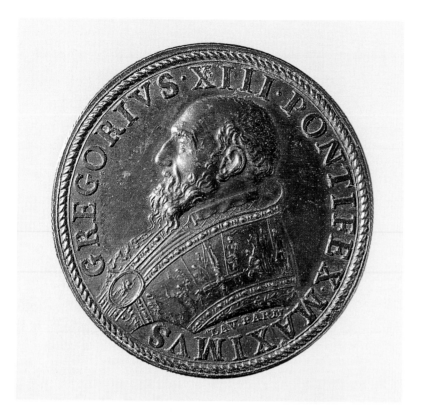

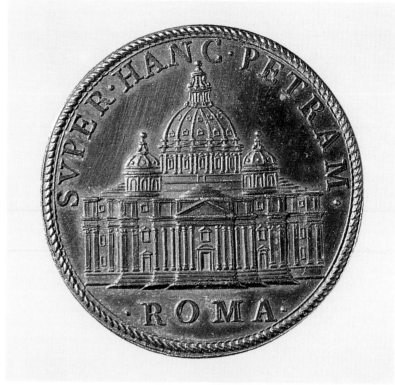

Lorenzo Fragni, Gregory XIII,
undated (cat. no. 98).

Paolo Sanquirico, Paul V, 1608
(cat. no. 99).

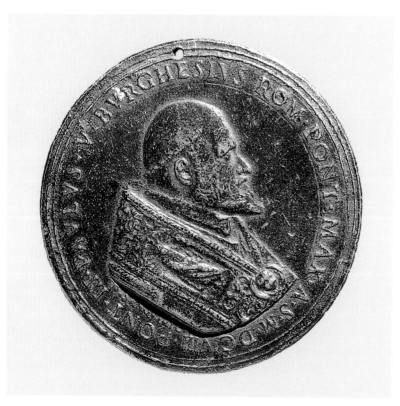

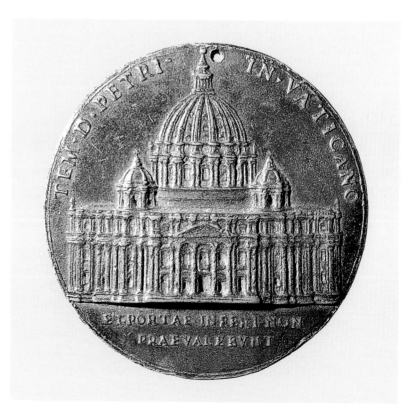

Gaspare Mola, Urban VIII, 1633
(cat. no. 100).

Gaspare Morone, Alexander VII, 1661
(cat. no. 101).

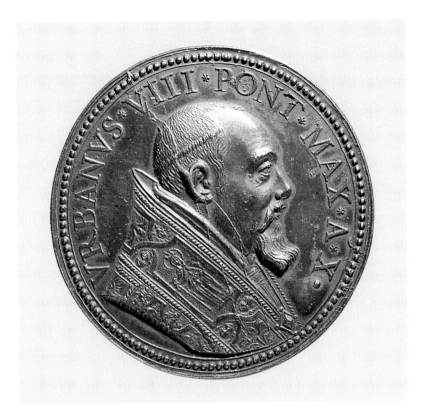

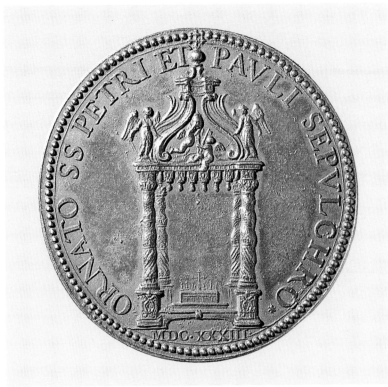

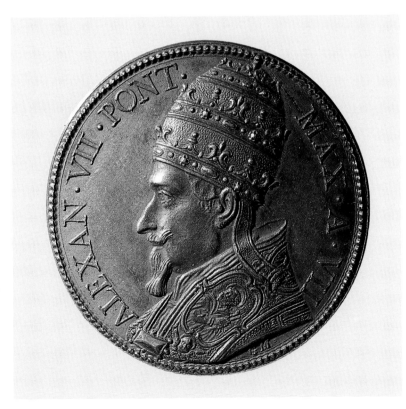

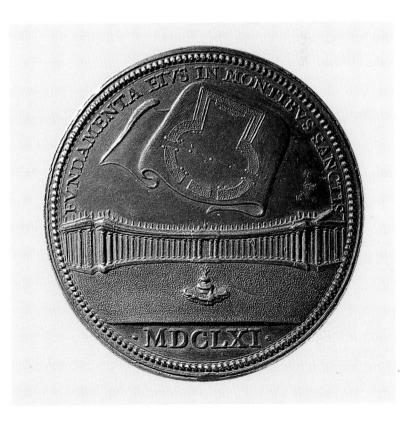

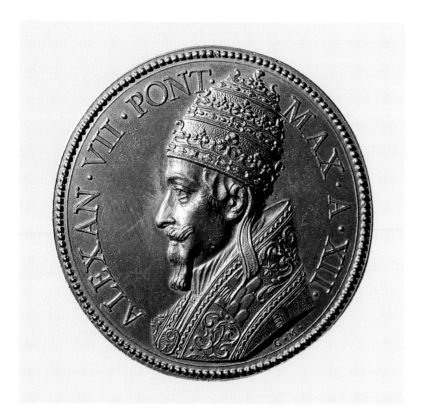

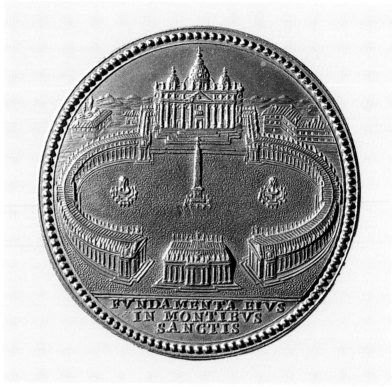

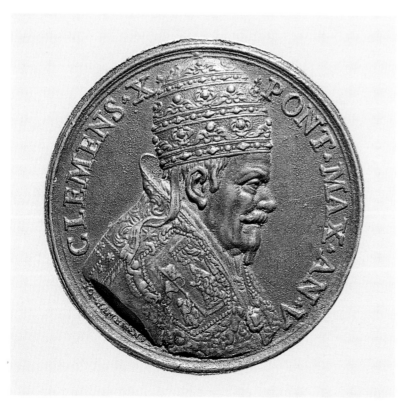

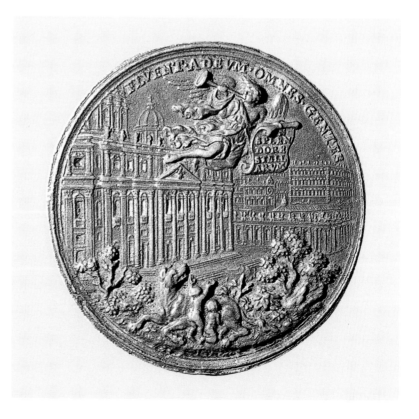

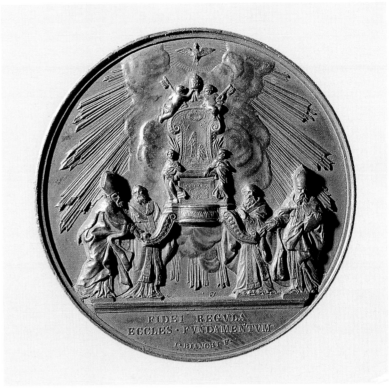

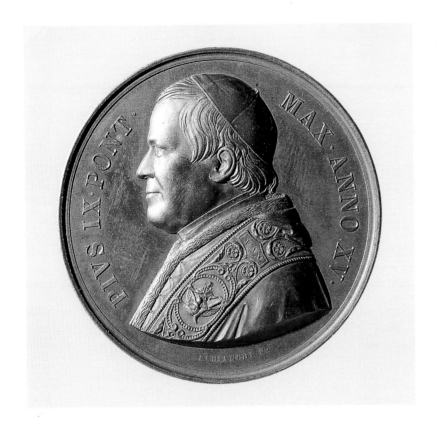

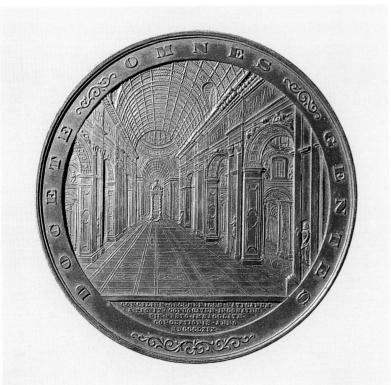

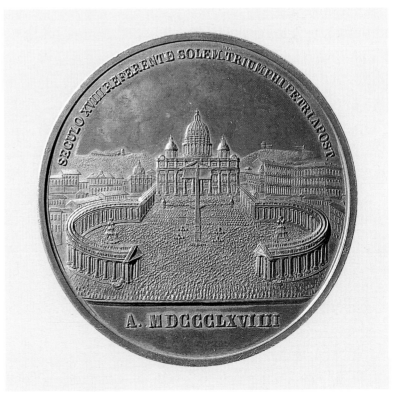

Egidio Boninsegna, Pius XI, 1925
(cat. no. 107).

Aurelio Mistruzzi, Pius XI, 1929
(cat. no. 108).

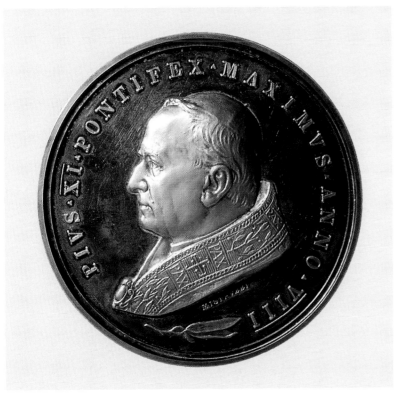

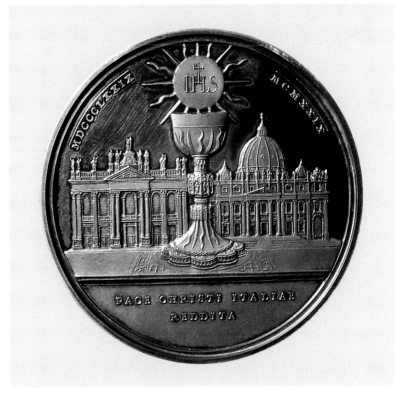

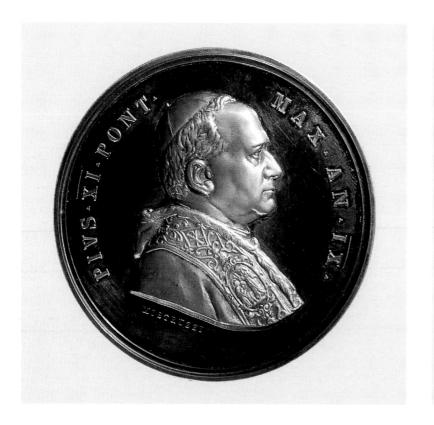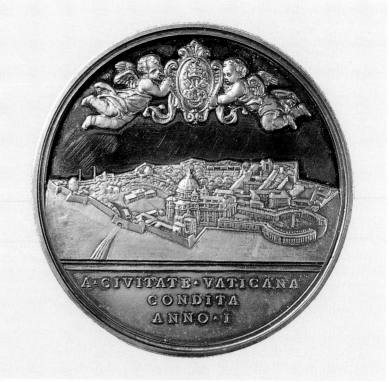

Goffredo Verginelli, Pius XII, 1950
(cat. no. 111).

*Aurelio Mistruzzi, Pius XII, 1950
(cat. no. 112).*

*Egidio Boninsegna, Pius XII, 1950
(cat. no. 113).*

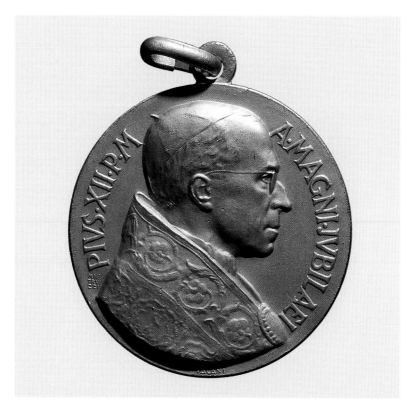

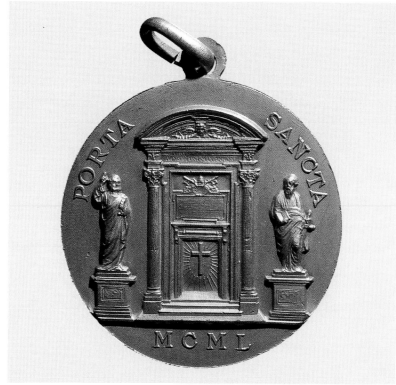

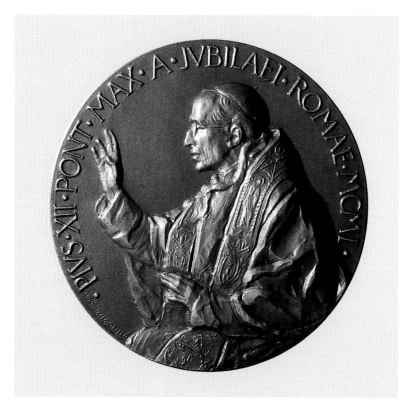

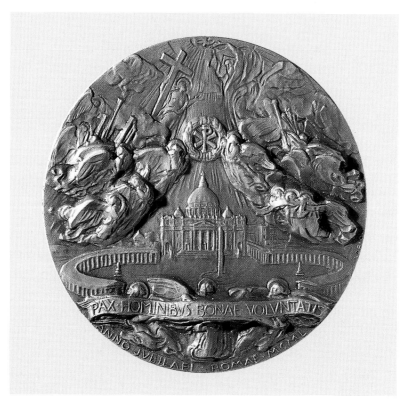

*Aurelio Mistruzzi, Pius XII, 1950
(cat. no. 112).*

*Egidio Boninsegna, Pius XII, 1950
(cat. no. 113).*

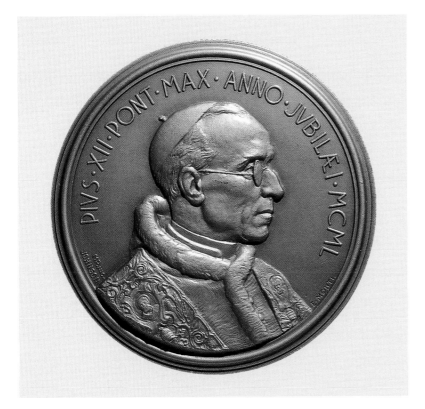

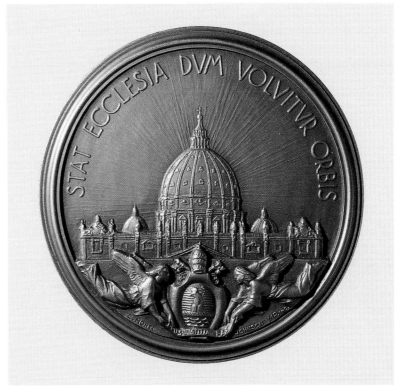

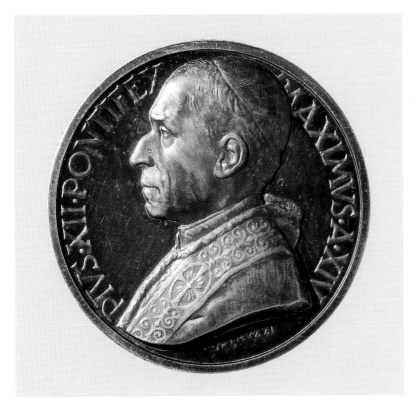

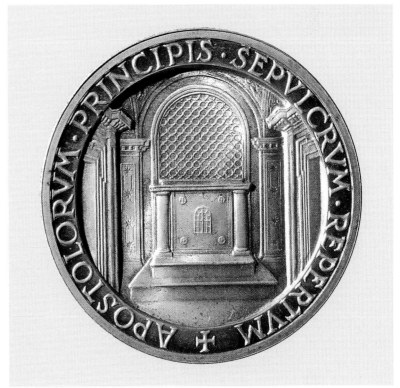

With Open Arms: Bernini's Piazza

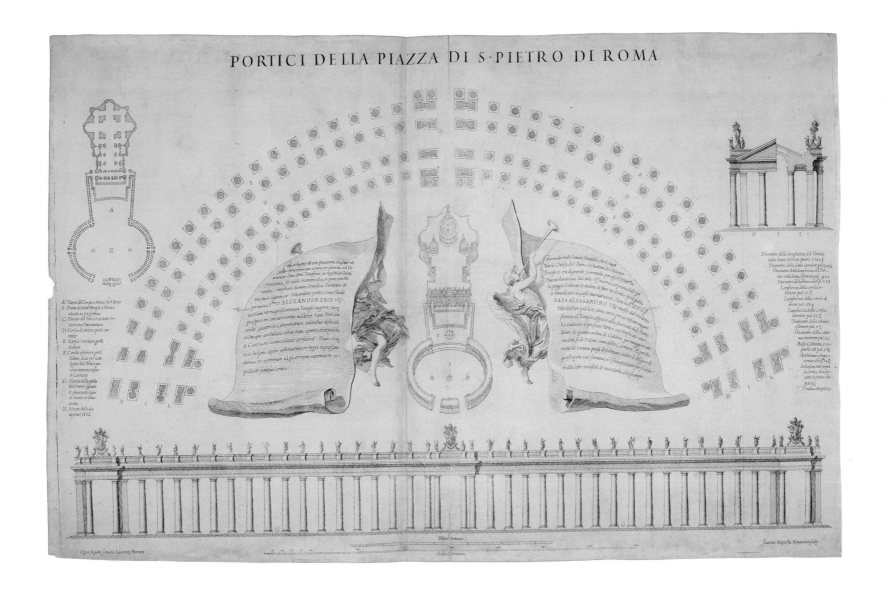

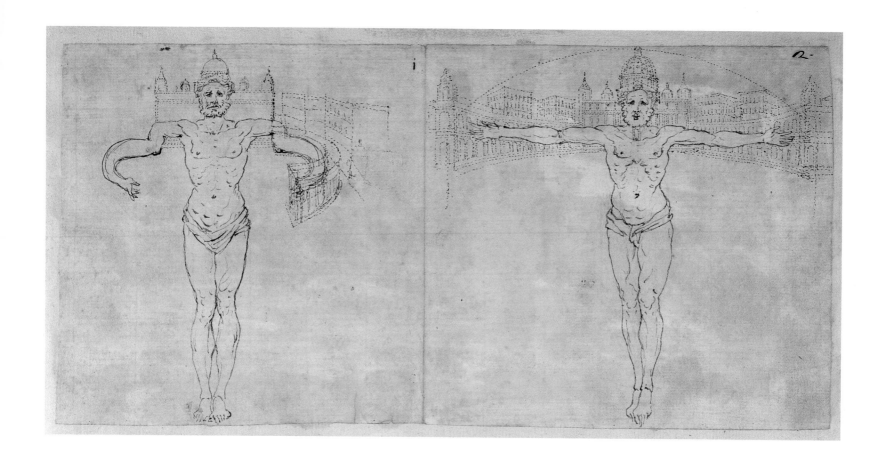

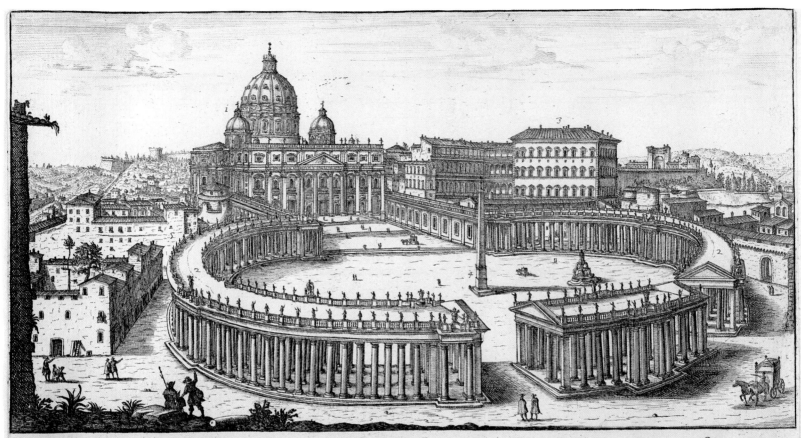

1 Basilica di S. Pietro.
2 Portici fatti da N. Sig.
3 Palazzo Apostolico.

PIAZZA E PORTICI DELLA BASILICA VATICANA FATTI DA N. S. PAPA
ALESANDRO SETTIMO.
Per Gio Iacomo Rossi in Roma alla Pace cō P. del S. P.

Gio Batta Falda di et f.

4 Obelisco del' Circo di Caio, è
Nerone.
5 Palazzo del' Sant' Officio.

3

Giovan Battista Piranesi, Saint Peter's square, 1748 (cat. no. 122).

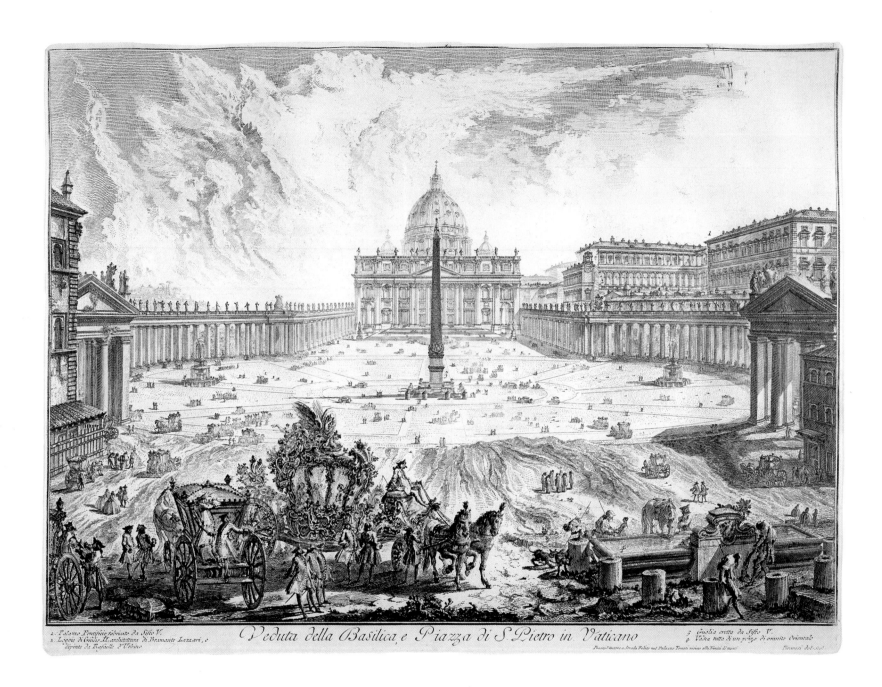

Veduta della Basilica, e Piazza di S. Pietro in Vaticano

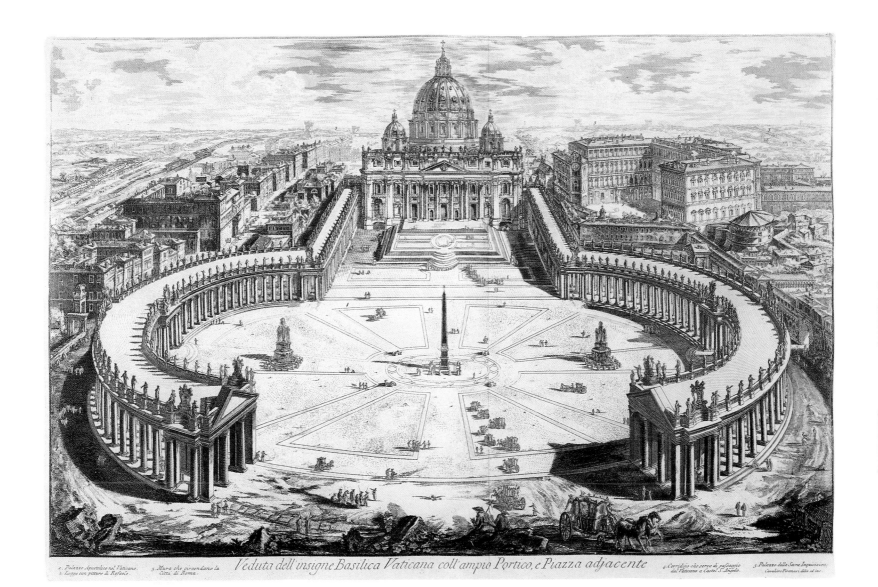

Veduta dell'insigne Basilica Vaticana coll'ampio Portico, e Piazza adjacente

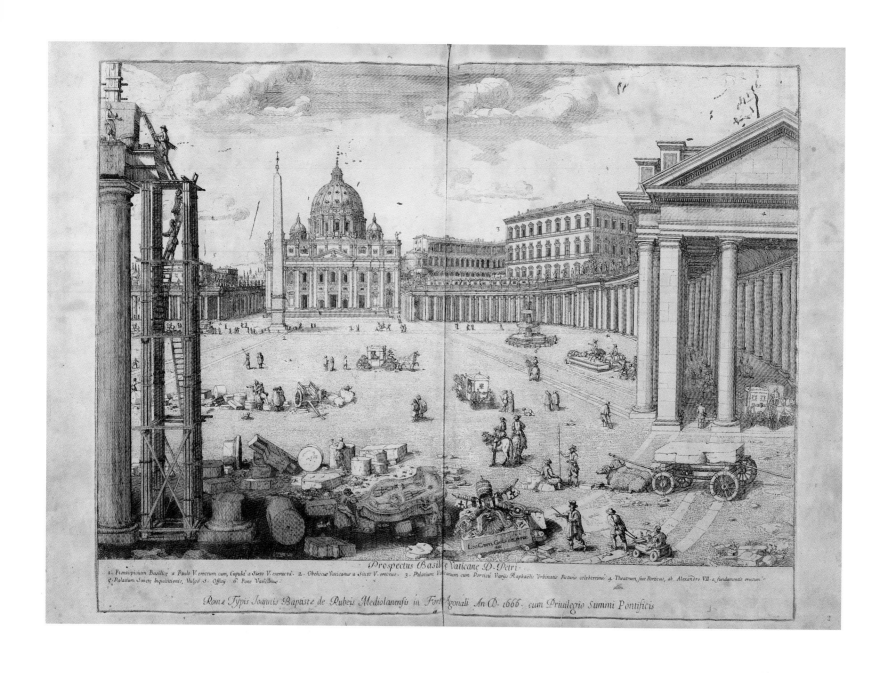

Prospectus Basilicæ Vaticanæ D. Petri.

1. Frontispicium Basilicæ a Paulo V. erectum cum, Cupula' a Sixto V. exstructa . 2. Obeliscus Vaticanus a Sixto V. erectus . 3. Palatium Vaticanum cum Porticu Variis Raphaelis Vrbinatis Picturis celeberrimæ . 4. Theatrum, sive Porticus, ab Alexandro VII. a fundamentis erectum .
5. Palatium Sanctæ Inquisitionis, Vulgo S. Offiej . 6. Fons Vaticanus .

Romæ Typis Joannis Baptistæ de Rubeis Mediolanensis in Foro Agonali An D. 1666. cum Priuilegio Summi Pontificis

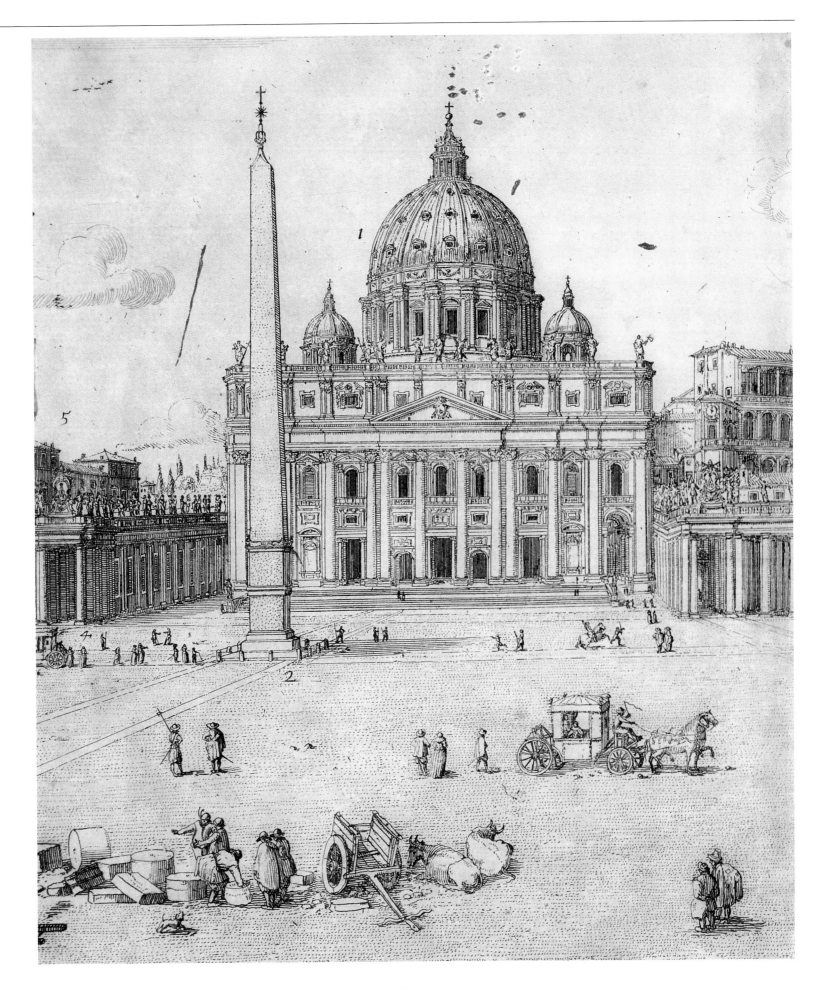

Catalogue

On Saint Peter's Tomb

1
Raffaele Capo
Portrait of Saint Peter
1847
Oil on canvas
Diameter 136 cm
Fabbrica di San Pietro, storerooms

In Saint Peter's, in room 5 of the stairs, near the monument to Maria Clementina Sobieski, is kept the most complete chronological series of paintings of popes in the world, ranging from Saint Peter, the Prince of the Apostles, to John Paul II.

On the night of 15 July 1823 the basilica of San Paolo fuori le Mura was devastated by a violent fire, apparently caused by a number of burning coals which fell from the braziers of the tinsmiths who were repairing the roof (Archivio della Fabbrica di San Pietro [AFSP], Diario vaticano, b. 41). This caused the destruction of almost all the frescoes of the "chronological series of the Supreme Pontiffs" on the entablature of the nave and the transept; the series was completed by Salvatore Monosilio (d. 1776) for the Holy Year of 1750 (AFSP, I P., S.A., V. 426, f. 122).

The few surviving paintings are now kept in the museum on the upper floor of the monastery of the Benedictines, to whom the basilica has been entrusted. The reconstruction, started in 1824 by Leo XII (1823-1829), was completed by Pius IX (1846-1878), who consecrated the new basilica in 1854.

Pius IX himself, with a brief issued on 14 May 1847, ordered that the chronological series of popes should be repainted so that they could be reproduced as mosaics; in fact, the *tondi* exhibited belong to this series (AFSP, III P., S. 29, P. 2, f. 943v).

For the execution of the paintings, the president of the Studio del Mosaico Vaticano at that time, H.E. Msgr. Lorenzo dei Conti Lucidi, treasurer of the Reverenda Fabbrica di San Pietro, involved all the artists of the celebrated Accademia di San Luca and appointed a commission which had the task of distributing the assignments and approving the completed works. It was composed of L. Poletti, F. Agricola, who succeeded Baron V. Camuccini at the head of the Studio del Mosaico Vaticano, Professor J. Alaux, director of the Accademia di Francia, and other members including F. Podesti and J.F. Overbeck.

The majority of the portraits in oils were painted in 1848 and 1849, while the execution of the mosaic copies continued until 1876.

The artists selected, who in some cases painted more than one portrait, included Eugenio Agnini, Domenico Bartolini, Pompeo Battaglia, Attilio Bavani, Roberto Bompiani, Nicola Bozzi, Costantino Brumidi, Vincenzo Canterani, Raffaele Capo, Antonio Chatelain, Michele Chiarini, Fabrizio D'Ambrosio, Casimiro De Rossi, Ignazio Farinelli, Domenico Foietti, Agostino Gagliardi, Carlo Gavardi, Francesco Grandi, Giuseppe Manno, Achille Mazzotti, Ercole Morelli, Nicola Pannini, Pietro Paoletti, Paolo Pizzola, Vincenzo Podesti, Domenico Rocchi, Luigi Scifoni, Marcello Sozzi and Paolo Spezia (AFSP, III P., S. 29, P. 2, ff. 659-782).

The portrait of the Prince of the Apostles, the first pope in Rome, was executed, as is indicated in documents in the AFSP (III P., S. 29, V. 6, p. 28), by Raffaele Capo and was then copied in mosaic from June 1848 to January 1849 by the master mosaicist Nicola De' Vecchi.

As has already been stated, it was the first of the chronological series of portraits of the popes, which was compiled on the basis of an antiquated chronology, now made obsolete by modern historical research. In this list – and adding the last five popes who are not included – there are 271 names. In the official list, included in the *Annuario* (Annals) of the Holy See, "The Supreme Pontiffs of Rome according to the chronology of the *Liber Pontificalis* and its sources, up to the present day", are enumerated 262 legitimate popes.

The *tondi* in oils in the Vatican collection also served for the illustrations in the book by L. Tripepi, *Ritratti e biografie dei Romani Pontefici da S. Pietro a Leone XIII*, published in Rome in 1879, which reproduces these portraits in their original chronological order.

Literature: L. Tripepi, *Ritratti e biografie dei Romani Pontefici da S. Pietro a Leone XIII*, 2 vols., Rome 1879; U. Thieme, F. Becker, *Allgemeines Lexicon der Bilden...*, Leipzig 1907-50; E. Benezit, *Dictionnaire des peintres...*, Paris 1942-65; *Roma 1300-1875. L'arte degli Anni Santi*, exhibition catologue, Milan 1984. (P.L.S.)

2
New Testament.
Epistles of Saint Peter
3rd century A.D.
15.5 × 14.2 cm
Biblioteca Apostolica Vaticana,
Bodmer Papyrus VIII

The two Epistles of Peter were probably drafted in Rome by a writer close to the apostle who produced a faithful interpretation of his thought.

The first one – dated A.D. 64 – was addressed to the faithful of the northwestern and central provinces of Asia Minor, the "pilgrims scattered among the pagans", and regards the duties of Christians.

The second, almost certainly written between A.D. 70 and 80, is aimed at a vast audience – all those who claimed the apostolic faith in common – and is intended to stimulate vigilance and perseverance in the faith.

The only copy which contains the two Epistles almost in their entirety is the Bodmer Papyrus VIII, which was published for the first time in 1959. Written in Greek by Coptic scribes, probably in Egypt, it is the oldest of the surviving fragments of this and other Epistles, since it is dated to the 3rd century A.D. Because of its small size, as well as the contents, it is believed that it was intended for private rather than liturgical use.

The two Epistles of Peter consist of thirty-six pages; the sheets are well-preserved, apart from the first one which is torn and has a number of lacunae.

The precious relic was presented by Martin Bodmer of Geneva to Paul VI in 1969 and then personally entrusted by the pope to the Vatican Library, where it is kept today.

The sheet exhibited contains the final part of the first Epistle and the beginning of the second.

Literature: *Beati Petri Apostoli Epistulae...* (facsimile ed.), Milan 1968. (A.R.)

3
Nicolas Beatrizet or Beatricetto
(1540-c. 1575)
The Delivery of the Keys
(or Pasce oves meas)
Mid-16th century
Copper engraving
23 × 33.5 cm
Biblioteca Apostolica Vaticana,
R.G. Stampe, V 3, no. 11

It was around 1515 that Pope Leo X Medici (1513-1521) commissioned Raphael to execute the preparatory cartoons for a series of tapestries depicting scenes from the Acts of the Apostles Peter and Paul which were to be hung in the Sistine chapel. When they were ready the cartoons were sent to Brussels to the workshop of Pieter van Aelst, who was the masterful weaver of the tapestries. Seven of the original cartoons are now in the Victoria and Albert Museum in London.

A plausible reconstruction of the disposition of the tapestries in the chapel was provided by Shearman (1972). The print exhibited depicts the dramatic moment of the delivery of the keys; Christ, who is standing, has just given the keys to Peter, who is surrounded by the other ten apostles (naturally Judas is not present). This scene is intended to symbolize the handing over by Christ – now nearing the end of his earthly mission – to the Prince of the Apostles and first pope of the Church of Rome. Beatricetto, who was of French origin, worked in Rome as a reproductive engraver from 1540 to 1565; in particular he engraved works

by Raphael and his school. In this reproduction, however, it is impossible not to notice the weakness of the line and the uniformity of the burin strokes, which with heavy crosshatching cause the expressivity of the faces to be lost.

It appears that the lower edge of the sheet has been cut off.

Literature: J. Shearman, Raphael's Cartoons *in the Royal Collections*, London 1972, pp. 21 ff.; S. Massari, in *Raphael invenit*, exhibition catalogue, Rome 1989, pp. 130 and 562. (A.R.)

4
Domenico Bigordi, called
Ghirlandaio (1449-1494)
Illuminated manuscript
1473
Parchment
59.5 × 40.5 cm
Biblioteca Apostolica Vaticana,
Ross. 1192, f. 93r

In the large initial letter M, the figure of Christ carrying the cross, the symbol of martyrdom and redemption, is splendidly illuminated against a background of a pleasant landscape with delicate tones of green and blue. In the oval of the border, Saint Peter is represented with the traditional iconography; in his hands he holds the keys, the symbol of papal power.

This manuscript sheet, as well as another two sheets from the same illuminated choir book in Florence, is bound together with other beautifully illuminated sheets which over the years were, regrettably, removed from various codices and assembled to form the present Rossiano manuscript.

In this large miniature, the hand of a great artist is evident.

In fact, the work was executed by one of the leading Tuscan painters of the Renaissance, Domenico Ghirlandaio, who was the first painting master to whom the young Michelangelo was apprenticed.

This authorship is demonstrated by the subscription "MCCCCLXXIII Florentia, Domenico Corradi"; an identical legend appears on another similar sheet, which comes from the same

choir book and was illuminated by the same artist.

Literature: *Raffaello e la Roma dei papi*, exhibition catalogue, edited by G. Morello, Rome 1985, p. 44. (G.M.)

5
Bust of Nero
1st century A.D.
Bronze
Height 37 cm
Biblioteca Apostolica Vaticana,
Museo Profano, inv. 7905

This bust shows Nero shortly before his death. The only bronze portrait known, it is dated circa A.D. 60.

The bust was probably meant to be placed on an already existing statue (a widely-used technique), but the plan was abandoned since it could not be fixed successfully.

The emperor is here depicted with his curly hair, for which he was famous, all around his head, and a thick beard which covers most of his cheeks and reaches his neck. The flabby, falling cheeks can already be seen here, although the bronze makes this less noticeable.

Nero Claudius Caesar Drusus Germanicus was born in Anzio in A.D. 37 and was adopted by the Emperor Claudius, whose second marriage was to Nero's mother, Agrippina. When Claudius died in A.D. 53, Nero, who in the meantime had married Claudius' daughter Ottavia, was proclaimed emperor by the Pretorian guard. His reign was characterized by ferocious cruelty, and he went as far as having some of his dearest relatives killed, including his mother and his wife. It was even said that his second wife, Poppea, died after being kicked by him when she was pregnant. It was because of these acts that his name became a synonym for cruelty and tyranny. He died in A.D. 68, killed at his own request by his slave Atte when escaping from Rome after a revolt by the Pretorian guard.

Nero's name is linked with the first great persecution of the Christians. The direct cause of this, as Tacitus reveals (*Annales* XV, 44), was the dread-

ful fire which devastated ten of the fourteen areas of Rome in A.D. 64. The people accused Nero of starting the fire, and so he blamed the Christians, who were arrested en masse and slaughtered.

Many of them were thrown to the circus animals, others were crucified, and still others were turned into burning torches, providing illumination for the garden pathways of his palace.

The apostles Peter and Paul were martyred during this period. The former was crucified upside down near the Vatican circus, whilst the latter, being a Roman citizen, was decapitated in the Tre Fontane area.

Literature: J.J. Bernouilli, *Römische Ikonographie. Die Bildnisse der Römischen Kaiser...*, Stuttgart 1882-84, II, 1, pp. 392-393, pl. XXIV; W. Helbig, *Führer durch die öffentlichen Sammlungen Klassischer Altertümer in Rom*, vol. I, *Die Papstlichen Sammlungen im Vatikan und Lateran...*, Tübingen 1963, p. 374. (G.M.)

6
**Epitaph on the mausoleum A
of Popilius Heracla**
Copy of the 2nd-century original
Alabastrine plaster, treated with dyes
52 × 57 × 3.5 cm
Fabbrica di San Pietro, storerooms

This object is a perfect reproduction of the marble tombstone placed over the portal of the mausoleum A of Popilius Heracla, which is situated in the excavated part of the necropolis under Saint Peter's basilica and crypts.

The important discovery, which was made above the tomb of Gregory V, situated in the southern vault of the crypts, eliminated all doubts concerning the hypothesis – proposed by Domenico Fontana at the end of the 16th century, but later taken up by others on various occasions – that the Constantinian basilica had been built on the arena of Nero's circus, where, according to tradition, Saint Peter was martyred.

The text of the inscription, part of which is given here, is a true testamentary codicil which is of great im-

portance because of the topographical indications which it contains: "D[IS] M[ANIBUS] EX CODICILLIS TRIPLICIBUS POPILI HERACL« C[AIUS] POPILIUS HERACLA HEREDIBUS SALUT[EM] VOS HEREDES MEI ROGO IUBEOQUE FIDEIQUE VESTR« COMMIITO UTI MONUMENTUM MIHI FACIATIS IN VATIC[ANO] AD CIRCUM IUXTA MONUMENTUM ULPI NARCISSI EX IS VI N[UMMUM] IN QUAM REM NUMERABIT".

Here the desire of the deceased to be buried in a mausoleum in the Vatican necropolis ("IN VATIV AD CIRCUM") is clearly expressed; this was near the circus, where there was also the large obelisk which Domenico Fontana moved in 1586 to the centre of the square in front of Saint Peter's basilica.

So far it has not been established exactly where the circus was located, nor has any light been shed on its size and orientation; built by Caligula and Nero it appears to have been constructed in the gardens that Caligula had inherited from his mother Agrippina. Be that as it may, the inscription on the mausoleum of Popilius Heracla and the phrase from Tacitus "clausum valle Vaticana spatium" (*Annales*, XIV, 14) confirms the presence in the immediate vicinity of the necropolis in which Saint Peter was buried.

Literature: F. De Visscher, in *Antiquité classique*, XV, 1946; B.M. Apollonj Ghetti, A. Ferrua, E. Josi, E. Kirschbaum, *Esplorazioni sotto la Confessione di San Pietro in Vaticano*, 2 vols., Vatican City 1951; J. Toynbee, J.W. Perkins, *The Shrine of St. Peter and the Vatican Excavations*, London 1956; M. Basso, *Simbologia escatologica nella necropoli vaticana*, Vatican City 1981. (P.L.S.)

7
F. Jurgenson
View of the interior of mausoleum I, known as "della quadriga"
1951-53
Oil on canvas
74.5 × 61.5 cm
Fabbrica di San Pietro, storerooms

This is one of a series of ten paintings depicting various views of the Vatican

necropolis which Pope Paul VI (1963-1978) gave to the Fabbrica di San Pietro in 1977.

It is an accurate representation of the interior of one of the most interesting mausoleums of the archaeological area underneath Saint Peter's, as it appeared shortly after it had been excavated.

The mausoleum, which adjoins mausoleum H, known as "Valerius Herma", is lavishly decorated with stuccoes, frescoes and a strikingly beautiful mosaic pavement, made with black and white marble tesserae.

This mosaic depicts scenes from classical mythology. It represents Mercury engaged in one of his many duties, namely that of guiding the souls of the dead down to the river Styx, the river of hate which surrounded Hades, the Greek underworld, where Charon the boatman was ready to ferry them across in his barque.

In recognition of the compassionate task that he carried out, the figure of Mercury was often carved on pre-Christian tombs.

In earlier times it had been thought that it was Pluto, also known as Hades, who took possession of the souls of the dead and led them to lake Avernus, the entrance to the nether regions, but later this dismal office was ascribed to Mercury, who because of this earned the title "psychopomp", which derives from the Greek for "conductor of souls".

The border, also in mosaic, surrounding the figurations described above, contains symbolic representations of animals: tigers and gazelles which alternate with plants and vases of flowers. On the walls, the pictorial decoration and grotesques with their vivid colours include bucolic figurations with peacocks, ducks and doves, other birds and floral motifs symbolizing the life which it is hoped that the deceased entering the nether world will enjoy.

The "della quadriga" mausoleum (measuring 4.53 × 2.31 m) was excavated in 1943, as is stamped on the brick bearing the coat of arms of the Fabbrica di San Pietro which was placed there.

Literature: V. Tocci, *Dizionario di mitologia*, Turin 1958; J.M.C. Toynbee, J.B. Ward-Perkins, *The Shrine of St. Peter and the Vatican Excavations*, London 1956; M. Basso, *Simbologia escatologica*, Vatican City 1982. (P.L.S.)

8
F. Jurgenson
View of the interior of mausoleum F, known as "C. Caetennius Antigonus"
1957-58
Oil on canvas
66.5 × 82.5 cm
Fabbrica di San Pietro, storerooms

The painting, which depicts mausoleum F (also known as "Caetennius Antigonus") in the Vatican necropolis, lays emphasis – also by reproducing the original colours – on the architectural structure of the burial chamber; this is embellished with elegant stucco decorations which are evidence of the eclectic customs of the Romans with regard to the burial of their dead.

Mausoleum F was the first to be discovered during excavations that from 1939 to 1946 unearthed part of the pre-Constantinian burial area under the basilica of Saint Peter's.

This splendid mausoleum, with its elaborate architectural forms, provides the dead with a replica of the *domus* of the living so as to favour their return to the joys of earthly life. In the middle there is a funerary altar with a dedicatory inscription. Within a geometrical decoration with vegetal motifs there is the inscription "M(ARCO) CAETENNIO ANTIGONO ET TULLIAE SECUNDAE CONIUGI EIUS" which, together with others on the cinerary urns, names the members of the family to which the mausoleum belonged.

There are a number of holes in the mosaic pavement which are testimony to the compassion of the living, who, in accordance with the pre-Christian funerary rites, poured perfumes and intoxicating liquids into them to give comfort to the wandering souls of the deceased.

In this pre-Christian mausoleum,

where, however, a number of the figurations foreshadow Christian iconography (for instance the open door, ivy leaves and the doves in a basket), there is the Christian tomb of Emilia Gorgonia. On this, which is behind the funerary altar mentioned above, there are typical examples of Christian symbology – a woman drawing water, two doves with an olive branch and the words "dormit in pace".

In the dedicatory inscription, the husband mentions the goodness and beauty of his young wife who is buried there.

On the facade of the mausoleum, which is very solidly built, there is a decorative panel in coloured terracotta representing a partridge and, on the right, another terracotta relief depicting an unusual architectural view.

Literature: J.B. De Tòth, *Grotte Vaticane*, Vatican City 1955; J.M.C. Toynbee, J.B. Ward-Perkins, *The Shrine of St. Peter and the Vatican Excavations*, London 1956; M. Basso, *Simbologia escatolgica*, Vatican City 1982. (P.L.S.)

9
F. Jurgenson
View of the interior of mausoleum H, known as "Valerius Herma"
1953-55
Oil on canvas
82.5 × 66.5 cm
Fabbrica di San Pietro, storerooms

The painting, which was also part of the series given by Paul VI to Saint Peter's, depicts the interior of the mausoleum of Valerius Herma, generally known as *dei Valeri*. Excavated in 1943, it is the largest of those discovered in the necropolis under the basilica of Saint Peter's. Originally it consisted of two burial chambers: one was reserved for the patricians, the other for the freedmen. The latter was partly demolished to make way for the construction of both the old and the new basilicas; in fact, only the west wall remains, with many niches containing cinerary urns and a well from which water was drawn for the building work connected with burial, cleaning and the preparation of the meals which

were often eaten there, as well as ritual purification.

On the east and south sides there are now some sarcophagi embellished with splendid hunting scenes. A tombstone bearing, top right, the cryptogram of Christ (X) is attached to the east side of the foundations of the triumphal arch of Old Saint Peter's. It was part of the tomb of a certain Flavius Istatilius Olimpius, who is remembered as a man of unparalleled meekness ("...numquam rixatus est").

In the chamber reserved for the patricians the elegance of the finely executed stuccowork is noteworthy. Besides architectural decorations, this also includes the representation of divinities and the deceased, housed in niches of various shapes and sizes. The divinities and mythological characters (gods and goddesses, satyrs, maenads, genii and so on) appear in dance poses or in movement, in contrast with the static quality of the figures of the dead. The decoration is completed with garlands and cornucopias, overflowing with fruit and flowers, and herms with hairstyles reflecting oriental taste.

In the centre of the mausoleum, placed on the floor, there is a large marble sarcophagus ornamented with fluting; the busts of the deceased couple are sculpted in bas-relief in the middle of the front, while the sides are decorated with shields surmounting lances.

Two splendidly executed marble heads of a man and a woman were found in the mausoleum of Valerius Herma. In fact, this is an extremely interesting example of the eclecticism of the Romans with regard to funeral rites, particularly reflected in the refined iconography of the decoration.

Literature: B.M. Apollonj Ghetti, A. Ferrua, E. Josi, E. Kirschbaum, *Esplorazioni sotto la Confessione di San Pietro in Vaticano*, Vatican City 1951; J.M.C. Toynbee, J.B. Ward-Perkins, *The Shrine of St. Peter and the Vatican Excavations*, London 1956; M. Basso, *Simbologia escatologica*, Vatican City 1982; M. Basso, *Guida della necropoli vaticana*, Vatican City 1986. (P.L.S.)

10

Gilded glass roundel with the busts of Peter and Paul

4th century A.D.
Glass and gold leaf, graffiti
Diameter 9 cm
Biblioteca Apostolica Vaticana,
Museo Sacro, inv. 768

Together with the traditional iconography, the words "PETRUS" and "PAULUS" identify the two personages portrayed in this splendid gold-glass roundel. In fact, Peter is portrayed with a short beard and curly hair, while Paul is bald with a pointed beard; however, according to some scholars, his features appear to resemble those of a number of portraits of Julian the Apostate (361-363) which were reproduced on contemporary coins.

The busts of the two apostles, in profile, but with the bust seen frontally, face each other; above them there is the martyr's crown; the circular edge of the roundel has a frame decorated with double indentations.

The work, which is well preserved and of excellent quality, comes from the catacombs and has been in the collections of the Museo Sacro at least since the mid-19th century.

Gold-glass vessels, which appear to have been made for funerary purposes because they have mainly been found in the catacombs and Christian cemeteries, are among the most important artifacts of the Early Christian period. In general they are the bases of drinking cups and were made by sandwiching gold leaf, decorated with graffiti depicting figures or letters, between two layers of glass which were then heated to bond them together.

Literature: C.R. Morey, *The Gold Glass Collection of the Vatican Library...*, Vatican City 1959, pp. 16-17; G.P. Daltrop, in *Art Treasures of the Vatican Library*, New York n.d., p. 169. (A.R.)

11

Early Christian terracotta oil lamp with the bust of a cloaked personage, probably Saint Peter

Second half of 5th century A.D.
Type: Provoost 9B; Pohl 1A;
Hayes 2A
Brick red clay, brick red paint
Length 13 cm; width 8.1 cm;
height 3.4 cm (without handle),
4.8 cm (with handle);
diameter of stamp 1.8 cm
Handle and spout incomplete; traces of burning on the spout
Biblioteca Apostolica Vaticana
Museo Sacro, inv. 1299

This lamp is of a type generally described as "North African", which was common in the Mediterranean area from the second quarter of the 5th century A.D. until the end of the 6th century A.D., and was probably produced in the regions of North Africa, especially Tunisia and Algeria.

It has been ascertained that this type of lamp was produced more or less in parallel with that of plates bearing relief decorations, above all those in light terra sigillata in style D. In fact, the decorative motifs executed on the circular top of the oil-chamber and shoulders of the North African lamps are often identical to those on these plates, so that it is possible to date the lamps fairly precisely.

On the shoulders of the lamp belonging to the Biblioteca Apostolica Vaticana there are decorated rims with geometrical motifs – six jewelled triangles and a jewelled drop – placed on both sides of the edge of the spout channel. On the circular upper surface is depicted the bust in relief of a male personage with his head turned slightly to the right. His hair is short and bristly, his eyes are large and expressive, his nose prominent and his mouth and chin are framed by a thick beard formed by small grooves. The personage is wearing a tunic, and a cloak falls from his left shoulder; part of his right hand protrudes from this. After studying this lamp, Garrucci maintained that the personage depicted on the top of the oil-chamber was Saint Peter, but subsequently this theory has only been accepted by Fallico and La Lomia, while in the opinion of other authoritative scholars, such as

Sotomayor, Testini and Pani Ermini, the identification of Saint Peter is "merely a hypothesis".

Apart from the date established by Fallico, which this writer considers to be too late, comparisons made by scholars with other similar lamps and with a number of ceramic trays in style D, on which there is a personage who resembles the one described above, would tend to suggest that it is indeed Saint Peter. A lamp found in a tomb near Tebessa (Algeria) is almost identical, except for the cross in relief which appears behind the left shoulder of the figure on the circular upper surface, which may be an attribute added later to the original mould. An identical example has been found in Tunisia, while those described in studies by Pani Ermini and La Lomia are similar as far as the bust on the top of the oil-chamber is concerned, but differ in the decoration on the shoulders. The two concentric rings inscribed on the bottom of the lamp belonging to the Museo Sacro appear on numerous examples of the "classical African" type, perhaps as the trademark.

On the basis of the decorative motifs on the shoulders of the lamp, which may be ascribed to the ceramic style D, this writer suggests that it should be dated to the second half of the 5th century A.D.

Literature: R. Garrucci, *Storia dell'arte cristiana nei primi otto secoli della Chiesa*, vol. VI, Prato 1880, p. 113, pl. 476, no. 5; M. Sotomayor, *S. Pedro en la iconografía paleocristiana*, Granada 1962, p. 209; P. Testini, "L'iconografia degli apostoli nelle arti minori", in *Saecularia Petri et Pauli*, Vatican City 1969, p. 306, no. 100; A.M. Fallico, "Nuovi elementi iconografici in alcune lucerne 'africane' del Museo di Siracusa", in *SicGym*, n.s. XXIII (1970), pp. 98-100, no. 26; M.R. La Lomia, "Lucerne fittili provenienti da un ipogeo cristiano di Sirte (Tripolitania)", in *Libia Antiqua*, VIII (1971), pp. 26-27, pl. XIII, g; A. Ennabli, *Lampes chrétiennes de Tunisie*, Paris 1976, pl. IV, no. 97; L. Pani, M. Marinone, *Catalogo dei materiali paleocris-*

tiani ed altomedioevali (Museo Archeologico Nazionale di Cagliari), Rome 1981, pp. 132-133, no. 219; "Atlante delle forme ceramiche, I, Ceramica fine romana nel bacino mediterraneo (medio e tardo impero)", in *Enciclopedia dell'arte antica classica e orientale*, Rome 1981, pp. 198-203, mould X. (M.T.P.).

12

Early Christian terracotta oil lamp with a jewelled monogrammed cross

Late 5th - mid-6th century A.D.
Type: Provoost 9B; Pohl 1A;
Hayes 2A
Reddish-orange clay, traces of reddish-orange paint
Length 13.2 cm; width 8 cm;
height 3.4 cm (without handle);
diameter of stamp 2.5 cm
Complete; traces of burning on the spout
Biblioteca Apostolica Vaticana,
Museo Sacro, inv. 1297

This lamp is of the so-called "classical African" type, with a round oil-chamber, an open spout-channel and a round top and spout.

Four geometrical motifs appear on the shoulders on each side: palmettes inside hearts and scroll ornaments with vegetal designs.

On the top a jewelled monogrammed cross in relief is represented with the bars splayed at the ends. The vertical bar of the cross and the curved part of the P are decorated with a series of lozenges which are adorned internally with a small ring and externally with four small rings placed at the sides of the lozenge, alternating with stylized lambs seen in profile within a raised ring.

The symbol formed by the joining of the cross and the P is the epigraphic monogram which, although rarely found in pre-Constantinian inscriptions, became widespread in Rome from the second half of the 4th century A.D. onwards to indicate the name of Christ in an abbreviated form.

In particular, this type of cross, which was jewelled and adorned with lambs, appears as well on the terra sigillata

plates made in style Ei, which was characteristic of the Oudna workshops. On the bottom of the lamp there is a raised ring which is linked to the handle by a ridge; inside the ring a V-shaped stamp appears.

A lamp with a cross decorated in a similar manner has been described by Menzel and a series of almost identical examples have been the subject of a study published by Delattre.

On the basis of the decorative motifs present on the shoulders and the top of the oil-chamber it is possible to date the lamp belonging to the Museo Sacro to the end of the 5th century or the first half of the 6th century A.D.

Literature: A.L. Delattre, "Lampes chrétiennes de Carthage", in *Revue de l'art chrétien*, 1891, vol. II, p. 307, nos. 622-633; M. Menzel, *Antike Lampen im Römisch-Germanischen Zentralmuseum zu Mainz*, Mainz 1969, p. 93, no. 610, pl. 78, no. 1; F. Testini, *Archeologia Cristiana*, Bari 1980, pp. 355-356. (M.T.P.)

13

Early Christian terracotta lamp with christogram

Late 4th - early 5th century A.D.
Type: Provoost 8F
Clay, paint
Length 13.2 cm; width 8 cm; height 3.4 cm (without handle)
Complete; traces of burning on the spout
Biblioteca Apostolica Vaticana, Museo Sacro, inv. 1963

On the shoulders there are borders delimited by deep grooves and embellished by a series of small rings coarsely imprinted with a sort of hollow stamp. In the central part of both borders there are rough concentric rings. On the slightly dished upper surface of the oil-chamber is represented a christogram in relief with the bars appliquéd and shortened as a result of the creation of two funnels.

In the centre of the vertical bar of the P there is a small ring.

The spout-channel is flanked by two deep grooves and the spout itself has a large hole for the wick.

The flat bottom bears a stamp with the linked letters P and E imprinted within an incised oval. In turn, the oval is encompassed by a lyre-shaped line which serves as a false base.

The pear-shaped oil chamber identifies the lamp's typology; it is one that is usually made from buff or yellowish clay in a fairly coarse mixture, coated with slip varying in colour from reddish-orange to dark brown.

According to a number of scholars, including Provoost, the fact that the clay is buff-coloured, and not reddish-orange as was the case with the lamps made of light terra sigillata, is evidence that they were produced in Rome or elsewhere in Italy, while most of the clay objects found throughout the Mediterranean area at this time were from Africa.

This hypothesis is supported by the fact that usually the Provoost 8 type has been found in the Christian catacombs in Rome and the area of production seems to be located in or near Rome.

The decorated motifs on the shoulders and the top of this type are very simple and coarsely executed, consisting mainly of themes from the natural world and Christian symbols (℞, ℞, †, +); this suggests that the lamps were "made by craftsmen, but on an intensive scale, probably due to the large, unceasing demand from the Christian customers" for use both in cemeteries and in their homes.

As regards the dating of the Provoost 8 type, on the basis of finds in cemeteries it varies from the mid-4th century A.D. to the end of the 5th century A.D.

The christogram represented on the top of this lamp is a theme that was very common all over the Roman Empire from the reign of Constantine onwards; the symbol is formed by the interlacing of the X and the P, the initials of Christ's name in Greek, and it may be used to embellish both the top and the bottom of the lamp.

The stamp on the bottom has been interpreted in various ways by scholars: "P[alma] E[merita], PE[rpetuo], P[alma] E[t] L[auraus]". Guarducci,

after examining the graffiti on wall "g" in the Vatican, suggested this sign, which occurs in various forms, could mean "PE[trus]" and dated it to a period after A.D. 315. In her opinion the symbol in question is of Roman origin and is evidence of Peter's immense popularity in Rome in the 4th and 5th centuries, to the extent that the initials of the apostle's name became a symbol of good luck, health and happiness. However, the present writer believes that this symbol served as a trademark and was, at the same time, a symbol of good fortune which also expressed the hope for salvation, while there are no grounds for interpreting it as *Petrus*.

There is a lamp which is similar both as regards the type and the decoration on the shoulders and the upper surface in the Museo Archeological Oliveriano in Pesaro.

This lamp may, therefore, be dated to the late 4th or the early 5th centuries A.D., because of the presence of both the christogram and the letters "PE".

Literature: M. Guarducci, *I graffiti sotto la Confessione di San Pietro in Vaticano*, Vatican City 1958, pp. 385 ff.; A. Provoost, "Les lampes à récipient allongé trouvées dans les catacombes romaines. Essai de classification typologique", in *Bulletin de l'Institut Historique Belge de Rome*, XLI (1970), p. 50; P. Testini, *Archeologia cristiana*, Bari 1980, p. 355; M.T. Paleani, A.R. Liverani, *Lucerne paleocristiane conservate nel Museo Oliveriano di Pesaro*, Rome 1984, vol. I, p. 46, no. 34, fig. 34; M.T. Paleani, "Le lucerne paleocristiane", in *Monumenti, musei e gallerie pontificie. L'Antiquarium Romanum*, vol. I, Rome 1993, p. 88. (M.T.P.)

14

Papal throne

1877
Pine wood
184 × 90 × 64 cm
Vatican Museums, inv. 30581

The elegantly carved and gilded wooden throne, which is now in San Giovanni in Laterano in the Museo Storico, was made in Paris in 1877 by Souvrezy in his studio at Rue de Turenne,

23, as is indicated by the two small inscriptions on the rear of the back. It was given to Pope Pius IX, Giovanni Maria Mastai Ferretti (1846-1878), to mark the fiftieth anniversary of his ordination as bishop.

In the Vatican archives no documentation has been found regarding the donor, to whom, in the opinion of the present writer, the coat of arms with a crown in the centre of the front crossbar of the seat belonged.

On the uprights of the back and under the enamelled metal coat of arms with Pius IX's insignia, which is situated at the centre of the crossbar of the back, there are three dates referring to his ordination as a priest in 1819, his ordination in 1846 as Bishop of Spoleto by Leo XII, Della Genga (1823-1829), and, lastly, his election as pope in 1846. The back is crowned by the symbols of the order, the ministry and the jurisdiction.

The covering of the back, seat and arms, with delicate figurative designs and ornamental motifs that stand out on the crimson border, is a tapestry from the Gobelins' factory, which seems to be a forerunner of its characteristic output of the late 19th century. The representation in soft colours of the delivery of the keys and the tiara, surrounded by the symbols of Matthew, Mark, Luke and John, allude to the pope's primatial power, which was included in the writings of the evangelists in the New Testament.

As part of the celebrations to mark the fiftieth anniversary of his ordination as bishop, the Società Cattolica Artistica Operaia Romana also gave Pius IX a throne, which is now in the San Giovanni in Laterano too; it is particularly interesting to compare its style and decoration with the throne that was made in France at the same time.

Literature: *Rome 1300-1875. L'arte degli Anni Santi*, exhibition catalogue, Milan 1984. (P.L.S.)

15

Pius IX's tiara

Mid-19th century
Gilt silver, gold, gems

and precious stones
Height 31 cm
Tesoro della Sagrestia Pontificia

The tiara, symbol of the pope's sovereign power, was used, at least from the Middle Ages to modern times, in the sumptuous ceremony of the coronation of the pope and when he was borne on the gestatorial chair to preside over the solemn liturgical celebrations in Saint Peter's. The three coronets which surround it symbolize the supreme authority of the Vicar of Christ on earth, and have been variously interpreted by the Church as alluding to the triple sovereignty of the pope over the Church militant, purgatorial and triumphant, to the three theological virtues (faith, hope and charity) or to the Holy Trinity.

During the papacy of Paul VI (1963-1978) the pope forwent the tiara as a gesture of solidarity with the poor and disinherited of the earth, in accordance with the policy laid down by the Second Vatican Ecumenical Council. The precious object exhibited was given to Pope Pius IX (1846-1878) in 1870 by the Civic Guard of Honour, which then became the army corps of the papal state and was known as the Palatine Guard; this was dissolved by Paul VI when, with the reform of the papal court, all pomp and outward display of temporal power was eliminated.

Embellished with pearls, gems and precious stones, the tiara bears on enamelled plaques of different colours an inscription which repeats the traditional formula which the cardinal deacon pronounced during the coronation ceremony: "JESV SVPREMO VICARIO INFALLIBILI; ORBIS SVPREMO IN TERRA RECTORI; REGVM ATQVE POPVLORVM PATRI" [To the infallible Vicar of Jesus Christ; To the supreme Governor of the world on earth; To the father of nations and kings].

Originally the tiara, or *regnum*, was a simple hat made of white cloth in the shape of an elongated helmet, which may have derived from the diadem that, according to legend, Constantine gave to Pope Sylvester (A.D. 335-314). Subsequently it was adorned with points and floriated lobes just like a true royal crown; it was apparently during the papacy of Boniface VIII (1295-1303) that it was given the form of a tiara with three coronets which it was to keep for centuries.

Literature: E.F. Twining, *A History of the Crown Jewels of Europe*, London 1960; *The Holy See. The Vatican Collections*, Brisbane 1988, p. 108. (G.M.)

Old Saint Peter's
The Original Basilica

16
Carlo Morelli
Portrait of Pope Sylvester
Mid-19th century
Oil on canvas
Diameter 135 cm
Fabbrica di San Pietro, storerooms

Despite the length of his papacy, little is known about the life and work of Pope Sylvester I (A.D. 314-335); this may be because of the strong personality and intense activity of Constantine, the first Christian Roman emperor (A.D. 306-337). Thus, during the first half of the 4th century A.D., the latter dominated the empire and the Church to such an extent that even the *Liber pontificalis*, the greatest collection of biographies of the popes in existence, goes into considerable detail about the buildings and gifts of Constantine, while little space is devoted to Sylvester I. However, he had the great pleasure of seeing the Church which he headed now finally at liberty to profess its doctrine and enjoy freedom of worship.

The generous donations of Constantine permitted the construction of magnificent basilicas and churches, such as San Giovanni in Laterano with its baptistry, San Paolo fuori le Mura and Old Saint Peter's. During Sylvester I's papacy, Rome began to take on the aspect of a Christian city.

A legend tells of the piety of Constantine, who began the construction of the basilica of Saint Peter's by digging the foundations with his own hands and carrying twelve baskets of earth on his own shoulders. However, the *Liber pontificalis* gives a detailed account of the construction of the venerated tomb of Paul the apostle, enclosed in the basilica as if it were in a precious coffer; on this Constantine ordered a solid gold cross weighing 150 librae to be placed. It bore the inscription: "Constantine Augustus and Helena Augusta built this royal chamber, surrounded by the basilica which is resplendent with similar magnificence". Furthermore, the same source specifies the other donations made by the emperor for the furnishings and the gifts in kind which came from all over the world.

Sylvester I was buried in the cemetery of Priscilla on the Via Salaria. His portrait for the chronological series of the popes was painted by Carlo Morelli; the mosaic, which was intended to adorn the entablature of the nave and transept of the basilica of San Paolo fuori le Mura, was made by Raffaele Castellini in the period from June 1853 to February 1855 (Archivio della Fabbrica di San Pietro, III P., S. 29, V. 6, p. 28).

Literature: L. Tripepi, *Ritratti e biografie dei Romani Pontefici da san Pietro a Leone XIII*, Rome 1879; G. Turcio, *La basilica di San Pietro*, Florence 1946; J.N.D. Kelly, *Grande dizionario illustrato dei papi*, Turin 1989. (P.L.S.)

17
Pieter van Lint (1609-1690)
and Pietro de Balliu
**Constantine Inaugurates
the Construction of the Basilica
The Pilgrims Go to Visit Saint Peter**
1637 and 1635
Engravings
29 × 41 cm each
Biblioteca Apostolica Vaticana,
Cicognara XII 541, nos. 109, 110

After the edict of Milan of A.D. 313, which finally recognized the right of Christians to practise their religion, the *Domus Ecclesiae* (the houses where the faithful met secretly) were spontaneously transformed into churches and important religious buildings were built with financial backing from Emperor Constantine himself. There were many of these, but the one that required most work and money was Saint Peter's. Constantine wanted to build the basilica over the shrine of Peter the apostle, which was situated on the Vatican hill; it was therefore necessary to level the hill in order to make enough room for the massive new structure. Legend has it that Constantine himself carried twelve baskets of earth on his back and that he laid the foundation stone of the building with his own hands.

In the first of the two engravings on this sheet (the one on the left), the emperor begins the building work while he kneels before Peter, who is seated with keys in hand and a halo over his head.

The second engraving (on the right) depicts pilgrims – young and old, including a woman – who, having gone to see the saint, kneel before him, thereby proclaiming the role of the future mother church of Christianity.

In the inscriptions at the bottom relating to the two prints, the engraver's name is given: "Petrus de Balliu sculpsit Romae" (the first is dated 1637, the second 1635); there is also the monogram of the artist who made the original drawings: the initials PVL refer to the Flemish painter Pieter van Lint. Born in Antwerp in 1609, he went to Rome in 1633, where he was in the service of Cardinal Domenico Ginnasio, for whom he executed paintings for churches in Rome and Ostia; he returned to his native land in 1643 and died in 1690.

Literature: E. Benezit, "Lint Pieter van", entry in *Dictionnaire des peintres, sculpteurs, dessinateurs et graveurs*, Paris 1976, vol. VI; P. Boccardi Storoni, *Storia della Basilica di San Pietro*, Pavia 1988, pp. 34 ff.

18
Alberto Carlo and Mauro Carpiceci
Reconstruction of Old Saint Peter's
1985
Various types of wood
242 × 127 × 75 cm
Rome, private collection

This wooden model is an accurate reproduction of Old Saint Peter's as it was towards the end of the 15th century, about thirty years before Donato Bramante (1444-1514) started on its demolition. On the south side of the church complex, which, without the portico and the atrium (56 metres wide and 62 metres long), occupied an area of over 118 metres in length by 64 metres in width, there were the rotundas of Santa Petronilla and Santa Maria della Febbre; next to them is the obelisk, which is now in the centre of the square.

Note, about halfway along the eastern arm of the Latin cross, the chapel of the choir built by Sixtus IV; this is the last addition, in chronological order, to be featured in the model, which illustrates the architectural evolution of Old Saint Peter's over a period of 1150 years.

In fact, it was Emperor Constantine (A.D. 306-337) who, at the beginning of the 4th century, built a funerary monument covered in precious marble over Saint Peter's shrine and around the "Apostolic memory". The same emperor ordered the building of a temple in which to venerate the sacred shrine, but it was the bishop of Rome, Pope Sylvester I (314-335), who took charge of the extraordinary project, with his own architects and masters of works, while Constantine provided the finance, the manpower and the necessary materials.

The large number of columns made of precious stone – such as Egyptian granite, red, grey and white marble, cipolin, African marble, breccia, Parian marble and porphyry – the bases and capitals, the large blocks for the entablature and whatever else was necessary came from the imperial stores or the great Roman buildings which were already going to rack and ruin.

Probably the first project involved the building of a large hall, with a north-south orientation and a choir at the west end, behind Saint Peter's shrine, and a great arch forming the entrance at the east end. But a true basilica was abutted onto this hall while it was being built.

This new structure was divided lengthwise by four rows of 22 columns which formed four aisles and a nave that was 23 metres wide. In front of the basilica, a large portico and an atrium where pilgrims could rest was then added; it was open to the sky, but comfortable and well protected.

Right from the start the transverse hall was embellished with precious marble, paintings and mosaics, while in front of the building was erected a *pergula* (a colonnade on a parapet) with elegant columns decorated with vine leaf motifs. Over Saint Peter's shrine and in the transept there were several gold and silver chandeliers. On the small altar of the Apostolic memory was placed a gold cross studded with gems; this was a gift from the emperor and his mother Helena.

Around the shrine of the martyred saint, along all the internal walls of the basilica, in the atrium and even along the external walls proliferated tombs, altars, chapels, oratories and mausoleums which were constantly being rebuilt and were brimming with relics, sumptuous gifts and precious works of art.

Saint Damasus, who was pope from 366 to 384, installed a font which was supplied with water from the Vatican hill, and soon the facade was resplendent with cerulean mosaics, while in the nave and aisles the coffered ceiling glittered thanks to a covering of pure gold leaf. In the atrium a fountain played perennially; in its centre was the large ornamental bronze pinecone which can still be seen today in the Cortile della Pigna in the Vatican. The basilica was further embellished during the pontificate of Saint Leo I (440-461), who was responsible for the covering of the facade with the splendid mosaic depicting the 24 venerables adoring the Lamb of God.

Pope Simplicius (468-483) completed the atrium with side porticos and adorned it with marble and mosaics; he also widened the flight of steps leading from the square in front of the basilica to the atrium and installed drinking-fountains and canteens for the pilgrims. From then onwards the atrium was referred to as *paradiso*.

The area near Saint Peter's shrine was altered considerably during the papacy of Saint Gregory I (590-604), who ordered that a new altar be built over the tomb and that the level of the presbytery be raised, both for liturgical reasons and to create a passageway within the apse which would allow worshippers to get as close as possible to the apostle's shrine.

Pope Honorius I (625-638) carried out major repair work on the roof beams and the restoration of the parts of the basilica covered with mosaic, gold leaf or otherwise decorated. The main door of the basilica was entirely covered with silver sheets and, subsequently, Pope Gregory III (731-741) adorned the *pergula* in front of the altar and made it even more majestic.

The great bell tower, to the right of the facade of the buildings in front of the atrium, was erected during the papacy of Stephen II (752-757). From 1119 to 1124 Pope Calixtus II incorporated Gregory I's altar in a new one and at the same time raised the level of the presbytery further, so as to make Saint Peter's shrine more accessible.

During the papacies of Boniface VIII (1294-1303), Benedict XI (1303-1304) and Clement V (1305-1314), Giotto di Bondone (1266-1336) and Pietro Cavallini (active in the late 13th century) renewed the pictorial and mosaic decorations in Saint Peter's. In particular, on the entrance wall of the atrium Giotto executed the great mosaic called the *Navicella*. From 1431 to 1464, under Popes Eugenius IV (1431-1447), Nicholas V (1447-1455) and Pius II (1458-1464), while a cultural evolution was taking place, the problem of the renovation of the basilica was given serious attention.

Leon Battista Alberti (1404-1472) planned the renovation of the nave and the access routes to the basilica, while Bernardo Rossellino (1409-1464) began the construction of the enormous choir at the west end and the imposing loggia of the benedictions at the east end.

Filarete (c.1400 - c.1469) designed the magnificent bronze door which is now at the main entrance of Saint Peter's, thanks to the alterations made by Paul V (1605-1621).

Pope Sixtus IV (1471-1484) continued the renovation work; he had a new ciborium placed over the altar of Calixtus II and improved the apsidal area. Set against the south wall, about halfway along it, he built a large and sumptuous chapel which, like the more famous Sistine chapel, was dedicated to Our Lady of the Assumption; it later housed his monumental tomb and the first *Pietà* by Michelangelo Buonarroti (1475-1564).

Literature: O. Panovinio, *De praecipuis... basilicis*, Rome 1570; M. Cerrati, *Tiberio Alfarano. De Basilicae Vaticanae antiquissima et nova structura*, Vatican City 1914; R. Krautheimer, "Some Drawings of Early Christian Basilicas in Rome: St. Peter's and S. Maria Maggiore", in *Art Bulletin*, no. 31 (1949); H. Egger, "Quadriporticus Sancti Petri in Vaticano", in *P.B.S.R.*, no. 18, n.s. 5 (1950); B.M. Apollonj Ghetti, A. Ferrua, E. Josi, E. Kirschbaum, *Esplorazioni sotto la Confessione di San Pietro in Vaticano*, 2 vols., Vatican City 1951; W. Perkins, "The Shrine of St. Peter and its Twelve Spiral Columns", in *Journal of Roman Studies*, no. 42 (1952); G. Grimaldi, *Instrumenta autentica..., Cod. Barberini lat. 2733, Biblioteca Apostolica Vaticana,* edited by R. Niggl, Vatican City 1972; G. Wolff Metternich, *Die Erbauung der Peterskirche zu Rom im 16. Jahrhundert*, Vienna 1972; R. Krautheimer, *Le basiliche paleocristiane di Roma*, vol. V, Vatican City 1980; A.C. Carpiceci, *La Fabbrica di San Pietro. Venti secoli di storia e progetti*, Florence 1983; A.C. Carpiceci, "La Basilica Vaticana vista da Martin van Heemskerck", in *Bollettino d'Arte*, no. 44-45 (1987); R. Krautheimer, "The Building Inscriptions and the Dates of Construction of Old St. Peter's: A Reconsideration", in *Romisches Jahrbuch für Kunstgeschichte*, 1989. (A.C.C.)

19

Giovan Battista Ricci da Novara (1537-1627)

North-south section of Old Saint Peter's
1616
Fresco transferred onto canvas
85.5 × 90 cm
Fabbrica di San Pietro, Vatican crypts, chapel known as "della Bocciata"

This fresco executed in 1616 by Giovan Battista Ricci da Novara was transferred onto canvas in 1957. It was part of a series of paintings executed in 1615-1616 on the orders of Pope Paul V (1605-1621) in the small chapels of the Vergine delle Partorienti and the Vergine della Bocciata in the Vatican crypts; these were intended to immortalize the old basilica and its most famous works of art.
This fresco was situated in the upper left, in the lunette near the altar of the chapel known as "della Bocciata", to the right of the marble statue of Saint Peter which was placed there.
The painting depicts the part of the old basilica which was still standing after the construction of the dividing wall in 1538 on the orders of Pope Paul III (1534-1549).
The dividing wall was built with a north-south orientation next to the eleventh column from the main entrance of the old basilica, and served to separate the building work on the new basilica from what remained of the pre-existing one. This part of the basilica was only demolished towards the end of 1605 when it was decided to extend the basilica designed by Michelangelo.
The dividing wall was built by Santi del Ciabattino, Cristoforo da Uggia and Bartolomeo Simonis. The features of its decoration are also known thanks to two drawings by Grimaldi (Cod. Barberini lat. 2733), one of which represents the surviving part of Old Saint Peter's in a similar way to the fresco which adorned the "della Bocciata" chapel. In the other drawing the whole of the dividing wall is depicted, without the walls between the aisles, which are only indicated by broken lines.
In the painting by Giovan Battista Ric-

ci da Novara the altar and tabernacle of the relic of Saint Andrew's head may be noted in the south (or left) nave aisle, while in the nave the altars of Saint Boniface, All Souls, Saint Anthony, Saint Anne, Saint Wenceslaus and Saint Erasmus are visible. In the background there is the altar of the Blessed Virgin of the Pillar, the chapel of Saints Simon and Jude and the altar of Saints Philip and James the Apostle. In the north (or right) nave aisle are visible the altar and tabernacle of the Volto Santo (the Veronica), where the Holy Lance was also kept.

Literature: M. Ferrabosco, *Architettura della basilica di San Pietro in Vaticano*, Rome 1620; V. Briccolani, *Descrizione della Sacrosanta Basilica Vaticana*, 4th ed., Rome 1828; T. Alfarano, *De Basilicae Vaticanae, antiquissima et nova structura*, Rome 1914; G. Cascioli, *Guida illustrata alle Sacre Grotte Vaticane*, Rome 1925; B.M. Apollonj Ghetti, A. Ferrua, E. Josi, E. Kirschbaum, *Esplorazioni sotto la Confessione di San Pietro in Vaticano*, Vatican City 1951; C. Galassi Paluzzi, *San Pietro in Vaticano*, Rome 1965; G. Grimaldi, *Descrizione della Basilica Antica di San Pietro in Vaticano, Cod. Barberini lat. 2733, Biblioteca Apostolica Vaticana*, edited by R. Niggl, Vatican City 1972; P.L. Silvan, "I cicli pittorici delle Grotte vaticane", in *Arte Lombarda*, no. 90-91 (1989). (G.M.S.)

20
Copy of the apse mosaic in Old Saint Peter's
17th century
Oil on canvas
133 × 99 cm
Biblioteca Apostolica Vaticana, Museo Sacro

The apse mosaic in Old Saint Peter's reproduced in this painting was executed on the orders of Pope Innocent III (1198-1216).
It was divided into two registers.
In the upper one was depicted Christ enthroned between Saints Peter and Paul, flanked by two palm trees, at the foot of which extended a landscape with a river, large flowers, two circular

buildings, small lions and human figures (according to Krautheimer it is a Nilotic landscape, a theme that was very frequent in antiquity, and the tiny men might have been pygmies).
In the lower register the twelve lambs (lambs or sheep are a symbol of the twelve apostles) go out symmetrically from the two holy cities of Bethlehem and Jerusalem; between them there are palm trees (the palm is traditionally a sacred tree, the branches of which were waved and strewn on the ground by the crowd which met Christ on his entry to Jerusalem); the figure of Christ, once again in the centre, is represented in the form of a mystic lamb standing on a small hillock from which four sacred rivers gush forth and is flanked on one side by the pope and on the other by a woman personifying the Roman Church (as is indicated by the legend).
Only small fragments of the mosaic have survived, but a number of drawings and the present painting reproduce its iconography.
The painting, now kept in the library, was part of the collection of the 18th-century Roman priest and scholar Agostino Mariotti (1724-1806), but it may well have come originally from the collection of Cardinal Alessandro Orsini, who died in 1626 (the two roses painted at the bottom might be a reference to him).
Besides, we know that a drawing from the Museo Cartaceo belonging to Cassiano del Pozzo (1598-1657), which is now at Windsor Castle, is an accurate reproduction of the painting and that Cassiano and Cardinal Orsini were close friends (Ruysschaert 1968, pp. 295 ff.).
Thus, the mosaic dating from the time of Innocent's papacy, which remained in the apse of Old Saint Peter's until the end of the 16th century, when building work on the new basilica started, was reproduced in the painting which passed from the possession of Orsini to that of Mariotti and in the drawing which Cassiano had made of the painting. The value of the work is, therefore, essentially of a documentary nature.

Literature: J. Ruysschaert, "Le tableau Mariotti de la mosaïque adsidale de l'ancien St-Pierre", in *RPARA*, no.40 (1968) pp. 295-317; R. Krautheimer, *Roma. Profilo di una città*, Rome 1981, pp. 257-258. (A.R.)

21
Domenico Tasselli
View of the facade and atrium of Old Saint Peter's
c. 1611
Drawing with watercolour
47.5 × 6 cm
Biblioteca Apostolica Vaticana, Arch. cap. S. Petri A 64 ter, f

In the background the drawing depicts the mosaic facade of Old Saint Peter's, which was decorated on the orders of Gregory IV (827-844) as a replacement for the original decoration dating back to the time of Constantine. It was largely restored under Gregory IX (1237-1241), who was himself portrayed in prayer in the work. The upper part of the mosaic represented the figure of Christ enthroned, surmounted by the symbols of the Evangelists.
Together with the facade of the basilica the drawing shows the central part of the old atrium – known as *paradiso* due to the great value of the marble and the beauty of the decorations – and, in the centre of the atrium, the monumental bronze pine-cone, dating from Roman times. According to some sources, the original function of this was to close the central oculus of the dome of the Pantheon. The monumental pine-cone is now kept in the Vatican Museums, in the large niche built by Pirro Ligorio in the Cortile della Pigna.
Situated in the centre of an aedicule and supported by porphyry columns, the pine-cone was crowned by two bronze peacocks, which had previously adorned Hadrian's mausoleum (now Castel Sant'Angelo) and are also in the Vatican Museums. Thus it was a famous and spectacular fountain that was even mentioned by Dante Alighieri in the *Divine Comedy* and was used by the pilgrims for their ablutions.

The long manuscript text on the left of the sheet provides interesting information about the buildings and works of art depicted in the drawing. It was written by Giacomo Grimaldi, notary and canon of Saint Peter's, who was witness to all the changes and demolition work which affected the basilica during the pontificate of Paul V (1605-1621) and left an ample record of this in his numerous manuscripts.

Literature: G. Grimaldi, *Descrizione della Basilica Antica di San Pietro in Vaticano, Cod. Barberini lat. 2733, Biblioteca Apostolica Vaticane*, edited by R. Niggl, Vatican City 1972. (G.M.)

22
Tiberio Alfarano (d. 1596)
Engraving representing a plan of Old Saint Peter's
1589-90
50 × 77 cm
Biblioteca Apostolica Vaticana,
St. Barb. X I 31, 73

Tiberio Alfarano was born at Gerace in Calabria, but his date of birth is unknown. He took holy orders at an early age and moved to Rome.
According to Cerrati, a scholar who made a critical study of the life and writings of Alfarano, he was already at Saint Peter's in 1544, and was able, therefore, to see Old Saint Peter's while it was still standing and was subsequently witness to its progressive destruction.
In 1567 he was nominated incumbent of Saint Peter's. He died in 1596 and was buried in the old sacristy of the basilica.
The print showing the plan of Old Saint Peter's was engraved, at Tiberio Alfarano's own expense, by Natale Bonifacio da Sebenico, an engraver who was highly regarded in Rome during the pontificate of Sixtus V (1585-1590).
Besides the names of the draughtsman and the engraver, at the bottom of the plan there is the legend "Roma Anno Domini MDLXXXX" which refers to the place and date of the engraving. In fact, the plan must have been completed in 1589, since a papal bull in which

Sixtus V acknowledged Alfarano's right to all royalties from the work and prohibited its unauthorized reproduction was issued on 13 September 1589.
In the upper part is the title of the plan ("ALMAE URBIS DIVI PETRI VETERIS NOVIQUE TEMPLI DESCRIPTIO") and the coats of arms of those to whom Alfarano dedicated his work.
On one side, there is Sixtus V's coat of arms with a lion rampant, crossed by a bend and surmounted by the papal tiara and two keys crosswise; on the other side, there is that of Cardinal Evangelista Pallotta (1548-1620), Dean of Saint Peter's.
As is shown by this title, the plan describes and represents Old Saint Peter's, the original basilica built by Emperor Constantine (306-337), with all the later additions and modifications made during the Middle Ages, and the part of the new basilica that had been built by Michelangelo (1475-1564). The plan of Old Saint Peter's is emphasized in comparison with that of the new basilica, which was printed more lightly.
The print provides invaluable information regarding the position of the innumerable oratories, altars, tabernacles, tombs and monuments which, over twelve centuries, had enriched the basilica constructed over the shrine of Peter the apostle with works of art and expressions of faith.
The plan is derived from the original which was drawn by Tiberio Alfarano and was kept in the Capitular Archive of Saint Peter's from the time of his death until a few years ago. It is now in the storerooms of the Fabbrica di San Pietro. Unlike the drawing, the print of 1589-90 provides examples of the parts of the actual structure of the buildings and there are differences in the decoration and captions.

Literature: M. Cerrati, introduction and notes to *Tiberio Alfarano, "De Basilicae Vaticanae, antiquissima et nova structura"*, Rome 1914; P.L. Silvan, "Le origini della pianta di Tiberio Alfarano", in *Rendiconti della Pontificia Accademia Romana di Archeologia*, vol. LXII, (1989-90). (G.M.S.)

23
Fragment of frieze from the oratory of Pope John VII
2nd century A.D. (?)
Marble slab
217 × 33 × 4 cm
Fabbrica di San Pietro,
Vatican crypts

The slab is part of a series of monumental friezes of Roman origin; these embellished the oratory built by Pope John VII (705-707) in Old Saint Peter's that was dedicated to the Virgin in 706. The oratory was adjacent to the entrance wall of the old basilica, close to the outer north nave aisle. It was destroyed, together with all the other oratories which existed in Old Saint Peter's, to make way for the new basilica in the first decade of the 17th century.
An idea of what the oratory was like is provided by a number of drawings, among which those executed by Grimaldi before the destruction of the oratory take pride of place, and by a fresco which Giovan Battista Ricci da Novara (1537-1627) executed in 1616 in the chapel known as "della Bocciata" in the Vatican crypts.
In the upper part of the entrance wall there were the mosaics representing scenes from the life of Christ, some fragments of which are still kept in the Vatican crypts, and under these there was the altar and oratory in which John VII was buried in 707, in accordance with his wishes.
The fragments, also called "candlesticks" due to the ornamental motifs resembling candelabra that are present in the composition, may be dated to the Roman era. They were removed from their original site and reused for the decoration of John VII's oratory.
According to Cascioli they either came from a temple dedicated to Apollo or from the Frigianum, the sanctuary of the Magna Mater Deum, situated near Old Saint Peter's, and they were made during the dynasty of the Antonini, the Roman emperors of the 2nd century A.D.
The elegant decoration of the friezes, with representations that were familiar

in the pre-Christian iconography of the classical period, may be given various interpretations from a symbolic point of view.
Among leaves and scrolls of acanthus there are hunting scenes animated by satyrs, birds and various beasts, lively putti and floral and vegetal motifs, as well as figures of Greek divinities such as Apollo, represented in his innumerable guises, and Diana, and the Roman goddess Flora.
Of the refined marble friezes described here, only five slabs have survived, and two of these are in fragments; they are now situated near the exit from the Vatican crypts.

Literature: P.L. Dionysius, *Sacrarum Vaticanae Basilicae Cryptarum Monumenta, Aeneis Tabulis Incisa et Commentariis Illustrata*, 2nd ed., Rome 1828; A. Sarti, I. Settele, *Ad Philippi Laurentii Dionysii Opus Appendix*, Rome 1840; D. Dufresne, *Les Cryptes vaticanes*, Paris-Rome 1902; G. Cascioli, *Guida illustrata alle Sacre Grotte Vaticane*, Rome 1925; G. Cascioli, *Guida illustrata al Nuovo Museo di San Pietro*, Rome 1925; G.B. De Tòth, *Grotte vaticane*, Vatican City 1955; G. Grimaldi, *Instrumenta autentica..., Cod. Barberini lat. 2733, Biblioteca Apostolica Vaticana*, edited by R. Niggl, Vatican City 1972; P.L. Silvan, "I cicli pittorici delle Grotte vaticane", in *Arte Lombarda*, no. 90-91 (1989). (G.M.S.)

24
Fragments of the Bramantesque tabernacle of the Holy Lance
Late 15th century
Marble
150.5 × 109.5 cm
Fabbrica di San Pietro, storerooms

The history of the relic of the Holy Lance, the weapon with which, according to tradition, Saint Longinus stabbed Christ's side, is linked to an intricate political affair involving the Islamic court of Constantinople and that of papal Rome, as well as the Grand Master of the Order of the Knights of Saint John in Rhodes, D'Aubusson, to whom the sultan of

Turkey, Bayezid II (1481-1512), had entrusted his brother Djem.

However, D'Aubusson, intending to please the pope, sent Bayezid's brother to Rome under guard. Innocent VIII (1484-1492) received him respectfully and allowed him such freedom of movement as he would have been able to account for to the Grand Master and the sultan.

The latter, in order to ingratiate himself with the pope, did not hesitate to send him the precious relic of the Holy Lance; this had formerly been kept in the Holy Treasury of Constantinople, but since the city surrendered to the Turks in 1453, it had been hidden in a Byzantine church.

It was Bayezid himself who brought the relic from Constantinople to Rome. With his retinue he sailed to Ancona, where he was received by Benincasa de' Benincasa, the bishop of the city, to whom he handed over the relic in the presence of Nicolò Ronciardo, the archbishop of Arles, and Luca Borsiani, the bishop of Foligno and the pope's confessor, who had been invited there for the occasion. The latter undertook to accompany the Holy Lance as far as Narni, where on 22 May 1492, with a magnificent ceremony it was entrusted to the papal Legates, Cardinals Giorgio Costa and Giuliano dalla Rovere, the future Pope Julius II (1503-1513).

On reaching Rome the relic was taken to the church of Santa Maria del Popolo, from where on 31 May 1492 Innocent VIII, assisted by Cardinal Rodrigo Borgia, who later became Pope Alexander VI (1492-1503), transported it in a solemn procession to Saint Peter's.

After blessing the crowd, Innocent VIII took the relic to his apartments for safekeeping until a suitable tabernacle to house it had been built. When the pope died (25 July 1492) the Holy Lance was placed in the tabernacle where the Holy Veil of the Veronica was kept.

In accordance with the wishes of Innocent VIII, his cardinal nephew Lorenzo Cibo was responsible for the restoration of the altar dedicated to the

Virgin built by Pope Gregory III (731-741), and above it he had the tabernacle which was to contain the Holy Lance built. This altar was situated in the north nave aisle, the same one which held the tabernacle of the Veronica. As may be seen in the engraving of a plan of Old Saint Peter's made by Tiberio Alfarano in 1589-90 and in the drawing of the Codice Barberini lat. 2733, ff. 124v and 125r by Giacomo Grimaldi, it was placed against the north wall, between the tomb of Pope Paul II (1464-1471), the work of Giovanni Dalmata (c. 1440-1509) and Mino da Fiesole (1431-1484), and that of Innocent VIII, made by Antonio Pollaiuolo (1431-1498). The latter tomb was reassembled in the new basilica and may still be seen today on the south side of the second pier on the left of the nave.

The tabernacle of the Holy Lance, which according to Torrigio was completed by the end of 1495, was designed in line with a type of tabernacle which was widely used in Rome in the Renaissance for the safekeeping of famous relics. Since these were often quite precious, it was thought advisable to place them high up in a well-protected container. The fragments exhibited formed one of the four sides of one of this receptacle, to be precise the side facing south, which was the front.

Following the demolition of the tabernacle to make way for the extension of the basilica which had been built by Michelangelo, the fragments were placed in the semicircular corridor of the Vatican crypts near the passageway leading northwards to Saint Peter's shrine. There they remained until 1925, when they were taken to room C of the Museo Petriano.

Other marble fragments from the same tabernacle may still be seen in the Vatican crypts, near the tombs of Popes Paul VI (1963-1978) and John Paul I (1978), as well as in room 5 of the crypts.

As regards the attribution of the sculptures of the tabernacle of the Holy Lance, in the past the names of Bernardo di Lorenzo and Francesco di

Giorgio have been put forward by Promis and Guattani, but after a stylistic examination of the surviving fragments the present writer is of the opinion that the work is to be ascribed to various artists who must be sought among those that the papal court, as a major provider of patronage, had attracted in large numbers from all over Italy in the second half of the 15th century to work on a more or less permanent basis in Rome.

Literature: F. Torrigio, *Le Sacre Grotte Vaticane*, Rome 1639; F.L. Dionysio, *Sacrarum Vaticanae Basilicae Cryptarum Monumenta*, Rome 1828; G. Cascioli, *Guida illustrata alle Sacre Grotte Vaticane*, Rome 1925; G. Cascioli, *Guida illustrata al nuovo Museo di San Pietro*, Rome 1925; G. Grimaldi, *Descrizione della Basilica Antica di San Pietro in Vaticano, Cod. Barberini lat. 2733, Biblioteca Apostolica Vaticana*, edited by R. Niggl, Vatican City 1972; G. Zander, "Considerazioni su un tipo di ciborio in uso a Roma nel Rinascimento", in *Bollettino d'Arte*, no. 26 (1984); P. Silvan, "I cicli pittorici delle Grotte Vaticane", in *Arte Lombarda*, no. 90/91 (1989); P. Silvan, "Le reliquie maggiori. La Santa Lancia", in *La Basilica di San Pietro*, no. 4 (1992). (P.L.S.)

25

Marble coat of arms of Cardinal Richard Olivier de Longueil

1465-70
Marble slab
93 × 60.5 × 8 cm
Fabbrica di San Pietro, Vatican crypts, room 5

This marble slab bears the sculpted coat of arms of the French cardinal Richard Olivier, who was born at Touques in Normandy to the Vicomte de Longueil.

After becoming Bishop of Coutances, he was ordained as cardinal in 1456 by Pope Calixtus III (1455-1458), who entrusted him with the task of rehearing Joan of Arc's trial.

A cultured, scholarly man who was venerated by his contemporaries, in 1465 he was nominated dean of Old Saint

Peter's by Pope Paul II (1464-1471). On his death in 1470 a grand funeral was held which lasted for seven days; during this ceremony 1400 librae of wax were consumed. He was buried in the oratory of Saints Processus and Martinian, which he had himself chosen as his burial place and had adorned with marbles while he was dean of Old Saint Peter's.

In the same period he moved the venerable bronze statue of Saint Peter, which had been in the above-mentioned oratory situated at the far left of the south transept of the medieval basilica, and provided it with a new pedestal. The marble slab with his arms was part of the old pedestal and was intended to commemorate his munificence.

Today the bronze statue of Saint Peter is situated in the nave of the basilica of on the south side of the pier of Saint Longinus and stands on an 18th-century pedestal in Sicilian jasper, which was made by Carlo Marchionni in 1757, during the papacy of Pope Benedict XIV (1740-1758).

For the Holy Year of 1750 the Vatican chapter had commissioned Luigi Vanvitelli to devise a new base for the bronze statue. The architect designed a large throne in grey bardiglio marble which, however, did not meet with the approval of the Vatican authorities and was never placed in the basilica. This throne is now in the church of San Pietro in Palazzi in Leghorn.

Literature: F.M. Torrigio, *Le Sacre Grotte vaticane*, ed. V. Mascardi, Rome 1639; P.L. Dionysius, *Sacrarum Vaticanae Basilicae Cryptarum Monumenta, Aeneis Tabulis Incisa et Commentariis Illustrata*, 2nd ed., Rome 1828; V. Briccolani, *Descrizione della Sacrosanta Basilica Vaticana*, 4th ed., Rome 1828; A. Sarti, I. Settele, *Ad Philippi Laurentii Dionysii Opus Appendix*, Rome 1840; D. Dufresne, *Les Cryptes vaticanes*, Desclée-Lefebvre, Paris-Rome 1902; G. Cascioli, *Guida illustrata alle Sacre Grotte Vaticane*, Rome 1925; G. Cascioli, *Guida illustrata al Nuovo Museo di San Pietro*, Rome 1925; G.B. De Tòth, *Grotte Vat-*

icane, Vatican City 1955; C. Galassi Paluzzi, *San Pietro in Vaticano*, vol. III, *Le Sacre Grotte*, Rome 1965; G. Grimaldi, *Instrumenta autentica...*, *Cod. Barberini lat. 2733, Biblioteca Apostolica Vaticana*, edited by R. Niggl, Vatican City 1972. (G.M.S.)

26
Statuette representing Christ Enthroned
c. 1215
Embossed copper, chased, gilded and embellished with *champlevé* enamelwork
Height 41 cm, width 19.5 cm
Biblioteca Apostolica Vaticana, Museo Sacro, inv. 2430

The figure of Christ enthroned – according to the most plausible hypothesis, proposed by M.-M. Gauthier – is part of a sculptural and decorative complex from the tomb of Saint Peter in the Vatican.
Christ in a mandorla must have been in the centre, in the middle of the three registers into which the antependium was subdivided; the twelve apostles, of whom five still exist today, were placed above and below; the statuettes must have been attached to a panel which closed the niche of the Pallia above Peter's tomb.
Also according to the scholar's convincing theory, the complex additionally included a lunette now in the Palazzo Venezia museum in Rome, which came from the convent of Santa Maria in Vulturella; twelve busts in relief representing personages from the Old Testament, together with the legend still in place, had the function of announcing the coming of the Saviour.
This panel, which originally bore thirteen figures, was made for Pope Innocent III (1198-1216) to mark the Lateran Council which began in 1215. The six surviving statuettes are testimony to the original work of artists from Limoges who, under his papacy, were particularly successful and were noted for their refined workmanship.
Almost twice as high as the apostles, Christ is here represented seated on a

throne which, however, is not visible to the beholder; he wears a crown adorned with semi-precious stones and originally decorated with gold; his eyes consist of two black globes of *pâte de verre*.
The blue tunic which he wears is also decorated with gold and semi-precious stones, some of which are missing; above it there is a cloak of the same colour, but with a white border. His left hand makes the gesture of blessing and his right one holds a large book, which is still decorated with one semi-precious stone, while the other is missing.
His face, now very smooth, has probably been deprived – by wear due to its being touched by worshippers – of the original decoration. His feet rest on a base with greenish floral decoration. Together with the other five figures, it has been in the Museo Sacro in the Vatican since 1757, the year in which the museum was founded on the orders of Benedict XIV.

Literature: M.-M. Gauthier, "La Clôture émaillée de la confession de Saint Pierre au Vatican, lors du Concile de Latran IV", in *Synthronon, Recueil d'études par André Grabar*, Paris 1968, pp. 237-246; W.D. Wixom, in *The Vatican Collections...*, exhibition catalogue, New York 1983, p. 33. (A.R.)

27
Statuette representing Peter the apostle
c. 1215
Embossed copper, chased, gilded and embellished with *champlevé* enamelwork
Height 22 cm, width 6.8 cm
Biblioteca Apostolica Vaticana, Museo Sacro, inv. 2428

To the right of Christ is situated Peter, founder of the Church of Rome and Prince of the Apostles. He is represented, according to the traditional iconography, with a short beard framing his face and the famous keys in his left hand. He is wearing a long green tunic and a blue cloak, which rests on one shoulder; in his right hand he holds a book.

As with Christ and the other figures, the eyes are formed by two globes, which in this case are green.
This statuette comes from the antependium of the niche of the Pallia in the Vatican and has been in the Museo Sacro since 1757; it was made by an artist of the Limoges school working in Rome around 1215.

Literature: see cat. no. 26. (A.R.)

28
Statuette representing Paul the apostle
c. 1215
Embossed copper, chased, gilded and embellished with *champlevé* enamelwork
Height 22.2 cm, width 7.4 cm
Biblioteca Apostolica Vaticana, Museo Sacro, inv. 2429

Paul, the apostle of the nations, is also represented according to the traditional iconography, bald with a long pointed beard. He is wearing a blue tunic and cloak and holds a large book with both hands.
This statuette comes from the antependium of the niche of the Pallia in the Vatican and has been in the Museo Sacro since 1757; it was made by an artist of the Limoges school working in Rome around 1215.

Literature: see cat. no. 26. (A.R.)

29
Statuette representing an apostle
c. 1215
Embossed copper, chased, gilded and embellished with *champlevé* enamelwork
Height 22.2 cm, width 7.4 cm
Biblioteca Apostolica Vaticana, Museo Sacro, inv. 2431

In the Museo Sacro this statuette is displayed next to that of Saint Paul. The apostle represented is wearing a light blue tunic and a blue cloak; he is bearded and has a large head. In his right hand he holds a book, while with his left hand he grasps the edge of his cloak.
This statuette comes from the antependium of the niche of the Pallia in

the Vatican and has been in the Museo Sacro since 1757; it was made by an artist of the Limoges school working in Rome around 1215.

Literature: see cat. no. 26. (A.R.)

30
Statuette representing an apostle
c. 1215
Embossed copper, chased, gilded and embellished with *champlevé* enamelwork
Height 22.4 cm, width 6.5 cm
Biblioteca Apostolica Vaticana, Museo Sacro, inv. 2432

This is the apostle usually placed next to Saint Peter. He has a pointed beard and, while his right hand hidden under his cloak holds a book, his left hand rests on his breast.
The tunic he is wearing is green, while his cloak is blue. This statuette comes from the antependium of the niche of the Pallia in the Vatican and has been in the Museo Sacro since 1757; it was made by an artist of the Limoges school working in Rome around 1215.

Literature: see cat. no. 26. (A.R.)

31
Statuette representing an apostle
c. 1215
Embossed copper, chased, gilded and embellished with *champlevé* enamelwork
Height 22.5 cm, width 6.9 cm
Biblioteca Apostolica Vaticana, Museo Sacro, inv. 2433

The last statuette of the series follows the usual pattern. The apostle's face is framed by a short pointed beard; two small black beads form his eyes.
He is wearing a green tunic and a blue cloak.
With both hands he holds a large book upright against his breast. This statuette comes from the antependium of the niche of the Pallia in the Vatican and has been in the Museo Sacro since 1757; it was made by an artist of the Limoges school working in Rome around 1215.

Literature: see cat. no. 26. (A.R.)

32
Giotto di Bondone (1267?-1337)
Bust of an angel
c. 1310-13
Mosaic of polychrome enamel
84 × 90 cm
Fabbrica di San Pietro, Vatican
crypts

It is most likely that Giotto's first visit to Rome, in the closing years of the 13th century, was made at the direct behest of Pope Boniface VIII (1294-1303). For while the Tuscan master was there, he executed a fresco in the benediction loggia in the Lateran, depicting Boniface VIII officially proclaiming the first Jubilee Year of 1300. Around 1310, Giotto returned to Rome, this time to work for the man who had been entrusted with the administration of Saint Peter's basilica during the exile of the papal court to Avignon – Cardinal Jacopo Caetani Stefaneschi (1270-1341). Giotto had by now reached his full artistic maturity, and the fame of his recently completed Paduan frescoes had apparently travelled to the cardinal. Stefaneschi commissioned Giotto to do a number of works for Saint Peter's, among which was the mosaic of the *Navicella*, or "little boat", from whence presumably comes this bust of an angel.

Stefaneschi's obituary notice, entered two years after his death into the Vatican's *Liber benefactorum*, carries a list of the works he commissioned to Giotto, most of which are now lost, including this description of the *Navicella*: "...in paradyso eiusdem basilicae de opere musayco historiam, qua Christus B. Petrum Apostolum in fluctibus ambulantem dextera ne mergeretur, erexit, per manus eiusdem singularissimi pictoris [Giotto] fieri fecit: pro quo opere duo milia, et ducentos Florenos persolvit". This entry tells us, in sum, that the mosaic was originally installed in the portico called "Paradiso"; that it depicts the episode of Christ walking on the water; and that Giotto was paid the rather large sum of 2200 gold florins for his efforts. Here the mosaic remained until 1610, when Pope Paul V (1605-1621) or-

dered the demolition of the parts of the original basilica that had survived the rebuilding campaign begun the century before. Grimaldi describes the removal of the mosaic: "Supradicta igitur Navicula beati Petri anno MDCX lignis ac tabulis circumsepta dicitur recta per quendam aggerem ruinarum campanilis et adiacentium aedificiorum, ad locum, ubi postea anno XIII sanctissimi domini nostri Pauli V suo iussu et impensa ad meridiem collocata et insigniter ornata fuit, et pristinae venerationi exposita, cui peregrinorum usui subjacet fons nobilissimus".

The cult-like veneration in which the mosaic had been held by the faithful since its execution protected it, at least for a while, from the dismemberment and outright destruction that was the fate of the majority of works in the old basilica at the time of the rebuilding campaign. In fact, it was not only preserved, but restored. Around 1617-18, the council of the Fabbrica di San Pietro hired the master mosaicist Marcello Provenzali (1577-1639) to repair the *Navicella*, after which it was installed in a new location. In 1630, the same council, worried that the mosaic would not survive the next phase of the renovations, commissioned the painter Francesco Beretta to do a 1:1 scale copy on canvas, so as to preserve at least the imagery, if not the mosaic itself, should anything go wrong. The painting was done on four separate canvases of 365 × 487 cm each (about 12 × 15 feet) and was hung in the church of the Cappuccini in Rome. After a subsequent stay in room C of the Museo Petriano, it returned to Saint Peter's and now hangs by the altar of the Transfiguration.

The 17th century saw yet another removal, restoration and reinstallation of the *Navicella*, when Alexander VII (1665-1667) began construction of Gian Lorenzo Bernini's (1598-1680) redesign of the facade and the piazza of Saint Peter's. At this point, the mosaic was in a condition that was assumed to have been beyond repair. Nonetheless, Pope Clement X (1670-1676) tried one last time to revive

Giotto's venerated work. He hired the mosaicist Orazio Manetti to restore the *Navicella*, but Manetti was only able to preserve, in respect to the 14th-century original, the basic narrative and iconographic structure. The tragic tale is best told by Baldinucci: "Having thus decided to erect new Porticoes, Alexander VII had it [the mosaic] removed. The glorious work lay reduced to ruin, at the end of its life... until Clement X of holy memory had it restored – or more accurately, entirely remade – by the hand of Orazio Manetti, in order to place it according to the design of Cavaliere Lorenzo Bernini, master sculptor, painter and architect, above the central door of the interior portico where it is now seen facing the great exit door of Saint Peter's". And it is there where Manetti's version of Giotto's original can still be seen today.

The mosaic fragment depicting the bust of an angel framed by a shield was discovered by chance in 1924 on the south wall of the Partorienti chapel in the Vatican crypts. It was immediately recognized as being identical to an angel described in Torrigio's contemporary account: "One sees then the face of an Angel in mosaic, seven *braccia* in height, which had been part of the *Navicella* mosaic... commissioned by Cardinal Giacomo Stefaneschi". Art historians have also been able to connect the Vatican angel, through documents and stylistic resemblances, to another mosaic of an angel framed by a shield in the church of San Pietro Ispano at Boville Ernica, a village about 50 miles south of Rome. This latter mosaic came to Boville Ernica (formerly Baucco) as a gift from one Monsignor Giovan Battista Simoncelli, a native of the village who had been a member of the council of the Fabbrica di San Pietro at the time of the demolition of the old basilica under Paul V. But despite ample documentary and visual evidence that the two fragments once belonged to the *Navicella*, we do not have any precise indication as to exactly how they would have fit into the whole. This is because Simoncelli's donation dates to around 1610-12,

which is prior to our only reliable reproductions of the mosaic in its entirety, in which the angels therefore do not appear: the drawings of Grimaldi from 1610-18, in the Codice Barberini lat. 2733; a fresco by Giovan Battista Ricci da Novara (1537-1627) of 1616 in the Partorienti chapel; and Francesco Beretta's copy on canvas of 1630. Art historians suggest that the angels either belonged to the decorative apparatus of the inscription placed below the central image, or to an ornamental border which surrounded the mosaic. Today, the oft-displaced angel has finally come to rest on the wall over the tomb of Pope Innocent VII (1404-1406) in the Vatican crypts.

Literature: *Liber benefactorum*, Biblioteca Apostolica Vaticana, Archivio di San Pietro, H56, f. 87r; G. Grimaldi, *Cod. Barberini lat. 2733*, Biblioteca Apostolica Vaticana, ff. 146v-149r; A. Munoz, "Reliquie artistiche della vecchia basilica vaticana a Boville Ernica", in *Bollettino d'Arte*, no. 5 (1911); A. Munoz, "I restauri della Navicella di Giotto e la scoperta di un angelo in musaico nelle Grotte Vaticane", in *Bollettino d'Arte*, no. 4 (1924-25); W. Paeseler, "Giottos Navicella und ihr spätantikes Vorbild", in *Romische Jahrbuch für Kunstgeschichte*, no. 5 (1941); P. Silvan, "I cicli pittorici delle Grotte Vaticane", in *Arte Lombarda*, no. 90-91 (1989); A. Tomei, "I due angeli della Navicella di Giotto", in *Fragmenta Picta*, exhibition catalogue, Rome 1989; G. Vasari, "Vita di Giotto", from *Le Vite...*, La Spezia 1991; P. Silvan, *Il mare via del Vangelo*, exhibition catalogue, Genoa 1992. (G.M.S.)

Jubilee and Pilgrimage

33
Reliquary of the Volto Santo or Mandilion of Edessa
3rd-5th centuries; 1623 (frame)
28 × 19 cm; 65 × 45 cm (frame)
Painting on cloth; frame in cast silver, embossed and chased, partially gilt, with enamel, pearls and precious stones
Tesoro della Sagrestia Pontificia

The venerated image preserved on the cloth is, together with the *acheiropoeitos* ("made without hands") of the Sancta Sanctorum in the Palazzo Laterano, the most ancient representation of Christ's face to be found in the city of Rome. The celebrated relic is known to have been in the Eternal City since at least 1200, and its presence in the monastery of San Silvestro in Capite, where it was jealously guarded, was documented from 1587. There it remained until 1870, when with the end of the Papal States, Pius IX (1846-1878), fearing that it might be stolen, ordered that it should be kept in the Vatican.

The image takes its name from the city of Edessa (modern Urfa) in Asia Minor, where it was kept initially. According to an ancient tradition it was taken there directly from Palestine at the time of Christ.

The apocryphal legend tells that Abgar, the king of Edessa, who was seriously ill, having heard about the miracles which Christ was able to perform, sent a servant to ask him to come and cure him. As he was not able comply with this request, Christ gave the servant a handkerchief on which he had imprinted the image of his face and told him to take it to the king, who, as soon as he received it, was restored to health.

Known in Arabic as *mandil*, in Greek as *mandilion* and in Latin as *mantelium*, that is handkerchief, this cloth reproduces Christ's face with great expressiveness; it is a perfectly frontal and symmetrical representation, with a pointed beard and long hair flowing down both sides of his face.

Two other versions of the *mandilion* are known. One, which has been lost, was kept in the Sinai; the other, on a panel, is kept in Genoa in the church of San Bartolomeo degli Armeni. Coming from Constantinople and dating from the 13th century, it appears to be a copy of the one in the Vatican, which, according to C. Bertelli (1968), has incredibly ancient lineaments, so that the prototype could well be the same, and should not be dated later than the 3rd century.

Also in Rome, in the basilica of Saint Peter's, another *mandilion* is kept, which according to pious tradition bears the imprint of Christ's face with the signs of the Passion.

Reproduced in innumerable prints and engravings and venerated by the pilgrims who came to Rome to gain the special indulgences of the Holy Year, during which it was displayed for the devotion of the faithful, the facial features of this image can now no longer be clearly distinguished.

According to Pfeiffer (1984) it may be a copy of the Holy Shroud in Turin, but it was known as the *vera icona* ("true image") of the Saviour. This name then came to indicate an actual person, that is Veronica or Saint Veronica, the woman who, as the apocryphal legend has it, dried Christ's face with a cloth as he bent under the weight of the cross while climbing towards Calvary, and this miraculously preserved the representation of his face.

The precious frame which now contains the cloth was commissioned by Sister Dionora Chiarucci in 1623 (the date and coat of arms of the donor are engraved on both feet of the base) from the Roman goldsmith Francesco Comi, who perhaps drew inspiration from works by Bernini.

Literature: A. Grabar, *La Sainte Face de Laon. Le mandylion dans l'art byzantine*, Prague 1931; S. Runciman, "Some Remarks on the Image of Edessa", in *Cambridge Historical Journal*, no. 3 (1931), pp. 238 ff.; A.M. Amman, "Due immagini del c.s. Cristo di Edessa", in *Rendiconti della Pont. Accademia Romana di Archeologia*, no. 38 (1965-66), pp. 185 ff.; C. Bertelli, "Storia e vicende dell'immagine edessena", in *Paragone*, no. 217 (1968), pp. 3-33; L. Cardilli Alloisi, in *Roma 1300-1875. L'arte degli Anni Santi*, exhibition catalogue, Milan 1984; H. Pfeiffer, "L'iconografia della Veronica", in *ibidem*; H. Belting, *Bild und Kunst*, Munich 1990; C. Bertelli, in *Splendori di Bisanzio*, exhibition catalogue, edited by G. Morello, Milan 1990, pp. 122-123. (G.M.)

34

Albrecht Dürer (1471-1528)
The Volto Santo between Two Angels
1513
Engraving
10 × 14 cm
Biblioteca Apostolica Vaticana,
R.G. Stampe V 82, no. 258

The representation of the Volto Santo of Christ, also called the Veronica (which means "true image"), is linked to various iconographic traditions.

Christ's face is always present, imprinted on a cloth; it may be held by Saint Veronica (the woman who on the road to Calvary is supposed to have dried Christ's face with a cloth or veil) on her own or included in the sacred narrative; the veil may be part of a more complex story (for instance, the Mass of Gregory the Great), or, as in this case, the veil with the representation of Christ may be held aloft by angels.

This splendid engraving bears the monogram of Albrecht Dürer, the great German painter, draughtsman and engraver. The son of a goldsmith, he was born in Nuremberg in 1471; at an early age he became adept at making woodcuts and copper engravings, graphic arts he helped to spread throughout Europe.

He went to Italy for the first time in 1494-95, when he visited Venice, and then in 1505 he returned to this city, where he stayed for two years; the first artist of the German Renaissance, he was strongly influenced by Italian art. Also a writer of treatises, he died in 1528 in Nuremberg.

In the diary of his journey to the Netherlands he often referred to this engraving, calling it the *Veronica*; in this "true image" of the suffering Christ wearing a crown of thorns, the artist seems to have represented himself (cf. the famous self-portrait in Munich painted in 1500).

This should not be a cause for surprise because his awareness of his own genius and the literal interpretation of the doctrine of *Imitatio Christi* (Imitation of Christ) in the early 16th century pro-

vide complete justification for this identification with the Son of Man; on the other hand Dürer also depicted himself as the suffering Christ in other works (for example in the *Great Passion*).

The date 1513 on the engraving marked a particularly significant point in the development of his graphic skills; in fact, in 1513-14 he produced three famous masterpieces: *The Knight, Death and the Devil*, *Saint Jerome in His Study* and *Melencolia I*.

In them, as in this less famous engraving, the graphic skills of the artist may be seen to be at the service of subjects drawn and engraved with a sense of total involvement. A confidently vigorous line, expressive but clear, renders light and shade and communicates human sentiment.

Literature: *Albrecht Dürer e la grafica tedesca*, edited by A. Costamagna, Naples 1977, esp. p. 41 and fig. 55; *The Illustrated Bartsch*, New York 1981, vol. 10, pp. 70-72; H. Pfeiffer, in *Roma 1300-1875. L'arte degli Anni Santi*, exhibition catalogue, Milan 1984, pp. 106 ff. (A.R.)

35

Albrecht Dürer (1471-1528)
The Veronica between Peter and Paul
1510
Engraving
13 × 10 cm
Biblioteca Apostolica Vaticana,
R.G. Stampe V 81, no. 27

Less well known than the previous one, this splendid print represents the holy cloth with the face of Christ held by Saint Veronica and placed between Peter and Paul.

In the first twenty years of the 16th century various engravers used this iconographic model, probably with the intention of making a reference to Rome and its most famous church, Saint Peter's, where the reliquary of the Veronica was kept (the *acheiropoeitos* – "made without hands" – also included the Holy Shroud of Turin and the Holy Shroud of Besançon, lost during the French Revolution).

Around 1525 Parmigianino (1503-1540) drew a Veronica that was very similar to this one for Ugo da Carpi (c. 1480 - after 1525), who used it as the basis for an altarpiece which he painted with his hands, without using brushes; it was placed in a chapel which was situated in the second bay of the right nave aisle of Saint Peter's, where the reliquary of the Veronica was also to be found.

With the demolition of the old basilica and its reconstruction, the painting was considered unsuitable for its original position. Although Dürer's work was executed fifteen years before that of Ugo da Carpi – so it is difficult to find a real link between these two works – there is a notable similarity between them from an iconographic point of view.

Peter and Paul are represented in accordance with the usual iconographic models: Peter with a short beard and curly hair, Paul with a long beard and almost bald; the former holds long keys, the latter a sword. Saint Veronica is behind, almost in the background, holding the sudarium with the image of Christ.

After a period devoted to painting, from 1509 to 1511 Dürer resumed his activity as an engraver with the *Small Paradise* and other works of a religious nature.

In this print the soft folds of the drapery are excellently rendered, with perfect light and shade effects (note, in particular, the light of the haloes).

Literature: H. Pfeiffer, in *Roma 1300-1875. L'arte degli Anni Santi*, exhibition catalogue, Milan 1984, pp. 106 ff. (A.R.)

36
Antoine Lafrery (1512-1577)
The Seven Churches of Rome
1575
Engraving
49 × 62 cm
Biblioteca Apostolica Vaticana,
Riserva S 6, f. 115

This famous print depicts seven important churches in Rome about ten years before the papacy of Sixtus V,

who was responsible for a major renewal scheme in the city. These are the churches that pilgrims visited in order to gain the indulgences of the Holy Year.

Within the city walls may be noted: Saint Peter's, with the saint holding keys and kneeling pilgrims; the drum of the dome under construction and the old façade; Santa Maria Maggiore with the Virgin holding the Child raising his hand in benediction and pilgrims; San Giovanni in Laterano – which at that time was dedicated to John the Baptist and John the Evangelist – with pilgrims; and lastly Santa Croce in Gerusalemme.

Outside the walls are depicted, from left to right: San Lorenzo al Verano, San Sebastiano and San Paolo.

In the legend at bottom right the artist begs our forgiveness if the churches, although "drawn from life", are not situated exactly where they should be "because there is not space enough"; he also refers to the event for which "this drawing was made", that is the Holy Year decreed by Pope Gregory XIII.

The Seven Churches of Rome, devised and engraved by Lafrery, is a print which forms part of his most famous collection, the *Speculum Romanae Magnificentiae*. In this volume he gathered – probably during the last ten years of his life – a large part of his own work, together with many works by other engravers (for example Enea Vico, Beatricetto etc.), making a total of 118 prints of Roman antiquities which were much appreciated by connoisseurs. Born at Salins in France, Antoine Lafrery worked intensely in Rome where, besides his activity as an engraver, he was also a dealer and publisher of maps together with Salamanca.

Also worth mentioning is the marked didactic flavour of the careful rendering of detail in the splendid picture, for example in the pilgrims' clothes.

Literature: F. Ehrle, *Roma prima di Sisto V. La pianta di Roma Du Perac - Lafrery del 1577*, Rome 1908; C. Huelsen, *Das Speculum Romanae Magnif-*

icentiae des Antonio Lafreri, 1921, pp. 132-133. (A.R.)

37
Blessing in Saint Peter's square
c. 1575
Engraving
63.5 × 49.5 cm
Biblioteca Apostolica Vaticana,
Cicognara XII 541, f. 3

The print represents the pope – he may be Pius V (1566-1572), since his coat of arms are to be seen on the Palazzo dell'Arciprete – while he blesses the crowd in Saint Peter's square.

The part of the new basilica designed by Michelangelo is seen under construction (when Michelangelo died in 1570, Vignola took charge of the building work); in fact, the drum which served to support the dome, which was then built in 1590, had been completed.

The pope is standing on the benediction loggia, which was built in the second half of the 15th century; the square is crowded with pilgrims who have flocked there with their carts and womenfolk.

The engraving bears the printer's name, Pietro de Nobili, and was perhaps executed for the Holy Year of 1575 with a view to being sold to the pilgrims. It was certainly made after the first half of 1572 because the campanile of Saint Peter's is depicted crowned with a dome; this was built after lightning had destroyed the one with a spire.

The print was copied from an original which may have been engraved by Étienne Du Pérac and printed in 1567 by Faleri. Another later edition, poorer in quality, was executed by Claudio Duchet and Ambrogio Brambilla, during the pontificate of Sixtus V (1585-1590).

The engraving was published in Antoine Lafrery's famous collection, the *Speculum Romanae Magnificentiae* (1575).

Literature: A. Grafton, in *Rome Reborn. The Vatican Library and Renaissance Culture*, Washington 1993, p. 19. (A.R.)

38
Bernardino di Betto, called Pinturicchio (1454-1513)
Crucifixion
c. 1495
Tempera on parchment
38.5 × 28.5 cm
Biblioteca Apostolica Vaticana,
Barb. lat. 614, f. 219v

This magnificent illuminated sheet, which is to all intents and purposes a painting, represents Christ on the cross between the Virgin Mary and Saint John, set against an elaborate landscape with delicate tones of violet and green, over which a rainbow arcs, symbolizing the forthcoming Resurrection.

A true masterpiece of Renaissance art, this loose sheet was for a long time attributed to Perugino (c. 1445/50 - 1523), Raphael's famous master. The extraordinary similarity of the figure of John the Evangelist to the one in the *Crucifixion* painted by the Umbrian artist in the chapterhouse of the church of Santa Maria Maddalena de' Pazzi in Florence lends convincing support to this theory.

Later, on the basis of stylistic considerations, the sheet was ascribed to Pinturicchio, although this writer is of the opinion that the original attribution is still valid.

At some point in the past the parchment sheet was inserted in the present manuscript, a missal which was probably illuminated on the orders of Cardinal Domenico della Rovere towards the end of the 15th century. Subsequently it went to the Biblioteca Colonna and then to the Biblioteca Barberini; since 1902 it has been kept in the Biblioteca Apostolica Vaticana.

The colours have maintained their original brilliance and, generally speaking, the miniature is well preserved, although a small amount of paint has peeled off the Virgin's cloak and the tree trunk to the left of the cross.

Literature: *Raffaello e la Roma dei papi*, exhibition catalogue, edited by G. Morello, Rome 1985, pp. 39-40. (G.M.)

39
Michelangelo Buonarroti (1475-1564)
Pietà
1975
Plaster cast
Height 175 cm
Vatican Museums

The French Cardinal Jean Bilhères de Lagraulas commissioned the famous sculpture from Michelangelo in 1497. Representing Christ lying in his mother's lap immediately after the descent from the cross, it was intended for the cardinal's tomb in the Cappella di Santa Petronilla, the ancient chapel of the kings of France, next to Old Saint Peter's.

Completed two years later, this sculptural group is the artist's only signed work. On the elegant strap which crosses Mary's bosom there is the inscription "MICHELANGELVS BONAROTVS FLORENT. FECIT". According to an amusing story, young Michelangelo, who was not yet famous, was obliged to sign the work at night after he had completed it because while standing in the crowd which was admiring his masterpiece he heard that it was being attributed to other sculptors.

Condivi, who was Michelangelo's friend and first biographer, expressed the opinion that the artist deliberately depicted the Virgin as a young woman because he wanted to stress the eternal nature of her purity and chastity, which was unsullied by sin.

The sculpture of the *Pietà* did not remain in the Cappella di Santa Petronilla for long because this chapel was destroyed to make way for the massive structure of the new basilica dedicated to the Prince of the Apostles which Bramante had started to build. After being frequently moved within the basilica, on the orders of Benedict XIV (1740-1758) it was finally placed in the first chapel on the right from the entrance, where it may still be admired by visitors to Saint Peter's.

In 1972 this incomparably beautiful sculpture was damaged by a deranged visitor who struck it with a hammer, causing considerable damage to the nose and a finger of the Virgin, which were very skilfully restored by the Vatican experts; this task was facilitated thanks to the existence of a perfect copy of the statue which had been made in 1930. It was from this copy that the present cast was made in 1975.

Literature: C. de Tolnay, *The Youth of Michelangelo*, Princeton 1943, pp. 145-150; R. De Campos, "La Pietà di Michelangelo e il suo restauro", in *Bollettino dei Monumenti, Musei e Gallerie Pontificie*, no. 1 (1959-74), pp. 33-35. (G.M.)

40, 41
Biagio Biagetti and Pio Cellini
Ceremonial trowel and hammer
1924
Gold, ivory and precious stones
30 cm; 33 × 24 cm
Biblioteca Apostolica Vaticana, Museo Sacro, inv. 10293a-b

Given to Pius XI (1922-1939) by the Central Committee for the Holy Year of 1925 in the name of the bishops from all over the world who had made a financial contribution to its realization, the two precious objects were used by the pope in the ceremonies of opening and closing of the Holy Door, both in the Holy Year of 1925 and in the extraordinary one held in 1933. The present pope, John Paul II, used the hammer and trowel for the opening and closing of the Holy Door of Saint Peter's for the extraordinary Holy Year of 1983.

The first Holy Year was proclaimed by Boniface VIII (1295-1303) in 1300; the event is repeated at regular intervals, which are now every twenty-five years. On the Christmas Eve preceding the Holy Year the pope goes to the portico of Saint Peter's (while the same ceremony takes place in the other major basilicas) and, with a hammer, knocks thrice on the Holy Door in order to open it. The door, through which for a whole year pilgrims will pass so as to gain indulgences, is then closed on Christmas Eve of the following year by the pope, who uses the trowel to apply the mortar with which he begins to wall up the door; this remains closed until the following Holy Year.

Initially everyday tools were used for this ceremony, but gradually it became the custom to offer richly ornamented hammers and trowels to the pope.

The precious objects exhibited were designed by Biagio Biagetti, director of the Vatican picture galleries, who drew his inspiration from the objects of the Italian Renaissance; they were masterfully chased by the Roman goldsmith Pio Cellini.

The trowel has an ivory handle decorated with the emblem of the Central Committee for the Holy Year in gold, surrounded by olive branches, a symbol of peace. Eight precious stones are set in the gold at the end of the handle. From the tang other olive branches support the solid gold blade, which is decorated in the centre with Pius XI's coat of arms, surmounted by a tiara and two keys crosswise and surrounded by a large laurel wreath. Above there is the inscription "COLLOCAMVS LAPIDEM CVM IVCUNDITATE" and below "ANNO IVBILAEI MCMXXV".

The hammer has an ivory handle decorated with gold ornament, with the Committee's emblem between olive branches at the bottom and the papal coat of arms at the top. Lengthwise on the handle the inscription "PAX CHRISTI IN REGNO CHRISTI" is engraved, while round it is inscribed "ANNO IVBILAEI MCMXXV". A number of precious stones are set in the head, which is made of solid gold and finely chased, and in the end of the handle.

Literature: P. Perali, *Cronistoria dell'Anno Santo MCMXXV...*, Rome 1928, pp. 92-94; G. Morello, in *Roma 1300-1875. L'arte degli Anni Santi*, exhibition catalogue, Milan 1984, p. 102. (G.M.)

42
Commemorative brick for the Holy Year of 1900
Terracotta
26 × 12.8 × 4.3 cm
Biblioteca Apostolica Vaticana, Museo Sacro, inv. 10300

This is a copy of the brick used by the pope to close the Holy Door in the basilica of Saint Peter's on 24 December 1900 at the conclusion of the Holy Year.

In a rectangular frame decorated with floral motifs there is the coat of arms of Leo XIII (1878-1903), surmounted by a tiara and two keys crosswise, with two inscriptions: in the upper part "AN. IVBIL. MDCCCC", and in the lower part "LEO XIII PONT. MAX. APERVIT ET CLAVSIT". On the side the origin is indicated: "R. FERRINI - P. PAOLOTTI, EX LATERIFICIO PERVSINO".

On the back is written in ink: "Alla Biblioteca Vaticana. 19 Dicembre 1900. Ing. Rodolfo Ferrini". This inscription shows that the brick was not used to close the Holy Door in Saint Peter's, but rather that it is a copy of one of the three specially decorated bricks donated by the same person; to be precise it is the first one, the work of a sculptor from Perugia, Romano Mignini, which was used by Leo XIII for the ceremony of the walling up of the Holy Door.

The tradition of donating the bricks to be included in the wall closing the Holy Door at the conclusion of the Holy Year goes back many years, and it derives from the custom of the faithful in Rome of enclosing religious objects and devotional parchments in the wall closing the door.

In the Holy Year of 1900 this tradition was radically renovated as a result of a curious variation on the brick theme. In fact, on that occasion use was made of twenty blocks, each made with the stone of a different Italian mountain, one in each region on which statues of the Saviour had been erected in the same year.

On these blocks there was either the representation of the monument erected on the mountain, or of a particularly remarkable edifice in the vicinity. For instance the block relating to Monte Catria (in the Marches) bore a representation of the sanctuary of Loreto. When they were removed from the brickwork in the door, which was opened on Christmas Eve 1924, these artistic blocks were exhibited in the Museo Petriano, which now no longer exists.

Literature: G. Morello, in *Roma 1300-1875. L'arte degli Anni Santi*, exhibition catalogue, Milan 1984, pp. 104-105. (G.M.)

43

**Commemorative brick
for the Holy Year of 1825**
Terracotta
26.5 × 12.8 × 4.1 cm
Biblioteca Apostolica Vaticana,
Museo Sacro, inv. 10295

This is a brick with relief ornamentation. In a rectangular frame there is the emblem of the Reverenda Fabbrica di San Pietro, that is to say two keys crosswise surmounted by a tiara, and the inscription "A. IVBIL. 1825. R.F.S.P."
This type of brick was used to wall up the Holy Door, the last door on the right in the portico of the basilica, on 24 December 1825, the day on which the Holy Year concluded; this was the last one celebrated in the 19th century because of the turbulent political situation in Italy. In fact, it was not until 24 December 1899 that these bricks were removed when the wall closing the Holy Door was demolished as part of the ceremony inaugurating the next Holy Year. The letters "AV" which may be noted on the brick are the initials of Agostino Vannutelli, bookkeeper of the Fabbrica and owner of a kiln which supplied the bricks for the ceremony; this was located near the now demolished church of Santa Marta, behind the apse of Saint Peter's.

Literature: G. Morello, in *Roma 1300-1875. L'arte degli Anni Santi*, exhibition catalogue, Milan 1984, p. 104. (G.M.)

44

**Commemorative brick
for the Holy Year of 1925**
Terracotta
29 × 14.5 × 3.5 cm
Biblioteca Apostolica Vaticana,
Museo Sacro, inv. 10304

This is a red brick with relief ornamentation. In a frame there is the emblem of the Reverenda Fabbrica di San Pietro and the inscriptions "R.F.S.P."

and "A. IVBILAEI MCMXXV". On the back there is the trademark of the kiln: "Cristoforo Veschi".
This is one of the ordinary bricks used to close the Holy Door, which, after being removed at the beginning of the next Holy Year, were donated to Vatican institutions and important personages as mementos.
The ceremonial of the closing of the Holy Door prescribes that the pope must himself lay three specially ornamented, gilded and silvered bricks which have been donated by an important personage. The wall is then completed by bricklayers using the bricks made available by the Reverenda Fabbrica di San Pietro.

Literature: G. Morello, in *Roma 1300-1875. L'arte degli Anni Santi*, exhibition catalogue, Milan 1984, p. 105. (G.M.)

45

**Mould for the imprint of the bricks
used to wall up the Holy Door
in 1750**
Oak
28 × 14 × 2.7 cm
Fabbrica di San Pietro, storerooms

In the centre the wooden mould bears the inscribed coat of arms, with keys surmounted by a tiara and the initials (R.F.S.P.) of the Reverenda Fabbrica di San Pietro in the Vatican; in the upper part there is the legend "AN. IUBI", and in the lower part the date "MDCCL". The purpose of the mould was to imprint the bricks used to wall up the Holy Door in Saint Peter's at the end of the Holy Year of 1750, during the papacy of Benedict XIV (1740-1758).
It was Pope Boniface VIII (1295-1302) who proclaimed the first Holy Year in 1300, during which plenary indulgences were granted to all those who made the pious pilgrimage to the four patriarchal basilicas of Rome (San Giovanni in Laterano, Old Saint Peter's, Santa Maria Maggiore and San Paolo fuori le Mura).
It now seems certain that the first pope to open the Holy Door in the Vatican was Alexander VI (1492-1503) to mark

the Holy Year of 1500. He thus began the tradition which required the pope to preside over the magnificent ceremonies which opened the Holy Year with the demolition of the wall and conclude it with the laying of the first brick.
Many contemporary accounts relate that as soon as the Holy Doors were opened not only the bricks, but even fragments of rubble were considered by the devout to be holy relics. The great desire of the faithful to possess and cherish bricks used to wall up the Holy Doors grew to such an extent over the centuries that the number of bricks used was increased, reaching the figure of 3000 employed in Saint Peter's during the last Holy Year.

Literature: *Rome 1300-1875. L'arte degli Anni Santi*, exhibition catalogue, Milan 1984. (G.M.S.)

46

Block for woodcut
16th century (?)
Lime wood
27 × 23 × 8 cm
Fabbrica di San Pietro, storerooms

The block for woodcut represents the apostles Peter and Paul, who may be recognized by their traditional attributes (the symbolic keys for Saint Peter and the sword for Saint Paul). The figures, which are wrapped in loose tunics with prominent vertical lines, are leaning on a cippus on which the coat of arms of the Reverenda Fabbrica di San Pietro in Vaticano stands out.
Woodcut, also known as xylography from the Greek *xulon* (wood) and *graphein* (to write), is the printing procedure which uses a wood block carved with special tools (small knives, gouges and burins), so that the parts cut away correspond to the white areas of the print and the design in relief, when inked, to the black areas. The types of wood most suited to this purpose are boxwood and pear, which have always been preferred due to their special qualities.
From a block of wood sawn along the grain (side-grain) a woodcut is obtained, while from a block sawn across

the grain (end-grain) the result is a wood engraving. The technique of woodcut was practised in the Orient from the 8th century onwards, but only appeared in Europe in the 14th century and was used for printing playing cards, maps, fabrics and, in particular, religious pictures.
It was enhanced by the invention, universally attributed to the Italian Ugo da Carpi (c. 1480-1532), of a special technique for producing colour prints. Involving the use of a number of blocks which were printed "in register", with this system he was able to obtain pictorial and light effects. The woodcut technique was superseded by the introduction of wood engraving, requiring the use of the burin, which was first exploited around 1775 by the Englishman Thomas Bewick (1753-1828).
A more thorough stylistic analysis of this wood block with Saints Peter and Paul and a comparison with other Late Mannerist examples has allowed it to be dated to the end of the 16th century. Among the most plausible hypotheses for the possible use of this wood block there is that according to which it served for the decoration of the frontispiece of a book published by the Fabbrica di San Pietro or a work linked to the activity of the Fabbrica.

Literature: M. Audin, *Les étapes de la gravure sur bois*, Paris 1933; G. Vasari, *Le vite*, Florence 1942-49, vol. I, ch. XXI; L. Servolini, *La xilografia. Tecnica e storia dell'incisione in legno*, Milan 1950; C. Contini, *Ugo da Carpi e il cammino della xilografia*, Carpi-Modena 1969; *Roma 1300-1875. L'arte degli Anni Santi*, exhibition catalogue, Milan 1984. (G.M.S.)

47

Michelangelo Buonarroti (1475-1564)
Pietà
Mid-16th century
Marble bas-relief
34 × 29 cm
Biblioteca Apostolica Vaticana,
Museo Sacro

One of Michelangelo's last works, the *Pietà* made for Vittoria Colonna,

friend and muse of the great artist, was very well known at the time. This is demonstrated not only by the various engravings which were made of it by artists such as Giulio Bonasone, Nicolas Beatrizet, Giovanni Battista de' Cavalieri and even Annibale Carracci, and by painted copies – among the most notable is the painting by Marcello Venusti, now in the Galleria Borghese in Rome – but also numerous devotional objects which reproduced the composition.

Condivi, Michelangelo's friend and biographer, gives us to understand that the artist executed a sculpture for Vittoria Colonna, to be precise a *Pietà*. However, according to Vasari, it was a drawing, identified by Tolnay (1953, pp. 44-62) as the one now in the Isabella Stewart Granger Museum in Boston. A similar drawing, now lost, is believed to have been made of the bas-relief in the Vatican library (Hermann Fiore 1992, p. 406).

Despite the fact that it is unfinished, this work renders the dramatic force of the Deposition in an extremely expressive manner, taking an innovative approach to its iconography. The Virgin Mary is seated, with her arms open in the age-old gesture of prayer, while on her lap lies the inanimate body of her Son, held up by two angels; he has just been removed from the cross, which looms up behind the figures and to which the whole group seems to be firmly attached.

On the upright post of the cross, which is Y-shaped in accordance with a model which is found in various drawings by Michelangelo, it is possible to read, both in the drawing in Boston and in Bonasone's engraving, the inscription "Non vi si pensa quanto sangue costa" (We do not think of the sacrifice He has made for us). This reflects the intense religious inspiration of the Roman reformist circles, of which Vittoria Colonna was one of the leading protagonists and with which Michelangelo had a relationship of dialectical confrontation.

The bas-relief, which Michelangelo must at least have begun (Marani 1992, p. 410), as Tolnay had suggested, was

then completed, in a manner of speaking, in his workshop by an assistant. The meditation on the death of Christ, expressed in the theme of the *Pietà*, had inspired the great masterpiece of his youth and dominated the last years of the life of Michelangelo, who executed at least three sculptural groups which dealt with it. Apart from the *Pietà* of Saint Peter's and this one made for Vittoria Colonna, he also sculpted both the *Pietà Rondanini* in the Castello Sforzesco, Milan, and the *Pietà* in Florence cathedral; this last was originally intended for his tomb and, in the compassionate figure of Nicodemus, it is even possible to recognize his self-portrait. Thus, continuous reflection on the nature of the Passion of Christ and his redemptive sacrifice was a constant feature of the creative output of this profoundly Christian artist.

Literature: C. de Tolnay, "Michelangelo's *Pietà* Composition for Vittoria Colonna", in *Record of the Art Museum of Princeton University*, 1953, pp. 44-62; C. Hermann Fiore, in *The Genius of Sculptor in Michelangelo's Works*, exhibition catalogue, Montreal 1992, pp. 406-407; P.C. Marani, in *ibidem*, p. 410. (G.M.)

The Modern Basilica

48
Michelangelo Buonarroti (1475-1564)
Letter concerning the work on Saint Peter's
1550-53 (?)
Biblioteca Apostolica Vaticana, Chig. H II 22, f. 25

"To the superintendents of the Fabbrica di San Pietro

"As you know, I asked Balduccio [Iacopo Balducci] not to send his lime if it was not of excellent quality. Now, since he has sent bad quality lime, he should certainly come and take it back. It is easy to see that he had previously made an agreement with whoever accepted it; this person does great favours for those who I have already sent away from the site, telling them not to come back, and he does nothing

but befriend those who are my enemies. I am of the opinion that they are all in league.

"Promises, gratuities and gifts pervert the course of justice: thus, with the authority which the pope has bestowed on me, I implore you from now onwards not to accept anything which does not serve our purposes, even if it comes from Heaven itself, so that I should not appear – as indeed I am not – in any way partial.

"Your Michelagniolo."

Having been appointed in December 1546 by Pope Paul III (1534-1549) Head of the Fabbrica di San Pietro (this commission was made official on 1 January 1547), Michelangelo replaced Antonio da Sangallo the Younger, who had died shortly before. It was not easy for the proud but weary artist to accept this onerous task. He was well aware that the assignment was a long one and that the work of the architects who had preceded him would have to be reckoned with. In the end, because of the insistence of the pope, who was a great admirer of his, he accepted, but on one condition: he considered the appointment to have been made by God himself and, consequently, he refused the remuneration which was due, but he wanted the pope to grant him complete freedom to make all the necessary decisions.

Michelangelo did not approve of Sangallo's project and preferred to return to Bramante's design; from 1550 onwards he dedicated a large part of his time to the construction of Saint Peter's, dismissing all the workers belonging to the so-called "Sangallo sect" who behaved dishonestly or disobeyed his orders. Hence this letter is testimony to his intention to restore morality and honesty; in it, the authority and professionalism of the aged and infirm artist are still strikingly evident.

Literature: *Il carteggio di Michelangelo*, edited by P. Barocchi and R. Ristori, Florence 1979, vol. IV, p. 360; R. Della Torre, *Vita di Michelangelo. L'uomo, l'artista*, Florence 1990. (A.R.)

49
Giuliano da Sangallo
(c. 1443/1445 - 1516)
Plan of Saint Peter's
1515-16
Light brown ink, bistre and leadpoint on parchment
45 × 38.5 cm
Biblioteca Apostolica Vaticana, cod. Barb. lat. 4424, f. 56v

Giuliano da Sangallo was born in Florence c. 1445 into a family of architects and builders of fortifications; in 1456 he was already in Rome where he studied the antiquities.

He was active in various artistic fields, above all in architecture: he invented a new type of Renaissance villa and was an expert in military building. Manifesting the innovative spirit that typified the century, he also collaborated on the great building projects of the early 16th century, such as that of Saint Peter's.

After the death of Bramante in 1514, he took over the building work on Saint Peter's together with Raphael and Fra Giocondo; it was Pope Leo X (1513-1521) who invented the office of *coadiutor operis* or *administrator* for him (this involved a sort of joint management in a slightly lower position than Raphael and Fra Giocondo).

He made many drawings of the plan of Saint Peter's, but he only deemed this drawing, the last one, worthy of being included in the *Codice Barberiniano*, even though it was not made for this codex but for his work and personal study. In it the artist attempts to harmonize Raphael's variant with the pre-existing plans by Bramante; in effect, this is the version which is closest to Raphael's project published by Serlio in his *Trattato di architettura*.

Careful preparation with leadpoint and ruler and the indication of the thickness of the walls by light brown ink and bistre are the hallmarks of what Frommel has called the most mature of his projects.

This plan may be dated to 1514-15, in any case before 1 July 1515, the year in which the architect left Saint Peter's. On the right-hand side there are a

number of measurements which Sangallo noted down in his own hand.

Literature: C.L. Frommel, S. Ray, M. Tafuri, *Raffaello architetto*, Milan 1984, p. 262; F. Borsi, *Giuliano da Sangallo*, Rome 1985, pp. 439-441; G. Morello, *Raffaello e la Roma dei papi*, exhibition catalogue, Rome 1985. (A.R.)

50
Fabrizio D'Ambrosio
Portrait of Pope Julius II
1848
Oil on canvas
Diameter 136 cm
Fabbrica di San Pietro, storerooms

On 18 April 1506, at the spot where there is now the south-west pier of the dome of Saint Peter's, known as the "pier of the Veronica", the foundation stone of the present basilica was officially laid.

There to bless it was Pope Julius II, Giuliano della Rovere from Savona (1503-1513), a man of great worth, vigorous, resolute and proud, who decreed that Old Saint Peter's should be demolished, despite the fact that it was highly venerated and full of religious, artistic and historical associations.

The pope had entrusted the task of preparing the project for the new basilica to the architect from Urbino Donato Bramante (1444-1514), who was particularly well versed in the building secrets of the ancient Romans. By combining the architectural features of the Pantheon with those of the Constantinian basilica, he designed a building on a Greek-cross plan, occupying a large square site which was over 145 metres long on each side, and crowned by an immense dome, which was to have been the most impressive monument ever to be built in memory of the apostle.

Two thousand men began to work uninterruptedly on building what was intended to surpass all the other churches of the world in terms of splendour and opulence. With surprising speed, chapels, oratories, altars, tabernacles, monuments, statues, tombs, paintings and mosaics, together with the ancient building itself, were destroyed. Although the apostle's shrine and the apse were left unharmed, because they were now in the open air, they were protected until 1592 by a construction in Doric style called the *tegurio di Bramante* (Bramante's hovel).

One of Julius II's great merits was that he patronized great artists and architects, including the young artist from Urbino known as Raphael and his fellow townsman Bramante and, above all, Michelangelo, to whom he entrusted the decoration of the ceiling of the Sistine chapel and the design of his funerary monument; the famous statue of *Moses*, now in San Pietro in Vincoli, should have been part of this.

The portrait of Julius II, which also belongs to the chronological series of Roman popes made for the basilica of San Paolo fuori le Mura, was painted by Fabrizio D'Ambrosio, who also executed the portraits of Clement I (88-97) and Benedict IX (1032-1045) for the same series.

The mosaic copy was made by the master of the Studio del Mosaico Vaticano, Cesare Castellini, in the period from October 1849 to March 1851, as is indicated in the documents of the archives of the Fabbrica di San Pietro (III P., S. 29, V. 6, p. 28).

Literature: L. Tripepi, *Ritratti e biografie dei romani pontefici da san Pietro a Leone XIII*, 2 vols., Rome 1879; J.N.D. Kelly, *Grande dizionario illustrato dei papi*, Turin 1989. (P.L.S.)

51
Roberto Bompiani (1821-1908)
Portrait of Pope Paul V
1849
Oil on canvas
Diameter 136 cm
Fabbrica di San Pietro, storerooms

The patronage of the Borghese Pope Paul V (1605-1621) is still evidenced today by the presence of his coat of arms and name on many prestigious monuments. Thus, at Santa Maria Maggiore he erected the column which had been removed from the basilica of Maxentius, crowning it with a statue of the Virgin. In the same basilica, which according to tradition was founded by Pope Liberius, he had a splendid chapel built and decorated; this bears his family name and is where his tomb is situated. In the Palazzo del Quirinale he built the chapel and renovated the portal.

Furthermore, he rebuilt Trajan's aqueduct, which since that time has been known as Acqua Paola, and constructed magnificent fountains, including the *fontanone* on the Janiculum, the one by the Sisto bridge and the one designed by Carlo Maderno in Saint Peter's square. In Campo Marzio he bought a palace, which he had enlarged (Palazzo Borghese), and he encouraged his cardinal nephew (Scipione Borghese) to build for himself the present Palazzo Rospigliosi. In the Vatican he rebuilt the chapel known as the Paolina, extended and embellished the library, built fountains and had a new entrance to the Vatican palaces built.

However, the name of Paul V is linked, above all, to the major building work he carried out in the basilica of Saint Peter's. In fact, it was Paul V who, after a long and heated debate, in which opposition to the project was loudly voiced, made the decision to demolish what remained of the Old Saint Peter's. In early 1606 a start was made on the demolition, beginning with the roof, followed by the chapels, altars, papal and imperial tombs and oratories, including that of John VII; the same fate awaited the portico, the atrium and fountain with the bronze pine-cone, the benediction loggia and the campanile.

Nonetheless, it was Paul V himself who instructed the archivist of the basilica, Giacomo Grimaldi, to document everything which had been demolished, destroyed or dismantled. And again it was Paul V who gave strict orders that whatever it was possible to save of the famous monuments should be reassembled in the Vatican crypts, since they constituted an irreplaceable religious and artistic heritage, although, unfortunately, on many occasions they were wantonly destroyed or stolen. In fact, splendid fragments were scattered around Rome, all over Italy and Europe and even in America.

During the pontificate of Paul V it was Carlo Maderno (1556-1629) who completed the basilica, the plan of which had been modified to a Latin cross, with the portico and the benediction loggia above it. Moreover, he designed the following chapels: the Cappella del Coro and the Cappella del Santissimo Sacramento, the Cappella della Presentazione and the Cappella della Cattedra (now the font) on the left; the Cappella di San Sebastiano and the Cappella del Crocifisso (now Cappella della Pietà) on the right.

Thanks to the untiring efforts of over seven hundred men, in 1612 the building work was terminated, with the facade now up to the attic storey. From 1613 to 1615, the facade was finished off with the cornice, while the attic was crowned by the statues of *Christ* and the *Apostles*. Together with the relief over the central entrance, representing *Christ Handing the Keys to Saint Peter*, the mosaic inscription on the entablature was also completed, the dividing wall was demolished and Saint Peter's shrine was rebuilt according to a design by Maderno and Ferraboschi; it was covered with precious marble inlays and bronze statues and ornamentation.

With the pomp and circumstance that befitted the greatest church in Christendom, the new basilica of Saint Peter's was opened for worship on Palm Sunday of 1615.

Before his death Paul V also desired that the square in front of the basilica should be finished off, while the 15th-century door designed by Filarete was adapted for the main entrance.

The portrait of Paul V was painted for the chronological series of the popes of Rome in the basilica of San Paolo fuori le Mura by Roberto Bompiani (1821-1908), a painter and sculptor who was to become president of the Pontificia Accademia di San Luca. Besides the portrait of Paul V, Bompiani also painted the portraits of the following popes: Damasus, Simplicius, Boniface II, Pelagius, Leo IV, Marinus

II, Benedict V, John XIX and Gelasius II (Archivio della Fabbrica di San Pietro, P. III, 5, 29, p. 2, ff. 659-782). The mosaic copy was made for the Studio del Mosaico Vaticano by Pietro Bornia from May 1850 to June 1851 (AFSP, P. III, 5, 29, V. 6, p. 28).

Literature: L. Tripepi, *Ritratti e biografie dei Romani Pontefici da san Pietro a Leone XIII*, Rome 1879; G. Turcio, *La basilica di San Pietro*, Florence 1946; E. Benezit, *Dictionnaire des Peintres...*, Paris 1942-65; *Roma 1300-1875. L'arte degli Anni Santi*, Milan 1984; J.N.D. Kelly, *Grande dizionario illustrato dei papi*, Turin 1988. (P.L.S.)

52
View of Saint Peter's square and the basilica under construction
1544-45
Pen, brown and red ink on white paper
29.9 × 43.8 cm
Biblioteca Apostolica Vaticana, Disegni Ashby, no. 330

The work of an anonymous Flemish artist, this is a view from the south-east of the area of Saint Peter's, with the roofs of the houses (later demolished) in the foreground, the basilica at the time when it was being rebuilt by Antonio da Sangallo the Younger (1545), the Palazzo dell'Arciprete, the benediction loggia, the palace of Innocent VIII and the Sistine chapel higher up, next to the campanile.
This drawing must have been made, therefore, at the time of the pontificate of the Farnese Pope Paul III (1534-1549), to be precise at the beginning of 1545.
The drawing is delicately executed, with reddish-brown tones and grey shadows, which are excellently employed to render the chiaroscuro effects in preference to cross-hatching.
The following legends appear on the sheet: "diemurenvanderstadt" (top left); "Sinte pieters kercke" (in the centre); "Die Toren gaet me" (top right).
This drawing comes from a private collection in Vienna and was given to Pope Pius XI in 1933 by the Istituto

Farmacologico Serono of Rome; it was erroneously placed together with the drawings of the Thomas Ashby collection, which was purchased in the same year by the Vatican Library.

Literature: D. Bodart, *Dessins de la Collection Thomas Ashby à la Bibliothèque Vaticane*, Vatican City 1975, no. 330; C.L. Frommel, in *Raffaello in Vaticano*, exhibition catalogue, Rome 1984, p. 162. (A.R.)

53
Antonio Labacco (b. c. 1495), after Antonio da Sangallo the Younger (1483-1546)
Facade of Saint Peter's
1548
Engraving
60 × 45 cm
Biblioteca Apostolica Vaticana, St. Barb. X I 13a, f. 17

In 1520 Antonio da Sangallo the Younger succeeded Raphael, whose assistant he had been, as the head of the Vatican building work.
There is a great deal of documentation of his many projects: in fact, together with the prints of the facade, the longitudinal section and the plan, there is a precious wooden model of the basilica which took years to make and cost large sums of money.
The engraving exhibited here depicts the facade as the artist had imagined it at the time of the Farnese Pope Paul III (1534-1549), with the bell towers as high as the central body of the church and careful attention being paid to the relationship between space and volume.
Antonio, who was born in Florence in 1484, trained with his uncle Giuliano da Sangallo; it was with him that Antonio went to Rome and, like him, studied the ancient monuments. Having begun to work independently in 1507, Antonio started to make a name for himself; he became a protégé of the Farnese, for whom he designed the famous palace and directed the building work on it; in the sphere of military architecture he built fortifications, including the Leonine walls in the Vatican. In 1536 Paul III appointed him as

architect of all the pontifical works. He died in Rome in 1546.
The facade of Saint Peter's drawn by Sangallo and engraved by Antonio Labacco (as the inscription states) is a clear demonstration of the artist's architectural skills; in fact the solidity of the volumes of the building corresponds to the plasticity of the exterior with cogent logic that is evident to all. At top left there is the Farnese coat of arms.

Literature: *Antonio da Sangallo il Giovane. La vita e l'opera*, acts of the 22nd conference on history and architecture, Rome 1986. (A.R.)

54
Portrait of Sixtus V
1588-90
Oil on canvas
161 × 109 cm
Vatican Museums, Historical Collection, Palazzo Lateranense

This painting, which can be dated to 1588-90 on the basis of its contents, was probably executed by one of the many artists who worked on the great decorative cycles commissioned by Sixtus V, such as those in the Vatican Library and the Palazzo Lateranense. It portrays Sixtus V (1585-1590), seated near a window, situated top left, through which the dome of Saint Peter's is visible.
Sixtus V had been living in the Palazzo del Quirinale because of his ill health. It is said that he had been asked to appear at his window in the Palace on 21 May 1590. When he did so, he beheld with wonder the enormous dome, which was now entirely vaulted.
According to the sources, on that day the greatest architectural undertaking of the Renaissance had been completed under the direction of the Lombard Giacomo Della Porta (c. 1533-1602), assisted by Domenico Fontana (1543-1607).
The *Avvisi di Roma* (Biblioteca Apostolica Vaticana, Cod. Urbinate lat. 1058) also record how the great event was celebrated: "21 May 1590. On Monday morning in the church of Saint Peter's a solemn High Mass was

celebrated, and then the last stone was laid in the dome of this church with great jubilation and firing of cannon... and all day long there were celebrations with the roar of cannon, firework displays and illuminations... while bread was distributed in generous quantities."
Thus, it was thanks to Sixtus V, the most energetic of the popes of the Catholic Restoration, that the magnificent project – which nobody had dared to continue after Michelangelo – was completed. For four centuries this basilica, with its dome rising majestically towards the heavens, has indicated the centre of Christendom to the pilgrims who flock from every corner of the earth, and announced the presence of the shrine of Peter the apostle in the most imposing church in the world, for which it constitutes a marvellous culmination. (P.L.S.)

55
Martino Ferrabosco, or Ferraboschi (d. 1623)
Plate for etching
1620
Copper engraved with a burin
44 × 70 cm
Fabbrica di San Pietro, storerooms

The copper plate was engraved by Martino Ferrabosco, who was born at Codelago in the diocese of Milan; he was an architect and engraver who worked principally in Rome.
It was used for plate no. XX of the volume entitled: *Architettura della basilica di San Pietro in Vaticano. Opera di Bramante Lazzari, Michel'Angelo Bonarota, Carlo Maderni, e altri famosi Architetti, da Monsignore Giovanni Battista Costaguti Seniore Maggiordomo di Paolo V. Fatta esprimere, e intagliare in più tavole da Martino Ferrabosco, e posta in luce l'Anno M.DC.XX*.
In 1684 a new edition of the book was published by the printing-office of the Reverenda Camera Apostolica, edited by Msgr. Giovanni Battista Costaguti the Younger and yet another edition was published in 1812 by De Romanis, again in Rome.

The volume, which opens with an elaborate frontispiece consisting of an architectural design bearing a dedication to Pope Innocent XI (1676-1689) and his coat of arms, is only known to us in the 1684 and 1828 editions; apparently no copies of the earlier edition of 1620 have survived.

The engraving, made from this copper plate, is presented in the text as follows: "Half of it shows the exterior of the dome, and the other half the interior... with blocks of travertine covered with gilded stuccowork, with figures composed of refined mosaic enamels."

The part of the dome depicted was built during the pontificate of Sixtus V (1585-1590) in just twenty-two months of incessant work under the direction of the architect Giacomo Della Porta (1540-1602).

In 1593, during the pontificate of Clement VIII (1592-1605), the following work was completed: the construction of the lantern, the covering of the external shell of the dome with lead sheeting and its internal decoration with mosaics, which are shown in the right-hand section of the engraving.

The elegant mosaics, based on cartoons by Giuseppe Cesari, called Cavalier D'Arpino (1568-1640), were made by the most skilled mosaicists of the day, namely Turchi, Torelli, Rosetti, Abbatini and Serafini, under the direction of Marcello Provenzale, who himself executed the group of God the Father.

The decoration of the interior of the dome, in the midst of glittering stars with the predominance of gold and blue, is divided into sixteen segments which spring from the double pilasters of the drum and converge on the crowning oculus. The trapezial and round grounds contain ninety-six figures. Starting from the bottom, half-figures of popes and saints buried in the basilica are represented; above them are the large figures of *Christ*, the *Virgin*, *John the Baptist*, *Saint Paul* and the twelve *Apostles*.

Higher up still there are the angels bearing the instruments of the Passion and the heads of cherubs, followed by

angels in adoration. Lastly, a group of seraphs surround the oculus, on which Clement VIII had the following dedication inscribed: "S. PETRI GLORIAE SIXTUS PP. V A. MDXC PONTIF. V".

Literature: M. Ferrabosco, *Architettura della basilica di San Pietro in Vaticano*, Rome 1684; V. Briccolani, *Descrizione della sacrosanta basilica vaticana*, Rome 1828; G. Turcio, *La basilica di San Pietro*, Florence 1946; P. Silvan, "Il IV centenario della cupola michelangiolesca", in *La basilica di San Pietro*, 2nd year, no. 5 (1990). (P.L.S.)

56
Alessandro Specchi (1668-1729)
after Carlo Fontana (1634-1714)
Erection of the Vatican Obelisk in front of the Basilica of Saint Peter's
Engraving
38.5 × 46 cm
Fabbrica di San Pietro, storerooms

The colossal obelisk, which is situated in the centre of Saint Peter's square, was brought to Rome from Heliopolis in Egypt around A.D. 40. The huge column of red Egyptian granite, which was placed on the Vatican hill to embellish the circus of Caligula (A.D. 37-41), measures 2.90 × 2.66 m at the base and is 25.36 m high; in Rome the only obelisk higher than this is the one with hieroglyphics erected at San Giovanni in Laterano.

Until 1586 the Vatican obelisk was situated on the south side of the basilica, next to the rotunda of Santa Maria della Febbre.

It had been the dream of various popes to move it in front of the basilica, but their plans had always been thwarted by the particular difficulties which this undertaking involved. Nonetheless, Sixtus V (1585-1590), a pope who was not easily discouraged, announced a competition which was won by his architect, Domenico Fontana (1543-1607).

A number of houses next to the basilica were demolished and a large breach was made in the rotunda of Santa Maria della Febbre, which functioned as a sacristy. On 30 April 1586 the operation of removing the obelisk

from its old site began; it was lifted up and then laid on an enormous slipway, which had been specially built so that it could be dragged into the square in front of the basilica, where it could be re-erected on its plinth which, in the meantime, had been rebuilt there.

During the summer, however, the work was hindered by the excessive heat, so that the gigantic task was only completed on 10 September of the same year.

It is Domenico Fontana himself (1590, p. 33) who describes how the operation was carried out, how many men were employed and how much equipment was needed. He recounts that at dawn on that day 800 men, with the aid of 140 horses and 40 mighty winches, began to lift the obelisk up. Fontana, who directed operations from a raised platform, gave his orders by sounding trumpets and ringing bells, while silence was imposed on all those present, with severe punishment being threatened for transgressors.

The engraving, which was included in the volume *Il tempio vaticano e la sua origine*, (1694, p. 169) by Carlo Fontana, who was a grandson of Domenico Fontana, shows the disposition of men and machinery, surrounded by the buildings which at that time faced the basilica, and he convincingly portrays the atmosphere of intense activity in which the epic event took place.

The drawing is by Carlo Fontana himself; he reconstructed the scene by using drawings, documents and mementos belonging to his grandfather Domenico.

The engraving, on the other hand, was executed by the Roman architect Alessandro Specchi (1668-1729), who also made all the other engravings in the above-mentioned volume.

Literature: D. Fontana, *Della transportatione dell'obelisco vaticano*, Rome 1590; C. Fontana, *Il tempio vaticano e la sua origine*, Rome 1694; V. Briccolani, *Descrizione della sacrosanta basilica vaticana*, Rome 1828; G. Turcio, *La basilica di San Pietro*, Florence 1946; C. D'Onofrio, *Gli obelischi di Roma*, Rome 1965. (P.L.S.)

57
Luigi Vanvitelli (1700-1773)
Illustration of the illuminations of the basilica of Saint Peter's
1750
Tempera on panel
320 × 282 cm
Fabbrica di San Pietro, storerooms

The illuminations (known as the *luminaria* in Italian) were prepared for special religious events, such as the eve of the feast day of Saints Peter and Paul, the opening and conclusion of the Holy Years and beatification and canonization ceremonies, or other important occasions including the coronation of the pope, various anniversaries and visits by sovereigns. In the latter case the *girandola* (a kind of revolving firework) would often be arranged at the Castel Sant'Angelo. In their celebratory role, the illuminations and the *girandola* stressed the importance of the event, both through their arrangement and quantity, although this changed considerably in the course of time.

For the Holy Year of 1750, Vanvitelli, as his grandson – who bore the same name – mentions in his biography of the architect, renewed and extended the illuminations on the east elevation of the basilica of Saint Peter's.

The plan shown in this large illustration, which originally included both the wings and the hemicycles of the colonnade, reflected the experience Vanvitelli had acquired in the preceding years; according to the documentation in the archives of the Fabbrica di San Pietro, he had started to take an interest in the illuminations as early as 1744. This project provided for the use of 653 *padelle* (a kind of tallow lamp) and 2900 lanterns, as well as the mobilization of 251 men, including *sampietrini* (the workmen traditionally employed for the maintenance and decoration of Saint Peter's) and assistants hired specially for the occasion. The lanterns consisted of cylindrical blocks of tallow which were 20 cm in height with a paper covering; they were placed on ceramic discs about 12 cm in diameter which were shaped so that they could easily be inserted into

the metal brackets fixed on the walls of the basilica, most of which are still in place today.

The *padelle*, on the other hand, were metal vessels which closely resembled the kitchen utensil (pans) from which they took their name. They were about 30 cm in diameter and 10 cm in height and, depending on where they were to be placed, they were equipped with stands or metal handles which varied in length. The *padelle* were filled with tallow, in which a number of wicks – of a different type from those used in the lanterns – were inserted.

The lanterns and the *padelle* were prepared in a large room, known as the *monizione delle fiaccole* (lit. supply of torches), which was in the attic of the basilica. It was equipped with a large fireplace and an enormous boiler in which the tallow was melted.

The *padelle* and lanterns were placed at the prearranged points and then lit by the men assigned to the *cavallo* (lit. horse, a small wooden board measuring about 30 × 10 cm, tied to the end of a rope), who let themselves down the part of the facade or dome for which they were responsible. So rapid and well-coordinated was the operation that the lights seemed to go on almost simultaneously; thanks to the masterly way they were arranged they produced a spectacular effect based on three different types of light, corresponding to three vertical surfaces: the facade, the drum and the dome.

The number of the lamps used for the illuminations reached a maximum of 790 *padelle* and 4400 lanterns, which, naturally, required an increase in the number of men employed.

However, in the 19th century the number of lamps used was gradually reduced and the occasions for which the illuminations were organized became rarer.

The last great illuminations took place on 17 April 1938 to mark the solemn canonization of Saints Giovanni Leonardi, Andrea Bobola and Salvatore de Horta. After this there were only two partial illuminations, in 1940 on the dome and in 1948 on the facade and colonnade.

Literature: *Codice Ottoboniano Latino 3118*, Biblioteca Apostolica Vaticana; F. Cancellieri, *Sagrestia vaticana*, Rome 1784; F. Cancellieri, *Le cappelle pontificie e cardinalizie*, Rome 1786; L. Vanvitelli, *Vita dell'architetto Luigi Vanvitelli*, Naples 1823; P. Mingazzini, "L'illuminazione della cupola di San Pietro in una descrizione di 120 anni fa", in *Roma*, 1925; M. Borgatti, *Castel Sant'Angelo in Roma*, Rome 1931; G. Turcio, *La basilica di San Pietro*, Florence 1946; A. Schiavo, "Il progetto di L. Vanvitelli per Caserta e la sua Reggia", in *Bollettino del Centro di Studi per la Storia dell'Architettura*, Rome 1953; C. D'Onofrio, *Roma vista da Roma*, Rome 1967; A. Schiavo, "L'illuminazione esterna di San Pietro e Luigi Vanvitelli", in *Studi Romani*, Rome 1975; A. Schiavo, *Il "libro del portinaio"*, in the *Strenna dei Romanisti* series, Rome 1977; P. Silvan, in *Roma 1300-1875. L'arte degli Anni Santi*, Milan 1984, pp. 454-456; M. Moli Frigola, in *Roma Sancta. La città delle basiliche*, Rome 1985, pp. 165-177. (P.L.S.)

58
Natale Bonifacio, after Giovanni Guerra
Saint Peter's Square and the Consecration of the Obelisk
1587
Engraving
53 × 38.6 cm
Biblioteca Apostolica Vaticana,
St. Barb. O. VIII, 40, tav. B

It was Pope Sixtus V Peretti (1585-1590), the great rebuilder of the city of Rome, who ordered the obelisk which was on the site of the old circus of Nero, at the side of the old basilica, to be moved into Saint Peter's square. The undertaking required the mobilization a large number of workmen and was directed by the pope's own architect, Domenico Fontana; on 10 September 1586 the Romans watched the spectacle of the erection of the obelisk in total silence.

The print represents the blessing of the cross which crowned the obelisk: the ceremony is depicted in great detail with all the pomp and circumstance of the procession; in the background there is the basilica built to Michelangelo's plan.

Natale Bonifacio was the perfect interpreter of the drawings of the draughtsman and architect Giovanni Guerra. Bonifacio had worked in Venice as a cartographic engraver and, during the Holy Year of 1575 he went to Rome where he met Lafrery and Duchet (important publishers of prints); he was also the engraver of Fontana's volume *Della transportatione dell'obelisco vaticano e delle fabbriche di N.S. Papa Sisto V fatta dal Cavalier Domenico Fontana architetto di Sua Santità...*; he worked exclusively with the burin.

This is the third of three prints made by Bonifacio after Guerra which regard the moving, erection and blessing of the obelisk.

Among the many inscriptions which adorn the print, the one situated in the box to the right above the obelisk is particularly worthy of note: "FORMA NOVAE BASILICAE D. PETRI IN VATICANO QUAM OMNES SPERANT".

At the top left there is the coat of arms of Sixtus V.

Literature: G. Dillon, "Un altro disegno di Giovanni Guerra per Domenico Fontana", in *Dal disegno all'opera compiuta*, acts of the international conference, Torgiano, October-November 1987, pp. 123 ff.; F. Borroni, "Bonifacio Natale", entry in *Dizionario biografico degli italiani*, pp. 201-204. (A.R.)

59
Gian Lorenzo Bernini (1598-1680)
Bust of Pope Urban VIII
1623-33
Bronze
Height (with plinth) 100 cm
Biblioteca Apostolica Vaticana,
Museo Sacro, inv. 2427

With the election as pope of Urban VIII (1623-1644; Maffeo Barberini), Gian Lorenzo Bernini, although still very young, consolidated his position as an artist in Rome and soon became the pope's leading sculptor and architect. It is natural, therefore, that Bernini produced many of the portraits – painted or sculpted in marble or bronze – of this highly cultured pope who promoted a large part of the renovation of Saint Peter's.

The bronze version exhibited is a replica of the marble bust in the Palazzo Barberini; in fact, it comes from its library, where it was kept until 1902, the year in which it was purchased by the Vatican Library.

However, the dating of the splendid original in marble is still in debate: it varies from 1631-32, based on a portrait of the pope engraved by C. Mellan and a letter written by Guidiccioni in 1632 which gives a detailed description of it (Wittkower 1955, p. 186 and D'Onofrio 1967, p. 383), to 1636-37, because of the suffering evident in the pope's face, the result of his severe illness (Wittkower 1966, p. 185), or even 1640-42, because of stylistic similarities with another bust of the pope which is in Spoleto cathedral and the replica in Camerino, produced by a later casting, which can be dated to 1643 (Lavin 1956, p. 259). Martinelli, too, definitely favours a later date – 1641-42 (1956, pp. 37-38) – as does Fagiolo dell'Arco (1640-43).

It is probable that the sculptor used the same terracotta model (perhaps the one recorded by Fraschetti in Bernini's home), for both the marble and the bronze versions, since with sandcasting it is possible to preserve the original model; thus, the artist could have continued to draw his inspiration from it. In any case, the Vatican bronze is of high quality and, according to Martinelli, it was chased by Bernini himself.

The bust is an excellent portrayal of the sitter, both as an expressive physical representation and for its psychological insight. The great care taken over the details (the lines on the forehead, the bags under his eyes, the excellent rendering of the draperies) is accompanied by the successful depiction of the pope seen as a private individual – solemn, calm and pensive.

Although the bust is rounded at the bottom and is armless, as always in Bernini's work, there is a sense of

movement, while the bronze seems to be moulded by the light which bathes its forms.

Literature: R. Wittkower, *Gian Lorenzo Bernini. The Sculptor of the Roman Baroque*, London 1955, 2nd. ed. 1966, p. 186; I. Lavin, in *The Art Bulletin*, no. XXXVIII (1956), pp. 255-260; V. Martinelli, *I ritratti di pontefici di G.L. Bernini*, 1956, pp. 37-38; R. Wittkower, *G.L. Bernini*, London 1966, p. 185; M. and M. Fagiolo dell'Arco, *Bernini*, Rome 1967, no. 97; C. D'Onofrio, *Roma vista da Roma*, Rome 1967, p. 383; M. T. De Lotto, "Busto di Urbano VIII", in *Bernini in Vaticano*, exhibition catalogue, Rome 1981, pp. 114-115; O. Raggio, "Bust of Pope Urban VIII", in *The Vatican Collections. The Papacy and Art*, exhibition catalogue, New York 1983, p. 84. (A.R.)

60
Workshop of Gian Lorenzo Bernini
(1598-1680)
Pier of the Veronica
Pen and brown ink with grey wash on light brown paper
38.4 × 24.6 cm
Biblioteca Apostolica Vaticana,
Arch. Chigi, inv. 24917

In this drawing the pier is seen as it had been designed by Bernini and, in fact, it was attributed to him by Fraschetti in 1900. However, in the catalogue of the exhibition *Bernini in Vaticano* it is considered to be a late copy and is attributed to an anonymous artist in the circle of Bernini, at the end of the 17th century; it is thought it may be a preparatory study for an engraving.
The same technical and stylistic features are found in the drawing in the Chigi archives depicting the tomb of Alexander VII (1665-1667), which could, therefore, be the work of the same artist.

Literature: M.T. De Lotto, in *Bernini in Vaticano*, exhibition catalogue, Rome 1981, p. 105. (A.R.)

61
Workshop of Gian Lorenzo Bernini
(1598-1680)

Angel bearing a cartouche
1630-35
Pen and brown ink, grey wash and white heightening
26.5 × 40.5 cm
Biblioteca Apostolica Vaticana,
Arch. Chigi, inv. 24915

The rearrangement of the crossing of Saint Peter's, under the huge dome, was ordered by Urban VIII (1623-1644) as early as 1624, with the intention of housing the relics kept in the niches of the piers in a more fitting manner. In fact, construction work did not start until 1628; in each of the four piers there was to be (from bottom to top): a niche containing a large statue, an ornamented balcony for the exhibition of the relics with an aedicule including two of the eight twisted columns from the ciborium in the old basilica, flanked by reliefs representing putti and angels holding the attributes of Saints Longinus, Helena, Andrew and Veronica and, above, small angels in flight bearing cartouches.
The handsome angel bearing the cartouche with the inscription "IN HOC SIGNO VINCE" was drawn to complete the decoration of the pier of Saint Helena carrying the cross and comes from the Palazzo Chigi at Ariccia. In fact, the sculptures were not executed exactly as shown in this drawing because the cartouche is given more importance and it is borne by putti.
The drawing can probably be dated to 1630-35, because the decoration work started in 1636 and was assigned to one of Bernini's assistants, Stefano Speranza, who then made the sculptures on the pier, or to another assistant from Bernini's studio.
In any case, the vigorous outlines of the angel, the taste for the picturesque, the volumes perfectly rendered with the aid of chiaroscuro and the totally Baroque grace of the figures of the putti make it a valuable work.

Literature: H. Brauer, R. Wittkower, *Die Zeichnungen des Gianlorenzo Bernini*, Berlin 1931, p. 23 and note 3; M.T. De Lotto, in *Bernini in Vaticano*, exhibition catalogue, Rome 1981, p. 105. (A.R.)

62
Giovanni Federico Greuter
(c. 1590-1662)
The Baldacchino of Saint Peter's
c. 1633
Copper engraving, burin
77.5 × 54.5 cm
Biblioteca Apostolica Vaticana,
St. Barb. X I 31, f. 4

When Maffeo Barberini became pope with the name of Urban VIII (1623-1644) he commissioned his young friend Bernini to design the baldacchino for the basilica of Saint Peter's.
The creation of this work took until 1633, the year in which the object-cum-monument was unveiled, while the execution of some of the minor details continued until 1635.
It was the first time that a mobile object, a canopy for the religious festivals, became a fixed structure. The traditional halting-place for the procession, the apparent centre of the basilica, was thus embellished with what is still today considered to be one of the splendours of Saint Peter's.
It was the inventive genius of the great artist combined with the spectacular nature of the Baroque style which produced this result, which would not, however, have been possible without the enthusiastic patronage of a pope who was fascinated by the use of emphatic forms.
This excellent engraving made by Greuter after a drawing by Stefano Speranza (one of Bernini's assistants) bears witness to the importance and the innovatory power of Bernini's masterpiece.
At the bottom there is the inscription "Molis aeneae quam fusili artificio URBANUS VIII.PONT.MAX. super Sanctorum Apostolorum Petri et Pauli tumulum excitavit, ornavitque. Ioannes Laurentius Berninus Eques, qui in Templo Vaticano opus perfecit, hic delinationem expressit". In the bottom margin, on the left, is inscribed "Scala palmor Rom. 80" and, on the right, "IO Federic.o Greuter incid.".

Literature: M.T. De Lotto, in *Bernini in Vaticano*, exhibition catalogue, Rome 1981, p. 102. (A.R.)

63
Circle of Gian Lorenzo Bernini
(1598-1680)
Portrait of Gian Lorenzo Bernini
c. 1640
Charcoal, sanguine and white heightening on white paper
21 × 14.5 cm
Biblioteca Apostolica Vaticana,
Arch. Chigi, inv. 24905

Attributed as early as 1900 to the circle of Bernini (Fraschetti, then Martinelli 1950, and Fagiolo dell'Arco 1967), this splendid portrait depicts the artist with the knight's cross which he was abe seen in the period 1620-22, as may seen from the engraving made by Ottavio Leoni (1578-1630) in 1622. In reality, the present portrait must have been executed later than this, not only because the sitter appears to be considerably older, but also because there is a great similarity to the famous self-portrait in the Uffizi, which can be dated to 1640.
This self-portrait, which is similar to the present drawing due to the pose of the sitter, is also comparable as regards the facial features, especially the expressiveness of the eyes and mouth. From a technical point of view the work may be compared to the drawings of *A Man Seen in Profile* and *Boy* in the same collection from the Palazzo Chigi at Ariccia and considered to be by Bernini himself.
While it is difficult to challenge the opinion of the reputable scholars of Bernini's drawing who have unanimously ascribed this work to a member of his circle, it must, however, be pointed out that both the lively approach and the light, rapid technique are extremely similar to those of Bernini. Thus, the drawing may have been by a talented pupil who was influenced to a considerable extent by his master's works, or by a portrait which was sketched by Bernini himself and then finished off by the pupil.
In view of what is stated above this writer believes that the work should be dated around 1640.

Literature: V. Martinelli, in *Commentari*, I, 1950, p. 181; M. and M. Fagiolo

dell'Arco, *Bernini*, Rome 1967, no. 250; L. Russo, in *Bernini in Vaticano*, exhibition catalogue, Rome 1981, p. 40. (A.R.)

64
Melchiorre Caffà (?) (1635-c. 1667)
Bust of Alexander VII
1660s - before 1667
Marble
Height 105 cm
Biblioteca Apostolica Vaticana,
Museo Sacro

Alexander VII, a member of the powerful Chigi family of Siena, was pope from 1655 to 1667. One of the great papal builders of the Baroque period, he was responsible for enlarging Saint Peter's square to its present dimensions, as well as other monumental works such as the construction of the Biblioteca Alessandrina. Here he is portrayed in a marble bust, in the manner of Bernini, lacking the arms, but with a lively expression and conveying a sense of movement.
This bust is certainly connected with the same portrait in bronze by Melchiorre Caffà in Siena cathedral (Wittkower 1955, Martinelli 1956). There is a bronze replica of the latter now in the Metropolitan Museum in New York; it is signed by Caffà and bears the date 1667.
The terracotta model by Caffà, from which the two above-mentioned copies are derived, is in the Palazzo Chigi at Ariccia: it is very likely this was also the source of inspiration for the artist who made this marble replica, which comes from the Palazzo Chigi in Rome and is still considered the work of an unknown sculptor who was a follower of Bernini and less talented than Caffà, even if it had previously been attributed to Bernini himself.
Melchiorre Caffà, at that time an unknown Maltese sculptor, may have been brought to Rome by Alexander VII, who had been a bishop in Malta. However, having moved to Rome and trained in the workshop of Ercole Ferrata (1610-1686), his artistic development was extremely precocious. His manner was similar to that of Baciccia

(Giovan Battista Gaulli, 1639-1709) and especially of Bernini, interpreted, however, in a pictorial manner; the work he produced in his brief career was characterized by its great coherence and masterly use of expressive effects.
Here the pope's face is strikingly portrayed, while a pictorial effect is imparted to the marble by the light which glides over and softens it. Note the presence of three mountains on the mozzetta (a short hooded cape closed by buttons which was worn by the pope and other prelates); this was the emblem of the Chigi family.
In the absence of documents or evidence from contemporary sources, the bronze exhibited here cannot be attributed to Caffà with any great certainty, despite the fact that it resembles the two splendid bronzes mentioned above. Nonetheless, the similarity to the terracotta model and the different finish of the marble bust compared to the bronze one, the coincidence of the dates (both Alexander VII and Caffà died in 1667), together with the provenance from one of the Chigi palaces – and it is well known that Alexander VII took an active interest in the works of art with which he delighted in surrounding himself – could all certainly give a new lease on life to the debate which has perhaps been brought overhastily to a conclusion.

Literature: R. Wittkower, *Gian Lorenzo Bernini. The Sculptor of the Roman Baroque*, London 1955, pp. 242-243; V. Martinelli, *I ritratti di pontefici di Gian Lorenzo Bernini*, Rome 1956, pp. 45-48; R. Wittkower, "M. Caffà's bust of Alexander VII", in *Metropolitan Museum of Art Bulletin*, no. 17 (1958-59), pp. 197-204; M.T. De Lotto, in *Bernini in Vaticano*, exhibition catalogue, Rome 1981, p. 146. (A.R.)

65
Gian Lorenzo Bernini (1598-1680)
Case for the cathedra of Saint Peter
1636
Gilt and painted wood
260 × 130 × 105 cm
Fabbrica di San Pietro, storerooms

The cathedra of Saint Peter, from which, according to tradition, the Prince of the Apostles preached, is a very ancient wooden seat made of acacia and oak and embellished with plaquettes of carved ivory.
In ancient times this venerable relic was kept, together with the bronze statue of *Saint Peter*, in the monastery of San Martino, which was located at the point at which there is now the pier of the Veronica, the south-western pier of the four which support the huge dome of Saint Peter's.
The cathedra, which is the historical title and material symbol of papal authority, was moved on various occasions. After the completion of the new basilica of Saint Peter's, the cathedra was put in the singular throne-shaped case in wood which was gilded and painted to simulate bronze; this was then placed in the chapel now used as a baptistery for the devotion of the faithful, as may be seen in the drawing by Domenico Castelli in the Biblioteca Apostolica Vaticana (cod. Bar. lat. 4409, f. 18) which has been the subject of studies by Battaglia (1943) and Lavin (1980). And there it remained, as is recorded in the inscription on the internal panel of the back, until 1666, the year the cathedra was placed in the imposing structure designed by Bernini in the apse of the basilica of Saint Peter's.
According to Worsdale, who gets his information from Pollak, the case was executed by Jacomo Balsinelli and Lorenzo Fiori, who were said to have received 43 *scudi* in payment, but the documents in the archives of the Fabbrica di San Pietro clearly indicate that the task was entrusted to Giovanni Battista Soria (AFSP, Conti diversi di artisti dall'anno 1633 al 1639, ff. 890v-891).
After being left abandoned for some years, the case was reused in 1705, when Pope Clement XI (1700-1721) ordered a copy of the real cathedra to be made and exhibited to the faithful. On the doors of the upper part of the case are relief representations of winged beings, their arms folded on their chests and the lower half of their

bodies transformed into scrolls of foliage; they resemble the so-called harpies on the canopy of Bernini's baldacchino over the tomb of Saint Peter.
The doors in the lower part are adorned with heads in open shells surrounded by vegetal arabesques, which are frequently found in Bernini's decorative works. The cherub in the lunette crowning the back echoes the cherubs on the bronze hangings of the baldacchino. The garlands under the symbolic bees, based on the emblem of the Barberini, consist of representations of laurel and oak leaves on the sides and olive leaves on the front. Internally the doors are painted in chiaroscuro with floral designs echoing the Berninesque motifs of the damasks for Saint Peter's and the Barberini hangings of Santa Bibiana.

Literature: G. Baglione, *Le nuove chiese di Roma*, Rome 1639; S. Fraschetti, *Il Bernini, la sua vita, la sua opera, il suo tempo*, Milan 1900; O. Pollak, *Die Kunsttatigkeit unter Urban VIII*, Vienna 1928-31; R. Battaglia, *La cattedra berniniana di San Pietro*, Rome 1943; M. and M. Fagiolo dell'Arco, *Bernini. Un'introduzione al gran teatro del barocco*, Rome 1967; M. Maccarone, "La storia della cattedra", in *Atti della Pontificia Accademia Romana di Archeologia, Memorie*, vol. X, 1971; *Bernini in Vaticano*, exhibition catalogue, Rome 1981; *Vatican Collections*, Brisbane 1988. (P.L.S.)

66
Copy of the cathedra of Saint Peter
1705
Oak
140 × 85 × 65 cm
Fabbrica di San Pietro, storerooms

According to a legend going back to the early days of Christianity, the cathedra of Saint Peter was an ancient seat made of oak and acacia wood, decorated with finely carved ivory plaquettes.
A copy of it, in oak, was made in 1705 on the orders of Pope Clement XI (1700-1721) as a reproduction of the original cathedra, which dates back to

the 9th century and had not been visible to the faithful since 1666 because up to then it had been incorporated in Bernini's monumental structure. The cathedra, traditionally, is the historical title and material symbol of the authority of the Apostolic See and, as a relic, has always been venerated by the devout. Still today, on 22 February, the Day of the Cathedra of Saint Peter, the festival is celebrated in the apse of Saint Peter's, where the altar and the magnificent monument are illuminated with seventy-two large candles; the monument was made by Bernini in the period from 1658 to 1666 with the assistance of his brother Luigi, Ercole Ferrata and Pietro del Duca.

The eighteen decorated tiles, attached to the lower part of the copy of the cathedra are recent reproductions (made in 1974) of the original carved ivory plaquettes. They represent the Labours of Hercules and a number of constellations; they have a purely decorative role and are not intended to suggest a link between the cathedra and either mythology or astrology. These plaquettes and the decorative openwork friezes were added in 1987 in order to make the reproduction of the cathedra as similar as possible to the original.

Literature: G. Cascioli, *Guida illustrata al nuovo museo di San Pietro*, Rome 1925; G. Turcio, *La basilica di San Pietro*, Florence 1946; M. Maccarrone et al., "La storia della cattedra", in *Atti della Pontificia Accademia Romana di Archeologia, Memorie*, vol. X, 1971; *Vatican Collections*, Brisbane 1988. (P.L.S.)

67
Gian Lorenzo Bernini (1598-1680)
Drawings for the cathedra of Saint Peter
1656-57
Black leadpoint
26 × 20 cm each
Biblioteca Apostolica Vaticana, Chig. a I 19, ff. 42v-43r

These two leadpoint drawings are part of a group of five revealing Bernini's first ideas on the construction of the

spectacular device he created to preserve the cathedra of Saint Peter, placed in the apse of Saint Peter's. Even though hastily traced out by the hand of the artist, all the same they give a good rendering of the idea and its subsequent realization.

First news of the decision regarding the definitive placing of the cathedra is in a passage of the Diary of Alexander VII (1655- 1667). On the day of 21st January 1657 the pontiff noted: "Sunday, ordered Cav. Bernini to start work on the Saint Peter's cathedra, and he says he will not be able to complete it in less than two years" (Morello 1981, p. 323).

The left-hand drawing shows the cathedra framed by the tortile columns that hold up the heavy baldachin, created by Bernini in 1624-33. The drawing on the right shows the cathedra in position above the altar of the apse, with details of the marble base for holding the statue of a Doctor of the Church.

The two sheets that contain the drawings are bound together with other sheets of drawings, mostly in leadpoint, collected by Alexander to form the current volume.

Here too these are quick sketches and thumbnail drawings, mainly architectural studies. They are valuable records, as they are nearly always in the hand of Bernini and occasionally by the pope himself. Alexander VII in fact was very interested in art and architecture.

During the long conversations and true and proper work sessions with Bernini, punctually registered in his diary, he at times intervened personally in planning of the work, also leaving some drawings to posterity (Morello 1992, pp. 205-206).

Literature: H. Brauer, R. Wittkower, *Die Zeichnungen des Gianlorenzo Bernini*, I-II, Berlin 1931; G. Morello, "Bernini e i lavori a San Pietro nel 'diario' di Alessandro VII", in *Bernini in Vaticano*, exhibition catalogue, Rome 1981, pp. 321-340; G. Morello, "I rapporti tra Alessandro VII e Gian Lorenzo Bernini negli autografi del papa"

(with inedited drawings), in *Documentary Culture. Florence and Rome from Grand-Duke Ferdinand I to Pope Alexander VII...*, edited by E. Cropper, G. Perini and F. Solinas, Bologna 1992, pp. 186-207. (G.M.)

68
Giacinto Gimignani (1611-1681) and Lazzaro Morelli
Cathedra of Saint Peter
1666
Pen, traces of leadpoint, ink, sepia wash, signed in white lead on beige paper
88.3 × 55.5 cm
Biblioteca Apostolica Vaticana, Arch. Chigi, inv. 24924

Bernini's first project for the cathedra of Saint Peter harks back to 1657 (under Urban VIII); its official presentation or rather its "unveiling" dates to 1666 (under Alexander VII).

Proud of his successful and much admired feat, in agreement with Alexander VII Bernini wanted to have an engraving made by Spierre, to a drawing by Giacinto Gimignani with the architecture details by Lazzaro Morelli (for Bernini's relations with Alexander VII see Morello 1990, pp. 185 ff.).

While Morelli the sculptor played an important role among those working with Bernini, the Pistoian painter Gimignani was chosen for his classic-Cortonesque taste, which pleased Gian Lorenzo, and perhaps also for his Tuscan origins, appreciated by the Sienese pope. This drawing is hence confirmed as an important stage in the task of divulging the cathedra. Its value is enhanced by the fact that it was presented as a gift by Bernini to the pope himself; it then remained in the Chigi archives where it was identified by Martinelli.

In an important article of 1983, Martinelli returns to the drawing, underlining the ability of the artist in rendering the "weighty multiple variety of form" in the sculpture and in the architecture, as well as the drawing's importance as a document in registering the changes the work underwent (for example the glazed oval of the gloria,

the new gilding of the gold parts). In actual fact the use of different drawing techniques by the two artists, the one specialized in architectural background and the other in the drawing of sculpture and decorative parts, makes the work under examination particulary effective in rendering the idea of the richness of the cathedra, desiring as it were to render glory to God and to amaze the faithful, filling them up with spiritual light.

Literature: L. Falaschi, in *Bernini in Vaticano*, exhibition catalogue, Rome 1981, p. 135; V. Martinelli, "Il disegno della cattedra...", in *Prospettiva*, nos. 33-36 (1983-84), pp. 219-225; G. Morello, in *Documentary Culture Florence...*, Bologna 1990. (A.R.)

69
Gian Lorenzo Bernini (1598-1680)
Charity, with four putti
c. 1627-28
Height 39 cm
Terracotta with traces of gilding
Biblioteca Apostolica Vaticana, Museo Sacro, inv. 2423

The statuette, which represents a young woman with bared breast intent on giving milk to her baby while three other little ones cling to her, represents Charity, and is a preparatory study for the statue of the same name sculpted by Bernini for the sepulchral monument of Urban VIII (1628-1647) in Saint Peter's.

Work on this imposing monument, destined to house the tomb of the pope and situated beside the altar of the cathedra, lasted roughly twenty years, that is for the entire duration of the Barberini pontificate.

The work, which dates back to the first studies for the monument, presents a version slightly different to the finished sculpture. In actual fact in the definitive version the statue of *Charity*, companion to *Justice*, placed on either side of the sarcophagus that carries the huge statue of the pontiff, acquires even greater impetus and airiness, the two putti embracing each other having been lost.

Along with other works, the statuette

in question was initially part of the artistic collection of Cardinal Flavio Chigi (Raggio 1983, p. 85), then preserved in Palazzo Chigi. It subsequently passed on to the museums of the Vatican Library in 1923, when the famous library at Casa Chigi, purchased by the Italian state, was donated to Pius XI (1922-1939) as a gesture of goodwill to start off the negotiations that led to the signing of the Lateran treaty.

Considered unanimously by experts as being in Bernini's hand, the statuette appears to have been carried out straight off, by hand, without reworking and with little buffing, as different fingerprints on the clay are visible.

The terracotta was restored in the Vatican workshops in the years 1980-81, where a thick layer of black varnish was removed which had been added on various occasions during the last century, perhaps to allow the statuette to take on the appearance of fake bronze.

Traces of another earlier patina of fake gilding were found beneath the black varnish, best conserved along the edges of the drapery.

Literature: *Bernini in Vaticano*, exhibition catalogue, Rome 1981, pp. 108-109; O. Raggio, in *The Vatican Collections. The Papacy and Art*, New York 1983, p. 85. (G.M.)

70
Francesco Borromini (1589-1667)
Project for housing the Navicella by Giotto
c. 1628
Pen and light brown ink
40 × 30 cm
Biblioteca Apostolica Vaticana,
Vat. lat. 11257, f. 3

The drawing presents a project for housing the famous mosaic, attributed to Giotto, known as the *Navicella*, due to the evangelic theme represented: Jesus walks on the waters of the lake and invites Peter to approach him without fear of drowning. It symbolizes the divine assistance Jesus ensured the Church.

The mosaic, commissioned by Cardinal Jacopo Stefaneschi, nephew of Bo-

niface VIII (1295-1303), was originally situated on the eastern wall in the interior of the four-sided portico before the basilica, and was subsequently moved to different locations. After total renovation, it is currently situated above the central gate inside the atrium of Saint Peter's.

Only a few fragments from the original work of the great painter remain, among which the angels, one preserved in the Vatican Crypts, the other in the church of Boville Ernica, close to Rome.

The exhibited drawing was carried out by Borromini in Maderno's workshop, who was entrusted with the work on the facade and the completion of the basilica, and proposed the idea of placing the mosaic on the inside facade of the entrance. The idea of placing two statues – these certainly representing Saint Peter and Saint Paul – on both sides of the central door was also an interesting one.

Some additions were made afterwards in a darker ink and sanguine (?), referring to works supervised between 1646 and 1649 by Virgilio Spada, who was a great friend and patron of Borromini.

Francesco Castelli, who changed his surname to Borromini at the age of 28 to distinguish himself from the numerous architects and builders of his family active in Rome, was a famous architect, and a contemporary and adversary of Bernini, who often surpassed him in fame and celebrity.

Literature: *Francesco Borromini. Disegni e documenti vaticani*, exhibition catalogue, Vatican City 1967. (G.M.)

71
Martino Ferrabosco (d. 1623)
View of the facade of Saint Peter's by Carlo Maderno
c. 1620, published 1684
Engraving
50 × 77 cm
Biblioteca Apostolica Vaticana,
Cicognara X 3690, pl. XII

In 1607 the architect Carlo Maderno, having come from Canton of Ticino in the wake of the well-known architect

Domenico Fontana, won the competition for the project for the completion of the Vatican basilica; work was finished in 1612.

Following the intentions of the clergy and the pope who demanded a longitudinal development of the church, in that they wanted to pay homage to the early Christian tradition, Carlo Maderno transformed the Greek cross of Michelangelo's design into a Latin cross.

The monumental facade with the colossal Corinthian order of columns that can be seen in this engraving had to in some way contain and balance the monumental nature of the dome and Michelangelo's centric layout. The bell towers, for which Maderno prepared the bases, are also represented in the engraving, but were actually never completed.

The view from above chosen by Ferrabosco shows the basilica set between the Vatican buildings and in a wider natural perspective, perfectly rendered by the quality of the mark which becomes thinner in the far distance.

The coat of arms of Paolo V (1605-1621) and of Cardinal Scipione Borghese complete the beautiful plate.

Literature: H. Hibbard, *Carlo Maderno*, London 1971, pp. 65 ff. (A.R.)

72
Gian Lorenzo Bernini
(1598-1680)
Project for Saint Peter's bell towers
1645
Pen, brown ink and grey watercolour
50 × 39 cm
Biblioteca Apostolica Vaticana,
Vat. lat. 13442, f. 3

Retained to be in the hand of Bernini already by Brauer and Wittkower (1931, pp. 42-43, pl. 157), the drawing represents the facade of the Vatican basilica according to the project by Maderno, but shows the two bell towers resting on the ground level. The definitive project drawn up by Carlo Maderno for the facade of Saint Peter's in fact includes the erection of two bell towers at either side of the facade, starting though from the level of

the attic, from where the drum of the dome also begins.

Bernini was entrusted to carry out the project, work beginning in 1637. The first bell tower was completed in 1641, but when cracks appeared in the structure because the foundations could not take the weight, part of it had to be knocked down. Bernini, bitterly criticized for having underrated the danger and having thus jeopardized the entire basilica, fell seriously ill out of grief, fearing that he might have forever lost the pope's confidence.

In 1645 Innocenzo X Pamphili (1644-1655), who succeeded Urban VIII Barberini, instituted a special Congregation of cardinals to once again face the problem of the construction of the bell tower. The Congregation consulted the major architects working at the time in Rome, who presented various projects, mostly today conserved in the current codex of the Vatican library.

Bernini was once again entrusted with the work. As well as the project shown here, with the bell towers rising from the very plan of the basilica and isolated from the facade, he had presented another project with bell towers of a lighter and more elegant structure. All the same, despite their being shown in different engravings and views of Saint Peter's, the bell towers were never built. Rather, in 1646 the still existing parts of the initial Bernini bell towers were definitively taken down.

Literature: H. Brauer, R. Wittkower, *Die Zeichnungen des Gianlorenzo Bernini*, I-II, Berlin 1931; F. Borsi, *Bernini architetto*, Milan 1980. (G. M.)

73
Facade of Saint Peter's
c. 1645
Pen and brown ink wash
111 × 123 cm
Biblioteca Apostolica Vaticana,
Vat. lat. 12442, f. 17

This large format drawing, obtained by placing different sheets together, presents a project for the restoration of the facade of the Vatican basilica

that is partially different from the one designed by Carlo Maderno.

Probably realized on the occasion of the second competition for the construction of the bell tower, as the Pamphili coat of arms on the same bear witness to, it is not attributable to Gian Lorenzo Bernini, nor possibly to his workshop. (G.M.)

74
Guasparri di Bartolomeo Papini, from a cartoon by Alessandro Allori (1535-1607)
Antependium of Clement VIII
1593-97
Tapestry in silk and gilt silver
102 × 371 cm
Biblioteca Apostolica Vaticana, Museo Sacro, inv. 2780

This altar antependium is part of a set of precious liturgical hangings created at the behest of the Gran Duke of Tuscany Ferdinando de' Medici, and presented in 1602 to Pope Clement VIII (1592-1605).

In actual fact, the idea for the creation of the set came from Gregory XIII (1572-1585) who in 1577 expressed to Cardinal Ferdinando his desire for a series of seven tapestries to be placed in the Sistine chapel at Advent and Lent, judging the existing tapestries by Raphael as unsuitable in that they were too gay and joyful.

On becoming grand duke after the death of his brother Francesco, Ferdinando took up the idea, modifying it in part.

This essentially is how the complete set of hangings with their complex iconography, covering the theme of redemption by way of the passion and resurrection of Christ, came to be created: they include a planet, an antependium, a cope, two dalmatics, a bust for the corporal, a veil for the chalice, two missal linings, a stole, a maniple and a rational.

After discussing the iconographic programme with don Giovanni de' Medici, Alessandro Allori was entrusted with drawing up the preparatory cartoons; the task of creating the tapestries fell to Guasparri di Bartolomeo

Papini, head tapestry maker of the Medici. According to Mancinelli (1983, p. 73) the beautiful frontal (a mobile altar facing or its fixed front) was created between 1593 and 1597 and was used up to the last century for the altar of the Sistine chapel. It was primarily used for the Holy Week even if records of other uses outside this liturgical occasion exist; it was recently restored (the antependium in 1957 and the rest in 1978-81).

Alessandro Allori, a friend and student of Bronzino (1502-1573), with this splendid fabric has left us an exquisite, elegant design reminiscent of the work of his former master.

The body of the dead Christ is held up by two angels; a basin with the crown of thorns and the nails of martyrdom is shown in the foreground, while behind we see the altar with the chalice. Two more scenes are represented to the left and to the right, the first depicting the descent of the dead Christ to limbo, the second celebrating Christ's appearance to Mary.

This is what could be described as a typical Easter iconography that confirms the use of the antependium on the occasion of Holy Thursday.

Literature: F. Mancinelli, in *The Vatican Collections*, exhibition catalogue, New York 1983, pp. 72-74; L. Cardilli Alloisi, *L'arte degli Anni Santi*, exhibition catalogue, Rome 1981, pp. 148-149. (A.R.)

75
Carlo Maratta (1625-1713)
Portrait of Clement IX
1669
Oil on canvas
145 × 116 cm
Musei Vaticani, Pinacoteca Vaticana, inv. 40460

Cardinal Giulio Rospigliosi, leading personality in the cultural and political life of Baroque Rome, poet and musician, was consecrated pope on 26 June 1667. Succeeding Alexander VII Chigi, he continued the enormous building programme commenced by his predecessor, including the famous colonnade of Saint Peter's square, a pro-

gramme that was destined to change the face of the city forever.

According to Bellori (Piacentini 1942, pp. 87-90), after admiring the portrait Maratta painted of his nephew, Cardinal Jacopo Rospigliosi, the pontiff personally asked Maratta, at that time Rome's most prestigious painter, to paint his portrait.

Carried out over a period of just a few days during Carneval 1669, the portrait was finished on Ash Wednesday the very year the pontiff died.

The work reveals Maratta's exceptional ability as a portrait painter, clearly inspired as he was by the famous portrait of Innocence X by Velázquez that was to become the obligatory model for papal portraiture throughout the 17th and 18th centuries.

The pontiff is shown three-quarters on, sitting on a throne with lozenge-shaped decorations (an allusion to the Rospigliosi coat of arms), a book in his hand. A bell and some papers are situated on a table nearby, the sheaves bearing the dedication and signature of the artist: "To our Lord's Holiness, Clemente IX, by Carlo Maratta".

The painting, previously part of the Rospigliosi family collection, was purchased by Louis Mendelssohn of Detroit and presented to Pius XI on 8 March 1931; subsequently it was placed in the Pinacoteca Vaticana.

Literature: M. Piacentini, *Le vite inedite del Bellori*, Rome 1942; F. Mancinelli, in *The Vatican Collections. The Papacy and Art*, exhibition catalogue, New York 1983; *Pinacoteca Vaticana*, Milan 1993. (G.M.)

76
Pompeo Batoni (1708-1787)
Portrait of Pius VI
1775
Oil on canvas
138 × 96 cm
Musei Vaticani, Pinacoteca, inv. 40455

The portrait, initially ascribed to Raphael Mengs and then correctly attributed to Batoni (Incisa della Rocchetta 1957, p. 4), shows Pius VI Braschi (1775-1799) at the beginning of his

pontificate. Regarded as the prototype for the official portrait of the pope, now in the Museo di Roma, and a number of other versions, the work faithfully conforms to the traditional iconography established by the famous portrait painted by Velázquez: the pope sits on the papal throne holding a sheaf of paper carrying the dedication: "To our Lord's Holiness Pope Pius VI. P. Batoni Pinxit 1775".

Pius VI was consecrated pope 15 February 1775. His long pontificate, lasting close to twenty-five years, allowed him to dedicate himself to important artistic works like the completion of the Museo Pio Clementino in the Vatican, the realization of the first Pinacoteca Vaticana, as well as the construction of the vestry of Saint Peter's, by the architect Carlo Marchionni. Overwhelmed by the events following the French Revolution, Pius VI was made prisoner and deported to France, while the Vatican library and museums were sacked by the French troops.

He died at Valence 29 August 1799 during his trip to Paris. His body was only brought back to Rome in 1802, but his wish to be buried as close as possible to the tomb of the Prince of the Apostles was not fulfilled. He is commemorated by the famous statue in the Vatican crypts, the last work of Antonio Canova, where he is represented kneeling, turned in adoration to the tomb of Saint Peter.

Literature: G. Incisa della Rocchetta, "Il ritratto di Pio VI di Pompeo Batoni al Museo di Roma", in *Bollettino dei Musei Comunali di Roma*, no. 4 (1957), pp. 1-4; F. Mancinelli, in *The Vatican Collections. Papacy and Art*, exhibition catalogue, New York 1983, p. 174; *Pinacoteca Vaticana*, Milan 1992. (G.M.)

77
Giovanni Maggi
View of Saint Peter's, the Vatican buildings and gardens
1615
Engraving
89.5 × 200 cm (with frame)
Biblioteca Apostolica Vaticana

This sweeping view shows the basilica of Saint Peter, the Vatican buildings and the gardens as they were in 1615 at the time of their refurbishment willed by Paolo V Borghese (1604-1621).

Comparing this view with that of the *Seven Churches* by Lafrery (present in the exhibition at no. 36), the changes brought about in both the church and the papal palace come to light. In Maggi's engraving the basilica rises on the left, showing the steps and square, the obelisk commissioned by Sixtus V and Maderno's facade already finished, the entire area crowded with horsemen and pilgrims.

To the right – among other things worth of mention – the courtyard of the Belvedere with the pine-cone niche (70) can be seen; Pius IV's *casina*, planned by Pirro Ligorio, is marked 58. Michelangelo's bastions can be observed on the extreme right. As far as the gardens are concerned, their layout remained unchanged from the end of the 16th century.

Maggi indicates 143 *topoi*, corresponding to the captions of a long legend, lost in the example conserved in the Vatican library, but fortunately present in the version preserved in the Bibliothèque Nationale in Paris and transcribed along with the others by Francesco Ehrle in 1914, in his commentary on the present view.

The legend gives us the date of the work – 1615 – and the name of the printer: Iacopo Mascardi; its attribution to Giovanni Maggi is also the work of Ehrle, the scholar putting forward a convincing comparative study in support of his reasonings.

Not much is known about Maggi. Born in the second half of the century, he died prior to 1621, and was above all known for his architectural drawings. Mascagni on the other hand was a famous Roman printer. The Maggi-Mascagni *veduta* is extraordinary for its size, its documentary importance and its great topographical precision.

Literature: F. Ehrle, *La grande veduta Maggi-Mascardi del tempio e del palazzo vaticano*, Rome 1914; A. Morello, M. Piazzoni, *I giardini vaticani. Storia,* *arte, natura*, Rome 1992, p. 25 and fig. 10. (A.R.)

78
Giovan Battista Piranesi (1720-1778)
Internal View of Saint Peter's
with the Central Nave
1748
Engraving
55 × 80 cm
Biblioteca Apostolica Vaticana,
R.G. Stampe O. XV.14, 4-5

The viewer is here drawn into Saint Peter's central nave, where he is invited to enter into the immense space underneath the sumptuously decorated barrel vaults and contemplate the pillars that support it.

The view is characterized by the union of monuments and human figures; the skilful modulation of the engraved marks carry the viewer from the foreground to the great cross-vault with Bernini's baldachin. The cathedra can be glimpsed in the background.

A group of noblemen stands off to the right and a small group of clergymen is seen in the centre. Elsewhere a knot of men are immersed in conversation, while one of them points with his hand. Our eye is drawn through the opening of the central nave to the left-hand nave (seen from the direction of the viewer).

The light enters from the right and is marked by the openings between the pillars. The refined and subtle cross-hatching of the barrel vault is worthy of note.

Literature: A. Bettagno, in *Piranesi e la veduta del Settecento a Roma*, exhibition catalogue, Mogliano Veneto 1989, pp. 12-14; M. Campbell, in *Piranesi. Rome Recorded*, New York 1989, pp. 7-14. (A.R.)

79
Giovan Battista Piranesi (1720-1778)
The Apse of Saint Peter's
1748
Engraving
55 × 80 cm
Biblioteca Apostolica Vaticana,
R.G. Stampe O.XV.14, no. 7

This close-up view of Saint Peter's from the side of the apse, forms part of Piranesi's Roman engravings.

A sense of the monumental involves and surprises the viewer, a vivid human participation being added to the view given the building. Attention is given to some minor details and curiosities that the artist notes at the foot of the sheet.

The architecture of "Michelagnolo Buonarota", which "was erected in part on the foundations of the Neronian circus", is embellished by "the place where the mosaics of Saint Peter's are worked" (1), the "sagristia" (2) close to where "the obelisk now to be seen in Saint Peter's square jutted straight out of the ground"; in (3) the artist tells us that the ball of the "great dome" can hold close on twenty people; in (4) the "Vatican hill" is shown; lastly "remains of granite and Parian marble columns" are noted (5), previously used in the basilica.

The desire to give a precise description of the history of a monument of fundamental importance to Christianity is indeed plain to see, and in this light every decorative and architectural detail is worthy of note. The romantic note in the "painting" of the ruins in the foreground is, however, equally worthy of attention: a tired human form props itself at the base of a fragment of a column.

Literature: A. Bettagno, in *Piranesi e la veduta del Settecento a Roma*, exhibition catalogue, Mogliano Veneto 1989, pp. 12-14; M. Campbell, in *Piranesi. Rome Recorded*, New York 1989, pp. 7-14. (A.R.)

80
Ferdinand Becker
(end of the 18th century - 1825)
Castel Sant'Angelo
First quarter of the 19th century
Pen and Indian ink and black chalk on white paper
28.4 × 42.1 cm
Biblioteca Apostolica Vaticana,
Ashby drawings, no. 11

Little is known of this artist, born in Bath, England, at the end of the 18th century and who died in 1825. What is certain is that he travelled in Italy and protrayed many *vedute* following the taste of the picturesque in vogue at the time.

Even though not always of high quality and not necessarily proportionally correct, in many cases Becker's landscape drawings are important in terms of the testimony they offer of the Italy of the times.

In this view from the banks of the Tevere (corresponding today to the Lungotevere Tor di Nona) with the land and the houses in the foreground, we immediately notice the Castel Sant'Angelo bridge and the castle itself appearing in all its monumental splendour against the waters of the river and the blue horizon.

In the distance we see Saint Peter's and the Vatican palaces, proportionally not true to reality.

Ashby writes on the back: "Bridge & Castle St Angelo, with St Peter's & the Vatican in the distance". (A.R.)

81-87
The Figure of Saint Peter

81
Giangiacomo Bonzagni
Julius III (1550-1555)
1550-55
O.: "IULIUS · III · PONT · MAX"
Right-facing bust of the pope,
bare-headed and with cope
R.: "ST · PRINCIPI · – – · DIVO · PETRO ·
APO"
Haloed left-facing bust of Saint Peter
Bronze
Diameter 26.35 mm; 8.53 g
Biblioteca Apostolica Vaticana,
Medal Collection

82
Giovanni Hamerani
Innocent XI (1676-1689)
1678
O.: "INNOCEN · – – · XI · PONT · M · A · II"
Right-facing bust of the pope,
with camauro, mozzetta and stole;
underneath the bust: "HAMERANUS"
R.: "AVDITE · VOCES · SVPPLICVM"
Saint Peter and Saint Paul
Gilt bronze
Diameter 31.40 mm; 13.03 g

Biblioteca Apostolica Vaticana,
Medal Collection

83
Giovanni Hamerani
Innocent XI
1679
O.: "INNOCEN - XI - – - PONT - MAX -
AN - III"
Right-facing bust of the pope, with
papal tiara and cope; underneath
the bust: "HAMERANI"
R.: "NON - DEFICIET - FIDES - TVA"
Saint Peter seated on the right
Bronze
Diameter 32.65 mm; 15.70 g
Biblioteca Apostolica Vaticana,
Medal Collection

84
Tommaso Mercandetti
Pius VII (1800-1823)
1814
O.: "PIVS SEPTIMVS - – - PONT -
M - A - XV"
Left-facing bust of the pope,
with zucchetto, mozzetta and stole;
underneath the bust:
"T. MERCANDETTI F.R."
R.: "RENOVATVM - PRODIGIVM"
"S.PONTIFICIS - REDITVS = RELIGIONIS -
TRIVMVIS = A - D - MDCCCXII",
in exergue on three lines
"MERCANDETTI - F - R",
on the exergue line
Saint Peter freed from prison
by the angel
Bronze
Diameter 40 mm; 21.04 g
Biblioteca Apostolica Vaticana,
Medal Collection

85
Giuseppe Cerbara
Leo XII (1823-1829)
1824
O.: "LEO XII PON - MAX - ANNO I -"
Right-facing bust of the pope, with
papal tiara and cope; underneath
the bust: "CERBARA F."
R.: "TECVM APERIAM - – - VT
THESAVROS ANNI SANCTIORIS"
Saint Peter looking heavenwards,
holds up the keys in his right hand,
whilst in his left hand he holds the
book against his side
Bronze

Diameter 42.55 mm; 32.53 g
Biblioteca Apostolica Vaticana,
Medal Collection

86
Giuseppe Girometti
Pius IX (1846-1878)
1847
O.: "PIVS IX PONT - – MAX - ANNO II -"
Right-facing bust of the pope, with
zucchetto, mozzetta and stole;
underneath the bust:
"G. GIROMETTI.F."
R.: "BASIL - VATICANÆ – DECVS -
ADDITVM"
"A-MDCCCXLVII", in exergue
The statues of Saint Peter and Saint
Paul are situated on both sides
of the staircase leading to the Vatican
basilica
Bronze
Diameter 43.40 mm; 45.36 g
Biblioteca Apostolica Vaticana,
Medal Collection

87
Francesco Bianchi
Leo XIII (1878-1903)
1902
O.: "LEO - XIII - PONT - – MAX -
AN - XXV"
Left-facing bust of the pope, with
papal tiara and cope; underneath
the bust: "BIANCHI"
R.: "ET - SVPER - HANC - PETRAM -
ÆDIFICABO - ECCLESIAM -"
"- MEAM -", in exergue
Saint Peter seated in profile with
the keys and an open book on which
can be read: "TV ES = PETRVS"
Silver
Diameter 43.50 mm; 34.52 g
Biblioteca Apostolica Vaticana,
Medal Collection

As far as the iconography in the history
of the Church is concerned, the med-
als bearing the figure of Saint Peter
can be divided into two categories:
those showing the bronze statue of the
saint in the central nave of Saint Pe-
ter's, and those based on the presum-
ed image of the apostle as it appears in
the mosaic "papal chronological or-
der" in the basilica in Ostia.
Apart from the different poses in
which the Prince of the Apostles is

portrayed and the iconographical
sources his depiction is based on, his
image takes on a wide range of mean-
ings, depending both on the historical
period and on the pope who wanted
the image reproduced in his medals.
This range goes from the motif of exul-
tation for the liberation of Pius VII –
freed from prison in Paris just as Peter
is thought to have been freed from
prison by an angel – to the denuncia-
tion of the lack of freedom for the
Church in post-Risorgimento Italy, as
in the case of a medal of Leo XIII, in
which Saint Peter is chained to a rock
and raises his eyes heavenwards in si-
lent prayer, albeit convinced of im-
pending freedom. Yet another medal
of the same pope shows an imposing
Saint Peter on the throne (as in the
statue attributed to Arnolfo di Cam-
bio) blessing the faithful with his right
hand raised in solemn dignity.
According to the Church, Peter did
not just receive the keys from Christ:
he was also appointed supreme Shep-
herd of the faithful (medal of Pius IX),
and entrusted with bringing them
back to the fold of eternal salvation,
through the celebrations during Holy
Year (medal of Leo XII). Thus all the
holiness of the jubilee is expressed in a
medal of Innocent X, referring to the
Holy Year of 1650: Saint Peter, impos-
ing amongst the clouds, seems to offer
the keys to his followers and their
Shepherd, in a gesture full of sacred
significance.
But the apostle is also the protector of
Rome, the city he wanted to die in, and
from which the teaching of his succes-
sors spread throughout the world.
Thus we see again an enthroned Saint
Peter in a medal of Clement IX, which
reads "PROTECTOR NOSTER", or the
saint watching over the city in a medal
from Innocent XI, or saving the citi-
zens from the scourge of the plague in
a medal of Alexander VII. (G.A.)

88-91
The Navicella

88
Lorenzo Fragni
Pius V (1566-1572)

1572
O.: "PIVS - V - PONTIFEX - MAX -
A - VI -"
Bust of the pope, bare-headed,
facing left with cope
R.: "IN - FLUCTIB - EMERGENS"
The miraculous catch
Bronze
Diameter 29 mm; 13.87 g
Biblioteca Apostolica Vaticana,
Medal Collection

89
Giorgio Rancetti
Clement VIII (1592-1605)
1601
O.: "- CLEMENS - VIII - PONT -
MAX - A - X"
Bust of pope facing left, bare-
headed, with cope; under the bust:
"GIOR - RAN -"
R.: "- SALVA - NOS - DOMINE -"
Jesus asleep in the boat with the
apostles, in a storm-tossed sea
Bronze
Diameter 39.75 mm; 28.11 g
Biblioteca Apostolica Vaticana,
Medal Collection

90
Ermenegildo Hamerani
Clement XI (1700-1721)
1719
O.: "CLEMENS XI- – - PONT - M -
AN - XIX"
Right-facing bust of the pope,
with camauro, mozzetta and stole;
underneath the bust: "E - H -"
R.: "VENTI - ET - MARE -
OBEDIUNT - EI"
Jesus in the boat with the frightened
apostles calms the stormy waters
Silver
Diameter 39 mm; 28.48 g
Biblioteca Apostolica Vaticana,
Medal Collection

91
Francesco Bianchi
Pius X
1906
O.: "PIUS - X - PONT - – - MAX - AN - III -"
Left-facing bust of the pope, with
zucchetto, mozzetta and stole;
underneath the bust: "BIANCHI"
R.: "CATECHESIS - TRADITIO =
LEGIBUS - FIRMATA"

"SEDENS · DOCEBAT = · DE · NAVICULA · TURBAS = · LVC · V · 3" in exergue on three lines
Jesus, seated in the boat, preaches to the crowd
Bronze
Diameter 43.65 mm; 37.12 g
Biblioteca Apostolica Vaticana, Medal Collection

"As Jesus walked along the shore of Lake Galilee, he saw two brothers who were fishermen, Simon (called Peter) and his brother Andrew, catching fish in the lake with a net. Jesus said to them, 'Come with me and I will make you fishers of men'" (Matthew, 4, 18-19).
"One day Jesus got into a boat with his disciples and said to them, 'Let us go across to the other side of the lake.' So they set out. As they were sailing, Jesus fell asleep. Suddenly a strong wind blew down on the lake, and the boat began to fill with water, so that they were all in great danger. The disciples went to Jesus and woke him up, saying, 'Master, Master! We are in danger. The boat is sinking!' Jesus woke up, and shouted at the wind and the waves; they died down and there was a great calm" (Luke, 8, 22-24).
It is between these two episodes, the "fisher of souls" and the "Salva nos Domine!", that this iconography, known in the papal medal collection as "Medal of the Navicella", is placed.
The Church developed three basic themes in the episode of the *Navicella*: the apostle's mission; man's fear; and the miraculous catch – all of which are extremely rich in exegesis and symbolic meaning. The engravers, however, except for rare exceptions, never managed to give them the artistic treatment they deserved, perhaps because they were influenced by the most famous portrayal of the *Navicella* in the mosaic by Giotto in the entrance of Saint Peter's basilica.
Thus, the *Navicella* became a staple part of the papal medallists' production, turned out on every possible occasion: to commemorate a pope's missionary work, or to mark important achievements in diplomacy; to empha-

size a moment of particular danger for the Church, or to raise a desperate cry for help to heaven: "IN FLUCTIBUS EMERGENS" (medal of Paul IV); "IMPERA DOMINE ET FAC TRANQUILLITATEM" (medal of Pius V); "SALVA NOS DOMINE" (medal of Clement VIII). But in all these cases, and in many others, the iconography is always the same; it should also be remembered that as far as this particular theme is concerned, minting dies which had already been made for previous popes were used. This means that we can talk of a "standard medal" when referring to the *Navicella* medals.
Perhaps Rancetti, with the medal for Clement VIII "SALVA NOS DOMINE", is the only artist who manages to rise above the rest, thanks to his undoubted ability as an engraver, and also because he all too obviously took inspiration for his drawing from a fresco in the Sala Clementina, which the pope was having decorated. The same goes for the medal for the nineteenth year of the papacy of Clement XI, made by the engraver Hamerani, along the lines of a painting by Maratta.
However, although the *Navicella* theme was widely used between the 16th and 18th centuries, it was used less frequently in the following centuries, until it disappeared altogether, perhaps beacause the Church, after crossing the stormy seas of the 16th and 17th centuries, was now sailing in calmer waters. (G.A.)

92-95
The Consignment of the Keys

92
Gianfederico Bonzagni
Marcellus II (1555)
1555
O.: "MARCELLUS · II · PONT· MAX"
Left-facing bust of the pope, bare-headed and with cope
R.: "CLAVES · REGNI · CELOR"
"· ROMA ·" in exergue
The consignment of the keys
Bronze
Diameter 26.35 mm; 16.95 g
Biblioteca Apostolica Vaticana, Medal Collection

93
Alberto Hamerani
Clement X (1670-1676)
1670
O.: "CLEMENS · X – PONT · MAX · AN · I"
Right-facing bust of the pope, with papal tiara and cope; underneath the bust: "ALB · HAMERAN · F ·"
R.: "TV · ES · PETRVS · ET · SVPER · HANC · PETRAM · ÆDIFICABO · ECCLESIAM · = · MEAM ·", in exergue
The consignment of the keys
Bronze
Diameter 41 mm; 36.14 g
Biblioteca Apostolica Vaticana, Medal Collection

94
Giuseppe Bianchi
Pius IX (1846-1878)
1869
O.: "PIUS · IX · PONT · MAX · SACRI · PRINC · A · XXIV ·"
Left-facing bust of the pope, with zucchetto, mozzetta and stole; underneath the bust:
"I · BIANCHI · S ·"
R.: "TIBI · DABO · CLAVES · REGNI · CÆLORUM"
"CONCILIO · OECVM · VATICANO = FELICITER · COEPTO = VI · ID · DECEMBR · = · A · MDCCCLXIX", in exergue on four lines
"FRAN · BIANCHI · INV · ET · SCVL ·", on the exergue line
The consignment of the keys
Bronze
Diameter 74.20 mm; 176.10 g
Biblioteca Apostolica Vaticana, Medal Collection

95
Egidio Boninsegna
Leo XIII (1878-1903)
1903
O.: "LEO · XIII · PONT · MAX · SACRI · PRINC · A · XXVI"
Left-facing bust of the pope, with papal tiara and cope; underneath the bust: "JOHNSON = EB · MOD · AC · INC · "
R.: "TU ES PETRUS ET SUPER HANC PETRAM = ÆDIFICABO ECCLESIAM MEAM ET PORTÆ = INFERI NON PRÆVALEBUNT = ADVERSUS EAM",

in exergue on four lines
Jesus declares the supremacy of Peter in the Church
Silver
Diameter 67.10 mm; 64.37 g
Biblioteca Apostolica Vaticana, Medal Collection

The most significant scene as far as the image of Peter is concerned, and also a recurring theme in the art of the Church, is the "Consignment of the keys": to the Church the keys are the symbol of the power to "bind and loosen", conferred upon Peter by Christ.
"Blessed are you, Simon son of John!" answered Jesus. "For this was not revealed to you by flesh and blood, but by my Father in heaven. And so I tell you, Peter: you are a rock, and on this rock I will build my church, and the powers of death shall not prevail against it. I will give you the keys to the Kingdom of Heaven, and whatever you bind on earth shall be bound in heaven, and whatever you loosen on earth shall be loosened in heaven" (Matthew, 16, 17-19).
The keys thus represent the passing of supreme power from the first pope – Peter – to his successors.
Of course, over the centuries, the keys took on further meaning: spiritual power, and also temporal power, the power to grant indulgences, and so on. However, the cornerstone of the belief remains the *potestas solvendi et ligandi*: the authority of the pope is in this *potestas* right from the very moment he is elected.
It was for this very reason that the keys were chosen as far back as the 16th century for the "election" medal, which was coined, usually on the initiative of the engraver, whenever a new pope was elected.
Although the scene had the weight of tradition behind it (the kneeling apostle receives the keys from Jesus), every artist has tried to interpret it according to his own ability and sensitivity.
Starting with the first examples, the medals for Marcellus II, in which the figures are fixed and rigid against an empty background, as if to emphasize

the holiness of the moment, to the much more complex interpretations of the medals for Clement X, for example. There are also variations, where instead of Christ handing over the keys to Saint Peter, we see Saint Peter and Saint Paul handing over the keys to the new pope; but the medals are usually of a standard type, and of varying degrees of artistic merit, depending on the skill of the engraver. (G.A.)

96-116
The Vatican Basilica

96
Cristoforo Foppa
known as Il Caradosso
Julius II (1503-1513)
1506
O.: "- IVLIVS - LIGVR - PAPA - SECVNDVS = - MCCCCCVI"
Bust of the pope facing right, with camauro and mozzetta
R.: "TEMPLI - PETRI - INSTAVRACIO = - VATICANVS - M -"
Saint Peter's basilica according to the plan by Bramante
Bronze
Diameter 55.5 mm; 54.35 g
Biblioteca Apostolica Vaticana, Medal Collection

97
Alessandro Cesati (obverse)
Giangiacomo Bonzagni (reverse)
Paul III (1534-1549)
1550
O.: "- PAVLVS - III - PONT - MAX - AN - XVI -"
Bust of the pope facing right, bare-headed and with cope
R.: "- AN - – IOBI – LÆO – - M - D - L -"
"PETRO - APOST - = PRINC - C -", in exergue on two lines
Saint Peter's basilica according to the plan by Sangallo
Bronze
Diameter 41.5 mm; 24.24 g
Biblioteca Apostolica Vaticana, Medal Collection

98
Lorenzo Fragni
Gregory XIII (1572-1585)
Undated

O.: "GREGORIVS - XIII - PONTIFEX - MAXIMVS"
Bust of the pope facing left, bare-headed and with cope;
under the lower edge of the bust: "LAV.FARM"
R.: " SVPER - HANC - PETRAM -"
"ROMA -", in exergue
Saint Peter's basilica with Michelangelo's dome
Bronze
Diameter 38.25 mm; 27.87 g
Biblioteca Apostolica Vaticana, Medal Collection

99
Paolo Sanquirico
Paul V (1605-1621)
1608
O.: "PAVLVS - V - BVRGHESIVS ROM - PONT - MAX - A - S - M - DC - VIII - PONT - III"
Bust of the pope facing right, bare-headed and with cope
R.: " TEM - D - PETRI - IN - VATICANO "
"ET - PORTÆ - INFERI - NON = PRÆVALEBVNT", in exergue on two lines
Saint Peter's basilica according to the plan by Carlo Maderno
Bronze
Diameter 57 mm; 57.5 g
Biblioteca Apostolica Vaticana, Medal Collection

100
Gaspare Mola
Urban VIII (1623-1644)
1633
O.: "VRBANVS - VIII - PONT - MAX - A - X -"
Bust of the pope facing right, bare-headed and with cope; on the lower edge of the bust: "G - MOLO"
R.: " ORNATO SS PETRI ET PAVLI SEPVLCHRO"
"MDC - XXXIII", in exergue
The canopy of Saint Peter's
Bronze
Diameter 41 mm; 33.64 g
Biblioteca Apostolica Vaticana, Medal Collection

101
Gaspare Morone
Alexander VII (1655-1667)
1661

O.: "ALEXAN - VII - PONT - – MAX - A - VII"
Bust of the pope facing left, with papal tiara and cope; under the lower edge of the bust: "G - M -"
R.: "FVNDAMENTA EIVS IN MONTIBVS SANCTIS"
"- MDCLXI -", in exergue
Panorama of one arm of the colonnade and part of Saint Peter's square with the fountain;
above: scroll with the original plan of the colonnade by Bernini
Bronze
Diameter 42.15 mm; 40.64 g
Biblioteca Apostolica Vaticana, Medal Collection

102
Gaspare Morone
Alexander VII (1655-1667)
1666
O.: "ALEXAN - VII - PONT - – MAX - A - XII"
Bust of the pope facing left, with papal tiara and cope; under the lower edge of the bust: "G - M -"
R.: "FVNDAMENTA EIVS = IN MONTIBVS = SANCTIS", in exergue on three lines
View of the basilica and Saint Peter's square with Bernini's colonnade, which had a third arm according to the original plan
Bronze
Diameter 41.35 mm; 31.16 g
Biblioteca Apostolica Vaticana, Medal Collection

103
Giovanni Hamerani
Clement X (1670-1676)
1674
O.: "CLEMENS - X - – - PONT - MAX - AN - V"
Bust of the pope facing right, with papal tiara and cope; under the lower edge of the bust: "- IO - HAMERANVS -"
R.: "FLVENT - AD EVM - OMNES - GENTES"
Panoramic view of the facade of Saint Peter's and the apostolic palaces; at the bottom: she-wolf with the twins, among plant motifs; at the top: a flying angel blowing a trumpet and carrying a scroll inscribed:

"IN SPLEN = DORE = STELL = ARVM"
Bronze
Diameter 41 mm; 31.58 g
Biblioteca Apostolica Vaticana, Medal Collection

104
Giuseppe Bianchi
Pius IX (1846-1878)
1860
O.: "PIVS IX - PONT - – MAX - ANNO XV -"
Bust of the pope facing left, with zucchetto, mozzetta and stole; under the lower edge of the bust: "I - BIANCHI F -"
R.: " FIDEI REGVLA = ECCLES - FVNDAMENTVM, in exergue on two lines
The cathedra of Saint Peter; underneath: "I - BIANCHI - F"
Bronze
Diameter 43.5 mm; 37.22 g
Biblioteca Apostolica Vaticana, Medal Collection

105
Pius IX
1869
O.: "- DOCETE - OMNES - GENTES"
"CONCILIUM - OECUMENICUM - VATICANUM - = A - PIO IX - CONVOCATUM - INCOHATUM - = DIE - FESTO - IMMACULATÆ - = CONCEPTIONIS - ANNO = MDCCCLXIX -", in exergue on five lines
The central nave of Saint Peter's basilica
R.: "SECULO XVIII REFERENTE SOLEMNIA TRIUMPHI PETRI APOST"
"A.MDCCCLXVIIII", in exergue
Saint Peter's square crowded with people at the opening of the 1st Vatican Council
Bronze
Diameter 72.5 mm; 163.52 g
Biblioteca Apostolica Vaticana, Medal Collection

106
Egidio Boninsegna
Pius XI (1922-1939)
1925
O.: "- PIUS - XI - – - PONT - MAX - A - IV -"
Bust of the pope facing right, with papal tiara and cope; on the left:

"E. BONINSEGNA MOD. F.LORIOLI
INC."; on the right: "FM LORIOLI &
CASTELLI-MILANO"
R.: "ANNO JVBILÆI = ROMÆ
MCMXXV", in exergue on two lines
Saint Peter's glorified by angels
Bronze
Diameter 70.25 mm; 147.6 g
Biblioteca Apostolica Vaticana,
Medal Collection

107
Egidio Boninsegna
Pius XI
1925
O.: "- PIUS - – P - P - XI -"
Half-length bust of the pope giving
his blessing and holding in his left
hand a scroll inscribed: "JVBILÆVM
= MCMXXV"
R.: "ANNO JVBILÆI – ROMÆ MCMXXV"
The dome of Saint Peter's with rays;
at the bottom, a plaque, bordered
with ears of wheat, on which can be
read: "VIDETE REGIONES = QUIA JAM =
ALBÆ SVNT = AD MESSEM"; on the
right, a monogram
Silver
Diameter 35.25 mm; 15.98 g
Biblioteca Apostolica Vaticana,
Medal Collection

108
Aurelio Mistruzzi
Pius XI
1929
O.: "PIVS - XI - PONTIFEX - MAXIMVS -
ANNO - VIII"
Bust of the pope facing left, with
zucchetto and cope; under the bust:
a small branch and "MISTRVZZI"
R.: "MDCCCLXXIX - MCMXXIX",
"PACE CHRISTI ITALIÆ = REDDITA",
in exergue on two lines
Large chalice and host, with rays,
against the background of the
basilicas of San Giovanni in Laterano
and Saint Peter's
Silver
Diameter 82.7 mm; 286.46 g
Biblioteca Apostolica Vaticana,
Medal Collection

109
Aurelio Mistruzzi
Pius XI
1930

O.: "PIVS - XI - PONT - – MAX -
AN - IX -"
Bust of the pope facing right, with
zucchetto, mozzetta and stole; under
the lower edge of the bust:
"MISTRUZZI"
R.: "A - CIVITATE - VATICANA =
CONDITA = ANNO - I", in exergue
on three lines
View from above of the Vatican
State; at the top, two angels holding
the coat of arms of the Holy See
Silver
Diameter 82.8 mm; 249.95 g
Biblioteca Apostolica Vaticana,
Medal Collection

110
Augusto Giacomini
Pius XI
Undated
O.: "PIVS - XI - – PONT - MAX"
Bust of the pope facing left, with
zucchetto, mozzetta and stole; on
the shoulder: "A. GIACOMINI"
R.: "BASILICA DI S.PIETRO = ROMA",
in exergue on two lines
Saint Peter's square; on the right,
above the exergue line:
"A. GIACOMINI"
Bronze
Diameter 61.2 mm; 101.25 g
Biblioteca Apostolica Vaticana,
Medal Collection

111
Goffredo Verginelli
Pius XII (1939-1958)
1950
O.: "- PIVS - XII - PONT - MAX - AN -
IVB - MCML -"
The pope seated on the left giving
his blessing, with papal tiara
and cope
R.: "- FIAT - PAX - IN - VIRTVTE - TVA -"
The dome of Saint Peter's
with rays, surmounted by a globe
of the Earth
Gilt bronze
Diameter 41.4 mm; 28.28 g
Biblioteca Apostolica Vaticana,
Medal Collection

112
Aurelio Mistruzzi
Pius XII
1950

O.: "PIVS - XII - P - M – A - MAGNI -
JVBILÆI"
Bust of the pope facing right, with
zucchetto and cope; on the left:
"MIS=TRV=ZZI";
under the lower edge of the bust:
"PAGANI"
R.: "PORTA - SANCTA"
"MCML", in exergue
The Holy Door of Saint Peter's
between the statues of Saint Peter
and Saint Paul
With holder
Gilt bronze
Diameter 36 mm; 20.18 g
Biblioteca Apostolica Vaticana,
Medal Collection

113
Egidio Boninsegna
Pius XII
1950
O.: "- PIVS - XII - PONT - MAX - A -
JVBILÆI - ROMÆ - MCML -"
The pope seated on the left, giving
his blessing, with zucchetto,
mozzetta and stole; at the bottom
left: "E. BONINSEGNA"
R.: "ANNO JVBILÆI - ROMÆ - MCML"
"PAX - HOMINIBVS - BONÆ -
VOLVNTATIS", on scroll held
by three angels
The Vatican Basilica glorified by
angels; on the right: "LORIOLI"
Bronze
Diameter 55.1 mm; 74.08 g
Biblioteca Apostolica Vaticana,
Medal Collection

114
Emilio Monti
Pius XII
1950
O.: "PIVS - XII - PONT - MAX - ANNO -
JVBILÆI - MCML"
Bust of the pope facing right with
zucchetto, mozzetta and stole; on
the right: "E.MONTI"; on the left:
"MP. INC. = JOHNSON"
R.: "STAT ECCLESIA DVM VOLVITVR
ORBIS"
Facade of Saint Peter's with rays
from the dome; underneath, two
angels holding the papal coat of
arms; on the left, "E.MONTI";
on the right: "JOHNSON MP. INC."
Bronze

Diameter 60 mm; 96.47 g
Biblioteca Apostolica Vaticana,
Medal Collection

115
Aurelio Mistruzzi
Pius XII
1952
O.: "PIVS - XII - PONTIFEX
– MAXIMVS - A - XIV"
Bust of the pope facing right, with
zucchetto, mozzetta and stole.
Under the lower edge of the bust:
"MISTRUZZI"
R.: "= APOSTOLORVM - PRINCIPIS -
SEPVLCRVM - REPERTVM"
The tomb of Saint Peter
Silver
Diameter 44 mm; 39.16 g
Biblioteca Apostolica Vaticana,
Medal Collection

116
Antonio Sperandio
John Paul II
1986
O.: "- JOANNES - PAVLVS - II - P.M.AN
MCMLXXXVI - PONT.SVI - VIII -"
Bust of the pope facing left, with
zucchetto and cope; on the lower
edge of the bust: "A.SPERANDIO"
R.: "- RESTORATION - OF - THE -
FACADE - OF - SAINT - PETER'S -
BASILICA - 1985 - 1986"
"POPE - JOHN - PAUL - II - WISHING -
TO - HONOR = THE - PRINCE - OF - THE -
APOSTLES - RESTORED - TO = ITS -
FORMER - GLORY - THE - FACADE -
OF - THE = PATRIARCHAL - VATICAN -
BASILICA = THROUGH - THE -
MUNIFICENT - GENEROSITY = OF -
THE - ORDER - OF - THE - KNIGHTS - OF
- COLUMBUS = AND - UNDER - THE -
DIRECTION - OF = ARCHBISHOP - LINO -
ZANINI - DELEGATE = OF - THE -
R.F.S.P.", in exergue on nine lines
Facade of Saint Peter's basilica
Gilt bronze
Diameter 69.7 mm; 182.58 g
Biblioteca Apostolica Vaticana,
Medal Collection

In the 2nd century A.D. there was al-
ready a firm belief that the remains of
the apostle Peter were buried on the
Vatican hill, on the right bank of the
Tiber. It was on this primitive, humble

grave that Pope Anicetus had a "memorial" (or *trophaion*) erected towards the middle of the 2nd century. But in 315 Pope Sylvester and the Emperor Constantine decided to build a great basilica on the memorial of the Prince of the Apostles.

However, by the time of Julius II, the great Renaissance pope, the still splendid construction of Constantine had fallen into a state of ruin, even though it had been continually embellished and restored over the centuries. Thus on 18th April 1505 Julius II laid the first stone of the new basilica to be built based on a plan by Bramante. A chronicler of the time recounts that medals "with the facade of the new Saint Peter's" were placed in the foundations. This date therefore marks the beginning of the long series of medals which have depicted all the most important moments in the centuries-old history of the world's greatest church. The medals showing Bramante's plan from the time of Julius II were followed by those with Sangallo's plan under Julius III and those showing the dome being built, under Pius V.

Some medals of Gregory XIII show the Michelangelo facade, which was never built, while others portray the facade by Maderno, carried out in the early 17th century during the papacy of Paul V.

The attention of the engravers was soon also directed at the immense square in front of the basilica. All the various phases in its transformation were documented in detail: the erection of the great central obelisk, the building of the two bell towers, later demolished, and so on right up to the magnificent colonnade, Bernini's masterpiece, both in its original form with three arms and in the final version with two arms.

Indeed, the engraver Gaspare Morone Mola was skilful enough to depict on a medal the plan of Bernini's design for the colonnade.

In addition to these impressive works, medals have continued to record all the subsequent changes which different popes have carried out to further improve the appearance of this square,

the heart of Roman Catholicism. These have ranged from statues crowning the "straight arms" of the colonnade (medals of Clement X), the paving which divided the immense elliptical piazza into clearly defined zones (medals of Pius VII), the paving stones themselves made out of cubes of porphyry (medals of Gregory XVI) right up even to the lighting system composed of four enormous gaslamps positioned around the obelisk.

Naturally there are also medals in honour of important monuments or works inside the basilica itself, beginning with Paul II's medal showing Saint Peter's tribune and continuing with others which even include panoramic views of the gigantic naves. But, particularly in this latter case, the art of engraving on coins comes very close to the art of painting, or even that of the miniaturist. (G.A.)

117
Virgilio Cassio
Portrait of Pope John Paul II
1978
Oil on canvas
Diameter 133 cm
Fabbrica di San Pietro, storerooms

The last portrait in the chronological series of Roman popes is of Pope John Paul II. This continues the series started by an open competition announced in 1849 by Pius IX (1846-1878), in order to replace the portraits destroyed in the fire of 1823 in the basilica of San Paolo fuori le Mura.
It was painted in 1978 by Virgilio Cassio, a former director of the Studio del Mosaico Vaticano, who entrusted Dario Narduzzi and Odoardo Anselmi with the mosaic reproduction. In 1979 it was hung in the basilica of San Paolo fuori le Mura, almost at the far end of the trabeation of the first south nave, on the right hand side, together with the portrait of John Paul I (d. 1978), the predecessor of the current pope. This painting was also the work of Virgilio Cassio and the mosaic artists Narduzzi and Anselmi.
According to the official chronological order, published in the *Annuario* of

the Holy See, John Paul II is the 262nd Vicar of Christ.
The chronological series of portraits of the popes kept in the Fabbrica di San Pietro, however, contains 271 paintings, because it was commissioned according to an ancient chronological list which historical research has now made obsolete.
The chronological series of portraits of the popes was exhibited in the Museo Petriano from 1925 until it was closed in 1945. The museum housed an historically, artistically and archaeologically important collection of relics, connected with the old and new basilicas. The series was later moved to the octagonal rooms of the basilica, in line with the San Leone Magno and the Vergine del Soccorso, or Gregorian, chapels.
The restored paintings constitute the most complete chronological series of portraits of the popes in the world today, and are now exhibited in room V of the so-called "Lumaca Sobieski", in line with the staircase leading down from the cupola terrace.

Literature: G. Cascioli, *Guida al nuovo Museo di San Pietro*, Rome 1925; J.N.D. Kelly, *Grande dizionario illustrato dei papi*, Turin 1989. (P.G.S.)

With Open Arms: Bernini's Piazza

118
Saint Peter's square
17th century
Oil on panel
73 × 49 cm
Vatican Museums, storerooms, inv. 2356

The panel depicts the basilica and Saint Peter's square as they were at the beginning of the 17th century, when the vaulting in the cupola had already been completed, but construction on the facade designed by Carlo Maderno had not yet been started.
It is one of the many souvenir-views of Saint Peter's, although the inclusion of some products of the imagination might lead us to think that it was not painted from life, but was based on

previous drawings and reproductions. The panel has been attributed to a Flemish painter because of its style, and the name of an unknown artist, F. De Vries, was once suggested, but this has not been accepted by critics.
It was published by H. Egger in 1911 as part of Count Lanckoronski-Brzezie's collection in Vienna, and donated to the Vatican Museums by his heirs.

Literature: H. Egger, *Römische Veduten...*, vol. I, Vienna 1911, pl. 22; C. Galassi Paluzzi, *La basilica di San Pietro*, Rome 1975, fig. 126. (G.M.)

119
Gian Lorenzo Bernini (1513-1680)
Giovanni Battista Bonacina (1650-1670)
Plan and elevation of Saint Peter's colonnade
1659
Engraving
54.6 × 84.5 cm
Biblioteca Apostolica Vaticana, St. Barb. XI 31, 1-6

This beautiful print by Bonacina shows the plan and elevation of the "porticoes" designed by Gian Lorenzo Bernini for Pope Alexander VII, as can be read on the inscriptions (in Latin and in Italian), held up by feminine putti that sound trumpets. While the plan of the colonnade and the parts in elevation show the structure and function of Bernini's architecture (see captions), in the small perspective drawing at the centre of the composition the basilica is shown with the entire project, in fact including the third wing conceived by Bernini (the one facing the basilica) that was actually never built. This is further evidence that the pope's idea of constructing a mother-square with open arms to welcome the faithful was well-known and approved of.
The quality of the mark is fine, being linear and schematic in the architecture, and well modulated in the human forms and in the drapery of the putti.

Literature: S. Boorsch, *The Buildings of the Vatican. The Papacy and Architecture*, n.p. 1983, pp. 28-30. (A.R.)

120

Drawing of Saint Peter's square superimposed on a human figure
17th century
27 × 41 cm
Ink
Biblioteca Apostolica Vaticana,
Vat. lat. 14260, f. 1

The first project submitted by Gian Lorenzo Bernini for widening the square before Saint Peter's, commissioned by Pope Alexander VII in 1656, was judged to be insubstantial by the congregation of works for the basilica. The congregation insisted on a lengthening and broadening of the square; however it was above all the pope's preference for the "oval" form that lead Bernini to his definitive formulation of the project.

This resulted in the creation of the form of the human embrace delineating the space where the worshippers would assemble and that also succeeded in the intent of a proportionally harmonious framing of the giant body of the basilica.

A drawing in Bernini's hand testifies to this idea and this intent: the church seen as the mother welcoming her children.

The two exhibited drawings, almost certainly in Bernini's hand, constitute one of the plates that go to make up a series of twenty-five drawings in the Vanvitelli collection, that stand as a "counter-project". The plates, according to a careful and convincing reconstruction by Wittkower (1939-40), probably illustrated a treatise unfavourable to Bernini, with all probability produced in clerical circles. Occurrences of this kind were not infrequent; one need only recall the criticism met by Bernini's plans for the bell towers of the facade in 1645. The scholar even gives us the name of the person who executed the plates: "Constanzo de Peris, inventor".

The problem denounced in these drawings lies in the way the basilica is linked to the portico by the wings or corridors. The left-hand drawing in fact shows the breaking up of the wings following Bernini's project, while the drawing to the right shows the arches of the porticoes directly linked to the faced of the basilica.

From its iconography, the face of the human figure chosen for the critical demonstration would appear to be Saint Peter.

Literature: R. Wittkower, "A counter project to Bernini's 'Saint Peter's Square' ", in *Journal of the Warburg Institute*, III (1939-40), pp. 88-106; T. Kitao Kaori, *Circle and Oval in the Square of Saint Peter*, New York 1974; F. Borsi, *Bernini architetto*, Milan 1980; *La basilica vaticana*, Florence 1989; G. Morello, "I rapporti tra Alessandro VII e Gian Lorenzo Bernini negli autografi del papa", in *Documentary Culture...*, Florence 1990, pp. 185-207. (A.R.)

121

Giovanni Battista Falda (d. 1678)
Saint Peter's square
1667-69
Engraving
27 × 41 cm
Biblioteca Apostolica Vaticana,
R.G. Stampe II 170, no. 3

This beautiful engraving is part of the first of three books of the *Nuovo Teatro delle Fabbriche et Edifici in prospettiva di Roma moderna* produced by Falda.

The first book, datable to 1665, was dedicated to the brother of the then-pontiff Alexander VII (1655-1667) and printed by Giovan Giacomo De Rossi, famous editor based in Rome. Falda, originally from Piedmont, worked in Rome in the second half of the 17th century. Together with Lievin Cruyl and others he was one of the principal advocates of a new genre of *veduta* less schematic than those of the 16th century, more attentive to the documentary value but for all that not lacking in vitality.

Falda created his perspectives himself, used the small format typical to the times and paid great attention to detail. He also engraved projects that had not as yet been carried out, as in this print, where the colonnade is completed by the third wing as intended by Bernini.

As well as demonstrating the esteem in which Bernini must have held him – to the point of allowing him to see and then to realize one of his projects that was still on paper – the print stands as an interesting document of a particular and important historic phase of the Vatican works: as is known, the idea of the third wing was never in fact realized. Falda, alongside Cruyl, was a faithful chronicler of the changes the eternal city underwent under Alexander VII. He enjoyed growing success during his lifetime and was much esteemed after his death.

He virtually always used the technique of etching for his prints, this allowing him to transfer the luminous pictorial effects of his hand to printing.

Literature: G. Lugli, in G.B. Falda, *Vedute di Roma...*, Rome n.d.; R. Piccinini, in G.B. Falda, *Vedute di Roma*, reprint Rome n.d. (A.R.)

122

Giovan Battista Piranesi (1720-1778)
Saint Peter's square
1748
Engraving
76 × 90 cm
Biblioteca Apostolica Vaticana,
R.G. Stampe O XV 14, no. 3

Born at Mogliano di Mestre in 1720 and trained in the Venice of Canaletto and of the *vedutisti*, Piranesi then went to Rome, where he learnt the art of engraving from Vasi, who was already quite famous. There, he spent much time drawing landscapes and ruins. His success as an engraver began with *Le carceri* (1750), a sort of romantic fantastic architectural invention, and continued with the *Vedute di Roma* (1748-1770 c.), a collection covering the last phase of his career and life. Piranesi, who was also an architect, died in his beloved Rome in 1778.

Piranesi's *vedute*, which soon surpassed Vasi's work in novelty and quality, combined factual precision with extraordinary imagination – in other words: the precision of what is and one sees with what could be and is not always seen. This beautiful image of the Vatican basilica shows the square in its final setting: the facade by Maderno, the Bernini colonnade, the obelisk, the fountains; the artist, however, embellished this with a foreground view of noble carriages and bridled horses, also including ordinary people resting beside the fountains while they water their horses.

The basilica is thus personalized, depicted in such a way as to attract the viewer, drawing him into the grand "square of the embrace" wished by Pope Alexander VII.

Literature: A. Bettagno, in *Piranesi e la veduta del Settecento a Roma*, exhibition catalogue, Mogliano Veneto 1989, pp. 12-14; M. Campbell, in *Piranesi. Rome Recorded*, New York 1989, pp. 7-14.(A.R.)

123

Giovan Battista Piranesi
View of Saint Peter's square
1748
Engraving
77 × 91 cm
Biblioteca Apostolica Vaticana,
R.G. Stampe O XV 14, no. 2

This engraving showing Saint Peter's square from above, forms part of the *Vedute di Roma disegnate e invise da Giambattista Piranesi*, as is written on the frontispiece of the volume. On the left-hand side one can see the Palazzo del Sant'Uffizio and the Palazzo Cese, where the auditorium now stands; the rest has almost all been lost. The teutonic cemetery still exists and the sacristy was not yet built. On the other hand, the view to the right more or less reproduces the existing situation.

The viewpoint is high enough to embrace the entire square, the colonnade and surrounding buildings, also giving a maplike view of the surrounding countryside and the urban area around the Vatican. Thus the spectator can grasp the idea of a embrace wanted by Pope Alexander VII and realized by Bernini, and its impact on the city and on the faithful.

Naturally the figures drawn to scale are minute; a carriage can be seen in the foreground to the right, a much-loved Piranesian "device", already encountered in another view of the square.

Literature: A. Bettagno, in *Piranesi e la veduta del Settecento a Roma*, exhibition catalogue, Mogliano Veneto 1989, pp. 12-14; M. Campbell, in *Piranesi. Rome Recorded*, New York 1989, pp. 7-14. (A.R.)

124
Lievin Cruyl (c. 1640-1720)
Saint Peter's square
1666
Engraving
53 × 38 cm
Biblioteca Apostolica Vaticana,
St. Chig. S 168

Born at Gand around 1640 and ordained as a priest, Lievin Cryil was probably in Rome between 1664 and 1670. During the pontificate of Alexander VII, along with Falda, he was a leading figure in the 17th-century revival of the *veduta*. In his works the objective representation of reality is tempered with a certain subjectivity: proportions are often altered to enlarge the field of view and the vantage point raised to enhance the scenic effect. This can be clearly seen in this fine engraving. Here the raised vantage point is moved off to the right, giving a particularly broad view of the square.

The basilica with the Maderno facade can be seen in the background: here the corridors separate off in turn giving rise to the curved wings of the colonnade; the right part reaches up almost to the foreground while the left one is concealed from view by the construction of the third wing planned by Bernini, but never actually built. The obelisk, commissioned by Pope Sixtus V, the Vatican buildings, one of the two twin fountains and, not far off, the drinking trough for the horses subsequently placed behind the apse of the church can also be seen.

Many figures are in view, including the workers from the Bernini works, and more specifically the two chisellers working around the great coat of arms of the Chigi family, a reminder of the figure who commissioned the undertaking, Pope Alexander VII. Carriages and gentlemen cover the square and the inside of the colonnade. The print is the first of a splendid volume dedicated to Alexander VII and published by De Rossi in Rome. To conclude, one should note the perfect modulation of the engraved mark, intense in the parts in shade and architectural lines, delicate in the areas of light.

Literature: B. Jatta, J. Connors in *Vedute romane di Lievin Cruyl*, exhibition catalogue, Rome 1992. (A.R.)

The Path of Faith
Works from the Italian Regions

The Ways of the Apostles
Gianfranco Ravasi

"Go ye therefore, and teach all nations... and, lo, I am with you always, even unto the end of the world." These are the last words spoken by the risen Christ on Mount Galilee at the end of Saint Matthew's Gospel (28, 19-20). And with these words a long road was opened in Christian space and time, sometimes straight and well-lit and at other times enveloped in the shadowy darkness of doubt, as was the case for the disciples at Emmaus. It is a road stretching from Jerusalem to Rome, like the structure of the Acts of the Apostles, in other words reaching out towards the horizon of the whole world. And yet it remains a "narrow way" as Christ announced in his sermon on the mount (Matthew 7, 13-14) and as was later confirmed in the Acts: "we must through much tribulation enter into the kingdom of God" (14, 22).

The "way" becomes almost the perfect artistic symbol to represent the spreading of the gospel and Christian existence itself. Emblematic of this is Saint Paul, whose conversion historically takes place on the road to Damascus, whose most fervent desire, as he writes to the Christians in Rome, is that "by the will of God a road might be opened for me to come unto you" (1, 10) and whose life was marked by "innumerable journeys" (II Corinthians 11, 26). The Christian "does not walk after the flesh but after the Spirit" (Romans 8, 4), "walks in newness of life" (6, 4), "walks by faith and not by sight" (II Corinthians 5, 7), "walks in love" (Ephesians 5, 2), fleeing "the way of destruction and misery to know the way of peace" (Romans 3, 16-17). The subject of the apostle's teaching is "the ways which be in Christ" (I Corinthians 4, 17; cf. II Peter 2, 21). On the other hand Israel had already been presented in the Old Testament as a pilgrim people: "we are strangers... and sojourners, as were all our fathers" (I Chronicles 29, 15). Christ had described himself as "the Way" (John 14, 6) and in the first centuries the Christians also identified themselves above all as followers of the "Way".

It is a way along which one must run, as Paul liked to stress: "forgetting those things which are behind and reaching forth unto those things which are before, I press toward the mark for the prize... Know ye not that they which run in a race run all, but one receiveth the prize? So run that ye may obtain" (Philippians 3, 13-14; I Corinthians 9, 24; cf. Acts 20, 24). It is a race that must not be "run in vain" (Galatians 2, 2; Philippians 2, 16). Paul writes to the Galatians: "Ye did run well; who did hinder you that ye should not obey the truth?" (5, 7). The Word of God runs with us too (Romans 10, 18) and shows us the ultimate goal "for here we have no continuing city, but we seek one to come" (Hebrews 13, 14). "Wherefore lift up the hands which hang down, and the feeble

knees; And make straight paths for your feet, lest that which is lame be turned out of the way; but let it rather be healed" (12, 12-13). And, having arrived at our destination, we can say, with Paul: "I have finished my course, I have kept the faith: Henceforth there is laid up for me a crown of righteousness, which the Lord, the righteous judge, shall give me at that day: and not to me only, but unto all them also that love his appearing" (II Timothy 4, 7-8).

If the "way" is a great metaphor for the whole of Christian existence, ecclesial and personal, the physical "ways" were the means through which the gospel was spread from Jerusalem to Rome, from the room of the last supper to all the different provinces of the Empire, as is implicit in the famous geographical and ethnic list in the story of the Pentecost (Acts 2, 9-11). This same text from the Acts of the Apostles is substantially based on an interweaving pattern of journeys taking place along the roads of the Roman Empire and their branches. Peter and Paul are the two protagonists and we shall return to them later. But there are also other personalities such as the deacon Philip who took the road to Samaria to preach the message of Christ there (8, 5-13) and to Gaza, converting the Queen of Ethiopia's eunuch en route (8, 26-40) and then settling in the Roman coastal city of Caesarea, the seat of the Procurator (21, 8). There is the disciple Barnabas, the Levite from Cyprus, whose travels, often in the company of Paul, have been carefully recorded with all their numerous stopping places (Antioch in Syria, Cyprus, Perga, Antioch in Pisidia, Lycaonia, Lystra, Jerusalem). There is John Mark, a rather weak wandering disciple (13, 13); Silas, another of Paul's companions, and Luke who makes a fleeting appearance after verse 16, 10, where that curious "we" occurs in the narrative, a sign that Paul's missionary experience was a shared one ("immediately we endeavoured to go into Macedonia").

Then if we wish to find out about the ways of the other apostles and disciples, we must turn to the enormous mass of Christian apocryphal accounts, in which true historical fragments appear side by side with legends and local devotions in a mixture which it is difficult to disentangle. Thus, according to the Acts of Andrew, Peter's brother preached to a Scythian tribe in southern Thessaly and in the Achaea at Patras, where he was crucified on two crossed poles by the Roman governor Egea. James, the son of Zebedee, according to a famous 7th-century tradition, arrived in Spain carried by a boat without oars which was pushed by the angels, thus giving rise to the famous cult of Santiago de Compostela. The Acts, however, record that he was "killed with a sword" by Herod Agrippa in the year 42 (12, 2). His brother John would come to be considered as

the great architect of Christianity in Asia Minor (both side by side with, and independently of, Paul) on the basis of the seven letters sent to the seven churches (Ephesus, Smyrna, Pergamos, Thyatira, Sardis, Philadelphia, Laodicea) mentioned at the beginning of the Apocalypse (chapters 2-3). The *Legenda aurea* (13th century) recounts that Philip preached for twenty years "in the land of the Scythes" and then arrived at Gerapoli in Phrygia where he was crucified. It should not be forgotten that one of the most important Egyptian-Coptic gnostic gospels is named after him.

For Bartholomew (often identified as the Nathanael of John 1, 43-51) vast horizons were opened up, according to the Apocrypha: Asia Minor, Armenia, Mesopotamia and India, where he was flayed alive on the orders of the brother of King Astiage. But, after being thrown into the sea, the coffin containing his corpse would be washed ashore in no less a place than the coast of the Aeolian island of Lipari. Thomas, whose adventures are recounted in thirteen sections of the Acts of Thomas, also reached India. His tomb at Mailapur is still venerated today and the Syro-Malabar and Malankar rites are dedicated to him. Moreover, as Eusebius of Caesarea reminds us, the Christian communities of northern Syria date back to Thomas, while a precious Coptic Gospel of Thomas also takes us back to Egypt. Matthew, the tax gatherer, appeared in Cyprus but especially, according to the *Legenda aurea*, in Ethiopia, although his tomb has been venerated in Salerno since the 10th century. James, the son of Alphaeus, also popularly known as James the Younger to distinguish him from John's brother of the same name, was the only one who did not move away from Jerusalem, since he has been traditionally identified with James "brother of Jesus" (Matthew 13, 55), head of the Church of Jerusalem (Acts 12, 17), architect of the mediation of the "council" of Jerusalem (15, 13-23) and martyred in the year 62. This identification is, however, contested by modern exegetes.

We do not have much information about Jude, not even in the Apocrypha. According to the above-mentioned *Legenda aurea*, he was martyred in Persia with Simon, the last of the apostles in the list handed down by the evangelists. According to the Acts of Andrew, Matthias, who took the place of Judas Iscariot among the apostles, preached to anthropophagites and was freed from them through the efforts of Andrew. As can be seen, the possible historical threads in these accounts are often entwined into a pattern which is mostly made up of legend and picturesque folklore. There remains however one indisputable fact: almost always the apostle does not die in Jerusalem but in some remote region, after travelling thousands of kilometres to preach the gospel of Christ. The Word of God could not remain tied to one people, one language, one land, one culture or one race but had to be proclaimed as far as the edges of the earth. As Paul wrote to the Colossians, "there is neither Greek nor Jew, circumcision nor uncircumcision, Barbarian, Scythian, bond nor free: but Christ is all and in all" (3, 11).

The "ways" of Peter and above all of Paul, on the other hand, are not recorded only in the fluid memory of apocryphal literature but are described in the second work of Luke, the Acts of the Apostles. Peter is the protagonist of the first twelve chapters of the book and it is in these pages that his missionary activity is described, also beyond the walls of the holy city. He went with John to Samaria to confer the Holy Spirit onto the newly converted (8, 14-17), stopping at Lydda where he healed the paralytic Aeneas (9, 32-35), and at Jaffa where he revived the disciple Tabitha (9, 36-43). He was the first to go to the house of a pagan, the centurion Cornelius, of the Italica cohort stationed at Caesarea, to proclaim the Christian *kerygma* to him and his family (chapters 10-11).

That journey from the house of Simon the tanner in Jaffa, where Peter was living, to the city of the Roman Procurators becomes therefore a symbolic journey prefiguring the travels of Paul among the various cities of Asia and Roman Europe. Apart from his speech at the "council" of Jerusalem (15, 7-11), Peter disappears from the Acts with the reference to another journey of unknown destination: after being freed from prison by an angel "he departed and went into another place" (12, 17).

Some have thought that this "another place" was Rome itself, supported in this theory by the fact that Peter's First Epistle was sent from "Babylon" (5, 13), a probable metaphorical allusion to the capital of the Empire, although when Paul wrote his famous epistle to the Romans, Peter could not have arrived there yet, since he is not referred to in the ample greetings contained in chapter 16 of the letter. It is certainly true, as John L. McKenzie writes, that the stay, the death and the burial of Peter in Rome are so tenaciously rooted in the tradition that few modern historians cast doubt upon them, nor do other churches lay claim to them. Two ancient witnesses, Saint Clement of Rome (I, 5) at the end of the 1st century and Ignatius of Antioch at the beginning of the 2nd century, do not affirm the presence of Peter in Rome but seem to imply it. On the other hand, the conviction expressed in the apocryphal Acts of Peter (2nd century) is explicit. Under Constantine the Vatican was considered the seat of the tomb of the apostle but, according to some archaeologists, certain graffiti would support a prior identification:

already at the beginning of the 3rd century Gaius of Rome claimed that the remains of Peter and Paul were respectively on the Vatican hill and on the Via Ostia.

Given the limits of our research, we do not wish to go into the merits of this complex debate, which involves historical, literary and archaeological elements and which tends to place the martyrdom of Peter in the context of the Neronian persecution in the years 64-67. We wish only to recall that striking symbolic episode which the above mentioned Acts of Peter, written between 180 and 190, describe as follows: "While Peter (in order to flee the persecution of Nero) was going through the gates of the city, he saw the Lord who was entering Rome to be crucified once again and he said to him: Lord, where are you going? The Lord replied: I am going into Rome to be crucified again! Peter then, returning to his senses, saw the Lord ascend into heaven and turned back into Rome". As is well known, a little church on the Via Appia Antica, rebuilt in the 17th century, commemorates this meeting, which provided the title for the successful novel *Quo vadis?* by the Polish writer Henryk Sinkiewicz (1846-1916), winner of the Nobel prize for literature in 1905.

"Rome has united the world with its roads," affirmed the 2nd-century Roman orator Helius Aristides. And Paul understood that the great roads of the Empire were the most precious instrument for the spreading of the gospel. This was not always an easy task because travelling on those roads was often a risky undertaking, as the apostle himself recalls in an autobiographical note: "Thrice I suffered shipwreck, a night and a day I have been in the deep; in journeyings often, in perils of waters, in perils of robbers, in perils by mine own countrymen, in perils by the heathen, in perils in the city, in perils in the wilderness, in perils in the sea, in perils among false brethren; in weariness and painfulness, in watchings often, in hunger and thirst, in fastings often, in cold and nakedness" (II Corinthians 11, 25-27). Indeed, as has been mentioned, his Christian adventure itself began on a road, the one to Damascus, and the book of the Acts is almost a continual account of the "ways of Paul", starting from that decisive journey from Tarsus to Antioch, on the invitation of Barnabus, and from there to Jerusalem (11, 25 ff.).

From chapter 13 of the Acts until the epilogue Paul the wandering missionary is a constant presence. And it is from this documentation that the three great missionary journeys of Paul can be reconstructed. We do not wish to go into a detailed recreation of these journeys here, something which is in any case already provided in many works on the apostle, and needs to be followed using a bibli-

cal atlas enabling the reader to trace the routes on a map. We shall limit ourselves here to providing a summary, noting that each of these journeys covered on average a total distance of at least 1500 kilometres. The first apostolic journey (12, 24; 14, 27) probably took place between A.D. 45 and 59 and reached Cyprus, Perga, Pamphylia, Antioch in Pisidia and Lycaonia. Paul was accompanied by Barnabus and was able to try out his preaching methodology. They first approached the synagogue in the city that they were visiting; if this contact failed (in Lycaonia the reaction of the local Jews was very hostile), both of them then turned their attention directly and publicly onto the Gentiles. The statement made in 13, 46-47 is very significant regarding the historical development that the Church would take: "It was necessary that the word of God should first have been spoken to you: but seeing ye put it from you, and judge yourselves unworthy of everlasting life, lo, we turn to the Gentiles. For so hath the Lord commanded us saying, I have set thee to be a light of the Gentiles, that thou shouldst be for salvation unto the ends of the earth" (Isaiah 49, 6).

At the end of the first journey tension was rising between Jewish-Christians and Christians of pagan origin. The "council" of Jerusalem settled the question (chapter 15; we do not wish to enter into the merit of the chronological discrepancies which emerge from a comparison of Galatians 2 and Acts 2 and which are resolved in all the various commentaries on the two texts). Paul was now ready for his second apostolic journey (15, 36; 18, 21), certainly the most important, although spoiled by the disagreements between the apostle and Barnabus because of John Mark: "And the contention was so sharp between them that they departed asunder one from the other: and so Barnabus took Mark and sailed unto Cyprus; and Paul chose Silas" (15, 39-40), and subsequently with the faithful Timothy, the son of a Jewish mother and a Greek father. Having crossed Cilicia, Lycaonia, Phrygia and Galatia, there occurred the great turning point which resulted in Paul's devoting his attention to Europe.

Let us leave the description to Luke who, as previously mentioned, became a member of the Pauline group from this moment. "And they... came down to Troas. And a vision appeared to Paul in the night; there stood a man of Macedonia, and prayed him, saying, Come over into Macedonia and help us. And after he had seen the vision, immediately we endeavoured to go into Macedonia, assuredly gathering that the Lord had called us for to preach the gospel unto them" (16, 9-10). It was thus that the gospel was heard for the first time on the continent of Europe, at Philippi, where Paul

had the bitter experience of prison. And then on to Thessalonica, Berea and even as far as Athens, where the apostle gave his famous sermon at the Areopagus, stirring up conflicting reactions (chapter 17). From Athens he went on to Corinth, a tumultuous metropolis of 600,000 inhabitants, with two ports and a scandalous lifestyle from the social and moral point of view. Here Paul founded that community which would later cause him so many problems and so much suffering, as witnessed in his two epistles to the Corinthians. Paul stayed here for a couple of years. The indifference of the Roman Proconsul of Achaea, Gallius, neutralized the hostility of the Jewish community towards the apostle. The two epistles to the Thessalonians were written here. It was the year A.D. 52-53 (the journey had begun in 49-50).

After a return to Antioch and a brief rest, Paul was once again on the road for his third apostolic journey (18, 23; 21, 17), between 53 and 58. He visited Phrygia and Galatia again and then focussed his efforts upon Ephesus. In this splendid coastal city the apostle founded a church and was subjected to a violent protest on the part of the city's goldsmiths – an expression of sharp hostility this time from the pagan side, motivated by economic reasons. It is possible that Paul was arrested again, considering certain allusions to his stay in Ephesus in the first epistle to the Corinthians: "I have fought with beasts at Ephesus" (15, 32), and the epistle to the Philippians: ("my bonds in Christ are manifest in all the palace, and in all other places... All the saints salute you, chiefly they that are of Caesar's household" (1, 13; 4, 22). But it was the church in Corinth above all which tormented the apostle, as witnessed by his first epistle to the Corinthians sent from Ephesus. The subsequent movements of Paul are not at all clear. The most fascinating document is his farewell to the elders of the church of Ephesus (20, 17-35), a real "pastoral testament" (J. Dupont) which contains within it a little pearl, a saying of Jesus unrecorded in the gospels: "There is more joy in giving than in receiving" (verse 35).

Arriving at Caesarea, Paul felt that his life was now entering its concluding phase: "I am ready not to be bound only, but also to die at Jerusalem for the name of the Lord Jesus" (Acts 21, 13). He went up to Jerusalem but his presence in the holy city sparked off a violent reaction from the Jews. This point was the beginning of what we could call the "way to Rome", the fourth and final journey of the apostle, no longer planned by him but imposed on him by the Roman occupation forces, who had rescued him from being lynched by the Jerusalem mob. The account in the Acts grows particularly lively (21, 18; 28, 31) and must be read fully. Having appealed to the superior authority of the imperial court, as a Roman citizen, Paul was transferred to Caesarea on the Mediterranean sea, where he was kept waiting for two years for a judgement because of the greed of the Governor, Felix, who was hoping to profit from a bribe from either the apostle or his Jewish adversaries. Festus, who succeeded Felix, finally tried the case but Paul demanded to be judged in Rome. "Hast thou appealed unto Caesar?, unto Caesar shalt thou go", was the conclusion of Festus (25, 12).

After an informal appearance before King Agrippa II, a Herodian descendant who was the guest of Festus, Paul's journey by sea began. The voyage is colourfully portrayed in chapters 27-28 of the Acts, which also trace a map of the different harbours and places where the ship stopped. Soon after Crete "there arose a tempestuous wind, called Euroclydon and.... the ship was caught and could not bear up into the wind" (27, 14-15), drifting for two weeks until it ran aground on the coast of Malta. A couple of extraordinary episodes (the viper and the healing of the father of an important Roman official) created an aura of respect around Paul. After three months the voyage resumed on a new ship. The apostle set foot in Italy for the first time at Syracuse; then, after stopping at Reggio Calabria, the final port of call was at Pozzuoli. Here Paul's eyes lit up with joy on seeing that "some brothers", in other words local Christians, were waiting for him. The news had, however, also reached Rome and some members of that Christian community were sent to meet the apostle and accompany him to the city where he was kept under house arrest.

Displaying a degree of sympathy for the correctness of the Roman system, and perhaps also trying to show that the Christians held respect for the imperial institutions, Luke concluded his work in this way: "And Paul dwelt two whole years in his own hired house, and received all that came in unto him, preaching the kingdom of God, and teaching those things which concern the Lord Jesus Christ, with all confidence, no man forbidding him" (28, 30-31). The apostle had thus reached the city to which he had sent his most important letter. In it, among other things, he had spoken of his plan to go to Spain (15, 24) but above all he hoped that he might "come unto you with joy by the will of God, and may with you be refreshed" (15, 32), in other words to meet the Christians of Rome and stay for some time with them. Saint Clement of Rome affirms that Paul then really did also reach the western Mediterranean region. But at this point verifiable information grows scarce and the ancient traditional accounts take over. For the apostle the end was approaching: "the time of my departure is at hand" (II Timothy 4, 6). In about

the year A.D. 67, perhaps, Paul was tried and condemned to death. Since he was a Roman citizen the penalty was carried out through beheading. According to tradition, this took place at Acque Salvie, near the present basilica of San Paolo fuori le Mura.

The earthly way of the apostle was thus sealed off for ever. Victor Hugo also placed Paul among the guiding lights of history, "a saint for the Church, a great man for humanity". But it would be the Christian faith over the centuries which would look upon him and Peter as two stars to the believer along the ways of life. Let us leave the concluding words to Saint John Chrysostom in his XXV Homily on II Corinthians: "Alone among the barbarians, alone among the Greeks, alone in every corner of the earth and of the sea Paul appeared and departed victorious. Like the fire which falls upon reeds and hay and transforms into its own nature everything that burns, so he too entered everywhere and transformed everything to the truth, a river that reaches everywhere and crushes every obstacle; like an athlete who both fights and runs and tightens his fists...Ceaselessly he launched himself everywhere, running first to some and then to others, helping here and then hurrying there, arriving faster than the wind. And he ruled the world as though it were just a house or a ship, lifting up those who were sinking under, giving strength to those who were falling. Giving orders to the sailors, he pulled on the ropes, manoeuvred the oars, hoisted the sails, gazing up at the sky above, doing everything alone, the helmsman, the sail, the ship and all, to deliver others from misfortune" (chapter III).

Literature

O. Cullman, *Il primato di Pietro*, Il Mulino, Bologna 1965.
C. Spicq, *Vie chrétienne et pérégrination selon le Nouveau Testament,* Cerf, Paris 1972. *Saint Pierre dans le Nouveau Testament*, Cerf, Paris 1974.
O. Kuss, *Paolo*, Ed. Paoline, Rome 1974.
J.L. Vesco, *In viaggio con san Paolo*, Morcelliana, Brescia 1974.
F. Mussner, *Petrus und Paulus Pole der Einheit*, Herder, Freiburg 1976.
R. Fabris, *Atti degli Apostoli*, Borla, Rome 1977.

E. Haenchen, *Die Apostelgeschichte*, Vandenhoeck-Ruprecht, Göttingen 1977[7].
R. Pesch, *Simon Petrus*, Hiersemann, Stuttgart 1980.
E.R. Galbiati, A. Aletti, *Atlante storico della Bibbia e dell'Antico Oriente*, Jaca Book, Milan 1983.
M. Guarducci, *Pietro in Vaticano*, Istituto Poligrafico e Zecca dello Stato, Rome 1983.
C.M. Martini, *Atti degli Apostoli*, Ed. Paoline, Rome 1985[7].
Sulle orme di Paolo, Società San Paolo, 2 vols., Milan 1993.

The Pilgrims' Ways
Franco Cardini

Although symbols and the language of symbolism are universal, it is difficult to find signifiers with analogous meaning in the "forest of symbols" stretching over different historical periods and different cultures. The human race has produced an infinite number of messages and symbolic objects, all however dependent upon a comparatively limited basic "keyboard": the circle, the cross and certain fundamental colours constitute the "universal letters" of an alphabet which has been employed by many different languages of infinite variety. And often the similarities and analogies between them are only illusory and superficial.

However, it appears that the idea of the journey belongs to that restricted category of symbolic values which the whole of human civilization, in all its multiple varieties, seems to identify itself with and recognize itself in. This is especially true for that Euro-Asiatic-Mediterranean world which, while anthropologically rich and varied, is nevertheless characterized by a strong interethnic and intercultural circulation of values. *Homo viator, status viatoris*: the need to travel, the desire to discover what lies on the other side of the waves or the dunes is coupled with a violent nostalgia for one's own place of origin. The journey is looked upon as an adventure but also as a return, calling to mind figures such as Gilgamesh, Abraham and Moses, as well as Ulysses.

If man is a traveller, if his anthropic and environmental conditions (and, deeper than these, some powerful urge from within his own self) force him to be a nomad and therefore a perpetual outsider, always a guest in the home of other people who in turn are themselves guests and outsiders (is there really such a thing as autochthony?), being *peregrinus* – "one who comes from outside" – is his fundamental existential "situation". In this regard, the original position of Christian *peregrini* in Jerusalem was precisely that: they were "outsiders" who had come to the Holy City to spend the remaining years of their lives, to die there and then rise again in the valley of Jehosophat. But soon, following in the tradition of the Jewish pilgrimage and also adapting itself to the many living models offered by pagan traditions in this field, the Christian pilgrimage developed into a journey which was limited in time, marked by a departure and a return – although, because of its inherent danger, there remained the possibility that it might come to an end without a return to one's own real home and homeland. However, what counted principally for the pilgrim was that his journey to the holy places (in so far as it was a symbol of his journey through life, that life in which, as the Dominican Jacopo da Varagine, Bishop of Genoa and hagiographer, said at the end of the 13th century, "we are all like

pilgrims in battle") should be above all a new Exodus out of the Egypt of sin and into the Holy Land of grace, the external manifestation of an internal process of conversion and salvation. By the end of the Middle Ages the various forms of *peregrinatio animae*, of internal pilgrimage, had come more and more frequently to replace the pilgrimage as such (or at least the one to Jerusalem, which had really become too costly even if not risky), while at the same time devotions centred upon "substitute" pilgrimages to those in the Holy Land had multiplied – for example those to the Sacri Monti organized by the Franciscans in sanctuaries which somehow reflected in their construction the image of the holy places, like Varallo in Valsesia or San Vivaldo in Valdelsa. It appeared to be the case that the true pilgrimage took place in the heart and that Christianity had no institution comparable to the Muslim *hajj*, no pilgrimage considered "obligatory". It thus becomes easier to understand why an entire ascetic-mystical tradition, whose roots can already be found in Jerome and Augustine, had always been wary of pilgrimages or had at least been careful not to encourage them. The attraction of the holy places, the desire to see and physically touch the places and the things which had in some way been in contact with the Saviour, was too strong an urge for the faithful to be adequately controlled simply by prudence and disciplinary measures.

It is difficult to understand this power of attraction of the pilgrimage in Christian spirituality if it is not viewed in the light of similar phenomena, from the anthropological-religious point of view, which are an integral part, if not of all, at least of most religions. They are, in any case, characteristic of the mythic-religious systems of antiquity, oriental as well as classical, of the three sister religions descended from Abraham and also of the Brahmanist-Hindu-Buddhist universe which has so many historical and formal connections with the Indo-European mythic-religious systems and of which it is itself a part (even though it may then have also developed in unrelated environments: such as Tibet, China and Japan).[1]

On the other hand, while recognizing the "universal" presence of the pilgrimage as a religious-devotional form, it should not be forgotten that its contexts and functions in the three historical transcendent religions based upon an omnipotent creator-God, Lord of the world and of all things, who each views as having established the great dialogue of Revelation with man, are different from those in the mythic-religious systems which have an immanent character. In the latter case the main objective of making a pilgrimage to places and sanctuaries rendered famous by being the setting for a myth, and perhaps also because of the presence of celebrated relics, is to

establish magical contact with centres of cosmic or chthonic force, with *omphaloi*, seats of cratofanic power susceptible to appearing under various forms, from the divinatory to the thaumaturgic-therapeutic. The Greek world was full of places of this kind, and the devotional attitudes of the faithful were not very different from those which Christians would later have (nor should it be forgotten that in certain cases, which must however be examined one by one without generalizing, there exists a sort of continuity-obliteration relationship between paganism and "popular" Christianity). In the case of transcendent religions, and especially with regard to the great pilgrimages to Mecca for the Muslims and to Jerusalem for the followers of Abraham and Moses, the essential thing is instead to establish contact with the physical places where the Divine is believed to have intervened in the affairs of man, not in the *tempus illud* of myth but in clearly defined, specific moments of history. Thus it is believed that places themselves become a pledge of the salvation promised by God in the plan of Redemption, part of the testimony of faith in this salvation.[2]

It is practically impossible to establish for certain when the phenomenon of Christian pilgrimage began[3]: it probably dates back to the time of the apostles, following on directly from the Jewish pilgrimage to Jerusalem. It is however very probable that a halt, or at least an interruption, occurred after the Emperor Hadrian destroyed the Holy City in A.D. 135 to build the Roman colony of Aelia Capitolina. But when, in about 330, the Empress Helena, Constantine's mother, initiated the colossal work of founding the great Christian sanctuaries of the Resurrection in Jerusalem and of the Nativity in Bethlehem, the Christian pilgrimage was reinvigorated and returned to establish itself with its own specific character. The holy places of Christianity had been created. We are well informed about visits to them thanks to a large number of pilgrimage diaries which constitute a true literary genre, the tradition of which still persists today.

It is a literary genre with characteristics which vary according to the homeland of the writer, the conditions under which the journey was undertaken on each occasion, the socio-cultural context of the Holy Land in different moments of its long and tormented history and the different values that the experience of going on a pilgrimage assumed over the history of Christianity.

A number of important phases can be identified in the history of pilgrimages by western Christians to the Holy Land.

The first phase lasted from Constantine's Empire until the Arab-Muslim conquest of Jerusalem (4th-7th centuries). Under the pro-tection of the Eastern Roman Empire, later known as the Byzantine Empire, pilgrims flocked to the Holy Land along the route of the ancient consular roads, which were still largely intact. Their journey – as witnessed by famous accounts such as that of Egeria the Galician or the anonymous traveller from Piacenza – could be carried out almost entirely on foot, except for sea passages across the Otranto channel and the Bosphorus. In the Holy City they found a state of order and stability, although somewhat disturbed by the endemic frontier war between the Byzantine and Persian Empires. The second phase lasted from the Arab-Muslim conquest until the crusades (7th-11th centuries).[4] Except for a few brief periods from time to time, the Muslims never prevented or hindered access by Christians to the holy places, which were always respected apart from during the reign of the Egyptian caliph al-Hakim, who was however considered a heretic even within Islam. Shortly before the Arab conquest Jerusalem had been captured by the Persians and the Basilica of the Resurrection destroyed. The Emperor Heraclius had allowed its reconstruction and the great building remained intact in this new form until 1009-10 when al-Hakim destroyed it once again. Proper restoration work was not begun until the middle of the 11th century. Meanwhile many things had changed in the West. Under the influence of practices borrowed from Irish monasticism, the custom of the "penitential pilgrimage", aimed at remedying particularly grave or public sins, had started. Later on, at the end of the 8th and the beginning of the 9th centuries, good diplomatic relations between the Emperor Charlemagne and the caliph of Baghdad Harun ar-Rashid had enabled the foundation of a large pilgrim hospice for the benefit of "Latins", in other words westerners, a few steps from the Basilica of the Holy Sepulchre. After the 9th-10th centuries, which was a critical period for Europe as a result of the wave of new barbarian incursions (Hungarians, Vikings, Saracens) coming on top of internal disorder, a wind of fresh and powerful vitality blew over the continent leading to renewed vigour both demographically and in the field of trade.

One effect of this impetus was the crusades, which began as an armed pilgrimage and a movement for the reconquest and reappropriation of the holy places by Christianity. The pilgrimages by land and the crusades themselves were reinforced because in the meanwhile, at the end of the 10th century, the Hungarians had settled along the middle reaches of the Danube and had become christianized, thus allowing rapid and safe access along the Balkans. It was precisely at this time, between the 9th and 11th centuries, that the devotion to the Holy Sepulchre became so widespread that in many

places in the West there emerged churches and chapels dedicated to it. There were even votive chapels that attempted in some way to imitate the external appearance of the temple in Jerusalem which housed within it what remained of the tomb of Jesus. In certain cases there were even more complex attempts to reproduce the entire basilica. Constructions of this type appeared for example in Aquileia, Acquapendente, Bologna, Bergamo and Mantua. They were always located along routes followed by pilgrims or near crossroads where pilgrims were to be found.

The ancient Roman roads had been abandoned, although here and there some stretches of them were restored.

Medieval civilization, which had now entered upon a phase of new development, opened up other lines of communication along which were spaced out pilgrim hospices and minor sanctuaries (although sometimes they were very important ones like the Santo Volto at Lucca or the church of Arcangelo Michele on Gargano). These were places which could be visited and venerated while travelling along the road to the "great" pilgrimage destinations, which were now not only Jerusalem but also Rome and Santiago de Compostela in Galicia.[5]

Along the Italian peninsula, between the western Alps and Rome, a new road had emerged since the time of the struggles between Byzantines and Lombards (6th-8th centuries), replacing the Roman roads which had by that time fallen out of use or become marshy or unsafe. This road, which was called *Via Francigena* because it came from the "land of the Franks" and led transalpine pilgrims towards Rome, crossed the Alps at the Great Saint Bernard Pass (after the 12th century the Moncenisio pass was preferred), traversed Piedmont and Lombardy as far as Piacenza, where it was possible to ford the Po, then crossed the Apennines at the Cisa pass called *Mons Bardonis* (derived apparently from *Mons Langobardorum*) and continued south along the Magra valley, reaching Lucca, and then south of the Arno to the Valdelsa before meeting up with a surviving stretch of the consular road, the Via Cassia, in northern Lazio. After visiting Rome and its relics, the pilgrims continued on their way mainly following the route of the Appia-Traiana road down to the ports in Apulia, from where it was possible to take ship for Epirus and from there, along the Egnatia military road, to Constantinople. The Anatolian peninsula was disputed between the Byzantines and a new people who had arrived from central Asia and recently converted to Islam, the Turks. It was not however impossible to cross it. This was the route followed by the pilgrims, whether armed or not, who were the protagonists of the first crusade.

The third phase of the pilgrimages is constituted by the crusades (11th-13th centuries). The conquest by the westerners of a coastal strip between the Levantine sea and the Jordan and the foundation of a "crusader kingdom", the economically and commercially active element of which was constituted by the merchant colonies of the Italian marine republics, especially in the port cities on the Syrian-Lebanese-Palestinian seaboard, led to a significant increase in maritime traffic. There followed a substantial improvement in the type of vessel used, enabling over the long term a crucial new development in the practice of pilgrimage. From that time on it was undertaken by sea, which made it possible to avoid the long dangerous crossing of Europe, the Balkans and Anatolia on foot, but on the other hand had the effect of raising costs because, while the pilgrim on foot could live on alms and make use of the charitable facilities located along the roads (the *hospitalia*), by sea he had to pay for transportation. The departure was from Genoa, Pisa, Venice and the Sicilian ports. Because of the technological characteristics of sailing at the time, ships remained constantly in sight of dry land. Meanwhile the Church developed a code of conduct for those who took the vow of pilgrimage which was parallel, and in many ways similar, to that which applied for crusading. Pilgrims enjoyed special prerogatives: they were recognized as *pauperes* and therefore exempt from lay legislation and placed under the jurisdiction of the Church; their lives and the goods they left behind in their homeland until their return were guaranteed under pain of excommunication; they enjoyed special spiritual privileges, the "indulgences". All of these advantages – which in practice of course did not always protect the pilgrim from the unexpected – depended upon taking an official vow of pilgrimage, which was commonly, even if not habitually, taken in the presence of a notary and usually involved a ceremony in church. During this ceremony the departing pilgrim received the emblems of his condition: the coarse garment of rough cloth, complete with wide hood, the rucksack, the sturdy stick reinforced with a metal tip (*bordone*). Then there were the distinctive badges for each pilgrimage clearly displayed on the hooded garment or hat and which served to identify the condition of the pilgrim and to indicate the eventual destination: the palm or the cross for Jerusalem, the papal keys or the "Veronica" (the image of Christ's face printed on a rectangular cloth, a famous Roman relic) for Rome, the ocean shell for Santiago. But in the end even minor pilgrimages had their own emblem. Dressed in this way pilgrims travelled along the roads and through the cities of Europe, where however, by this stage, they were not always well received. The citi-

zenry were suspicious of tramps and always wondered whether the pilgrim's robes were really on the back of a pious Christian or a penitent sinner and not simply a disguise for a good-for-nothing or perhaps even a criminal. For their part, the pilgrims realized that their road would be full of difficulties and dangers and, before leaving, they made a will.[6]

The fourth phase of the pilgrimages is represented by the rule of the Mamelukes over the Holy Land (13th-16th centuries). As we know, the crusades to the Holy Land ended in failure at the close of the 13th century. The West lost the lands which it had conquered two centuries earlier and all the subsequent clumsy attempts to recover them were in vain. From this time, until 1516-17, the Holy Land fell under the control of the Sultans of Cairo, who belonged to a military class of slave origin called the "Mamelukes". They demolished the ports of the Holy Land, reducing the country practically to a state of penury. Their policy was motivated both by the desire to discourage further attempts at reconquest on the part of the Europeans and also by the need to favour Egyptian coastal cities at the expense of those in Palestine and Syria. From that time on the two cities at the mouth of the Nile, Alexandria and Damietta, became the main ports of the eastern Mediterranean.

The Venetians were the ones who proved to be most proficient at taking advantage of the new situation, practically monopolizing pilgrim traffic to and from the Holy Land for about the next two hundred years and transforming it into a lucrative business thanks to a fairly reliable "shipping line" service. Ships departed from Venice twice a year (in March-April and in August-September) and, hugging the Balkan coast and the Peloponnesus (the "Morea") and calling at the principal Greek islands, they finally reached Jaffa, the nearest port to Jerusalem on the Palestinian seaboard. Here the passengers were disembarked and then taken back on board a few days later. The pilgrim paid a pre-arranged all-inclusive price for this service, which usually included food on board ship and certain "extras", such as being accompanied by a guide. For their part the Mamelukes were satisfied by being paid a tax for entry to the Holy Land, where the pilgrims, at least after the 1340s, could count on the assistance of the Franciscans from the Custody of the Holy Land, who were expert guides and were able to provide help for any eventuality as well as acting as intermediaries between the pilgrims and the Muslim authorities whenever necessary. However the new relationship established with the lords from Cairo, and the more frequent contact with the Nile ports which resulted from it, produced a particular effect: starting in the 14th century, it

became increasingly common for pilgrims, rediscovering a popular tradition from the first centuries of Christianity, to attempt to reach Jerusalem from the south by means of a march across the Egyptian desert and the Sinai peninsula, where it was possible to visit the famous monastery of Saint Catherine and the "Mount of Moses".

The fifth phase of Christian pilgrimages has lasted from the rule of the Ottomans until the present day (16th-20th centuries). The Ottomans from Istanbul conquered the Holy Land in 1516-17 and initially this coincided with a worsening of conditions for the Christian community and for pilgrims. However the situation soon returned to normal and, apart from a few incidents, relationships between the Ottoman authorities, local Christians and western visitors remained good. From that time until the present day, in spite of the succession of political changes which have taken place in that troubled area of the Near East, the flow of pilgrims has never ceased, even though the golden age of pilgrimages to Jerusalem seems to have come to an end in the 16th century. However, the experience of the pilgrimage, and the writing of memoirs about it, still continues and so too does the fascination of a journey which can, even today, take on an exotic late-romantic aura or provide an excuse for a cruise in which the religious motives occupy a very subordinate position. Nevertheless it seems to have resisted the passing of the centuries and to have kept intact its value as a call to return to one's Paternal Home, bearing witness to a human condition in which we all find ourselves, in the words of the first Epistle of Saint Peter, "advenae et peregrini".

[1] For the oriental context, cf. *Les pèlerinages*, Paris 1960; for the passage from Judaism to Christianity, *Les pèlerinages de l'antiquité biblique et classique à l'Occident mediéval*, Paris 1973.

[2] For pilgrimages in general, cf.: R. Roussel, *Les pèlerinages*, Paris 1972; P.A. Sigal, *Les marcheurs de Dieu*, Ligugé 1974; *Les pèlerins de l'Orient et les vagabonds de l'Occident*, Paris 1978; R. Oursel, *Pellegrini del medioevo*, Milan 1979; *Le pèlerinage*, Fanjeaux 1980; J. Sumptien, *Monaci santuari pellegrini*, Rome 1981; J. Chélini, H. Branthomme, *Les chemins de Dieu*, Paris 1982;

Medioevo in cammino. L'Europa dei pellegrini, Orta San Giulio 1989.

[3] But the studies cited in the previous note are substantially in agreement in finding that the phenomenon goes back at least to the 2nd century A.D.

[4] Cf. *Pellegrinaggi e culto dei santi in Europa fino alla I crociata*, Todi 1963.

[5] Cf. R. Stopani, *Le vie del pellegrinaggio nel medioevo*, Florence 1991.

[6] Cf. M. Rowling, *Everyday Life of Medieval Travellers*, London-New York 1971; R. Finucane, *Miracles and Pilgrims*, London 1977.

The Ways of the Artists
Marina Righetti Tosti-Croce

"Per visibilia invisibilia demonstrare": a medieval note on the relationship between images and evangelization

The interpretation of an artistic document requires critical evaluation which is always extremely complex and structured. From a single episode it must draw out characteristics of style, both formal and iconographical, historical and documentary data, relationships and links with fields of similar production, indications about who was responsible for commissioning it and for the benefit of whom, ideological programmes which influenced its realization: in other words, all the complex network of forms and ideas which lay behind it and which resulted in its creation. Unfortunately, in the case of certain historical eras, the cultural fabric which has survived until the present day is so badly torn that our reading of a work is limited to the data which the work itself has been able to preserve within its own intimate distinctive structure. On the one hand there are technical and structural characteristics and links with other artistic documents: the connection between frescoes and the walls and buildings which they decorate is just one example of this. On the other hand, in the case of figurative works of art, there are narrative and iconographical elements. However it is not always possible to create a precise reconstruction if, for example, unusual subject matter is based upon literary works which have been lost or if the artist has synthesized material from several different sources into a new figurative context. The key for the interpretation of such work may be missing because of the loss of historical-cultural documentation crucial to the moment of creation of the work.

Unfortunately, in the particular case of the early centuries of Christianity, we lack the historical documentation which alone could reconstruct for us the complex interconnected background to a work of art, the system of thought which programmed and devised it. And clearly any interpretation which attempts to put forward hypotheses without documentary basis is intrinsically improper. However it was precisely these first centuries of Christianity which were the most fertile breeding ground for sacred art. It was during this period that new iconographical formulae came into existence, the forms of new liturgical objects were devised, form and meaning were linked in ways that today appear completely obvious but which originally required the formulation and structuring of thought of the most painstaking kind.

In other cases, through a series of different sources and literary documents, we can restore the complex of ideas forming the basis of works which, unfortunately, have since become lost. In this case, too, any operation seeking to extend the application of this data to other works of art, even if they are contemporary, must be considered illegitimate.

All of this explains the difficulty, from both the historical and critical point of view, of attempting to describe the links between works of art and evangelization as it was practiced by the Church historically. It is obvious that all sacred art has a function which is closely linked to religious devotion, but, to go beyond this self-evident observation, the subject requires careful study, with clearly defined objectives, of the individual artistic document both with regard to those who commissioned it and those for whom it was intended as well as to its iconographical plan.

In direct contrast to this period of relative scarcity of documents, the Early Middle Ages is perhaps a good example of an era for which extremely significant evidence exists. Indeed it is able to reconstruct for us so intensely the religious fervour of this completely new historical age and the inner driving force of its personalities that the result is truly moving.

This is the case with the so-called Gospels of Saint Augustine (Cambridge, Corpus Christi College, ms. 286), a 6th-century code, probably illuminated in a Roman *scriptorium*. The history of the code is inseparably linked to the most famous missionary undertaking of Pope Gregory the Great, the evangelization of the Anglo-Saxons. According to a traditional story, which was confirmed by the Venerable Bede in his *History of the Angles*, Gregory saw some blonde youths who had been brought to Rome as slaves. When he discovered that they belonged to a people called the Angles, he said that these *Angles* were destined to become *angels*. To this end Gregory organized one of the first missions which was specifically dedicated to the conversion of people who were still pagan.

In the spring of 597, after various setbacks, Augustine, who had been the prior of the Roman monastery of Saint Andrew, founded by Gregory the Great himself, landed on the island of Thanet, at the mouth of the Thames. He was accompanied by a small group of companions of whom he was abbot. Augustine informed Ethelbert, the King of Kent, of his arrival. There was a favourable outcome to the meeting between the king and the group of Roman monks, who walked behind an icon of the Saviour, almost as though under its protection. The group of missionaries were allowed to settle in Canterbury and thus they were able to begin their work of converting the people.

These are the facts behind Augustine's work of conversion of the Angles. But a parallel and fundamental role was played by those codes which Augustine and the Roman monks brought with them.

The only remaining evidence of them is exactly the code known as the Gospels of Saint Augustine. It represented not only the basic text of the new community, the source from which the Word was spread, but also the prototype for the creation of new codes which were illustrated and spread as indispensable aids for preaching. Thanks to these illustrations, devised on the basis of a language combining classical memories and new figurative demands, the text of the Gospel also became a formidable vehicle for the spreading and taking root of a new culture of images in the cultural environment of the Anglo-Saxons. Its influence was felt over many centuries in the production of illuminated manuscripts in the *scriptoria* which came to be set up there.

In this case, therefore, the historical development of evangelization, through its material instruments, which consisted essentially of the code of the Gospels of Saint Augustine, influenced a particular cultural development in an area whose underlying classicism would no doubt surprise those who examine the links with Rome solely from the geographical point of view.

But, apart from the cultural role played by this code, what is especially important to observe is its function as a "container of images", a means of figurative display, whose evangelizing function for the Church has already been clearly shown, particularly for the benefit of those who were not able to read.

At the beginning of the 5th century, Paolino of Nola already states that he had the church in his city decorated with images recounting Biblical episodes, specifically aimed at those who were unable to read. Writing to the Bishop of Marseilles, Pope Gregory the Great himself is even more explicit about the role of images because "in ipsa [pictura] etiam ignorantes vident quid sequi debeant, in ipsa legunt qui litteras nesciunt". Figurative texts therefore become an example, a model for living, and at the same time a basis for instruction for those who "litteras nesciunt", who are incapable of distinguishing letters.

The sharp decline in literacy in the early centuries was a dramatic event, the consequence of the end of the Roman Empire and the chaos caused by the inflow of all those peoples who until that time had been kept outside, or at least pressed against, the eastern frontiers. Now, in successive waves, they overran the socio-cultural fabric of the civilized regions. Even centuries later, well into the 13th century, Saint Bonaventura was able to refer to Biblical images as a clearer form than writing.

However, in addition to their function as a form of text recounted through media other than writing, images also functioned as a model for living. Gregory wrote that they show "quid sequi debeant" to those who look at them. This too had by now become a clear and well established position. In the 5th century Nilus of Ancira had stated that portrayals of Biblical scenes could encourage the desire to emulate such glorious actions. This attitude of looking upon images as role models continued throughout the medieval period. Thus, in the 13th century, images were praised, not only over the written word but also over the spoken word, as being more effective in stimulating devotion among those who beheld them. The words of Giovanni Balbi of Genoa make this idea very clear; he stated that "ad excitandum devotionis affectum quod ex visis efficacius excitatur quam ex auditis".

This profound understanding of the effectiveness of systems of visual communication had certainly also been reached in the Early Middle Ages. We find evidence of this if we examine, side by side, a text and a work of art both of which are again from the early 6th century and linked to Gregory the Great. He wrote: "I do not avoid the irregularity of barbarisms, I do not pay attention to the distinction between state and movement nor prepositional structures because I value *vehementer indignum* to force the words of divine revelation into the rules of Donatus". His words refer to the fact that Latin permeated by "the irregularity of barbarisms" was the most effective means for the transmission of the evangelical message in the period between the 6th and 7th centuries. But they also point to an artistic way of transmission entrusted to new languages. This is what takes place in another work linked to the name of the great pope, which, like the Gospels of Saint Augustine, could be described as a "missionary work". This work is the binding for the Gospels, which is kept among the treasures in the cathedral of Monza. According to tradition, Gregory the Great sent it as a gift to Theodolinda, the Queen of the Lombards, in 603 after her and her people's conversion to Catholicism from Arianism. In this case, too, the missionary work was directed and carried out by Gregory the Great in person.

The great jewelled cross, the *signum salutis*, that stands out from the two plates of the binding is an echo of the Constantinian sign of victory. It is certainly a Roman sign just as the cameos mounted on the four corners of each plate are Roman, "classical". But the *cloisonné* decorations around the edges and the internal framing squares, and the jewels which are mounted with the cabochon technique reflect the methods used in Lombard jewellery in the 6th-7th centuries. The great message of salvation coming from the cross is entrusted to a new language, a wonderful synthesis of classical La-

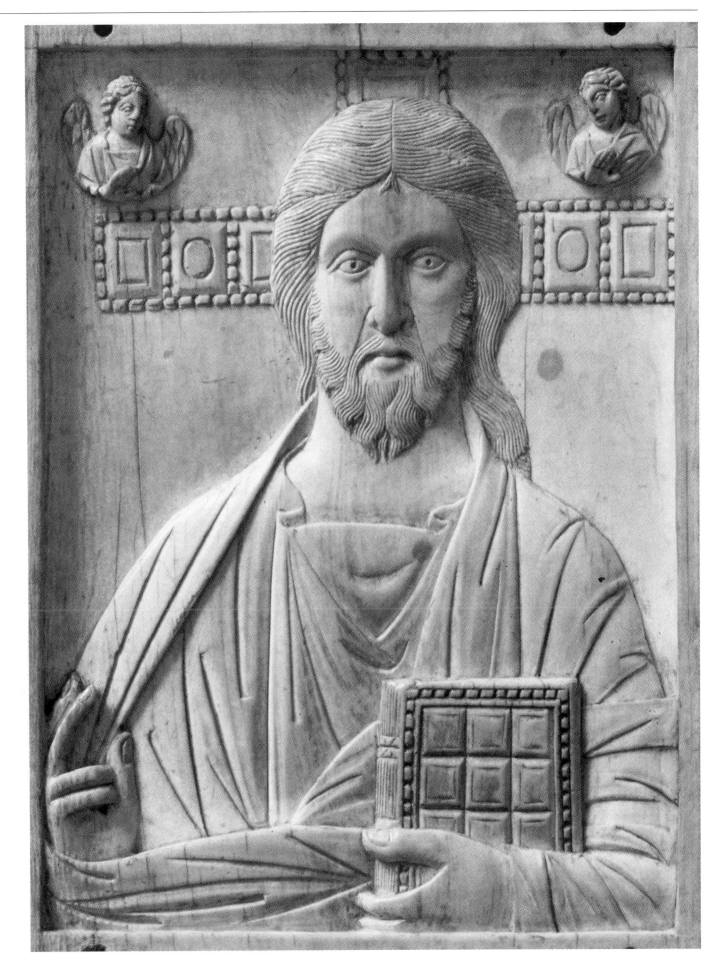

tin and the new artistic "barbarian" languages, displaying an immediately tangible, and at the same time spiritual, recognition of the new religion and culture of an entire people. The Lombards, who had appeared in 568 on the eastern frontier as a terrible danger, had already by the turn of the century managed to assimilate themselves into the Latin world, feeding upon it to create a new, original culture.

As always it was Gregory the Great who expressed, with a phrase as effective as an advertising slogan, the significance and the rationale behind artistic creations linked to sacred subjects. "Per visibilia invisibilia demonstrare": this was a further step in the thinking of the pope. Rather than considering a work of art as a more or less weak reflection of a superior concept of Beauty, as in the case of Augustinian aesthetics, he looked upon it as an indispensable tool for the route back towards the contemplation of the divine.

All the preceding neo-Platonic considerations are obviously condensed in this idea, as well as the echoes of works which precociously influenced medieval aesthetics. This is true for the thoughts about light expressed in the long *titulus* of the oratory dating back to the years between 494 and 519, which is an annex to the bishop's palace in Ravenna. The decorative and narrative system here excludes syntactic links. It is based on figures of great symbolic significance, such as those of the four angels almost cut out from the gold background in the act of holding up a shield with Christ's monogram. The text represents a genuine aesthetic and symbolic manifesto: "Either the light was born here, or made prisoner, it has a free kingdom here; perhaps it is the first light, which came from where heavenly beauty now comes. Perhaps private walls generated a shining glimmer and the ray, made prisoner here, shines without the external rays. You see the marble bloom in a serene sparkling and the reflections of each stone of the purple vault..."

These thoughts on the light striking the gold background, giving it physical form by reflecting there and yet at the same time spiritualizing it, are taken up again and at a deeper level over six centuries later. Suger (abbot of Saint-Denis from 1122-1151) wrote some passages commenting on the renewal of the ancient royal abbey of Saint-Denis, which he transformed into one of the first great Gothic constructions. These are among the most famous texts written in the Middle Ages on the anagogical value of works of art, in other words, their function, as seen by the Church, of guiding man from the tangible to the Invisible, of helping him to cast off materialism and enter a different spiritual dimension.

Of particular significance in this sense is Suger's description of the central door on the west side, where the Passion, Resurrection and Ascension of Christ were depicted in gilded bronze by the artist at the time: "Nobile claret opus, sed opus quod nobile claret / clarificat mentes, ut sant per lumina vera / ad verum lumen, ubi Christus ianua vera. / Quale sit intus in his determinat aurea porta: / mens hebes ad verum per materialia surgit, / et demersa prius hoc visa luce resurgit" (The noble work shines, but the work which nobly shines enlightens minds so that they can go on, through true lights, to the one true Light where Christ is the true door. This golden door shows how it exists in the things of this world: the blinded mind rises up to the truth through that which is material and from its darkened state it is raised up on seeing this light).

Erwin Panofsky regarded Suger as a key figure in the history of ideas about art (E. Panofsky, *Meaning in the Visual Arts. Papers in Art and on Art History*, Doubleday, Garden City, N.Y. 1955). In a well known commentary he interprets this passage by Suger saying that the soul, being incapable of attaining truth without the help of the material, will be guided by the "true lights" (*lumina vera*), even though they are purely perceptible phenomena, to the "true Light" (*verum lumen*) which, according to the Church, is Christ; and thus it will rise up or rather "rise up again" (*surgit, resurgit*) from its worldly bonds as Christ is seen to rise up in the *Resurrectio vel Ascensio* portrayed on the doors.

As we have seen, these are ideas which, in fact, permeated the entire medieval period. The radical position of Bernard of Chiaravalle was in direct contrast to them. In his *Apologia ad Willelmum* (1124) he laid down, or rather reproposed, a completely different set of aesthetic principles which were in stark contrast, substituting the richness and splendour of gold and sculpture with the absolute rationality of the sign and the laws of mathematics. This represented total opposition, pointing to a completely different way for art to guide man to the divine, a way which would now be based on values which were absolutely rational. The *formosa difformitas* and the *difformis formositas*, an admirable verbal synthesis of the formal and narrative wealth of Romanesque sculpture, were now suppressed as being elements disturbing contemplation. They were replaced by the absolute purity of structures measured according to mathematical formulae, concrete allusions to absolute eternal perfection. This was also a way which completely broke up preceding medieval aesthetic principles and which opened up new artistic research. Architectonic spaces now became symbolic, analogical spaces and, through further evolution, dramatic spaces. These were the spaces of mendicant architecture which made it immediately obvious,

even to the most inexpert of observers, that there was a tangible difference between the space reserved for the people and that reserved for the celebration, for the sacrifice. The former, represented by the naves, consisted of wide open spaces which could be easily crossed and were reserved for listening to sermons. The latter, that of the altar, covered by a vault and suffused by the transfiguring light from the great apsidal windows, was reserved for the celebration of the mystery of the incarnatiom. A total revolution, also from the architectural point of view, was thus carried out by the Church in the mechanism of evangelization.

With Saint Francis and his friars, the Church became a missionary body once again, walking the roads and preaching to the people in the vernacular so that everybody could understand. The teaching of Gregory the Great was once again put into practice: the words of the Revelation, he believed, cannot and must not be crushed by grammatical rules and formalisms.

The Early Middle Ages provides a wealth of examples connected with this subject which deserve further and more extensive investigation. It is impossible not to mention, even if only briefly, a famous picture cycle whose missionary function appears to be indisputable. These are the frescoes in the church of Santa Maria Foris Portae at Castelseprio, in which iconographical analysis has revealed the presence of scenes which are extremely rare and often practically unique. The main subject of the cycle is the story of the birth and childhood of Christ, presented on the basis of texts of certain apocryphal gospels, from which are drawn episodes which are only apparently marginal. This is the case, for example, in the scene of the Nativity of the detail concerning the figure of the midwife, who is incredulous at the continuing virginal state of Mary. Her outstretched hand is suddenly miraculously dried. Other scenes of great symbolic significance are connected to this one: the image of the Almighty on a shield and that of the cross enthroned, veiled and decorated by the crown, between two adoring angels in flight holding a globe dominated by the cross. The cycle therefore clearly and decisively stresses the unity of the human and the divine nature of Christ and the miracle of the incarnation.

This is an affirmation whose full significance can only be interpreted, in the historical sense, if it is viewed from the perspective of a particular moment of cultural development, the period between the occupation of the territory by the Lombards and the years when they were converted from Arianism to Catholicism. In the historical period before their arrival in Italy the Lombards had been followers of the heresy spread during the 4th century by Ari-

us, a priest from Alexandria in Egypt. According to his teaching, which was opposed by the Church, Christ was not the Son of God but only the noblest of His creatures and therefore different from Him by nature and radically inferior to Him in authority and dignity. This heresy had resisted the various condemnations pronounced on it by the Councils and, spreading first in the East, it had been adopted by different barbarian peoples, the Goths, the Vandals and the Lombards, who had brought it to the West. The iconography of the scene in Castelseprio, a persistent affirmation of the unity of the two natures in the person of Christ and of his divine glory, was clearly an anti-Arian manifesto and its motivation can be found only in this particular historical moment. Further confirmation of the dating of the cycle during the early Lombard period in Italy comes from this. Only at this moment can the rare iconography of the cycle be precisely contextualized and interpreted as part of a programme for the evangelization of the Lombards.

Art and Celebration

Gold Longobard cross, 10th century
(cat. no. 125).

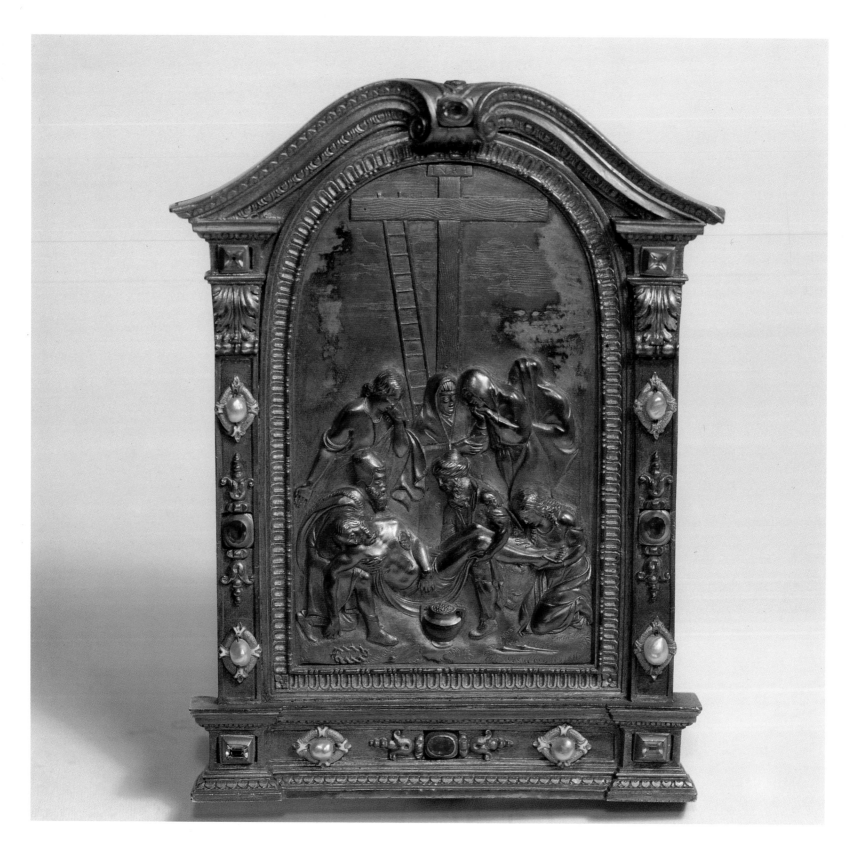

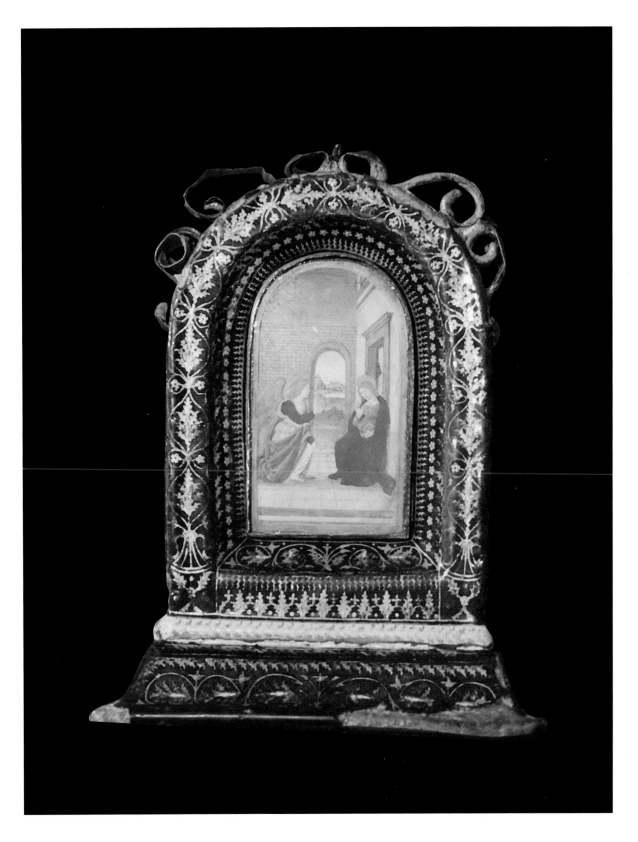

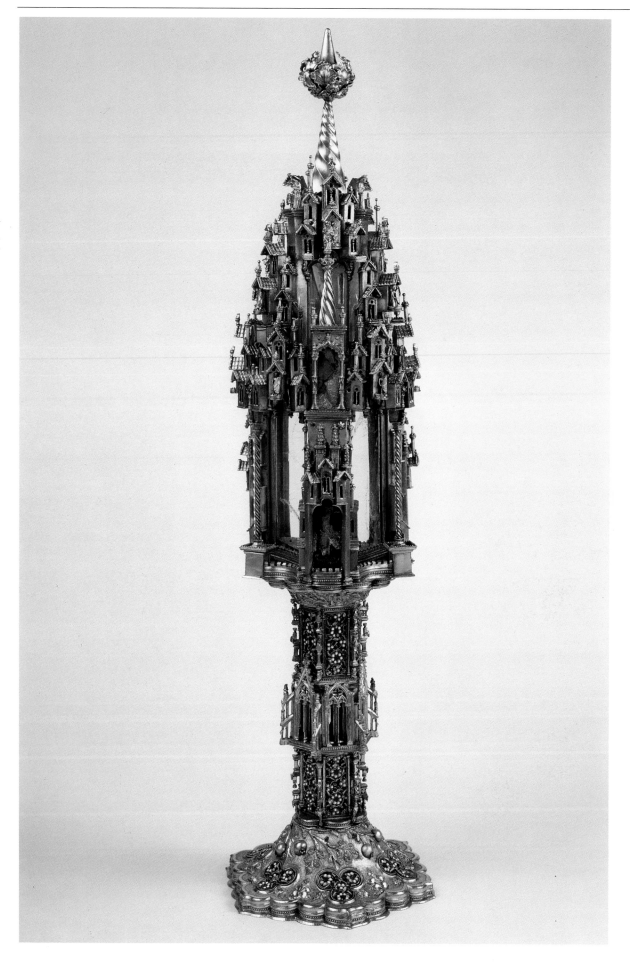

*Nicolò Lionello, Monstrance, 1435
(cat. no. 128).*

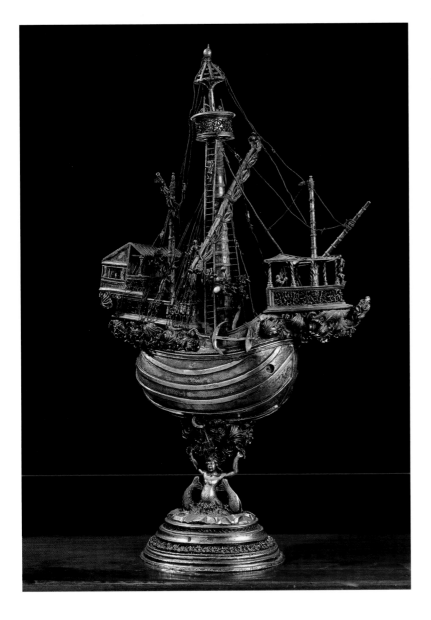
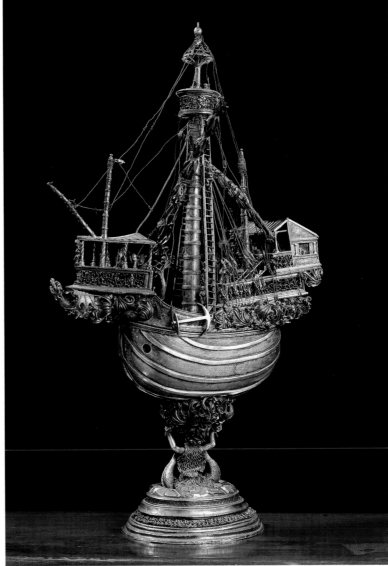

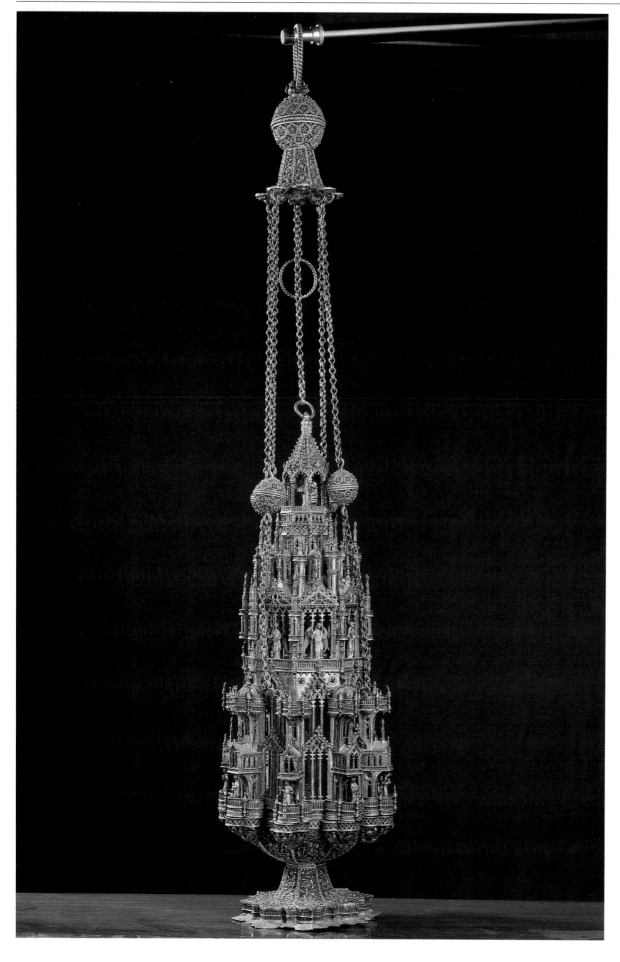

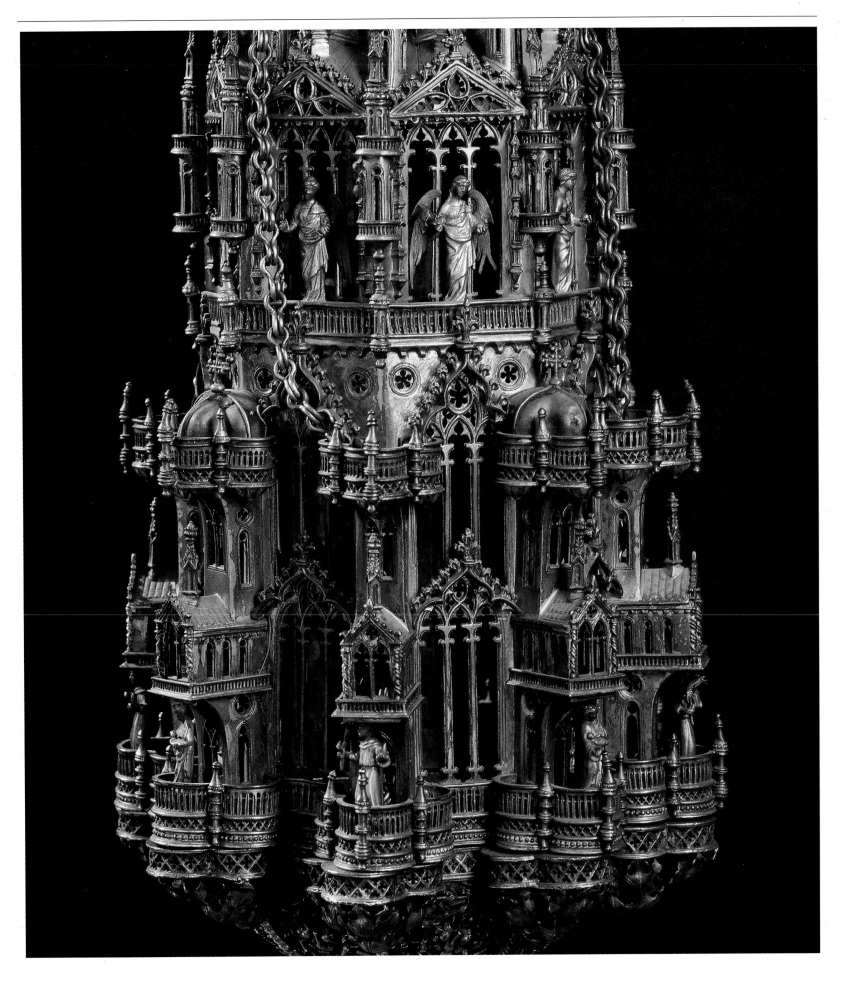

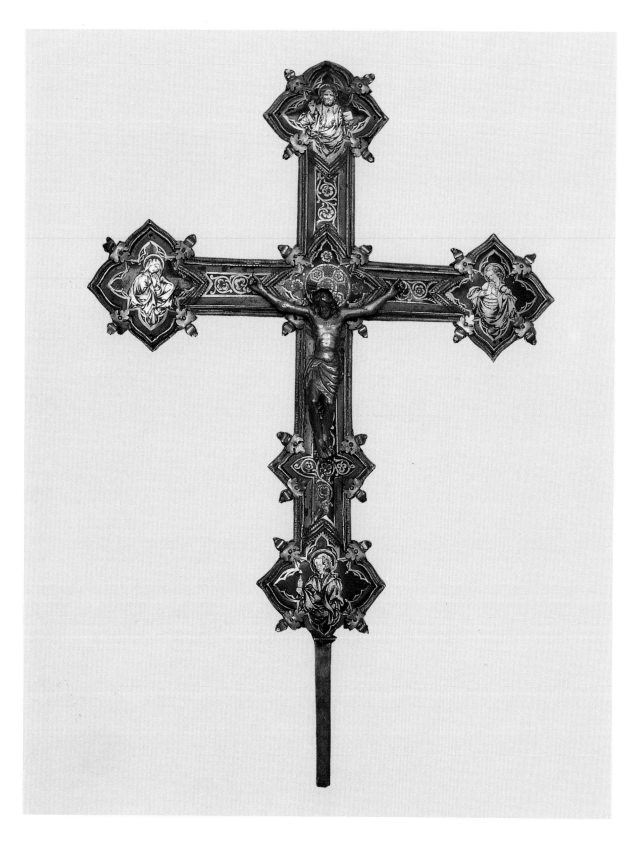

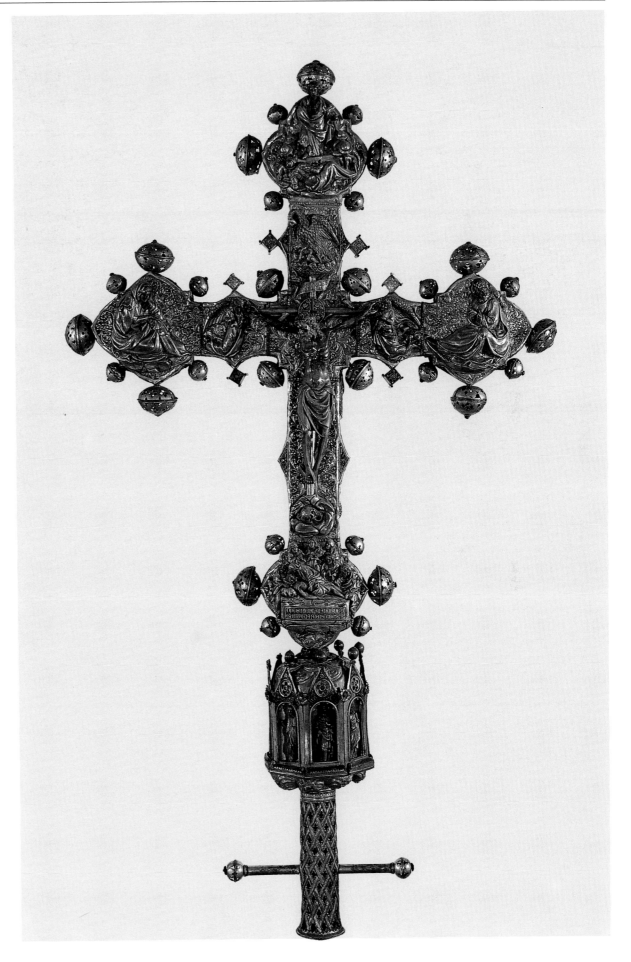

Nicola da Guardiagrele, Processional cross, 1434 (cat. no. 132).

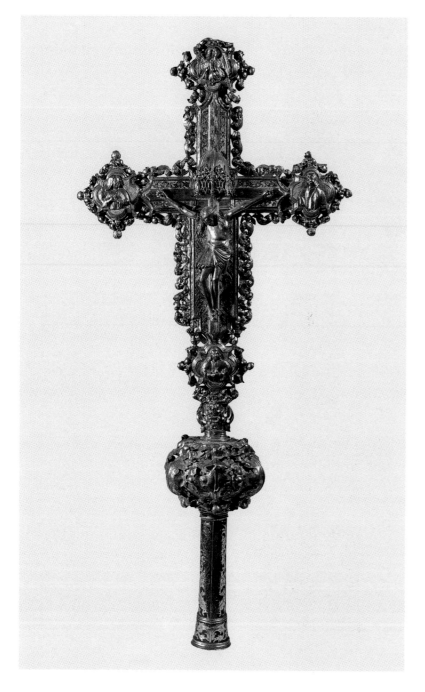
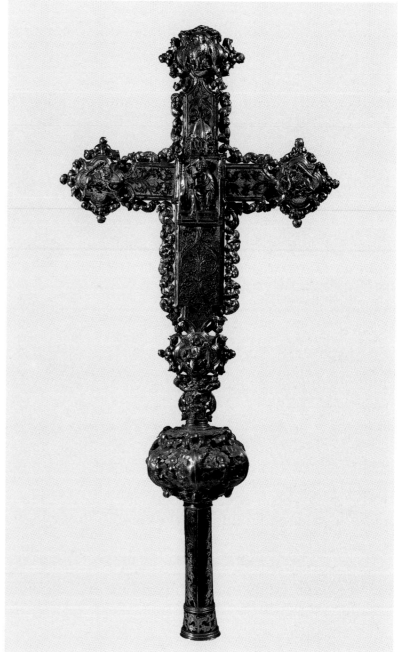

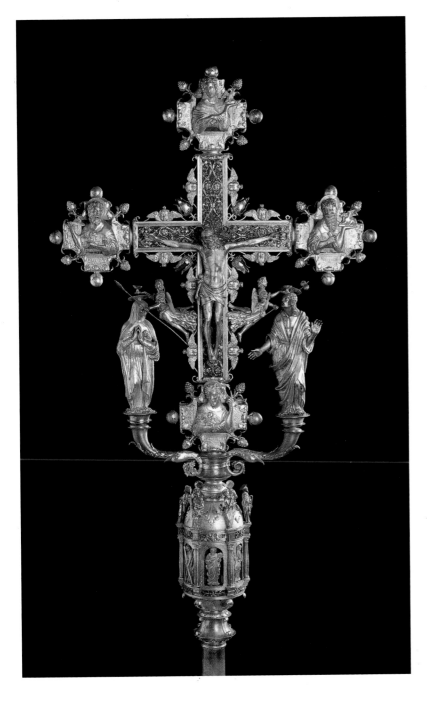

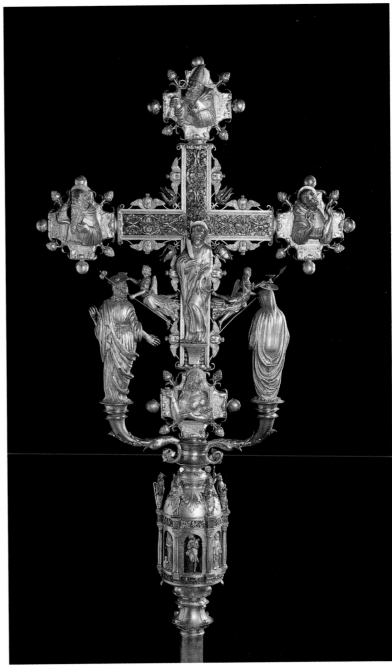

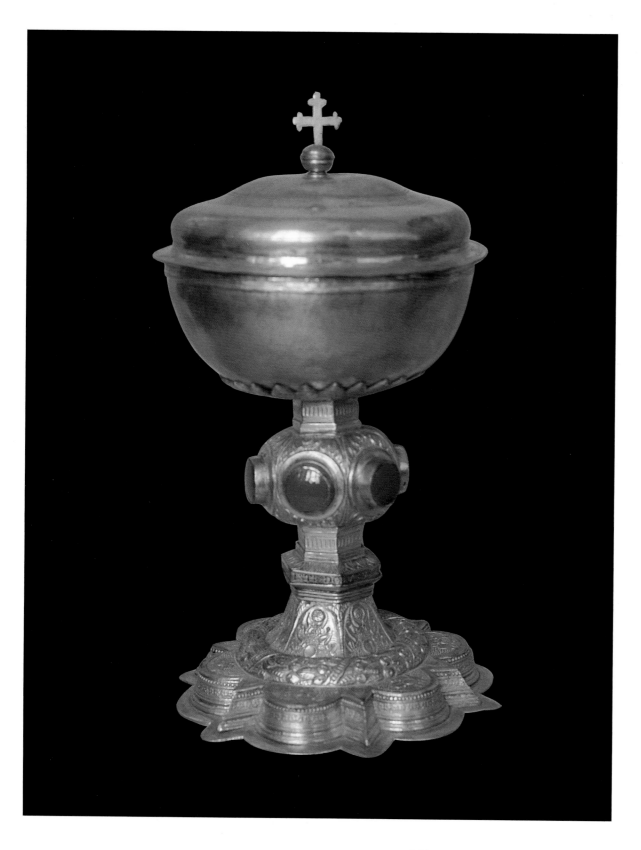

Chalice, 1496 (cat. no. 135).

*Giovanni Mameli, Candlesticks,
16th century (cat. nos. 136, 137).*

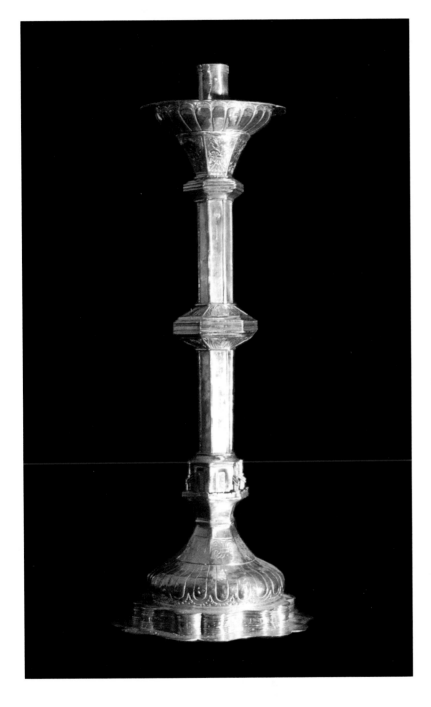

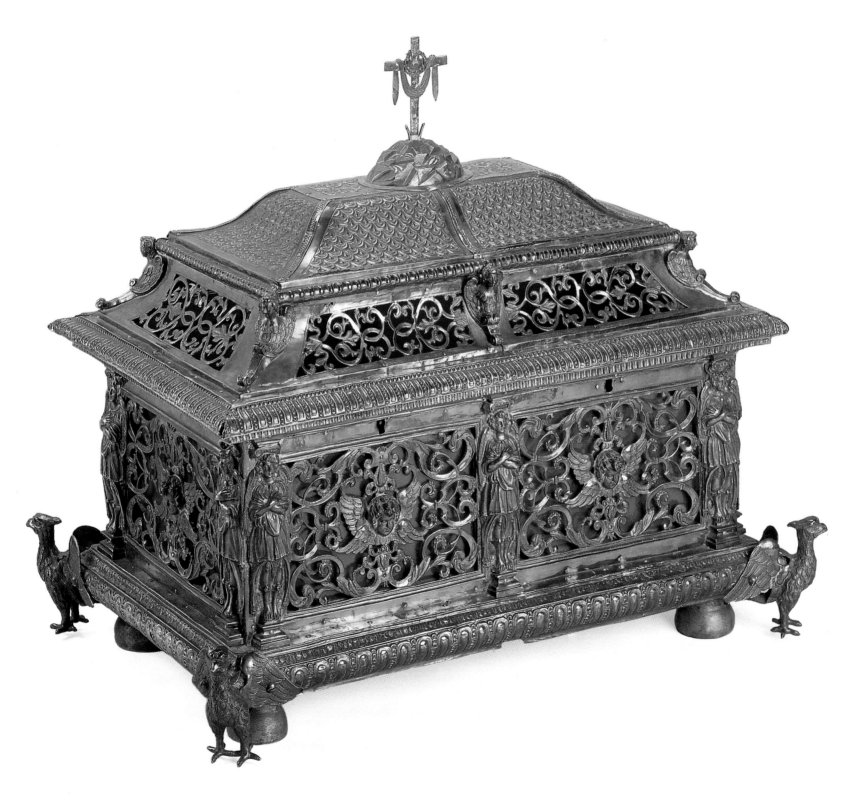

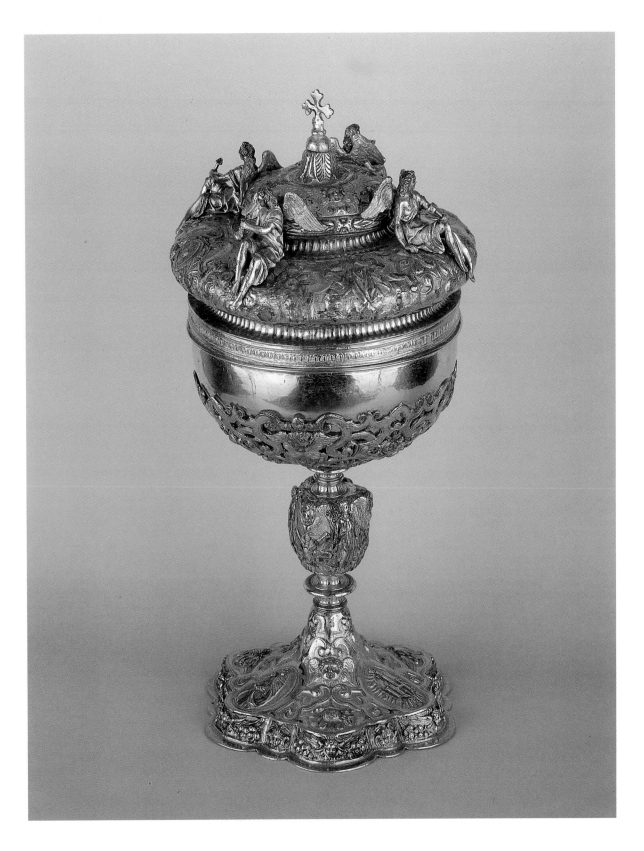

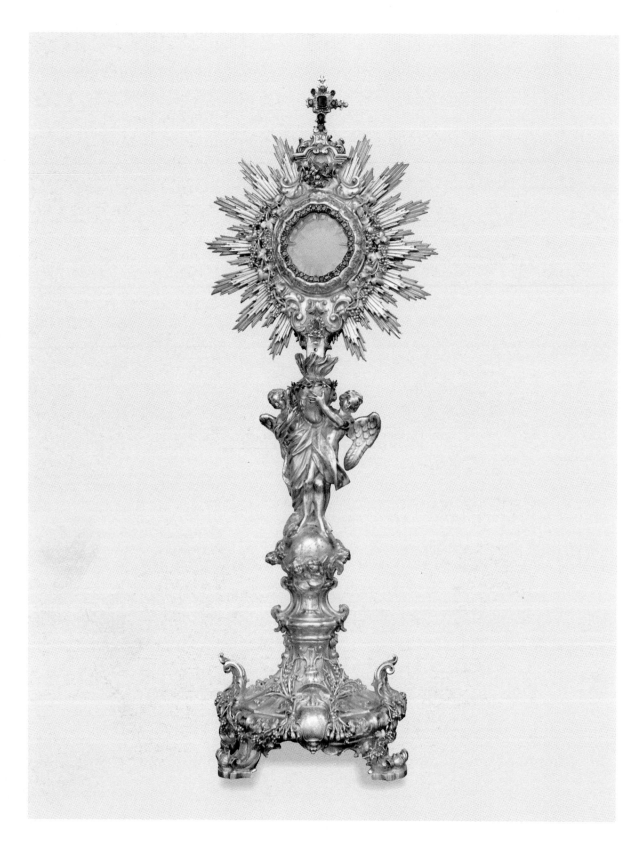

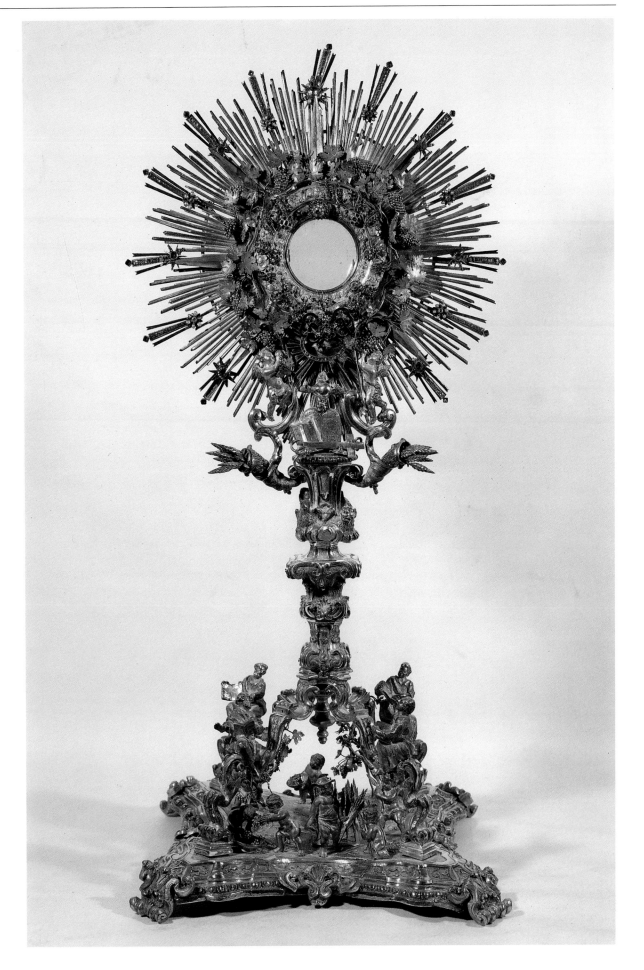

Monstrance, 1753 (cat. no. 141).

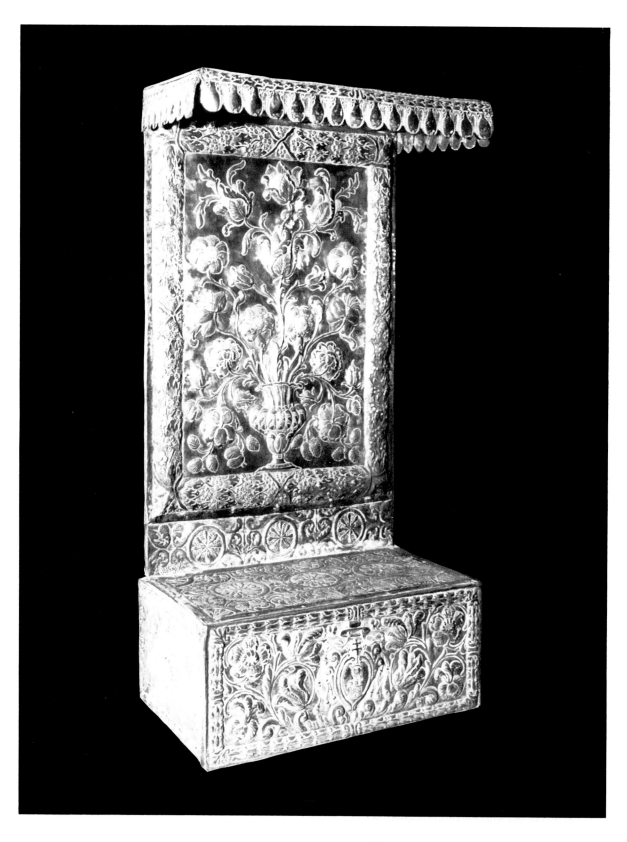

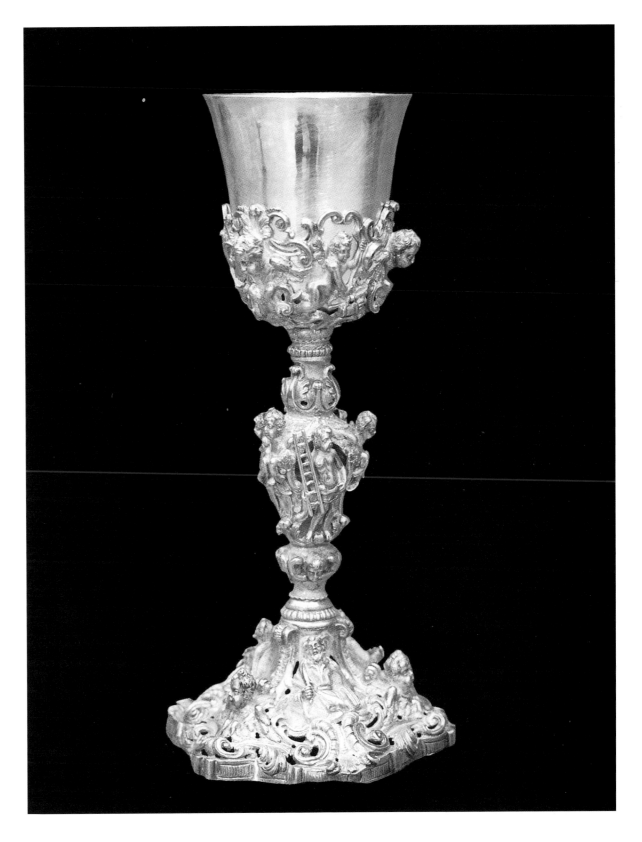

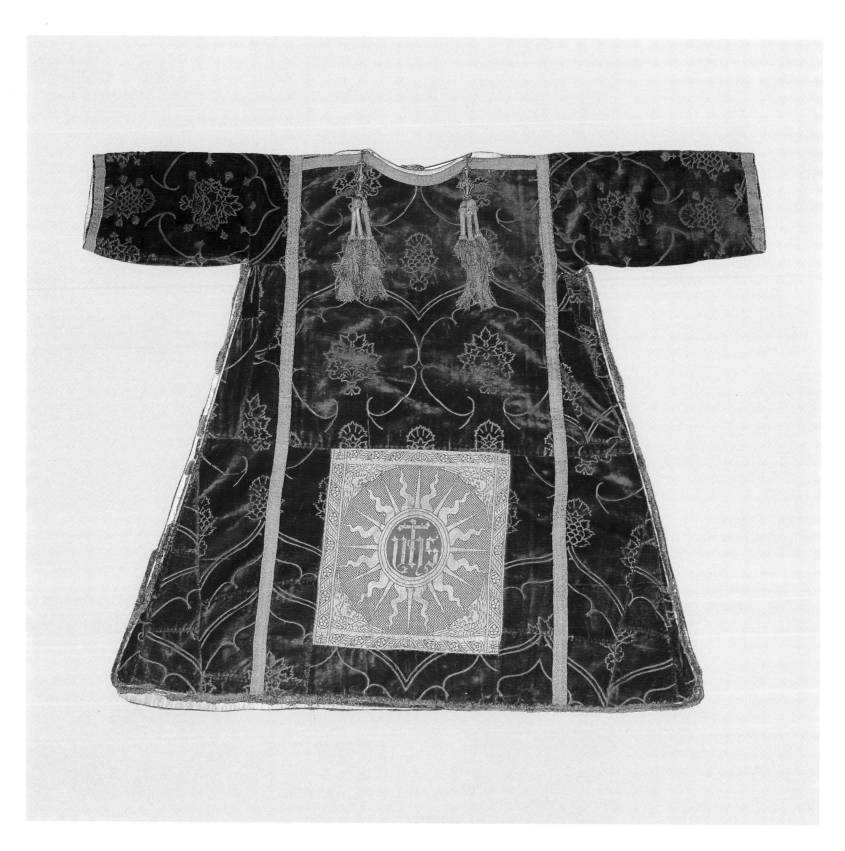

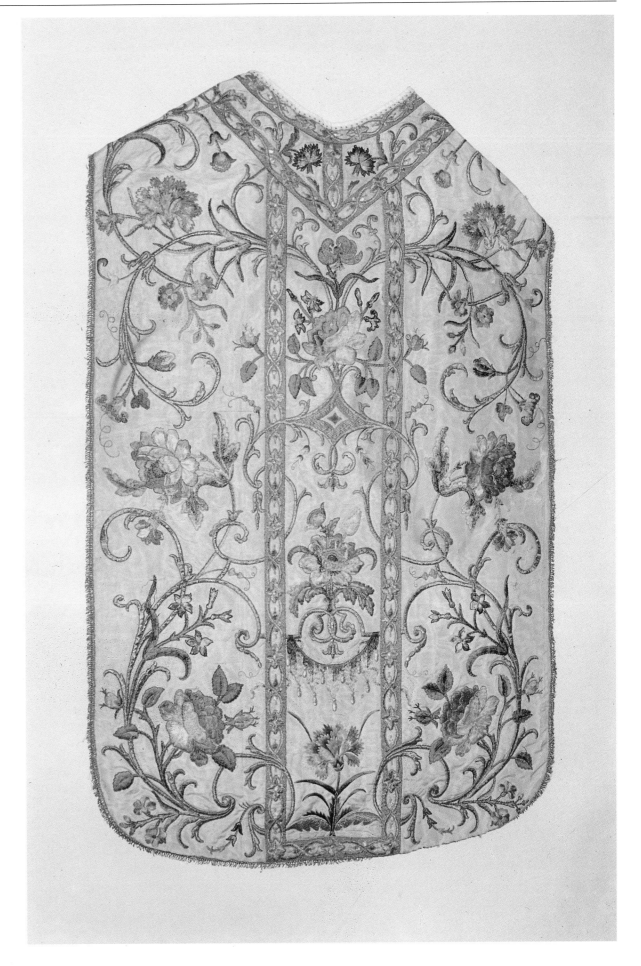

Chasuble, 17th century (cat. no. 146).

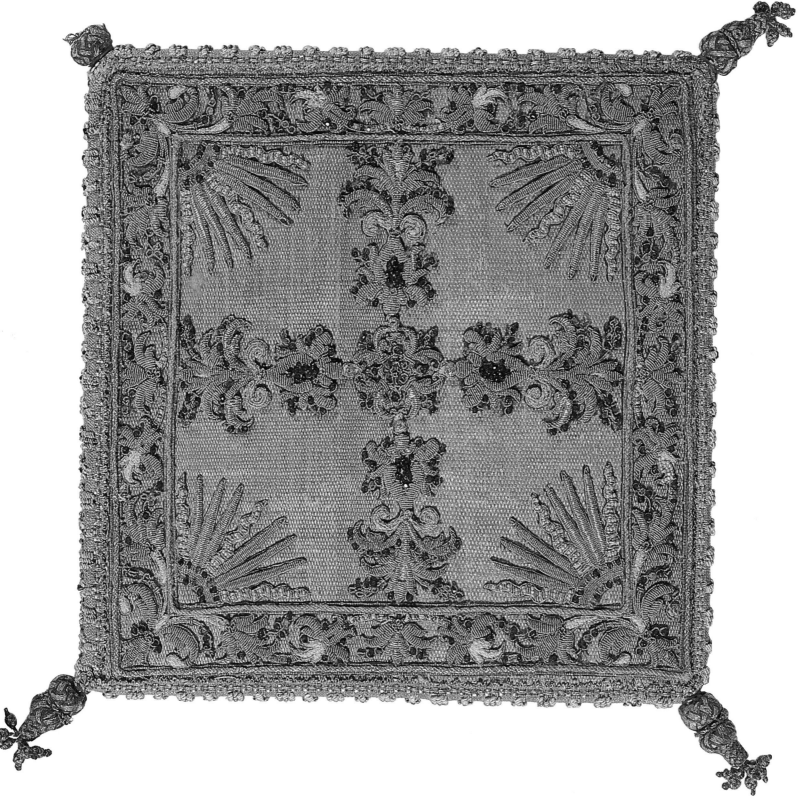

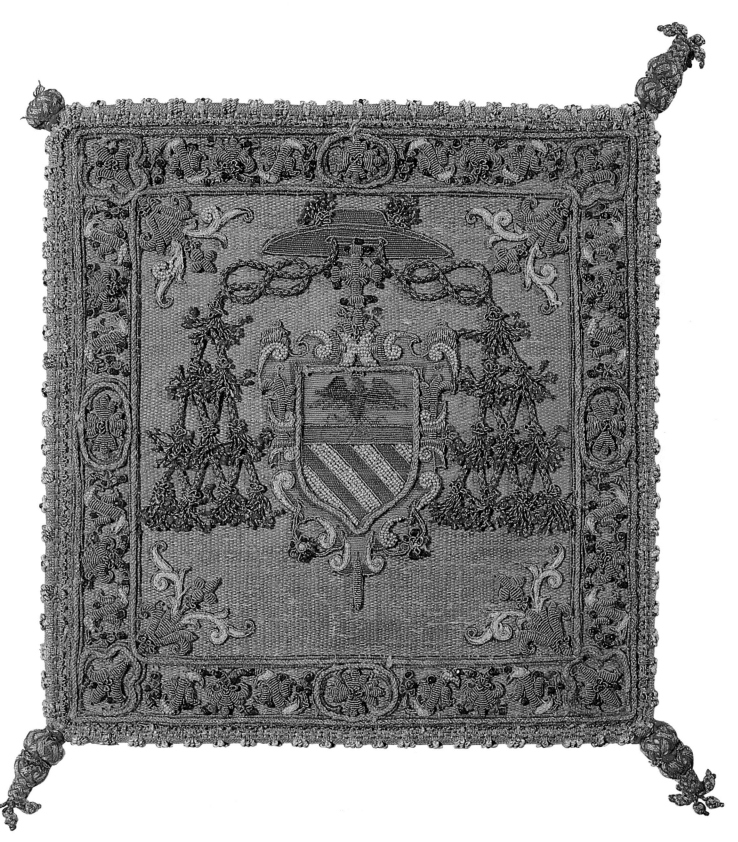

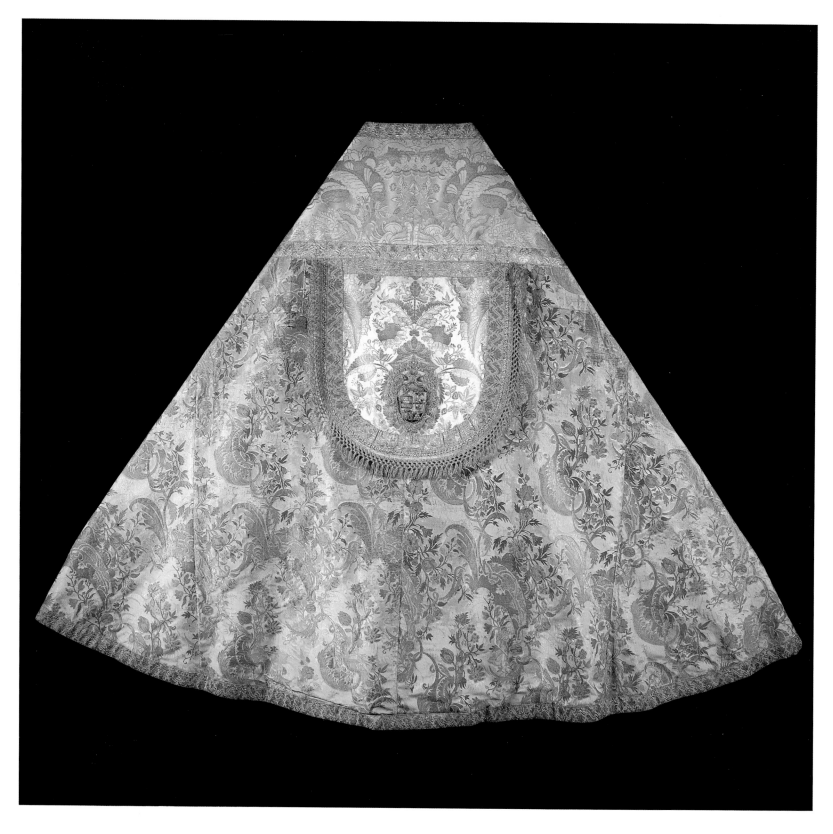

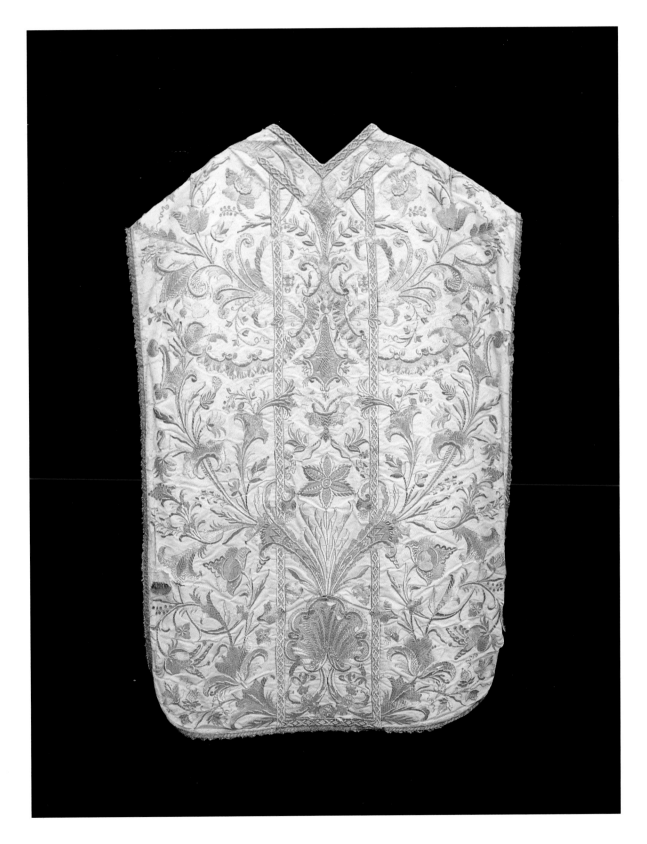

Art and Devotion

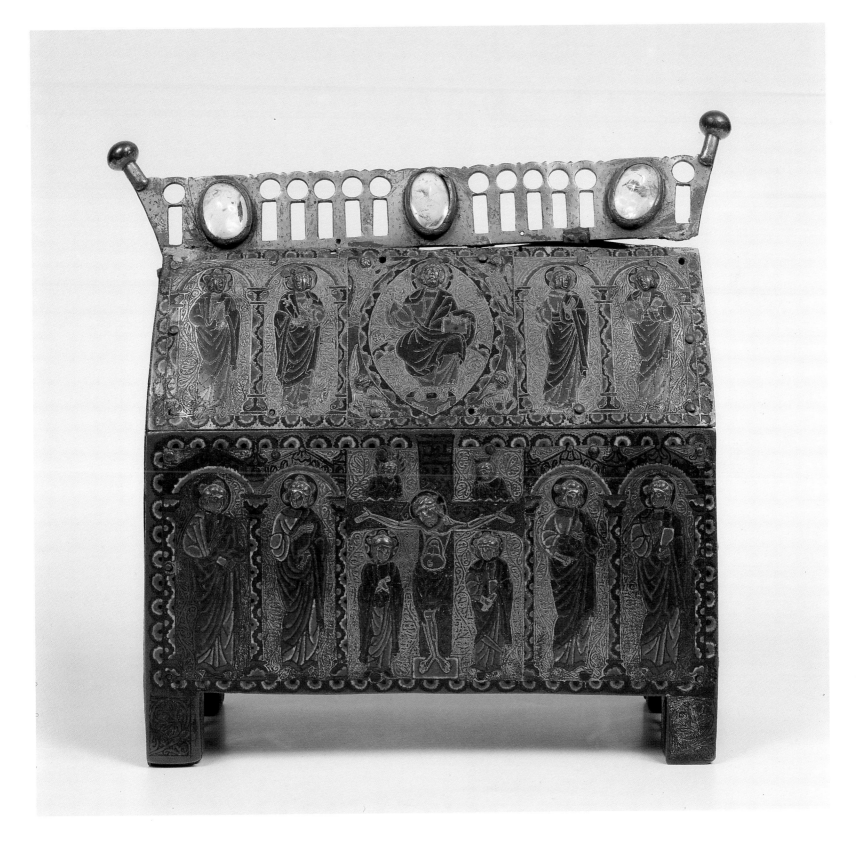

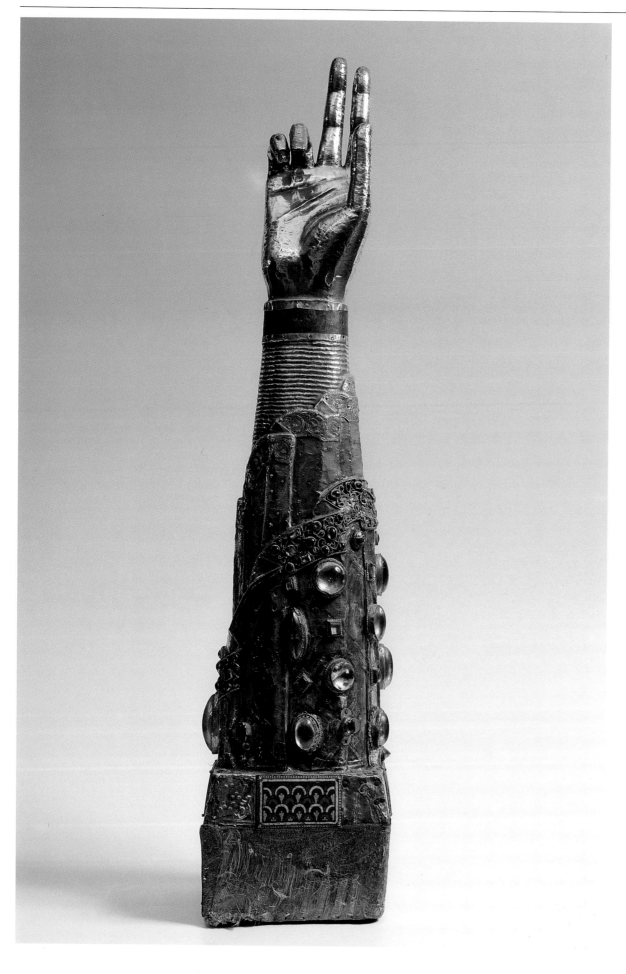

Reliquary of Saint Grato, early 13th century (cat. no. 151).

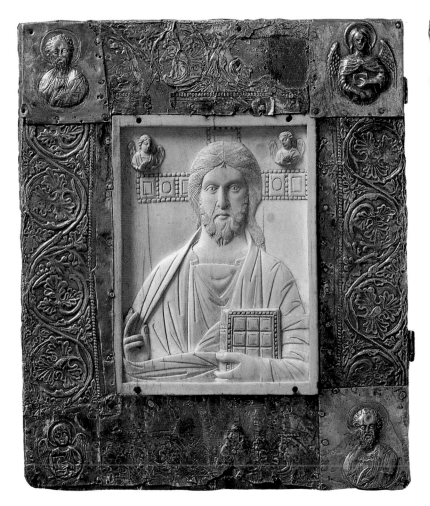

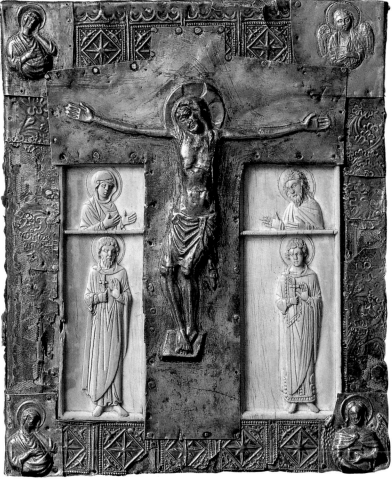

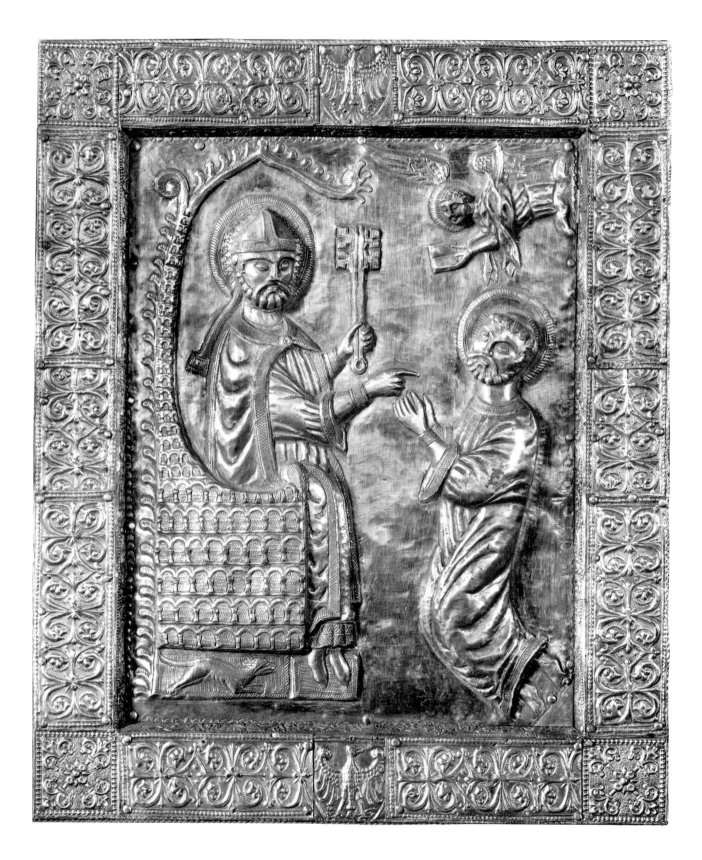

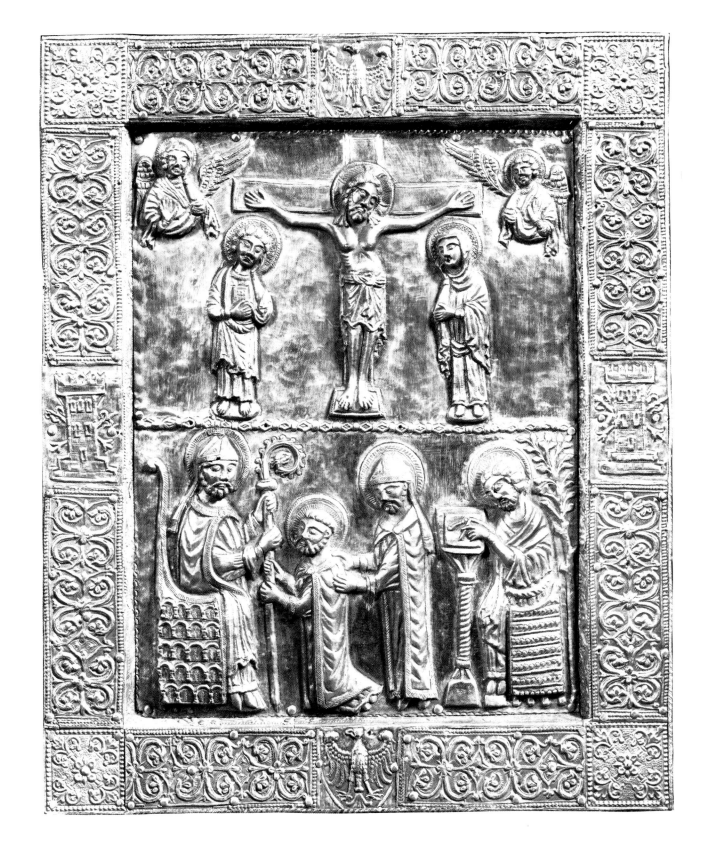

Rombolo Salvei, Reliquary of the Virgin, 1379 (cat. no. 154).

Reliquary of Saint George, 1390-1400 (cat. no. 155).

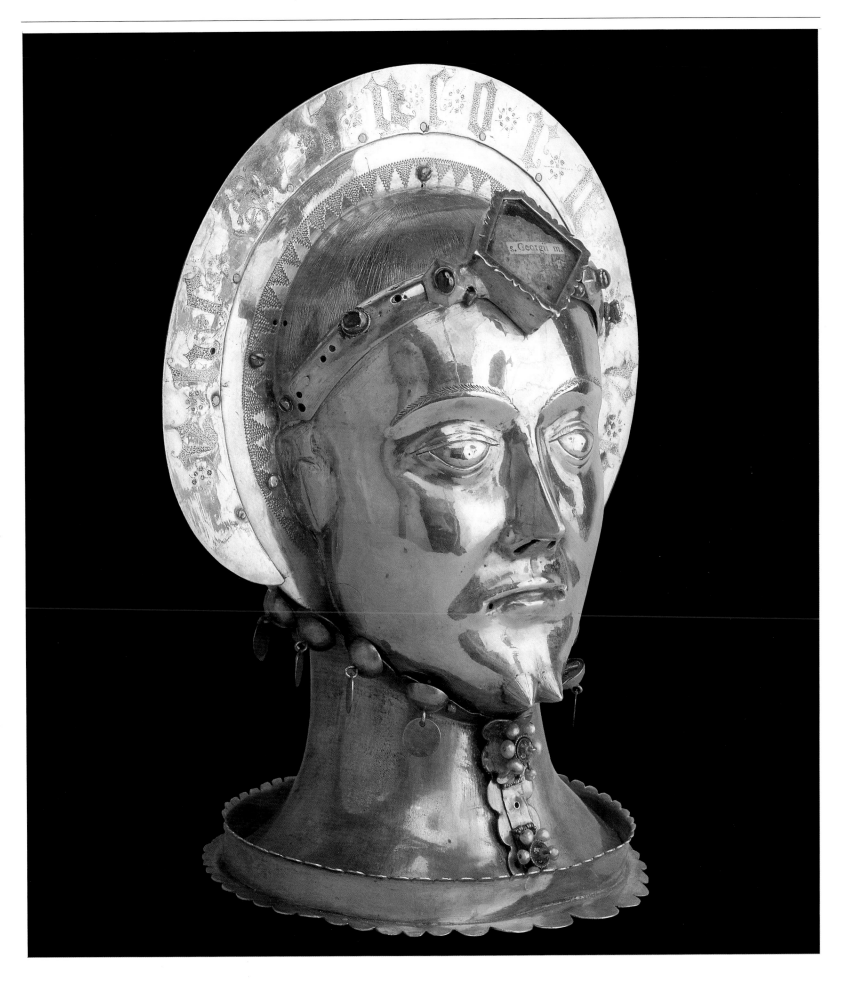

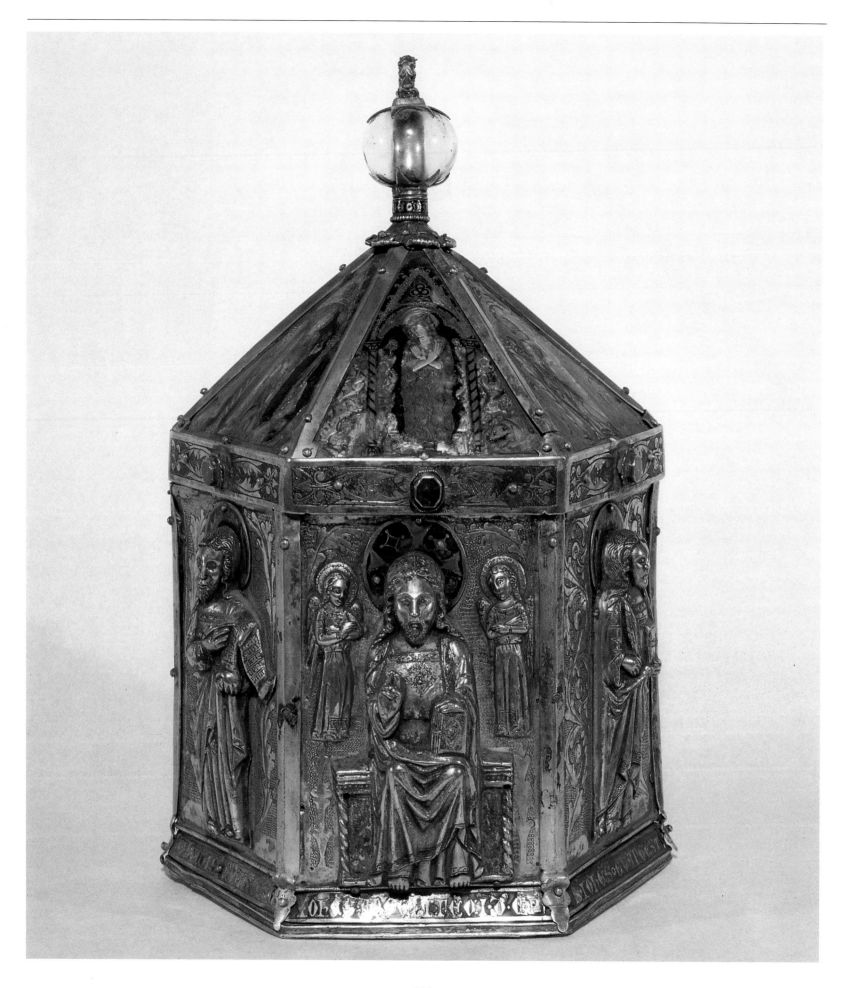

Giovanni D'Angelo da Civita di
Penne, Reliquary, 14th-15th century
(cat. no. 156).

Staurotheca of Saint Leonzio, 12th
century (cross); 15th century (base)
(cat. no. 157).

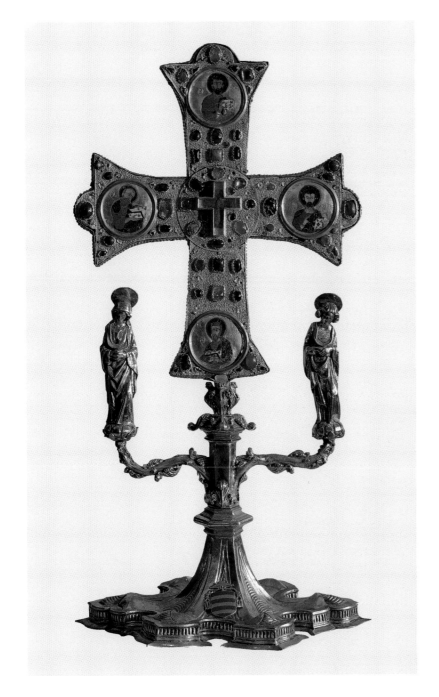

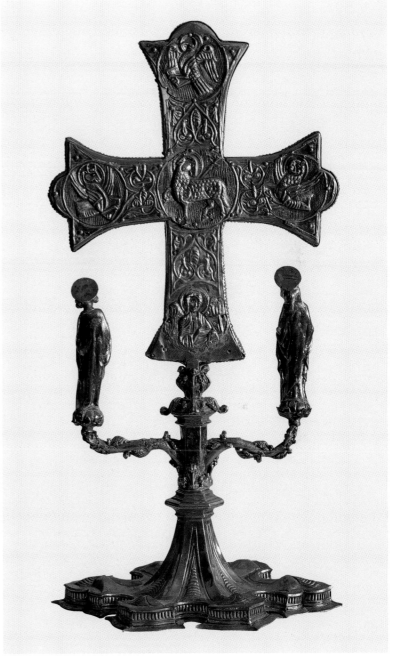

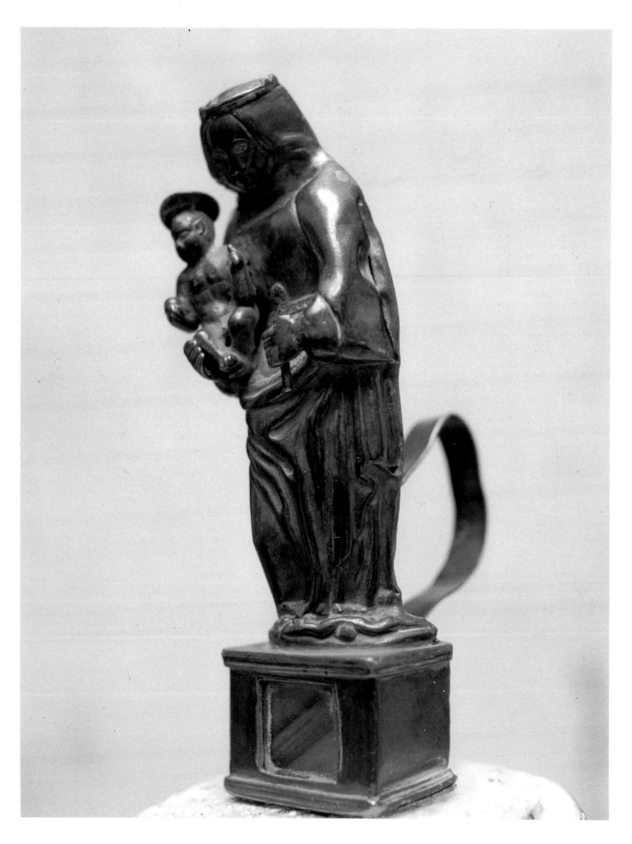

A. Le Clerc, Turin, city of the Holy Shroud and of the Blessed Sacrament, 1761 (cat. no. 159).

Art and Artists

Crucifix, 12th century (cat. no. 160).

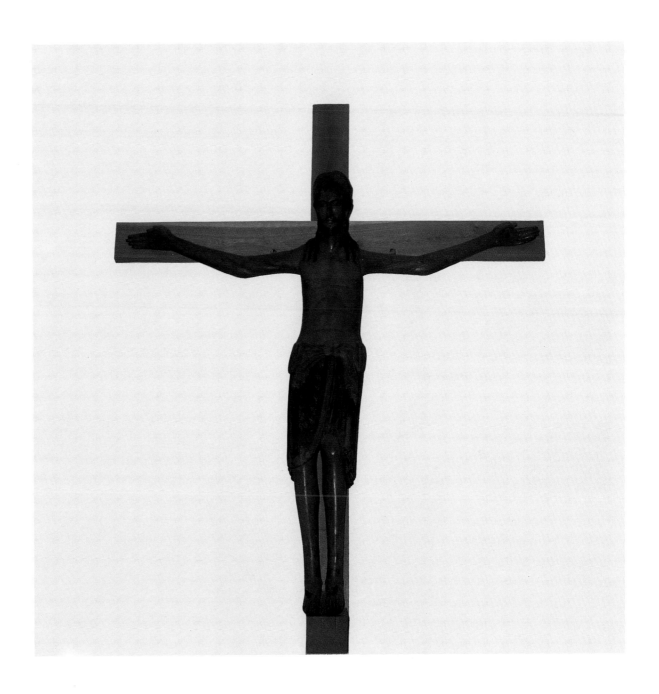

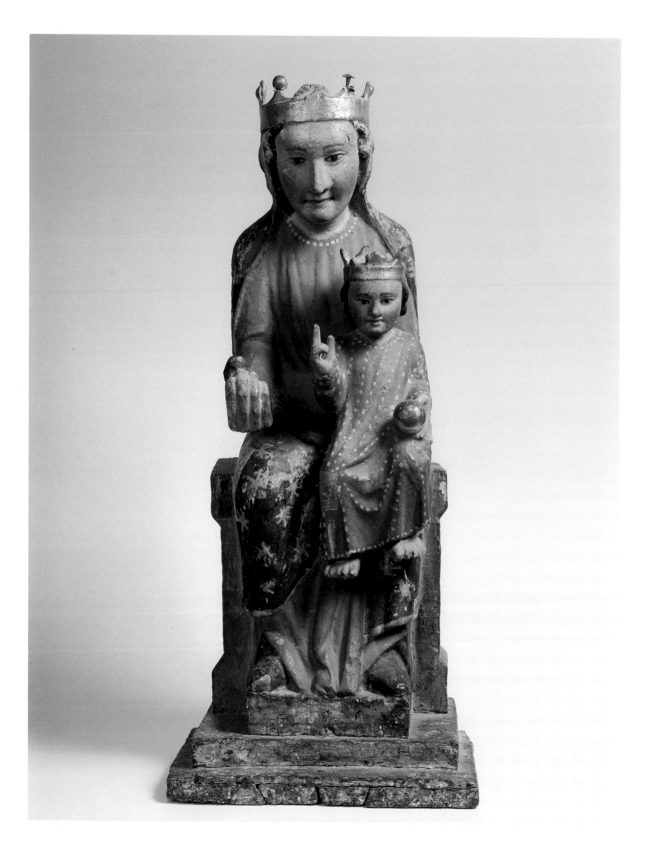

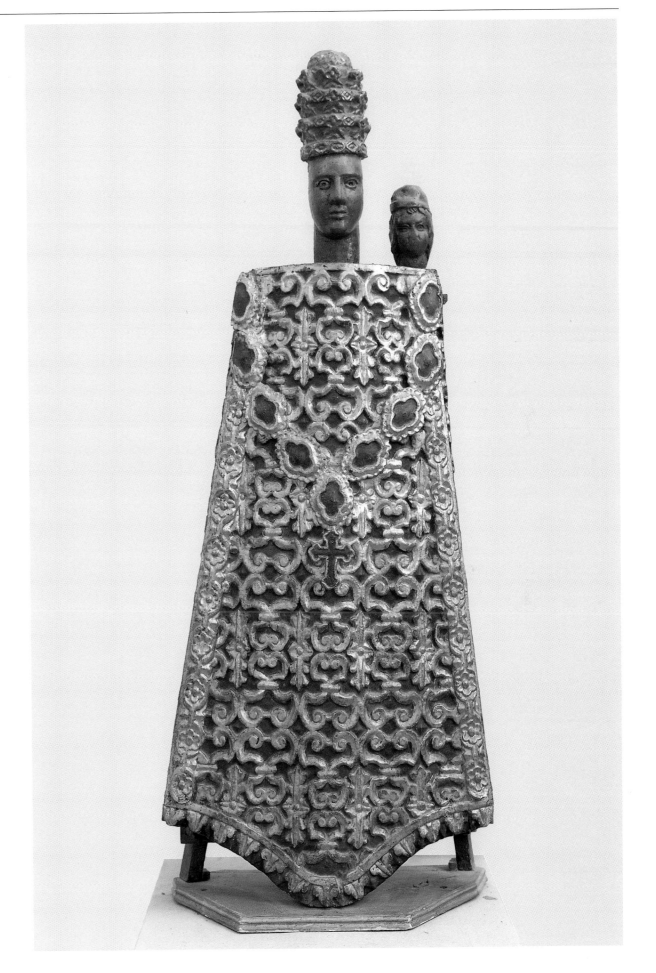

*Black Madonna, 16th century
(cat. no. 162).*

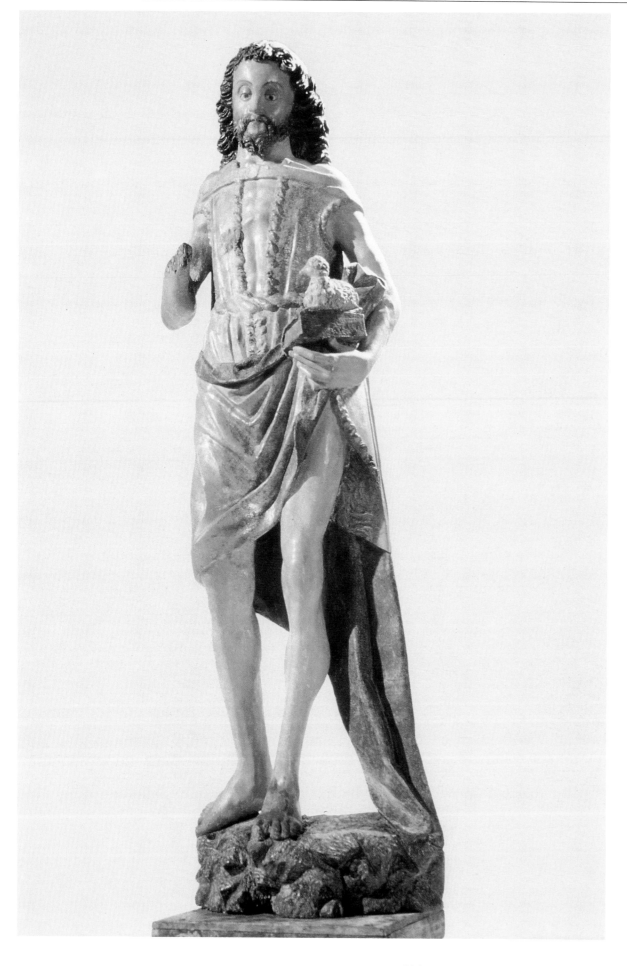

Saint John the Baptist, 15th century (cat. no. 163).

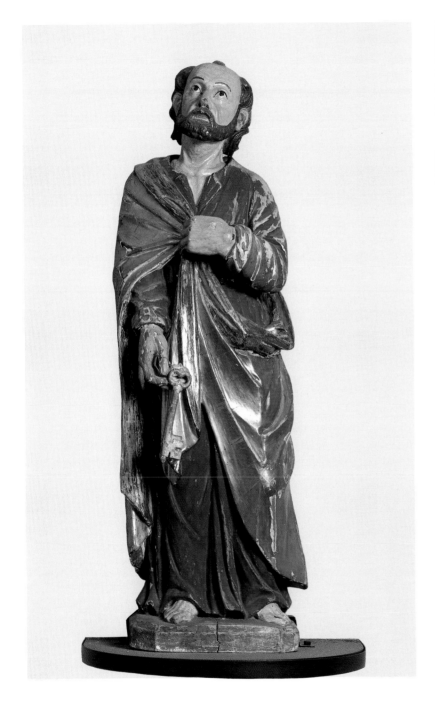

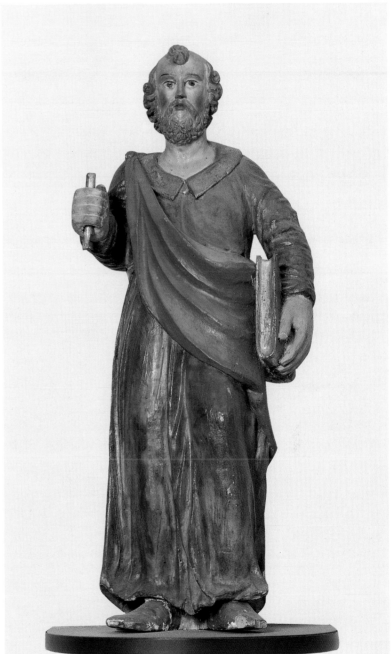

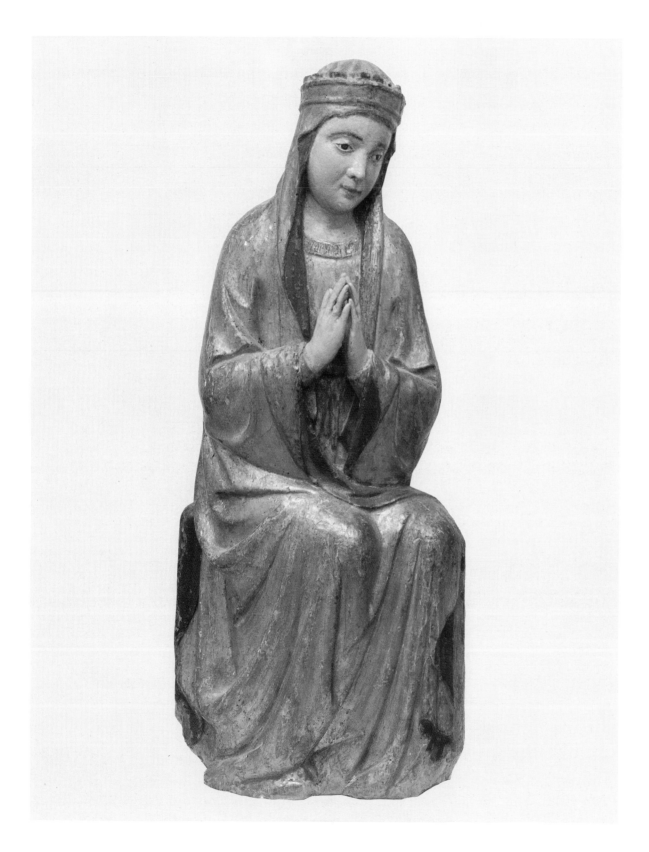

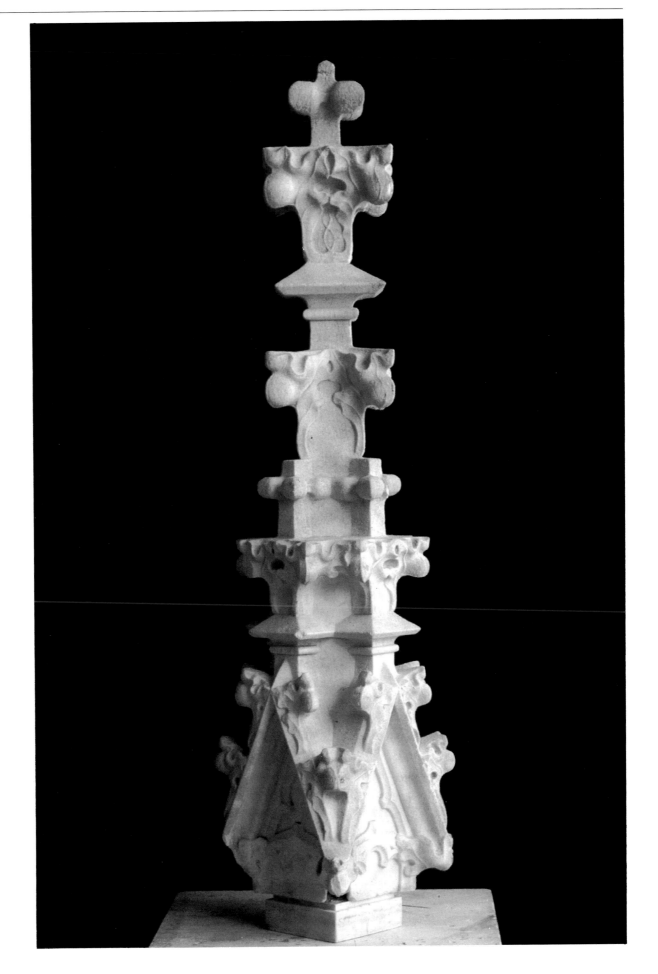

Small pyramid, early 16th century (cat. no. 167).

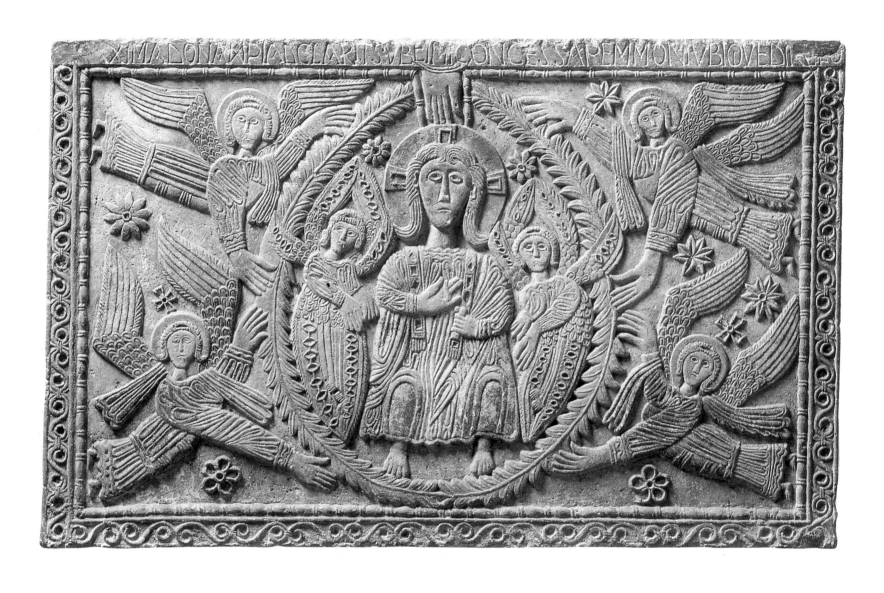

Ratchis altar, 737-744, front and sides
(cat. no. 168).

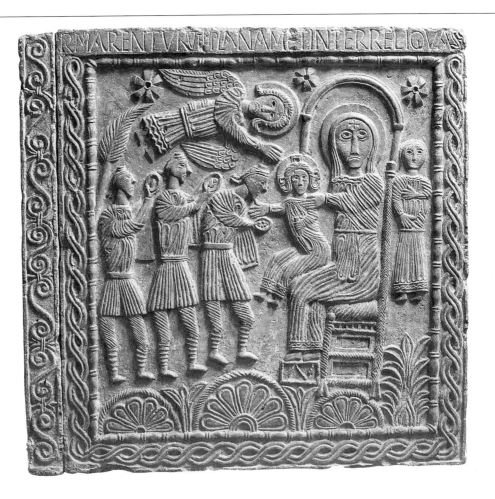

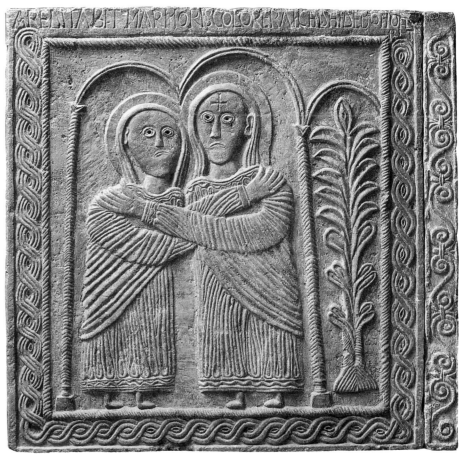

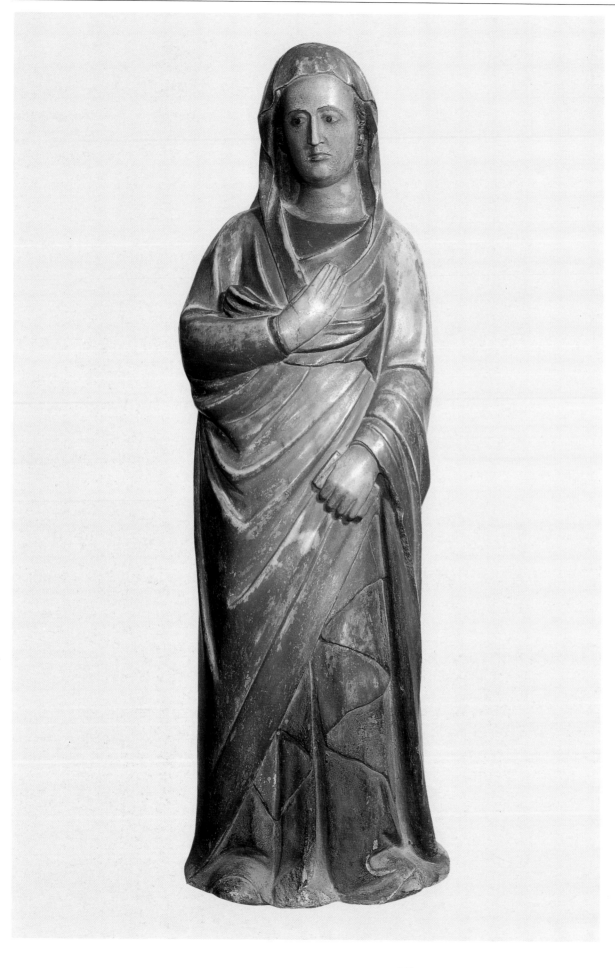

*Madonna, 14th-15th century
(cat. no. 169).*

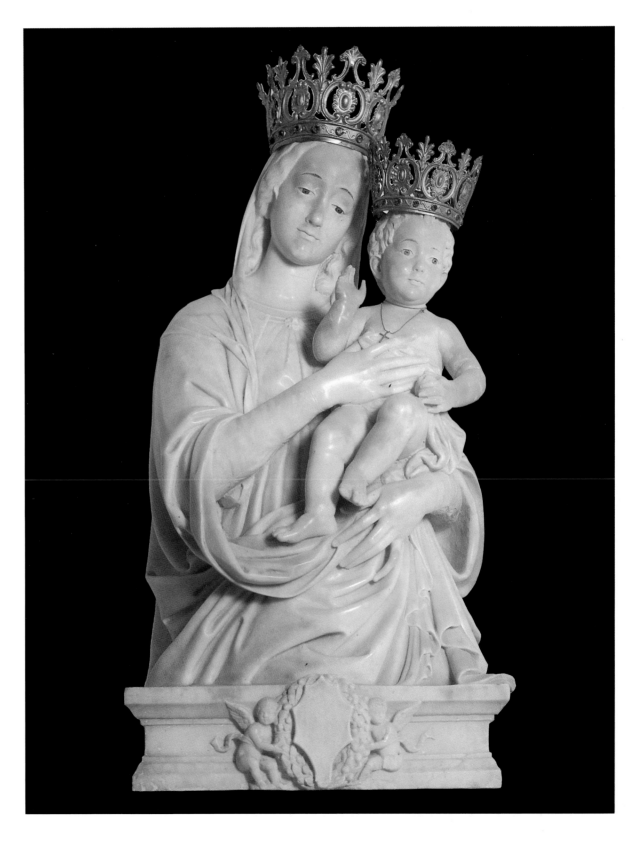

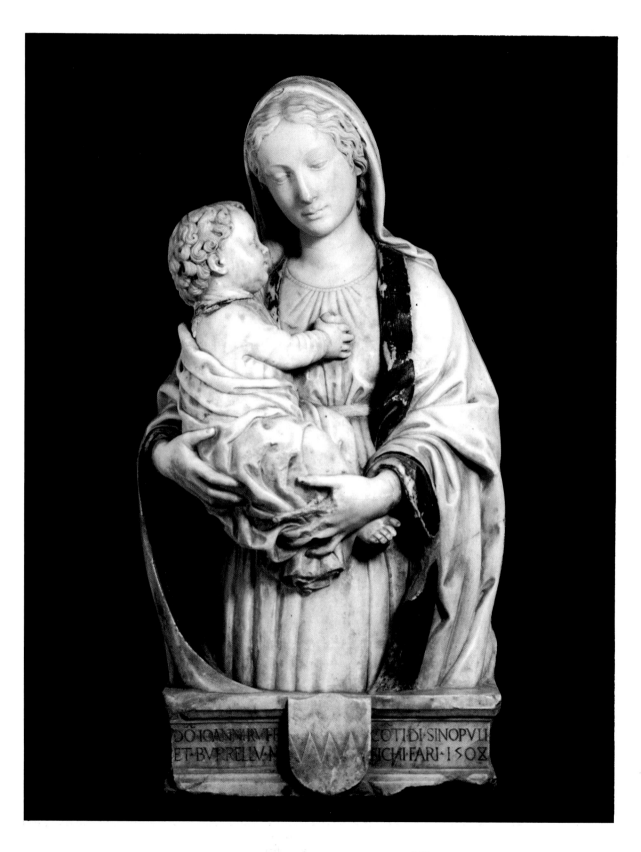

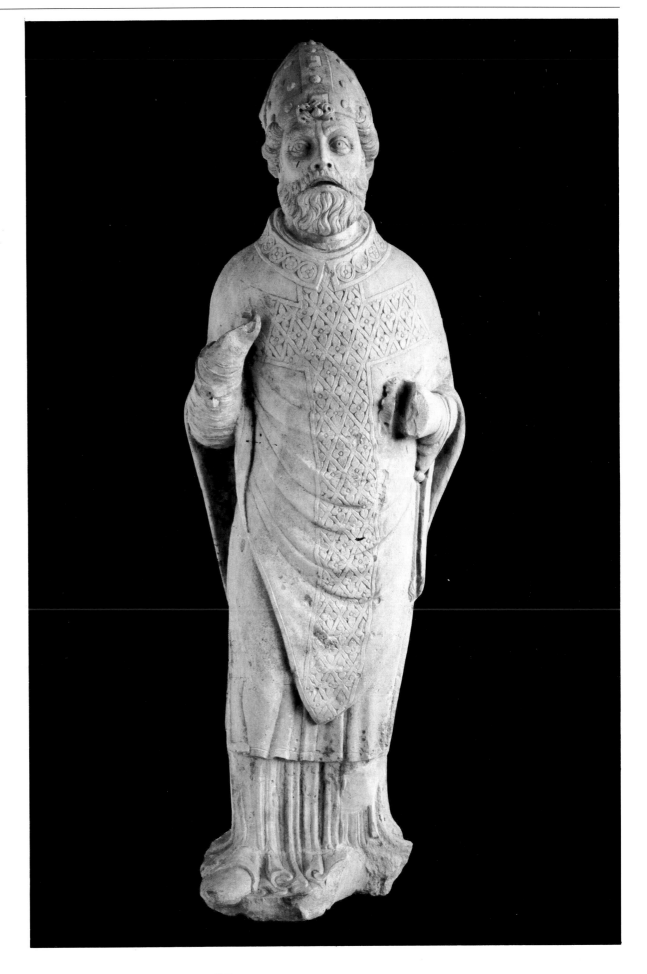

Statue of Saint Primianus,
14th century (cat. no. 172).

Altobello Persio da Montecaglioso,
Our Lady of the Annunciation
and Angel, 16th century
(cat. nos. 173, 174).

Pietà, 16th century (cat. no. 175).

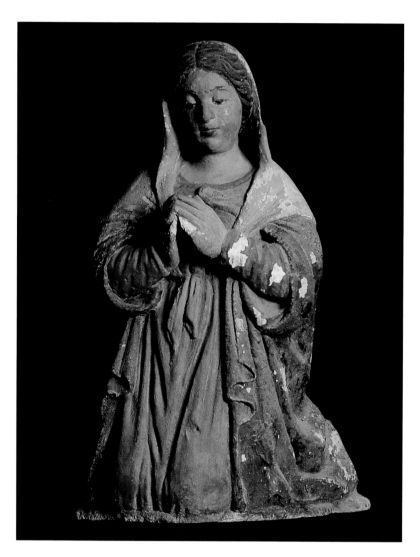

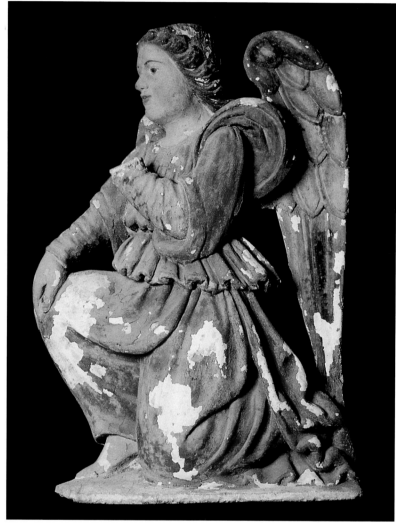

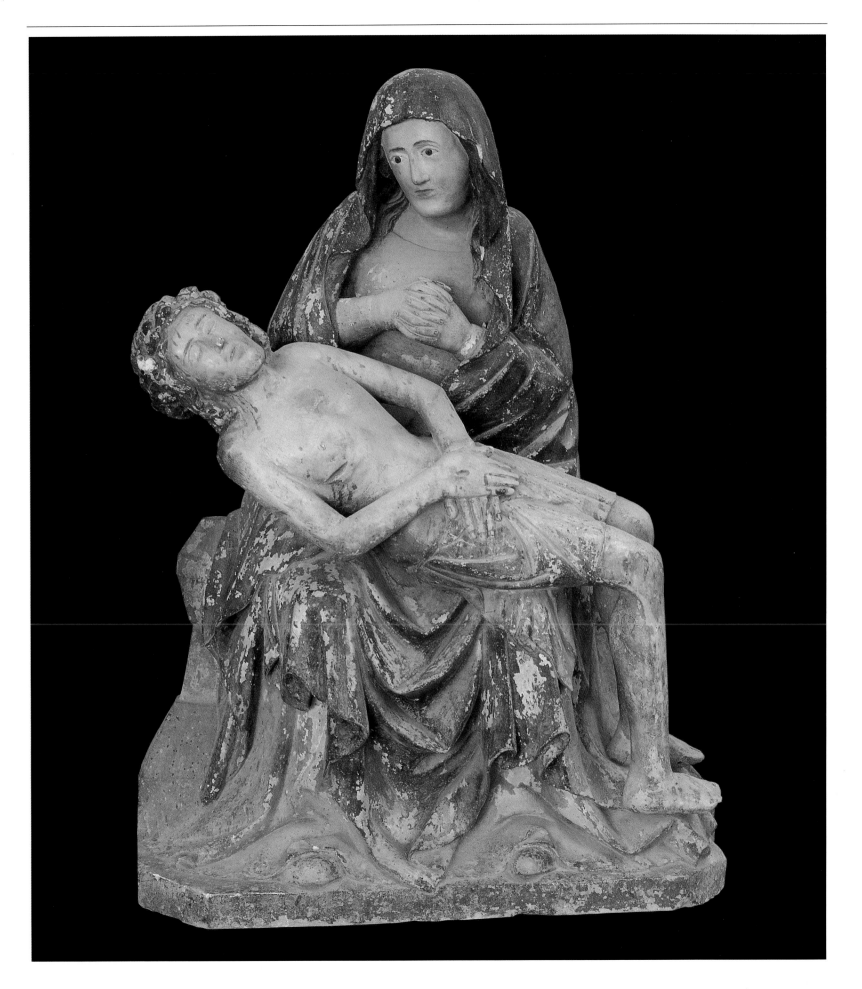

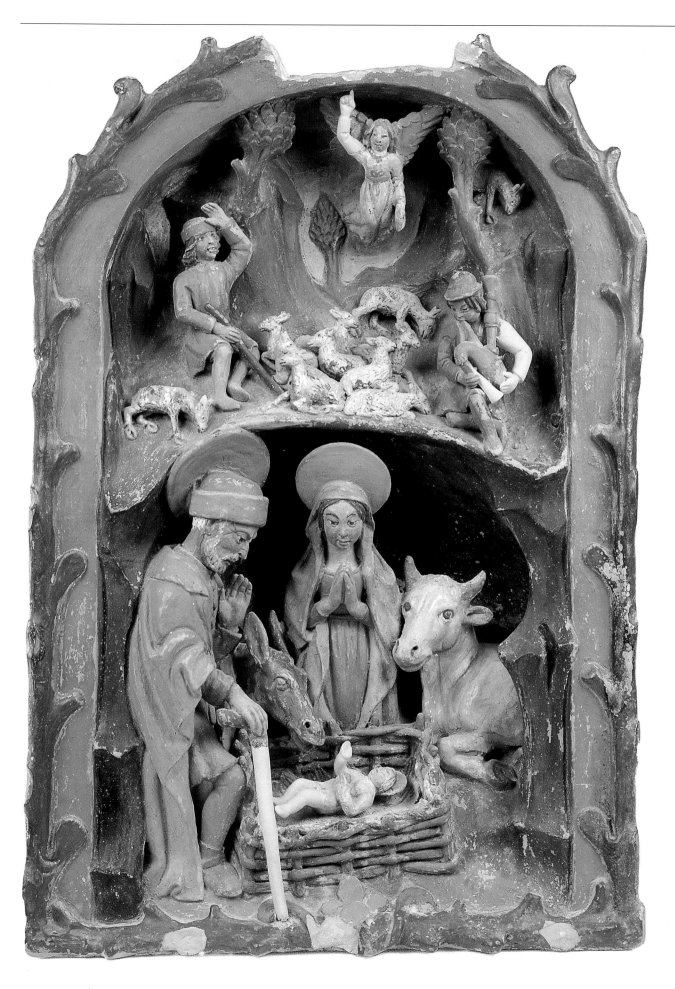

School of Silvestro dell'Aquila,
Madonna (fragment of a sculpture
group), 15th century (cat. no. 177).

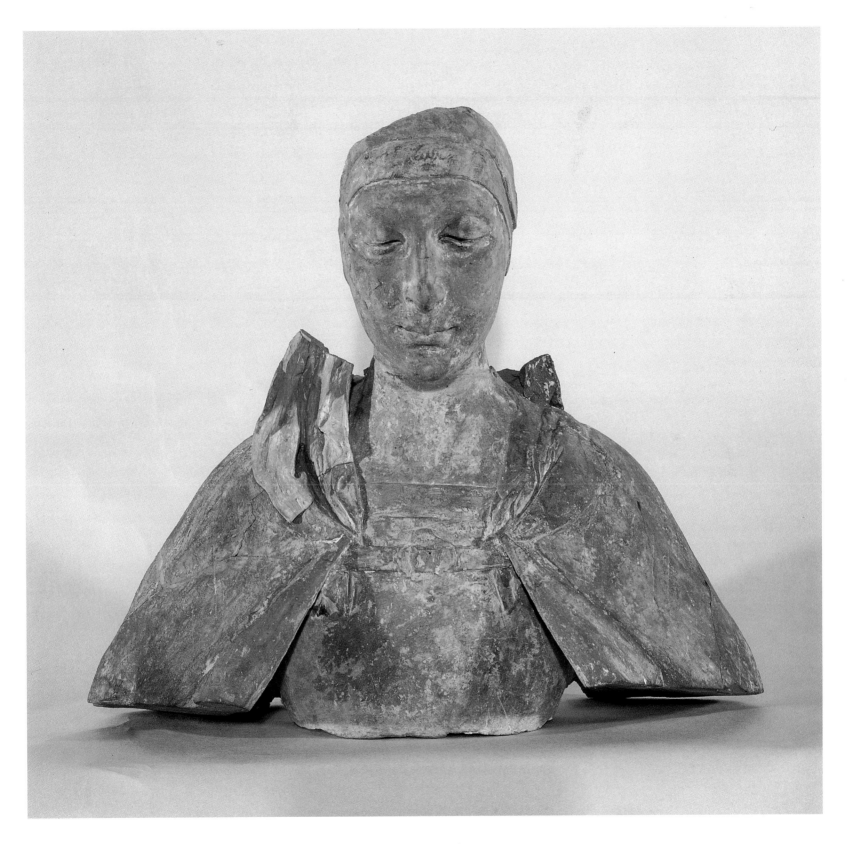

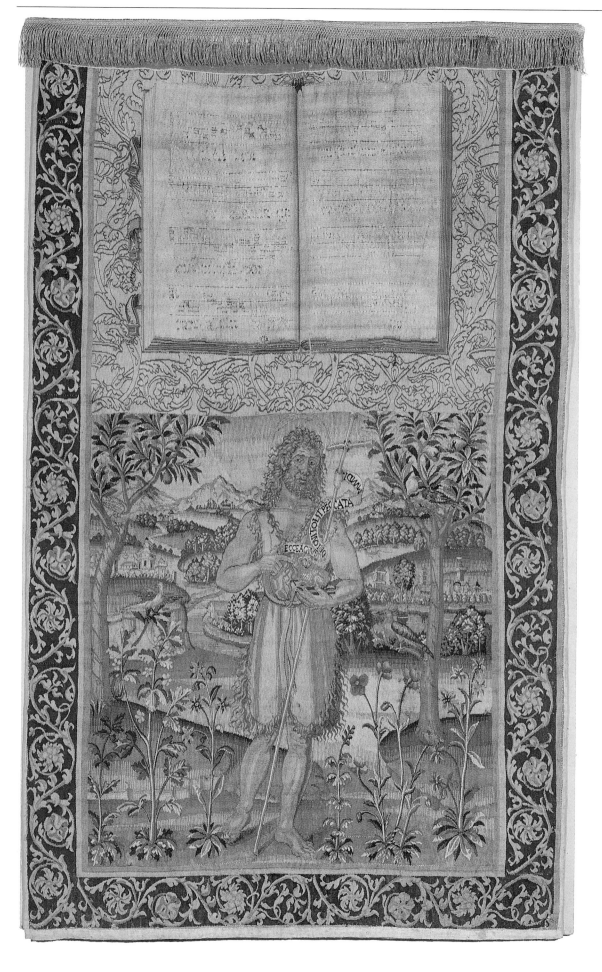

Antonio Maria da Bozolo, Saint John the Baptist with an open chorale, c. 1536-37 (cat. no. 179).

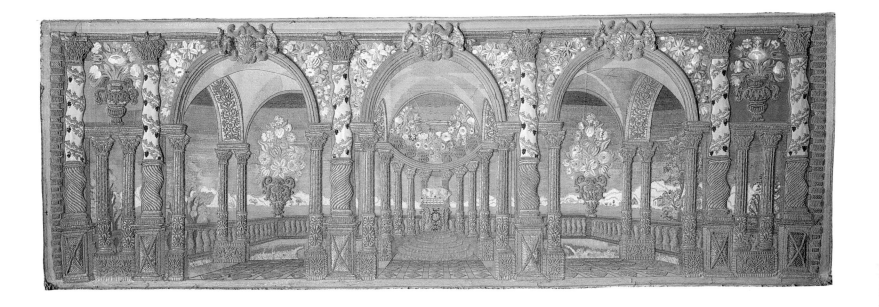

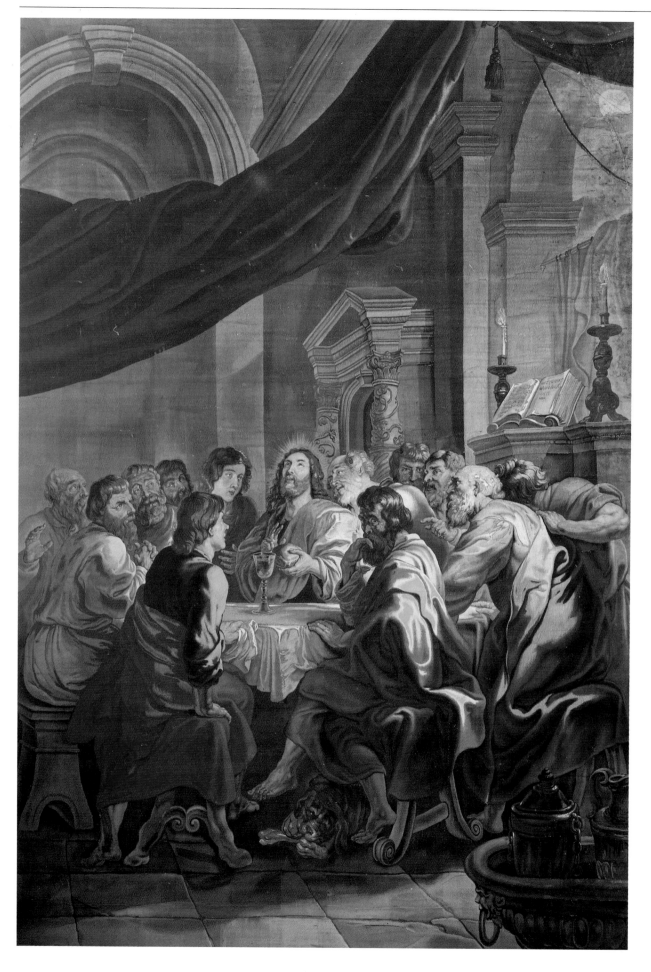

To designs by Pieter Paul Rubens,
Institution of the Holy Communion,
17th century (cat. no. 181).

To designs by Pieter Paul Rubens,
The Assumption of the Virgin,
17th century (cat. no. 182).

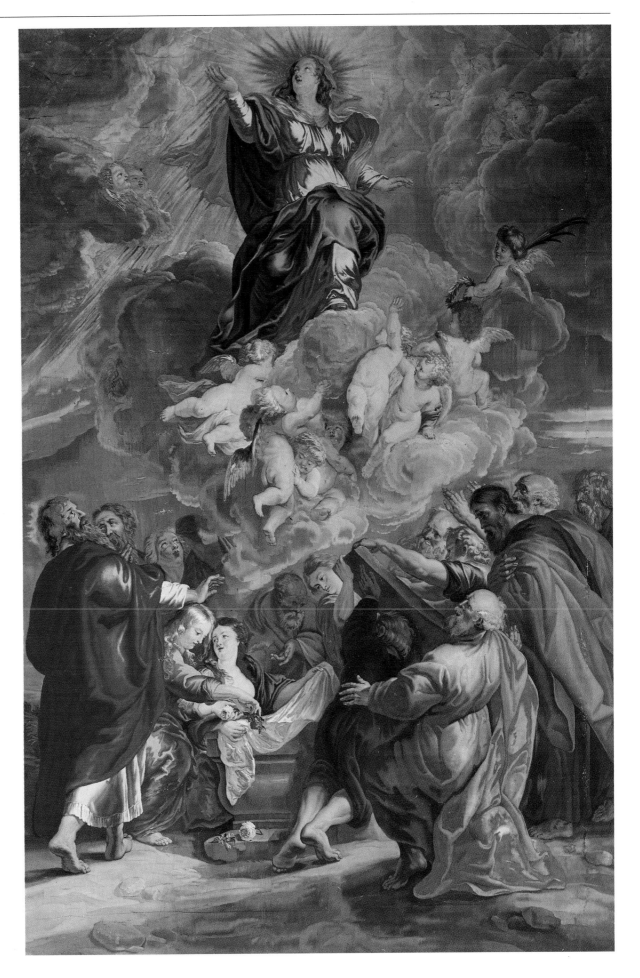

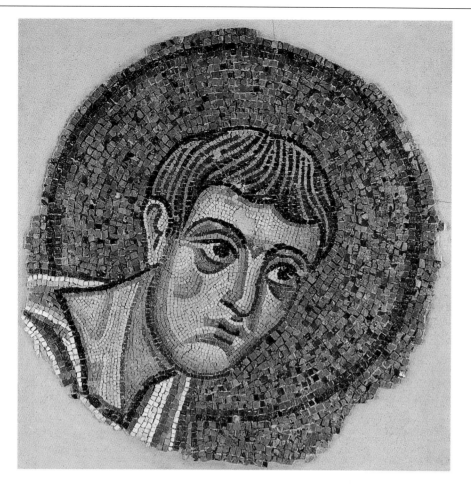

Heads of the apostles John and Peter, 12th century (cat. nos. 183, 184).

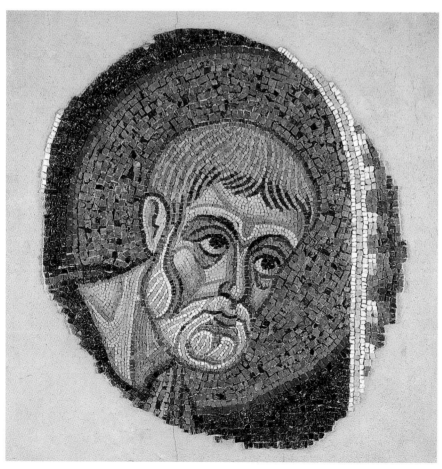

*Saint Olivia, Saint Venera, Saint
Rosalia, Saint Elias, 13th century
(cat. no. 185).*

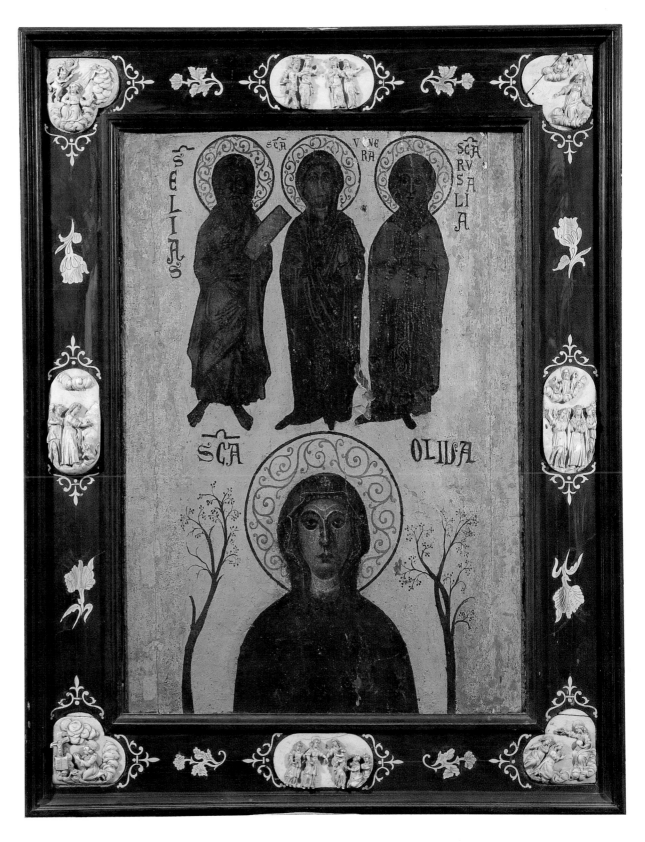

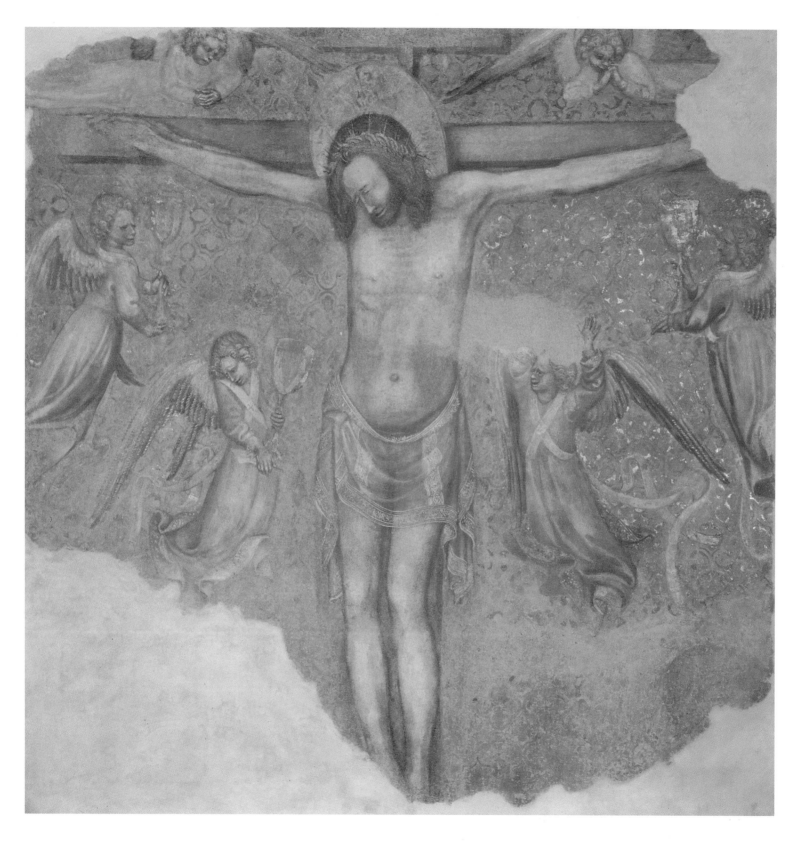

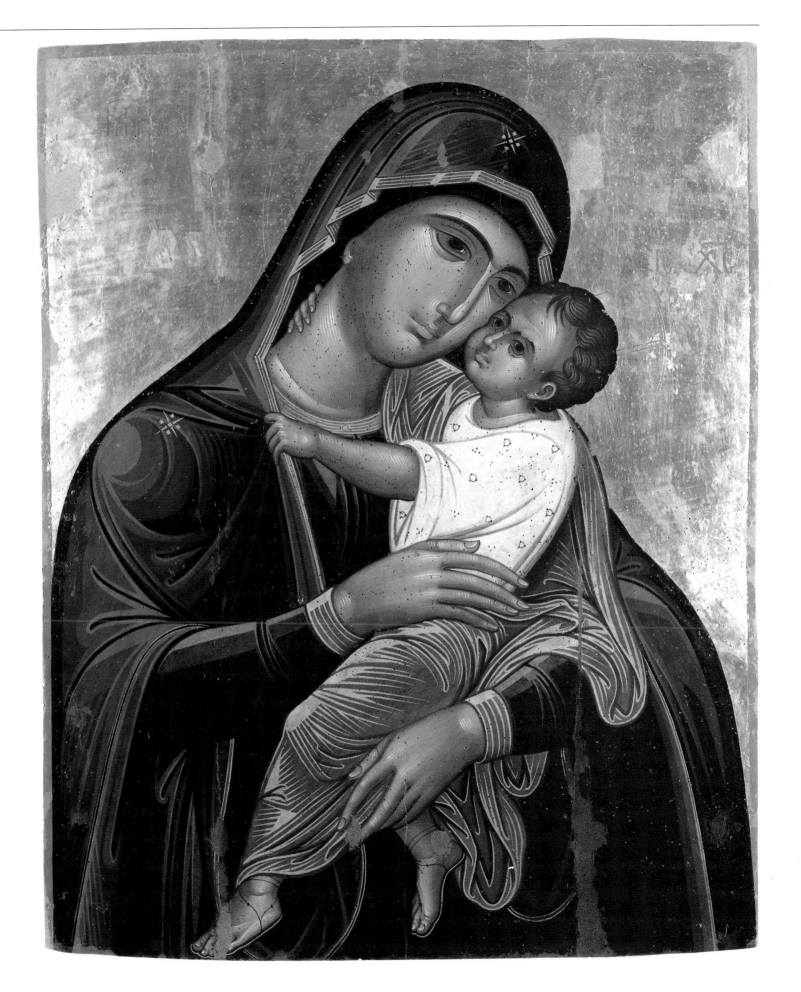

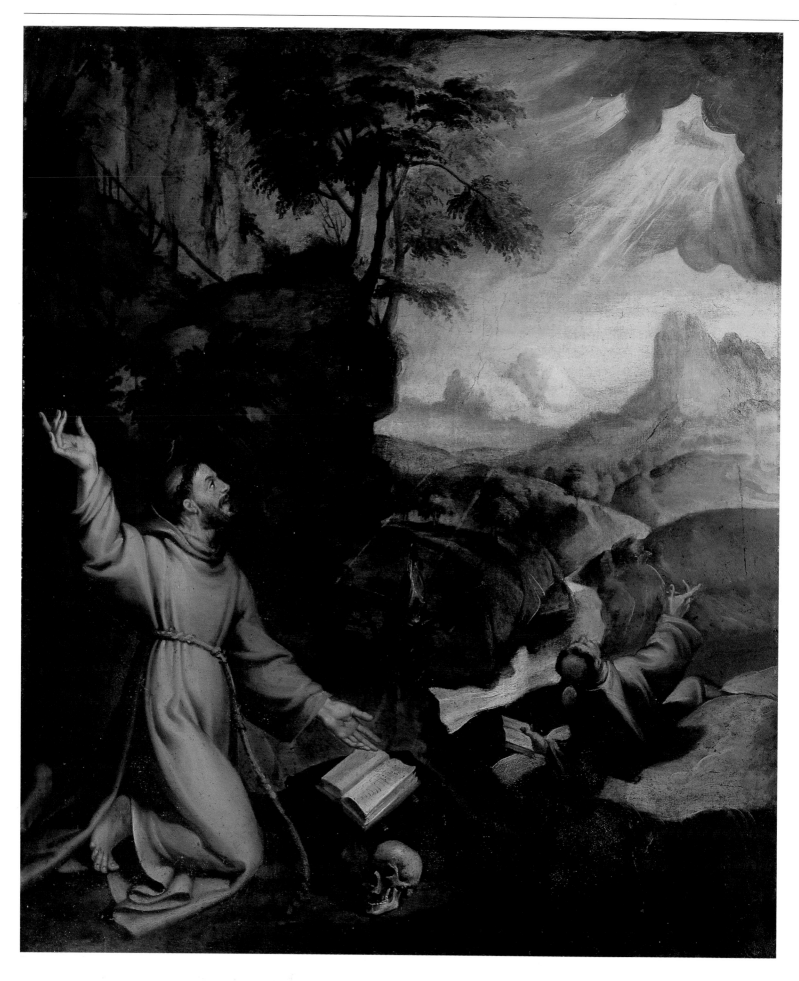

Bartolomeo Passerotti, *Saint Francis Receiving the Stigmata*, 16th century (cat. no. 188).

Ludovico Carracci, *Christ's Fall under the Cross*, 17th century (cat. no. 189).

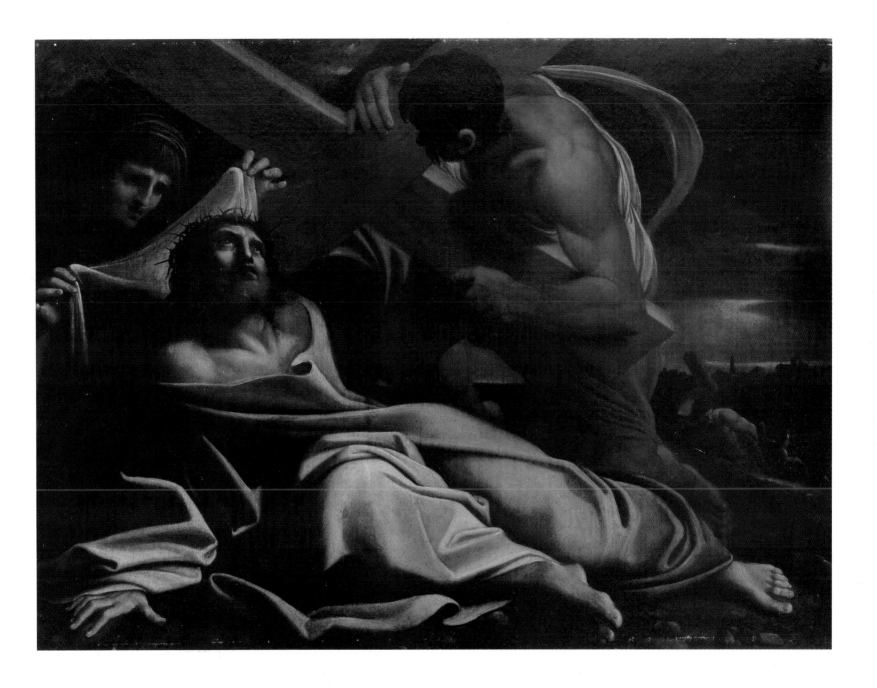

Bartolomeo Passerotti, *Saint Francis Receiving the Stigmata*, 16th century (cat. no. 188).

Ludovico Carracci, *Christ's Fall under the Cross*, 17th century (cat. no. 189).

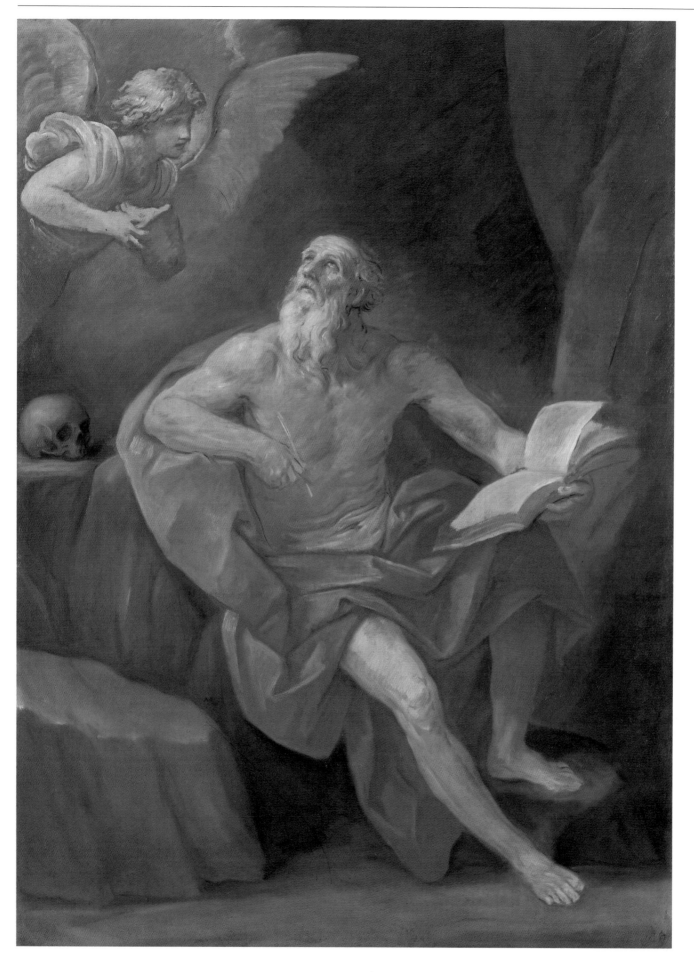

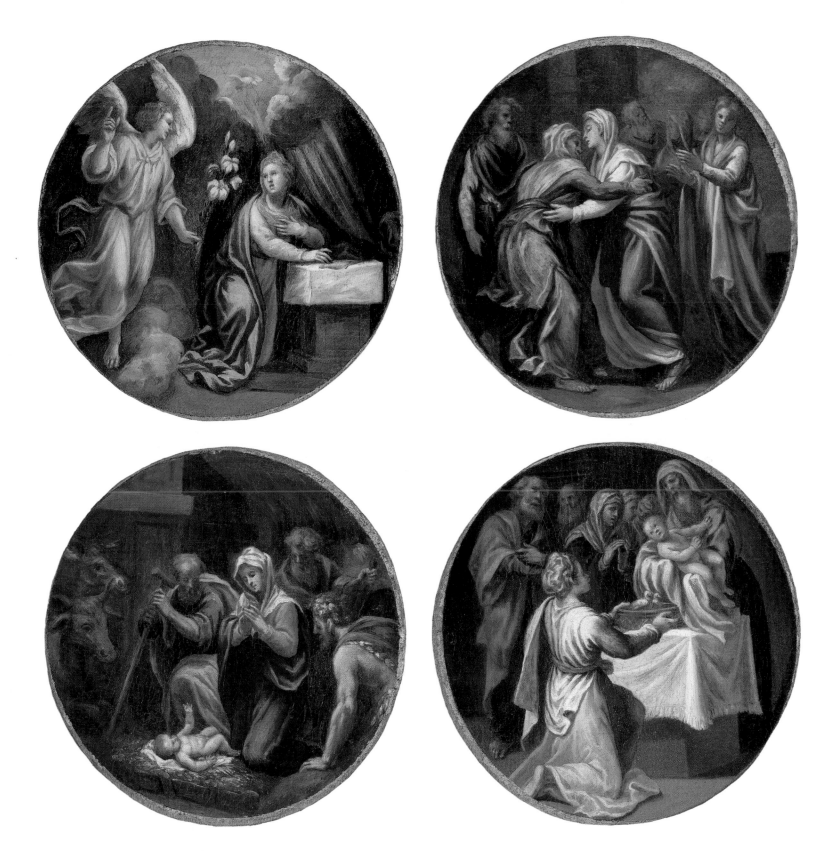

Guido Reni, Saint Jerome and the Angel, 17th century (cat. no. 190).

Vincenzo Campi, Mysteries of the Rosary, 16th century (cat. nos. 191-194).

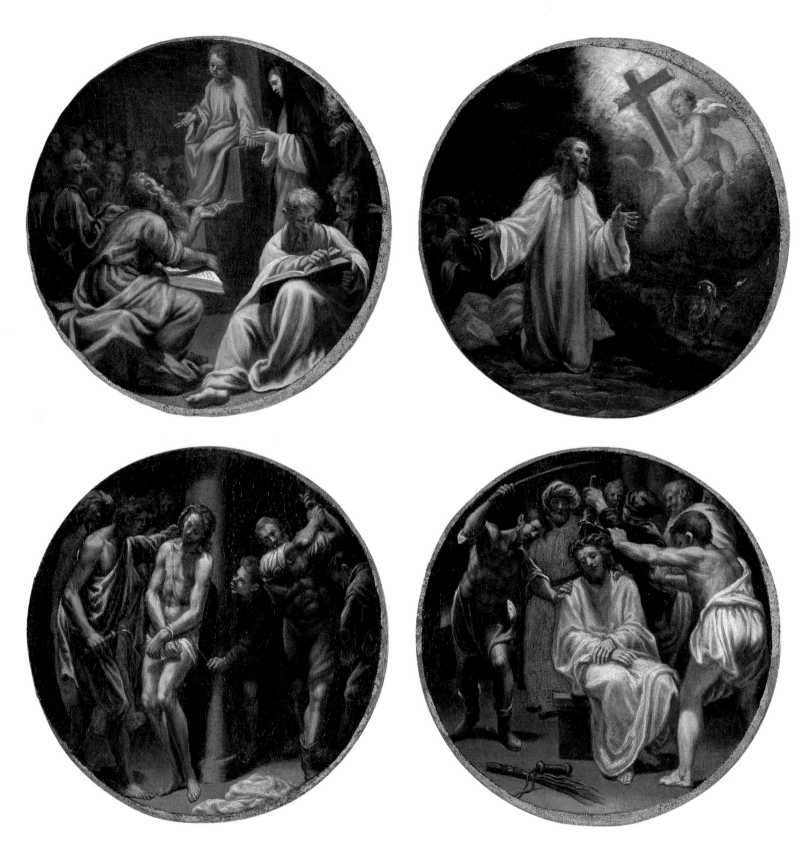

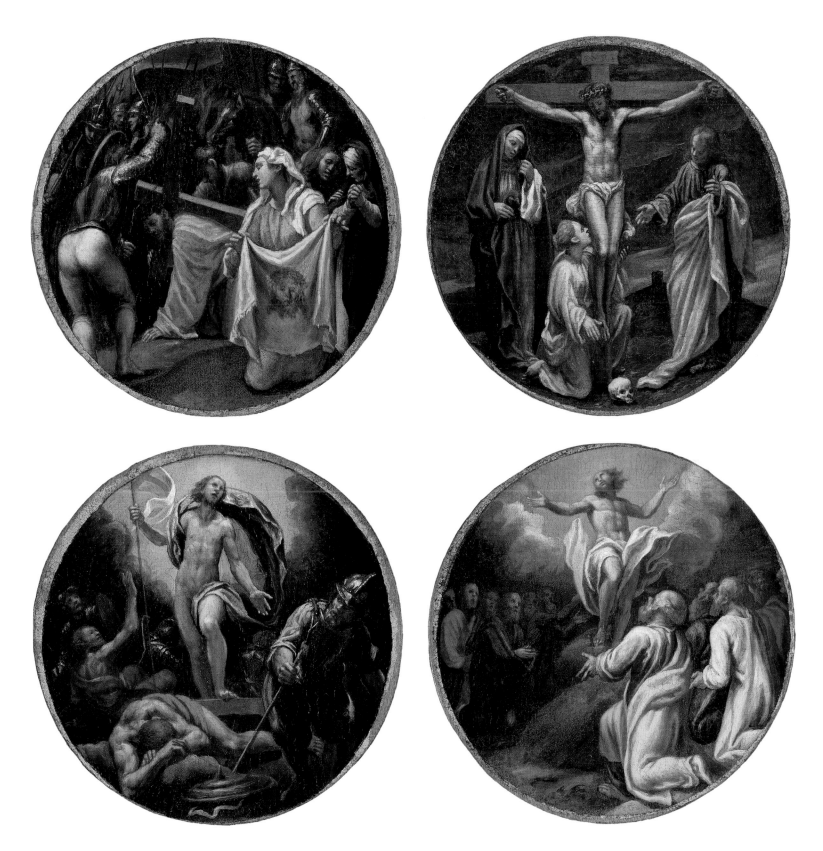

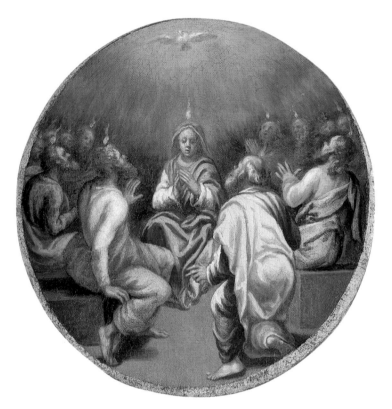

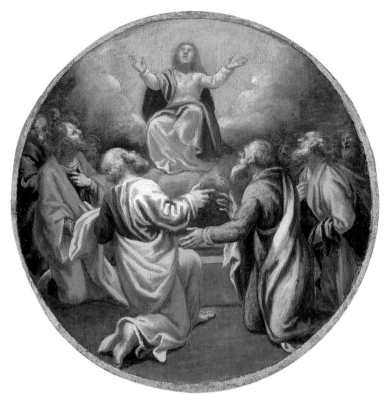

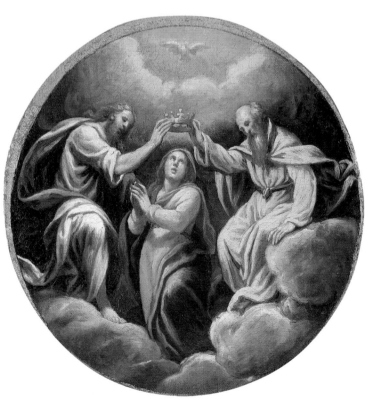

Mattia Preti, Presentation of Jesus in the Temple, 17th century (cat. no. 206).

Pietro Novelli, Madonna and Salvator Mundi, c. 1634 (cat. no. 207).

Standard with effigy of the Madonna di Bonaria, 17th century (cat. no. 208).

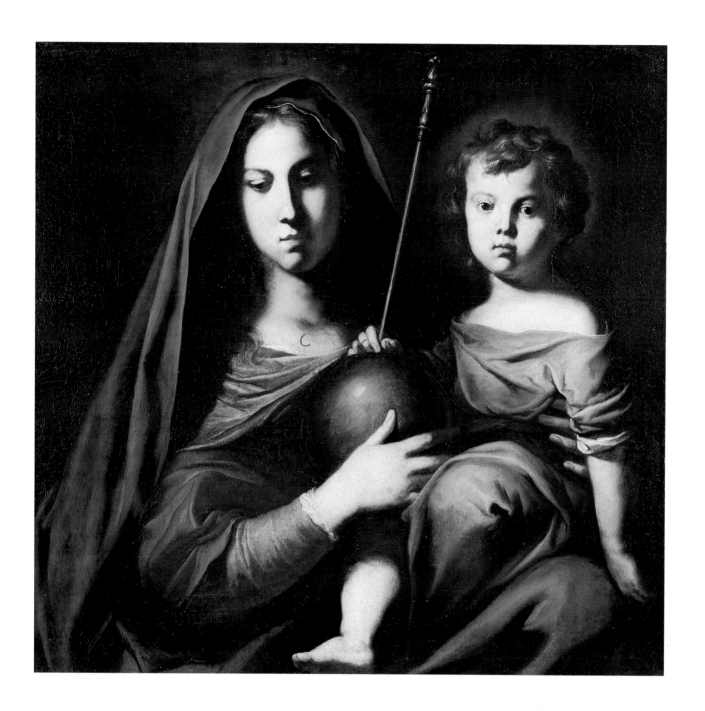

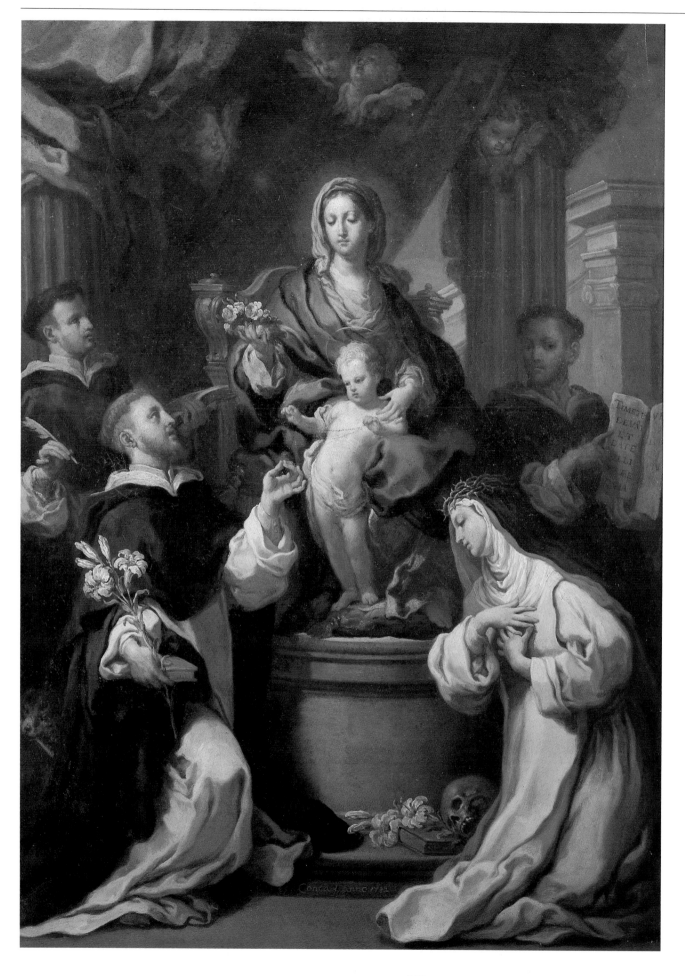

Sebastiano Conca, Madonna and Child, with Saint Dominic and Saint Catherine, 1732 (cat. no. 209).

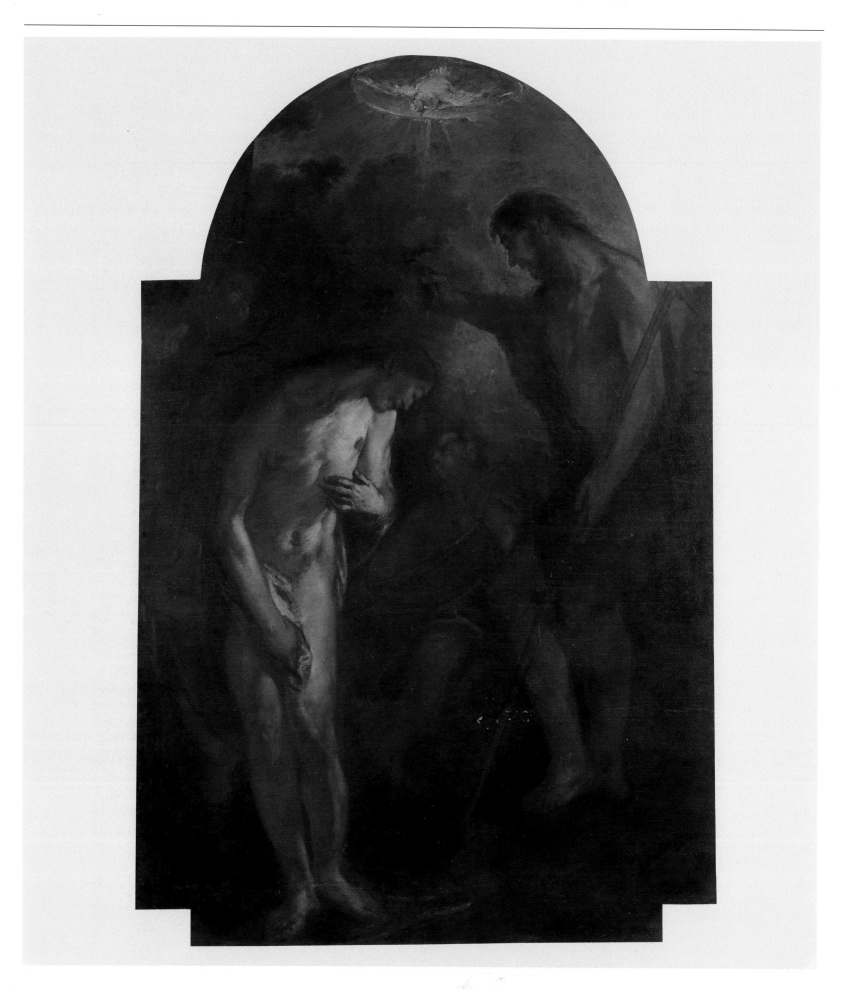

270

Giuseppe Bazzani, Baptism of Jesus, c. 1760 (cat. no. 210).

Giovanni Segantini, The Bell Ringer, 1879 (cat. no. 211).

Catalogue

Art and Celebration

125
Gold Longobard cross
10th century
Gold
19.5 × 14.5 cm
Benevento, metropolitan church

The cross bears signs of ten settings of different diameters though the original stones are missing. The vertical stave is marked by three settings in the lower half and two in the upper, while the cross-piece has four settings, two on either side. A large ovoid setting marks the crossing where the two staves meet. The staves are bordered by fine lines of small embossed beads. Between the two settings on the upper vertical, punctuated by a miniscule Greek cross, two lines bear the inscription "PET/RUS" set out vertically in uncial letters.

This precious cross, typical *Signus agnitionis*, was sewn onto the white linen winding sheet (there are still eight of the ten ringlets for attaching the thread) wrapped around the body of Bishop Peter, head of the church of Benevento from 891 to 914. Peter won the title of "sagacissimus" for his political and religious action; in fact, he managed to curb the tyranny of the occupying Byzantines while favouring the reconquest of Benevento by the Longobard Duke of Spoleto, Guido IV. Acclaimed prince of Benevento, Peter was forced to leave the city for political reasons and take refuge with Guaimaro II at Salerno, where he died in 914. By the will of the people his remains were transported back to Benevento and deposited in a stone sarcophagus that came to light in 1950, during the reconstruction of the cathedral destroyed by the war. (G.G.)

126
Giovanni Battista Scultori
Veneration icon with Deposition for the rite of peace
1562
Gilt silver and precious stones
16.2 × 12.2 cm
Mantua, Museo Diocesano

The frame is set with four diamonds, six pearls and four rubies. The pearl mounting is embellished with touches of white enamel.

The work, property of the basilica of Santa Barbara, was probably given by the Dukes of Mantua to the palatine church and was initially preserved in the chapel of Precious Blood.

The scene depicted follows a common model that has its origins in the Middle Ages, when the veneration of Christ's sufferings began to spread. It is probable that the vase placed under the body of Christ refers to the container in which the blood of the Saviour was collected. This reliquary was and still is the pride of the church and the city of Mantua. (P.R.)

127
Instrument for the rite of peace
15th century
Enamelled copper and miniatures on parchment
15 × 10 × 4 cm
Amalfi (Salerno), cathedral

The instrument for the rite of peace is an ancient liturgical object which was kissed by priests and the faithful at the moment during the celebration when the priest and the congregation exchanged the sign of peace.

This rite, which was part of the ancient liturgy and then fell into disuse, was revived as part of the liturgical reform of the Second Vatican Council.

The instrument on display is a very rare example of enamelled copper of the Venetian school of art of the 15th century. The decorative foliage in gold supports a small aedicule, protected by glass, containing a parchment with the scene of the Annunciation.

The colours of the parchment have become very pale with the passage of time. (R.V.)

128
Nicolò Lionello (c. 1400 - c. 1462)
Monstrance
1435
Gilt silver and enamels
61.5 × 17.3 cm
Gemona (Udine), Tesoro del Duomo

In the inventory of the church of Gemona of 1446, among the other sacred furnishings there is mention of "unam cuppam sive tabernaculum magnum argenteum deauratum novum magni ponderis et precii", denominated more simply in a previous inventory (1439) "cuppa magna argentea deaurata noviter facta". This is the monstrance for which the goldsmith from Udine Nicolò Lionello received various payments for a total sum of 331 lire and 7 *soldi*. However, this was not the entire sum paid, as some registers are missing, specifically those relating to the years 1440 and 1441; a final payment was even made in 1448.

Derived from Venetian prototypes of the Gothic era (for example, see the processional cross in the cathedral of Capodistria and the candelabras of doge Cristoforo Moro, Tesoro di San Marco, Venice, c. 1462-71), the Gemona monstrance is unusually tall. The hexagonal foot is embellished by a precious decoration on the theme of plants (fruit and leaves of the pomegranite tree) and small flowers formed by pearls united in trilobate designs on a blue, red and green background. Out of it grows an extremely ornate stem with Gothic knot and tabernacle made up of six trilobate bifores and rampant arches.

The most spectacular part, where the imagination of the goldsmith has been given free rein, is the cell of the Sacrament, made up of a striking series of spires, pinnacles, towers and tabernacles; these once held thirty statuettes of which only thirteen have survived, supported on pillars that contain three (originally six) enamels depicting Justice, Fortitude and Temperance. A spiral-form cuspid sustaining a sphere made of crumpled leaves surmounts the scene.

It is a solution that accents and emphasizes the motifs present in other works. Here comparisons could be made with the crosses of Taller Burgalis (prior to 1516) in the museum at Oviedo, and of Enrique de Afre (1518) in the Museo Diocesano-Catedralicio at Orense. The composition immediately appears to be dominated by Gothic spiritu-

ality, above all by "that curse of small tabernacles" – to use Michaelangelo's words – that prevents a rational reading of the piece, instead evoking the fantastic.

Finally the architectural structure appears almost to be a stylistic compromise recalling the design of the reliquary with the uncorrupt tongue of Saint Anthony of the Paduan basilica, carried out by Giuliano di Firenze and Lorenzo Ghiberti in 1436, in the same period hence as the Gemona monstrance.

Literature: A. Rizzi, *Capolavori d'arte in Friuli*, exhibition catalogue, Milan 1976, p. 25; F. Gurrieri, *Il Tabernaculum Magnum di Nicolò Lionello*, Florence 1978; A. Rizzi, *Profilo di storia dell'arte in Friuli*, vol. 2, *Il Quattrocento e il Cinquecento*, Udine 1979, pp. 92-93; L. Perissinoto, G.P. Nimis, *Gemona. Un recupero di storia, una prospettiva del futuro*, Udine 1980, pp. 158-159; E. Catello, "Argenti italiani", in *Gli argenti in Europa dal Medioevo al 1925*, Milan 1981, p. 15; D. Gioseffi, *Udine. Le arti*, Udine 1982, p. 96; N. Drusin, in G. Ganzer, *Il tesoro del Duomo di Gemona*, exhibition catalogue, Pordenone 1985, pp. 38-41, n. 1; G. Ganzer, "Documenti d'arte orafa", in *Il Duomo di Gemona*, Udine 1987, pp. 73-76.

129
Ludwig Krug (1488/90 - 1532)
Navicula
16th century
Gilt silver
55 × 20 cm
Padua, Tesoro della Basilica di Sant'Antonio

In this exceptional silver navicula, the classic shape of a ship's keel, typical of the incense carrier for the Christian liturgical rite, takes on a special form. The historian Bernardo Gonzati does not hesitate to confirm it as "the only one of its kind in that shape".

The base of the incense-boat is formed by a siren supporting with its head and arms a ship completely made of silver and with its characteristic elements sculpted in full relief: masts, sails, yards, anchors, pullies and ladders...

The helm, though, is missing. Various figures can be seen: men-at-arms and sailors in various points of the ship, some up the ladders, other pulling in the sails, others standing sentry, all anyway in action. In the noble part of the ship, astern, the admiral is sitting and reading amidst his officers. A bizarre detail is constituted by a tree of flowers and fruit placed at the centre of the ship.

It is very difficult to assign a date to the precious object, but surely it is prior to 21 April 1542. At that date, in fact, the censer is catalogued in an inventory. But it was almost certainly conceived after 1466: the inventory of that year bears no trace of it.

It is also difficult to identify the author. The artefact is engraved with the letters "I.F.N." that are also carved under a marble bust in a niche to the right of the Saint Anthony's chapel in Padua. It is impossible to say what these letters mean or to whom they refer. Today critics tend to attribute the incense-boat to goldsmith Ludwig Krug.

Literature: Bernardo Gonzati, *Il santuario delle reliquie*, Padua 1851; *Archivio Sartori*, vol. I, p. 770. (R.V.)

130
Attributed to Filippo Baldi
Thurible
1440
Gilt silver
55 × 18 cm
Padua, Tesoro della Basilica
di Sant'Antonio

Called "great thurible" (*turibulum magnum*), this masterpiece of the silversmith's art is first mentioned in an inventory of the possessions of the basilica of Saint Anthony of Padua in 1466.

The author of this finely chased, engraved and silver filigree work is unknown. Some scholars associate its style with Bartolomeo of Bologna who lived during the first half of the 15th century.

Recent studies attribute the work to Filippo Baldi, indicating 1440 as its presumed date of creation. The thurible has been conceived as a pyramid-

shaped tower with pierced octagonal base. The body of the tower, which is the cover for the censer, is divided into three architectural orders culminating in a small tabernacle in the centre of which stands a statue of Saint Anthony holding a lily in his right hand and a book in his left. The saint is wearing the Minorite costume typical of the mid-15th century.

The incensory is also called "thurible of Sixtus IV", i.e. Francesco della Rovere who, prior to becoming pope, was the General of the Franciscan order. It is certain that if the precious object was given as a present by Della Rovere, this occurred prior to his becoming pope, and consequently when he was still cardinal. Della Rovere was in fact elected pope on 9 August 1471, while the censer is among the treasures of the basilica of Padua certainly before 1466.

Literature: Bernardo Gonzati, *Il santuario delle reliquie*, Padua 1851; *Archivio Sartori*, vol. I, p. 770. (R.V.)

131
Attributed to Parri Spinelli
(1387-1453)
Processional cross
15th century
Copper, gilt silver and enamels
50 × 30 cm
Florence, Archbishop's Palace

The cross is completely girded by a cord frame.

Its terminals are star-shaped and the motif is repeated at the point where the arms cross and again, in a smaller scale, at Christ's feet.

A flowering vine runs along the arms of the cross while, on the obverse, where the arms cross, similar flowers, but here isolated, underline a nimbus; on the corresponding position on the back of the cross the Agnus Dei is situated. The Eternal giving his blessing, the Madonna, Saint John and Mary Magdalene are depicted within lobated and cuspidate frames on the terminals of the obverse, with the evangelists John, Matthew and Luke on the back.

The cross was tentatively attributed to

Parri Spinelli by Dora Liscia on the occasion of the exhibition "L'oreficeria nella Firenze del Quattrocento". It is an interesting hypothesis which does have some stylistic foundation, at least as regards the enamelled figures in the final parts of the arms of the cross. However, in the absence of formal or objective evidence one cannot go beyond speaking of a hypothesis. Without a doubt, though, the kind of culture and attitude reflected by the object point towards a refined artist of the late Gothic period in contact with an environment already permeated by Renaissance ideas and concepts.

The cross, already denoted as exceptional by Filippo Rossi, who defined the piece as "magnificent in type", in fact presents some singular features that set it apart from the most common typologies of its kind: first and foremost, the structure that permits the slightly rounded solution of the arms; the shape of the terminals, much more dynamic than the usual – even afterwards – lobated square; and the vine, which loses the appearance of the *arbor vitae* to finish in the form of a classical volute. But above all it is the Christ figure that has perceptibly changed in proportion, form and attitude, even if the exposed ribs and the thinning of the waist stand as a continuation of tradition.

These features characterize a work that evidently raised doubts even in the mind of a scholar of Marie Madeleine Gauthier's experience; within a single publication, she dates the artefact to a period spanning from the last third of the 14th century (in the catalogue) to the beginning of the 15th century (in the text).

In the latter Gauthier fully appreciates the innovations made by the author of the Florentine cross, with its strongly modelled Christ, the use of enamel as a means for giving more intensity to the lines, the return to classic leaves and flowers, and above all the new formal conception the artist reveals with regard to the object in itself, and in relation to its surrounding space: "il remplace les pommettes de l'époque précédent par des fruitelets, gaînés d'une

cupule feuillue et étirés en pointes pour signaler les axes de cette architecture de métal, et pour orienter par leurs rayons l'espace environnant". (A.C.)

132
Nicola da Guardiagrele
Processional cross
1434
Silver
150 × 85 cm
L'Aquila, Museo Nazionale
d'Abruzzo

The obverse shows the Crucifix amidst the angels, with a pelican, symbol of love and resurrection; at the ends of the cross are depicted the Resurrection, the Virgin, Saint John and the Deposition.

The reverse carries the Saviour enthroned, surrounded by the four evangelists and four fine enamel panels, with the insignia of Cardinal Agnifili and the Chapter of L'Aquila.

The octagonal base holds eight beautiful statuettes of saints in full relief, set in cuspidate niches. The overall effect is that of a complex, magnificent object of exceptional formal and decorative richness.

The cross of San Massimo is one of the most representative works of the art of Nicola da Guardiagrele, the most illustrious of the Abruzzo master goldsmiths. After a long period of oblivion, he was rediscovered thanks to the "historic" exhibition at Chieti in 1905, winning great acclaim.

All the same, the documentation on the artist is even today almost exclusively limited to his output, all signed and dated.

The hypothetical identification with Nicolò della Guardia, cited by Giorgio Vasari, as well as the supposed attribution of the surname of Gallucci, long accepted in the literature about him, have been refuted. One can only presume the master was born a little after 1390, going by the date of his first known work, the beautiful monstrance of Santa Maria Maggiore at Francavilla a Mare, dated 1413.

This was followed by the monstrance

of San Leucio of Atessa (1418), the processional crosses of Lanciano (1422) and Guardiagrele (1431), the antependium of Teramo cathedral and the cross of San Massimo (both consigned in 1434), held to be his masterpieces, from which the crosses of Monticchio and San Giovanni in Laterano are derived.

His last known work is the bust of Saint Justin in the cathedral at Chieti, finished in 1455.

Mystery still shrouds Nicola's training, despite the heated debate about it that has continued for decades.

His works, however, faithfully reflect the cultural environment from which he sprang, permeated by the salient themes of the cultural and artistic currents of his times, already having penetrated and been favourably accepted throughout Italy.

The cross of San Massimo stands as a compendium of all the principal techniques linked to the goldsmith's craft (embossing, enamelling, chiselling): a work that demonstrates his complete maturity.

Here Nicola refines his expressive means, tempering them in his profound knowledge of Florentine expertise. In his highly personal interpretation of Ghibertian humanism, he gets away from the devotion to the Gothic reminiscences that are plainly evident in his early work.

Literature: L. Gmelin, *L'oreficeria medioevale negli Abruzzi*, Teramo 1891, p. 63; F. Ferrari, *Nicola Gallucci da Guardiagrele*, Chieti 1903; M.R. Gabrielli, *Inventario degli oggetti d'arte della provincia dell'Aquila*, Rome 1934; E. Carli, "Nicola da Guardiagrele e il Ghiberti", in *L'Arte*, XLII (1939), pp. 144 ff. and 222 ff.; M. Moretti, *Museo Nazionale d'Abruzzo*, L'Aquila 1968, p. 46; B.M. Colasacco, *Tesori d'arte dei musei diocesani*, Rome 1986, pp. 152-153; G. Mancinelli, in *Guardiagrele, il colore del tempo*, Pescara 1986, pp. 182 ff.; S. Gallo, in *Documenti dell'Abruzzo teramano*, III, 1, "La valle dell'alto Vomano ed i monti della Laga", Pescara 1991, pp. 319 ff. (C.T.)

133
Processional cross
15th century
Gilt silver
75 × 34 cm
Piazza Armerina (Enna), Tesoro del Duomo

In both its form and iconography, the decoration of this work links it to the group of 15th-century processional crosses made either by Spanish craftsmen living in Sicily, or by local masters inspired by Iberian models. However, slight variations on the standard Spanish prototype mark it as being distinctly Sicilian in style.

The presence of Spanish silversmiths in 15th-century Sicily is well-documented (Bresc Bautier 1979, p. 114), and we know of at least two works from the period that are certainly of Spanish origin: the reliquary of the Sacred Cross, and that of the Sacred Thorn at the abbey of San Martino delle Scale by Pietro di Spagna (Di Natale 1989, cat. nos. II, 5 and II, 6 pp. 181-184). Another work from this region associated with a Spanish master is the processional cross of the cathedral of Mazara del Vallo, attributed to Giovanni di Spagna (Abbate 1981, p. 47). More numerous still are the works inspired by such models, which by the end of the century had come to replace those based on the Pisan sources that had been especially popular in western Sicily. The elements of this cross most typical of the Spanish Gothic are the acanthus-leaf decoration on the frame, similar to that found on the gilt backgrounds of Spanish polyptychs (Longhi 1953, p. 7); the aedicules which host two figures of Christ, crucified on the recto and resurrected on the verso; and the powerful expressiveness of the imagery, particularly that of the crucified Saviour.

The cross has not received a great amount of scholarly attention. Gioacchino Di Marzo mentions it in his study of the Gagini (1880-83, vol. III, p. 605), Antonino Ragona includes it, without caption, in an inventory of the silver holdings of the Tesoro del Duomo, and it was exhibited at the Museo Pepoli in Trapani in 1989 (Di Natale 1989, cat. no. II, 4, pp. 180-181).

Though there are some variations, the cross essentially follows the iconographic programme preferred by Sicilian masters who specialized in painted processional crosses. On the front side is the crucified Christ, knees dramatically buckled and head hanging low, linking it to that aspect of the Gothic tradition which tended toward the morose and the tragic, another example of which is in the cathedral of Palermo (De Francovic 1938, p. 197). At the very top of the cross is the christological symbol of the pelican, and at bottom is Christ in the act of offering his blood from a chalice. This last detail is rare if not unique among Sicilian processional crosses, whether silver or painted. Occasionally Christ is depicted here in *Pietà*, following an iconography of likely Spanish origin, but even this in itself is rare. Among the few other examples are the silver cross of Gerona, recorded in an inventory of 1470 by Guidiol (Paolini 1964, no. 2, p. 3), and the painted cross from the cathedral of Palermo which was mounted atop an altarpiece of the *Presentation of the Virgin*, commissioned to a local painter (sources give the name of Tommaso De Vigilia) in 1466 by the Archbishop of Barcelona, Nicolò Puxades (Di Natale 1992, p. 59). In any case, the three principal parts of the vertical axis of the Piazza Armerina cross all address the same theme with the same didactic intent: salvation through sacrifice. At top the pelican offers food from its own belly to nourish its young; at centre is Christ, sacrificed on the cross for the redemption of humankind; and at bottom, the Saviour offers his own blood in a gesture signalling the eucharistic rite. On the finials of the transverse arms of the recto are the Virgin and Saint John, in keeping with the traditional iconography.

The other side of the cross is centred upon the classic pre-Tridentine image of the resurrected Christ emerging from the tomb, one foot lingering behind, standing rigidly erect, vexillum in hand, draped in a long cape. The symbols of the four evangelists decorate the ends of the cross – the eagle of John, the lion of Mark, the angel of Matthew, and the bull of Luke – which is again consistent with the iconography generally used in Sicilian painted crosses of the 15th century. The presence of the Risen Christ, however, is rather exceptional in processional crosses, though we do find it in the verso of the cross of San Nicola di Randazzo, executed in 1498 by Michele Gambino (Barbera 1981, p. 51). The cathedral of Piazza Armerina also houses a painted cross that bears comparison with this silver one (Di Natale 1992, p. 75). Though its wooden frame is now lost, it must have been similar to that of the painted cross by Pietro Ruzzolone (1484) in the Chiesa Madre di Termini Imerese, the curled acanthiform borders of which suggest common stylistic origins for all three of the crosses.

Literature: G. Di Marzo, *I Gagini e la scultura in Sicilia nei secoli XV e XVI*, Palermo 1880-83, reprint 1980, vol. III, p. 77; G. De Francovic, *L'origine...*, 1938; R. Longhi, *Frammento...* 1953; M. G. Paolini, *Ancora del Quattrocento...*, 1964; G. Bresc Bautier, *Artistes...*, 1979; G. Barbera, in *Le arti decorative...*, 1981, cat. no. 5, p. 51; V. Abbate, in *Le arti decorative...*, 1981, cat. no. 2, p. 47; M.C. Di Natale, in *Ori e argenti di Sicilia*, exhibition catalogue, edited by M.C. Di Natale, Milan 1989, pp. 180-181; M.C. Di Natale, *Le croci dipinte...*, 1992; A. Ragona, *Il Santuario di Maria SS. delle Vittorie a Piazza Armerina*, Genoa n.d., n.p. (M.C.D.N.)

134
Iacopo and Damiano da Gonzate
Processional cross
1524
Silver and enamels
120 × 59 cm
Busseto (Parma), collegiate church of San Bartolomeo

This processional cross is the work of the brothers Iacopo and Damiano da Gonzate, sons of Filippo and authors of, among other works, the four *Evan-*

gelists in the choir of Parma cathedral and dated 1508. It may be considered without doubt one of the highest examples of the goldsmith's art in the first half of the 16th century.

Imbibed with Renaissance spirit, this cross is inspired by the tradition of Gothic Lombard crosses and in particular the one by Ambrogio Porri and Agostino Sacchi (1478) and that by the goldsmith S. Facio (1262), conserved in Cremona cathedral.

The silver cross, most of which gilt, is decorated with minute acanthus leaves on a ground of blue enamel, with semiprecious stones, cherub's heads, statues in full relief and busts of saints.

The statue of Saint Bartholomew is situated on the back of the cross, centrally placed between Saint Augustine, Saint Anthony of Padua, Saint Francis of Assisi and Mary Magdalene. The small pedestal supporting the statue of the saint bears an inscription with the name of the authors and the date: "IAC. FILIPPI / ET DAMIANI / FRATR. DE / GONZATE / PARMEN. / OPUS / MDXXIIII". (R.V.)

135
Chalice
1496
Gilt and enamelled copper
Height 25 cm
Certaldo (Florence), Parish church
of San Lazzaro

The base of the chalice is a complex polygonal foot resting upon a gradual sequence of step-like mouldings, decorated with rosettes and a ring of beads. The body, copiously studded with nails, is ornamented with rosettes and a laurel crown braided with a ribbon. In the upper part, broad acanthus leaves demarcate six separate areas. The hexagonal stem is interrupted by a cornice bearing the inscription: "CALIX ISTE DONATUS FUIT PLE S. LAZAI ANO 1496". At the centre is a *nodo*, or "knot", compressed at the extremities, decorated with a foliate motif and six round nails, each carrying a medallion of blue enamel. On the underside of the cup are lance-shaped leaves, delicately veined. The cup itself, smooth

and undecorated, is surmounted by a ribbed lid with a small cross at the top. This cover is not part of the original design, but was added when the chalice came to be used also as a ciborium.

136, 137
Giovanni Mameli
Candlesticks
16th century
Silver
56 × 12 cm
Cagliari, collegiate church
of Sant'Eulalia

This elegant pair of silver candlesticks is attributed to Giovanni Mameli, the most famous and gifted goldsmith working in Sardinia at the turn of the 16th century.

The attribution is based not only on stylistic traits typical of Mameli, but on the presence of the stamp of the city of Cagliari as well ("CA"). Additional confirmation of the attribution lies in the fact that the two candlesticks belong to the confraternity of the Holy Sacrament, who commissioned a number of works for the collegiate church, among which is a processional cross that is certainly by Mameli. (L.P.)

138
Urn for Holy Thursday
Late 16th - early 17th century
Cast silver, embossed and engraved
57 × 84 × 37 cm
Vercelli, cathedral

This urn is displayed and carried in procession during Holy Week. As noted by Viale (1973, p. 39), it is an extremely fine piece of craftsmanship, and should be dated between the end of the 16th and the beginning of the 17th century.

The overall design is not unlike that of certain reliquary cases from the period. Four eagles constitute the base, while the corners and the two longer sides are marked by standing angels, their function intriguingly merged with that of caryatids. The side panels are decorated with intricate arabesques emerging from the winged heads of angels, and the cover echoes this pattern with simpler forms, their

rhythms measured by *baccellate*, or "pod-shaped" ornaments.

The lack of archival documentation as to who commissioned the urn, and the absence of stamps or inscriptions on the object make it difficult to know exactly where it was made, or who may have made it. The aforementioned details point to the Lombardian school of the turn of the century, particularly to the goldsmiths of Milan, about whom much more has become known. Yet we cannot discount the possibility that the urn was crafted in Vercelli itself, given its close links with Milan, to which it was subject at this time. The depth of those connections is demonstrated by the events of the 16th century which pitted the Euseban chapter of Vercelli cathedral against Bishop Carlo Ferrero in an argument regarding the rebuilding of the cathedral. It was only Carlo Borromeo's replacement of Ferrero with a new bishop, Giovanni Francesco Bonomi of Cremona, that resolved the tension (cf. *Bernardino Lanino...*, 1986).

Literature: V. Viale, *Il duomo di Vercelli*, Vercelli 1973; *Bernardino Lanino e il Cinquecento a Vercelli*, edited by G. Romano, Turin 1986. (C.S.)

139
Pyx
c. 1600
Cast silver, gilt and embossed
Height 34 cm
Arona (Novara), collegiate church
of the Santi Martiri

The foot of the pyx is an archaic structure of six rounded lobes, decorated with a braided plant motif, festoons of fruit and the heads of angels, among which are set three oval medallions bearing images of the Madonna and Child, Saint Joseph and the monogram of Christ.

The "knot" at the centre of the stem is decorated with angels and the symbols of the Passion. The underside of the cup continues the pattern of plants, festoons and heads of angels from the base. The cover seals a cup of generous dimensions and repeats the theme from below, together with four angels

in full relief and the symbols of the Passion.

Though it is presently in the church of the Santi Martiri, this pyx probably belonged originally to the collegiate church of Santa Maria. It is in fact listed in its inventory of 1629, and may well have come there as part of Federico Borromeo's donation of "every kind of ornament and furnishing that one could wish for" (from *L'Instromento della Donazione delle Sacre Reliquie ad opera di Federico Borromeo*). Stylistically, the pyx is closely related to another in the the nearby parish church of Ornavasso (Novara), and to a chalice, probably donated by the Bishop Ludovico Taverna (1579-1616), in the cathedral of Lodi (Spantigati 1977, cat. no. 34, p. 132). Further comparison can be made with a monstrance from 1579 in the Museo del Duomo in Milan (Bossaglia, Cinotti 1978, cat. no. 31, p. 63). In sum, this magnificent object can be seen as part of the rich production of the diocese of Milan at the close of the 16th century, and as one among many signs of the great renewal initiated by Carlo Borromeo and carried on by Federico Borromeo. It shares with the works of Annibale Fontana a classicizing revision of Lombardian Mannerism.

Literature: C. Spantigati, in *Arona sacra. L'epoca dei Borromeo*, exhibition catalogue, edited by G. Romano, Arona 1977, cat. no. 34, p. 132; R. Bossaglia, M. Cinotti, *Tesoro e Museo del Duomo*, vol. I, Milan 1978, cat. no. 31, p. 63. (P.V.)

140
Monstrance
18th century
Silver
Height 80 cm
Cava de' Tirreni (Salerno), cathedral

The monstrance is a liturgical receptacle of crystal or glass containing the consecrated host so that it can be exposed for adoration by the faithful. The word "monstrance" itself, from the Latin *monstrare* meaning "to show", indicates its function. Monstrances began to appear from the 14th

century, initially in France and Germany. In ancient times reliquaries were used to display the consecrated host. They had the form of a cylinder of glass or crystal, resting on a chalice without a bowl and surmounted by architectural decorations in Gothic style. Towards the end of the Gothic period larger monstrances were made with two side pieces on which small statues were placed as in Gothic triptychs.

The round form was subsequently replaced by a flatter shape. In the Renaissance period the Gothic model was still favoured. However a more meaningful form for the monstrance developed during the Baroque period: the one which we know today with the host at the centre and rays emerging from it. These monstrances, of which the one on display is an example, were called "sun monstrances". (R.V.)

141
Monstrance
1753
Silver, enamel, precious stones
80 × 35 cm
Catania, Tesoro della Cattedrale

This splendid monstrance is distinguished above all by its decorative richness and compositional originality. The base serves as a stage for delightful scenes of the harvest that seem at first to be purely secular, but which in fact maintain a clear religious theme whereby grapes and grain symbolize the blood and the body of Christ.

Playful *putti* at work are depicted on the base, which is decorated as well with friezes of shells and pods. The base seems conceived as a separate environment, joined to the stem only by four curved buttresses, upon which are seated the four evangelists, each with their respective sacred text. A sequence of knots carries the shell and pod decoration up the stem, ending with the symbols of the evangelists and two cornucopia overflowing with corn, signalling the abundance of Divine Grace. Between the cornucopia are the tablets of the Commandments, with the symbols of Faith (the cross),

Hope (the anchor) and Charity (the lamp's flame), along with the Sacred Heart of Jesus and the dove of the Holy Spirit, which underlines Christ's role as the unifying link between the Old and New Testaments. Above this dense cluster of symbols is a final knot of enamelled blue and green vines, a half-moon made of diamonds and the sunburst aureole itself, which has at its centre the circular container for the Host.

The plant motifs of the aureole are mingled with rosettes and ribbons studded with rubies, sapphires, pearls, diamonds and other gems which take their symbolic significance from Revelations 21, where John describes the twelve foundations of the Heavenly Jerusalem as being ornamented with these same precious stones. Vines and bunches of grapes surround the core of the aureole, along with star forms and jewelled rosettes which ultimately open out into a diaphanous halo of gold and blue enamel rays interspersed with golden lances.

The abundance of stars and the presence at the very top of a comet allude specifically to the birth of Christ, and more generally to the cosmic power and omnipresence of the Creator, represented here in the person of the Son. The frieze along the base bears the insignia of the guild of Messinese goldsmiths and silversmiths – a shield with a cross and crown, with the letters "MS" (*Messanensis Senatus*). The initials of the magistrate who certified the work, followed by the last three numbers of the year in which he certified it ("AP753"), are also inscribed there, as are the initials of the silversmith "DG". There can thus be no doubt that we have here a masterful piece of silversmithery, made in Messina in 1753.

Literature: M. Accascina, *Oreficeria di Sicilia dal XII al XIX secolo*, Palermo 1974, p. 35; M. Petrassi, *Gli argenti italiani*, Rome 1984, p. 51; M. C. Di Natale, in *Ori e argenti di Sicilia*, exhibition catalogue, edited by M.C. Di Natale, Milan 1989, pp. 293-294. (M.C.D.N.)

142
Tronetto
Early 18th century
Embossed and engraved silver
92 × 47 × 25.5 cm
Cagliari, Tesoro del Duomo

This *tronetto*, or "little throne", is used for the display of the Most Holy Sacrament. It is exquisitely embossed and engraved with floral patterns, which mark it clearly as late-Baroque in style. Despite the absence of a seal or signature, it can be dated with relative accuracy on the basis of the coat of arms of Bernardo di Carinena which is embossed on the front of the object. Carinena was Archbishop of Cagliari from 1699 to 1722. (L.P.)
Work unavailable for exhibition.

143
Chalice
18th century
Silver
24 × 8 cm
Cava de' Tirreni (Salerno), parish church of San Pietro

The chalice is the cup containing consecrated wine in the Christian liturgy of the mass. Originally no distinction was made between the cups used in the liturgy and ordinary unconsecrated cups, which were usually made of glass, bronze or wood. At most, glasses gilded with simple decorations were used. Soon, however, chalices of gold and silver began to appear, in addition to those made of less precious materials. From the 9th century they were made almost exclusively with precious metals.

The ancient chalice usually consisted of a large bowl with handles and a base. At the beginning of the High Middle Ages the bowl became oval and was separated from the cone-shaped base by a large node. The stem appeared in the Romanesque period. But it was during the Baroque period that the chalice took on what have now become its traditional features, with the small bowl in proportion to the base shaped with wide curves. The bowl was usually stylized in the form of a flower-cup. (R.V.)

144
Mitre
13th century
Gold, silver, pearls and enamel
27 × 21 cm
Amalfi (Naples), cathedral

Though the mitre is today the liturgical headgear worn by bishops, it has not always been so. In the 8th century, the pope alone was allowed the supreme honour of wearing the white conical cap which is the mitre's predecessor. In the 10th century, the privilege was passed down to the cardinals of Rome, but it was not until the beginning of the 11th century that kings, emperors and certain bishops were granted the right to wear a mitre. The King of Bohemia, for example, had to be given explicit permission to do so from the pope himself in 1060.

The classic form of the mitre, of which this one from Amalfi is an example, was established around the 12th century. In the centuries that followed, the height and the density of ornament tended to increase. Modern taste, however, seems to have checked that development, and the mitre is again a relatively sober liturgical ornament.

The mitre exhibited here, a true "gem" of the jeweller's art, is said to have belonged to Bishop Ludovico of Toulouse, who died in 1297. (R.V.)
Work unavailable for exhibition.

145
Tunicle
Mid-16th century
Crimson red velvet, silk, gold thread
105 × 70 cm
Lucca, Diocese

The tunicle (or "little tunic"; also called a dalmatic) is the liturgical vestment of the deacon, the minister who assists the priest in the Catholic liturgy and proclaims the Gospel during the mass, and who otherwise concerns himself with charitable works. The deaconate was instituted by the apostles in the first Christian community of Jerusalem. The two best-known early deacons are Stephen, the first Christian martyr, and Lawrence, deacon of the church of Rome.

The tunicle is unlike the chasuble insofar as it has sleeves, and most often assumes a rectangular form. Very much like the chasuble, though, the colour of the tunicle is dictated by events in the liturgical calendar.

This particular example from the mid-16th century is in an excellent state of preservation, apart from some fraying in the fringe. The most exceptional aspects of the garment are the superlative quality of the velvet, and the brocade panels on front and back, into which are woven in yellow silk and gold thread the monogram of Christ supported at the corners by cherubim. The style and technique of this tunicle leave no room for doubt that it was crafted in Lucca. (R.V.)

146
Chasuble
17th century
White silk with gold thread
120 × 70 cm
Lucca, Diocese

The chasuble is the liturgical vestment worn by the priest during the celebration of the mass. Its original form was that of a great circular cape with a single aperture for the head. Over the centuries the chasuble was modified, in part to facilitate movement of the arms, eventually finding its classic form, of which the chasuble displayed here is a fine example. Recent tendencies toward liturgical reform, exemplified in the decisions of the ecumenical council known as Vatican II, seem to reflect a new preference for the older form.

Despite some minor restorations and a slight fading of the colours, this chasuble retains all the vitality of its extraordinary embroidery. The floral and vegetal ornaments are executed with the highest standards of artistry and workmanship. There are unfortunately no indications that would enable us to date the garment or attribute it with certainty. (R.V.)

147
Purse for a corporal
Early 17th century

Silver brocade, gold and pearls
29 × 29 cm
Benevento, metropolitan church

Archival documents inform us that the donor of this work was Cardinal Pompeo Arrigoni, shrewd diplomat and distinguished jurist (he participated in one of the hearings on Galileo's *proposizioni*), twice nominated for the papacy, and Metropolitan of Benevento from 1607 to 1616.
In a manuscript of 1729 from the Capitolare of Benevento (ms. 484), the purse is described as follows: "of silver brocade embroidered with gold, pearls and garnets; on one side the emblem of the late Cardinal Archbishop Arigonio, and on the other a cross with four corresponding bows".
Because of the preciousness of its materials, its artistic excellence, and the importance of its function in the liturgy, this purse – itself a container for the corporal upon which was placed the bread and wine – had a container of its own. According to an undated manuscript also in the Capitolare (ms. 281), it was stored in a special casket-shaped box, trimmed with braided gold thread and lined in red satin.
As described in the aforementioned manuscript, one side of the purse bears the Arrigoni coat of arms, framed by fluent arabesques and relief friezes studded with garnets and small pearls that reflect the surrounding blue, surmounted by a cardinal's hat and a Greek cross. The manuscript extends the description: "...bordered in red and gold, with a black eagle set in gold at the top; bands of azure carry the letters AR, joined together with golden threads". On the other side, broad arabesques studded with small garnets form a distinctive Greek cross set against a silver brocade framed with pearls and yet more garnets. At each corner of the border are nine golden rays, three of them decorated with tiny pearls. (G.G.)

148
Cope
18th century
Silk and gold

280 × 135 cm (overall)
212 × 19 cm (orphrey)
Pistoia, Museo della Cattedrale

The pattern of this cope is based on a module which develops horizontally and is then repeated, in slightly different form, vertically. This abstract module is ingeniously assembled so as to suggest the unbroken intertwining of realistic floral and vegetal motifs. But beneath the apparently continuous progress of the floral pattern over the surface of the cope, one can always recognize the underlying structure of two separate elements running cross-directionally in the manner of a chequerboard, one a bit larger and more realistically detailed than the other. Exuberantly twisted leaves and colourful floral clusters complete the decoration, all of which is set in seeming relief against a background of yellow silk.
The narrow vertical frieze, called an orphrey, and the central shield are from a later period. Here, a structure of lace-edged ribbons underlies a lively composition made of serrated leaves, flowers and pomegranates.
The decorative strategy of disguising a fundamentally abstract structure with richly detailed figurative ornamentation is a hallmark of the "post-bizarre" style, of which this cope is an example. The consummate elegance of the garment's design and workmanship, along with its exceptional length would suggest that it was crafted in France, though it should be remembered that Italian workshops did produce copies of French prototypes. The orphrey and shield are also French in style, but were more likely fabricated in northern Italy, insofar as their chromatic range is slightly less refined and imaginative than that of genuine French textiles of this period.

149
Chasuble
18th century
Interwoven with gold
106 × 71 × 70 cm
Cava de' Tirreni (Salerno), basilica of Santa Maria dell'Olmo

The chasuble comes from the ancient *casubla*, a type of cloak which was wrapped around the whole body having an equal length at all points. In ancient times the *casubla* was considered the clothing of the poor. But from the 4th century it replaced the toga of the ancient Romans, becoming a garment worn on festive occasions and thus passing into the sacred use of the Christians.
Until the 13th century, its form changed very little, retaining the idea of the large cloak.
The taste for using precious material and rich decorations on chasubles started in the Middle Ages. A preference developed for using precious types of material rather than simple cloth. Oriental silks were used, for example, or the cloth itself was interwoven with precious materials like gold. Chasubles such as the one on display were not rare in the 18th century. Their merit lies not in the artwork itself but in the way in which they have been made. (R.V.)

Art and Devotion

150
Reliquary
Late 12th century
Gilded copper with *champlevé* enamels, embossed copper, crystal
25 × 27 × 10.5 cm
Aosta, Museo del Tesoro della Cattedrale, on temporary loan from the church of Santa Maria, Châtel Argent, Villeneuve (Aosta)

The reliquary *a cassetta*, or "little box", assumes the simple architectural form of a parallelepipedon, with a rectangular base resting on four small feet. The four sides and the two sloping planes of the top are held together with a species of rivet, some of which have been lost. The rear panel of the top is hinged so as to allow access to the interior of the reliquary. The "roof" is crowned with lacy fretwork, embellished further by three large *cabochon* crystals, and is crowned at each end by finials in the shape of small spheres. The central element,

perhaps a cross, is missing (cf. the similar reliquary of Saint Thomas à Becket in the Tesoro della Cattedrale of Anagni, Frosinone).

The enamel decoration is done in the *champlevé* enamel technique: on the front panel is the Crucifixion, attended by personifications of the sun and moon, the Madonna, and Saint John the Evangelist, with four saints arranged beneath segmented arches on either side; on the roof is a central medallion of the *Majestas Domini* surrounded by the symbols of the Evangelists and four of the apostles, among whom we can recognize Peter and Paul. The sides of the reliquary carry the figures of Saint Paul and a sainted bishop offering a blessing. The bodies of the figures stand out in relief against a *vermiculé* background, while their faces are embossed in lower relief.

The back of the reliquary is densely decorated from top to base by an alternating sequence of rosettes and quatrefoils. As Viale (1949) justly observed, the richness of ornament and the virtuosity of execution rank this reliquary among the finest pieces to have come out of the famed workshops of Limoges. Its close stylistic and iconographic affinities with a reliquary in the collection of the Metropolitan Museum of Art in New York, datable to around 1175-85, would suggest a similar date of execution for the one exhibited here (cf. Gauthier 1987, no. 219, p. 188).

Literature: L. Gonse, "Exposition retrospective de Turin", in *Gazette des Beaux-Arts*, 1880; P. Toesca, *Aosta*, catalogue of Italian art and antiquities, Rome 1911; V. Viale, *Gotico e Rinascimento in Piemonte*, exhibition catalogue, Turin 1949, no. 42, pp. 242-243, pl.; L. Mallè, "Antichi smalti cloisonné e champlevé nei secoli XI-XIII in raccolte e musei del Piemonte, I", in *Bollettino della Società Piemontese di Archeologia e Belle Arti*, 1949, pp. 36-79 (pp. 74-79); V. Viale, M. Viale Ferrero, *Aosta romana e medievale*, Turin 1967, p. 54, fig. p. 56; N. Gabrielli, E. Brunod, *Arte sacra in Valle d'Aosta*, exhibition catalogue, Aosta 1969, no.

11, pp. 21-22; L. Garino, *Museo del Tesoro. Cattedrale di Aosta*, Aosta n.d. (but 1985), no. 12, p. 116; S. Vasco Rocca, in *Tesori d'arte dei musei diocesani*, exhibition catalogue, ed. by P. Amato, Turin 1986, entry on pp. 72-73; M.M. Gauthier, *Emaux méridionaux*, I, Limoges 1987, no. 219, p. 188; E. Rossetti Brezzi, "Le vie del Gotico in Valle d'Aosta", in *Gotico in Piemonte*, Turin 1992, pp. 287-359 (p. 299, note 33). (S.B.)

151

Reliquary of Saint Grato
Early 13th century
Silver (embossed, engraved, filigreed, and partially gilt), crystal, semi-precious stones, *champlevé* enamels, silk brocade
76 × 14 × 14 cm
Aosta, Museo del Tesoro della Cattedrale

The decoration of this magnificent reliquary is a veritable catalogue of the various techniques of the jeweller's art. Taking the form of an arm terminating with a hand in a gesture of blessing, it is constructed over a core of wood, and then covered with fine sheets of silver which are worked so as to suggest three layers of sleeves. The innermost of the three clings to the wrist in tight horizontal pleats, while the intermediate one hangs in flat vertical folds, its scalloped hem decorated with an incised vegetal pattern. The outer sleeve is the shortest and the most extravagantly ornamented, falling in broad folds that effectively suggest a stiff, heavy fabric. The diamond pattern is made thereupon from engraved sheets of gilded silver, semi-precious stones, and *cabochon* crystals. A braid of filigree studded with gems is crafted so finely as to simulate embroidered silk.

The upper part to the base is a truncated pyramid, covered in engraved silver. On each side is a rectangular plaquette of *champlevé* enamel done in a variety of geometric and vegetal patterns. The lower part of the base carries on one side a Crucifixion – though the figure of Christ is missing – with

the sun and moon in raised relief. The other sides have lost their original metalwork, which was replaced with panels of silk brocade with vegetal motifs in the Baroque era. Close inspection reveals other losses in the sleeves, in the area of the diamond pattern, in the filigree, and in the gem settings. The inner sleeve once had a decorative border at the wrist, and that too has been lost. Documents record the replacement of the fifth finger in 1612 (at which time 24 gem settings were counted missing), and then another restoration in 1785 (Duc 1896, p. 33). Reliquaries which reproduce in their external form the part of the body contained therein were common in the Gothic period, particularly those in the shape of an arm. In Aosta alone, there are at least two others of this type – a contemporary counterpart in the collegiate church of Sant'Orso, and a late 13th-century example in the cathedral which contains the arm of Saint Giocondo.

The reliquary of Saint Grato must have come from the studio of an Aostan goldsmith who was fully aware of the tastes and technical innovations, largely French, of the early 13th century. The similarity of the filigree and gem mounts to those of a processional cross at the cathedral, datable to the first third of the 13th century, supports a similar date for this reliquary (Rossetti Brezzi 1992, pp. 296-297). The *champlevé* plaquettes, however, are not from Aosta, but more likely of Rhenish-Mosan origin, dating from the late 12th or early 13th century.

Literature: P.E. Duc, *Culte de Saint-Grat*, VI, Turin 1896, p. 33; P. Toesca, *Aosta*, catalogue of Italian art and antiquities, Rome 1911, pp. 53-55; V. Viale, *Gotico e Rinascimento in Piemonte*, exhibition catalogue, Turin 1949, no. 41, p. 242, pl. 258; L. Mallè, "Antichi smalti cloisonné e champlevé nei secoli XI-XIII in raccolte e musei del Piemonte, II", in *Bollettino della Società Piemontese di Archeologia e Belle Arti*, 1950-51, pp. 54-136 (pp. 131-132); V. Viale, M. Viale Ferrero, *Aosta romana e medievale*, Turin 1967,

pp. 54-55; E. Rossetti Brezzi, "Le vie del gotico in Valle d'Aosta", in *Gotico in Piemonte*, Turin 1992, pp. 296-297. (S.B.)

152

**Cover of an Evangelistary,
with Christ Teaching**
10th century
Frame: 13th-15th century
Ivory
26 × 21 × 8 cm
Udine, parish church of San Pietro in Carnia

This evangelistary cover is composed of two wooden tablets finished with engraved silver, into which are set ivory panels originally belonging to a triptych, now dismembered, of the *Deesis*. The principal ornament of the front cover is an ivory panel depicting Christ Pantocrator in half-length. His austere face is framed by a beard and shoulder-length hair parted in the centre. In his left hand he holds a closed Book of the Gospel, while his right hand offers a gesture of blessing. Behind his head is a large jewelled cross with a small bust of an angel on each of the transverse arms. The frame is decorated with a trefoil grape-leaf pattern engraved in silver, interrupted at the corners by plaquettes with the busts of two saints (top left, bottom right) and two angels (top right, bottom left).

The back cover incorporates two other ivory panels. The Virgin and John the Baptist, both praying in three-quarter pose, are placed in the upper part; underneath are two standing saints, one of them bearded, each of them holding a cross. Thanks to traces of inscription on the backgrounds of these latter two, the saints have been identified as Theodore and George (Goldschmidt, Weitzmann 1934). These two panels, recycled from another source, are set at the sides of a central Crucifixion scene in silver *repoussé*. The whole arrangement is bound by a frame similar to that of the front cover, decorated with floral tracery and a geometric pattern of squares containing lozenges and eight-pointed stars. The outermost corners, as on the

front cover, carry the busts of two saints (upper and lower left) and two angels (upper and lower right).

The disparate parts of this precious binding are clearly not contemporary. The proportions and posture of the figures from the former *Deesis* triptych are comparable to those in the so-called "Niceforo" group of ivories, and would thus seem to belong to the 10th century. The stout figures of George and Theodore are very close in style to those on an ivory reliquary from Cortona, dating with certainty from 963-969, as an inscription reveals. Further affinities can be found with the figures on the side panel of a triptych in the Kofler-Truniger collection in Lucerne, or on the Borradaile triptych in the British Museum, and also with another in the treasury of the cathedral at Altötting, which date from the latter half of the 10th century. The bust of Christ Pantocrator bears particularly close iconographic and stylistic comparison with the central panel of a triptych in the Musée du Palais des Arts in Lyon, which is also certainly from the second half of the 10th century. To the same period can be dated the ivory binding of the Zuglio evangelistary, which perhaps came out of Constantinople. The other parts of the binding under discussion, however, are quite a bit less ancient: the embossed silver framing elements are from the 12th century, while the Crucifixion and corner plaquettes with saints and angels, clearly the products of a local workshop and not of a high artistic level, were made in the 14th-15th century.

Literature: P. Molmenti, *La storia di Venezia nella vita privata dalle origini alla caduta della Repubblica*, vol. I, Venice 1905; L. Venturi, "Opere d'arte a Moggio e a San Pietro di Zuglio", in *L'Arte*, XIV (1911), p. 473; A. Goldschmidt, K. Weitzmann, *Die Byzantinischen Elfenbeinskulturen des X.-XIII. Jahrhunderts*, Berlin 1979; A. Rizzi, "Il tesoro della chiesa di San Pietro in Carnia", in *Sot La Nape*, IV, no. 3 (1955), p. 5; P. Bertolla, G.C. Menis, *Oreficeria sacra in Friuli*, exhibition catalogue, Udine 1963, no. 22, pp. 44-45; I. Furlan, in *Venezia e Bisanzio*, exhibition catalogue, Venice 1974, nos. 34, 42, 43. (C.R.)

153
Reliquary of the Gospel of Saint Mark of Patriarch Pagano della Torre
1319-32
Gilt silver
32.2 × 27.2 cm
Venice, Tesoro di San Marco

The sacred relic that lies beneath the modern glass cover is a single folio of parchment bearing the letters CTS and DIXIT. The folio comes from one of five fascicules that once comprised a 5th-century Latin version of the Gospel of Saint Mark, long believed to have been written by the saint himself. In 1420, the Doge Tommaso Mocenigo obtained three of them from the Austrians at Cividale, whence they were then taken to Murano by Mocenigo's chancellor. Eventually they were transferred with great ceremony to Saint Mark's cathedral in Venice.

In 1355, two fascicules of the same evangeliary had been sent to Prague as a gift from the bishop of Aquileia to his brother, Emperor Charles IV, and they are still venerated today in Prague cathedral. Between 1319 and 1332, prior to the separation of the Gospel of Saint Mark from the other three, the Patriarch Pagano della Torre had the complete evangelistary bound and covered in silver.

The figures in the Crucifixion group correspond closely with those on the cover of the Gospel of the Epiphany at Cividale, not only in the poses of the Virgin and Saint John, but in the form of their pedestals and the decoration of the drapery borders. We can thus infer that this particular part of our binding, or at least its model, was copied in Aquileia sometime after 1250-70. The artist of the Saint Mark's cover, however, has transformed the original vertical format of the scene into a lateral one, pushing the flying angels out to the sides and creating broad open spaces between the figures.

The scenes of the life of Saint Mark are conceived in another style, more linear than sculptural, and perhaps a bit primitive. The figures are blocky and stout, draped in undifferentiated garments, and all seem to have the same massive head. This is almost certainly the result of their having been taken from a painting, probably an antique manuscript illumination from Saint Mark. This is further confirmed by the architectural form of the baldachin reduced to an outline; the way in which the kneeling saint seems suspended in the air; the typology of plant-like decoration on the throne's wooden arcades reminiscent of Carolingian miniatures. In other areas, pains have been taken to differentiate the figures, varying the forms of the throne and the decorative patterns of the haloes and garment borders. The hem of Saint Peter's cloak, for example, is cross-hatched, while the others remain unornamented. And, in the scene of the delivery of the key, his halo is cut with the same pattern as those of the Virgin and Saint John in the Crucifixion scene, a motif which also appears on the reliquary of the Holy Blood in Saint Mark's, from 1283.

It is clear that the recombination of these disparate elements was a bit forced. The central panels have been cut down on all sides in order to fit this format; the edges are irregular, almost mutilated, and mounted too tightly; and the stamped frieze reliefs are often cut too short. The absence of Pagano della Torre's coat of arms on the front side remains a mystery.

154
Rombolo Salvei
Reliquary of the Virgin
1379
Gilt silver
56 × 36 × 27 cm
Pistoia, Museo della Cattedrale

The multifoil form of the base is boldly decorated with architectural motifs, and from this springs the filigreed stem, which in turn supports a larger pedestal in the form of a temple, complete with mullioned windows and spires, echoing the typical forms of a late Gothic cathedral. Crowning the reliquary is the half-length figure of an angel, emerging from another architectural base, who holds aloft the crystal case containing the relic of the Madonna. An inscription on the base informs us of the artist's name and the date of execution: "Rombolus Salvei de Florentia me fecit: opus fieri anno 1379 extentibus operari opere Sancti Jacopi Conno Bartolomei Dondori, ser Antonio Puccetti Tommasus Bartolomei de Astensibus Nerius Jacopi Fieravanti".

The first scholar to transcribe the inscription and offer extended discussion of the reliquary was Beani (1903, p. 164). The reliquary originally contained a fragment of the True Cross which, according to Arfernoli, had been donated to the city of Pistoia in 1357; it seems that it was subsequently destroyed in a fire of 1558. Today, after a number of modifications, especially to its upper part, the reliquary now contains a relic of the Virgin.

Literature: G. Tigri, *Pistoia e il suo territorio*, Pistoia 1854; G. Beani, *La cattedrale pistoiese*, Pistoia 1903; A. Chiti, *Pistoia: Guidastorico artistica*, Pistoia 1956; G. Marchini, "L'altare argenteo di San Jacopo e l'oreficeria gotica a Pistoia", in *Il gotico a Pistoia nei suoi rapporti con l'arte gotica italiana, Atti del II Convegno internazionale di studi*, Pistoia 1966.

155
Reliquary of Saint George
1390-1400
Silver
Height 24.5 cm
Chieri (Turin), church of San Giorgio

This reliquary in the form of a bust of Saint George was completely gilded around 1950, and as a result has lost some of its original vitality. It has also suffered from numerous tamperings and losses in recent times, as is revealed by a comparison with a photograph taken in 1939 on the occasion of the exhibition "Gotico e Rinascimento in Piemonte". Giovanni Roma-

no's detailed entry for the catalogue of another exhibition (Romano 1979, pp. 274-275) documents the addition to the saint's nimbus of a second band, on which is stamped the somewhat indecipherable inscription, "YHT [or YBT] TUTOR [?] YHT [or YBT]". This addition probably dates from 1441, the year in which San Giorgio was officially consecrated as a parish church.

In contrast to previous studies by Viale and Cavallari Murat which propose an early date of 1300-50, Romano's careful research into the costumes found in late 14th-century frescoes and miniatures push the date of execution to the end of the 14th century.

As for the location of the workshop that crafted the reliquary, these same comparisons with frescoes and miniatures suggest an address that might be either Piedmontese or Lombardian. The imprint of the Piedmont is especially clear in the characterization of the saint, the liveliness of which approaches a certain ferocity.

Literature: G. Romano, in *Giacomo Jaquerio e il gotico internazionale*, exhibition catalogue, Turin 1979. (C.S.)

156
Giovanni D'Angelo da Civita di Penne (active late 14th - early 15th century)
Reliquary
14th-15th century
Silver
23.3 × 13.8 cm
L'Aquila, Museo Nazionale d'Abruzzo

This reliquary takes the form of a small temple or pavilion decorated with polychrome enamels, rock crystal, and silver which has been variously gilded, embossed and engraved, on an underlying structure of wood. It is missing one of the six triangular silver panels which ornament the cover. Inscribed on the base of the reliquary is the name of the artist, along with those of the saints depicted on the sides – Mark, Anastasius, Maximus, Luke and John the Evangelist.
The cover is dedicated to the Magdalene, Saint Catherine of Alexandria,

and the scene of the Annunciation, all figured beneath elegant Gothic tabernacles.

This beautifully crafted and artistically sophisticated reliquary constitutes the basis of our knowledge of Giovanni D'Angelo da Civita di Penne, who worked in a particularly important period in the history of Abruzzese goldsmithery. We can see evidence of his influence in the cross of the parish church of Cesacastina in the area of Teramo – though of more modest quality, certain passages of drapery and a shared vegetal motif confirm the connection. It has been recently suggested that we should recognize here the innovations introduced to Abruzzo at the dawn of the 15th century by the Master of the Beffi Triptych. It was he who painted the notable fresco cycle in the church of San Silvestro in L'Aquila, and from whose circle emerged the Master of the Caldora Chapel.

Literature: L. Gmelin, *Die Mittelalterliche Goldschmiedekunst in Abruzzen*, Leipzig 1890, p. 15; G. De Nicola, "L'Oreficeria nella Mostra d'Arte Antica Abruzzese", in *Rassegna d'Arte*, V (1905), p. 156; V. Balzano, *L'arte abruzzese*, Bergamo 1910, p. 110; U. Thieme, F. Becker, *Allgemeines Kunstler Lexikon*, vol. XIV, Leipzig 1921; G. Matthiae, *Il Castello dell'Aquila ed il Museo Nazionale Abruzzese*, Rome 1959, p. 16; M. Moretti, *Il Museo Nazionale d'Abruzzo nel Castello cinquecentesco dell'Aquila*, L'Aquila 1968, p. 51; V. Pace, "Per la storia dell'oreficeria Abruzzese", in *Bollettino d'Arte*, 1972, p. 82; S. Gallo, in *La valle dell'alto Vomano ed i monti della Laga. Documenti dell'Abruzzo Teramano III-1*, Pescara 1991, pp. 319 ff. (C.T.)

157
Staurotheca of Saint Leonzio
12th century (cross); 15th century (base)
Silver, gold, enamels, semi-precious stones
28 × 25 cm (cross);
21 cm (height of base)
Naples, Tesoro del Duomo

A staurotheca is a cross-shaped reliquary which contains a fragment of the True Cross of Jesus Christ. This particular staurotheca, from the Reliquary chapel of Naples cathedral, is composed of two distinct parts, whose obvious differences in style are a function of their having been made in different periods: the form of the base is typical of the late Gothic period, while the cross itself is much more archaic.
The base is securely datable to the tenure of the man whose coat of arms appears there – Oliviero Carafa was a cardinal of the diocese of Naples from 1458 to 1484. The matter of dating the cross, however, is more complex.
The so-called cross of Saint Leonzio, one of the few examples of Norman goldsmithery in Campania, was for a long time thought to have been commissioned by the Neapolitan bishop Saint Leonzio (thus the persistence of the misnomer) between the years 649 and 653. Tagliatela, the priest from Naples who first proposed this date, was certainly not taking into account the technical and stylistic evidence which clearly pushes the date of execution several centuries ahead. A more plausible thesis is that of Berteaux, who attributes the cross to the school of Monte Cassino at the time of the abbott Desiderius, in the late 11th or early 12th century.
Further difficulties are encountered in the acute stylistic differences between the two sides of the cross: the front is elegant and formally unsurpassable, while the back is awkward and coarse. Angelo Lipinsky (1960) has made the suggestion that "the present anterior face of the so-called Saint Leonzio cross was originally the posterior; the original anterior must be either lost, or damaged beyond recognition".
The part of the cross most worthy of close attention is of course the front, with its rich filigree decoration, the four great medallions of the Evangelists executed in enamel, all of this embellished with rich clusters of gems and pearls.

Literature: F. Bologna, "Per una revisione dei problemi della scultura me-

ridionale dal IX al XIII secolo", in *Sculture lignee nella Campania*, Naples 1950; A. Lipinsky, "La stauroteca del Duomo di Napoli", in *Partenope*, Jul.-Sept. 1960; G. Tagliatela, *La stauroteca di san Leonzio nella cattedrale di Napoli*, Naples 1977. (R.V.)
Work unavailable for exhibition.

158
Statuette of the Madonna di Bonaria
16th-17th century
Silver
20 × 8 cm
Cagliari, basilica of Nostra Signora di Bonaria

The small statue of the Madonna di Bonaria is a reproduction in miniature of the venerated wooden statue in the sanctuary of the same name.
The statuette is clearly the work of a craftsman and is unique.
The small size of the statue was intended to facilitate taking it around the various cities and towns of Sardinia. The devotional object used to accompany whoever assumed the task of collecting offerings for the ransom of Sardinians who had been taken as slaves by Saracen pirates during their frequent raids on the towns and villages along the island's coast. On the back of the silver statue there is a small handle that allowed it to be held up and offered to devotees to kiss.
It can be dated, mainly because of the period in which the pirates were known to have made their incursions, to sometime between the 16th and the 17th century. (L.P.)

159
A. Le Clerc
Turin, city of the Holy Shroud and of the Blessed Sacrament
1761
Etching
50 × 38.5 cm
Turin, Biblioteca Reale, Inc. IV 2

The Holy Shroud is the burial garment which, according to the tradition, is supposed to have enveloped Christ's body and on which his image was imprinted. The Holy Shroud is presented along the upper edge, supported by

angels and small putti. In the middle is the miracle of the Blessed Sacrament. At the sides are the patron saints of Turin: Salutore, Avventore, Octavius, the Blessed Amadeus, and John the Baptist, who is in the group on the left with the shield of the House of Savoy and a tablet bearing the inscription: "FACITE / IUDICIUM ET IUST / DILIGITE PUPER / ET DOMINUM DABI / PACEM IN FINIB / VESTRIS". At the bottom there is a perspective plan of the city. At bottom centre, a scroll with the dedication: "Ang. Ill.mi SIGNORI dell'AUGUSTA CITTÀ di TORINO / L'Idea del celebre MIRÀCOLO dell'EUCHARISTICO SAGRAMENTO, Seguito / a - 6 - giugno - 1453 - adorato dai nostri SANTI PROTETTORI, accompagnato dal / Ritratto del SANTISSIMO SUDARIO e la Pianta in Prospettiva di questa / AUGUSTA CITTÀ, con la speranza d'un grazioso aggradimento alle / Loro SIGNORIE ILLUSTRISSIME diuotamente Dona Dedica Consacra" (To the Ill. LORDS of the AUGUST CITY of TURIN / The Idea of the celebrated MIRACLE of the EUCHARISTIC SACRAMENT, Followed / on 6 - June - 1453 - worshipped by our PATRON SAINTS, accompanied by the / Portrait of the HOLY SHROUD and the Plan in Perspective of this / AUGUST CITY, with the hope of a gracious approval from / Their MOST ILLUSTRIOUS LORDSHIPS lastingly Dona Dedica Consacra). On the spiral of the scroll, in the centre: "A. Leclerc f."
At the sides of the scroll, between colours and cannon: the Savoy coat of arms on the left, the coat of arms of the city of Turin on the right. In the bottom left-hand corner: "JULIUS CESAR GRAMPIN / Iuven et delineavit. / TAURINI"; at the sides of the dedication, legends with 13 captions for interpretation of the map. Along the bottom edge, the printer's notes: "Si stampano e si vendono in Torino Sotto gli Portici di Piazza Castello all'Insegna del S. Sudario con Privilegio di Sua Altezza Reale. Joan: Bogliettus excudit 1761" (Printed and sold in Turin Under the Porticoes of Piazza Castello at the Sign of the H. Shroud under Charter of His Royal Highness. Joan: Bogliettus excudit 1761).

This print is from the second edition of the engraving, published for the first time in 1701 by Giovanni Boglietto. The two editions are easy to distinguish, not only by the different dates they bear, but also by the cancellation of the publisher's name at the end of the dedication as well as in the printer's notes. The name of Joan Bogliettus still appears along with the date, 1761 instead of 1701. The dates are indicative of the great esteem in which the Shroud was held during the reigns of Amadeus II and Charles Emmanuel III.
Publications and numerous pictures in Turin's Biblioteca Reale document the popularity of the Holy Shroud. In the possession of the House of Savoy since 1453 and coming from Chambéry, it was put on show in Turin for the first time in 1578. Over the course of the centuries it was displayed at dynastic ceremonies and weddings, as a symbol of political and religious power.
This etching draws an eloquent parallel between the Holy Shroud and the Blessed Sacrament, portraying them as protectors of the city.

Literature: A. Peyrot, *Torino nei secoli*, Turin 1965, p. 292; for A. Leclere cf. E. Bénézit, *Dictionnaire critique et documentaire des peintres, sculpteurs, dessinateurs et graveurs*, Paris 1966 *ad vocem*; for Grampini cf. A. Baudi di Vesme, *L'arte in Piemonte dal XVI al XVIII secolo*, Turin 1966 *ad vocem*; A. Bo in *La Sindone di qua dai monti. Documenti e Ricerche*, Turin 1978, no. XVII. (G.B.)

Art and Artists

160
Crucifix
12th century
Wood
210 × 210 cm
Acerra (Naples), Hall of the Bishop's Palace

This wooden crucifix is the most important cultural and religious treasure of the town of Acerra.
Already in the 19th century, Gaetano Caporale pointed out its value: "Until

about two years ago, in the oratory one could see a crucifix of wood, with a figure larger than life, of incorrect proportions, clumsily carved; this is a sculpture from the times of the Anjou, of extreme interest to the arts: as can be observed in the rendering of the hair and even moreso in the drapery that falls around his loins in symmetrical folds" (Caporale 1893, p. 197).
The Crucifix is presented to the public for the first time here in its recently restored form. Before restoration, the work was completely covered by a coat of brown paint, which detracted from the delicacy of the modelling.
The removal of the layer of paint revealed the original polychrome decoration, with its purplish-pink flesh tones and blue-green loincloth. During the cleaning process, the left arm was found to be an addition of recent craftsmanship. The thumb of the right hand is also a recent repair.
The style of the Acerra Christ fully corresponds to that of the groups of monumental and ivory sculptures found in southern France and Spain during the second half of the 12th century. These in turn developed out of the innovations in sculpture that took place in Provence and are a compelling example of their fanciful decorative solutions.
The Crucifix dates to no later than the end of the 12th century.

Literature: G. Caporale, *Ricerche sulla diocesi di Acerra*, Naples 1893; F. Bologna, R. Causa, *Sculture lignee nella Campania*, Naples 1950. (R.V.)
Work unavailable for exhibition.

161
Madonna and Child
Early 14th century
Carved, painted, and gilt wood
58 × 20 cm
Gignod (Aosta), Museum of the parish church of Sant'Ilario
From the chapel of Variney, Gignod

The Madonna is seated in a simple throne with no back, in a rigidly frontal position, her feet resting on a base in the form of a board. The Child, seated on his mother's left knee, is raising his

right hand in blessing and holding the orb in his left. Both are crowned; some pieces of the Virgin's crown are missing and the attribute that she held in her right hand (a fruit?) has also been lost.
Traces of the original colouring can be seen under the heavy repainting in places.
The typological scheme of the group, derived from the Romanesque model of the *Sedes Sapientiæ*, was very widely used on both sides of the Alps between the 13th and 14th century, as is shown by the numerous examples to be found in the Vallais, the canton of Fribourg, Upper Savoy, and Valle d'Aosta. Within the large series of such works in Valle d'Aosta, an evolution of style can be seen that progressively modifies the solemn composure of the pose into a more lively one, in which the emphasis on the affectionate relationship between mother and child is a sign of the influence of French Gothic trends. Among the oldest examples, we can cite the *Madonna* from the church of Saint-Léger at Aymavilles, now on deposit at the Museo del Tesoro della Cattedrale of Aosta (Garino 1985, no. 8, p. 114), the one formerly in the Craveri-Giacosa collection and originally from Cogne (Brunod 1981, pp. 468-469, fig. 413), the one in the Passerin d'Entrèves collection at Saint-Christophe (Brunod-Garino, vol. III, 1990, p. 417, fig. 42), another in the parish museum of Gignod (*Gignod. Arte sacra e cultura materiale*, 1981, p. 85 and fig. p. 89), and the *Madonnas* formerly in the chapels of Vigneroisa at Champorcher and of Praz in the parish of Issime (Vicquéry 1987, pp. 94-95, fig. 59; pp. 146-147, fig. 145).
These all still show marks of the classically influenced period known as "1200 style" and date from around the middle of the 13th century. A later phase, between the end of the 13th and the beginning of the 14th century, is represented by the *Madonnas* in the Accademia di Sant'Anselmo in Aosta (Brunod 1981, p. 341, fig. 288), in Quart castle (at present in the Collezioni Regionali; *ibidem*, p. 338, fig.

285), in the parish church of Saint-Dénis (Brunod-Garino 1990, p. 145, fig. 19), in the Santuario della guardia of Perloz, and in the Museo Civico of Turin, originally from Valgrisenche (Brunod 1981, pp. 410-411, fig. 364). In its stylistic and iconographic affinities, the *Madonna* of Variney is very close to the examples in Saint-Dénis and Perloz.

Literature: G.C. Sciolla, *Aosta. Museo Archeologico, Tesoro della Collegiata, Tesoro della Cattedrale*, Bologna 1974, p. 66; E. Brunod, *La Cattedrale di Aosta*, Quart-Aosta 1975, p. 414, fig. 298; E. Brunod, *Diocesi e Comune di Aosta*, Quart-Aosta 1981, p. 415, fig. 259; L. Garino, *Museo del Tesoro. Cattedrale di Aosta*, Aosta n.d. (but 1985); D. Vicquéry, *La devozione in vendita*, Rome 1987; E. Brunod, L. Garino, *Bassa Valle e valli laterali*, Quart-Aosta 1990; E. Rossetti Brezzi, "Le vie del Gotico in Valle d'Aosta", in *Gotico in Piemonte*, Turin 1992, pp. 287-359. (S.B.)

162
Black Madonna

16th century
Painted wood
137 × 54 × 30.7 cm
Ancona, Museo Diocesano
d'Arte Sacra

The statue depicts the Madonna of Loreto and the Child, standing and frontally placed. The Virgin has a crown in the form of a tiara and is wearing a richly ornamented dalmatic and a necklace with ogival links that terminates in a small cross.
The object, now kept in the Museo Diocesano d'Arte Sacra of Ancona, comes from the church of Santa Maria Liberatrice in the Posatora district of Ancona.
The statue was discovered some thirty years ago during the restructuring of the church: it was hidden behind a dilapidated partition at the end of the right-hand apse.
Although it was in a fairly good state of preservation, the *Madonna* underwent restoration in 1974, with unsatisfactory results that are particularly obvious in the two heads.

It is a wooden statue made from a single shaped and carved board, to which the heads of the Madonna and the Child have been added. It is clear that the artist's intention was to imitate the image of the Virgin carved out of dark wood that used to be kept in the votive chapel of the sanctuary of Loreto. The character of a two-dimensional and hieratic image, typical of the *Madonna* of Loreto, is accentuated in this version by the technical simplification and by the rather archaic style of the two heads.
The presence of the tiara-shaped crown makes it possible to date the statue to the 16th century.
A final limit to this date is set by the offering from the town of Recanati of a statue with a crown in the form of a tiara on its head. The citizenry brought the *ex voto* to the sanctuary in a solemn procession on 25 March 1498, along with other gifts to offer thanks for the Virgin's divine intervention putting a stop to an outbreak of plague that had claimed many victims. The documents record that this crown remained on the Madonna's head until 1638, when it was replaced by another sent by the king of France, Louis XIII.
The statue can be dated to the second half of the 16th century on the basis of a careful formal analysis of the rich decoration of the dalmatic. The motifs of ogival links with scroll-shaped ends and the stylized floral elements, both schematically juxtaposed in vertical rows, can be found in both the sculpture and the architecture of that period, as well as in the patterns of textiles and examples of goldsmith's art from the late *Cinquecento*.
Further evidence for this date is provided by numerous copperplate engravings tinted in watercolour from the end of the 16th century, in which the iconographic prototype of the Virgin with the dalmatic and the tiara is meticulously reproduced.
One may speculate that the wooden statue was commissioned for the church dedicated to Santa Maria Liberatrice, built in 1531 with the consent of Bishop Baldovinetto de' Baldovinetti (1523-1538) in gratitude for the

liberation of Ancona from the plague. This is all the more likely in that the church was built on the site of a shrine devoted to the *Madonna* of Loreto in memory of the tradition that the Holy House, on its way from Tersatto in Yugoslavia, had alighted there at Posatora, before going on to Loreto.

Literature: F. Grimaldi, *La tradizione lauretana nelle stampe popolari*, Loreto 1980; F. Grimaldi, *Santa Maria porta del Paradiso Liberatrice dalla pestilenza*, Loreto 1987; *Il sacello della Santa Casa*, edited by F. Grimaldi, Loreto 1991. (L.Z.)

163
Saint John the Baptist

15th century
Polychrome carved wood
110 × 32 × 23 cm
Miglionico (Matera), church
of Santa Maria Maggiore

The saint is represented standing upright. With his left hand and forearm he is holding a book and a dove, while his right arm, unfortunately mutilated, presumably rested on his breast.
The expression on his face, surrounded by shoulder-length flowing locks and partially concealed by a short but straggling beard, is one of humble submission with his gaze fixed on the ground: a humility that contrasts admirably with the majestic dignity of the upright body, signifying the immense importance of his mission as Christ's harbinger.
The short, humble garment, sleeveless and with no ornament or decoration, opens to reveal his lean but powerful chest. A braided cord holds it closed at the waist and its hems look rough and frayed. Not even the long cloak succeeds in covering the saint's shoulders and merely spreads out along the right leg to conceal it partially with a drapery that is totally lacking in affectation. In reality, the mantle performs an important structural function in the composition of the figure: the long piece of material that descends as far as the rocky bank on which the saint's feet are precariously balanced is actually a supporting element that ensures the

stability of the figure and emphasizes its verticality.
The solution adopted by the unknown artist to mask this function for aesthetic reasons is a remarkable one: the trailing part of the cloak has none of the stiffness of a wooden support; instead an impression of movement is created by the deep fold that, hanging down to the ground, elegantly runs along its final curve.
The modelling of the visible parts of the body, with its careful and anatomically accurate representation of the muscles in the strong and bony legs and arm, of the chest on which the arrangement of the ribs on the sternum can be clearly seen, the lean and protruding collar bones, the powerful neck, and the delicate features of the face, all suggest that the work should be dated to around the end of the 15th century, when elements of the late Gothic tradition were already blending with the greater naturalness of early Renaissance art. The Neapolitan influence that some have detected in the work is undoubtedly part of a much broader cultural climate that left its mark on many areas of the south that were under the artistic sway of the capital. (A.A.)

164
Saint Peter

17th century
Painted wood
79 × 32 cm
Aosta, Museo della Cattedrale

Although the statue came to the museum along with the following *Saint Paul* (cat. no. 165), they are in different styles, even if coming from the same cultural background.
The saint, portrayed as was customary with the keys, is gazing heavenwards. His bare feet stand on a small rectangular base with rounded corners. The folds of the mantle are richer and conceal the shape of the body, whose massive forms are clearly visible in the *Saint Paul*, while the bony face has more expressive features, with the vigour of folk art.

Literature: L. Garino, *Museo del Teso-*

ro. *Cattedrale di Aosta*, Aosta n.d. (but 1985), no. 77, p. 88. (S.B.)

165
Saint Paul
17th century
Painted wood
79 × 32 cm
Aosta, Museo della Cattedrale

The statue comes from a church in the Valle di Ayas. Along with the *Saint Peter* described previously, it was rediscovered on the antique market at the end of the 1970s by Msgr. Edoardo Brunod, who later donated it to the cathedral.

The saint, draped in a broad cloak, holds a book in his left hand and the traditional iconographic attribute of the sword, whose blade is now missing, in the right. Although rather summary in the drapery, the modelling is finer in the features of the face and the carefully carved curls of the beard and hair.

The statues are part of the Baroque repertory that was used to decorate almost all churches of the Valle d'Aosta during the 17th and 18th centuries, and in that region was more or less the monopoly of the carvers of Valsesia.

Literature: L. Garino, *Museo del Tesoro. Cattedrale di Aosta*, Aosta n.d. (but 1985), no. 77, P. 88. (S.B.)

166
Madonna di Calciano
15th century
Wood
Height 90 cm
Tricarico (Matera), Bishop's Palace

The image of the Virgin Mary known as the *Madonna di Calciano*, as it comes from the fortress of that name, and now kept in the Bishop's residence in the diocese of Tricarico, is a polychrome wooden sculpture of fine artistic workmanship.

The Virgin is in the attitude of prayer and suggests the possibility of a missing figure, that of an angel announcing her divine maternity. The sculpture, by an unknown artist, displays stylistic affinities with the Neapolitan school of

Andrea da Firenze. A number of scholars are inclined to see the influence of Jacopo della Quercia as well.

Literature: A. Grelle Iusco, *Arte in Basilicata, rinvenimenti e restauri*, Matera 1991. (R.V.)

167
Small pyramid
Early 16th century
Candoglia marble
141 × 30.5 × 30.5 cm
Added base: 6 × 17 × 17 cm
Milan, Museo del Duomo

The *piramidina* ("small pyramid") of Milan cathedral alternates with the *falcone* ("bollard") and the *fiocco* ("tuft") along the entire length of the *falconature*, and there are about 1300 of them. By *falconatura* is meant the highly decorative marble coping, typical of the Gothic style, that caps the outer walls of the cathedral on several levels: these copings may be flat, enclose the spires or be rampant, and cover a total distance of about one mile.

The *piramidina* maintains the architectural style and volume constant, while the ornament (the more typical Gothic curled leaf, known in the jargon of the builders of Milan cathedral as the *gattone*), uniform in every element although diminishing in size from the bottom to the top, differs from element to element and is extremely variable according to the period and taste. These styles range from the late Gothic to mature Gothic, flamboyant Gothic, Baroque Gothic, Neo-classical, and neo-Gothic.

This *piramidina* dates from the early decades of the 16th century and was replaced, owing to its state of preservation, in the *falconatura* of buttress P12, the one that encloses the southeast spire of the southern transept arm of Milan cathedral. (E.B.)

168
Ratchis altar
737-744
Front: 89 × 144 cm
Sides: 89 × 87.5 cm
Cividale (Udine), Museo Cristiano

The altar is a parallelepiped ornamented with bas-reliefs on all four sides. On the front is carved the scene of the *Majestas Domini*, i.e. of Christ in Majesty. Four flying angels support the mystical mandorla (formed by palm fronds) in which Christ, between two cherubs, is seated on an invisible throne. From above, the hand of God the Father touches the glory of his Son, in confirmation of his divinity.
Represented on the left-hand side is the meeting of the Virgin (distinguished by a small cross on her forehead) with Elizabeth.
The scene of the *Adoration of the Magi* is carved on the right-hand side.
There is a square opening in the middle of the back of the altar: this is the *fenestella confessionis* through which people could see the relics kept inside. At the sides of this opening are two crosses, decorated with geometric patterns.
According to the inscription carved on the upper edge, this altar was donated to a church of San Giovanni in Cividale (probably San Giovanni in Valle) by Ratchis, Duke of Friuli from 739 to 744, the year in which he succeeded Liudprand as king of the Longobards. The work, one of the best known from the entire early medieval period, belongs to a broad and ramified artistic current of the tendentially abstract and "anti-classical" language that held sway in the whole of the Mediterranean basin from the 7th to the 11th century. The figures on this altar are carved in flattened relief: their clothing is covered with close-packed and tiny parallel folds. Their proportions appear to be considerably distorted: the arms are sometimes longer than the body, the hands enormous and the feet very small. In this far more spiritual than material vision of the body (devoid of any sense of volume, two-dimensional, fused with the clothing into a single indistinct shape), the artist always gives particular emphasis to the faces, which appear to be constructed around the large and astonished eyes.
In their original conception and execution, the bas-reliefs of the Ratchis altar were intended to be coloured (as

we are informed by the inscription on the upper edge). The work was also embellished with polychrome enamel decorations, set in the eye sockets and hair of the figures, the wings of the cherubs, and in the centre of the stars.

Literature: M. Brozzi, *L'altare di Ratchis nella sua interpretazione simbologica*, Trieste 1951; C. Mutinelli, "L'Ara di Ratchis", in *Quaderni dalla FACE*, no. 33 (1969), pp. 9-23; A.M. Romanini, "Problemi di scultura e di plastica medioevale", in *Artigianato e tecnica nella società dell'Alto Medioevo occidentale*, Spoleto 1971, p. 456; C. Gaberscek, "Note sull'altare di Ratchis", in *Memorie Storiche Forogiuliesi*, LIII (1974), pp. 53-72; A. Rizzi, *Profilo di storia dell'altare in Friuli*, vol. I, *Dalla Preistoria al Gotico*, Udine 1975, pp. 23-24.

169
Madonna
14th-15th century
Painted marble
90 × 30 × 23 cm
Mantua, Museo Diocesano

The work, owned by the parish church of Frassine (near Mantua), is presently conserved at Mantua's Museo Diocesano "F. Gonzaga".
The original context in which the statue stood was lost when the church to which it belonged was demolished. In any case, the statue is linked to popular tradition that suggests a different identity for the figure. In fact, according to this tradition, she is Saint Ann, the mother of the Virgin Mary, and the book she holds is the Holy Scripture, which she taught to the Mother of the Lord. The sculpture is one of the few remaining examples of painted marble in the Mantuan diocese. It may have been part of the decoration of the main altar of the demolished church, in accordance with the custom of setting alongside the altar the images of the given church's patron saints. (P.R.)

170
Madonna dell'Alica
15th century
Marble

Height 87 cm
50 × 28 × 1 cm (stand)
Bova (Reggio Calabria), church
of Pietrapennata

This statue is known as the *Madonna dell'Alica* because it came from the small church of the Alica, an ancient mountain hermitage for Basilian monks.
The white marble sculpture is in full relief and depicts the Madonna tenderly holding with one arm the naked Child, who is shown in a gesture of blessing. The stand is decorated with two small angels bearing a shield. The head of the Madonna is slightly bowed and her face has an expression of sweet melancholy; the Child is shown deep in thought and with a fixed gaze. The arrangement of the group is marked by its supple refinement and may be traced to the school of the Gagini family. The purity of the lines, the gracefulness of the figures and the softness of the drapery are reminiscent of the output of Florentine workshops during the Renaissance, which was taken up and spread in the south of Italy by Domenico and Antonio Gagini and their followers.
Numerous works from the Gagini workshops – which did a bustling trade in Palermo, Massina and other Sicilian centres – were introduced into the Italian peninsula by the Franciscan monks.

Literature: R. Frangipane, *Inventario degli oggetti d'arte d'Italia*, vol. II, *Calabria*, Rome 1931, p. 295; R. Frangipane, *Il Rinascimento artistico tra storia e leggenda in Calabria (la scuola gaginesca)*, Rome 1969. (R.M.D.)

171
Antonello Gagini da Messina
(1478-1536)
Madonna and Child
1508
White marble
97 × 52 × 40 cm
Sinopoli (Reggio Calabria), church of
Santa Maria delle Grazie

A white marble sculpture in full relief. The sacred group stands on a short base that bears the following inscription: "Do Joanni Ruffu Conti di Sinopoli et Burrello mi fichi fari" and the date 1508. In the middle of the desk is set the coat of arms of the Ruffo family: five hills, three stars, and a count's coronet with horse's head. The Madonna, who is clasping the Child to her breast, was almost certainly carved by Antonello Gagini for the Ruffo family, feudal vassals and counts of Sinopoli.
Mary is portrayed with her head slightly bowed and is highly reminiscent, in her expression of gentle melancholy, of the other sculpture, also attributed to Antonello, at Seminara. The purity of lineaments and nobility of composition to be seen in both works reveal the influence of the great Dalmatian sculptor Francesco Laurana (c. 1430-c. 1502). The drapery in which the two bodies are clothed is very soft and blurred; the Mother's fine hands grip the Son strongly and his embrace is very tender. Altogether, the group shows the influence of the Florentine Renaissance as well.
Antonello Gagini, son of the architect and sculptor Domenico Gagini who had moved to Palermo from Bissone in Lombardy, worked in Messina, where he had a flourishing studio and carved statues for the towns and cities of Calabria as well as those of Sicily. His sculptures can be found all over these two regions, in forms that were imitated with less skill by his followers.

Literature: A. Frangipane, *Inventario degli oggetti d'arte d'Italia*, vol. II, *Calabria*, Rome 1933, p. 312; R. Frangipane, *Il rinascimento artistico tra storia e leggenda in Calabria (La scuola gaginesca)*, Rome 1969. (R.M.D.)

172
Statue of Saint Primianus
14th century
Stone
110 × 30 × 22 cm
Ancona, Museo Diocesano
d'Arte Sacra

Saint Primianus, frontally placed, wears the alb and chasuble; his face is that of an old man, with beard and moustache, and he wears a bishop's mitre on his head.
Although its state of preservation does not permit a definitive identification, the statue almost certainly represents Saint Primianus. This attribution is made possible by a photograph of the same object published in an inventory in 1936, where the bishop appears with his right hand raised in blessing and the left holding a pastoral staff. The compiler of this inventory states that this is a stone statue of Saint Primianus from the church in Ancona dedicated to the same saint and probably carved in the 14th century.
This ecclesiastical personage is considered by local writers and many scholars to have been the first bishop of the city of Ancona, and to have lived in the 4th century, although there are no documents proving the authenticity of Saint Primianus and his episcopate.
The oldest record of the saint in Ancona is a report of the discovery of the bishop's relics in 1373 in the church of Santa Maria in Turriano. Following this event, the church was dedicated to Saint Primianus.
Subsequently this building was reconstructed and then renovated in the second half of the 18th century by the architect Ciaraffoni. The church was completely destroyed by bombing during the World War II, together with all its ornaments and vestments.
It appears that an inscription placed alongside the relics described Saint Primianus as Greek. This suggests that his body, like those of other saints including Saint Cyriacus, the city's chief patron, was brought there from the East by ship and placed in the church of Santa Maria in Turriano, which stood near the harbour. The fact remains, however, that prior to 1373 none of the surviving liturgical documents, episcopal chronologies, or iconographic records mention or depict the saint, or even refer to churches dedicated to the first bishop. In the present state of studies and research the problem of the origin and spread of the cult of Saint Primianus remains open. Above all it is difficult to understand why Primianus was not considered to have been the Dorian city's first bishop until after the discovery of his relics. The oldest representation of the saint seems to be the statue we are examining here. The discovery of the sacred relics places an upper limit on the date of the object; stylistic and formal analysis, in any case, provides confirmation of a date somewhere in the second half of the 14th century.
The care taken over the minute diamond-shaped decorations and the stylized, ogival floral elements visible on the cross and the collar of the chasuble, the accuracy of the representation of the mitre studded with precious stones, and the detailed and elegant depiction of the curls of the hair, beard and moustache show the statue to be a product of the late Gothic period. These features are combined with the natural flow of the drapery, curved lines in the liturgical gown, and an elegant and composed spiral structure to the figure, bestowing a certain monumentality and austere dignity on the statue.
A degree of stiffness in the treatment of the arms and in the fixity of the face makes it possible to compare the object with contemporary wooden statues from the Marche.
In this production, as in the statue of Saint Primianus, the characteristics of preciosity and worldliness drawn from Tuscan-Sienese examples are reinterpreted in a way that lends them a sacred courtliness.

Literature: L. Serra, *L'arte nelle Marche*, vol. I, Pesaro 1929, p. 248; *Inventario degli oggetti d'arte delle Provincie di Ancona e Ascoli Piceno*, Rome 1936, p. 13; V. Pirani, *Ancona dentro le mura*, Ancona 1979, p. 171; M. Natalucci, *Ancon Dorica Civitas Fidei*, Ancona 1980, pp. 27-28. (L.Z.)

173, 174
Altobello Persio da Montecaglioso
(1507-1593)
Our Lady of the Annunciation Angel
16th century
Polychrome stone
61 × 42 × 20 cm; 65 × 46 × 20 cm

Matera, chapel of the Confraternita del Corpo di Cristo and of the Madonna di Costantinopoli

The two sculptures form an integral part of the central altar of the chapel of the Madonna di Costantinopoli. The *Announcing Angel* and *Our Lady of the Annunciation* are located to the left and right respectively of the sculpture depicting *Christ Resurrected*, set in a niche and surmounted by the image in full relief, in the lunette, of *God the Father* giving his blessing.

Carved on the base of the *Christ* is the inscription: "ALTOBELLUS Pº F. 1540". The affinities and similarity of execution between the *Christ* and the group of the *Annunciation* lead us to believe that the latter was carved by the same artist, who was definitely active in Matera during the first half of the 16th century.

Only the year before, Persio had made the magnificent altar frontal of Matera cathedral, employing the same naturalistic and popular style that he used for the solid and compact figures of the *Annunciation*.

The swollen mass of the image of the Virgin is, to some extent, contained and checked by the pyramidal shape marked out by the folds of her dress and cloak, gathered at the waist and held back by her arms in an attitude of prayer.

The roundish face of the graceful maiden is not lacking in dignity, notwithstanding her act of submission to the Divine Will: it expresses the frame of mind of those humble souls who, their heads held high and their gaze fixed on the ground, accept their destiny, without question or rebellion.

The figure of the *Announcing Angel* is similar, but different in its interpretation. Here too, the masses of the sculpture are swollen and forceful, but the treatment of the drapes of the clothing is more painstaking, especially in the tangle of folds at the bottom, in the way that these climb up to the flounce of the bodice, and in the airy flourish of the shoulder.

What in the image of the Virgin was a ponderous stillness, anchored to the earth with all the weight of a human and mortal creature, in the angel seems to be sublimated into the lightness of the supernatural being, and to tend toward a transcendental dimension.

The two sculptures are not in an ideal state of preservation. Careful restoration, aimed at removing the layers of grime and of paint that has oxidized over the course of time, as well as the removal of any repainting and the filling of some holes, would return the two sculptures to their intrinsic artistic value, alongside their devotional significance which is immediately apparent to the faithful.

Literature: A. Grelle, *Arte in Basilicata*, 1981, p. 78-80; S. Calò, C. Strinati, C. Guglielmi Faldi, *La cattedrale di Matera nel medioevo e nel rinascimento*, 1977, pp. 72-76. (A.A.)

175
Pietà
16th century
Polychrome stone
100 × 70 × 32 cm
Melfi (Potenza), Bishop's Palace

The work represents the Virgin, seated on a throne, supporting the body of the dead Christ on her lap. Mary's hands, crossed on her breast in the act of prayer, the rapt expression of the eyes in the sorrowful face, the rigid composure of the erect bust, and the head tilted slightly over her right shoulder, express an enormous pathos that, however, reaches its peak in the figure of Christ.

With the body stretched, in the stiffness of *rigor mortis*, the head unexpectedly raised, in line with the bust, Christ is presented in the crude reality of motionless and timeless death.

The lowered eyelids, the mouth left open in the exhalation of the last breath, the delicate features of the handsome face framed by the mass of tidy curls, convey an impression of serenity that is slowly transformed into pain and suffering as one becomes aware of the wounds in the side and hands, devoutly crossed on his stomach. Even the rigidity of the folds of the loincloth, which looks almost as if it is glued to the lower limbs, instills a sense of death and anguish that is, nevertheless, completely devoid of desperation.

The sculptural group is based on a carefully gauged geometrical scheme: an exact triangle, defined by the figure of the Virgin, with the base formed by the short dais of the throne and the soft folds of the dress, and the head at the vertex; it is rounded off by the swelling of the cloak that descends gently along the shoulders as far as the feet, and intersected by the straight and unyielding line of Christ's bust. Without disturbing the overall composition and with great sensitivity, the artist makes the knees bend so as to have the figure fit naturally into the imaginary geometrical design.

This is, undoubtedly, a scheme of northern European origin, already established by the turn of the 14th century. Anna Grelle (1981, p. 49) cites it as an example of the diffusion of Lombard and Burgundian themes at a local level, pointing to the *Vesperbild* of Venosa as another example.

The present state of preservation of the work is precarious, chiefly because of the instability of the coating of paint: although they do not interfere with perception of the chromatic relationships, losses of paint from several parts of the clothing and flesh do slightly compromise the overall effect of the work. A complete restoration, including the removal of any repainting, would return the work to its full artistic value, just as its emotional and devotional impact has remained intact.

Literature: A. Grelle, *Arte in Basilicata*, 1981, p. 49. (A.A.)

176
Crib
15th century
Pottery with unfired colouring
63 × 43 cm
Faenza (Ravenna), parish church of the Santissimo Cuore di Gesù in Zattaglia

The "Franciscan" crib left in the care of the Museo Internazionale delle Ce-

ramiche in Faenza, belongs to the diocese of Faenza (Ravenna). Originally, it was in the hilltop parish church of Zattaglia, apparently built on the site of a hermit's oratory from the 14th century and enlarged around 1497.

The crib, now on display in the renowned Faenza museum, should be dated to the same period. A. Corbara, who has carried out an authoritative study of the piece, holds that it is an example of early Faenza ware (1973, pp. 63-72). Its stylistic origins should not be sought in the contemporary and better-known glazed terracotta of Della Robbia, but in the Ferrara school, where the Flemish influence was strong.

A scalloped niche (63 × 43 cm), bordered by two sprigs of a branch rising from the base, contains two scenes, one above the other: at the bottom, the newborn Child adored by the Virgin Mary and Saint Joseph and kept warm by two animals; at the top, the angel announcing the Nativity to the shepherds.

The model, perhaps intended for glazing, was only biscuit fired, and then colored without firing at a later, unknown date. The stately immobility of the lower composition is contrasted by the liveliness of the upper scene, with the angel bursting frontally from the sky and rousing the shepherds who are guarding their flock in a hilly nocturnal setting.

This type of model is known from the period 1477-1509. Groups of Faenza pottery: the *Deposition* (1487) formerly in the Pasolini collection in Faenza, now in the Museum of Modern Art in New York; the *Lament* formerly in Ancona cathedral, lost during the war; the *Nativity* and *Deposition* of Ostra Vetere in the church of the Crucifix, and a few other pieces in the Faenza area.

The hypothesis of the Faenza-Ferrara connection is supported not only by the stylistic characteristics but also by the documented presence in Ferrara of a master in works of *preda* (terracotta), Fra Melchiorre of Faenza, along with other modellers from that city, in 1490.

Literature: A. Corbara, "La plastica fiamingheggiante del tardo Quattrocento e la linea Faenza-Ferrara. Un presepio a Zattaglia", in *Faenza. Rivista del Museo*, LIX, 1973, pp. 63-72. (A.S.)

177
School of Silvestro dell'Aquila
Madonna (fragment of a sculpture group)
15th century
Polychrome terracotta
38 × 46 × 33 cm
L'Aquila, Museo Nazionale d'Abruzzo

In the fine modelling of the face and the admirable harmony of the proportions of the shoulders and bust, this *Madonna* (fragment of a group) preserves intact the stylistic features typical of the production of Silvestro dell'Aquila (c. 1450 - 1504). He was the greatest interpreter of the golden age of Florentine art in Abruzzo, which he came to know through the intermediary of the high talents of Verrocchio (1435-1488) and Desiderio da Settignano (c. 1430 - 1464).

Once the genius of Silvestro had become established in L'Aquila, his style spread widely through the works of many minor artists, though these were usually of good quality. This led to the development of a highly standardized production that was of far from secondary importance in the history of the region's art: these characteristics are clearly exemplified in the delicate features of this small statue, whose charming form is perhaps even enhanced by its present, fragmentary condition.

Literature: V. Mariani, "Un capolavoro di plastica abruzzese", in *Vita artistica*, III, no. 1 (1932), p. 30; L. Mack Bongiorno, "Notes on the Art of Silvestro dell'Aquila", in *The Art Bulletin*, XXIV (1942), pp. 239-241, fig. 16; P. Rotondi, "Contributi a Silvestro dell'Aquila", in *Emporium*, LVIII no. 687, (1952), p. 105; M. Chini, *Silvestro aquilano e l'arte in Aquila nella II metà del sec. XV*, Aquila 1954, pp. 178-183. (C.T.)

178
To designs by Antonio Benci, called Pollaiolo (c. 1431 - 1498)
Antependium of Sixtus IV
1476-78
120 × 380 cm
Assisi, Museo della Basilica di San Francesco

The antependium of Sixtus IV is all that remains of a series of liturgical paraments donated to the basilica of San Francesco by Pope Sixtus IV.
The antependium of Assisi consists of a frontal (patterned cloth with embroidery appliqués) and an *aurifregio* (figured and embroidered band) with a fringe of gilded silver.
The frontal depicts Pope Sixtus IV (Francesco Della Rovere) kneeling in front of Saint Francis, who is holding up his right hand with the signs of the stigmata and has a cross in his left.
Between the two figures the divine light is represented by the symbols of a sun with rays and tongues of flame. To the right and left of the two figures branches of oak with acorns and foliage frame two coats of arms of the Della Rovere family. Around the trunks of the trees are inscribed the words "Sixtus IIII Pont. Maximus".
The two figures of the saint and the pope take up the entire height of the frontal and, since one is kneeling and the other standing, this means that the figure of the pope is larger. The difference in size between saint and pope may have a twofold significance: on the one hand it introduces a sense of depth in the relationship between the two figures, and on the other it stresses the importance of the pope as the supreme representative of divine authority. By its constitution, in fact, the Franciscan order had always been under the direct protection of the papacy. The repetition of the Della Rovere coat of arms further underlines the family ambitions of Sixtus IV.
The upper part of the antependium is a band with the Madonna and Child in the middle and twelve saints, six on each side, arranged in order of importance. In addition to Saint Francis, it is possible to recognize several saints of the Franciscan order, including Saint Clare, Saint Anthony of Padua and Saint Bernardine of Siena.
The technique used to weave the antependium was extremely complex: it was woven in a single piece, including the borders, rather than by the usual method involving parallel strips of cloth sewn together. The materials used were very precious: gold thread, gold leaf, silk, velvet, brocade, and bouclé.
The antependium was made to a design by Pollaiolo. This attribution, put forward by Venturi (1906), has been confirmed by various scholars. The design was made in pen on silk and then embroidered with close-stitched silk thread.
A tentative date can be assigned to the antependium on the basis of a number of facts. Sixtus IV became pope in 1471. In 1473 the antependium was not yet listed in the inventory, and did not appear there until 1478. In July of 1478, in fact, the 250th anniversary of the canonization of Saint Francis was celebrated. The antependium might well have been commissioned for these festivities.

Literature: A. Santangelo, *Tessuti d'arte italiani*, Milan 1959; A. Busignani, *Pollaiolo*, Florence 1970; A. Garzelli, *Il ricamo nell'attività artistica di Pollaiolo, Botticelli, Bartolomeo di Giovanni*, Florence 1973; D. Devoti, *L'arte del tessuto in Europa*, Milan 1974. (R.V.)

179
Antonio Maria da Bozolo
Saint John the Baptist with an open chorale
c. 1536-37
Tapestry of wool and silk;
warp: 5 threads each cm
200 × 120 cm
Monza (Milan), cathedral of San Giovanni Battista

The basilica of San Giovanni Battista in Monza is home to a series of eleven tapestries from the 16th century depicting various episodes in the life of John the Baptist. Nine of them are large-scale wall pieces; the two others, one of which is exhibited here, served as coverings for a pulpit or lectern, and are thus significantly smaller.
The tapestry is framed at the sides and bottom by a border of gilded leaves and flowers set against a blue ground (as in nos. 5 and 6 of the larger group), and is divided internally into two parts. In the upper zone is an open chorale, or choir book, on a bright flowered background, complete with the musical notation and texts of an *antiphon* and a *responsorio*, executed in embroidery stitches which are unfortunately now rather worn. In the lower part is the figure of Saint John in a landscape, standing among slender flowering plants. He holds the Lamb of God and a processional cross with a banderole bearing the inscription "ECCE AGNUS DEI QUI TOLLIT PECCATA MUNDI". The form of the tapestry tells us exactly how it functioned: the figure of Saint John would have hung down in front of the pulpit in the manner of an antependium, while the depicted choir book would have been folded over the top so as to provide a cushion for the actual book (thus the wear and tear in that particular area). According to Forti Grazzini (1988), the pose and the modelling of the saint's hair suggest that the altarpiece by Marco d'Oggiono in the chapel of Saint John in Santa Maria delle Grazie in Milan may have served as a stylistic model.
Beginning in the 14th century, tapestries imported from northern Europe or produced in local workshops became an important part of the collections of Lombardy's wealthiest churches: the cathedrals of Milan, Monza, Como, Cremona, and the Milanese church of Santa Maria della Scala all have significant tapestry holdings (Forti Grazzini 1987). It remains uncertain as to exactly how the Saint John cycle came into the possession of the cathedral at Monza, or where it came from. Two notes by Frisi (Monza, Biblioteca Capitolare, pp. 7-8b) coming from lost registries refer to "a tapestry in the Flemish manner" (1536-37) and "one piece of tapestry

made in Milan" (1566). An inventory from 1566 records eight large tapestries "of the life of Saint John the Baptist" near the main sacristy, and "tapestries which are placed over the pulpit with the figure of Saint John and a type of choir book", this latter clearly referring to the two tapestries of Saint John the Baptist with an open chorale. A later inventory of 1581 mentions as well the nine large tapestries. Documents recording the pastoral visits to Monza of the archbishop of Milan Federigo Borromeo (1621) inform us that the nine large pieces were hung along the central nave, five at left and four at right. This was later confirmed by Campini (1767), who also tells us that the two smaller pieces were in fact used to ornament the pulpit.

The first scholar to effectively address the difficult problem of attribution was Bernareggi (1926), who recognized the influence of Luini and Gaudenzio Ferrari and hypothesized the involvement of the designers of the cartoons for the *Life of the Virgin* in the cathedral of Milan (1533-41), noting as well a possible connection with the cartoons of the *Birth of the Virgin* and the *Assumption of the Virgin* in the cathedral of Como.

As for the weaver of the Monza tapestries, Baroni and dell'Acqua (1946) made a convincing case for the involvement of the Milanese Antonio Maria da Bozolo.

Among the numerous studies that followed, there is one which is particularly intriguing in that it proposes the name of Giuseppe Arcimboldo, who in 1566 was in fact working in Monza cathedral – on the *Tree of Life* fresco in the transept, and on the cartoon for the tapestry depicting the *Sermon to the Soldiers* (Da Costa Kaufmann 1988). Forti Grazzini (1988) extends Kaufmann's attribution to include the last six of the eleven tapestries, leaving the first five for further discussion. The entire process of executing the tapestries, from the design of the cartoons to the weaving, most likely took place over a thirty-year period, beginning around 1535 (Forti Grazzini 1988).

Literature: *Inventario de la Sachristia de S.to Ioannes Bap.ta...1566*, Milan, Archivio Curia Arcivescovile (ACA), *Visite Pastorali, Monza*, ms. vol. III 2, ff. 37-38; *MDLXXXI Inventario de la Sachrestia de S.to Gio. Batta in Monza*, Milan, ACA, *Visite Pastorali, Monza*, ms. vol. XVI, f. 199; *Atti della visita pastorale dell'arcivescovo Federigo Borromeo*, 1621, Milan, ACA, *Visite pastorali, Monza*, ms. vol. XXVI; G. M. Campini, *Descrizione dell'insigne real Basilica collegiata San Giovanni B.tta di Monza*, 1767, Milan, Biblioteca Ambrosiana, ms. V 16 sup., ff. 14, 20, 21; A. Bernareggi, "Gli arazzi del Duomo di Monza", in *Arte Cristiana*, no. XIV (1926), pp. 237-242; C. Baroni, G. A. dell'Acqua, *Italienische Kunst. Ambrosiana Mailand*, exhibition catalogue, Lucerne 1946; T. Da Costa Kaufmann, "Le opere di Arcimboldo a Monza e la carriera iniziale dell'artista", in *Studi Monzesi*, no. 3 (1988), pp. 5-17; N. Forti Grazzini, "Arazzi", entry in the *Dizionario della Chiesa Ambrosiana*, I, Milan 1987, pp. 199-203; N. Forti Grazzini, "Gli arazzi", in *Monza: Il Duomo e i suoi tesori*, edited by R. Conti, Milan 1988, pp. 107-139. (R.C.)

180

Antependium with the Mystic Lamb
17th century
Embroidery, multicoloured silk, gold, silver, coral
105 × 320 cm
Palermo, church of Gesù

Architectural scenes, in perspective, with views of great depth, as if seen through a telescope, are often to be found in the symbolic antependia, most likely to have been made in Palermo, with beads of coral from Trapani. The most significant example, owing to its artistic quality, is this one depicting the Mystic Lamb of the Novitiate House. Here the illusionism of the scene is represented almost pictorially.

The custom of decorating antependia with illusionistic scenes of architecture is typical of the period, and various panoramas, terraces or porticoes are to be found on numerous antependia of silver, mottled marble and coral. The last two of these techniques are typically Sicilian.

Particularly sumptuous architectural motifs and rich decorations of coral can be found on the antependium of the church of San Giuseppe in Palermo (Abbate 1986, no. 112), but none of them achieves the sweeping and luminous depth of perspective and the freshness of composition of this terrace. It is roofed by a broad portico with domical vaults and columns surmounted by Corinthian capitals, and overlooks a vast panorama, defined by stretches of rusticated wall, in a synoptic wide-angle view.

In this work the gaze is led step by step into the central portico, paved with squares of coral that mark out the space as far as the steps of the sacrificial altar where the Mystic Lamb is immolated; or through the side one as far as the typical balustrade, also made out of pieces of coral, and further still toward the unreal snow-covered panorama in the background, which creates a contrast with the spring-like luxuriance of the vases with flowers of various kinds and colours at the corners of the terrace. The first columns are spiral, in a typically Baroque style, and split into two parts by different decorations. The lower part is ornamented with coral, the upper one with vine shoots, from which hang symbolic bunches of grapes executed in grenadine.

The symbology of the sacrifice of the Lamb, of Christ, is underlined by the red grapes, symbol of his blood. The spiral columns are made with filling. According to the theory of the Jesuit Villalpando, the design for the spiral column was given by God to David and used by Solomon for the temple in Jerusalem, and is the most suitable for insertion in a work of architecture containing the symbolic altar of the sacrifice of the Son of God. Moreover, the Lamb, placed on the book of the seven seals, refers to the *Apocalypse* of John, making it possible to interpret the portico filled with flowers of the altar frontal as the heavenly Jerusalem.

A parallel to the style of the antependium can be found in the one made of mottled marble, the typically Sicilian marble inlay, in the sanctuary of the Vergine di Gibilmanna (Ruggieri Tricoli 1992, p. 112). This was designed by Paolo Amato, the famous architect of the Palermo senate house, and executed by the marble worker Baldassare Pampillonia in 1684 for the chapel of Libera Inferni in the Palermo cathedral.

A closer parallel, in terms of the similarity of the materials used and of the technique of realization, as well as the figurative typology, can be drawn with the contemporary antependium in the church of Santa Maria in Corteorlandini in Lucca, also the work of Sicilian craftsmen.

Literature: G. Tescione, *Il corallo nella storia e nell'arte*, Naples 1965, p. 284; G. Tescioni, *Il corallo nelle arti figurative*, 1972, p. 143; M.C. Di Natale, in *L'arte del corallo... in Sicilia*, exhibition catalogue, edited by C. Maltese and M.C. Di Natale, Palermo 1986, cat. no. 78, pp. 239-240; V. Abbate, in *ibidem*, no. 112; M.C. Ruggieri Tricoli, *Il teatro e l'altare. Paliotti d'architettura in Sicilia*, Palermo 1992. (M.C.D.N.)

181
To designs by Pieter Paul Rubens (1577-1640)

Institution of the Holy Communion
17th century
Tapestry of wool, silk, gold and silver
505 × 350 cm
Ancona, Museo Diocesano d'Arte Sacra

The tapestry depicting the *Institution of the Holy Communion* is one of the four masterpieces of the weaver's art in the Museo Diocesano in Ancona. These tapestries were acquired in Flanders by the Confraternity of the Holy Sacrament of Ancona, to be displayed "...in due solemnity above the high altar" of the church of the Santissimo Sacramento.

As well as the *Institution of the Holy Communion*, the tapestries represent the *Assumption of the Virgin*, the *Ad-*

oration of the Shepherds, and the *Resurrection of Christ*. Over the last few years they have been brought back to the splendour of their original colours and workmanship by the restorer Claudia Kusch, after being shut away in a closet in the sacristy of the church of the Santissimo Sacramento for over a century.

While the restoration was being carried out, the tapestries were subjected for the first time to study and research in order to reconstruct their origin and subsequent history.

As far as this tapestry is concerned, the studies have shown that the subject should properly be seen as the *Institution of the Holy Communion*, rather than as a *Last Supper*. This iconographic theme was frequently represented during the Counter-Reformation and is one of the most expressive of a cultural climate that was heavily influenced by the decisions taken at the Council of Trent. There can be no doubt that Rubens also contributed to the diffusion of a subject closely bound up with the culture and concerns of his time.

Historical and artistic investigations have revealed that, during his career, the painter from Antwerp only produced one altarpiece depicting the theme of the *Last Supper*, but that he made many drawings and sketches of the subject.

The altarpiece of the *Last Supper*, commissioned by Caterina Lescuyer, was painted for the chapel of the Holy Sacrament in the church of San Romualdo in Malines.

Recent studies compare the tapestry and the painting, now in the Pinacoteca di Brera, and show clear compositional parallels between the two works. In both, the figures of the apostles are massed close together at a table placed diagonally, so that one corner is set in the middle of the scene. Christ appears at the centre of the composition, raising his eyes to heaven and blessing the bread. The figure of Judas, placed in the foreground and facing the observer, lacks the intense light that plays on the features of the other personages.

Right at the front, on the right, appears a basin containing a pitcher, a detail alluding to the episode of the washing of the disciple's feet. In the upper part there is the outline of a piece of classical architecture, with a drape hanging down on the left.

Such compositions became popular as a result of the various engravings made from the Malines altarpiece. Circulating in the major centres of Flanders, these could be enlarged by the master tapestry-weavers to make their cartoons.

Literature: A. Pianosi, "Gli arazzi rubensiani del Museo Diocesano di Ancona", in *Arazzi rubensiani e tessuti preziosi dei Musei Diocesani di Ancona e Osimo*, exhibition catalogue, Ancona 1989. (L.Z.)

182
To designs by Pieter Paul Rubens
(1577-1640)
The Assumption of the Virgin
17th century
Tapestry of wool, silk, gold and silver
505 × 350 cm
Ancona, Museo Diocesano d'Arte Sacra

Along with the other three tapestries belonging to the Confraternity of the Holy Sacrament of Ancona, the *Assumption of the Virgin* was woven by the Raes manufactory of Brussels in the first half of the 17th century, to cartoons attributed to Pieter Paul Rubens.

In addition to their historical and artistic importance, it is worth underlining the magnificent colours and perfect craftsmanship of these masterpieces: this is clearly revealed by analysis of the fabric, with its warp of wool and wefts of wool, silk, and silver and gold thread.

Prior to the recent restoration, carried out in Ancona by Claudia Kusch, this tapestry had a number of slashes running the full height of the work. Such grave damage was inflicted during the Second World War. During the war the tapestries, wrapped and rolled up, had been placed in a large box for se-

curity and stored in the lowest part of the campanile of the church of San Francesco alle Scale in Ancona. During a bombing raid in June 1944 the tapestries were torn by shrapnel that penetrated the box.

The *Institution of the Holy Communion* suffered the least damage, with a few small tears, the *Assumption of the Virgin* and the *Resurrection of Christ* were deeply slashed in numerous places, while the *Adoration of the Shepherds* was unquestionably the most severely damaged.

The author of the first historical and artistic study of the hangings states that the *Assumption of the Virgin* was one of the subjects most frequently requested from artists who worked on behalf of the Catholic Reformation, although perhaps the only one that did not illustrate an episode from the life of Christ.

Recent investigations have established that Rubens tackled this subject no less than a dozen times, producing grandiose altarpieces commissioned, for the most part, by large religious orders with ties to the cult of the Assumption of the Virgin.

Among the group of works produced by the master during the second decade of the 17th century, a number of iconographic compositions similar to that of the Ancona tapestry can be identified. In particular, the sketch in Buckingham Palace in London has an absolutely identical composition to the work in the provincial capital of the Marche. The author concludes that the total identity of the composition in London and the tapestry, where the weaving seems to vie with the painting in the representation of the flesh tones and the expressiveness of the faces, can be attributed to the propagation of themes linked with Baroque tastes and sensibilities.

Literature: A. Pianosi, "Gli arazzi rubensiani del Museo Diocesano di Ancona", in *Arazzi rubensiani e tessuti preziosi dei Musei Diocesani di Ancona e Osimo*, exhibition catalogue, Ancona 1989. (L.Z.)
Work unavailable for exhibition.

183, 184
Heads of the apostles John and Peter
12th century
Mosaic
74 × 72 cm each
Ravenna, Museo Arcivescovile

Along with a *Madonna at Prayer*, the two heads of *Saint John* and *Saint Peter* are all that remain of the mosaic in the apse of the ancient cathedral of Ravenna, the Basilica Ursiana. The mosaic in the apse represented the Gospel story of the resurrection of Jesus Christ. The heads of John and Peter come from that mosaic and belong to the scene of the visit to the tomb, originally located on the right of the bowl-shaped vault of the apse (Gerola 1912; Furlan 1974). Peter's face – recognizable by the white beard – and halo are set against a dark background that indicates the interior of the tomb. The profile and a section of the wall of the tomb are visible on the right. The head of the apostle John has a gold background, a sign of an outdoor setting. The two faces, the work of the same artist (Demus 1984), have close stylistic affinities with the figures of *Saint Mark* and *Saint Hermagoras* in the apse of Saint Mark's basilica in Venice, as well as with other mosaics in the northern Adriatic region, especially the figure of the *Apostle Philip* in the chapel of the Sacrament in San Giusto in Trieste.
Note the variety and vividness of style and the gamut of colours, characteristic of the mosaics in Ravenna, which make them unique in the world.

Literature: Gerola, "Il mosaico absidale dell'Ursiana", in *Felix Ravenna*, no. 5 (1912), pp. 177-190; Furlan, *Le icone bizantine a mosaico*, Milan 1979; O. Demus, *The Mosaics of S. Marco in Venice*, Chicago-London 1984. (R.E.)

185
Saint Olivia, Saint Venera, Saint Rosalia, Saint Elias
13th century
Tempera on panel
76.5 × 62 cm (with frame)
58.5 × 42 cm (without)
Palermo, Museo Diocesano

This small panel by an unknown 13th-century Sicilian painter in the Byzantine manner is one of the oldest representations of Saint Rosalia in a nun's habit. It came to the Museo Diocesano of Palermo from the church of Santa Maria dell'Ammiraglio, the Martorana, after recovery from the antique market (Orlando 1880). Here the saint can be seen in the company of Saint Elias and Saint Venera, while the place of honour is given to Saint Olivia.

In the 18th century, however, the panel was mounted in a new frame of deal veneered with ebony and studded with small finely carved ivory medallions depicting scenes from the life of Saint Rosalia. By the 17th century Rosalia was already considered the principal patron saint of Palermo, after the discovery of her bones on mount Pellegrino and the liberation of the city from the plague of 1624. She is shown rejecting the foolish life of the court and setting off for the purifying life of the hermitage. Subsequently she is tempted by the devil but redeems the weakness of Eve by resisting. Next we see her, crowned with roses, as she carves the traditional inscription in the cave of the Quisquina, and then engrossed in prayer before the Crucifix, presented to the Madonna and Child, kneeling in front of Christ who crowns her, accompanied by angels to the Ercta cave (mount Pellegrino), and finally at the moment of ecstasy.

The absence of the more usual iconographic attributes of Saint Rosalia, who is portrayed in the habit of a Basilian nun, in keeping with a tradition that she was indeed such, is probably due to the antiquity of the work, even though there is no other evidence for her cult at that date (Collura 1977).

It is certain, however, that in the 18th century not only was the decorative appearance of the work changed but so was its religious significance, by giving more space to Saint Rosalia on the new frame than she had in the picture itself. Times, tastes and devotions change, and the frame testifies to all this, thereby acquiring a fundamental historical importance.

The most typical iconographic attri-bute of the saint is the crown of roses, which she almost always wears on her head in the manner of a halo. The roses, which are also a well-known symbol for Mary, are a reference on the one hand to her name, Rosalia, and on the other to the rosary, which is also sometimes placed in her hands, establishing yet another link between the virgin of Palermo and the Mother of God.

Other elements that are almost always present in the varied iconography of Saint Rosalia are the pilgrim's staff and bowl, the crucifix, the skull and sometimes the hourglass as well, both referring to the transience of earthly life, and the book. Through a real, but also introspective pilgrimage of expiation then, the saint overcomes ephemeral contingency and rises mortified and purified to the contemplation of the divine, to superhuman and eternal values, guided by her love for Christ: "Ego Rosalia Sinibaldi Quisquinae Amore Domini mei Jesu Christi".

Literature: P.G. Orlando, *Della più antica immagine di santa Rosalia dipinta in Palermo*, Palermo 1880; P. Collura, *Santa Rosalia nella storia e nell'arte*, Palermo 1977; M.C. Di Natale, "Arti minori nel Museo Diocesano di Palermo", in *Quaderno n. 4 dell'Archivio Fotografico delle Arti Minori in Sicilia*, 1986, p. 35; M.C. Di Natale, *Santa Rosalia nelle arti decorative*, Palermo 1991, p. 21. (M.C.D.N.)

186
Attributed to Michelino da Besozzo
(1388-1445)
Crucifixion amongst Suffering Angels
c. 1417
Detached fresco on plastic reinforced with fibre-glass; restoration by Anna Luchini, 1990
Monza (Milan), Museo del Duomo

Between 1884 and 1885, the marble altarpiece of the Santo Chiodo in Monza cathedral was adapted to house the statue of the Virgin of the Rosary (Conti 1991). On the wall behind the middle niche was a "Christ on the Cross, fresco painting", which the anonymous author of a note dated 7th January 1885 and kept in the Archivio Capitolare del Duomo (Cart. XLIV bis, no. 39) believed had been moved there in 1682, the date "inscribed on the plaster around this panel [*sic*]". The inscription might refer to the solemn removal of the relics of the Cross in 1681, after the completion of the new altar for the chapel (Zanni 1989), and it could well be that the fresco, removed whole from a wall of the chapel, was walled in behind the niche in the middle of the altarpiece and placed on the back wall, thus blocking out the central window.

The *Crucifixion* probably belonged to a larger decorative scheme in what was formerly the chapel of the Santo Chiodo, dedicated to the Virgin of the Rosary from 1885. In a deed dated 21 April 1417 (Frisi 1794), Duke Filippo Maria Visconti exempted the canons and churchwardens of Monza cathedral from paying the duty on materials used in the decoration of the chapel, with particular reference to *colorum picturae* and *aurum*. The records of the pastoral visit of Archbishop Federico Borromeo in 1621 show that the chapel was frescoed with Stories of Christ and the Virgin *a latere Evangelii* and *a parte vero Epistulae* respectively. The last evidence of the cycle comes from Canon Campini (1767), who remembers the decision in 1719, after the reintroduction of the cult of the Santo Chiodo, to commission Borroni and Castellino to redecorate the chapel, to the detriment of the already existing paintings, which were in a bad state of repair.

The anonymous author of the note dated 7th January 1885 again informs us of the removal of the painting to the basilica archives. It was only in 1990 that a painstaking restoration was carried out by Anna Luchini, when the fresco was transferred to a plastic panel reinforced with fibre-glass. This restoration process resulted in greater clarity of interpretation (Lucchini 1991).

The central figure of Christ dominates the once gilded background; he is dressed in a fine garment with a regular pattern of quatrefoils enclosing a cross-shaped leaf motif. Beside the Christ figure and above the cross, in an almost symmetrical pose, are three pairs of angels *pleurants*, three of whom gather the blood which trickles down from the hands and side of Christ in large golden chalices.

The fine weave of the golden tapestry in the background, the precisely-drawn, fragile anatomy of Christ on the cross, the thin veil wrapped around his thighs, the soft folds and the chromatic iridescence of the angels' tunics, and the intense feeling conveyed by the faces and gestures of the characters, bear witness to the rare quality of this painting. The restoration carried out by Lucchini has revealed some important technical details. The fresco was finished in five days: the pair of angels above the scaffold; Christ; the pair of angels on the right; those on the left; and on the lower right-hand side a fifth day's work shows the outline of the halo for another figure, revealing that the painting was part of a larger pictorial design. The artist's fine brushstrokes give depth to the faces, the angels' wings, the folds of the garments and Christ's hair. There is a minute attention to detail in the delicate handling of the skintones, especially in the Christ figure with its pallor of impending death, and in the precious quality of the gold-edged veil, which has miraculously survived intact.

The superb quality and meticulous technique of the painting have led Liana Castelfranchi to believe it is the work of Michelino da Besozzo (Castelfranchi 1991). Toesca (1912) mentions the fresco in passing, attributing it to the Zavattari brothers, while Mazzini (1962) makes a guarded reference to Michelino. The doubt and uncertainty, due to the poor state of repair of the painting, were overcome by Castelfranchi (1989), who saw the hand of the Lombard artist beneath the heavy patina: the gold decoration which reminds us of "the enchanting floral tapestries in the *Offiziolo Bodmer* (New York, Pierpont Morgan Library)", the propensity for "a well-ordered composition" and the diffi-

cult comparison, owing to the difference in scale, with the *Crucifixion* inserted in the central quatrefoil of the *bas de page* in the frontispiece of the *Epistole di San Gerolamo* (London, British Library, Eg. 3266), dated 1414, are the first points of reference for the scholar. After restoration, these became even more convincing, and were substantiated by new comparisons: with the page from the *Elogio funebre di Gian Galeazzo Visconti* for the iridescence of the angels' tunics; with a *Pietà* watercolour, in a leaf inserted in a Tito Livio codex in the Biblioteca Apostolica Vaticana (Vat. Lat. 1854; Castelfranchi 1991).

Michelino's presence in Milan had up to now been documented until 1404 and after 1418; in 1410 he was in Venice and in 1414 he decorated a manuscript for the Cornaro family. The attribution of the Monza *Crucifixion* sheds light on Michelino's work after his stay in the Veneto region.

Literature: Archivio Capitolare del Duomo di Monza, cart. XLIV bis, no. 39; G.M. Campini, *Descrizione dell'insigne real Basilica Collegiata San Giovanni B.tta di Monza*, 1767, Milan Ambrosiana, ms. V16 Sup., ff. 43-44; A.F. Frisi, *Memorie storiche di Monza e sua Corte*, Milan 1794, II, pp. 195-196; P. Toesca, *La pittura e la miniatura in Lombardia*, Milan 1912, p. 503; F. Mazzini, "Note di pittura lombarda tardogotica", in *Arte Lombarda*, no. 12 (1962), pp. 29-31; L. Castelfranchi Vegas, "Gli affreschi gotici", in *Monza. Il Duomo nella storia e nell'arte*, edited by R. Conti, Milan 1989, pp. 178-180; A. Zanni, "Gli arredi lignei", in *ibidem*, p. 157; R. Conti, "Regesto dei documenti 1876-1890", in *Monza. La Cappella di Teodolinda nel Duomo*, Milan 1991, p. 179, doc. 67; L. Castelfranchi, "Una Crocefissione di Michelino da Besozzo", in *Arte Lombarda*, no. 98-99 (1991), pp. 181-187; A. Lucchini, "Note di restauro", in *ibidem*; L. Castelfranchi Vegas, "I cicli pittorici medievali", in *Università Popolare di Monza. Il restauro delle lesene dell'Altar Maggiore del Duomo di Monza*, Monza 1992, p. 42. (R.C.)

187
Madonna and Child
16th century
Icon
98 × 80 cm
Ancona, Museo Diocesano
d'Arte Sacra

At the centre of the panel, against a gold background, appears the half-length figure of the Virgin Mary, tenderly clasping Jesus.

The icon formed part of the decoration of the iconostasis in the church of Santa Anna dei Greci in Ancona, along with other panels at present kept in the Museo Diocesano of the same city.

Only seven icons of the original iconostasis have survived; the others were lost during the dismantling of the decoration and in the damage caused to the church by the air raids of the Second World War, as well as by a postwar planning scheme.

The first description of the iconostasis dates from 1923; later, in 1936, Serra claimed it was an "18th-century imitation of Byzantine [art]". It is only recently that the church of Sant'Anna has been subjected to a more thorough and probing analysis that has made it possible to reconstruct the history of the church and to reexamine the paintings from a historical and artistic viewpoint. The church, originally dedicated to Santa Maria in Porta Cipriana and already listed in the 13th century, was ceded for the use of Greek merchants by Clement VII with the Bull of 31 August 1524.

The pope's decision to grant the repeated requests for a church of the Orthodox rite in Ancona was motivated by the fact that the Greeks formed a very highly developed colony from the economic point of view. He gave his consent after the Levantine merchants based in the Adriatic port had committed themselves to paying a fixed yearly fee to the Apostolic Camera for Saint Peter's Day. Only after the Bull of 1531 made the building the full property of the community was the church renovated and the iconostasis installed.

As to the panels in the church of Sant'Anna, the painter Lorenzo Lotto (c. 1480-1556) wrote in his account book that he had painted three "small pictures" for this church in 1551, representing the *Visitation of Saint Elizabeth*, the *Veronica* and the *Head of Saint John the Baptist*. The three paintings have been destroyed, but a photograph taken before the bombing raids of the Second World War shows that they were located in the bottom row of the iconostasis, the proskinesis. The remaining icons consist of four ovals depicting the *Raising of Lazarus*, the *Ascension*, the *Transfiguration on Mount Tabor* and the *Dormitio Virginis*, and three panels of larger size: *Saint Nicholas of Myra*, *Madonna Glicophilousa* and *Madonna Odighitria with Saint Ann*.

The paintings, which are stylistically homogeneous, may be attributed to a painter of what Lazarev has called the Italo-Cretan school, and dated to the second half of the 16th century. The so-called Italo-Cretan school, maintaining the academicism of the late Paleologi manner adopted in the 15th century and expressed by an accentuated linear style in a dry and detailed form, absorbed western, and in particular Venetian, influences in the 16th century. Especially after the fall of Constantinople in 1453, the contacts between Cretan and Venetian artists became more and more frequent, giving rise to important schools like that of San Giorgio in Venice.

In the panel of the *Madonna Glicophilousa*, in particular, echoes of the Paleologi period can be seen in the elongated module of the images, in the highlighting and the strong shades of colour, and in the canonical features of the figure, drawn from the Byzantine iconographic repertory.

At the same time one gets the impression that the painter of the Ancona panels had been influenced by artistic developments in the Marche during the second half of the 16th century, or that he felt obliged to measure up to the icons painted by Lotto for the same church.

Lotto, for his part, met the requests of the Greek merchants by painting the pictures in accordance with the typology, taste and tradition of Byzantine art. It is not impossible, however, that an Italo-Cretan school had been established in the central Adriatic region, given that icon painters set up studios in Puglia and Basilicata as well. Evidence for this hypothesis comes from the fact that there are numerous icons in the Marche dating from the 16th century, which are now kept in the Museo della Santa Casa in Loreto, Osimo cathedral, and the Museo Diocesano in Fermo. This particular icon not only constitutes an important artistic testimony of the Italo-Cretan school in the Marche, but also documents the special relationship between the East and the port of Ancona, a link that has given particular importance to the artistic and cultural life of that city and determined its economic and commercial development.

Literature: V. Lazarev, *Storia dell'arte bizantina*, Turin 1967, p. 409; C. Sandroni, *La distrutta chiesa di Sant'Anna dei Greci d'Ancona e le sue icone*, unpublished thesis, Faculty of Art History, Urbino 1985-86; *Splendori di Bisanzio*, exhibition catalogue, Ravenna 1990. (L.Z.)

188
Bartolomeo Passerotti (1528-1592)
Saint Francis Receiving the Stigmata
16th century
Oil on canvas
101 × 85 cm
Bedonia (Parma), Diocesan Seminary

Bartolomeo Passerotti was the leading exponent of Bolognese Mannerism. In 1560, he was already solidly established in Bologna, with a workshop situated near its two towers. Following the Zuccari brothers' example, Passerotti presented himself in Bologna as a scholarly artist, well-versed in the sciences and liberal arts, and a friend of the most prominent personalities of the culture of the time. In addition to paintings for altarpieces, he dedicated himself to portraits – in which he developed a highly effective language – and to "genre" paintings made to Flem-

ish models. This led him to experiment with greater naturalism, which in turn strongly influenced the realism of the Carracci family and followers.

It is not easy to identify the author of *Saint Francis Receiving the Stigmata*; some critics have considered it the work of Passerotti's many workshop assistants. However, present criticism tends to favour the attribution to the master himself. Passerotti's hand may be recognized above all in the rendering of the details.

The quality of the painting is most evident in the compositional lay-out, enhanced by the landscape in the distance. Note also the presence of Passerotti's favourite yellow and clear blue tones, another element which corroborates this attribution.

189
Ludovico Carracci (1555-1619)
Christ's Fall under the Cross
17th century
Oil on canvas
114 × 152.2 cm
Bedonia (Parma), Diocesan Seminary

Ludovico Carracci was the cousin of Agostino and Annibale and the eldest of this family of painters. Among them, he showed the most enduring and cogent faith in the premises of amiable naturalness that had guided, from about 1580, their resolute stance against Mannerist abstraction. While compared to Annibale he had fewer opportunities from the outset to put his theories to the test in large projects, his *Flagellation* and *Crown of Thorns* (both in the Bologna Pinacoteca) immediately show his tendency to depict a troubled and intensely dramatic version of reality and of the psychology of his subjects.

Christ's Fall under the Cross shows Jesus when he falls on the road to Calvary and Veronica mercifully dries the sweat off his face. A guard holds the cross up. The thieves bearing their crosses and the procession of soldiers climb up the hill towards the place called Golgotha. In the background, Jerusalem stands out darkly against the misty twilight.

The painting dramatically emphasizes the psychological state of the characters. The skilful handling of the light, with its special focus of chiaroscuro tones around the faces of the subjects, confirms Ludovico Carracci's intensely dramatic bent. According to Carlo Cesare Malvasia, Carracci would have died of a broken heart if the large Annunciation fresco in the Bologna cathedral had not been a success.

There does not seem to be a trace of *Christ's Fall under the Cross* in the critical analyses of Ludovico's work. It is hard to believe that a painting as important as this, today conserved in Bedonia, could have passed unobserved by Ludovico's early biographers. It seems fairly safe to guess that it was the painting in the Landini home in Bologna described by Malvasia (1678) as "a Christ bearing the cross, dropped to the ground, with the Virgin crying, Veronica and a soldier, over a doorway". Though the painting in the Bedonia seminary does not show Mary crying, the format fits in well with Malvasia's description of its position "over a doorway", that is, a rectangular canvas, preferably viewed from below and thus suited to decorating the space of a wall above a door.

The custom in Bologna of displaying one's paintings beneath the porticoes on solemn religious occasions has afforded us two other descriptions of the painting, where it is again attributed to Ludovico Carracci.

190
Guido Reni (1575-1642)
Saint Jerome and the Angel
17th century
Oil on canvas
235 × 175 cm
Piacenza, Capitular Sacristy

The subject of this previously unpublished painting is one that was tackled several times by Reni. In the disposition of the figure of the saint, seated with an open book resting on this left knee, the composition is remarkably similar to the painting of the same subject in Detroit. While in the rendering of the face of the main figure, with its gaze turned upward and to the left, where the angel appears, it is possible to detect a clear reference to the picture in Vienna.

In the work in Piacenza cathedral the greatest emphasis is undoubtedly given to the figure of Saint Jerome, as it is set in a central position in the space of the picture while the angel, represented at half-length, is confined to the small area in the upper left corner of the canvas. The setting is reduced to the essential, and the spiritual tension of the work is entrusted to the representation of the saint, depicted in an attitude of rapt contemplation.

In comparison with the other two paintings mentioned, the *Saint Jerome* in Piacenza seems to give a more mystical atmosphere to the relationship between the divine messenger and the saint, who is presented in a sort of spiritual isolation. Consequently the painting is to be regarded as one of Reni's last works, in that it displays the stylistic characteristics typical of the final period of his career, which have not always met with enthusiastic approval. The majority of modern critics, on the other hand, are in agreement with the judgment put forward by G.P. Zanotti in his *Dialogo... in difesa di Guido Reni*: "although the works of Guido Reni's late style do not have the same force as the early ones, they are beautiful as well, and in excellent taste, and pleasing to all who understand painting, as highly delicate things, and worthy of every praise".

The *Inventario legale dei beni di Guido Reni*, discovered by J.T. Spike, lists as no. 27, "a Saint Jerome with an angel which was said to belong to the Poet". Spike proposes a hypothetical identification with the picture in Detroit, but it could also refer to the picture in Piacenza cathedral. The work was found by D.S. Pepper in the sacristy of Piacenza cathedral. (C.C.)

191-205
Vincenzo Campi (1531-1591)
Mysteries of the Rosary (15 tondi)
16th century
Oil on canvas
Diameter 35 cm

Busseto (Parma), collegiate church of San Bartolomeo

The son, like Giulio and Antonio, of Galeazzo Campi, Vincenzo was the youngest member of the 16th-century family of Cremonese painters. Probably born in the second half of the 1530s, initially he only worked under the aegis of Giulio, but on the latter's death (1572) he established closer ties with Antonio. Partly as a consequence of his later date of birth, however, his stylistic development followed a different course from that of his two elder brothers, with a less accentuated adherence to Manneristic culture and a profound propensity toward naturalism. It was from the second half of the 1560s, in works like *Christ Nailed to the Cross* (1575, Pavia, Museo della Certosa), that Vincenzo's painting took on more explicit naturalism.

Vincenzo's aptitude and his inclination towards observation from life are evident in his production of still lives. While these are undoubtedly influenced by similar Flemish works, they also show the concern for representation of *naturalia* that makes these works a fundamental reference for subsequent developments in the still-life genre, and not just the paintings of Caravaggio. The painter died in 1591, two years after completing the exacting task of decorating the church of San Paolo Converso in Milan with frescoes which had been begun by his brother Antonio.

The tondi are a series of fifteen *Mysteries of the Rosary* that may have been intended to frame a single large canvas, a picture of the Virgin Mary that has now been lost. The inscription visible on the back of one of the pictures tells us that the scenes were "repaired" by Francesco Boccaccino (c. 1660 - c. 1741). In all likelihood, this involved cutting out the individual pictures and fixing them on panels, owing to the deterioration of the support.

With the Romanesque influences and academic insistence on design that had characterized Vincenzo's earliest works now completely faded, the tondi of Busseto reveal an extraordinarily

rapid and irregular brushwork. The painter's attention is concentrated on depicting the infinite refractions of the light that catches the bodies and their clothing at an angle. Rapid touches of a lighter colour reveal their parts, with a sense of depth that is not designed by the space created only by means of patterns of light and shade. The result is a new, surprising and simplified vision of form, within which the chance effects of light, analyzed with the kind of empirical rigour that was to be typical of Caravaggio, become the absolute protagonist. It is worth noticing the absence of a light source in these scenes. In this way the bodies are given greater relief by the darkness and by the patterns of light and shade, without reflections.

Literature: P. Vitali, *Le pitture di Busseto*, Parma 1819, pp. 57-58; E. Seletti, *La città di Busseto*, Milan 1883, vol. I, pp. 150-151; N. Pelicelli, *Busseto*, Parma 1913, p. 89.

206
Mattia Preti (1613-1699)
**Presentation of Jesus
in the Temple**
17th century
Oil on canvas
190 × 130 cm
Catanzaro-Squillace, church of Santa Barbara in Taverna

The painting depicts the Madonna kneeling, Saint Joseph standing, and the aged Simeon holding the divine Child delicately in his arms. Other figures can be seen in the middle and to one side and serve as wings to the sacred representation. The sacred group stands out against a bare and dark background; the light, entering at an angle, brings out the colours and bestows a sense of profound spirituality on the figures.
The canvas is one of Mattia Preti's finest. Known as the "Cavalier Calabrese", the artist was born in the small town of Taverna in the province of Catanzaro, in 1613, and worked in Rome, Modena, Naples and Malta, where he died in 1699. He is rightly considered one of the greatest Italian painters of

the 17th century. The *Presentation*, which is reminiscent of the works of the artist's full maturity, shows signs of the distant influence of Caravaggio in the transverse illumination and dark background, but there are also echoes of Correggio and Guercino. The picture was painted for the church of Santa Barbara in his native Taverna, and was followed by numerous others, sent at various times from Malta, where Mattia Preti lived for about forty years (and was made a Knight). On that island he was engaged in the grandiose decoration of the cathedral of Saint John of the Knights in La Valletta and in numerous commissions that arrived from every part of Italy.
In this canvas, the calm serenity, the profound spiritual content and the plastic consistency of the group, which is given a particularly solid appearance by the angle of the light, are a clear demonstration of the painter's great skill. His abilities were particularly apparent in the works of the period he spent in Naples (1653-60), when he – together with Giordano – brilliantly and audaciously renewed the whole of Neapolitan painting, above all with the great pictorial cycles of the church of San Pietro a Maiella and the seven votive frescoes (now destroyed) for the plague of 1656 that decorated the seven gates of the city.

Literature: B. De Dominici, *Vite de' pittori, scultori e architetti napoletani*, Naples 1742 (anast. repr. Bologna 1979); A. Frangipane, *Mattia Preti*, Milan 1929, pp. 82-83; A. Frangipane, *Inventario degli oggetti d'arte d'Italia*, vol. II, *Calabria*, Rome 1933, pp. 91, 93; C. Refice Taschetta, *Mattia Preti. Contributi alla conoscenza del Cavalier Calabrese*, Brindisi 1959; R. Longhi, *Scritti giovanili (1912-1922)*, Florence 1961; G. Carandente, *Mattia Preti a Taverna*, Milan 1966; M.P. Di Dario Guida, "Formazione e consistenza del patrimonio artistico delle chiese di Calabria", in *I beni culturali e le chiese di Calabria*, proceedings of the convention in Reggio Calabria-Gerace (1980), Reggio Calabria 1981, pp. 241-266; N. Spinosa, "Baroque et classicisme à Na-

ples dans la seconde moitié du XVIIe siècle", in *La peinture napolitaine de Caravage à Giordano*, Paris 1983; J.T. Spike, "La carriera pittorica di Mattia Preti", *Mattia Preti*, edited by E. Croce, Rome 1989, pp. 15-50; J.T. Spike, "Su una tela di Mattia Preti a Napoli nel 1658", in *Brutium*, LXX, no. 3 (1991). (R.M.D.)

207
Pietro Novelli (1603-1647)
Madonna and Salvator Mundi
c. 1634
Oil on canvas
90 × 83 cm
Palermo, church of Sant'Orsola

The painting was first numbered among the works of Pietro Novelli by Padre Fedele da San Biagio (1788, p. 177), who recorded its presence in the oratory of the confraternity in the church of Sant'Orsola. Lazzaro Di Giovanni (ms. 2QqA49, 1827, c. 109r), on the other hand, saw it "in the third chapel" on the right of the church and described it as a "very fine picture on a small canvas".
Agostino Gallo (1828, p. 60) attributes it to the late period of the painter's career.
Guido Di Stefano (1940, p. 39) compares the Madonna with the Benedictine one of 1634 where she is portrayed with Saint Scholastica. M.P. Demma (1990, no. II, 62, p. 314), however, is more inclined to believe that it is a late work.
Angela Mazzè (1990, p. 209) accepts the date proposed by Di Stefano, which remains the most plausible, and notes that the work presents "a Marian iconography that is unprecedented in Novelli's production".
The dimensions and subject of the painting are obviously determined by the requirements of the client, the confraternity of Sant'Orsola, which wanted it for the secluded but cramped environment of the oratory. Perhaps the desires of the client were also responsible for the unusual iconography and the 16th-century style, in which echoes of Bellini and Raphael are blended with the manner of van Dyck. These

elements, however, are typical of Pietro Novelli, the greatest Sicilian painter of the 17th century. He was born in Monreale in 1603, to Pietro Antonio, a painter and mosaicist who worked on the mosaics of that town's cathedral. In Palermo, the very young Pietro Novelli was a student of Vito Carrera from Trapani, who in 1619 was painting in the Royal Palace. It should be remembered that Caravaggio's *Nativity* had been in the oratory of San Lorenzo since 1608, but undoubtedly the most important event in Pietro's training was the visit to Palermo, however fleeting, of Anthony van Dyck. As Guido Di Stefano (1940) observed: "And from then on, and it could be said forever, the lessons of van Dyck, his elegant forms and dark tones, would form the essence of Novelli's art".
The sure line and balanced glow of the light tints that stand out strongly against a dark background are enlivened by the brilliant blues of Mary's cloak that is reflected in the terrestrial globe, whose central position makes it the fulcrum of the entire composition.
The broad and essentially pyramidal construction of the painting is matched by the both simple and majestic figures of the Child and the Virgin. The intense gaze of Jesus, directed at the observer, is softened by the absorbed and mournful look of the Mother, alluding simultaneously to the glory and the sorrow of the divine Family, like two pans of a balance whose needle is the slender scepter that points upward from the world to God.
Antonino Mongitore (ms QqC63, f. 210) wrote of the painter: "Pietro Monrealese [...] applied himself to painting [and] proved as excellent at painting on canvas as in fresco, and enriched the churches and palaces of Palermo with sacred pictures. [...] He was also a skilled architect, thereby deserving to be appointed Engineer and Architect of the Senate of Palermo and the Kingdom of Sicily for His Royal Majesty. During the riots that disturbed the serenity of Palermo he,

while accompanying the Captain of the city, [was] struck by an arquebus [and] to universal sorrow his life ended after three days on August 25, 1647".

Literature: P. Fedele da San Biagio, *Dialoghi familiari sulla pittura*, Palermo 1788, p. 177; L. Di Giovanni, *Le opere d'arte delle chiese di Palermo*, ms. 2QqA49, 1827, c. 109r, Palermo, Biblioteca Comunale; A. Gallo, *Elogio storico di Pietro Novelli*, Palermo 1828, p. 60; G. Palermo (Di Marzo Ferro), *Guida istruttiva per Palermo e i suoi dintorni*, Palermo 1858, p. 435; G. Di Stefano, *Pietro Novelli*, Palermo 1940, p. 39; A. Mongitore, *Memorie dei pittori, scultori, architetti, artefici in cera siciliani*, ms. QqC63, f. 210, edited by E. Natoli, Palermo 1977, p. 128; A. Mazzè, in G. Di Stefano, *Pietro Novelli il Monrealese*, Palermo 1977, p. 128, no. 504; M.P. Demma, in *Pietro Novelli e il suo ambiente*, exhibition catalogue, Palermo 1990, no. II, 62, p. 314. (M.C.D.N.)

208

Standard with effigy of the Madonna di Bonaria
17th century
Silk, gold and silver
40 × 70 cm
Cagliari, basilica of Nostra Signora di Bonaria

This standard from the treasury of the celebrated sanctuary of Bonaria in Sardinia is a typical work of Sardinian craftsmanship. The style of the Madonna's clothing, with its woven triangular pattern, is very interesting and clearly of Spanish derivation. This way of depicting the Madonna's cloak was very common in the Spanish empire, including Latin America, in the 17th century.
The standard was used to head the thanksgiving procession of slaves who had been ransomed by offerings collected from the faithful (see cat. no. 158).
The procession wound its way through the streets of Cagliari, from the cathedral to the sanctuary of the Madonna di Bonaria. (L.P.)

209

Sebastiano Conca (1680-1764)
Madonna and Child, with Saint Dominic and Saint Catherine
1732
Oil on copper
52.5 × 38.5 cm
Naples, Diocesan Curia

The work is the sketch for the great altarpiece of the same subject donated by the artist himself to the confraternity of the Santissimo Rosario at Gaeta in 1737.
Between the airy Neapolitan picture – with its light and transparent tones that, together with the flowing lines, create an elegant and refined effect – and the more terse composition of the altarpiece, with its classic pyramidal structure of 16th-century derivation, stand two other paintings: the canvas depicting the same subject in the church of San Sisto at Onelli, surrounded by *Mysteries* in ovals, and the one in the church of Sant'Anna at Benevento where the place of the Dominican saints is taken by Saint Louis Gonzaga and Saint Mary-Magdalen dei Pazzi, which has the same formal composition.
A comparison of these four works shows that it was in the painting in Naples that Conca came closest to the *rocaille* taste that was developing in the Naples region during the 1730s and 1740s. In fact, Conca's long and profitable stay in the capital followed the invitation from Vanvitelli to the painter, already advanced in years, to move to Naples to paint, among other things, a number of canvases for the Palatine chapel in Caserta. Unfortunately, these have come down to us in a more than fragmentary condition.
Conca's late activity in Naples was not objectively of the highest quality, although it has been undervalued by critics. Nevertheless, it marks an important stage in the artist's career.
Notwithstanding the repetitive nature of the formulae and stylistic features, which he had already developed in Rome, by the middle of the fourth decade of the century Conca had already shown himself to be the most accom-

modating interpreter of the tendency. This painting, while it does not yet display the stiffness of form and poverty of ideas of Conca's last years, provides support for this argument.
So Conca's formula went down well in Naples. Evidence for this comes from the large number of commissions, both public and private, that the painter received from the date of his definitive return to Naples, in 1752. He was almost certainly obliged to rely on the assistance of his studio to fulfill these orders, which did not improve the quality of his late output.

210

Giuseppe Bazzani (1690-1769)
Baptism of Jesus
c. 1760
Oil on canvas
187 × 128 cm
Mantua, Museo Diocesano

The work, which belongs to Mantua cathedral, is at present in the Museo Diocesano F. Gonzaga of that city. It was painted shortly before the artist's death. Laid aside and forgotten, it was rediscovered and restored in 1946 and put on show for the first time in 1950. The painter has strived to make clear the meaning of the Gospel story. At the moment of the baptism a new creation takes place: the light that comes from the Spirit causes a new humanity to emerge from the darkness of matter and of the human condition, the humanity that is revealed in the person of Christ.
The way he bows beneath the Baptist's hand speaks of the Saviour's twofold humility: he submits, that is, to the action of the Spirit as well as to the ministry of the Forerunner. (P.R.)

211

Giovanni Segantini (1858-1899)
The Bell Ringer
1879
Oil on canvas
140 × 70 cm
Trent, Museo di Arte Moderna e Contemporanea

Giovanni Segantini's *The Bell Ringer*, painted between 1879 and 1880, offers

a foretaste of the painter's symbolist leanings in the last decade of his life. In this painting, Segantini's classical realism gives way to a quest for elements that, although still based in reality, are chosen with an eye to their suggestivity: rather than a scene from real life it has the quality of a dream. It is clear that the place depicted in the picture is the bell tower of the church of Sant'Ambrogio, but it is an extremely generalized representation. This is accentuated by the single source of light, which the painter locates at the foot of the cross. It is a light that barely cuts through the gloom, leaving everything indefinite and lending a mystical quality to the scene. Significantly, Primo Levi sums up the work in a single phrase: "Red spot on black ground". There is also a drawing of the painting, made after the picture itself. Both painting and drawing are initialed at the bottom with the interlaced monogram G.S.
The present location of the drawing, of which a photograph exists, is unknown. (R.Z.)

212

Standard of Saint Ephysius
18th century
Cloth, gold and silver thread
93 × 88 cm (with frame)
60 × 60 cm (without)
Cagliari, parish church of Sant'Anna

On one side of the standard is depicted Saint Ephysius, patron of the city of Cagliari, and on the other the arms of the Royal House of Savoy, which ruled Italy prior to the foundation of the Republic in 1948.
In 1815 Victor Emmanuel I, who also bore the title of King of Sardinia, entrusted the standard to the 3rd company of his bodyguard. Later the standard was given to the last commanders of this company, Marchese Manca di Villahermosa and Count Sanjust di San Lorenzo. To honour the memory of the Blessed Amadeus IX, they donated it to the collegiate church of Sant'Anna, which has a chapel dedicated to this beatified member of the house of Savoy. (L.P.)

Glossary

Acheropita: from the Greek, meaning "not painted by human hands". It originally referred to images of Christ which had miraculously appeared on objects such as the veils of Kamuliana and Edessa, the latter of which is said to have been sent by Christ himself to the ailing King Abgar I. Subsequently the term came to be used for painted images of Christ (and eventually of the Virgin as well) which were believed to be possessed of miraculous powers. The oldest and most famous of these depict the Saviour realistically, his bearded face at once severe and infinitely merciful. Among them is the celebrated icon of Christ in the Sancta Sanctorum at the basilica of San Giovanni in Laterano in Rome, which is credited with having saved the city in the 8th century from Agilulfo and his Lombard warriors (*Liber pontificalis*, ed. Duchesne, I, p.443).

Antependium: from the Latin, meaning "hung in front". The term used in the late Middle Ages for the cloth which covered the front of the *mensa*, or Communion table. Eventually it was extended to the fixed decoration on the front of the altar. By the 4th century, the altar had come to be commonly decorated with precious metals, as is attested by the *Liber pontificalis* in its descriptions of the Constantinian basilicas. The same source records, in the life of Pope Zachary (741-752), antependia which cover two, and sometimes all four sides of the altar. In the mosaics of San Vitale and Sant'Apollinare in Classe in Ravenna, the altars appear bedecked instead with luxurious fabrics. Among the earliest antependia, it is worth noting the three magnificent examples in Sant'Ambrogio in Milan (9th century), and those at the cathedrals of Aquisgrana and Basel (the latter of which is now at the Musée Cluny in Paris). The iconography of antependium decoration was based at first on the theme of Divine Majesty, but by the 13th century, the story of the Passion prevailed. The practice of conducting the mass with the celebrant turned toward the altar limited the relevance of figurative decoration:

while the antependia of pontifical altars retained the importance of figuration, standard altar types began to tend toward purely decorative motifs.

Altar cross: in the 4th century, the cross, by then a universal cult object, made its entrance into the liturgy. It was placed above the altar, on the Communion table, or at the centre of the ciborium (see entry).

Baldachin: from *Baldacco*, the medieval Italian name for Baghdad. A cloth of precious material, mentioned in ecclesiastical inventories beginning around the 11th century. As the name indicates, the baldachin originated in Baghdad, and then later came to be manufactured in the West. The same term was used for a draped, tent-like canopy that was either propped up by four stiff poles or hung from above. A baldachin can be permanent or moveable. However, insofar as the concept of the baldachin seems to be connected to something fragile, it would thus be more appropriate to use the term ciborium (see entry) for the more solid, permanent type. Gian Lorenzo Bernini's structure over the main altar of Saint Peter's in Rome is very close to the concept of the baldachin. Here, the traditional ciborium is replaced by a true *baldacchino* – that is, an architectural element is replaced by a largely pictorial one.

Bookbinding: the procedure which fixes the sequence and protects the pages of a codex or a printed book. The art of bookbinding, necessitated by the transition from the scroll to the codex, was born in the Coptic monasteries of Egypt around the 2nd century A.D. The papyrus (see entry) pages of the first books were bound with layers of papyrus glued between them, and a cover of leather sewn with laces that held the pages together. The bindings of the parchment (see entry) manuscripts of the Middle Ages became more solid, with sturdy panels of wood fastened to the spine by leather straps. By the 4th and 5th centuries, the binding had itself become a precious ob-

ject. The 6th century saw the great development of the liturgical book and, consequently, of the art of the book cover, which became especially rich in the Carolingian period. After the turn of the millennium, book covers came to be decorated in enamel as well. There followed a phase of decline, culminating in the 13th century, at which time the art of bookbinding, in part because of the laicization of the book, was reduced to simple covers made from inferior leather.

Candelabrum: a decorative support with two or more arms, to which candles are attached. The placement of candelabra beside sacred images and portraits of the dead dates back at least to the 4th century, at which time the *Liber pontificalis* records Constantine's donation of gold and silver candelabra to the basilicas of Rome. The same source also mentions candelabra with multiple arms supported by floral structures called *lilia*, in use until the 9th century. In this period the candelabra were placed on the floor at the sides of the altar. They were realized in precious metals and richly adorned with pearls and gems. After the 11th century they were placed directly upon the altar and their size was consequently reduced. Some miniatures (see entry) tell us that candelabra were also placed by the Stations of the Cross. Their forms and materials seem not to have been determined by liturgical prescription, but rather by their specific function or location.

Candlestick: a stand which holds a single candle, in contrast to the candelabrum (see entry), which holds more than one. The use of candlesticks dates back to the very beginnings of the Christian liturgy, connected as they are with the symbolism of light. The late 5th-century *Statuta Ecclesiae antiquae* in fact prescribes, in the ceremony of initiation into the order, that the presiding acolyte should hold in his hand a candlestick with a large candle. The first liturgical candlesticks derive without variation from the Roman era. The oldest examples of funereal can-

dlesticks are comprised of a stem resting on three or four feet, surmounted by a cup. The most basic form of the candlestick documented from the early Christian era – feet, stem, a small bowl to catch the wax, and a mount for the candle – became more elaborate over time, introducing for example animal forms to the feet. The type of candlestick composed of a circular or polygonal base, with or without feet, and a slender stem interrupted by one or more protruding ornaments called "knots", is the type that was perpetuated over the following centuries, and which survives to this day.

Catacombs: from the post-classical Latin *catacumbae*. Subterranean tunnels, often of multiple levels, with niches and burial vaults cut into the walls, used by the first Christians as cemeteries and secret meeting places. The etymology of the word is unclear: it is probably derived from a Greek expression meaning "near the crypts", used to describe a cavernous depression in the ground between the second and third mile of the Appian Way, where the basilica of San Sebastiano would eventually be erected. This site, discovered in the early 20th century, was one of the most important Christian cemeterial complexes in Rome, highly venerated in memory of the apostles Peter and Paul. The term "catacomb" came thus to designate any underground Christian cemetery, more so in Italy than in other parts of the Empire, but above all in Rome, where the pliant terrain lent itself to the excavation of extensive tunnels, sometimes with multiple levels and running several kilometres. Into the walls of these tunnels (called *cryptae* by the early Christians) were cut the rectangular holes that functioned as tombs, covered with brick or marble slabs, disposed horizontally and stacked in as many tiers as the height of the wall would allow. The tunnels open in some cases into chapels (called *cryptae* or *cubicula*) which may have contained the remains of a martyr, or were used simply for secret liturgical ceremonies.

Cathedra: the seat of the bishop located at the rear of the apse in the first Christian basilicas, clearly a derivation of the seat used by the magistrate in the pagan basilicas. A symbol of great dignity among the pagans, it assumed the same significance for the Christians, as is evidenced by their custom of representing Christ enthroned in such a chair in catacomb paintings, and their veneration of the *cathedrae* of the apostles and the first bishops in the earliest Christian churches. In the oldest basilicas, they would have been classical in structure, and fashioned of precious materials.

Censer: a vessel of silver or silver-plate in which incense is burned during religious ceremonies.

Chalice: the vessel used for the conservation of the wine in the liturgical celebration of the Eucharist. Most likely, the chalice was originally an ordinary drinking cup, used by the pre-Constantinian Christians in the services they held in their homes. Subsequently the decoration became more refined and the materials more precious, but the basic form never changed: the cup is joined to the foot by a protruding ring (called a knot), and ornamented in various ways. Chalices are most commonly made of gold or silver, and are often embossed or engraved with figural decorations in low relief (*anaglyphs*).

Chasuble: from the Late Latin *casubla*, meaning "travel garment". A liturgical garment which is usually ornamented, worn by the priest in the celebration of the mass and in certain rites directly connected with it. It derives from a type of Roman overgarment common in the 4th and 5th centuries (called a *paenula* or *amphibolus*) in the form of a cape or mantle closed on both sides, with an opening for the head. The first chasubles maintained this form, but eventually it was modified for practical reasons: it was shortened and opened up at the sides, and eventually came to assume the present scarf-like form of a scapular.

Chorale: a liturgical book of large format, oftentimes decorated with miniatures (see entry), which contains the parts of the daily offices meant to be sung. Chorales were widespread after 1300, though we do have some earlier examples as well. They are often written in Gothic script (Gothic chorale), with strong, solid bindings which are not infrequently decorated with precious metals and enamel. Depending on its specific function in the liturgy, a chorale might be called by any of several names: antiphon, gradual, pontifical, or psalter.

Ciborium: from the Latin *ciborium*, meaning "Egyptian bean" and referring to a type of cup whose form is reminiscent of a bean pod. A marble tabernacle on four columns which shelters the altar in Christian basilicas. It was sometimes hung with curtains between its columns, which at certain moments in the liturgy would close the altar from the congregation's view. As a symbol of divinity and a means of protection, the ciborium was known in some Near Eastern civilizations, but was most important in the Jewish liturgy. The earliest Christian ciborium seems to be the one recorded in the *Liber pontificalis* from the Constantinian basilica of San Giovanni in Laterano in Rome. Representations on ancient medallions show that, in the earliest period, the ciborium had two basic forms: one with a roof of two sloping sides, and the other with a vaulted roof. The ciborium saw many variations in the art of Byzantium, and throughout the Middle Ages. Sometimes the ciborium also functioned as a reliquary (see entry).

Colobium: from the Greek, meaning "truncated". A tunic worn by the first Christian monks, which was either sleeveless or short-sleeved.

Cope: from the Latin *cappa*, meaning "raincoat". Liturgical vestment in the form of a great cape, with an open front secured at the chest by a clasp. The cope was always made of precious material, though its colours varied according to the rite for which it was used. It was worn in certain formal ceremonies such as consecrations, benedictions and processions, but never during the mass. It came into liturgical use during the 8th century, and was universally adopted in the 11th century.

Crèche: the term, which in the strict sense refers to an animal stall or a trough, is commonly used to indicate the representations of the birth of Christ which are displayed in churches and homes during the Christmas season. The crèche has its origins in liturgical representations of Christmas Eve, like the famous crèche of Greccio from which Saint Francis took inspiration in the year 1223. The oldest surviving crèche is that of the basilica of Santa Maria Maggiore in Rome, a work by Arnolfo di Cambio, located in the so-called Cappella del Presepio, which since the 7th century had been the locus of a cult devoted to the cradle of the Redeemer. The crèche had become extremely popular by the second half of the 15th century: large-scale figures in wood or terracotta were arranged before a painted backdrop, which was subsequently displaced by landscapes carved in relief. In Naples, the crèche developed into a true art form, as is shown by the precious example kept in San Giovanni a Carbonara (1484). The 17th and 18th centuries saw the richest flowering of this art, during which time the crèche became an occasion of spectacular scenographic compositions.

Crozier: a long staff ending in a spiral, an attribute of bishops, abbots and abbesses. Its precise origins are uncertain, though it may derive from the Jewish pastoral tradition, symbolizing the judicial and doctrinal power exercised by bishops and abbots in their capacity as "shepherds of souls". The forms of the first pastoral staffs were various. It was not until the 11th century that the spiral, or scrolled, type came into standard use. By the end of the 11th century the spiral had come to be decorated with tiny sculptural groups, depicting Saint Michael and the dragon, the Annunciation, the *Agnus Dei*, figures of saints, or scenes of battling animals. In the Gothic era, floral and vegetal decorations were added to these figural groups. Structurally speaking, the crozier is composed of a wooden or metal pole terminating in a cap, into which the finial is inserted or screwed. Just as the forms of the crozier were various, so were its materials – the first staffs were usually made of wood, and then came to be made as well of cast silver, ivory (especially in the Romanesque and Gothic periods) and copper.

Dalmatic: a garment originating in Dalmatia, entering into use throughout the Roman Empire by the 2nd century, above all in the East and Africa. It took the form of a calf-length tunic with wide sleeves that distinguished it from the colobium (see entry). Worn over the tunic itself, the dalmatic was trimmed along the borders and decorated with red disks. Though it was born as a luxurious ecclesiastical vestment, it became over time a garment of common use, while continuing to function as a means of distinguishing oneself in public. After a tenure of papal exclusivity, it was allowed to be worn by deacons, for whom it became the standard vestment by the 12th century. Bishops wore the dalmatic during the high mass, under the chasuble (see entry).

Die: a type of stamp used in metalwork. Made of hardened steel, it carries in the hollow of one end designs, inscriptions or figures which then appear in relief when stamped onto the surface of an object. Generally, it is fitted to the chassis of a minting press, or to a press used for stamping finished objects. The die came to be used particularly for the minting of coins and medallions, in which case a separate die bearing the design of the opposite face would be attached to the anvil beneath.

Dome: architectural structure created by the complete rotation around the

vertical axis of a circular or parabolic arch. The dome is generally placed upon a circular architectural element called a drum, and joined to a polygonal structure beneath by means of pendentives. There are examples of pseudo-domes in Cretan and Mycenaean art (Atreus' Treasure, 14th century B.C.) and in the funerary architecture of the Etruscans. It was not until the Roman era, however, that the perfect solution was found for constructing a dome on a monumental scale, thanks to the discovery of the technique which anticipated the use of concrete cast over a wooden armature. The most celebrated example in Roman architecture is without doubt the dome of the Pantheon (built in the 1st century B.C.; rebuilt by Hadrian in the 2nd century A.D.). In the 5th and 6th centuries, domes were built in Ravenna with lightweight terracotta shingles, laid one on the other, forming a dome of overlapping rings which was closed from the exterior with a polygonal drum. Interesting solutions were also discovered in the East, particularly in the churches of Constantinople and the Muslim mosques. Brunelleschi's design for the dome of Santa Maria del Fiore in Florence marks a great turning point in the history of this architectural element, signalling the end of the medieval era and the beginning of the Renaissance.

Enamel: a vitreous substance made from a mixture of silicates and alkaline borates, with the addition of opacicizing agents and coloured pigments. Enamel was kiln-fired onto ceramic and metal objects as a covering or a decoration. In the sense in which it is used today, the word "enamel" appeared relatively late: from antiquity to the high Middle Ages it was called by the generic name *vitra*. It seems that vitreous substances intensely coloured by metallic oxides were first known in the fabrication of transparent glass, which requires the elimination of the natural colour of the materials through a complex process of purification and cleaning. Two different procedures were used during the Middle Ages for

enamelling objects: *cloisonné* and *champlevé*. In *cloisonné*, the enamel fills the grooves and channels formed by fine bands of metal applied onto the object's surface, creating a design, while in *champlevé* the enamel fills a design that has been cut directly into the metal surface. This latter process, recorded by the Romans, was certainly in use by the beginning of the Christian era, even if few examples survive. *Cloisonné* made its appearance later, and became the predominant enamelling technique until the Romanesque period. Also of notable importance is Byzantine enamel work, which reached its greatest flowering in the 10th and 11th centuries, gracing almost every kind of ecclesiastical furnishing, and applied to secular objects as well. Extending across a sheet of precious metal, on which were laid the fine filaments of gold that circumscribe the finished design, Byzantine enamel, noted for its intensity of colour, exercised enormous influence over western European enamel until the Carolingian era.

Engraving: the term refers to both the art of incising designs into a hard surface and to the finished products of that art. Engraving can be an end in itself, serving along with other techniques as finished decoration, or it can be used for reproduction onto other materials. The main purpose of an engraving, in the strict sense of the word, is to be reproduced in multiple copies on paper by means of a press. The engraving can either be incised or in relief: in the first case, the incised grooves are filled with ink, while in the second case, the ink is applied to the raised surfaces which have not been cut. For incised engravings, copper, zinc and steel are the metals most commonly used, and the print is produced using a copperplate press. Relief engraving, on the other hand, is done on wood and printed typographically, which makes it particularly suitable for the decoration of books. The various processes of metal engraving can be grouped into three categories: that which is cut directly by hand; that

which makes use of the properties of corrosive substances; and that which utilizes electricity. Engraving on wood is also called xylography (see entry).

Evangelistary: a liturgical book containing selections from the Gospels to be read during the mass. The richness of the decorations and miniatures in the oldest evangelistaries qualify many of them as exceptional works of art.

Filigree: the technique of braiding and joining, with the aid of a silver and borax solder, fine filaments of precious metal. In application to papermaking, the term refers to the transparent (though still visible) mark left by the network of metal threads stretched over the frame that receives the wet paper pulp. Used by paper manufacturers to distinguish their products, these marks are useful to us as a means of dating the paper itself.

Holy Shroud: a linen drapery with which the Jews often wrapped their dead. The term has come to be used almost exclusively for the cloth which, according to the three synoptic Gospels, was used to wrap the body of Christ prior to his entombment. The first notice of the Holy Shroud dates back to the 7th century, attesting to its presence first in Jerusalem and then in Constantinople. During the Middle Ages, many churches claimed to possess the Holy Shroud. One of these shrouds remains to this day in the cathedral of Turin, where it has been since 1573 (in 1453 it came into the possession of the dukes of Savoy). The Turin Shroud is a single piece of linen cloth (4.36 x 1.10 m) which bears on both front and back the imprint of the body of a man who was approximately 1.78 metres tall. After extensive and sophisticated examination, it was agreed that the shroud had indeed been used to wrap a human body.

Icon: in Byzantine art, a sacred painted image isolated on a wooden panel for purposes of veneration. The faces of Christ, the Virgin, and the saints were represented according to an

iconographic canon regulated by the Church Fathers, utilizing techniques which foretell the widespread use of natural earth pigments. Icons also came to be considered an integral part of the liturgy, because the miracle of Incarnation – the assumption of visible form on the part of the Saviour – was seen as being as important as his Word.

Ivory: an organic material used since prehistoric times for sculpture, engraving and jewellery. The most precious type is taken from the tusk of the elephant, as it is far superior in colour and density of grain to that of the hippopotamus or the walrus – though walrus ivory imported from northern Russia was widely used in the Middle Ages. Ivory was a favoured material for ecclesiastical furnishings and for small, intricately carved diptychs, the relatively easy datability of which provides invaluable assistance in reconstructing the stylistic history of this art form.

Jubilee, or Holy Year: from the post-classical Latin *iubilaeum*, derived from the Hebrew *yobel*, or "year of the goat horn", as the beginning of the celebration was announced by a horn. Year during which the pope granted formal plenary indulgence to those who performed certain pious acts. Mosaic law states that every fifty years the earth should be left to rest, and in this same period the rich are obliged to return to the original owners all the land that had been taken from them, and all slaves are granted freedom. In honour of this Jewish tradition, the year of indulgence proclaimed by Pope Boniface VIII on 22 February 1300 was given the name "jubilee". The same pope established that the jubilee should fall every hundred years. In response to a petition submitted in 1342 to Clement VI by the people of Rome, the interval was changed to fifty years. During the later tenure of Sixtus IV, it was further cut to twenty-five years. The jubilee year begins in Rome at the first Vesper services of Christmastide with the opening of the Holy

Doors of the four main basilicas. Throughout the course of the jubilee year, the faithful pass through these doors hoping to obtain indulgences. In addition to the *giubileo ordinario*, or fixed jubilee year, the Church has been known to declare in times of particular difficulty a *giubileo straordinario*, which is an unscheduled, or "extraordinary" jubilee year.

Lectionary: from the Latin *lectionarium* or *lectionarius*, derived from *lectio*, *-onis*. A liturgical book containing scriptural excerpts from the Old and New Testaments, with the exception of the Gospels, to be read during the mass. The lectionary takes the name *capitulary* when it contains only the beginning and end of each excerpt, and either *comes* or *liber comicus* when it contains the whole. There also exist lectionaries which collect separately the Epistles and the Gospels: these were used only for the high mass, generally in the cathedrals and the abbey churches. Written with exceptional calligraphic care and illustrated with miniatures (see entry), early lectionaries can be useful tools for the study of sacred texts, allowing us to reconstruct their tradition.

Mandilion: from the Byzantine Greek term, equivalent of the Latin *mantelium*. According to a tradition dating back to the 4th century, there was conserved at Edessa a piece of linen which had come in contact with the face of Christ, and upon which his image had been miraculously impressed. The legend goes on to tell of Christ sending the cloth to the gravely ill King Abgar I, in order to induce his recovery. In 944 the miraculous *mandilion* was brought to Constantinople, where it was venerated until 1204. During the period of the crusades, the mantle was lost without a trace. Subsequently, claims to possession of the mandilion were made by Genoa (the icon conserved at San Bartolomeo degli Armeni since the 14th century) and Rome (the icon of San Silvestro in Capite, presently in the Vatican collections).

Mausoleum: from the Latin *mausoleum*. Term originally used for the monumental tomb of Mausolus (377-353 B.C.), ruler of Caria, erected in the centre of the city of Halicarnassus and considered by the ancients to be one of the seven wonders of the world. Begun by the architects Satiro and Pitide while Mausolus was still alive, the construction of the grandiose monument was carried on by Artemesia, his wife and sister. At her death in 351 B.C., the sculptural decoration was still not yet completed. According to the most plausible reconstruction, the tomb would have had a square floor plan and a high base, on which was raised an Ionic colonnade which supported at its vault a pyramid of twenty-four steps surmounted by a quadriga with statues of the king and queen. This design was repeated in a series of minor monuments in the Mediterranean and Near East, to which we now refer by this term. Coined originally for the tomb of Mausolus, it has come to be used for any monumental tomb, such as those of Augustus and Hadrian in Rome, or those of Theodoric and Galla Placidia in Ravenna.

Miniature: from the Latin *minium*, from which is derived the verb *miniare*, or "to paint with cinnabar or red lead". The type of painting used, particularly in the Middle Ages, to illustrate handwritten books. Miniature painting, or manuscript illumination, is like mural painting in that it must decorate a flat surface, and is thus a fundamentally two-dimensional art, characteristic of an age which by the 5th century had lost track of the ability to create the illusion of three dimensions, regaining it only in the 15th century. The purpose of the miniature is to accompany a text as a sort of figurative translation, an age-old function going back to the scrolls of ancient Egypt. Miniatures have illustrated manuscripts since Hellenistic times, but our knowledge of their earliest forms are based entirely on written descriptions, inasmuch as the oldest preserved illuminated manuscripts belong to the 4th century A.D. In addi-

tion to being an invaluable means of preserving ancient iconographic traditions, miniatures also serve as important measures of stylistic innovation, as is demonstrated, for example, by the great historiated initials of Insular manuscripts (7th-8th centuries). Partly because of the circumstances of survival, but also because of the importance given to painted miniatures, one can say that our knowledge of medieval painting is essentially founded on illuminated manuscripts.

Mitre: ceremonial hat with an elongated bicuspid form. The origins of the mitre are uncertain, though the writings of the Church Fathers do mention hats being worn by bishops and priests. The mitre was adopted by bishops as a result of a specific concession by the pope, and seems to have entered into its current use after the turn of the millennium. The form of the mitre has undergone various modifications over the centuries: originally it was a low, rounded cap, which was later creased at the center to form two horns (at first round and then pointed) which are the precursors of the two cusps that characterize the definitive form. In the original type, the horns were disposed at the sides, while the present form maintains them at front and back. The first mitres were made of canvas with gold braids. Over time, they became more extravagantly decorated with gold and silver *lamé*, embroidery and precious stones.

Model: the term referring to any actual object which an artist intends to reproduce, either in the same or in different dimensions. In sculpture, it also applies to the exemplar (or study) of a work, made in clay, plaster, wax or other media, which serves as the basis for the execution of the finished version. In ancient and medieval times there existed organized catalogues of models for painters and sculptors. They offered various compositional and decorative schemes, or studies of isolated details, with the aim of assisting the artist in the execution of his work.

Monstrance: from the Latin *monstrare*, meaning to show. A container for the display of the consecrated host. This practice was born in the late Middle Ages in response to the affirmation of the doctrine of transubstantiation. The vessel used for the display of the Sacrament derives its form from reliquaries (see entry). Given the analagous relation of a saint's relic with the consecrated host – a relic of the body of Christ – it is not surprising that the host was originally placed in a separate compartment of a reliquary that may also have contained a relic. The forms of the first monstrances, therefore, did not differ much from those of the pyx (see entry) and certain other reliquary types. It was during the 15th and 16th centuries that the monstrance found its own distinct range of forms, which can be divided into four categories: tower-shaped, disc-shaped, cruciform and with figures. Only the first two types have been maintained. Silver and gold are the materials most common to the monstrance, though sometimes gilt copper and, very rarely, engraved and gilt wood were used.

Mosaic: from the medieval Latin *musaicus*, or *musaeus opus*, alterations of *musaeus*, derived from *Musa*. A decorative technique consisting of the reproduction of a preliminary design using small fragments (called "tesserae") of stone, ceramic or glass, applied to a solid surface with mastic or cement. By extension, the term came to be used as well for the decoration resulting from this technique. The origins of mosaic are ancient: traces of encrustations of vitreous enamel dating from the first dynasty have been found in Egypt, where the technique reached its greatest heights during the reign of Ptolemy. It seems that the art of mosaic was imported to Italy from Egypt, though some scholars are presently re-evaluating the influence of the Orient on the development of the mosaic in western Europe. The first examples of floor mosaics in classical Greece are from the 5th-4th centuries B.C. – these are largely monochrome stone mosaics with subtle colouristic suggestions.

The first mosaics made with marble tesserae came later, during the Hellenistic era. In the 1st century B.C., the Roman floor mosaic (*pavimentum mosaicatum*) had definitively developed the use of regular, more or less square tesserae, borrowing geometric motifs from Greek art and then going beyond to incorporate elements of architectural decoration. This type reached its highest level of refinement in the first Imperial era, with the appearance of polychrome floor mosaics representing grand pictorial compositions in the Hellenistic tradition. The two-coloured mosaic continued to flourish as well, enjoying an uninterrupted development until the 4th century A.D., making as much use of geometric and floral motifs as of a fantastic repertoire of fish, tritons, nereids and sea monsters. In the Christian epoch, the mosaic became the principal ornament of the churches: the mosaic technique, intrinsically tending towards schematization, was ideally suited for the expression in abstract forms of the new religious concepts. Italy conserves a number of monumental mosaics from this period, which distinguish themselves from Byzantine mosaics insofar as they represent an unbroken link to the late-antique tradition.

Mother of God: tradition holds that the first icons of the Virgin were made by Saint Luke, who is said to have painted her on three occasions during her lifetime. These three portraits done by Luke constitute the three fundamental types of Marian icons. The first is the *Eleusa*, or the Madonna of tenderness, which tradition explains as depicting the gesture of intense affection exchanged between the Madonna and Child at the moment he reveals to her his future death and resurrection. The face of the Madonna carries a mixed expression of love, sadness and serene acceptance of the divine will. The second canonical type, called *Odeghitria* (meaning "the one who shows the way"), represents the Virgin holding the Child on her left arm, indicating with her right hand "the Way, the Truth and the Life".

The Christ Child, already given the features of an adult, holds in one hand the scroll of the Law, and with the other imparts a gesture of benediction. The third type, called the *Virgin Orant*, is an image of the Madonna without the Child. Instead, she turns towards his implied presence with arms raised in supplication, interceding on behalf of the faithful. A variation on this type, called the *Madonna of the Sign*, depicts the Virgin frontally with arms raised, wearing a medallion at her breast bearing the image of Christ Emmanuel – that is, the Saviour in his pre-incarnational state.

Nave: the lengthwise division of a church, from the portal to the main altar. More generally, the term refers to any interior architectural space demarcated by aligned rows of roof supports, such as columns or pilasters.

Navicula: a container for incense in the form of a little boat. The navicula was widely used in the 14th and 15th centuries, superseding other forms. It was usually made of precious metals, sometimes with enamel decoration. Some rare examples survive which are made from crystal, semi-precious stones, or with a nautilus shell serving as the cup. The navicula is composed of a circular or polygonal foot, a stem, the boat-shaped cup, and a lid with two symmetrical flaps, hinged at the center.

Necropolis: from the Greek, meaning "dead city". The term originally designated the subterranean sepulchres of the Egyptian city of Alexandria, but is now used by archaeologists to indicate any group of sepulchres from the pre-Christian period. For the Christian era, "cemetery" is the preferred term. Given the importance that many ancient civilizations attributed to cults of the dead and to belief in the afterlife, the burial complexes called necropoli have always been archaeology's richest source of testimony and documentation of the cultures that built them.

Niello: from the Latin *nigellus*, dimin-

utive of *niger*. The jeweller's technique of incising a gold or silver surface with a burin, and then filling the grooves with a black compound (also called niello) made with red copper, pure silver, lead, yellow sulfur and a bit of borax. Upon contact with the incised metal which has been pre-heated, the niello dissolves and penetrates the incisions. After cooling, the superfluous niello is wiped away, and the design stands out in black against the smooth polished surface of the metal. In the Renaissance, small niello plaquettes were frequently used to decorate chalices (see entry) and monstrances (see entry).

Obelisk: from the Latin *obeliscus*, Greek *obeliskos*, diminutive of *obelos*, or "spear". A type of commemorative monument from ancient Egypt, characterized by a slender and elongated quadrangular form ending in a pyramidal point. The pharaohs usually erected obelisks in pairs, placing them at the entrances of temples to commemorate the thirty-year jubilee. On the four faces were carved orders of protocol, royal pronouncements and dedications to divinities. The stone used for obelisks was generally syenite, though there are some rare examples in basalt. In the quarry, the obelisk was first worked on three sides; holes were drilled along the fourth side at intervals of at least 75 cm, into which were inserted wooden wedges which were then moistened, whereby the swelling of the wedges would break the obelisk free of the rock. The inscriptions were carved at the quarry, and the finished obelisk was then transported to its destination by way of the river. The tallest existing obelisk is the one that lies, still incomplete, in the quarry of Assuan (41.75 m), followed by that of the Piazza San Giovanni in Rome (32 m). Many obelisks were brought to Rome in the Imperial age; one went as well to Constantinople during the reign of Theodosius. In the 16th century, Pope Sixtus V re-erected many of the obelisks that had long lay fallen in the streets of Rome.

Odeghitria: see entry Mother of God

Pantocrator: meaning "omnipotent", or "he who is capable of all things". The name given to Christ in the eastern Church as ruler of the world. The image of the Pantocrator – the bust of Christ in formal benediction – derives from portrayals of the Saviour on medallions which were widespread in Early Christian art, appearing in the 5th century and assuming particular importance in Byzantine art. The image spread especially to the mosaic decoration of the domes and main apses of churches, where Christ, his right hand in a gesture of benediction, proclaimed the power of God-Man over the cosmos, holding in his left hand a book, open or closed, symbolizing the new Law he brings. His circular nimbus is inscribed with a cross, on the arms of which one reads the three Greek letters that signify "He who is".

Papal throne: the seat from which the pope conducts his duties. The medieval form of the throne derives from the proto-Christian *cathedra* (see entry). The most common type of throne, as attested by medieval iconographic sources, was that of a folding chair made from wood or metal, similar to the Roman *sella curulis*. The folding chair was followed by a more bench-like seat, derived from examples in stone. The canopy under which the pope would sit was reduced over time to a small half-dome, and eventually became a part of the throne itself. While in the Romanesque period the thrones were frequently covered in precious metals and gems, Gothic examples were more likely to have sculptural decorations.

Papyrus: a marsh plant cultivated in Egypt and, at least since the 6th century A.D., in Sicily. Papyrus normally reaches a height of three to four metres, and from its long stalk is extracted a material widely employed throughout antiquity for writing. Pliny the Elder left a detailed account of the method of preparing papyrus (*Naturalis historia*, XIII, 11, 71-72): the stalk of

the plant, peeled beforehand, was cut into thin longitudinal strips (*phylirae*) which were then stretched one next to the other, with a margin of overlap, on a wet board. On the quadrangular sheet thus obtained was placed another layer of strips disposed transversally. This double sheet (called a *plagula*) was then pounded and left to dry in the sun. Approximately twenty of these sheets were required to make a scroll, with care always being taken that the fibres of each *plagula* were parallel to those of the adjoining one. It was in this form that papyrus came to be traded, its price varying according to its quality. We know that in the Roman epoch the best papyrus were the types called *ieratica* and *amphiteatrica*, which were particularly compact, smooth and white. New types were introduced in the Imperial era – *augustea*, *liviana*, and *claudia* – which were especially luxurious in their extra length (between 24 and 29 cm as compared to the 20 cm of *ieratica*). Papyrus of lower quality was called *emporeutica*, and was often used merely as wrapping paper. The length of the scrolls (called *volumina*) was variable, and they were designed to be written on only one side (examples of scrolls with text on both sides are very rare). The fibres on the recto, or front side, ran vertically such that the alignment of the script, disposed in columns, was the same as that of the fibres. To each scroll was attached, at the beginning or the end, an ivory or wooden rod, and to that was added a strip of leather bearing the title of the work written on the scroll. The scrolls were wrapped, and then sealed in large *capsae* or *thecae*, or simply placed in open racks. By the 2nd century A.D., papyrus was also used to make books in the familiar codex format: sheets of papyrus were assembled in fascicules, and then sewn and bound together. Between the 2nd and 4th centuries A.D., this new form of the book gradually replaced the scroll, and papyrus, too fragile to withstand the stress of folding and sewing, was quickly superseded by parchment (see entry). In addition to being used for literary writings, single sheets of papyrus were used for documents as well – in fact the oldest surviving Greek writings on papyrus are a fragment of the *Persians* by Timotheus (4th century) and a matrimonial contract from 311 B.C. The use of papyrus for documents continued into the Middle Ages and began to disappear only when the Arab invasions interrupted normal contacts between East and West.

Parchment: the skin of certain animals specially prepared for writing. Parchment was widely used throughout the Middle Ages, as much in the West as in the Greco-Byzantine world. According to tradition, parchment was invented in Pergamon in the 2nd century B.C. in order to sidestep the embargo on the export of papyrus (see entry) from Egypt. However, this account reported by Pliny the Elder (*Naturalis historia*, XIII, 11) has no basis in fact. Ancient documentary sources, among which is a 20th-dynasty Egyptian scroll (1195-1085 B.C.), tell us instead that the use of animal skin as a writing surface is much older and more widely spread among different civilizations. According to the standard medieval prescription, parchment was prepared by leaving the detached hide in lime for three days; once the hair and impurities had been removed with a curved scraper, it was stretched over a frame and left there to dry. Further treatment assured the smoothness of the parchment: the more carefully these operations were carried out, the more difficult it would be to distinguish the flesh side from the hair side. Parchment was made from the skin of goats and sheep, or from that of calves (particularly prized was the skin of an unborn calf). Though we have numerous written accounts (Cicero, Horace, Martial) of the use of parchment in Roman book production, the oldest actual surviving fragments date only to the 3rd century A.D. By the 4th-6th centuries A.D., it was common to colour parchment destined for luxurious manuscripts with purple dye, as is evidenced by the purple-coloured manuscripts in both Greek and Latin that survive from the 5th and 6th centuries. Parchment dyed in this way came back into fashion, as a means of imitating late-antique models, in the Carolingian scriptoria (see entry) – and, in a few exceptional cases, during the Humanistic age. Parchment from the book production centres of Great Britain (Insular parchment) is most characteristic of the High Middle Ages: thick and rigid, it is greyish in colour and slightly fuzzy to the touch.

Pensile cross: along with the introduction of the altar cross (see entry) came the practice of suspending a cross, usually one of great preciousness, above the altar. It is often treated as a votive offering, donated to the church by high ecclesiastical and lay authorities.

Processional cross: a cross which is carried in procession, either at the end of a staff or by an extension of the vertical arm of the cross itself. The practice of opening liturgical ceremonies with a procession led by a cross is ancient, and witnessed by innumerable sources. The first such crosses were not mounted on a staff, but carried in hand, as illustrated in the famous mosaic of San Vitale in Ravenna of the *Procession of Justinian*, wherein the bishop Maximian carries a golden jewelled cross. Later, the cross was attached to the end of a pole (or *asta* in Italian, from whence comes the term *croce astile*). Among the oldest examples of *croci astili* are the so-called Desiderius cross, which dates from 756-774, and the later silver-gilt cross (9th-11th centuries) at the museum in Cividale.

Processional standard: a processional banner of moderate or large dimensions, generally composed of a rectangular cloth attached to a pole. The standard, also called a gonfalon, is a descendant of medieval war flags, and was used as an emblem by municipalities by the Church, by confraternities and by religious organizations in general. The rectangular cloth of the standard is woven from linen, cotton or hemp, and in some cases might be made of silk or velvet. It hangs from a horizontal rod, which is in turn attached by cords to one or two vertical poles. Less frequently, it is fixed directly to a single vertical staff. The standard may be decorated with figures of the Virgin, the saints, or with the insignia of the group that carries it. All these decorations were either painted, embroidered or executed in *appliqué*.

Purse: from the post-classical Latin *bursa*, meaning "little sack". A quadrangular container, no longer in use, for the corporal cloth. The purse, or *borsa*, is made of two rigid panels, usually of a heavy paper, lined on the inside with silk or linen, and decorated on the outside with textiles related colouristically to liturgical vestments. It is closed on three sides and trimmed with braided cords and tassels at the corners. On the front are various kinds of decoration, either painted or embroidered. The purse, with the corporal inside and a veil draped over it, was used to cover the chalice and the paten during the transfer from sacristy to altar, and vice versa.

Pyx: sacred vessel used for the storage of the consecrated host. Containers with this specific purpose have existed since the earliest days of Christianity, although their forms, dimensions and functions have varied. In the 11th century the use of the pyx was standardized, such that it could serve no other purpose than to contain the body of Christ. At the beginning of the 13th century the form of the pyx changed from that of a small cylinder to a vessel with a foot – at first low and round, then higher and more geometrically complex. The cup and the cover also gained in complexity, assuming in the Gothic period rather elaborate forms, often decorated with enamel. By the end of the 16th century, the type of pyx comprised of a foot, a stem, a broad cup, and a rounded cover surmounted by a small cross had become firmly established as the definitive form.

Reliquary: a container varying in form and materials (though always precious) for the conservation of sacred relics. A relic can be the mortal remains of a saint, or any object associated with his or her life, work or martyrdom. The practice of venerating such relics goes back to the origins of Christianity, and seems to have been linked to the cult of the martyrs.

Reliquary "a busto": (or "in the form of a bust") a reliquary type documented as early as the 10th century in the cathedral of Clermont, but which did not become widespread until the 15th century and after. Basically, it is an evolved form of the reliquary *a testa* ("in the form of a head"), comprising an entire bust down to the waist, or sometimes to the shoulders. The earliest examples are wooden structures covered with precious metal, usually silver. The base was more often sheathed in a less valuable metal such as copper, which eventually may have been gilded. Later examples can be made either of solid silver, cast and engraved, or of less noble materials such as wood or *papier maché*. The relic was housed inside the head, or, as has become the practice in recent years, in a small compartment sealed in glass, set into the front panel of the base.

Reliquary "a cassetta": (or "small box") a medium-sized container, usually less than 50 cm, in the form of a rectangular box closed by a flat lid. The materials used for their fabrication might be silver, copper, bronze or wood, or perhaps engraved and painted ivory.

Reliquary "a croce": (or "cruciform") the term refers to any container for relics taking the shape of a cross, which are comparable to altar crosses, pensile crosses, and processional crosses. Reliquaries containing fragments of the True Cross are called *staurothecae* (see entry).

Reliquary "a teca": a covered container for relics which may or may not allow one to directly view the relic through one or more transparent sides. Called *capsae* or *capsellae* in the early sources, they belong to the most ancient typology of reliquaries. The materials used to make them varied among metals, wood, ivory and stone.

Reliquary "improprio": (or "improper") this term refers to containers used not for genuine relics, but for materials – like sand from the Holy Land, or oil burned at the grave of a martyr, or the substances said to have seeped from the tombs of the saints – to which popular devotional consensus had attributed miraculous or apotropaic powers. More accurately, they are part of the tradition of the so-called *eulogiae* (benedictions), and belong among the devotional objects associated with pilgrimages.

Sacramentary: a liturgical book used by the Church until the 10th-11th centuries which contains the parts of the mass to be read by the celebrant (prayers and prefaces), along with the procedural formulae followed by bishops and priests in the administration of the sacraments and other celebrations of the liturgical year (extraordinary functions). After the 10th-11th centuries, the sacramentary was replaced in part by the missal, in part by the pontifical, and in part by the ritual. Among the earliest surviving sacramentaries is the Leoniano, or Veronese (named after the library in which it was discovered in 1713), written in the second half of the 6th century. Also worthy of note are the *ancient Gelasiano* sacramentary, of which we possess the archetype (Reg. lat. 316); the *Gregoriano* (attributed to Gregory the Great) which was compiled between 592 and 595; and the 8th-century sacramentary also called the *Gelasiano*, which is in fact a composite of the original version and the *Gregoriano*.

Sarcophagus: from the Latin *sarcophagus*, meaning "he who eats meat". A funerary urn made of stone, marble or terracotta, often decorated in high or low relief, widespread in classical antiquity and the Middle Ages. The use of sarcophagi goes back to the earliest Egyptian dynasties, where they would be ornamented in some instances with architectural motifs, or the effigies of the deceased. Greek sarcophagi were made of wood or earthenware, characteristic examples of which are the trapezoidal sarcophagi of Clazomene (6th century B.C.). Soon after, the first marble versions appeared, which were architectonic in structure, and decorated with reliefs, cornices and acroteria. In Etruria, the prevailing type through the 6th and 5th centuries B.C. was the triclinial sarcophagus, which bore carved effigies of the deceased couple on its cover. In the 3rd century B.C., Roman sarcophagi were made from stone in the form of an altar, sometimes with a Doric frieze. The popularity of the practice of cremation during the Republican era and the beginning of the Imperial era limited the production of sarcophagi for a time, but it picked up again around the 2nd century A.D., with the sarcophagus now taking a more coffin-like form, with a flat cover and frontal decoration. The first Christian sarcophagi did not differ greatly from their pagan models: the earliest and most significant examples are the sarcophagi of Via Salaria in Rome (no. 181, Museo Lateranense) and La Gayole, in Brignoles. In the following period, Christian sarcophagi tended toward a common compositional format: at the centre, among scenes alluding to the theme of salvation, was set the figure of the Good Shepherd, or of the Orant, which eventually became through symbolic substitution the portrait of the deceased. Beginning in the 6th century A.D., sarcophagi from the workshops of Ravenna and Milan had acquired a rigid architectural format. Throughout the Middle Ages the sarcophagus remained bound to late Imperial models, while the Renaissance witnessed a return to the examples of classical antiquity as the primary sources of inspiration.

Scriptorium: a term referring as much to the room within a religious institution where codices are produced as to the institution itself (the scriptoria of Corbie, or Monte Cassino, and so on). Some scriptoria were actually schools of calligraphy, where a graphic master would guide disciples in the execution of a canonical script. In many cases, however, a scriptorium was simply a place where any devotee capable of writing would copy existing texts to the best of his ability, without the formal guidance of a master.

Staurotheca: a Christian reliquary in the form of a cross (or sometimes a rectangular box with a cruciform receptacle) in which is conserved a relic of the True Cross. Numerous examples of this type of reliquary have come down to us, especially from the 5th-10th centuries. They are made from precious materials like gold, silver and ivory, and are richly ornamented. Some are particularly small in scale, as they were meant to be worn around the neck.

Tiara: the crown worn exclusively by the pontiff. Since the 8th century the pope had worn during processions a conical cap of white cloth edged with a band of gold. In the 10th century, it assumed the form of a crown, to which a second level was added under Boniface VIII, and then yet a third at the beginning of the 14th century. The resulting triple-tiered crown came thus to be called the *triregnum*, with all the attendant symbolism of the triune power – imperial, royal, sacerdotal – of the pope. The aforementioned conical cap remained in use through the 13th century, and then began to widen toward the top, eventually becoming fully round, and more ample than the base. This transformation allowed room for sumptuous decorations of engraved precious metals and gems, while the summit was crowned with a small cross.

Tunicle: liturgical vestment of the subdeaconate, similar in form to the dalmatic (see entry).

Veneration icon: usually a sacred image on a small panel used to usher in

302

the "peace" – that is, the kiss which initiates the Communion. The kiss of peace, traditionally a Jewish greeting, was adopted by the early Christians as a sign of fraternity and reconciliation. It was maintained in the liturgy of both the Roman and western Churches until the 13th century, whether exchanged among the clergy or the congregation. Around this time, the veneration icon came to replace the exchange of a kiss or embrace at the moment of the Agnus Dei. The earliest examples were made of stone, wood or terracotta, while in the 15th century they tended to be made of metal. After a period of widespread use, from the 15th through the 18th century, it fell into disuse.

Xylography: the technique of engraving on hard wood, usually with the aim of printing the resulting relief design. Any number of types of wood can be used, so long as they are hard and densely grained. Fruitwoods are ideally suited for this technique, but for the most delicate work, boxwood is preferable. There are two different techniques of xylography which correspond to the two different ways of working the wood: *di filo* (with the grain parallel to the cutting surface), and *di testa* (with the grain perpendicular). The preparation of a woodblock to be cut with this latter technique is a particularly delicate operation, since one must laminate together numerous small pieces of endgrain in order to make a panel of sufficient size. Far less problematic is the *di filo* technique, as it is not difficult to find single boards of the desired dimensions.

Photographic Credits

Aurelio Amendola, Pistoia; Sergio
Anelli, Electa, Milan; Archivio
Alinari, Florence; Archivio
Fotografico dei Musei Vaticani,
Vatican City; Archivio Fotografico
della Biblioteca Apostolica Vaticana,
Vatican City; Archivio Fotografico
della Reverenda Fabbrica di San
Pietro, Vatican City; Archivio
Fotografico della Soprintendenza ai
Beni Artistici della Basilicata,
Matera; Ernani Arcoarte, Turin;
Antonio Bisca, Ravenna; Giuseppe
Bonetti, Benevento; Enzo Brai,
Palermo; Elio Ciol, Casarsa della
Delizia - Pordenone; Franco Marini,
Rome; Marco Ravenna, Correggio -
Reggio Emilia

Printed for Electa
by Fantonigrafica - Elemond Editori Associati